Fourth-Century Styles
in Greek Sculpture

WISCONSIN STUDIES IN CLASSICS

General Editors

Richard Daniel De Puma and Barbara Hughes Fowler

Fourth-Century Styles in Greek Sculpture

Brunilde Sismondo Ridgway

THE UNIVERSITY OF WISCONSIN PRESS

The University of Wisconsin Press
114 North Murray Street
Madison, Wisconsin 53715

Copyright © 1997
The Board of Regents of the University of Wisconsin System
All rights reserved

5 4 3 2 1

Printed in the United States of America

Publication of this volume has been made possible in large part through the generous support and enduring vision of Warren G. Moon

Library of Congress Cataloging-in-Publication Data
Ridgway, Brunilde Sismondo, 1929–
 Fourth-century styles in Greek sculpture /
Brunilde Sismondo Ridgway.
 498 pp. cm.—(Wisconsin studies in classics)
 Includes bibliographical references and index.
 ISBN 0-299-15470-x (cloth: alk paper)
 1. Sculpture, Greek—Themes, motives. 2. Sculpture, Hellenistic—Themes, motives. I. Title. II. Series.
NB90.R565 1997
733.3'0938—dc20 96-41949

In memory of Warren G. Moon
(1945–1992)

Contents

Plates ix
Illustrations xiii
Preface xv

1 Greek Sculpture in the Fourth Century 3
2 Architectural Sculpture on the Mainland 25
3 Architectural Sculpture in the East (Non-Greek) 78
4 Architectural Sculpture in the East (Greek) 111
5 Original Reliefs: Funerary 157
6 Original Reliefs: Votive, Mythological, Document 193
7 The Issue of the Great Masters 237
8 Lysippos: A Case Study 286
9 Random Harvest 321
 Conclusions 364

 Bibliography 375
 Credits for Plates 390
 Selective Index 391

Plates

At the end of the book

1. Dexileos' Stele, Athens, Kerameikos Museum P 1130
2a–d. Yalnızdam Stele, Antalya Museum: (a) Side A; (b) Side B; (c) detail of Side A; (d) detail of Side B
3. Bassai, Temple of Apollo, metope, London, BM 512 (Madigan 1992: Pronaos 1.1, no. 45, pl. 15)
4. Bassai, Temple of Apollo, metope, London, BM 517A (Madigan 1992: Opisthodomos 5.1, no. 35, pl. 12)
5. Bassai, Temple of Apollo, metope, London, BM 519 (Madigan 1992: Opisthodomos 6.2, no. 43, pl. 14)
6. Bassai, Temple of Apollo, frieze (Centauromachy), London, BM 525 (Madigan 1992: no. 134, pl. 43)
7. Tegea, Athenaion, helmeted head from west pediment (without restorations), Athens, NM 180
8. Ephedrismos group from Tegea (without restorations), Rome, Conservatori Museum 1465
9a–b. Maenad (akroterion), front and back, Oxford, Ashmolean Museum 1928.530
10. So-called Aura (akroterion), Copenhagen, Ny Carlsberg Glyptotek 2432
11. Running peplophoros, akroterion from limestone Athenaion (?) Delphi Museum 8605
12. Nereid Monument from Xanthos, east façade, as presently reconstructed in London, British Museum
13. Nereid Monument from Xanthos, podium friezes 1–2, as presently reconstructed in London, British Museum (corner view)
14. Nereid Monument from Xanthos, frieze 2, west façade, London, BM 877 (Childs/Demargne 1989, pl. 60.1)
15. Nereid Monument from Xanthos, frieze 2, north side, London, BM 876L (Childs/Demargne 1989, pl. 65.2)
16. Nereid Monument from Xanthos, frieze 2, south side, London, BM 869 (Childs/Demargne 1989, pl. 48.1)
17. Nereid Monument from Xanthos, frieze 2, west façade, London, BM 868c (Childs/Demargne 1989, pl. 65.1)
18. Nereid Monument from Xanthos, frieze 3, north side, London, BM 886/893 (Childs/Demargne 1989, pl. 128.3)

Plates

19 Nereid Monument from Xanthos, frieze 1, north side, London, BM 857 (Childs/Demargne 1989, pl. 32.1)
20 Nereid from Xanthos, Nereid Monument, north side, London, BM 909
21 Nereid from Xanthos, Nereid Monument, north side, London, BM 911
22 Nereid from Xanthos, Nereid Monument, west façade, London, BM 912
23 Akroterial figure from Xanthos, Nereid Monument, east façade, London, BM 919 (Childs/Demargne 1989, pl. 151.1)
24 Trysa Heroon, Land Battle frieze, west wall (left side, interior), Vienna, Kunsthistorisches Museum
25a–c Trysa Heroon, City Siege sequence (Troy?), west wall (center, interior), Vienna, Kunsthistorisches Museum
26 Halikarnassos Maussolleion, Amazonomachy (podium) frieze, London, BM 1020–1021
27 Halikarnassos Maussolleion, Amazonomachy (podium) frieze, London, BM 1006
28 Halikarnassos Maussolleion, so-called Maussollos, London, BM 1000
29 Halikarnassos Maussolleion, horse from crowning quadriga, London, BM 1002
30 Funerary loutrophoros, Athens, NM 808 (foot, neck, and handles restored; cf. Kokula 1984, 200, Cat. O 30, and p. 130 n. 55)
31 Funerary Stele of Damasistrate, Athens, NM 743
32 Stele of a warrior, Athens, NM 834.
33 Stele of Two Warriors, Moscow, Pushkin Museum
34 Funerary stele with family scene, Athens, NM 870
35 Funerary stele, New York, Metropolitan Museum of Art 11.100.2, Rogers Fund 1911
36 Stele of Mnesikles, Princeton University, The Art Museum y86.67, Fowler McCormick, Class of 1921, Fund
37 Funerary Lion, Chaironeia, Greece
38 Stele of Hegeso, Athens, NM 3624
39 Stele of Mnesarete, Munich Glyptothek, GL 491
40 Stele of Kallisto, Athens, NM 732
41 Stele of Krinylla and family, Philadelphia, University of Pennsylvania Museum MS 5470
42 Stele of a young girl, Princeton University, The Art Museum y204, Gift of Mrs. Ernest Sandoz
43 Young girl, Providence, Museum of Art, Rhode Island School of Design 13.1478, Gift of Mrs. Gustav Radeke
44 Funerary stele, Philadelphia, University of Pennsylvania Museum MS 5675

Plates

47a–b	Sarcophagus of the Mourning Women, two views, Istanbul Archaeological Museum 368
48	Modern ex-votos in the grotto of St. Rosalia, Monte Pellegrino (Palermo)
49	Votive relief to Amphiaraos from Oropos, Athens, NM 3369
50	Votive relief to Asklepios, from south slope of Akropolis, Athens, NM 1377
51	Votive relief dedicated by Eukles, from the Vari cave, Athens, NM 2012
52	Battle relief, New York, Metropolitan Museum of Art 29.47, Fletcher Fund 1929
53	Votive relief with Birth of Asklepios, from south slope of Akropolis, Athens, NM 1351
54	Votive relief to Asklepios, from Epidauros, Athens, NM 173
55a–c	Tribune of Eshmoun, Sidon: (a) three-quarter view; (b) left side; (c) rear
56	Diskobolos (by Naukydes?), Rome, Capitoline Museum 1865
57	Diskobolos (by Naukydes?), Vatican Museum 2349
58	Ganymede and the Eagle, Vatican Museum 2445
59	"Pothos," Rome, Conservatori Museum 2417
60	Head of "Pothos," Würzburg, Martin von Wagner Museum
61	Frenzied Maenad, Dresden, Albertinum und Staatliche Kunstsammlungen 133
62	Eirene (and Ploutos), by Kephisodotos, New York, Metropolitan Museum of Art 06.311, Rogers Fund
63	Hermes and Child Dionysos, from theater at Minturnae, Naples, Museo Nazionale 155747
64	Hermes of Olympia, view of back, Olympia Museum
65	Hermes of Olympia, detail of head, Olympia Museum
66	Aphrodite Knidia, by Praxiteles, Vatican Museum 812, detail of head, right profile
67	Variant of Knidian Aphrodite, Munich, Glyptothek GL 258
68	Herakles Farnese, Naples, Museo Nazionale 6001
69	Herakles Epitrapezios, from Villa del Sarno, near Pompeii, Naples, Museo Nazionale 2828
70	Herakles Epitrapezios, Paris, Musée du Louvre MA 28
71	Sandalbinder (Hermes) from Perge, Antalya Museum 3.25.77
72	Sandalbinder, unfinished, Athens, Akropolis Museum 2192
73	Dancer, Berlin, Staatliche Museen SK 208
74a–c	Bronze Athena from the Peiraieus, Peiraieus Museum, various views
75	Classicizing Peplophoros, rear view, Boston, Isabella Stewart Gardner Museum
76	Athena, Rospigliosi Type, from Velletri, Florence, Uffizi 185

Plates

- 77 Artemis from Gabii, Paris, Musée du Louvre MA 529
- 78 Armed Aphrodite, from Epidauros, Athens, NM 262
- 79a–c Demeter from Knidos, London, BM 1300: (a) detail of front; (b–c) views of head from rear
- 80a–b Apollo Kitharoidos Patroos (by Euphranor?), Athens, Agora Museum S 2154; (a) right profile; (b) detail of torso
- 81 Hermes from Andros, once Athens, NM 218 (now Andros Museum 245?)
- 82 Hermes of Richelieu type; Providence, Rhode Island School of Design Museum, 03.008, Gift of Mrs. Gustav Radeke
- 83a–d Bronze Youth from Antikythera Wreck, Athens, NM 13396: (a) front; (b) detail of torso, front; (c) detail of torso, back; (d) face
- 84a–c Bronze Youth from Marathon, Athens, NM 15118: (a) front; (b) reconstruction by R. Carpenter; (c) reconstruction by R. Heidenreich
- 85a–e Bronze Boxer from Olympia, Athens, NM 6439
- 86a–b Bronze krater from Derveni, Thessaloniki Museum: (a) full view; (b) detail of shoulder figure

Illustrations

1 Dexileos' family plot, reconstruction 4
2 Dexileos' family plot, plan 5
3 Mazi Athenaion, reconstruction of Zeus and giant, from east pediment 31
4 Mazi Athenaion, reconstruction of goddess and giant with wolf-head helmet, from east pediment 32
5a–b Epidauros, Asklepieion, reconstruction of west (a) and east (b) pediments and akroteria 35
6 Delphi, Tholos, reconstructed elevation 42
7 Delphi, Tholos, section through elevation 43
8 Epidauros, Tholos, reconstructed elevation 46
9 Epidauros, Tholos, section through elevation 47
10 Xanthos, Nereid Monument, reconstruction of west façade 80
11 Xanthos, Nereid Monument, reconstruction of north side 85
12 Trysa, Heroon, plan 90
13 Trysa, Heroon, drawing of doorway, interior side 91
14 Limyra, Heroon of Perikle, reconstruction of north façade 95
15 Limyra, Heroon of Perikle, reconstruction of north akroterion (Perseus and Medousa) 97
16 Halikarnassos, Maussolleion, groundplan 115
17a–b Halikarnassos, Maussolleion, reconstructions by G. Waywell 116–17
18a–c Halikarnassos, Maussolleion, reconstructions by K. Jeppesen (east, west, and south sides) 118–20
19 Priene, Athenaion, reconstruction of pteron coffers in place 137
20 Priene, Athenaion, reconstruction of coffer with Kybele and giant 138
21a–d Dresden Maenad, reconstructions 256
22 Villa del Sarno, plan, with indication of findspot of bronze Herakles 301

Preface

Students who have used my books on the various phases of Greek sculpture have often asked me why I chose to write on the third century B.C. (the first Hellenistic century) before I wrote on the fourth, thus breaking the chronological sequence of my survey. In so doing, I was keeping a promise made to a younger scholar, from which I have been released. I have now therefore written on fourth-century Greek sculpture, and I must admit that I am indeed grateful for this unintentional delay. Many important monuments have been officially published in the interim, and my own approach to ancient art and culture has been sharpened by continuous discussion with colleagues and students from different institutions and, especially, from my own, who have not spared me their criticism and constructive questioning. Moreover, through my teaching, I have benefited from ideas and problems raised in the context of seminar discussions, so that I feel a true indebtedness to the participants, who are here acknowledged.

The first outline for this book was conceived as a series of six lectures for the University of Aberdeen in Scotland, delivered from October to December 1989 as part of the Geddes-Harrower Visiting Professorship in Classical Archaeology at that institution. Each presentation was followed by a class meeting, in which I had the opportunity to answer questions and clarify or expand on some of my points. I want to thank the students who attended faithfully both lectures and classes; in particular, I wish to acknowledge here the warm reception given to me by the members of the Classics Department at Aberdeen, especially Professor Patrick G. Edwards, and all those in Scotland who made my stay there so memorable.

In the Spring of 1992, together with Professor Kim Hartswick, I gave a Bryn Mawr graduate seminar on monumental bronzes, in which the following students participated: Alexis Castor, Kerri Hame, Sean Hemingway, Susan Jones, Tom Milbank, Kalliopi Prekas, Jami Terry, and Sian Wiltshire. Some of their reports touched on the fourth-century pieces mentioned in this book. One more graduate seminar at Bryn Mawr College, in the Fall of 1993, focused on fourth-century architectural sculpture; the participants were Alexis Castor, Christine Cummings, Sean Hem-

Preface

ingway, Niki Holmes, Meredith Kato, Mireille Lee, Tom Milbank, Terrance Rusnak, Sian Wiltshire, and Blake Woodruff. I am glad to record here my gratitude to all of them.

Finally, in March 1995, I delivered a series of four lectures in the Hanes-Willis Series for the Department of Art of the University of North Carolina at Chapel Hill. These were specifically focused on the parts of this book I had already written and on those I planned to write. I took with me the completed text of the first six chapters, which was made available to the audience of my lectures. In particular, Mary C. Sturgeon, chair of the Art Department, former student, and close friend, was responsible not only for the initial invitation to give the lectures and for great hospitality, but also for reading those chapters carefully, catching errors and commenting on ideas. I am most grateful to her for providing me with this excellent opportunity to present my thinking to a wider and so well informed public.

Others deserve my thanks in this context; I have tried to acknowledge their contribution individually at appropriate points in this book, but some of them need special mention. C. Arnold-Biucchi, S. G. Miller-Collett, J. J. Pollitt, and R. A. Stucky provided access to special publications that would otherwise have been unavailable to me. W. A. P. Childs read Chapter 3 and gave me the benefit of his extensive knowledge of Lykian monuments and bibliography. Alice A. Donohue read the section of Chapter 4 that deals with the Maussolleion, on which she had expressed some thoughts during a lecture she delivered at the National Gallery of Art (Center for Advanced Study in the Visual Arts) in Washington, D.C., in January 1994. Joan Reilly read Chapter 5 on funerary reliefs because of her special expertise on that subject. Mark Fullerton read the entire manuscript, providing important comments that made me rethink some of my positions. Finally, G. Roger Edwards continued to serve—as he has now done for several years—as my most important intellectual mentor, source of scholarly information, bibliography, and general inspiration, critical reader of every page, and encouraging cheerleader.

W. A. P. Childs, W. Jashemski, M. J. Mellink, A. Pasquier, and C. A. Picón generously helped me with illustrations. R. A. Stucky lent me his irreplaceable photographs of the Tribune of Eshmoun, despite the current inaccessibility of the monument they depict and the dangers of overseas mailing. I. Jenkins, M. Padget, and K. Vierneisel freely granted permission to publish photographs of objects in their museums (London, Princeton, and Munich respectively). The photographic collection of Bryn Mawr College, through the kindness of Carol W. Campbell, was again put at my disposal. Eileen Markson, head librarian for Art and Archaeology at Bryn Mawr College, and her assistant Carol Vassallo, answered innumerable bibliographical questions and provided much help. The excellent research resources of Bryn Mawr College are gratefully acknowledged.

It is customary, in a Preface, to point out personal failings and quirks of style. Inconsistency, as usual, is my major problem, especially in the transliteration of ancient names, for which I have tried to use the form of the language in which

Preface

they were originally written—except, as usual, for the few that have become too entrenched in common usage to allow me to do otherwise. I have given most scholarly references in abbreviated format, so that the Bibliography at the end of the book could serve as a general survey of significant publications on fourth-century art and sculpture; but works of more general import or of only passing relevance to my topic have been cited entirely in endnotes. Here again, consistency is not complete, but readers should be able to find all the references they might need. All dates should be understood as being B(efore) C(hrist), except when otherwise specified. In some such cases I have used the adjective Imperial; in others I have spelled out A(fter) C(hrist). I have used A(nno) D(omini) only when a precise year is involved. Finally, I have tried to use classical, in lower case, to refer to ancient Greek and Roman art and culture in general, and Classical, in upper case, when I meant specifically the fifth and fourth centuries B.C.

In terms of content, this book follows much along the lines of my previous publications on Greek sculpture. Inevitably, there is a certain amount of overlap with my earlier work on Hellenistic sculpture from 331 to 200 B.C., but I have consistently sought either to refine my previous positions or to update them. Regrettably, as bibliography increases, so does the number of my pages! I have tried to provide a great deal of information and subsidiary comments in the endnotes, which should be used to supplement my main text; they will also allow students who are so inclined to retrace my own readings, check my sources, and go beyond my positions. I consider these notes an integral part of this book, not simply a form of documentation. I have made extensive use of the photographic riches of the *Lexicon Iconographicum Mythologiae Classicae*, and I owe a real debt to the beautiful plates and extensive bibliographical captions of L. Todisco, *Scultura greca del IV secolo*. Consistent reference to these two publications (the latter's plates cited directly within the text, when dealing with the difficult field of types and Roman copies), and to A. Stewart's *Greek Sculpture* should facilitate investigation of the monuments beyond the more limited photographic commentary to my own pages that I was able to provide. [ADDENDUM: J. Boardman's *Greek Sculpture: The Late Classical Period* appeared after my manuscript was closed, but I have been able to insert references to his abundant illustrations before final printing. I have also benefited from a prepublication copy of C. C. Mattusch, *Classical Bronzes*.]

In my attempt to express my own opinion throughout, I trust I have made clear what can be considered factual evidence and what instead is personal speculation. A constant effort of my publications is to alert against excessive attributions and uncritical use of Roman evidence, even if this approach makes me a minimalist. I hesitated in writing the concluding section, because students have a tendency to take notes and consider each pronouncement final. I plead that they do not do so. Instead, I urge them to treat each idea as a building block, to be first examined and tested, and only then accepted for further construction.

In January 1994 I regretfully took early retirement from Bryn Mawr College in

Preface

order to devote myself to research and writing, and in hope of finishing my series of books on Greek sculpture; yet I have found that greater availability of time leads to extended reading and more leisurely writing. It has thus taken me longer than usual to complete this work, which I began in the Fall of 1993 and I officially close today. The computer, I trust, will allow me occasionally to bring it up to date during the editing stages, as time and press reviewers may require, but my basic research should be considered completed by the underwritten date. I want to thank the staff of the University of Wisconsin Press for their sustained interest in my work, and especially Elizabeth Steinberg and Jane Barry, old acquaintances from my previous publications, and most helpful readers and editors of my manuscript.

I cannot close without a biographical note: the grandchildren (grandsons!) are now two, my own children are still four, with the additions of two fine daughters-in-law, and my husband is still the mainstay of my professional and private life.

Brunilde Sismondo Ridgway
August 22, 1995 [final bibliographical update: February 11, 1996]
Bryn Mawr College

Fourth-Century Styles
in Greek Sculpture

CHAPTER 1

Greek Sculpture in the Fourth Century

In the spring of the year 394/3, at the age of 20, Dexileos, son of Lysanias, from the Attic deme of Thorikos, died in the Battle of Corinth, fighting for Athens against Sparta. A carved wide slab surmounted by a low pediment with painted palmette akroteria (Pl. 1) marked his cenotaph in the family plot at the Kerameikos cemetery in Athens, and its funerary inscription named him "one of the five knights," perhaps an elite corps charged with a special mission.[1] The relief shows Dexileos on his horse, rampant over a fallen enemy, in the act of thrusting a weapon at the naked foe. Dexileos, by contrast, wears a belted chitoniskos and a chlamys fastened over his right shoulder and fluttering against the background with clear tubular folds ending in zigzags and mannered omega-patterns. The enemy's baldric and the sword in his right hand, Dexileos' javelin, and his horse's reins were added in metal; the approximate carving of the horseman's hair, once thought to have been covered by a bronze wreath, is now considered hidden under a metal cavalry helmet, on analogy with the state relief commemorating the same military event (Athens NM 2744). Vivid colors on background and garments, perhaps even on the animal, and painted details on the human figures would have added to the visibility of the scene, meant to be seen from a distance as the stele stood on a tall, curving wall closing off the triangular space of Lysanias' family plot (Ill. 1). The monument is likely to have been erected shortly after Dexileos' death, perhaps within the same year.

Plate 1

Across the Aegean sea, at the site of Yalnızdam in modern Turkey, corresponding to ancient Lykia, a double-faced stele was accidentally found in a funerary context; it is now in the Antalya Museum (Pls. 2a–d).[2] Its suggested chronology is based solely on stylistic and iconographic grounds, but the monument should be at least 30 years later than Dexileos' stele. The slab is tall and narrow under a small pediment with (painted?) palmette akroteria. One side of the amphiglyphon shows a warrior on a horse rampant above a fallen enemy, in a composition so close to that

Plates 2a–d

Greek Sculpture in the Fourth Century

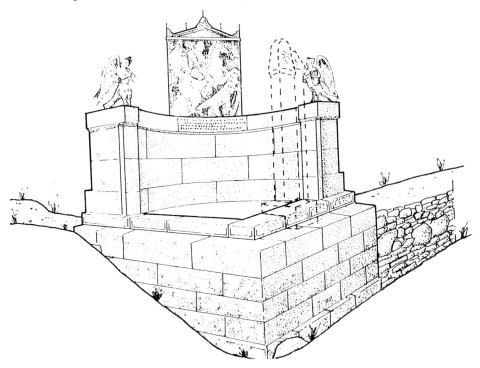

Ill. 1. Dexileos' family plot, reconstruction (after Ensoli 1987)

of the Kerameikos monument that some kind of relationship between the two should be postulated. Yet details vary, pointing out the non-Greek nature of the Lykian carving. Moreover, the opposite side of the gravestone has a depiction so far unparalleled within the Hellenic sphere, and of clear Eastern flavor: a bearded man wearing tunic and himation and leaning on a staff under his left armpit raises his right hand with palm outward; partly hidden behind him, a small boy in a long garment is frontally posed, holding an object now no longer discernible because of a break.

Together, these two reliefs—Dexileos' stele in Athens and the amphiglyphon from Lykia—may be said to embody the essence of fourth-century sculpture, not only at its inception, but also throughout its course. They symbolize the shift of emphasis from the Greek Mainland, especially Athens, to the non-Greek world of Asia Minor, in anticipation of the great expansion to the East promoted by Alexander the Great. Iconographic and stylistic parallels in Eastern monuments of the fourth century clearly demonstrate that the Greek cultural infiltration which we normally assume to have begun around 330 was already in full force by the turn of the century, and therefore independent of political events and military action. In addition, at least during the first five decades, Athens is no longer rebuilding and

Greek Sculpture in the Fourth Century

thus no longer at the forefront of sculptural and architectural progress, although its influence is strongly felt everywhere; its main production, in terms of surviving originals, is best represented by funerary monuments. The fervor of artistic activity within Greece is now centered in the Peloponnesos, where new sanctuaries rise and old shrines receive new forms. Because the two gravestones briefly mentioned above can stand for this new phase of sculptural production, they will be analyzed in detail, to set the foundations for a wider discussion of what constitutes fourth-century styles.

Dexileos' Stele

In its position within the triangular funerary plot, on the curved wall that formed the farther boundary, the gravestone of the young warrior dominated the enclosure (Ill. 2). Placed at the crossing point of two streets, one of them the second major artery through the Kerameikos cemetery (the so-called Street of Tombs), the plot stood considerably higher than street level. The wall supporting Dexileos' stele ended in two piers surmounted by marble musical sirens; the one playing the lyre (Athens NM 774) has survived virtually intact, although all its metal additions are missing; the second one is hypothetically restored as playing the pipes.[3] Together,

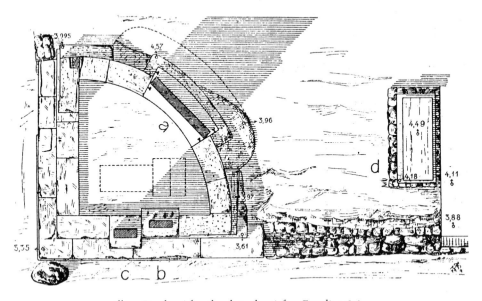

Ill. 2. Dexileos' family plot, plan (after Ensoli 1987)

these mythical creatures provided the funerary lament and expressed the grief absent from the stele itself, which stresses instead the moment of glory of the young horseman. This unearthly threnody for Dexileos perpetuated, in a sense, the *epitaphios logos* pronounced by public orators over the war dead.

The casualties of the Corinthian War (395–387) were commemorated by Lysias in a lengthy oration whose text has survived.[4] It is traditional in nature, but moving in its eloquence, and begins with a narrative of the previous glories of Athens. For our purposes, it is significant that the defeat of the Amazons, the city's role in burying the Seven against Thebes, and its help to the Heraklidai head the list of important events, as if these mythological episodes carried the same validity as the historical wars against the Persians and that against Sparta for which the oration was being delivered. It is therefore not surprising that Dexileos' stele should recall the first Parthenon metope of the west side, where the Amazonomachy was in fact depicted.[5] The fluttering mantle and the galloping horse lend to the relief a heroic quality comparable to the mythological narrative and probably functioned as a quotation in the eyes of the Athenian visitors to the grave. Given the fact that this was not Dexileos' true burial place, the monumental layout of the plot and its implications have given rise to the theory that the entire setting should be considered a heroon.[6]

Stylistically, Dexileos' stele is characterized by the same flamboyant and decorative style typical of the last decades of the fifth century. The horseman's short-sleeved chitoniskos adheres to his thigh with deep catenary folds that model the leg and reveal its profile contour against the roundness of the abdomen. The latter, outlined by the rich, curving kolpos, shows a hint of the navel; thus the same costume is rendered as both thick and diaphanous. The mantle displays the same tubular folds as the Nike Balustrade reliefs, including the small nicks and bends and the mannered endings at the hem.[7] The contrast between the "valleys" flat against the background and the widely spaced ridges has a pictorial quality that would have been enhanced by color; the curving outline, creating a virtual niche behind Dexileos' head, suggests rapid movement, yet the presence of the fallen enemy under the horse's hooves is incompatible with a full gallop. Both the chlamys and the horse's pose are therefore unrealistic ideograms and compositional devices. The vanquished foe is rendered in an effective foreshortened position, with a strong bend at the waist that recalls similar kneeling figures on the friezes of the Hephaisteion and the Nike Temple.[8] But stylistically, both his head and Dexileos' follow a new canon: smaller in proportion to the body, with narrower eyes more deeply set at the inner corner, thus lending the eyebrows a hint of upward tilt. Yet pathos is completely absent from the scene.

To judge from the traces (or lack of them) of metal attachments, Dexileos' weapon did not reach the enemy's body (similarly, as Clairmont has noted, in the state relief the hoplite threatens but does not actually wound his opponent). Yet the horseman is clothed, and it is the enemy who is rendered in what we tend to call "heroic

Greek Sculpture in the Fourth Century

nudity." This apparent reversal of traditional visual messages should make us reconsider, or at least nuance, our interpretations; in this case, nakedness may convey helplessness and future despoliation rather than innate strength and heroism. The action scene is also remarkable as compared with previous gravestones with more static and neutral iconography.[9]

Optical refinements in the facial features of both men and animal take into account the angle of viewing of the stele. The carving is quite high, so that the farther sides of the horse's and Dexileos' faces are also rendered, although in much less detail. Note that the depth of the relief is greater toward the center of the (straight) slab, as is common also in some earlier stelai, but this technique heightens the illusion of concavity produced by the curved base carrying the inscription and the semicircular wall on which it stood. The total monument, so carefully planned within the funerary plot, both attracted viewers and kept them at a physical distance, thus creating a certain isolation of the stele as well as its quasi-theatrical display.[10]

In summary, Dexileos' stele can be viewed in the tradition of fifth-century monuments, indeed as a quotation from some of them, which, however, had a religious (architectural) rather than a funerary nature; at the same time, it reflects a new canon of proportions in the size of the human head and the rendering of facial features. It combines pictorialism with plasticity, illusionism with the spatial three-dimensionality of the total setting, and it places the individual in a heroic context by virtue of its action-composition and its careful distancing of the viewers.

The Yalnızdam Stele

By contrast, we know nothing about the setting of this amphiglyphon, not even which side was considered the more important; we can only assume that all-around viewing was encouraged, given the presence of the two carved faces. There is no agreement as to the human figures: is the cuirassed rider in the Dexileos pose the same man as the one in civilian garb on the opposite side, or are they distinct individuals? I see them as two aspects of one person, the warrior and the citizen, with the connection made explicit through the long hair of both images. The rider seems beardless, and present damage prevents us from verifying the existence of a mustache; if clean-shaven, he may represent the man at an earlier stage in his life, and thus imply that, unlike Dexileos, he did not die in a cavalry encounter. The warlike setting of Side A would therefore serve exclusively to emphasize his valor and perhaps his contribution to the service of his country. The bearded man shown frontally on the opposite side (Side B) is clearly older, as suggested also by the presence of the small attendant. Whether Greek considerations apply, and the man's gesture and garb should be understood as priestly worship, is debatable, but its better parallels are found on Phoenician and Etruscan sarcophagi that may be supposed to have religious connotations.[11]

For all its imitation of a Greek prototype, the Lykian stele betrays its Eastern

Greek Sculpture in the Fourth Century

nature in many details. The rider wears not only chlamys, chitoniskos, and corselet, but also long Oriental trousers and tiara; a long sleeve is clearly marked on the right arm. The nudity of his opponent in this case may indicate a different nationality, perhaps Greek, although no allusion to a specific encounter between Ionians and Lykians need be read into the scene. The horse has a flaming topknot, as seen on Persian mounts. The relative lack of metal attachments is suggested not only by the absence of drill holes (only the horse's reins may have been added separately) but also by the rider's weapon, entirely rendered in stone. What the enemy held is less easy to see: his raised right arm is carved virtually into the horse's side, as is the right leg of the rider.

As a whole, the technical level of the sculpture is inferior to that of Dexileos' stele, and although the relief is high in places (the horse's head has the hint of the farther eye and ear), it is generally shallow and barely contained within the slab—on Side A, the animal's left front leg wraps around the flattened vertical edge and its hoof is carved on the side; the enemy's mantle is almost engraved onto the base fascia. The drill has been used to outline the right side of the horseman against the background, and foreshortening effects have been attempted; but the enemy's pose is quite awkward, with his left leg apparently terminating at the knee, and so is the horse's. Effects of drapery and features are obtained through linear patterns, and the chlamys fluttering behind the horseman has so few ridges that it requires close observation to be noticed, now that the color is lost. By contrast, the flaps of the rider's tiara and his loose curls wave against the background, but the effect is of disarray rather than of logical response to movement. Extensive weathering of the surface makes its reading more difficult.

The scale of the main figure on Side B seems larger, more space being obtained through a narrower bottom margin.[12] Also the relief level is higher, so that in profile the stele seems to bulge on this side, as contrasted with the flat outline of Side A. The bearded man's tunic under the himation is typical of Oriental garb, and the left foot, awkwardly rendered in full profile, wears a shoe ending in a recurved tip—a Near Eastern fashion. The right foot, frontal and foreshortened, overlaps the base line and denotes the free leg, with a suggestion of contrapposto at hip level. The young attendant, in his long robe, does not seem to rest on the same groundline as his master.

Here too the overall modeling is minimal, the patterns are linear, the man's frontal face with its long hair appears almost flattened, and the hair mass surrounding it looks artificial. The draping of his long mantle with the catch at the right ankle follows Greek plastic conventions, and so does the flattening of the material over shin and thigh; but the wavy folds bunched at the waist seem decorative rather than realistic, and the rendering of the tunic exaggerates the shape of the right pectoral.

In summary, the Yalnızdam stele presents a curious mixture of Greek and non-Greek iconography—Side A adds a touch of pictorialism through the wide space

Greek Sculpture in the Fourth Century

above the rider's head, but Side B uses the unusual frontal figure to dominate the field. It retains the formula of the pedimented top with akroteria, but the carving disregards the frame, which does not correspond from side to side. In the rendering of drapery, it superficially respects Greek conventions but turns them into calligraphy and decoration. It adds Oriental elements to the costumes, and shows faces as wider than the Greeks', although the fallen enemy of Side A seems a different breed. Its meaning, beyond its funerary context, cannot be fathomed, nor should it be surmised solely on the basis of Greek practices. We cannot reconstruct the route by which the "Dexileos motif" reached the Lykian site; certainly the amphiglyphon master was local, and not particularly talented, although the total monument would have been impressive in its original state; we can be sure that it was painted, on analogy with other Eastern sculptures.

DEFINING THE FOURTH CENTURY

The analyses of these two funerary monuments (the second somewhat lengthy because the Yalnızdam stele is still relatively unknown) have set the stage for a definition of the period. Should the fourth century be considered, at least in Greece and in the field of sculpture, as the logical continuation of the fifth, or as a break from previous conventions? Should it be called Classical or High Classical, or even post-Classical? Is it valid to bracket it between 400 and 331, as this book does, or should it be broken down into discrete phases, according to stylistic formulas?

If we take historical events as landmarks, some justification for the bracketing may exist. In 405 Athens suffered a major defeat at Aigospotamoi, and had to surrender to Sparta in 404, thus putting an end to the last phase of the lengthy and ruinous Peloponnesian War. To be sure, the Thirty Tyrants imposed by Sparta ruled only for a brief time, and as early as 403 Athens was able to reestablish a democratic regime that lasted until Demetrios of Phaleron seized complete power in 317. But the year 400 can be taken as an approximate date for the virtual disappearance of the city from the forefront of sculptural productivity. As Stewart sees it, continuity can be found only in "nonarchitectural relief: documentary, votive, and funerary."[13] At the other end, 331 marks the year of the Battle of Gaugamela, a site not far from the Tigris in Mesopotamia; this third encounter (after the Battle of the River Granikos in 334 and the Battle of the River Issos in 333) broke the force of the Persian resistance and can be said to have accomplished the original goal of Alexander's campaign: to avenge the Mainland Greeks and to liberate the Greeks of Asia Minor. It is, moreover, tempting to establish the symmetry with the date of the Battle of Actium, in 31 B.C.—which determined the end of the last Ptolemy, and thus the last descendant of Alexander's empire—and to bracket an exact 300-year span for the Hellenistic period.

Yet, as always, historical events as such seem to have little impact on sculptural production and style. Social circumstances can indeed influence types of sculpture

Greek Sculpture in the Fourth Century

and iconographic formulas, and victory monuments can be erected for specific commemorations, but no exact correlation can be established between "wars and kings" and stylistic development. Moreover, any focus on individual occurrences tends to imply that "the Greeks" were a monolithic unit, so that the defeat or victory of one city, even one as powerful as Athens, would affect equally the inhabitants of other poleis on the Mainland, let alone those of Asia Minor or Magna Graecia. That this is not the case can be shown by regional preferences and differences throughout the history of Greek art, and will become evident, it is hoped, by the end of this book.[14] Finally, should history still be considered important as providing secure dates in a sea of chronological approximations, other events could be chosen as significant: 394, when the Athenian fleet led by Konon could score a decisive victory over the Spartans at Knidos; 386, the Peace of Antalkydas (also known as the King's Peace) between Sparta and Persia; or 371, the Battle of Leuktra, which marked the end of Spartan supremacy and the beginning of the Theban hegemony. At the other end, 323, the year of Alexander's death, could seem more significant than 331, and is in fact taken by many as the true beginning of the Hellenistic period. Even Stewart, who presumably writes on sculpture by style, as suggested by the titles to his chapters 8–13 (covering the span from pre-600 to c. 430), focuses on history for the fourth century, breaking it down into c. 430–c. 360 (ch. 14, "The Peloponnesian War and Its Legacy"), c. 370–c. 330 (ch. 15, "Late Classic"), and c. 340–c. 310 (ch. 16, "The Age of Alexander").[15] It is clear that no obvious decision can be made on purely historical grounds.

In stylistic terms, the situation appears even more fluid. To cite only some of the more recent opinions, we have already seen that Stewart thinks of "Late Classic" as spanning solely the middle decades of the fourth century. Harrison has made a case for extending the late fifth-century style down to c. 375, and this position finds many supporters.[16] As for nomenclature and conception, some scholars would consider "Classical" the production of both the fifth and the fourth centuries; some call "High Classical" the span c. 450–430; whereas others think of the phase 400–330 as deserving that title; and Borbein, in the subtitle to his major 1973 article, has given it the name "Nachklassik." Marcadé sees fourth-century sculpture as largely the "development" (in the mathematical sense of the term) of tendencies of the previous century that artistic personalities like Pheidias and Polykleitos had overshadowed; Blanche Brown (1973) writes about *Anticlassicism in Greek Sculpture of the Fourth Century B.C.;* and Pollitt acknowledges a continuum from the early fourth century to the late first, with a break at the end of the Peloponnesian War.[17]

In view of these many, and often contradictory, opinions, it is important for me to set here the reasons for my choice of timespan and my definition of styles. As to the first, I take comfort in the fact that no advocate of historicity could deny that the year 400 B.C. (however reckoned by local calendars) did in fact occur throughout

Greek Sculpture in the Fourth Century

the ancient world and gave place in turn to the following century. This is therefore a convenient starting point for my stylistic analyses, independent of any happening, whether historical, political, or social; in turn, the terminal date of 331 is again convenient, not only on ideological but also on practical grounds, since my *Hellenistic Sculpture I* (1990) began its survey from that moment. As for the second choice, I am convinced, as I have already discussed for the fifth century, that not one style but many coexisted during the period under consideration. I have, in fact, come to realize that stylistic trends ebbed and flowed almost from the very beginning, and this point needs further elucidation, as well as a slight digression into earlier artistic periods.

Lingering Styles
In writing about Archaic sculpture in the 1970s, I had suggested that the end of the period, around 480, marked the beginning of Archaistic and Lingering Archaic—the first as a symptom of stylistic fatigue evident in mannered forms and excessive decoration, which in time turned to an intentional revival of earlier patterns as an indication of greater antiquity or venerability; the second as an expression of conservatism and preference typical of outlying areas, yet without implications of provincialism and time lag. In revising my work in the early 1990s, I could state, however, that Archaistic traits, intended as deliberate revival of an earlier style, had already appeared well before 500.[18] In addition, a 1982 symposium on the transition from Archaic into Classical had asked me to investigate the reasons for the changes in the Late Archaic style that eventually led to its demise. I suggested then that Archaic forms developed very rapidly during the first two decades of the fifth century because a great deal of building activity took place at the time, thus proportionately increasing the demand for architectural sculpture on a scale well beyond the tempo for private or public dedications. This abundant production could not fail to result in greater experimentation, and consequently in alterations in style. The argument sought support in the comparable phenomenon occurring in ancient architecture, where profiles of capitals and moldings vary from side to side of a given structure despite being part of a single, simultaneous project.[19]

A similar situation exists with regard to the so-called Early Classical or Severe Style. Although the distinctive forms originate and predominate during the decades 480–450, Lingering Severe and Severizing styles can be shown to exist well after the terminal date—Severizing (a term I coined after the already current Archaizing) as a distinct product of revivalist tendencies, beginning in the Hellenistic but especially strong during the Roman period, meant to render subjects taken from precise Greek mythological topics, as much a stylistic quoting as a literary citation.[20]

Lingering Severe, however, needs further attention. I had thought at first that this trend corresponded to Lingering Archaic and was prompted by the same motivations; others saw it as either inept or provincial manifestations. Yet a wider-

Greek Sculpture in the Fourth Century

ranging survey of sculptural styles during the second half of the fifth century has now convinced me that the phenomenon was much more common than I had surmised, or rather, to look at it from a different perspective, that the developments of what is considered the true Classical style took place primarily, and almost solely, in Athens and its territory, while the rest of the Greek world continued at a more sedate pace to produce works with virtually Severe traits.[21] What could be the explanation for this state of affairs?

In 1986 Hallett suggested some plausible reasons for the change from Severe into Classical. According to his conception, the Severe style, continuing along the lines of Late Archaic developments, brought along a form of naturalism and "boldness" in poses and expressions that was very attractive in some ways, but resulted in a weakening of the monumentality still inherent in the previous phase. In an attempt to integrate the new "Severe" realism with the symbolism and structure of the Archaic style, the Classical style was born; greater or lesser emphasis on the various characteristics would produce "Severe" works even during the Classical period, and "Classical" works already during the Severe phase. The hieratic monumentality of Archaic sculpture was recovered in divine images that appeared idealized because they had lost the individualizing traits of the Severe.

This theory is attractive, but further consideration shows it to apply primarily to Attika. Very little remains from the Peloponnesos, especially now that its bronze statues are lost. Boiotia and Thessaly, Sicily and South Italy, even Etruria, and, farther east, Crete, Rhodes, most of the Aegean islands, and Cyprus continued to use their own versions of the Severe style. Asia Minor is a virtual sculptural desert until the great phase of construction during the fourth century, and non-Greek areas, like Phoenicia with the Sidonian sarcophagi, and Lykia with its funerary monuments, do not seem to enter the picture until after 400, especially in light of the revised chronology for the Nereid Monument to be discussed in a later chapter. Even Euboia, a close neighbor of Attika, may have retained earlier forms, if the pedimental sculptures adapted for the Temple of Apollo Sosianus in Rome indeed come from the Classical Apollonion at Eretria. After La Rocca's brilliant demonstration, the so-called Apollo the Archer is correctly identified as Theseus in an Amazonomachy, and its apparently Severe style has to be downdated to after 438, since the central Athena from the same composition wears a vestlike aigis split in the center, like the Pheidian Parthenos.[22]

For Magna Graecia, Etruria, and to some extent Cyprus, lack of marble and the consequent predominant role of terracotta sculpture might have engendered repetitiveness and retention of styles and iconography typical of earlier times, thus explaining the phenomenon of Lingering Severe. Yet this solution cannot apply to the other areas, rich in the same materials available to Attika. To be sure, no account can today be taken of the many missing bronze statues, and to base our judgment on Roman copies of free-standing monuments is equally impossible, not only be-

Greek Sculpture in the Fourth Century

cause we cannot be sure that these replicas were faithful to their alleged prototypes, but also because of the dangers inherent in the attribution and dating of such works, on which no agreement can usually be reached. Only in exceptional cases do we have absolute proof that a statue carved in Roman Imperial times closely reproduces a Greek original; and, interestingly enough, many of these copies relate to Attic works, like the famous Nemesis of Rhamnous, now firmly identified through recognition of fragments from the very image by Agorakritos.[23]

When Roman copies are set aside, our primary information on typical fifth-century styles comes from Attic monuments, and specifically from that great sampler of sculptural forms that is the Athenian Akropolis. If my theory on the development from Late Archaic into Severe has any validity, it should apply also to the change from Severe into Classical, as sparked by the furious tempo of the Periklean building program, which in the span of 15 years saw the entire embellishment of the Parthenon: two pedimental compositions in the round at over-lifesize scale, 92 carved metopes in high relief with figures only slightly smaller than lifesize, a continuous frieze approximately 1 m. high depicting over 600 humans and animals, Nikai as lateral akroteria[24] in addition to a major floral ornament in the center, and a lion-head spout at each corner of the roof. If we push our survey to the end of the fifth century, we can add the Erechtheion (Karyatids and friezes) and the Nike Temple (two pediments, four friezes, akroteria, and a figured balustrade), with its alleged twin, the Ilissos Temple (continuous frieze, on all four sides), the distant relative in the valley, the Hephaisteion (two pediments, 18 relief metopes, and two friezes) with its cousins at Sounion (pediments, two friezes), Rhamnous (akroteria, an elaborate statue base), and Acharnai (? Temple of Ares, akroteria and perhaps a series of relief figures of disputed provenance), and other assorted architectural monuments of which only *disiecta membra* remain.[25] It may be noted in this context that the Parthenon metopes and the Nike Temple friezes were each attributed to more than one carving phase by some scholars, and that the same dichotomy in construction has been postulated for the Hephaisteion sculptures and, more recently, for the Nike Balustrade. Since this modern phenomenon of split-dating recurs in connection with other architectural examples from different periods (for instance, the Halikarnassos Maussolleion sculptures, to be discussed in Chapter 4), it should perhaps be acknowledged that developments through practice, and not intervals in execution, are responsible for the changes in style that we tend to translate into chronological terms.[26]

While Attika was feverishly repairing the Persian damage and erecting new structures, other areas were less active, having done their building in earlier times, and perhaps also being somewhat depleted by years of tribute to the Athenian empire. Whatever works of sculpture were then created continued to be in a "Lingering Severe" style, which from this point of view could indeed be called "provincial" if by the term we mean non-Attic, but should certainly not be considered inept simply

because it does not correspond to those forms that years of Athenocentrism in our studies have conditioned us to expect everywhere. Non-Athenian sculptors came from elsewhere to Athens seeking work: Kresilas from Crete, Agorakritos from Paros, perhaps Paionios from Mende and Kallimachos from Chios.[27] At the end of the Peloponnesian War, when Athens was finally defeated, or even sated in its thirst for construction, a diaspora of sculptors could have occurred, who took with them the tenets of the advanced Classical style and spread it abroad. Where intense building activity took place, for instance, at Epidauros or Tegea, styles developed; elsewhere, a sort of "Lingering Classicism" pervaded the minor arts, and was used perhaps as a symbol of Athenian greatness. Works like the fourth-century Derveni Krater can still echo the Nike Balustrade styles in their flamboyant form, in what may have been a programmatic imitation of "Imperial" formulas.

"Classical" Style in the Late Fifth Century
The fourth-century monuments mentioned above will be discussed in later chapters. Here it may be useful to review an earlier intrusion of Attic styles into the Peloponnesos—Pheidias' work on the chryselephantine Zeus at Olympia—because it may be the exception that proves the point. It seems now certain that the Athenian master began to work on that colossal image shortly after he finished the Athena Parthenos for the Akropolis, therefore after 438/7. But this major commission was basically a single statue, although accompanied by minor figures like the Nike on Zeus' hand, the Charites and Horai on the upper part of his throne, and other embellishment of that monumental seat as described by Pausanias (5.11.2–7), like the 29 images standing(?) on the bars spanning its legs, the two sphinxes devouring Theban children, probably at the armrests, and perhaps relief scenes with the Killing of the Niobids below. Of all this rich repertoire we can recover faint echoes only in some of the molds excavated from Pheidias' workshop, some Neo-Attic reliefs with the Niobids' myth, and perhaps the very fragmentary sphinxes from Ephesos—too little to determine Pheidian style. As for the Zeus itself, the modern reconstruction of the Athena Parthenos at full scale in Nashville, Tennessee, by Alan LeQuire, has taught us that these chryselephantine images, because of their enormous size, were likely to impress the viewer primarily by their awesome presence and the glittering array of their materials, rather than by their style.[28]

How long it took to make the Zeus is unknown, but it was certainly no less than the nine years required by the Athena Parthenos, and it was probably more, given the greater complexity of the work. A twelve-year span would take us to c. 425, just in time for Paionios to win the commission for the akroteria to the Temple of Zeus (not in aesthetic competition among artists, but probably by proposing the most economical and feasible model), and to create his marble Nike commemorating the victory of the Messenians and Naupaktians over Sparta at the Battle of Sphakteria. This is in fact the single witness we still possess to the expansion of the

Greek Sculpture in the Fourth Century

"Rich Style" into the Peloponnesos during the fifth century, and the one most easily explained by visualizing Paionios as part of Pheidias' entourage.[29] A second one may be provided by the Temple of Apollo at Bassai.

This famous building was decorated with carved metopes over the two porches and with a continuous frieze above the Ionic columns and epistyle running around the interior of the cella. Its unusual plan and sculptural embellishment have been repeatedly discussed, but only now do we approach a final publication, with detailed drawings of the architecture by Cooper and a full analysis of the sculptures by Madigan. Yet this official presentation, still in progress, has already sparked further debate and contrasting opinions.[30] We shall briefly discuss it here, as a necessary preliminary for our review of the fourth century.

Chronology seems finally established, with construction spanning the period from 429 to c. 400. This assessment is based on a variety of grounds, not simply on the style of the sculptures, and is therefore likely to be widely accepted. Madigan sees the subjects of the metopes as the Rape of the Leukippidai on the south (rear) side, and the Return of Apollo from the Hyperboreans on the north (Pls. 3–5), with geographic allusions strengthened by the respective location of the panels. The frieze, according to his interpretation, carried three, rather than the acknowledged two, subjects: a Centauromachy (Pl. 6), taking place at the time of thanksgiving at a rural sanctuary for Peirithoos and Hippodameia's first child; and two Amazonomachies, that of Herakles, Telamon, and Peleus at Themiskyra, and that of Achilles and Penthesileia at Troy. Although he visualizes the program as a unit, Madigan postulates three main sculptors and a workman: the "Master of the Metopes"; the "Master of the Stone Swords," who carves eight slabs; the "Master of the Bronze Baldrics," who carves another eight; and a "Paratactic Workman," who completes the seven remaining slabs of the frieze. In arranging the sequence, Madigan follows Cooper's lead, based on the backer course for the sculptured slabs and their various cuttings for fastenings to backers and architrave. The resulting placement has the Centauromachy occupying all but the SE corner of the east side (seven slabs) and the entire north side, above the great doorway (four slabs); the Amazonomachy of Herakles takes up the last slab on the east side, the entire south side above the central Corinthian column (three slabs), and approximately half of the west side (four slabs); the Trojan Amazonomachy fills the remaining portion of the west side (four slabs), ending exactly at the NW corner.

Cooper's reading of the architectural markings has been disputed by Jenkins and Williams, who, in a recent rearrangement of the sculptural display at the British Museum, have reexamined the Bassai frieze and have reinstalled it according to the "Corbett arrangement," named after Peter Corbett, who had first proposed this specific sequence of slabs. They have not expressed an opinion about subject matter and style, but have postulated a phase of disrepair, perhaps after a fire, and a refurbishing in the second or first century B.C. This restoration would not have involved

Greek Sculpture in the Fourth Century

a resetting of the frieze, but simply a reinforcement of its fastenings, with "new cuttings ... let into the face of the sculptures, and pins ... slotted into shallow depressions let into the architrave below," thus explaining at least one set of markings as later than the original construction. In their arrangement, which is almost a reversal of the Cooper/Madigan plan over the long (east and west) sides, the Centauromachy occupies all but the first (SW) slab of the west, and the entire north side above the doorway; the Amazonomachy fills the remaining space: the east and south sides and the beginning of the west.

Some suggestions by the two British scholars are certainly valid, as indicated by the redressing of the top left corner of slab 527 to accommodate the projecting sculpture on slab 520. Other elements of their arrangement seem less satisfactory, as for instance the positioning of Apollo and Artemis' chariot as the last slab of the north frieze, so that the reindeer seem to run away from the action at best, and at worst look as if they might collide with the warriors of the Amazonomachy on the opposite side of the same (NE) corner. Further thinking is needed on such points. For our purposes, however, it is significant to note that both proposals (the American and the British) visualize an uneven breaking of the subject matter, with only the two short sides (north and south) being fully occupied by a single myth. Those entering the cella would have first focused on the Amazonomachy of Herakles, with its Parthenonian arrangement of the two main, centrifugal figures above the Corinthian column; they would have then turned around, looking back toward the great doorway, above which they would have seen the Centauromachy. Yet an inspection of the long sides would have inevitably brought about the realization that two, or even three, narratives coexisted back to back, producing what to us might seem an unpleasant and difficult reading.

Even more difficult for Athenian-trained eyes might have been the juxtaposition of styles. As Madigan's names for his anonymous sculptors make clear, one master preferred to carve weapons directly in the stone, another to add them in bronze. Yet other commentators have used such terms as "pictorial" and "flamboyant," typical of Athenian renderings; comparisons have been made with Athenian monuments, including Dexileos' stele; and even an Attic-trained Paionios has been postulated as the main Bassai sculptor. A recent proposal by Felten would instead see the Bassai style as a logical expression founded on local and earlier traditions, not in stone carving but in painting and bronze, which brought with it a virtual translation of engraving motifs into marble sculpture. This same explanation would accommodate also the virtuoso appearance of the Nike of Paionios. I would not deny a strong local component in the styles of the Bassai sculptures, but I would also want to account for the Attic mannerisms and compositional schemata that recur on the frieze.

Metal vessels and armor of Peloponnesian manufacture may surely have served as means of transmission for body types, specific motifs, and renderings of drapery, but a great deal of engraving must also have taken place in the decoration of the

Greek Sculpture in the Fourth Century

gold drapery of the Olympia Zeus, and perhaps of his throne, footstool, and base. Certainly a large amount of painting was involved as decoration for the screens mentioned by Pausanias around the image, and made by Panainos, a relative of Pheidias.[31] It seems to me, therefore, that the ultimate influence at Bassai could still be traced back to Athenian developments, perhaps as diffused by the workforce active at Olympia with Pheidias. Pausanias (1.40.4) mentions a chryselephantine Zeus for Megara left unfinished by Theokosmos of Megara, a student of Pheidias. Kolotes, another of Pheidias' followers, seems to have remained in Elis, where he worked in the same gold-and-ivory technique (Paus. 5.20.2; Pliny, *NH* 35.54). It stands to reason that some of the artisans employed at Olympia were Peloponnesian, and they would have sought other work when the main commission ended. Bassai would then be an example of what could be produced toward the end of the century, in a mixture of local traditions and Attic second-hand influences. This mixture will be seen to continue in several other works of clearly fourth-century date.

As, architecturally, the Temple of Apollo marks a turning point[32] in the planning of sacred buildings—its shortened cella, its texturing of interior surfaces by means of engaged non-structural columns, its mixture of orders, the first Corinthian capital—so, sculpturally, it proves significant in its use of stylistic forms that are harbingers of fourth-century preferences. Despite the differing styles of the three masters, some features may be isolated as chronologically distinctive. Perhaps the most obvious is the rendering of the eyes: narrower, more triangular in profile, with eyeballs that are concave and sinking, rather than convex and bulging, between sharp lids that may not join at the outer corners (e.g., slabs 525 [cf. Pl. 6], 535, 536, 537). An impression of pathos is occasionally conveyed by deeply set inner corners, arching upper lids, or slanting eyebrows, as incipient traits of the expressionism that will be typical of the advanced fourth century (e.g., slab 532). Faces are rounder and heads smaller than in fifth-century monuments; female hair strands are pulled back at the temples, rather than festooning down from the central part (e.g., slabs 534, 537), and male hairstyles are short but lively, with a broken outline. Drapery is both transparent and voluminous, with tension folds that occasionally cross the entire body from breast to ankle (e.g., slab 541), and a tendency toward linearity. But some modeling lines seem to have turned into pure pattern, and there are "erratically looping folds,"[33] creating unexplained bunches that will recur in many other fourth-century works. Where drapery is treated as heavy, or hair as long, the drill is extensively used, providing contrasts of light and shadow, but in some cases expediency and speed may have prompted use of that tool. One fragment from a metope (cf. Pl. 5) has a rendering of old age and sagging flesh that could be taken for Hellenistic.

Compositionally, greater foreshortening and spatial depth than on Dexileos' stele have been noted by Madigan (1992, 96), who believes the gravestone copies a lost

prototype approximately 20 years earlier. I am not so sure. I would rather stress the second possibility: that the funerary monument relied on its curved base and its carefully planned viewpoint for its illusion of background penetration; but certainly the Bassai frieze is notable for its daring effects and contorted poses. The visual juxtaposition of different subjects may also be acceptable by the fourth century: we shall find it again in the Delphic Tholos, and perhaps in other monuments. To be sure, it was probably present in large Archaic monuments like the parapet of the Ephesian Artemision, or the metopes of the "Treasury" at Foce del Sele, but in general the Mainland monuments, especially of the fifth century,[34] adopted clear breaks in subjects corresponding to architectural articulations.

APPROACHES TO THE FOURTH CENTURY

Because of its complexity—as transitional phase, as continuation of the achievements of the previous century, as harbinger of the multifaceted Hellenistic period—the span under consideration is one of the most difficult ones to analyze or, for students, to cover. Until quite recently, moreover, some key monuments had not received full publication and were thus imperfectly known. This is, for instance, one of the drawbacks of Brown's otherwise stimulating book (1973), which could not take into account the ongoing restorations of the Epidaurian sculptures from the Temple of Asklepios, or the new theories on the Maussolleion. A somewhat similar problem affects Stewart's *Skopas of Paros* (1977), which from its title seems focused on a single master but extends beyond his works to consider antecedents and consequents. Other publications concentrate on single monuments or, again, on individual sculptors. Finally, wide-ranging treatises can devote little attention to the fourth century. Among these I would single out Stewart's *Greek Sculpture: An Exploration* (1990), which attempts both a personal and an objective approach, dealing with the author's own interpretation of stylistic, cultural, and social trends, but adding objective lists of attributions culled from the ancient sources and other relevant testimonia.

Two more works deserve specific mention. As this text is being written, a book on the fourth century, by John Boardman, is in progress as part of the same series that has already given us surveys of Archaic, Classical, and Hellenistic sculpture.[35] Because of the requirements of the established format, and because of its author, we can expect it to be comprehensive but brief, pithy and stimulating, authoritative without much discussion of alternative views, with copious and serviceable, albeit small, pictures. It will be extensively used, like its predecessors. The second publication is the very recent and beautifully illustrated volume by Todisco (1993).

To the extent that its compass is limited to the span of time here under review, Todisco's book achieves great depth, and, being thoroughly informed and up-to-date, it is invaluable; but its organization by masters, its generous inclusion of traditional attributions, even if tempered by critical comments, and its reliance on Ro-

Greek Sculpture in the Fourth Century

man copies undermine its usefulness. In addition, Todisco concentrates on statuary in the round, thus making very limited use of architectural sculpture and funerary/votive reliefs. The picture of fourth-century styles and subjects emerging from his pages seems slanted and amorphous.

To my mind, in fact, the most significant features of fourth-century styles are presently to be found in architectural sculptures. Certainly, those are the monuments providing the safest witness, since they are undoubted originals whose chronology can be supported by constructional and other evidence. In their geographic distribution, location on buildings, official sponsorship and public exposure, themes, and implied messages, such carvings are eloquent expression of the changing times and styles. In this book, they shall be studied not only per se, but also in contrast to comparable structures devoid of sculptural decoration, to highlight the possible reasons for inclusion or exclusion of figural embellishment from a civic monument. Although a roughly chronological sequence will be followed, geographic considerations will also determine groupings of buildings for discussion, so that comparisons may be more cogent and meaningful.

If the architectural picture is rich and complex, much less clearly defined is our understanding of free-standing sculpture. The fourth century is thought to have seen the emergence of great masters not only as men of genius in their field, but also as individual personalities whose lives and anecdotes attracted the attention of contemporaries and later sources. Whether or not this is the case will be discussed later, but in my opinion the styles of the great fourth-century sculptors—Praxiteles, Skopas, Lysippos—remain as nebulous as those of their fifth-century predecessors. We have only debatable originals by their hands, and the possible echoes of these masters' works in Roman copies are both inevitably distorted and unreliable, with attributions mostly based on brief mentions in later ancient writers or on modern subjective evaluations of a sculptor's style. Since agreement among scholars in the "attribution game" is notoriously rare, reconstructing a master's oeuvre is often an impossible task, which will be pursued here only insofar as hard evidence is available. To some extent, this skeptical approach is demanded as a corrective for the apparent confidence of handbooks and other publications on sculpture—Todisco's volume included.

It is the basic thesis of my book that many stylistic trends coexisted within the fourth century, some of them innovative but some traditional or even revivalist. Some styles certainly developed in what may seem like a coherent and logical sequence, based on iconographic precedents and quotations, and on the ancient belief that tradition is to be prized over originality. Yet we must beware of fabricating just such a sequence *because* it appears logical to us, arranging in coherent fashion what may instead have been scattered in time and space. Linear development may be as much a modern construct as an ancient tenet, and solely a scrupulous examination of the evidence should prevail. Only when a work has been placed as firmly as

possible within its proper time span can we hope to reconstruct its cultural and ideological context. The diffusion of Attic styles and the penetration of Greek forms and subjects in non-Greek areas of Anatolia will also play a major role in our survey, even if local significance cannot be confidently recovered.

NOTES

1. Ensoli 1987 gives the most extensive discussion of the stele, its arrangement within the family plot, and its parallels. To her bibl., add Clairmont 1983, 219–21 no. 68A; the other two monuments connected with the casualties of the Battle of Corinth are treated on pp. 209–12 no. 68A, pl. 2 (Athens NM 2744; cf. Boardman 1995, fig. 122) and pp. 212–14 no. 68b, pl. 3a (Athens NM 754; cf. Boardman 1995, fig. 121). See also Clairmont 1993, Intro. vol. 49, cat. vol. 2, 143–45, no. 2.209. For a review of state monuments, including that of Dexileos, see also Stupperich 1994, 95. For another reconstruction of Dexileos' precinct, see Boardman 1995, fig. 112.1, and cf. fig. 120.

It is estimated that over a thousand Athenians died in that battle. Dexileos' name recurs among the ten cavalrymen (plus one who died at the Battle of Koroneia) listed on the fascia of NM 754, a floral frieze that was once fastened atop a now missing slab, probably containing a relief. The anthemion frieze has in fact occasionally been connected with the battle relief topping the casualty list by tribes (NM 2744), but technical considerations prevent this association. Harrison 1988, 99–100 and n. 8, has accepted A. Raubitschek's suggestion that NM 754 once topped the Albani relief, which she would therefore downdate to 394/3. For the more traditional dating of the Albani relief within the 5th c., see, e.g., Ridgway 1981a, 144–45, figs. 104–5. Since NM 2744 marked the actual grave of the war dead, Dexileos would have been commemorated by a second cenotaph (NM 754), besides his family plot.

2. The first mention of the stele's find was made by M. J. Mellink, *AJA* 76 (1972) 269 figs. 25–26 on pl. 60, who suggested that the two sides were not contemporary, but revised her comments in favor of a unified chronology in *AJA* 77 (1973) 303. See also Borchhardt 1976, 25 n. 41, 104 (dated c. 350; with Eastern comparisons for the mantled man); Zahle 1979, 345 cat. 70, with discussion on pp. 264–65 (including comparisons for the frontal figure) and chronological chart on p. 320 (dated c. 370–360); Bruns-Özgan 1987, 114 (with comparisons of the frontal figure to other Lykian monuments and acceptance of a date in the first half of the 4th c.; cf. also her n. 434 on p. 99 for the Oriental, esp. Hittite, derivation of his shoes), pp. 223–24, 290 cat. V.7, pl. 20.1–2; Ensoli 1987, 261 n. 312, 265 n. 320, and esp. 283 and n. 404, pl. XIIIb; Clairmont 1993, Cat. vol. 2, 145 n. 1, no. 2.209bis.

3. On the akroterial sirens, see Ensoli 1987, 291–310; NM 774 is illustrated on her pl. 16 and by Todisco 1993, pl. 97. See also Clairmont 1993, Cat. vol. 1, 5–6 no. 2a–b, fig. 2; Boardman 1995, fig. 115. Because the siren's face resembles the copies of the Eirene by Kephisodotos, it is often assumed that the musical monsters were added to Dexileos' precinct around 380–370 or later; yet Ensoli discusses the complex as a unified conception.

4. Connor 1966, 9–25, provides excellent commentary and translation of Lysias' oration for the dead in the Corinthian War.

5. See, e.g., F. Brommer, *Die Metopen des Parthenon* (Mainz 1967) pl. 4; for a stylistic comparison to the Dexileos stele, see Ridgway 1981a, 25, and 96 for comparison to renderings on the Bassai frieze.

Greek Sculpture in the Fourth Century

6. Note the title of Ensoli 1987, who gives a full discussion. This theory is not undermined by the fact that two tall and narrow stelai were later added on the front south wall of the precinct, for Dexileos' siblings, Lysias and Melitta, who died in mid-4th c. Two more burials were included in the plot: one, behind Dexileos' stele, for Lysanias, surmounted by an inscribed trapeza, and one behind the west front wall, marked by an uninscribed trapeza. The respect granted this wealthy Thorikian family is suggested not only by the prominent location of its plot, but also by the fact that the precinct was spared during the destruction of the Kerameikos graves in 338. Only the west section of the front wall was robbed of its stones, which were replaced by a later, more irregular wall. For these details, see Knigge 1988, 111–13, no. 18. The heroization of Dexileos is stressed also by Vermeule 1970, on the basis of the decoration of the red-figure vases found within his precinct, one of which carried an image of the Tyrannicides (pp. 103–7, no. 3).

7. See, e.g., Ridgway 1981a, figs. 71–72.

8. See, e.g., Ridgway 1981a, fig. 48 (Hephaisteion east frieze) and fig. 58 (Nike Temple frieze).

9. The only parallel would be the much larger Albani relief, of unknown purpose and disputed interpretation, on which see supra, n. 1. Madigan 1992, 96, accepts the theory that a lost funerary monument of c. 420 provided the prototype for this and other stelai, but I would rather stress the similarity with temple sculpture, of greater visibility and impact. Comparisons between the Dexileos stele and the iconography of Amazonomachies, specifically that of the Parthenon west metopes, are made by Stähler 1992, 88 and 93–94; he makes the same suggestion for the Albani relief (pp. 94–95), which he dates to the 420s. On heroization and nudity, see infra, Chapter 5.

10. This aspect has been extensively analyzed by Borbein 1973, esp. 178–82.

11. For such parallels, see V. M. Strocka, *JdI* 94 (1979) 166–67 and figs. 5a–c; they are mentioned also by Bruns-Özgan 1987, 223–24 and n. 434. Note that she calls the face with the frontal man Side A and the face with the rider Side B. The other authors cited in n. 2 follow my system of nomenclature. Comparable Etruscan and Phoenician sarcophagi: see also Hitzl 1991, figs. 91–97, and Boardman 1995, fig. 233.

12. Bruns-Özgan 1987, in her catalogue entry, gives the height of the rider's side as 1.52 m., that of the frontal figure's side as 1.67 m.

13. Stewart 1990, 172. This statement, however, refers exclusively to continuity, and not to the input of future Athenian masters, such as Kephisodotos, Praxiteles, and Euphranor.

14. At a much broader level, and with reference to style rather than to sculpture alone, see Davis 1990, 23–29, on the relative impact of historical events.

15. Stewart 1990. Note, however, that his ch. 17, "Early Hellenistic," surveys the period c. 320–c. 220, thus reverting, apparently, to purely stylistic criteria, despite the overlap with the previous phase.

16. Harrison 1985; in her terminology, the "Bold Style" would prevail in the decades 480–440, what is often called the "Rich Style" would be labeled instead "Beautiful" (c. 440–375), and would be superseded, after 375, by a style she would name "Realistic," because it is "more realistic in its aims and effects than any which had existed before in Greek Art" (p. 42).

17. Classical as 5th–4th cs.: e.g., Boardman 1993, 83, but also, conversely, Classical as 480–400, Boardman 1985. High Classical = 450–430: e.g., Stewart 1990, 150 (although

considered the style of only two centers: Athens and Argos). High Classical = 450–400: e.g., Stähler 1983. High Classical = 4th c.: e.g., Pollitt 1972, 136: "If one approaches the art of the fourth century from the standpoint of *what it expresses*, rather than from the standpoint of formal stylistic analysis, it is possible to make a case for it having more in common with the art of the succeeding Hellenistic age than with its High Classical precedents"; the "continuum" quotation is from the same page. Marcadé 1988 states that the Athenian disaster in 405 does not mark a break and points to the historical situation elsewhere; he acknowledges, however, that the genres differ from one century to the other.

18. Ridgway 1977: 304–14 (Archaistic), 303, 317–18 (Lingering Archaic). Ridgway 1993: 464–65 n. 11.11; cf. also pp. 445, 454–55 (Archaistic), 458–59 and nn. (Lingering Archaic). Although the term "lingering" seems to connote passivity, it is here retained for convenience; in all cases it is meant to imply a deliberate choice in perpetuating a specific style, until enough time has elapsed that its use may convey an intended message (e.g., from Lingering Archaic to Archaizing: cf. infra, n. 20).

19. E.g., on the Temple of Zeus at Olympia. For full and additional references, see Ridgway 1985.

20. For discussion of Severizing and Lingering Severe, see Ridgway 1970, chs. 7–9. The theory connecting Severizing to mythological topics is specifically advanced by Simon 1987.

21. For Lingering Severe as inept or provincial, see Harrison 1985. My wider survey was prompted by a symposium held in Palermo on February 10, 1990; Ridgway 1995a elaborates on the positions I am here summarizing. My points were reiterated at a public lecture on the occasion of the opening of the refurbished Ancient Galleries at the Art Museum of Princeton University, April 21, 1990.

22. La Rocca 1985 and 1986. Cf. also *The Greek Miracle, Classical Sculpture from the Dawn of Democracy: The Fifth Century B.C.* (Washington, D.C., 1992) 128–29 no. 23. I would accept this interpretation of the sculptures, which carries important consequences also for the Niobid figures now in Copenhagen and in the Terme Museum (cf. Ridgway 1981a, 55–59), although some opposition to the attribution has now been published: G. Hafner, "Die beim Apollontempel in Rom gefundenen griechischen Skulpturen," *JdI* 107 (1992) 17–32, esp. 31. For another suggestion about the reconstruction, see R. M. Cook, "The Pedimental Sculptures of the Temple of Apollo Sosianus," *AA* 1989, 525–28.

See also Ridgway 1981a, 116–17 and n. 15, for comments on the lack of 5th-c. sculpture outside Attika.

23. G. Despinis, *Symbole ste melete tou ergou tou Agorakritou* (Athens 1971); Stewart 1990, 165 figs. 403–7.

24. This arrangement is suggested by M. Korres on the evidence of traces for heavy doweling of the corner figures onto the extant bases: "Chronique des Fouilles," *BCH* 115 (1991) 837 and fig. 3 on p. 839.

25. For attribution of sculptures to other Attic temples of the late 5th c., see, e.g., Stähler 1983; Delivorrias 1990. The two (akroterial?) female statues in Paris have now been officially catalogued: Hamiaux 1992, 236–39, nos. 251–52 (Ma 3072, Ma 3516). The relief figures traditionally connected with the Temple of Ares have been tentatively associated with the Great Altar of Athena on the Akropolis: E. B. Harrison, "The Classical High-Relief Frieze from the Athenian Agora," in H. Kyrieleis, ed., *Archaische und Klassische Griechische Plas-*

Greek Sculpture in the Fourth Century

tik 2 (Mainz 1986) 109–17, Summary p. 232, pls. 117–22. Cf. also Ridgway 1981a, 100, for previous positions. For the Ilissos Temple, most recently, M. Krumme, "Das Heiligtum der 'Athena beim Palladion' in Athen," *AA* 1993, 213–27 (the frieze would be showing the acquisition of the Palladion by Ajax after the fall of Troy, and the fight on the Phaleron shores, when the Athenians took it from the Argive); K.-V. von Eickstedt, "Bemerkungen zur Ikonographie des Frieses vom Ilissos-Tempel," in W. Coulson et al., eds., *The Archaeology of Athens and Attica under the Democracy* (Oxbow Monograph 37, Oxford 1994) 105–11 (the temple is to Artemis Agrotera; slab D shows the Rape of the Leukippidai and is independent from slab E, which shows another scene of violence).

26. I have already mentioned this point, with all appropriate references and additional examples, in Ridgway 1985, 10–11 and bibl. in nn. 38–41, esp. 38–39. For the Nike Temple Balustrade, see Harrison 1988, followed by Stewart 1990, 166–67, 173 (albeit with some reservation).

27. For recent discussions on these sculptors, with testimonia, see Stewart 1990: 89–92, 271 (Paionios); 168, 324 (Kresilas); 269–70 (Agorakritos); 271–72 (Kallimachos). For the suggestion that this last sculptor is from Chios, see Fuchs 1986, esp. 284–89.

The name conspicuously missing from my list is Polykleitos of Argos and the Peloponnesian School, whose works could significantly fill the gap I postulate outside Attika. On the other hand, the Doryphoros seems to me a clear continuation of trends prevalent in the Severe period, not a new stylistic departure: the Doryphoros' head, as preserved in copies, has the tight hair cap, heavy jaws, and large oval face of the Severe style. Of Polykleitan female statues nothing remains, or can even be attributed with confidence, although see Delivorrias 1995. See also Ridgway 1995b, on the many works attributed to Polykleitos that reveal a more advanced rendering, thus suggesting that they belong to the master's school or are even later. For a more inclusive view of the Polykleitan school extending well into the 4th c., see now Todisco 1993, 45–55.

28. In other words, I believe that the colossal images, because of their very size, could be trendsetters exclusively for iconography, not for style. Only the approximately lifesize details could be and were imitated, sketched, and copied.

On the Throne of Zeus at Olympia see, e.g., Ridgway 1984a, 41 and nn. On the Theban sphinxes, see now also the possible echo in a terracotta relief probably from Egypt, as suggested by F. Brommer, "Phidiasische Nachklänge," in *Kanon* (Festschrift E. Berger, *AntK* BH 15, Basel 1988) 42–45, esp. 43–45 no. 4, pl. 10.4. The kneeling figures considered by K. Stähler possible copies of the Nikai at the feet of Zeus' throne (*Boreas* 1 [1978] 69–93) have now been tentatively attributed to Magna Graecia, originally as basin-bearers: R. Kabus-Preißhofen, "Die Statuette eines knienden Mädchen klassischer Zeit," *AntP* 19 (1988) 11-20.

On the Nashville Athena, exhibited to the public in May 1990, although still ungilded, see, e.g., B. S. Ridgway, "Parthenon and Parthenos," in N. Basgelen and M. Lugal, eds., *Festschrift für Jale Inan* (Istanbul 1989, publ. 1991) 295–305.

A 1994 Ph.D. dissertation for the University of California at Berkeley, by Kenneth Shapiro Lapatin, "Greek and Roman Chryselephantine Statuary," deals with all evidence, from prehistoric to Roman times; publication in a revised version is forthcoming.

29. On the Nike of Paionios and the master's connection with Pheidias, see Stewart 1990, 89–92, and T 81 on p. 271 with added refs. See also Ridgway 1981a, 108–11.

Greek Sculpture in the Fourth Century

30. F. Cooper, *The Temple of Apollo Bassitas 4: Folio Drawings* (Princeton 1992); Madigan 1992. A different sequence of frieze slabs is discussed by I. Jenkins and D. Williams, "The Arrangement of the Sculptured Frieze from the Temple of Apollo Epikourios at Bassae," in O. Palagia and W. Coulson, eds., *Sculpture from Arcadia and Laconia* (Oxbow Monograph 30, Oxford 1993) 57–77, including an appendix (III), on the marble analysis of the sculptures, by K. J. Matthews. The quotation in my text, infra, is from p. 68. In the same volume, pp. 47–56, see also F. Felten, "Die Friese des Apollontempels von Bassai und die nacharchaische arkadische Plastik." For my previous position on the Bassai sculpture, see Ridgway 1981a, 31–32, 94–96. For illustrations: Boardman 1995, figs. 4. 1–3 (metopes), 5.1–5 (friezes, with drawing of the entire sequence).

31. Note that Strabo (8.353–54) mentions that Panainos painted Pheidias' Zeus, especially the drapery. The geographer, who did not visit Olympia, may have confused the screens with the garment, but since some ancient bronzes are known to have been painted, the possibility that gold was embellished with colors should not be discarded outright: H. Born, "Patinated and Painted Bronzes: Exotic Technique or Ancient Tradition?" in M. True and J. Podany, eds., *Small Bronze Sculpture from the Ancient World* (Malibu 1990) 179–96. Pheidias was renowned in Roman times for his skills in *caelatura* and *toreutice*; however, the notion may have been erroneous (see infra, Chapter 8). In addition, Isager 1991, 180 n. 662, equates *toreutice* in Pliny with sculpture—but the reference to Pasiteles may not support his claim, since the sculptor was probably sketching a lion, not making a model.

32. See, however, Kelly 1995, who argues that the plan of the Classical temple fully reflects that of the (single) Archaic predecessor.

33. The quotation is from Madigan 1992, 98; he points to the existence of these loops in the Erechtheion frieze. For the fragment showing old age (not a silenos' torso, because the mantle seems drawn over the head), see his no. 43, part of metope O(pisthodomos) 6, pl. 14, pp. 9–10: here **Pl. 5**.

34. We do not know, however, what subject(s) appeared on the Erechtheion frieze(s), although Felten 1984, 110–17, esp. 115, believes it shows the festival procession at the Skira. For the latest additions, see K. Glowacki, "A New Fragment of the Erechtheion Frieze," *Hesperia* 64 (1995) 325–31.

The Temple of Poseidon at Sounion was thought to have had three different subjects in a frieze running along the interior faces of the front pteroma (cf. Ridgway 1981a, 84–85), but a new theory by Felten (1987) would reconstruct an arrangement comparable to that of the Hephaisteion: an east frieze over the pronaos stretching from outer colonnade to outer colonnade (with a Centauromachy), and a west frieze over the opisthodomos running from anta to anta (with the Kalydonian Boar Hunt—said to be the first example in sculpture before Tegea, but disregarding the Archaic "Sikyonian" metope at Delphi; for another possible Archaic precedent, a frieze block from the area between Miletos and Myus, see Ridgway 1993, 404 n. 9.15).

35. For these volumes, see Boardman 1978 and 1985, Smith 1991. For the 1995 book, see now the Addendum to the Preface.

CHAPTER 2

Architectural Sculpture on the Mainland

We shall begin our survey of fourth-century sculpture by looking at architectural decoration, not because it is the best expression of contemporary artistic styles, but because it is represented by undoubted Greek originals, without the intermediary of the Roman copyists, and with its narrative content may serve to highlight beliefs and contacts from site to site. To call such meaningful sculpture "decoration" may seem to misrepresent its religious purpose; yet its location on buildings and its role in their embellishment, together with carved capitals, moldings, antefixes and waterspouts, confirm that it also had a strong, if not primary, ornamental function.

ARCHITECTURAL SCULPTURE IN THE PELOPONNESOS

The Argive Heraion (Argolid)
The Bassai temple mentioned in the previous chapter was probably completed by the end of the fifth century. Another Peloponnesian temple, however, may stand at the very threshold of the next century, or perhaps even stray past 400: the second Temple of Hera at the Argive Heraion.[1]

This very important Doric building and its architectural sculpture are still awaiting a complete and modern reconsideration. Excavated in 1892–95 and published early in this century, their dating has been conditioned by the mention in Pausanias (2.17.3–5) that connects the new cult image in the second Heraion, a chryselephantine Hera, with the famous Polykleitos, and a smaller Hebe, in the same technique, with the master's pupil Naukydes. The one fixed point available—423, the destruction by fire of the much earlier temple (Thouk. 4.133.2)—has been taken to be only a relative *terminus post quem*, in order to accommodate Polykleitos' career, which cannot be stretched to the end of the century. Thus the new building would have been planned before its predecessor burned, an assumption made possible by the entirely different location selected for the second temple. This

chronology, which finds apparent support in Pliny's *floruit* for Polykleitos (*NH* 34.49: 90th Olympiad = 420–417), has carried with it the dating of the surviving pedimental and metopal fragments from the Heraion, influencing stylistic analysis. But Pliny's mention is unreliable in that Polykleitos is named together with Myron and Pythagoras (undoubtedly earlier), as well as Skopas (undoubtedly later), and it is unlikely that a chryselephantine statue would be made before a roof over its head was assured, given the precious and delicate nature of its materials. By contrast, the opposite situation seems to have been possible—that a cult image was made well after its temple was completed, as was certainly the case for the Pheidian Zeus at Olympia and perhaps the one by Theokosmos for Megara; other examples could be adduced.[2]

A possible solution has been sought in the proven existence of a Polykleitos the Younger, a member of the "second generation" of Polykleitan pupils. According to the most recent study, this younger master was probably Naukydes' brother, which would explain the collaboration of the two in making the chryselephantine images for the Heraion, and would date it around or even after 400. A connection of Naukydes with Athens seems implied by an inscribed base from the Akropolis, and may be used to confirm possible Attic influences on his style, but these considerations are based on attributions of debatable validity and need not affect our evaluation of the Heraion decoration.[3] As both the Parthenon and the Temple of Zeus at Olympia show, the main master involved in the making of the cult image need not be responsible for the entire program, and even less for the actual carving of architectural sculpture, given the time-consuming process of the chryselephantine technique at colossal scale. The only true implication of having such a sizable and precious sculpture within the cella (a decision obviously taken early enough during construction to include massive foundations for its support) is that it may have determined the placement of further embellishment on the exterior, rather than the interior, of the building, to avoid competition with the cult image(s).[4]

Recent architectural investigations have clarified the chronological issue and the distribution of the sculptural decoration. According to Pfaff, the completion of the Classical temple should be put at the end of the fifth century, and the profile of the Doric capitals suggests a date around 400 B.C. The cella was wider than usually rendered in published plans, obviously meant to accommodate the cult image. Architectural sculpture consisted of pedimental compositions clamped to the tympanon walls with metal attachments, and of metopes in high relief not only over the porches, as traditional in the Peloponnesos, but also, at larger scale, over the peristyle, although probably just on the façades. Pausanias gives us the topics of the decoration, but without distinguishing by location: "the sculptures above the columns represent, some the birth of Zeus and the battle between the gods and giants, others the Trojan War and the taking of Ilium."[5] Fragments recovered suggest a metopal Amazonomachy, which has therefore been thought to be the one at Troy,

Architectural Sculpture on the Mainland

to explain Pausanias' reference. The west pediment would then have depicted the Iliopersis, as the final phase in a story that had special meaning for the Argives and their epic heroes, and as supported by some extant fragments.[6] The east façade would have carried the Birth of Zeus in the gable, accompanied by the Gigantomachy on the exterior metopes. We can only assume that Pausanias omitted to mention the subjects of the metopes over the porches, as he did omit to comment on the entire Parthenon frieze.[7] Fragments of a central floral akroterion also survive.

As the Parthenon building accounts show, pedimental statuary could be sculpted after a roof was already in place; but the same cannot be done for high-relief metopal slabs, which must be carved on the ground and slipped into position before cornice and ceiling coffers can be installed. We therefore know that the two sets of sculptured panels, of differing dimensions, were planned from the beginning and must be approximately contemporary with the column capitals, now dated around 400. On the other hand, the topical connection between metopes and pediments ensures simultaneous planning and confirms Attic influence, not only because of the unusual (i.e., non-Peloponnesian) placement of carved metopes on the exterior, but also because, as on the Parthenon, the birth of the temple owner (or, at the Heraion, of her powerful spouse) depicted on the gable is accompanied by that deity's participation in the Gigantomachy of the metopes immediately below. The Heraion even improves on the Parthenonian schema by connecting pedimental and metopal subjects also on the west façade, in a temporal sequence hitherto unprecedented. How this coherent program was affected by the subjects of the metopes over the porches is at present impossible to fathom.

Connections between the Heraion and the Parthenon have been noted before, yet I would hesitate in ascribing them to the strengthening of the alliance between Argos and Athens against Sparta, as occasionally suggested. As I have always maintained, sacred structures must carry first a religious message that can be understood and accepted through the centuries; political allusions, while not to be excluded, have a temporal nature that may make them meaningless for the very next generation of worshipers, and may totally escape, at all times, the visitors from a different polis—and the Argive Heraion, as a sanctuary, had a major value for the whole Peloponnesos, not just for Argos.[8] I would rather stress the interest in precious new cult images, indeed promoted, if not initiated, by the Athena Parthenos,[9] and the tendency for increased sculptural decoration on sacred buildings sparked by her temple on the Akropolis. Architecturally, moreover, the second Heraion is fully in keeping with Peloponnesian and innovative fourth-century practices: according to Pausanias, it was built by Eupolemos of Argos; it had the newly fashionable shortened plan of 6 × 12 columns, and a novel marble sima carved with lotus flowers and tendrils on which cuckoo birds perch. Since the chryselephantine Hera in the interior held a scepter crowned by just such a bird, sacred to her, the correlation between temple owner and sima would not have escaped even the casual viewer,

but this iconographic coherence extended to moldings seems unprecedented. The continuous row of lion-head waterspouts over the flanks (although in itself of Magna Graecian derivation) would have recalled the famous temple of Hera's consort at Olympia.

Regrettably little can be said about the sculptures of both metopes and pediments until complete publication is achieved. The remains are also quite fragmentary, some of them only feet on shallow plinths, from the gables. I shall therefore only attempt to update previous information and make a few comments of my own. Perhaps the most remarkable new acquisition is the recovery and attribution to one of the pediments of a spectacular female figure recomposed from two joining fragments: **Athens NM 1578 and 4035**.[10] The now headless female, wearing chiton and himation, appears in striding motion forward and to the (spectator's) left, with her drapery pressed by the wind against her opulent torso and partly billowing behind her. The short overfold of her chiton, moreover, curves and flutters against her chest and left arm, as if lifted by an upward draft, and describes one of those "erratical loops" already noted on the Bassai frieze. Other comparable traits are the circular folds outlining the breasts and the tension "ribbons" below them. On the strength of this sculpture, a definite affinity with the Bassai workshop could be postulated.

Similarity with Bassai is less apparent in the heads and bodies preserved from the metopes, although female figures in "flamboyant" and transparent drapery recur. Male warriors from the Heraion seem leaner, less muscular, with the only definite patterns produced by epigastric arches and, occasionally, ribs, although with a comparable bend at the waist that recalls fifth-century Attic renderings.[11] Faces are more oval and finer, even when augmented by the presence of an Attic or Phrygian helmet, as on the metopes; the hair escaping from such headgear over the temples seems more voluminous and wilder. Eyes, in particular, appear wide and bulging, without the melting gaze noted in some Bassai figures; mouths are partly open, with an expression of feelings apparently absent from the Arkadian sculptures.

Iconographic details worth noting are the apparently total nudity of the males, with only the occasional fluttering chlamys. A leg wearing a greave has been attributed to the west pediment, as well as a head with a Corinthian helmet; the fighters on the metopes do not seem to wear body armor other than helmets, but they carry large round shields. The metopal Amazons have a more varied attire: one wears a sleeved Eastern costume with an animal skin protecting her torso like a cuirass,[12] others have transparent chitoniskoi with looping folds that occasionally leave one breast bare, and some carry a chlamys. Only the Phrygian helmet and the occasional low-relief pelta against a background confirm the subject. Poses are daring, with figures moving forward and out of the metopal frame, as it were, to attack underlying opponents. Of the Gigantomachy series, perhaps only one panel with

Architectural Sculpture on the Mainland

traces of a chariot to right can be definitely recognized, but some fragments with flying drapery have been reconstructed by Eichler as two goddesses running to the right, a male head has been tentatively identified as Herakles, and another with traces of a hand grabbing it by the hair could perhaps also be attributed to that sequence.[13]

The same rendering of features, although in a slightly different style, may be noted in a head from the same sanctuary, long considered to come from a free-standing statue, but now believed to be architectural: the so-called Hera, **Athens NM 1571**. The ponytail over the nape, the wavelets of hair strands at the temples, and the braid over the central part recall some of the Erechtheion Karyatids so closely that the resemblance seems intentional. On the other hand, the Heraion head was meant to be seen from its right, as its asymmetrical structure and perhaps its heavy weathering on that side suggest, and its oval is more refined, less heavy than that of the Akropolis maidens. The piece, once adorned with metal earrings, has now been attributed to the temple decoration. This connection raises some questions about three other heads tentatively assigned to the gables, which differ from the rest because of their (once) inserted eyes.[14]

This peculiar feature could be understandable if the heads were feminine, and thus perhaps attributable to the two "idols" extant from the Heraion—in this case, obviously from the Ilioupersis composition in the west pediment. The inserted eyes would then have been used to convey the venerability of the images, or perhaps their "wooden" medium and their statuelike quality in contrast to the other figures within the gable. But of the three fragmentary pieces, only one is undoubtedly feminine, and one of the male heads clearly expresses anguish. Their all-round finish has also prompted the alternative suggestion that they may belong to a free-standing combat group set up near the temple. This explanation seems more plausible, but some comments should here be made about the two pedimental idols.

Usually mentioned in connection with Archaistic sculptures, the two fragmentary pieces represent obviously divine images being grasped by larger, human figures. The fingers of a left hand appear on the left shoulder of **Idol G**, while those of a right hand are visible over the right shoulder of **Idol H**. In both cases, the human arm crosses the idol's back diagonally, indicating approach from the opposite direction. Fragments of draped figures in violent motion coming from the same pediment imply a surrounding scene with fleeing women, as appropriate to an Ilioupersis. What is remarkable about the two "statues" is that **Idol H** is depicted in a simpler costume than **Idol G**, which wears the ruffled himation with diagonal edge typical of many Akropolis korai. **Idol H**, in its foldless garment, may be shown in the tight-fitting tunic typical of Daedalic statuary. An Ilioupersis including two divine images is possible, although not common.[15] If one statue is meant to represent the Palladion being grasped by Kassandra as protection against Ajax, should the second be another image of Athena, either being stolen by Odysseus and Dio-

medes, or being held by Helen as she is being threatened by Menelaos? A different goddess may also have been intended—for instance, Aphrodite as Helen's protectress. The important point remains that the composition, for all its apparent mirror-image symmetry, creates a sartorial distinction between the two "xoana" that may have chronological meaning, and thus suggests a surprising knowledge of what clothing fashions may have prevailed in much earlier times.[16]

The Temple of Athena at Mazi (Elis)
The sculptures of this relatively little-known temple have now received thorough publication, and, despite their highly fragmentary state, deserve greater attention than they have attracted so far. They represent two pedimental compositions, and parts of a female figure with cuttings for the attachment of wings, which should be a Nike akroterion. From the east gable we have four heads, one of them female, and various fragments, of varying diagnostic importance; from the opposite gable comes an almost complete figure of a nude but helmeted warrior, and again many fragments, some of which are particularly significant.[17]

One of the three male heads from the east side wears an old-fashioned hairstyle occasionally called the krobylos: two braids crossing over the nape and tied over the forehead, passing under long strands at the temples pulled up into a roll (Ill. 3). This complex coiffure is here made more elaborate by sideburns in front of the ears, into which metal curls were inserted. Combined with the flowing beard, this distinctive hairstyle serves to identify Zeus, of which it is characteristic, especially during the Severe period. Another male head from the same pediment wears a peculiar headdress: an animal head, with inserted ears and snout, forms the calotte of a helmet with standard neckguard and separately added cheekpieces. The "veristic" features of the male face—knotted brow, rolling eyes, hooked nose, open mouth showing its teeth—combine with the unusual headgear to suggest a giant. The animal had been considered a boar, but Ismene Trianti suggests now a wolf (*lykos*), and connects it with an Arkadian Gigantomachy in which a mythical King Lykaon and his sons (including one named Arpolykos) were destroyed by Zeus' thunderbolts in an episode very similar to the traditional Battle of Gods and Giants. A mid-sixth-century vase in the Louvre shows Arpolykos fighting Hera, and it is therefore plausible to associate the Mazi giant with the female head from the same pediment (Ill. 4). The remaining male head, bare but with the same ferocious and wild features as that of Arpolykos, probably represents Zeus' opponent.[18]

Other fragments from the east pediment include a hand grasping the hilt of a metal sword, part of an arm inside a *porpax*, to which the shield was attached separately, in marble, and a female sandaled foot emerging from drapery folds and resting on a shallow plinth. The lesser fragments from the opposite gable—a horse's hoof, a foot in a soft shoe (boot) with an upcurved toe—indicate its topic: an Amazonomachy, with the Eastern enemy fighting on horseback against naked Greek

Architectural Sculpture on the Mainland

Ill. 3. Mazi Athenaion, reconstruction of Zeus and giant, from east pediment (after Trianti 1986)

warriors. A metal plaque found on the north side of the temple in 1978 lists several men to whom citizenship was granted by the Triphylians.[19] Since the Triphylian towns achieved autonomy in 399, this inscription must be dated after that date. In addition, the new citizens are called Makistioi, which suggests that the site of Mazi corresponds to ancient Makistos. Finally, Athena is mentioned as guarantor, thus providing identification for the temple as one dedicated to that goddess.

The important aspects of this group of sculptures are as follows. First of all, the temple itself, preserved only at the level of the foundations, retains however enough scattered elements of its superstructure to ensure proper reconstruction of its elevation. The building is sizable, about as large as the Hephaisteion in Athens, and only slightly smaller than the Temple of Apollo at Bassai. Its 6 × 13 plan, with pronaos and opisthodomos, and the shape of its Doric capitals suggest a definite date within the first half of the fifth century. Yet there is no doubt that its pedimental sculptures date considerably later. The additions to the empty gables may have been made after 399, when the cities of Triphylia acquired independence, and this suggestion

Architectural Sculpture on the Mainland

Ill. 4. Mazi Athenaion, reconstruction of goddess and giant with wolf-head helmet, from east pediment (after Trianti 1986)

is confirmed by the stylistic parallels that can be drawn between the Mazi sculptures and those from Bassai, the Argive Heraion, and the Temple of Asklepios at Epidauros, which represents the latest possible range (c. 380–370). It is therefore important to note that significant architectural embellishment could be added to an earlier structure, either because of increased financial resources or because of new trends in temple decoration. A third hypothesis would also be the timely availability of a suitable sculptural workshop.

The second major point is the already-mentioned affinity with other Peloponnesian architectural sculpture. Trianti has offered a sensitive description and analysis of all the pieces, and has found additional parallels in another group of **architectural sculptures from an unknown temple, presently in the Patras Museum**. They come from an area between modern Bozaitika and Kastritsio, near Patras and the river Charadros (Achaia), and consist of two male and one female torsos, the latter probably a Nike akroterion, because of its larger scale. The two male figures, approximately half-lifesize, are obviously engaged in fighting, since the left hand

Architectural Sculpture on the Mainland

of an opponent adheres to the right side of one torso (Patras Museum 100), and a strut on the left hip of the second torso (Patras Museum 621) suggests a proximate figure. A large cavity in the back of no. 100, with traces of a metal tenon, indicates its fastening to a tympanon wall. Trianti postulates an Amazonomachy as the subject of the composition.[20]

The four sets of sculptures—from Bassai, the Argive Heraion, Mazi, and the Patras Museum—are attributed by Trianti to four different Peloponnesian workshops working between 410 and 380, some of them open to Attic influences.[21] Affinities among the four are indeed remarkable, and I would advance the possibility that at least some of the same workmen participated in the commission at all four sites, with Bassai probably leading the way and being the most progressive in terms of fourth-century traits. In the heads from the Argive Heraion and Mazi (whether divine, human, or monstrous), in fact, eyes are still bulging and prominent, and the Mazi goddess (Hera?) even exhibits the overlapping of the lids at the outer corner of her left eye and the rose-bud mouth that we tend to associate with Attic fifth-century style. Once again, more or less direct Attic influence may be postulated, but within a Peloponnesian context.

A third point lies in the choice of subjects. Mazi has been considered under Athenian inspiration, understandable since Athena was the recipient of the cult. Yet the Gigantomachy seems to have had a local character, and both it and the Amazonomachy of the west gable could have been suggested by the similar topics at the Argive Heraion. Certainly, the Peloponnesian towns had no special reason to emphasize victory over the Amazons as allusion to the Persian Wars, by which they had not been directly threatened and affected—hence, the possible shift to an Amazonomachy at Troy (rather than at Athens, as on the shield of the Athena Parthenos, or the apparently more generic one on the Parthenon west metopes),[22] its epic connection repeated and underscored by the Ilioupersis pediment at the Argive Heraion, with special meaning for local heroes. In moving the topic from metopes to pediment, the Mazi sculptors further increased the importance of the Trojan Amazonomachy, and the trend was later continued at Epidauros, where again the two themes (Ilioupersis and Battle against the Amazons at Troy) were joined in the two gables. And if Epidauros may be taken as evidence, we may further assume that no central deity occupied the axis of the Mazi tympanon, or was even present, as contrasted with pedimental compositions of the fifth century. This shift from mythological to epic themes of the Trojan cycle[23] and this interest in local (Peloponnesian) allusions may have already found their beginnings in the Bassai frieze, if Madigan is correct in seeing one Amazonomachy as the battle between Achilles and Penthesileia. The interconnections of these four architectural sculptures are therefore made even more obvious by their respective subjects.

A few more comments at random on the Mazi and Patras sculptures may not be amiss. The two divine heads from the east Mazi pediment show simplified or even

Architectural Sculpture on the Mainland

roughly finished surfaces on the sides that would have been invisible when in position, thus helping to place them facing in the correct direction. By contrast, the two giants' heads, and even the almost entirely preserved warrior from the west gable, seem finished more thoroughly all around, and so are the two torsos in Patras. The use of metal attachments (Zeus' curls, the hilt of the sword) seems conditioned by their importance, since the cheekpieces of Arpolykos' helmet were added in marble, as was the shield to the extant *porpax*. The wolf-head attribute to suggest the giant's name recalls the practice in the Gigantomachy of the Siphnian Treasury at Delphi over a hundred years earlier. Another anachronistic trait for the fourth century is Zeus' braided hairstyle, a peculiar iconographic choice meant to evoke past times and fashions; although obviously derived from bronze prototypes, it is here rendered with a softness of surfaces more reminiscent of work in clay. The same "sfumato," almost impressionistic treatment is observable in all other heads, not only for the hair, but also for beards and mustaches. The west pediment warrior and the two male torsos in Patras strongly recall the fighter on the metope from the Argive Heraion, and display the same heroic nudity, as well as the enhancement of the ribcage and the sharp indentation at the waist that suggest an intake of breath. Both the Mazi and the Patras pedimental compositions seem to have been accompanied by akroterial Nikai, both figures with separately inserted wings and transparent, windblown drapery. In this case as well, the choice of subject may have been determined by Parthenonian influence or simply by the battle topics of the gables. To be sure, Nikai as akroteria were increasingly popular, and the Temple of Zeus at Olympia may have provided an equally powerful prototype, which we tend to discount because it has not survived.

The Temple of Asklepios at Epidauros

The recent and beautifully illustrated publication of its sculptural decoration, so painstakingly and brilliantly recovered from *disiecta membra* by Nicholas Yalouris, has finally made this important material generally available. Here personal comments will primarily be advanced on what I consider the most significant facts we gather from this monument. Primary among them is the specific chronology of its work plan, one of the best available for an ancient temple. As is well known, a limestone slab found near the building was inscribed with detailed accounts of the division of labor for the structure and its accessories, the letting out of contracts to workmen and their guarantors, and the relative payments, in chronological order. It has therefore been estimated that the temple took four years, eight months, and ten days to be completed.[24] The precise date for its erection is, however, unspecified.

Although suggested years range from 394 to 361–353, the most authoritative proposal advocates the span 375–370, as supported also by the letter forms of the building inscription. A recent attempt to correlate monuments and historical events has also emphasized 377 as the date of the second Athenian maritime confederacy,

Architectural Sculpture on the Mainland

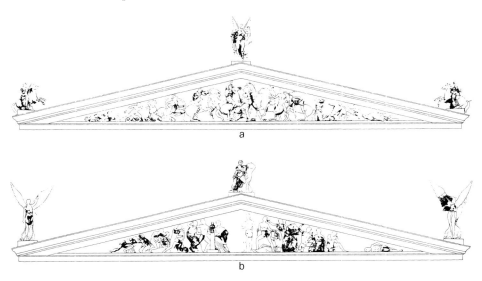

Ills. 5a–b. Epidauros, Asklepieion, reconstruction of west (a) and east (b) pediments and akroteria (after Yalouris 1986)

and would see in the program of the Epidaurian sanctuary a deliberate effort at promoting an international image for Asklepios. The subjects of the temple pediments would have been chosen as allusion to Athens and its monuments (the Parthenon, the Nike Temple), with a "conciliatory tone" meant to pacify old enemies in the aftermath of the Peloponnesian War.[25] As already stated, I cannot subscribe to purely political reasons for religious decoration, and I would again stress local connections and influences as determining the choice of the Trojan themes: the Amazonomachy of the west pediment and the Ilioupersis of the east (Ills. 5a–b).

The Asklepieion is said to be one of the smallest Greek temples,[26] but it was certainly one of the most ornate. Its shortened plan of 6 × 11 Doric columns was made possible by the omission of the opisthodomos, although the rear of the building was fully visible from the abaton and the Tholos. Its Doric order on the outside had blank metopes, as usual in the Peloponnesos, but both pediments were filled with richly painted sculptures provided with metal attachments,[27] and the akroteria were particularly elaborate, alternating, as it were, single and double figures all around the roof. In addition, the marble lateral sima with its rhythmical lion-head spouts was decorated with a carved rinceau surmounted by the palmettes of the so-called rampant antefixes—as if the end ornaments of the cover tiles, having found their place usurped by the continuous gutter, had decided to climb over it to make their presence known.[28] All architectural details were picked out in vivid colors.

Once past the outer colonnade, such ornateness increased. As we learn from the building accounts, there were gates between the columns, the wooden coffers had

Architectural Sculpture on the Mainland

faces (*prosopa*), looking down on the worshipers, and other ornaments,[29] the cella door was in wood and ivory with gold nails, the ceiling was decorated with silver. The floor was paved with alternating black and white limestone slabs, and the cella walls, if Roux's reconstruction is correct, were lined with tangential Corinthian columns in Π-shaped formation, which would have created a forestlike backdrop for the chryselephantine statue of the seated Asklepios flanked by his dog and his snake. Thus the arrangement of interior columns initiated by the Parthenon for both structural and aesthetic reasons, and further developed at Bassai with the introduction of the first Corinthian capital, here found its first totally non-structural appearance, made irrelevant by the small size of the cella and further reducing its very limited interior space. The vegetal richness of all capitals, combined with the fluted shafts, must have resulted in a texturing of the wall surfaces almost comparable to figural sculpture. Thus, for the first time, architectural embellishment of the interior competed with free-standing sculpture, not only in terms of voids and masses, but also in its dazzling array of colors.

The cult image, according to Pausanias (2.27.2), had an inscription identifying its maker as Thrasymedes of Paros. This is the same man mentioned in the accounts as working on the ceiling and the cella door, thus suggesting his familiarity with working in precious metals and costly materials (and his strong financial backing?), rather than his creative skills. But the inscription itself is surprising, although Pausanias (5.10.2) mentions a similar one with Pheidias' name under the feet of the Zeus at Olympia. Were they labels added in later times rather than true signatures? And if contemporary, were they allowed because neither man was a local citizen, or to add fame to the image? This last suggestion seems unlikely in the case of Thrasymedes, otherwise little known, and it casts a peculiar light on these man-made idols, thus differentiated from the more highly venerated, and unattributed, cult images of earlier times.

The Asklepios sat on a throne decorated—as Pausanias states—with the exploits of Argive heroes: Bellerophon and the Chimaira, Perseus and Medousa. But the total image seems to have rested on a stone base, although Pausanias does not mention it. Fragmentary slabs of dark limestone have been connected with this pedestal, and it has been suggested that the τύποι provided by Timotheos for 900 drachmas may have been reliefs molded or carved for such a base.[30] This issue is most important because of the debate over the exact meaning of the Greek term, and the implications it may carry for the entire sculptural program of the Asklepieion.

Three points are made in support of translating the word as "models":

(1) Hektoridas, one of the masters working at the Asklepieion, was first asked to execute the sculptures for half a pediment, and was then commissioned to produce the other half after an interval of at least 18 months. He could not have accomplished the task in a satisfactory manner had models for the entire gable not been available.

Architectural Sculpture on the Mainland

(2) Timotheos was paid 2,240 drachmas for a set of three akroteria over one pediment. Even allowing for the complexity of some of these sculptures, this sum is considerably larger than that paid for the *typoi,* which therefore must have been of lesser value or, at least, less time-consuming.

(3) Timotheos—and this is perhaps the most influential reasoning of all—was later famous, since he was called to collaborate with the greatest masters of his time on the sculptural embellishment of the Maussolleion at Halikarnassos. He must therefore have been the mastermind behind the entire program of the Asklepieion.

To take these points in reverse order, we can immediately point out that Timotheos has probably been singled out because the other masters named by the building accounts remain totally unknown to us from any other source.[31] His participation in the Maussolleion, as we shall argue in Chapter 4, may have been due to entirely different reasons, such as his ownership of a trained workshop, manned by the workmen who had been with him at Epidauros. As for the second point, philologists are unanimous in rejecting "models" as a possible translation for a word consistently used to mean "reliefs," *paradeigma* being the standard ancient term for a prototype. The sum paid to Timotheos for the *typoi* would, however, be adequate for a set of reliefs, at small scale, to be applied to a base. Finally, Hektoridas himself could have prepared his own sketch or model for the entire gable, even if finances permitted only the execution of one half of it at a time.[32] One further clue could be provided by the fact that Timotheos' commission for *typoi* was guaranteed by the same man, Pythokles, who served as guarantor for Thrasymedes' work in the interior of the cella; yet he also guaranteed for Timotheos' akroteria, and thus his participation may not be construed to imply support of artistic production by location.[33]

It should also be stressed that the men mentioned in the building inscription were probably the organizers of the workforce, rather than the sole carvers of the sculptures. Thus Hektoridas must have had unnamed assistants helping him make his one pedimental composition, and so must the maker of the second gable, whose name is now lost. One set of akroteria was by Timotheos, the set over "the other pediment" by Theo[. . .].[34] No information exists as to the specific side on which each man worked, and thus, although all akroteria survive in some form, none can be attributed to Timotheos with certainty. Neither can we recognize Hektoridas' hand, although it has been suggested that he was responsible for the east pediment, whose diverse style may reflect two phases of execution.

As Yalouris has pointed out, no divinity was present on either gable. Yet it still seems surprising to find Penthesileia at the center of the western Amazonomachy (Ill. 5a), towering on her rampant horse over a wounded Greek, as another rushes to his defense. The complex group was carved from a single block, at least for the portions that interconnected, so that the fragile equine legs could rest against a human torso and a second could serve as support under the horse's body, all of them

standing on the same shallow plinth.[35] Granted that the relatively small scale of the figures would have required a still manageable block, as compared with the colossal pedimental groups of the Parthenon, this is nonetheless a superb feat of workmanship, made more impressive by its compositional plausibility. Technically, however, some shortcuts were taken, in that the Amazon's body is rendered with a dislocated left hip made invisible by placement against the tympanon wall. The sculptures were therefore executed with economy of time, some of them anatomically incorrect, some left virtually unfinished in the rear. Yalouris comments that both the pedimental and the akroterial figures resemble reliefs rather than works in the round, and that they recall metalwork or painting in their daring compositions.

The wounded Greek kneeling under Penthesileia's mount might be Machaon, Asklepios' son, who, with his brother Podaleirios, took part as doctor in the Trojan War, and his defender is probably Achilles.[36] Although we know that Machaon died at Troy, we would still wonder at a choice of subject that seems to emphasize the personal tragedy of the temple deity. Perhaps Asklepios' humanity was here highlighted, in keeping with the compassionate mission of his cult. Certainly the extant faces express a higher degree of pathos than we have encountered so far: eyes are deeply set at the inner corners, angled up toward the central axis of the face under slanting eyebrows, foreheads are deeply creased, and mouths are open in anguish. Although external devices are thus used to convey expression, mood is also rendered through poses, violence rippling from figure to figure, to end up in the broken, almost segmented corpses lying at the corners of both gables over drapery that seems to emphasize disarray in its irrational patterns of light and shadow.

Iconographically, the Greeks are mostly naked with a few backdrop mantles and metal shields and weapons; the Amazons wear chitoniskoi and boots, but no true Oriental attire, perhaps further to remove potential allusions to the Persian Wars. The queen, Penthesileia, has an Oriental tiara with an added metal ornament, perhaps as a symbol of royalty. One Amazon being grabbed by the hair wears a thick crown of braids—a hairstyle that recurs on the opposite pediment on a Trojan woman[37] once again, is it a sign of ancient fashion, or a suggestion of youth, an age before the dedication of youthful hair? King Priam too wears the Oriental headdress, which is here grasped by an opponent in the midst of a scene already characterized as an Ilioupersis by the episode of Ajax and Kassandra (Ill. 5b), who is being pulled away from an Archaistic idol displaying an aigis.[38] Granted that the violence at the Palladion is the most distinguishing (and thus inevitable) feature of that myth, the allusion to the west pediment of the Argive Heraion would not have gone unnoticed.

The elderly ruler's face is a mask of pathos—creased forehead, angled eyes, open mouth. His hair is treated impressionistically, as is that of other figures. Eyes are often blurred depressions between shallow lids, drapery clings to bodies with excessive transparency, and on heavier clothing the drill is used extensively and harshly.

Architectural Sculpture on the Mainland

In particular, a kneeling Trojan woman exhibits on her lap a peculiar bunching of folds riddled with dark channels that seems out of place in the Classical period; another woman, her leg crossed by the strong diagonal of a male thigh, is covered by a mantle that combines tubular and nicked ridges with one mannered omega-fold above an oval area of confused shallow patterns strongly reminiscent of the Olympia sculptures almost a century earlier.[39] It seems as if the mastery of the modeling line has here been intentionally abandoned in favor of coloristic and dramatic effects; or perhaps the impossible rationality of fifth-century drapery is now reduced to less meaningful but more "realistic" design. There are, however, marked differences in style between east and west pediment and even, as Yalouris notes, within the east gable as a whole, which he then attributes to Hektoridas, whose work was staggered in time. The scale of the east figures is also slightly larger than that of the west, thus facilitating assignment of fragments, but both pediments would have contained approximately 21 statues each, including as many as four horses on the west side.

Correlation between pediments is remarkable—two events of the same war, one (on the west front) taking place before the other.[40] But so is that between pediments and akroteria (cf. Ills. 5a–b). If the east gable truly depicted Asklepios' son, so did its central akroterion portray his parents, Apollo in violent struggle with a mostly missing figure, Koronis.[41] That a scene of rape could be considered appropriate glorification of the temple owner suggests an understanding of events entirely different from our current thinking. Apollo has the typical "hero in distress" type of mantle that in its fall hampers rather than helps movement and suggests impulsive action. Here too deep drill work is combined with excessive transparency over the prominent right thigh; only the catch of folds at the ankle reveals that the leg is in fact covered. Color would have helped perception. The god's face seems only approximately rendered, his right upper arm an undifferentiated cylinder. Although the practice goes back to the Severe period, kidnaping or struggling groups had become popular as akroteria toward the end of the fifth century. They will continue well into the fourth.

This central group is accompanied at Epidauros by two flying Nikai at the corners. Their slender, almost masculine bodies had prompted the suggestion that at least one of them was an Eros or a male demon, but Yalouris is correct in labeling both Victories.[42] Certainly, their attenuated breasts and hips make them quite different from their spiritual predecessor, the Nike of Paionios. Their message might again connect with the pedimental composition: victory for the Greeks at Troy, or Apollo's "victory" over Koronis, or Asklepios' victory over disease and human misery. Given the many contests held at Epidauros during the four-year festival, both in the stadium and in the theater, the allusion could be entirely generic, and simply appropriate for a lateral akroterion. But there is no mistaking the central Nike of the west side.

Architectural Sculpture on the Mainland

Once considered Epione, Asklepios' wife, this opulent female was correctly identified after the recovery of its wings. Yet the erroneous identity had been suggested by the large bird held by the Victory, probably a partridge, whose Greek name (*perdix*) recalls a medicinal herb (*perdiktion*) common in Asklepian prescriptions.[43] This allusion to the temple owner may weaken the akroterial connection with the battle taking place in the underlying gable, although, once again, the Greeks were victorious in the Amazonomachy. All three Nike akroteria (both east and west) have transparent and flamboyant drapery, uplifted by rising winds into strange flares and loops, but the "Epione" is much more closely connected to fifth-century practices in her modeling folds around prominent breasts and rounded abdomen. Her advanced left leg imitates Paionios' Nike even in the inverted-V pattern of folds topping the thigh, but her leg, although impossibly rendered as if bare, is still covered by the garment, as the side view clarifies. From that angle, the billowing of her skirt is seen to create an effective counterpoise to her weight shift, and the total figure displays an eloquent sinuous contour most effective from a distance.

As the central group over the east gable was accompanied by single images at the corners, so this single west Nike is complemented by lateral groups: female figures centripetally riding toward her on rampant mounts. Their transparent drapery in windblown patterns has prompted for them the identification as breezes, and it has even been argued that the left (NW) Aura comes from the sea, because a finlike pattern appears behind the right foreleg of her horse. Personal inspection has convinced me that the rendering is simply meant to convey the rippling skin of a lively animal; the motif recurs on the Amazon group in the Boston Museum of Fine Arts, where no doubt exists as to the nature of her mount.[44] Yet the two akroterial riders are intentionally differentiated, not only in their costume (sleeved versus sleeveless, belted versus unbelted, pinned versus slipped chiton, raised versus lowered mantle) but also in their anatomy, once again rounded breasts and stomach contrasting with more adolescent forms. Their identity can no longer be fathomed, although the traditional interpretation may be fully appropriate to this health resort of antiquity.

The above-mentioned **Amazon group in Boston** presents a peculiar problem. Its similarity to the Epidaurian Penthesileia is so great that it even extends to the unusual detail of the dislocated left hip. Remains of an opponent under her horse may lead to an even closer correspondence. Yet no trace of attachment to a tympanon wall remains, and the sculpture has been considered a funerary monument in the round or a votive offering, as well as a pedimental composition. Yalouris would place the so-called Alba Youth in Copenhagen under the Amazon's mount, and stresses their affinity to the Asklepieion sculptures, which he considers part of the same artistic circle. I would have thought the Boston Amazon somewhat earlier than the Epidaurian one, but such fine chronological distinctions are impossible to sustain.[45]

Another group of sculptures that have been connected with the Epidaurian work-

Architectural Sculpture on the Mainland

shops comes from the nearby **Sanctuary of Apollo Maleatas**, on the high hill overlooking the theater. In fact, Apollo's cult preceded that of Asklepios at the site, although it was in turn preceded, during prehistoric times, by that of a female deity not better identified. Archaic remains of unknown plan were replaced in the early fourth century by a hexastyle prostyle Doric temple, with pedimental decoration said to be by the same craftsmen who worked at the Asklepieion. Some sculptural fragments were recovered by early excavations, but renewed investigation is bringing to light additional material, although highly fragmentary. We therefore can only mention here a female head (NM 4837), the lower part of a woman's draped legs in motion, perhaps an akroterion (NM 4703), and, among the recent finds, the head of a youth with short hair, only roughly worked on its right side; the torso of a woman wearing an unbelted peplos open on one side, unfinished on the back; the fragment of an arm being grasped by a hand. The figures would have been approximately 80–90 cm. high.[46]

In summary, we have six, possibly seven, complexes of architectural sculpture strongly connected by chronology, style, and subject matter: the Bassai frieze, the fragments from the Argive Heraion, the Mazi and Patras pediments (and akroteria), and those from the Epidaurian Asklepieion and the Maleatas temple, with the Boston/Copenhagen group a plausible addition.[47] Cults at Bassai, the Argive Heraion, and the sanctuary of Apollo Maleatas had a long tradition, but the sculptural decoration of the respective temples has no known Archaic predecessors. The Mazi Athenaion was erected approximately half a century before the carving of its pediments, but again no previous tradition existed. The Asklepieion was the first temple in an area whose monumentalization began in the late fifth century. Not enough is known about the Patras and the Boston/Copenhagen sculptures.

Given the relative paucity of architectural sculpture in the Peloponnesos prior to approximately 400, this outburst of activity during the first quarter of the fourth century is truly remarkable. Even the forms of architectural sculpture are significant, since only pedimental compositions are well enough attested in the general area during the Archaic period, primarily at Olympia, and sculptured metopes find their first expression at the Temple of Zeus within that sanctuary. Continuous friezes are totally absent until Bassai, unless friezelike compositions are included, such as the decoration on the armrests of Zeus' throne. It would seem, therefore, as if only the international shrine at Olympia could have served as the Severe prototype for this later flourishing of architectural sculpture, and, eventually, Athenian monuments and practices, as perhaps diffused by their itinerant workforce. It is also significant that so much was accomplished in the Peloponnesos over a relatively short span of time, in a relatively concentrated geographic area, and with strong interconnections in matters of both style and iconography. It seems therefore justifiable to stress Athenian imitation and influences, even if indirect, in contrast to

Architectural Sculpture on the Mainland

local traditions. Yet Peloponnesian and Kykladic masters were probably chosen for most of the undertakings, and topics stressed local heroes, despite their apparent similarity to Athenian themes. The notable shift to epic subjects may have been conditioned by this desire for local relevance.

How deeply entrenched were Peloponnesian tastes and practices may be shown by some later examples, which acquire greater illumination by being reviewed in contrast to comparable structures. This comparative approach must briefly take us outside the Peloponnesos.

DISSIMILAR TWINS

(A) The Tholos at Delphi

This spectacular building—a landmark in touristic posters for Delphi—remains so imperfectly known that it is hard to remember that it was the most highly decorated Doric structure after the Parthenon, itself never to be paralleled later. A round building with 20 columns, it had two sets of carved metopes: a larger series on the outside, and a smaller one behind the peristyle, above the cella walls, for a total of 80 panels (as against the 92 of the Parthenon). Its marble roof carried two concentric marble simas with rinceaux and rampant palmette antefixes, as well as lion-head spouts (Ills. 6–7); on rainy days, it has been pointed out, the circular structure with its many jets of water would have looked like an enormous fountain.[48] The conical

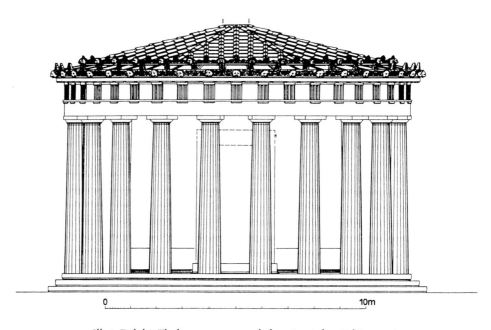

Ill. 6. Delphi, Tholos, reconstructed elevation (after *GdDs* 1991)

Architectural Sculpture on the Mainland

roof with marble tiles in herringbone pattern was segmented into eight sections, somewhat like an umbrella, and each section may have contained an akroterion, as shown by the extant cuttings for bases behind the first sima and the fragments of sculpture recovered. They seem to be female dancers in swirling, transparent drapery and backdrop mantles—perhaps a veritable chorus of *Aurai*.[49] The apex finial was probably floral. Given the pronounced slope of the Delphic terrain, by virtue of which each structure could be viewed both from above and from below, the attention paid to the decoration of this roof may be explained by its great visibility as worshipers approached the Athena Pronaia sanctuary from the road above.

Architecturally, this building is as heavily ornate as the Epidaurian Asklepieion. Carved toichobate moldings, lozenge-shaped ceiling coffers bordered by maeander patterns and with central stars, the use of dark stone set off by white, not only for the floor but also for a tall bench lining the interior of the cella and supporting ten tangential Corinthian columns, are all points of similarity with the Asklepieion. It has in fact been suggested that the same workshop was active in Epidauros and Delphi. Vitruvius (7. praef. 12) mentions that a Theodoros of Phokaia wrote a book about the Delphic Tholos; could he have confused the name with that of Theodotos (of Phokis?), the architect of the Temple of Asklepios? Others would reject this equation[50] and stress Athenian influence on the Tholos metopes, but similarities

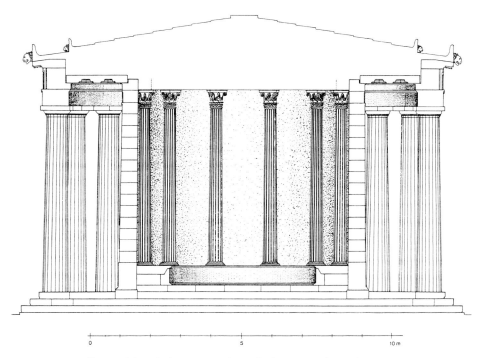

Ill. 7. Delphi, Tholos, section through elevation (after *GdDs* 1991)

Architectural Sculpture on the Mainland

with the Peloponnesian group of architectural sculpture are undeniable and may be significant. Chronology is also comparable, since the Tholos has been dated c. 380–370, although solely on stylistic grounds.

The carved metopes have been found scattered around the site, often cut back, broken up, and reused in later constructions. Because they were in exceptionally high relief, some figures have survived and can be rejoined to their backgrounds, but others were deliberately effaced and retain only faint traces of the original composition. There seems no doubt that the outer series of panels depicted an Amazonomachy. Traces of peltas and Oriental caps, and fighting women in chitoniskos, chlamys, and, occasionally, pardalis, wielding axes or shooting bows, are sufficient to document the theme, but it is impossible to tell where it took place. It was, moreover, not the only subject over the columns. Remains of centaurs with long beards and receding hairlines suggest that a Centauromachy was also included. Some panels may fall under either category. One of the most skillfully recomposed shows a male from behind, almost in the round, standing in front of a rampant horse that he is attempting to restrain. This three-dimensional rendering is unprecedented in earlier reliefs and will probably not find another parallel until the Gigantomachy of the Pergamon Altar.[51] Another metope, its figures badly chiseled off, retains the outline of a warrior with shield and fluttering mantle advancing toward a figure grasping a column surmounted by a round vessel. It has been suggested that the latter indicates a sanctuary where asylum is being sought;[52] other metopes from the larger series contain elements of landscape—for instance, a rock on which a warrior kneels while being attacked by an Amazon. In general, the manipulation of space is remarkable, with figures overlapping the upper fascia and stretching out beyond their visible and invisible frames.

The subject of the smaller metopes, above the cella wall, is more difficult to determine. Traces of a hydra and a bull have suggested the deeds of Herakles and Theseus, but some figures in quiet poses, one of them a peplophoros resting her right elbow on a support, have been interpreted as a possible divine assembly. A number of heads survive from both smaller and larger panels, some with the concave rendering of the eyes already noted at Bassai and Epidauros; a bearded face is said to resemble the Priam from the Asklepieion, a youthful male to anticipate Lysippan style.[53] Given the almost unpublished state of the smaller metopes, very few comments can here be attempted.

Amazonomachy and Centauromachy are age-old subjects traditionally employed when a large sequence of panels had to be filled, because no limitation existed as to the number of participants. The juxtaposition of the two themes immediately recalls the west and south metopes of the Parthenon, but, by the same token, it also reminds us of the Bassai frieze, and we have seen the Amazonomachy used for pediments and other metopes at the Peloponnesian sites discussed above. Yet only Bassai may compare in the visual *continuum* of the two subjects, which the viewers could perceive side by side, without break.[54] Whereas a traditional Doric building

Architectural Sculpture on the Mainland

could separate each theme at the corners, a round structure would inevitably have offered some points of view from which a change in topic would be fully apparent. Were there visual devices by which such a shift could be masked or perhaps even emphasized? We can no longer tell, but this consideration may have played a role in the decoration of the later Epidaurian Tholos. As for the inner metopes, deeds of Herakles and Theseus (together with an Amazonomachy) had already been used on the panels of the Athenian Treasury in the neighboring sanctuary of Apollo, but the circular plan would have presented equal problems of definition, although the outer colonnade might have provided set frames for the visual compass of a viewer standing outside the building.[55]

The inner metopes are too imperfectly known and therefore cannot help in determining the appropriateness of their topics to the building they decorated; can we do better with the subjects of the outer metopes? If the Amazons are taken as allusion to the Persian foe, the historical events may have been too remote in time to justify it. Given the location of the Tholos within the precinct of Athena, it is more logical to associate the sculptural decoration with that of the Parthenon, dedicated to the same goddess. The Athenian connection would then acquire stronger probability; yet one wonders whether a Phokaian (or even a Phokian) architect would have wanted to stress such a connection, or whether the priesthood at Delphi would have allowed such inferences. In the first three decades of the fourth century, Athens would hardly have been strong enough, politically, to influence the international sanctuary,[56] and only its artistic repute might have carried some weight in the choice.

This problem of interpretation is made more complex by the fact that we have no notion as to the function of the Tholos. Pausanias does not seem to mention it in his account of the sanctuary of Athena Pronaia, and speculation based on plan and decorative details has not met with general agreement. Among the various proposals are that it was a concert hall, a heroon, a temple to Athena, a repository for weapons or other dedications, or a treasury meant to house nine chryselephantine statues that would have stood on the inner bench, framed by the Corinthian columns.[57] This last suggestion rests on an analogy with the arrangement within the Temple of the Athenians on Delos and the Philippeion at Olympia, which undoubtedly held statues, and on the fact that the bench within the Delphic Tholos is treated like a statue base. But no traces of such statues remain, and the remarkable decorative richness of the building is by itself not enough to support its identification as a treasury. The purpose of the Tholos must, at present, remain an open question.

(B) The Tholos at Epidauros

Equally controversial is the function of another round structure (Ills. 8–9), which a building inscription calls a *thymele*. This is the term usually reserved for the small round altar in the center of a theatrical orchestra, and it hardly seems to apply to

Architectural Sculpture on the Mainland

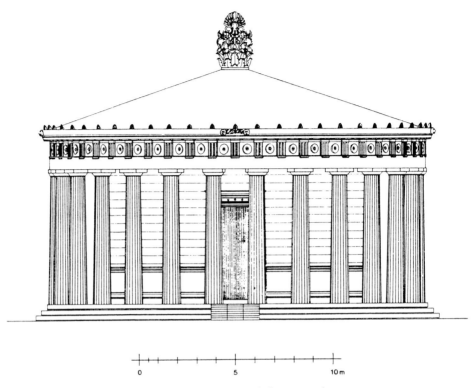

Ill. 8. Epidauros, Tholos, reconstructed elevation (after Roux 1961)

such a splendid and large construction. Suggested identifications include a concert hall (here slightly more plausible because of the hollow basement), a place for Asklepios' snakes (because of the labyrinthian nature of the foundations), a cenotaph for the hero/god of the sanctuary, or a temple to the chthonian Asklepios.[58] Once again, the sculptural decoration has been used to support some theories, with but relative success.

Pausanias (2.27.5) attributes the building to the architect Polykleitos, although he seems to think of him as the famous fifth-century sculptor. Yet even the Epidaurian theater is given to him in the same passage, and both the building inscription and the plans firmly set both these structures within the following century. There is nothing inherently implausible in a sculptor functioning also as an architect (as we have probably seen at the Asklepieion, and will certainly see at Tegea), so this Polykleitos may easily have been a descendant of the Argive master, the second of that name.[59] According to the accounts, the Tholos may have taken at least 30 or as many as 50 years to be completed, beginning immediately after the Asklepieion was finished and with an interruption of the works after inception, perhaps because of war. The bracket 370–340 is most often cited as likely. Some names mentioned

Architectural Sculpture on the Mainland

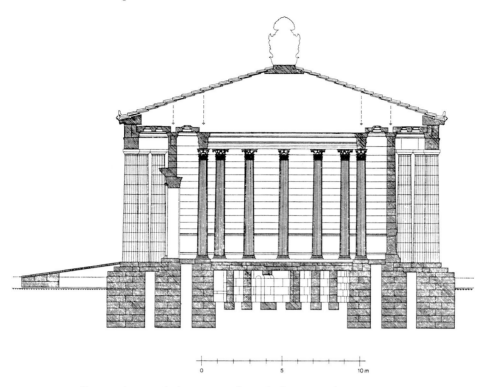

Ill. 9. Epidauros, Tholos, section through elevation (after Roux 1961)

in connection with the temple recur also in the Tholos accounts, implying some continuity of local workshops. Yet the similarity with the Tholos at Delphi is often emphasized, the earlier even being considered the inspiration for the later structure.

Larger than this predecessor (26 outer columns), the Epidaurian building was also in the Doric order, but its 14 Corinthian columns on the inside stood on the floor, away from the walls. Similarities include the use of orthostats, sima (albeit single) with rampant antefixes and lion-head spouts, elaborate moldings, contrasting black and white stone, and decorated coffers. Yet everything is even more ornate at Epidauros, especially the spectacular coffers with two different sets of central devices in the shape of flowers (lilies and poppies) and akanthos leaves. The Corinthian capitals are both unorthodox and among the most elaborate in existence. The doorway had massive jambs recalling those of the Erechtheion north portal, and other moldings have also suggested comparisons with Athenian buildings. It is therefore all the more surprising to find that no inner metopes existed and that the outer panels were carved with a repetitive design without variation.

What such design represents may still be debated. Some see the carvings as rosettes, repeated also on the door jambs; others read them as mesomphalic phialai,

Architectural Sculpture on the Mainland

and connect them with libations and cult. One suggestion, building on italic parallels for the motif of the sima, believes the phialai imitate metal vessels imported from Magna Graecia, possibly as votive offerings. Perhaps coincidentally, the only precedent for a sequence of metopes with repetitive motifs, vegetal in nature, occurs in sixth-century Megara Hyblaia, on a funerary Doric structure. A later example, a tetrastyle amphiprostyle Doric Heroon/Mausoleum from near the stadium at Messene, of the third century, had rosettes carved "throughout the building."[60]

Was the single pattern chosen because it avoided the issue of the changing subjects? or the difficulty of carving on a convex panel? Considering the size of the building, the slight curvature involved should not have created a problem for skilled workers. Athenian influence and imitation, advocated for both the Delphic and the Epidaurian Tholos, should have produced similar results. Local tradition may have been an obstacle, given the example of the blank metopes on the Asklepieion and probably the Temple of Apollo Maleatas, but certainly the abundant sculptural decoration of the former (which implies no tabu on figural scenes in connection with the cult of Asklepios) should have encouraged narrative embellishment, especially on a building planned by a sculptor/architect. Yet perhaps stress should be placed on the total lack of figural carvings. The metopes, whether phialai or rosettes, might have been meant to complement the rinceaux of the sima and the floral finial of the exterior, as well as the emphasis on vegetation provided by coffers and Corinthian capitals in the interior, in a global symbolic message of regeneration and life. Or perhaps, and this may be the hypothesis closest to the mark, tastes in architectural sculpture were changing, and decorative emphasis was shifting from the outside to the inside of the buildings, or to different monuments, such as altars.[61] This suggestion should be kept in mind as we consider the next pair of examples.

(A) The Temple of Athena Alea at Tegea (Arkadia)
The only certain date for this building is provided by the information (Paus. 8.45.4) that it replaced a predecessor destroyed by fire in 395. That Archaic temple is the subject of current investigations, but it does not seem to have had architectural sculpture. It did, nonetheless, determine for its successor the old-fashioned, elongated plan of 6 × 14 columns, which included an opisthodomos. Yet within the compass of this tradition, the new structure was thoroughly innovative while fully in keeping with the latest trends. It was entirely in marble (rare for the Peloponnesos), and the interior of its cella was lined on three sides by engaged Corinthian columns, which in turn supported a second story of engaged Ionic columns.[62] The vegetal motifs of the capitals of the lower order combined with the carved molding of its bases (which continued along the wall into a toichobate) and with the carved epikranitis to create richly ornamented horizontal accents. At the same time, the fluted column shafts and the small bays of the intercolumniations provided a vertical texturing of the walls and a general rippling effect along the interior surfaces.

Architectural Sculpture on the Mainland

This spectacular backdrop framed an ivory statue of Athena by Endoios, of the sixth century, which is likely to have been small and therefore not in direct competition with its architectural setting. This image was taken to Rome by Augustus (Paus. 8.46.1), at which time it was probably replaced with the statues of Hygieia and Asklepios seen by Pausanias,[63] which have no cultic connection with the temple and probably served simply to fill the void.

For all its interior richness, the temple exterior was somewhat sober. Pedimental sculpture filled the two gables and figural akroteria stood at the corners (although the two central ones were floral). But the outer metopes were blank, and only those over the porches had applied decoration, with a system comparable to the Erechtheion frieze. Such removable sculptures were easily lost, and little from them survives. Yet inscriptions on the architrave blocks have given some clues as to their subjects: *Kapheidai* (the children of Kepheus) appeared on the pronaos, whereas *Auga, Telephos,* and *A*[*leos?*] on the opisthodomos suggest that episodes from the life of Telephos (perhaps from conception to infancy and maturity) decorated the western panels.[64] Two points are particularly important about the metopes. The first is the strong emphasis on local heroes and families, directly connected with Tegea, even if their myths may not have been very widely known; they all belonged to the family of Aleos, who was said to have established the cult of Athena Alea, named after him. The second point is the possibly pictorial arrangement of the metopal figures, postulated on the basis of the uneven alignment of the inscribed names on the architrave; the images would have appeared staggered against the background, perhaps to convey a sense of depth and recession in space. This same uneven pattern of inscriptions occurs, however, on the famous relief from Tegea in the British Museum, on which the Zeus of Karian Labraunda is flanked by the Hekatomnids Ada and Idrieus.[65] Here all figures stand on the same groundline, but the god is much taller than the two mortals, thus reflecting the placement of the labels. This relief is crucial for the chronology of the temple, and we shall return to it later.

The subjects of the pediments are known from Pausanias (8.45.6–7): the Kalydonian Boar Hunt on the east, and the Battle of Telephos and Achilles on the plain of the Kaikos River on the west. Once again, the emphasis is on local heroes, but at least the façade topic is an event of Panhellenic interest and involvement, although appropriate to the building, not only because Atalante was a descendant of Aleos, but also because the boar's hide (Paus. 8.47.2) and tusks were allegedly housed in the temple until the latter were carried off by Augustus together with Endoios' Athena. As has often been noted, the correlation between metopes and pediments is striking, especially on the west side, where a possible temporal sequence may have existed from panels to gable. Equally striking, although debated, is the apparent absence of gods from both pediments. Pausanias lists the participants in the Boar Hunt (including Theseus, Telamon, Peleus, and Iolaos) and places the boar in the center, thus virtually excluding the presence of Athena or other deities, who

would not have been relegated to the margins of the composition. He gives no such listing for the west pediment, and a youthful head wearing a lion-head cap or helmet had usually been identified as Herakles watching in anguish as his son is wounded by Achilles. Another suggestion has attributed to the gable the upper fragment of a much more mature Herakles, bearded and wearing the traditional *leonte*.[66] Thus the less canonical cap would simply allude to Telephos' paternity, and the beardless rendering would be in keeping with the sequence of generations, highlighted by proximity. Other authors, however, see in this piece a free-standing statue. Even without this addition, Stewart identifies the lion-cap head as Telephos, and excludes Herakles from the composition. At the present state of our knowledge, it is impossible to decide, although I would at least favor the Telephos identification.

But why would a topic have been chosen that seems to emphasize the defeat of the local hero? Indeed, other scholars have visualized the west composition as a duel between the two protagonists, with both Dionysos and Herakles watching or even separating them, and Athena in the center, as against the more general battle reconstructed by Stewart. I would not credit an Athena confined to the rear pediment, and would surmise that mythical events carried no "blame" for the Classical Greeks—like the possible treachery of the chariot race between Pelops and Oinomaos at Olympia, the (implicit?) death of Machaon and the sacrilege of Ajax at Epidauros (and the rape of Koronis). At Tegea, perhaps it was sufficient to show Telephos' descent from Herakles to add indirect glory to the city. But I would, again, be skeptical of reading in the choice an implicit counterclaim to the Macedonian Argeadai's presumed lineage from the same hero, or a possible anti-Spartan message in the sculptural program.[67]

Attribution to either gable is made easier by the slightly larger size of the western figures. Stylistically, however, all seem fairly homogeneous, although in highly fragmentary state. Thus heads are the most readable pieces from the pediments, and the male ones are indeed the most distinctive among fourth-century sculptures. Rhys Carpenter used to describe them to his classes as "cannon-ball heads" because of their massiveness and their powerful necks, short and about as wide as the heads themselves (Pl. 7). Novel traits are the now emphatic horizontal division of the forehead, with the lower half protruding over the eyes in the so-called Michelangelo bar, and the swelling eyebrow muscle that overlaps the eyelid at the outer corner. The eyes themselves are rounded and almost rolling, certainly bulging rather than "melting" or concave, as in earlier renderings; they seem hidden in enormous cavities created not only by the overhanging brow but also by the eyes' deeply set inner corners—hence an expression of the famous *pathos*. But the eyebrows are not visibly angled upward, as at Epidauros, and thus the effect is strongest when the heads are seen from below, as intended, rather than at eye level. Note, moreover, that the boar displays a very similar eye rendering, which should thus be taken as a stylistic convention rather than as a purely expressive device.[68]

Uncovered heads display short curls hugging the skull, rather than "heroic" or

Architectural Sculpture on the Mainland

antiquarian coiffures, whereas longer strands, or at least definite sideburns, are suggested on the helmeted heads. Boxer's (cauliflower) ears add to the apparent brutality of the warriors. The headgear is a version of the Attic helmet, albeit without cheekpieces, and seems to be close to actual fourth-century forms—another manifestation of the new tendency to render events of the remote past in contemporary terms.[69] The sole female head, although only half of it survives, shows somewhat the same traits as the male faces, in attenuated version: the eye is narrower and less prominent, the eyebrow muscle less bulging, the orbital cavity somewhat less deep; the forehead seems smoother. The hair is perhaps the most diagnostic feature, in that strands are pulled straight back toward the nape, rather than undulating around the temples, and seem to frame a triangular forehead—a pattern that is best represented by the various replicas of the Knidian Aphrodite. Stewart attributes this head to the akroteria on the basis of scale and size. A female torso assigned to the east pediment had its head worked separately and inserted in a prepared cavity—a somewhat unusual technique for pedimental sculpture.[70]

One female figure, long considered Atalante, has now been convincingly labeled an akroterion, since another similar statue has surfaced, but in matching rather than in mirror-image pose. We may therefore have one corner akroterion from each of the gables. Both figures wear a peplos with overfold, unpinned over the right breast, but the second adds a mantle, at present visible only on her back, where it rides low like a scarf trailing to the ground. In contrast to the first statue, not enough is preserved of the upper body of the second to be sure that it had no wings. Stewart restores it as a Nike, and Gulaki supports the idea by suggesting that two Victories from Side are Imperial imitations of the Tegea sculpture.[71] Distance in time and place may imply generic, typological affinities, rather than direct inspiration. In stylistic terms, both bodies are strong and assertive, with full breasts and rounded stomachs made more prominent by the sinking drapery between the legs, which partly uncovers the powerful thighs. Folds are harsh ridges acting almost like diagonal slashes across the bodies, stressing movement and tension rather than texture and modeling. Transparency is expressed through adherence and flattening, rather than as the nature of the cloth itself, which seems uniformly substantial. Identification and message are difficult to fathom: why Nikai over a struggle that the local hero lost (even if he may have won the battle)? And why "Nymphs" over the Boar Hunt? Personifications of regional, topographical features may seem inappropriate at roof level.[72] Perhaps akroterial females flanking central floral ornaments had by now become conventional; yet other examples of roof decoration were more distinctive, as we shall see later.

The last issues concerning the Tegea sculptures are the matters of attribution and chronology. Pausanias mentions only that Skopas was the architect of the temple, and the maker of the images of Asklepios and Hygieia. This information has universally been taken to imply that the master would have at least provided models for the entire sculptural program, and therefore the Tegea heads have become a corner-

Architectural Sculpture on the Mainland

stone in the definition of Skopasian style. Yet Stewart's statement—that they "so resemble those of other statues of his preserved in copy" as to ensure at least Skopas' direction—seems to me questionable, not only because such resemblance is relative (indeed, the Tegea heads remain stylistically unique), but also because some traits can be found in other contexts, as part of the general artistic climate of the time. Had Skopas truly been engaged in sculpturing two large divine images, he would have had little time for other tasks, especially if he was responsible for architectural supervision.[73] Moreover, the partly unfinished, almost approximate quality of the carving of the Tegea sculptures suggests workshop practices rather than masterly hands.

The situation is complicated further by the possibility that Skopas was simultaneously engaged at the Halikarnassos Maussolleion and at Tegea. The Karian building will be discussed in Chapter 4; here suffice it to state that a certain connection between the two sites is assured by the presence of the above-mentioned relief with Zeus, Ada, and Idrieus. This fragmentary slab was traditionally assumed to be a votive relief dedicated at Tegea by a (presumably Karian) worker who had followed Skopas to the Peloponnesos after construction at Halikarnassos was over. A more recent theory, based on the size and thinness of the stone as well as on historical considerations, sees the carving as the heading for a decree, presumably set up by the local authorities, to thank the two Hekatomnids for donations to build, or to complete, the temple to Athena. Indeed the royal couple is known to have contributed to other Greek religious structures, at Priene and at Delphi. It is therefore possible to believe that Karian interest in Arkadian matters was sparked by Skopas' involvement with both projects, in which case Halikarnassian dates seem safer than those for Tegea.[74] A *terminus ante quem* for the Record-relief is probably given by the death of Idrieus in 344, which would accord well with a stylistic chronology around 350–340 for the Tegea sculptures, as well as for architectural details.

(B) The Temple of Zeus at Nemea (Corinthia)

No architectural sculpture of any kind survives from this temple, and it would therefore seem useless to consider it in a chapter devoted to that subject were it not for the fact that the same masons who worked at Tegea are often postulated to have worked at Nemea. The plan of the temple is sufficiently different (albeit with similarities) to discount Skopas' participation as architect at this second site; yet details, such as the carved sima and other moldings, are close enough to support the workshop connection. In addition, material discovered in the kiln that served to make the roof tiles for the temple has allowed a fairly precise dating of its construction to the 330s and 320s.[75] It therefore seems logical to assume that masons released from working at Tegea moved to Nemea to contribute to the new building project.

This was not the first temple at the site, an Archaic structure having preceded it.

Architectural Sculpture on the Mainland

This early shrine was, however, destroyed at the end of the fifth century, and the entire sanctuary remained more or less inactive for many decades, since even the famous Panhellenic Nemean Games were moved to Argos. Perhaps under Macedonian impetus, a refurbishing of the area took place in the 330s that involved the revamping of the earlier altar and the erection of a new temple. With the return of the Games, a new era of prosperity began, which was to last for some centuries.

The new Doric temple had a modern plan: 6 × 12 columns, without opisthodomos, but with the inclusion of a sacred crypt, accessible from the cella by means of a descending staircase. This "adyton" at the west end of the cella was separated from it by a Π-shaped colonnade of Corinthian columns, which in turn supported a series of Ionic half-columns backed by Ionic pilasters. The visual effect would have been somewhat comparable to the interior of the Athenaion at Tegea, but at Nemea the columns stood at a distance from the cella walls, and therefore their decorative effect was somewhat lessened. Whether an image of Zeus stood within this enframing colonnade is not certain, although Pausanias (2.15.2) states that at the time of his visit, the roof had "fallen in and the cult statue is missing." Given the mystery nature of the cult, it is possible to assume that no major idol stood within the cella, and at least none has been recorded by the ancient sources.[76] Another feature of the interior, somewhat comparable to Bassai, is the presence of an enormous doorway into the cella, with massive jambs projecting into it and a (now missing) threshold in dark limestone, providing some color contrast as at Epidauros.

The exterior of the temple was sober. The Doric columns were quite slender, with almost straight echini, as compared with fifth-century forms and proportions, and the entablature was lighter, yet many refinements have now been observed in the masonry, including curvature. The metopes were blank, and no pedimental or akroterial sculpture has been recorded. The only decorative touch (beyond painted details) would have been provided by the lateral sima with rampant antefixes, lion-head spouts, and carved rinceaux. The total effect has been called stiff and mannered,[77] but this judgment may derive from our preference for Periklean standards.

It may seem unwarranted to compare Tegea and Nemea on the tenuous basis of a common workshop tradition. It may even be argued that Nemea was so sober because Skopas the sculptor was not involved, and that the richness of Tegea reflected his plastic interests. Yet the similarities go beyond the details of the sima and partake of a common Peloponnesian trend in the fourth century, beginning with the shortened plan of the Asklepieion at Epidauros and its manipulation of the interior by means of a Π-shaped Corinthian colonnade. Tegea and Nemea both use the Ionic order above the Corinthian, and seem to imitate the architectural vocabulary of stoas rather than of other temples. Even Bassai can only be considered a remote inspiration. If, as Roux (1961) has argued, a Peloponnesian (Argive) school can be postulated behind these formulas, the role of the architect is somewhat les-

sened by comparison to the strength of the trained masons who seem to have moved from area to area as demand arose. At Tegea, the length of the plan was dictated by respect for the predecessor; at Nemea, neither the predecessor nor the inclusion of the crypt could provide sufficient impetus for a longer plan. It seems therefore appropriate to look for other reasons behind the choices made with respect to architectural sculpture.

As I see it, during the Archaic and Severe periods, only the Panhellenic Olympia had shown a true interest in architectural decoration, perhaps in imitation of the other international sanctuaries. The rest of the Peloponnesos remained rather immune to such embellishments.[78] The impact of the spectacular Athenian building program at the end of the fifth century must have been strong enough to overcome regional tendencies. The availability of trained workmen would have added to the inclination. Diffusing *both* from Olympia and from Athens, such Atticizing trends produced carved metopes, friezes, pediments, and figural akroteria where none, to our knowledge, had previously been used: at Bassai, the Argive Heraion, Epidauros, Apollo Maleatas, Mazi, and eventually Tegea. This last building may have received its influence through the Asklepieion and, given the tradition that both Skopas and Timotheos worked on the Halikarnassos Maussolleion, the link may be found in their respective workshops (some scholars even postulate that Skopas was a pupil of Timotheos, to explain the connection). Obviously, on the example of Olympia (Pelops and Oinomaos), even the "Atticizing" topics of the sculptural decoration took on a Peloponnesian cast, with emphasis on regional heroes, and perhaps a slight weakening of the emphasis on traditional divinities. By the mid-fourth century, local tendencies were again coming to the fore: the Epidaurian Tholos, despite its imported Pentelic marble and its imitation of Attic forms (mediated through Delphi?), and the Temple of Zeus at Nemea can be seen as the product of this revival, with greater focus on the interior of the buildings. Athenian influence had by now waned, and building activity had shifted to Asia Minor. Whatever new structures were being built in the Peloponnesos were of a civic nature and required no religious message through architectural sculpture.

Perhaps in support of this theory comes the evidence of decorated altars, despite their virtual absence from our record. A **triglyph altar with decorated metopes at Epidauros** has been briefly mentioned above.[79] Another, more elaborate example—the so-called **Federal Altar**—was built at Tegea presumably at the same time as the Athenaion; Pausanias (8.47.3) tells us that it depicted Rhea and the Nymph Oinoe holding baby Zeus and flanked by four Arkadian Nymphs on either side; the Muses were also included together with their mother Mnemosyne, and a beautiful female head, the so-called "Hygieia," has occasionally been attributed to it. Such a richly decorated altar seems more in keeping with early Hellenistic formulas, as at Priene,[80] and at any rate, it cannot be profitably discussed here for lack of concrete evidence.

One more building at Tegea, whose nature is, however, unknown, carried sculp-

Architectural Sculpture on the Mainland

tured group akroteria. A fragmentary **symplegma at Tegea** has now been recognized by Despinis as the counterpart of the better-known "Ephedrismos" group in the Conservatori Museum in Rome, showing a woman in rapid motion to left while carrying a companion on her back (Pl. 8). The sculpture in Rome, once restored with plaster additions (now removed), was usually thought to come from Magna Graecia, given its findspot in the Lamian Gardens; it was also dated to the Hellenistic period because of its dramatic drapery, the bared breasts of the two women, and its spatial complexity. The identification of its matching piece at Tegea clarifies origin and probable dates for both within the late fourth century. Scale suggests a building smaller than the Athenaion but roughly contemporary.[81]

Plate 8

ADDITIONAL ARCHITECTURAL SCULPTURE

Akroteria

Roof decoration may provide the most abundant category of extant evidence. The most recent acquisition as a Greek original is a splendid **Maenad in Oxford**, headless and armless, with overfolded peplos opening over the projecting right thigh, and animal skin (*nebris*) crossing the torso diagonally below the uncovered left breast (Pls. 9a–b). Two long hair strands loose over the left shoulder (visible only from the rear) and a snake used as a belt add to the impression of abandon and wildness. Drapery is transparent over the abdomen, with a definite hint of the navel, despite the double layering; long curving ridges model the forms beneath. Hitherto considered a Roman copy of an early Hellenistic original, the Maenad has now been compared with similar figures, especially those from the Tegean Athenaion, and thus dated around 350–330; an akroterial function seems the most likely, perhaps for a temple to Dionysos that would justify a thematic connection.[82] Could the mid-fourth-century Dionyseion at Eretria be a suitable candidate for this remarkable piece of sculpture? Since several pieces of architectural sculpture from that site were taken to Rome, this akroterion could also have been part of the *spolia*, and would have then found its way from Rome into a British collection.

Plates 9a–b

Stylistically fairly close to the Oxford Maenad is the so-called **Palatine Aura**, especially in the long folds delimiting the rounded abdomen and in the massing of the drapery between the legs; some scholars would date it, however, still within the fifth century, and even the most recent discussion considers it at least one generation later than the Oxford piece. Attribution to a definite building or even workshop has been wide-ranging—from Attika to Magna Graecia.

In August 1995, a second replica of the type was found within the estate of Herodes Atticus at Loukou in Arkadia, but only newspaper accounts are so far available on this exciting discovery.[83]

More definitely fourth-century is the so-called **Aura in Copenhagen** (Pl. 10), which has even been connected with Timotheos on the basis of its style. Once again, attribution to a specific building and geographical area is impossible, although the

Plate 10

55

akroterial function seems assured. Other sculptures in the same situation are the **Formia Nereids** riding hippocamps (reputedly from the Temple of Poseidon at Hermione), and other figures tentatively grouped as Aurai in the *LIMC* entry.[84] It seems best here to limit our review to the few other pieces with a definite provenance.

Comparable to the Formia Nereids, in that they ride dolphins, are some female figures that were even copied in Roman times, but whose original fragments were excavated in the **Athenian Agora**; their attribution remains uncertain, but their provenance is unquestionable, and their stylistic affiliations are with Attic workshops. Also from the Agora is a splendid **female figure in transparent drapery**, with uncovered left breast and mantle falling between the legs after looping over the advanced right thigh; her dating within the first quarter of the fourth century is clearer than her association with a specific structure. Finally, some **peplophoroi from the sanctuary of Athena Pronaia** in Delphi, because of their mid-fourth-century style, have been associated with the limestone temple there (Pl. 11).[85] The predominance of female figures is remarkable, and so is the preference for renderings of motion, perhaps encouraged by the aesthetic appeal of transparent and agitated drapery; group compositions with interactive participants, so popular in the late fifth and early fourth centuries, seem to diminish in frequency as time progresses.

To be sure, akroterial sculptures are very close to free-standing statues, and are often difficult to differentiate from them. Weathering patterns alone are insufficient, since one-sided exposure to the elements may have occurred after destruction. Unfinished or simplified treatment of the back may indicate pedimental, as well as akroterial, function. A pronounced tilt forward is not enough to single out a figure as a roof ornament, in that some undoubted akroteria stand straight, whereas dedications like the Nike of Paionios lean into space. Even a balancing mass of drapery to the rear of a figure is, by itself, inadequate indication, yet it seems to be a frequent characteristic of the pieces we have analyzed in this chapter; it creates a dramatic contour when the image is viewed from the side. Finally, we should not omit to mention that an ancient roof carried decoration beyond that at the three peaks of a gable. That special antefixes may have existed along the ridgepole is suggested by the evidence of the Alexander Sarcophagus, and we have examples of waterspouts (or even corner embellishments at sima level) in the shape of animal heads appropriate to the temple owner or the location of the building: seals at Phokaian Larisa, hounds at the Epidaurian Artemision, rams at the Eleusis Telesterion, to mention a few from different periods. More difficult to visualize are the many birds, in either stucco or wood, says Pausanias (8.22.7), that stood over the **Temple of Stymphalian Artemis, at Stymphalos**. He believes they were wooden, but does not give us a date for the building, and we have not recovered it.[86] This instance points out how much we might be missing from the superstructures of Greek temples that,

Architectural Sculpture on the Mainland

like the gargoyles of a Gothic cathedral, would have added a great deal to the underlying message and the total appearance.

Pediments

Pausanias remains our only source also for some pediments, not otherwise known. He describes a **Temple of Herakles at Thebes** (9.11.6), for which the famous Praxiteles—hence in the fourth century—seems to have carved most of the Twelve Labors, in an arrangement that is hard to visualize; Herakles and two Nikai appeared also on the pediment of the Asklepieion at Titane, in the Corinthia (Paus. 2.11.8), but no chronological indication is here given.[87] Among the extant figures, a reclining Herakles in Athens may have decorated a shrine for that hero, a small seated Muse probably comes from the **Temple of Apollo Patroos** in the Agora, and we have the occasional small relief pediment from a funerary naiskos, also in that city.[88] But by and large, pedimental decoration seems to have been limited to major temples in international sanctuaries; indeed, beyond the examples previously discussed in this chapter, only the **Temple of Apollo at Delphi** need be considered. Destroyed in the earthquake of 373, the building took a long time to be re-erected, but it retained the traditional elongated plan (6 × 15) and the customary decoration. The sculpture (Apollo and the Muses on the east, Dionysos and the Thyiades on the west) was completed late enough to qualify as early Hellenistic and therefore I have discussed it at greater length elsewhere.[89] Here it suffices to repeat that its workshop was Athenian but its inspiration local: major gods in the center, accompanied by their entourage, as in the Archaic predecessor.

Metopes

One small composition, **Artemis stepping on a Giant**, whom she probably threatens with her bow and arrow, has been tentatively considered pedimental as well as metopal. It comes from a sanctuary of Artemis and Apollo at Kalapodi, a site in Phokis near ancient Hyampolis perhaps to be identified with the famous oracle of Apollo at Abai. The history of the site is complex, with remains of two seventh-century buildings destroyed around 575, replaced by two other structures in turn destroyed by the Persians in 480, until the erection of a Classical building, 6 × 14, at the end of the fifth century. Yet the extant sculptural fragments, although of the right date, are too small for the main temple, and they have therefore been thought to come from a lesser building, or, more tentatively, from a base or votive relief.[90] Given the lacunose state of the panel, and the lack of other evidence for architectural sculpture from the site, this example could be eliminated from our count.

The Kalapodi relief has been judged to be under Athenian influence, yet Athens itself has produced very little in the line of carved metopes. Junker lists only a panel from a small **funerary shrine**, depicting three mourning women. Whatever civic

Architectural Sculpture on the Mainland

structures were erected during the fourth century seem not to have required sculptural embellishment. The only series of (four) possible metopes comes from **Sparta**, but its chronology is variously given as second or fourth century. The subject, an Amazonomachy, would be appropriate for both periods, and the evidence for dating is purely stylistic, since the fragmentary reliefs were found reused in the walls of a modern house. Finally, the mid-fourth-century **Artemision at Kalydon** has yielded fragments of a marble panel depicting fighters with shields, which probably decorated only the cella front. It is worth noting that the earlier Temple of Poseidon at Molykreion, attributed to the same architect, to our knowledge carries no such sculptural decoration.[91]

What is in fact remarkable is the number of extant Doric buildings erected on the Greek Mainland during the fourth century without the benefit of architectural sculpture. Even the incomplete chart drawn up by Knell (1983), which includes only peripteral structures, lists 14 (one doubtful) temples without decoration, as against six (one doubtful) with some form of it; yet other, non-peripteral Doric shrines could be added, some of them on the Kyklades with interior Π-shaped colonnade, but equally sober in their appearance.[92] It would therefore seem as if the Mainland Greeks through the entire fourth century had scant interest in the traditional forms of sculptural embellishment, despite the greater elaboration of cella interiors and the use of carved coffers.

Friezes
The land of the continuous frieze is, traditionally, Asia Minor, or, conversely, Attika. It is therefore not surprising that, in this review of the Mainland, the single example we can cite comes from the **island of Delos**, under strong Athenian influence. It is a peculiar item, so badly weathered as to be stylistically unreadable. Its date, around the middle of the fourth century, is based on a building account of 345/4 indicating that work was already at an advanced stage by that time. The structure to which it belonged, the so-called Building 42, is located near the Artemision; it is unusual in plan and unclear in function, although several suppositions have been advanced. The almost square plan was fronted by a porch of 10 Ionic columns, and the roof was in two levels, with a central core raised like a clerestory above the side wings. The clerestory also had large windows, which suggest the need for strong lighting of the interior. The Ionic frieze seems to have depicted the Deeds of Theseus, each episode contained within a frame produced by raised borders following the vertical joins of the component blocks, so that the total effect was that of a series of metopes rather than a continuous strip. This almost Doric treatment of an Ionic feature has been attributed to Athenian influence.[93]

In summary, it appears that none of the examples discussed in this more extensive review of Mainland practices contradicts the conclusions already drawn for the en-

Architectural Sculpture on the Mainland

tire Peloponnesos. Relatively little building activity took place in Athens, at least for religious purposes, and elsewhere what was erected either replaced destroyed structures, thus following previously established forms of architectural sculpture, or did not use figural decoration, at least to judge from the present state of the evidence. Smaller, private shrines may have been more readily adorned than larger, official ones. The Peloponnesos provides therefore the most numerous examples of both new temples and sculptural embellishments, and takes the leading role in the development of architectural forms and stylistic development. Yet, in so doing, the area seems to have overcome its own tradition and to have accepted eagerly Attic fashions and perhaps even Athens-trained workmen, beginning around 400, in a phenomenon that has not usually been sufficiently stressed or considered against its wider context.

We can see the impact of Athenian practices spread like ripples in a pond, but we can also note the return to placid waters, that is, to conventional preferences and forms, after approximately half a century. What is remarkable, however, is not that such impact was felt at all, but rather that it could be so strong and last as long as it did. Undoubtedly, two or three workshops went from commission to commission and were partly responsible for perpetuating this flurry of architectural decoration, although interest and requests may have come from the individual poleis and priesthoods. Major innovations were, however, introduced: interiors were more richly decorated than exteriors, coffers were elaborately carved, orders were juxtaposed and superimposed, in a form of non-figural sculpture. As for the extant narrative compositions, themes may seem to have been borrowed from the Athenian repertoire, but they took on specific regional meaning, with emphasis on epic tales and local heroes rather than on gods, who gradually relinquished the center of pediments.

Emotions could be expressed not simply through context but also through manipulation of facial features, and drapery became increasingly illogical yet also "minimalist," with fewer folds and patterns but greater play of light and shadow. That some of these fourth-century pieces could have been considered Hellenistic is significant. As for the ubiquitous Amazons, their Oriental attire was also toned down to virtual hints and attributes, in contrast to the colorful long-sleeved, trousered, and highly patterned costumes of the Archaic period. Equipment such as helmets and footwear, anachronistically, may also have come to reflect contemporary usage rather than the earlier antiquarian trends. Technically, however, carving seems to have been hastier, more approximate, with backs of figures often left partly unfinished and occasionally hacked down for fastening to a background. Even scale seems not to have been kept uniform from one pediment to another, although no pattern of importance can be detected. Impressionistic renderings may have been an element of style as much as a symptom of expediency.

It now remains to see how such architectural sculpture was adopted by the cities

Architectural Sculpture on the Mainland

of Asia Minor, but in order to understand its role, we must consider it first in its non-Greek setting.

NOTES

1. Trianti, 1985 and 1986 (p. 166), believes that the sequence is different, the Bassai frieze being later than the sculptures of the Argive Heraion, which she dates c. 410. Her suggestion is, however, based on stylistic grounds, whereas architectural details may suggest the reverse progression here followed.

2. Argive Heraion: discovered by an early traveler in 1831, first officially excavated by the American School, and published by C. Waldstein et al., *The Argive Heraeum*, 2 vols. (Boston/New York 1902–1905); the sculptures from the temple and the general area are discussed in vol. 1. On the pediments, see Eichler 1919, 18–46; Delivorrias 1974, 189–91. Cf. also Ridgway 1981a, 32–34 and nn. 36–38, 41; Stewart 1990, 169, with additional bibl.; Boardman 1995, figs. 6.1–2 (metopes), fig. 7 (sima).

Plans for a second temple before 423: H. Lauter, "Zur frühklassischen Neuplannung des Heraions von Argos," *AM* 88 (1973) 175–87. On Pliny's scrambled chronology, see, e.g., Stewart 1990, 237–38, T 1. For the gold-and-ivory statues cited, see here Chapter 1. An apparent exception—the chryselephantine Dionysos by the 5th-c. Alkamenes seen by Pausanias (1.10.3) in the second Temple of Dionysos near the theater in Athens, which excavational and architectural evidence dates to the mid-4th c.—may not be reconciled with the norm even if we distinguish between an Alkamenes the Elder working on the (Severe) Olympia west pediment, and a younger sculptor by the same name, Pheidias' contemporary, whose career could stretch into the next century: cf. J. P. Barron, "Alkamenes at Olympia," *BICS* 31 (1984) 199–211. Pausanias may have been given erroneous information about the Dionysos, in keeping with the understandable tendency to attribute all chryselephantine cult images to Pheidias or his collaborators. Other suggestions are made by A. Delivorrias, *EAA Second Suppl. (1971–1994)* vol. 1 A–CARR (1994) 172–79 s.v. Alkamenes, esp. p. 177: that the statue was transferred from the Temple of Dionysos *en Limnais*, or that a possible reproduction stood in the 4th-c. temple. The Greek scholar believes in a single sculptor, and seems to question the ancient sources' statement that Alkamenes was a pupil of Pheidias, thus allowing the master a longer span of activity.

3. For a *stemma* of the Polykleitan School, see Todisco 1993, 46, fig. 11, with special discussion of Polykleitos II and Naukydes on pp. 52–54 and 51–52; on the basis of all available evidence, the sculptors of the second generation are said to have lived approximately between 440–420 and 370–350. The base for a votive offering on the Athenian Akropolis signed by Naukydes is mentioned on p. 46 (cf. E. Loewy, *Inschriften griechischer Bildhauer* [Leipzig 1885] no. 87). Todisco would accept as a replica of the Argive Hera a (modified) Roman seated figure in the Boston Museum of Fine Arts (his pl. 39), definitely in advanced "Rich Style." He seems, however, to accept also as pertinent a classicizing head in the British Museum (his pl. 40) that to me seems stylistically incompatible (cf. Ridgway 1981a, 234). The supposed correlation of this head with almost contemporary coins of Argos can be shown to be unwarranted: see Ridgway 1995b, 186, fig. 10.6, and the numismatic contribution by Arnold-Biucchi 1995, esp. 222–24. See also B. S. Ridgway, "Birds, 'Meniskoi' and Head Attributes in Archaic Greece," *AJA* 94 (1990) 583–612, esp. 607 and n. 98; cf. also U.

Architectural Sculpture on the Mainland

Kron, "Götterkronen und Priesterdiademe: Zu den griechischen Ursprüngen der sog. Büsterkronen," in *Festschrift für Jale Inan* (Istanbul 1989, publ. 1991) 373–90, esp. 381–82.

Todisco's position seems largely based on Linfert 1990, who discusses the descendants and students of Polykleitos on pp. 240–43 (with two *stemmata* on p. 242), attributes the Hera and the architectural sculpture of the temple to Polykleitos II (pp. 254–60), and believes that the female head Athens NM 1571 (infra, n. 14) belongs at least to the same workshop (pl. 122).

The attribution of the Argive Hera to Polykleitos II is strongly rejected by Delivorrias 1995. The Greek scholar defends authorship by the famous Polykleitos and would recognize the Hera in a head with (missing) inserted eyes and bared upper left torso, in Thessaloniki, which he had once considered a possible Aphrodite: *LIMC* 2, s.v. Aphrodite, no. 178; see also, more nuanced, Delivorrias 1991, 147 and fig. 26 on p. 148.

4. Not everybody would agree that Pheidias' involvement in the Parthenon was largely limited to the making of the Athena Parthenos, especially in the light of Plutarch's statement that he was the supervisor of the entire project. For a different viewpoint see, however, Ridgway 1981a, 17 and n. 3, 75–76 and n. 8, 161, and bibl. there cited; add N. Himmelmann, "Planung und Verdingung der Parthenon-Skulpturen," in *Bathron: Beiträge zur Architektur und verwandten Künsten* (Festschrift H. Drerup, Saarbrücken 1988) 213–24, esp. 219–22. Isager 1991, 151, points out that Plutarch is the only author to testify that Pheidias had worked on the Parthenon as *episkopos*, a designation unparalleled in any other reference to Athenian society, and that no early source provides information about the master's contribution to that building.

It is worth noting that no such large idol as the Athena existed in the Apollonion at Bassai, at least until the Late Hellenistic/Early Roman period: B. Madigan, "A Statue in the Temple of Apollo at Bassai," in O. Palagia and W. Coulson, eds., *Sculpture from Arcadia and Laconia* (Oxford 1993) 111–18. Madigan postulates that originally a small (Archaic) ivory image stood in the "adyton" and was taken to Rome by Augustus (116 n. 26). At any rate, no foundations have been found within the cella, or in the rear room, to accommodate a sizable cult image. There was therefore no visual competition for the sculptured friezes and the architectural articulation of the walls within the *sekos*.

5. Pfaff 1992, on date of temple: 301–18, also *AJA* 93 (1989) 269; on the metopes: 149–53, 235–38, also *AJA* 97 (1993) 299–300; on the pediments: 175–76 (one figure has a square cutting for a dowel). The translation of Pausanias' passage is taken from J. G. Frazer, *Pausanias: Descriptions of Greece* vol. 1 (London 1913).

6. A tradition even existed that the "true" Palladion had been taken to Argos: cf. *LIMC* 2, s.v. Athena, p. 1019. For additional comments on the choice of subjects, and their possible connection with earlier and later examples, see also infra, on the Mazi temple sculptures, and n. 23.

7. This traditional interpretation of the iconographic program is perhaps less sound than we assume, as Mark Fullerton has pointed out to me. Pausanias' cryptic sentence may refer exclusively to the subjects of the pediments, with no consideration of any set of metopes at all. Elsewhere in his writings, in fact, the periegetes tends to mention only the most significant architectural sculpture, usually that of the gables, omitting the metopal topics entirely. The birth of Zeus, moreover, does not seem to have been connected with a specific iconogra-

phy during the Classical period, and only the Late Hellenistic Temple of Hekate at Lagina illustrated the story of the swapped stone in one of its friezes: cf. *LIMC* 6, s.v. Kronos, p. 145, section B.b with commentary on p. 146, and no. 24, pl. 66, for the Lagina scene.

Could Pausanias have described the Argive pedimental compositions in a sequence of cause and consequences? The Trojan War, of course, led to the Ilioupersis, and the birth of Zeus to the new order established by the victory against the Giants. If this were the case, there would be no reason to see the metopal Amazonomachy as part of the Trojan cycle—the fight of Herakles at Themiskyra would be just as plausible, since it involved Peloponnesian heroes (see Madigan 1992, 75)—and not enough remains of the sculptured panels to allow us to choose between the two events. It should be stressed, in fact, that only the obvious presence of Penthesileia, as at Epidauros, would distinguish the Trojan battle from the others.

Against these very valid objections some arguments can still be raised. Pausanias mentions the birth of Zeus in the same terms he uses to describe the birth of Athena on the Parthenon (ἐν τοῖς καλουμένοις ἀετοῖς τὴν Ἀθηνᾶς ἔχει γένεσιν. 1.24.5; ὑπὲρ τοὺς κίονάς ἐστιν εἰργασμένα, τὰ μὲν ἐς τὴν Διὸς γένεσιν: 2.17.3). In addition, the expression "above the columns" recalls the reference to the 21 shields dedicated by Mummius at Olympia (τοῦ δὲ ἐν Ὀλυμπίαι ναοῦ τῆς ὑπὲρ τῶν κιόνων περιθεούσης ζώνης κατὰ τὸ ἐκτὸς ἀσπίδες εἰσίν, 5.10.5), which in fact hung below the gables. Pausanias seems, moreover, punctilious about specifying location on pediments in most cases. On the other hand, he describes the metopes of the Temple of Zeus at Olympia as being above the doors, which, although inaccurate, could be acceptable for the pronaos panels but not for those of the opisthodomos. These reliefs are probably included by the periegetes because of his interest in Herakles' representations at Olympia, rather than as architectural sculptures per se.

8. Importance of sanctuary: e.g., Hale 1995, Stewart 1990, 169; political motivation: e.g., Todisco 1993, 52. The Peloponnesian calendar reckoned years by the tenures of the priestesses of the Argive Heraion: *EAA*, s.v. Argo, p. 624. Pfaff 1992, 308–13, discusses whether the Attic traits in the Heraion architecture are sufficiently strong to postulate a pro-Athenian motivation; he concludes that simply the prestige of Athenian architecture and the availability of trained craftsmen may have promoted imitation.

9. Note, however, that at the Argive Heraion, as in Athens, an earlier idol had been saved from destruction, and, at the Heraion, this seated Hera of pear wood was kept in the same temple as the chryselephantine image, where it was seen by Pausanias.

10. On the joining of the two pieces and their connection to a pediment (because of a cutting in the lower fragment for its fastening to the tympanon wall), see Trianti 1985, 118–19, pls. 82–83; Trianti 1986, 164 and nn. 40–41, pl. 144.3–4; the join was made by S. Triantis. See also Yalouris 1992, 78 n. 315. The upper piece (NM 1578) has been extensively discussed by Raftopoulou (1980), who, however, did not know of the connection with NM 4035 and therefore considered the striding figure akroterial; cf. her pp. 122–23 for comparisons with the Bassai sculptures, and pp. 127–29 for comparisons with Peloponnesian bronze mirror covers. Eichler 1919 attributed the upper torso fragment to the east pediment. Since that piece was found in the nearby village of Chonika, its findspot does not help in determining to which of the two Heraion pediments the figure belonged.

As of October 1994, the two joined pieces were displayed in the Athens National Museum

Architectural Sculpture on the Mainland

with the label "probably from the Heraion (akroterion?)." Other Heraion sculptures on exhibition are: NM 4070a (fragment of metope); NM 1573 (body of warrior "in center of panel of large shield"); NM 1574 (Amazon); NM 3500 (Warrior with Amazon, "probably from W pediment"); NM 1472 (warrior's torso "probably from W pediment"); NM 3869 (Archaistic Athena; see infra); NM 1571 (Head of Hera; see infra). I owe this information to the kindness of C. Czapski.

11. By contrast, the Bassai males occasionally display hints of abdominal divisions, and in general appear to have a more emphatic median line (*linea alba*). One male torso recently attributed to the Heraion west gable is indeed comparable to the metopal warriors, but seems too well finished all around for a pedimental location. It was found in Rome in 1907 (cf. *NSc* 1908, 46–47, fig. 1; MN 39164), and was probably reused in antiquity: J. Dörig, "Ein griechisches Original in Thermenmuseum," *AntP* 22 (1993) 69–71, pls. 20–23.

12. Cf. Eichler 1919, fragment i, fig. 35 on p. 51; the animal skin had originally been considered a true cuirass.

13. This head would then belong to a giant, but the subject could also be appropriate for the Amazonomachy, if the battle was not entirely one-sided. The metopes are discussed by Eichler 1919, 46–90, with figs. 52, 57, 62–64 for the Gigantomachy. Cf. also *LIMC* 4, s.v. Gigantes, no. 21. It may be significant that both the west pediment and the west metopes seem to be better preserved than the sculptures on the east facade.

14. Head NM 1571: see, e.g., Todisco 1993, pl. 41; *LIMC* 4, s.v. Hera, no. 118, pl. 410, considered perhaps too young to be an image of Hera, and dated c. 420. The architectural attribution is made by Trianti 1985, 119. The braid in female coiffures deserves attention; it recurs also among the sculptures from the Asklepieion at Epidauros, and may have specific iconographic meaning, perhaps of adolescent or unmarried status. For a discussion of braids on male heads, see, most recently, A. Herrmann, "The Boy with the Jumping Weights," *BClevMus* 80 (1993) 299–323, esp. 304–7.

Of the heads with inserted eyes, one (Athens NM 4817, female) has convincingly been given a provenance from the Heraion by Raftopoulou 1971, on the strength of its similarity to two fragments from that site, NM 1565 (the anguished head) and NM 1566, both male. Yet the assignment to the gables is made tentatively, the possibility of a free-standing group is advanced, and only a workshop connection is suggested by the title of the French summary on pp. 329–31: "Tête provenant de l'atelier de l'Heraion Argien."

15. The letters used to indicate the pieces are those given by Eichler. **Idol G**, Athens NM 3869: Eichler 1919, fig. 23; cf. *LIMC* 2, s.v. Athena, Palladion, no. 97, cross-referenced to Aphrodite no. 36. **Idol H**, Eichler 1919, fig. 24. Both figures have been discussed within the context of Archaistic sculpture by M. D. Fullerton, "Archaistic Draped Statuary in the Round of the Classical, Hellenistic, and Roman Periods" (Ph.D. dissertation, Bryn Mawr College, 1982) 49–55; and id., *The Archaistic Style in Roman Statuary* (Leiden 1990) 57–58, and 191 n. 5. The two idols have also been considered by C. Czapski in her M.A. thesis for Harvard University (1993). On the iconography of Kassandra and the Palladion, see most recently J. B. Connelly, "Narrative and Image in Attic Vase Painting: Ajax and Kassandra at the Trojan Palladion," in P. J. Holliday, ed., *Narrative and Event in Ancient Art* (Cambridge/New York 1993) 88–129. Two palladia with differing costumes comparable to those on the Heraion are shown on a cup by Makron (Leningrad [St. Petersburg] 649, *LIMC* 2, s.v. Athena, no. 104,

pl. 715); but the cross-referencing to Aphrodite mentioned above indicates that two cult images within the Ilioupersis may indicate different goddesses.

16. This distinction is especially notable in that it reflects the chronological/stylistic sequence as we understand it from the archaeological evidence, rather than inventing costume types, as they appear, for instance, on vases. Note the much more symmetrical depiction of two identical idols on a Tarentine frieze dated c. 330–275: J. C. Carter, *Sculpture of Taras* (Philadelphia 1975) 75–76, no. 222 (Group L), pl. 40. The subject is difficult to explain, in that both idols wear a polos, only one statuette is being grasped by one of the female figures, and the central male carries a lagobolon rather than a sword or other weapon.

17. The main publication of the Mazi sculpture is Trianti 1985, with numerous photographs of details, but see also the extensive summary of her findings in Trianti 1986, which includes mention of nine fragments from the east pediment (p. 158, pl. 139.1–10), and six from the west (p. 159, pl. 141.1–8). Boardman 1995, fig. 8, believes the animal on the helmet is a sea monster (*ketos*).

18. Reconstruction drawings of the two fighting groups: Trianti 1986, 161, fig. 2 (Zeus), 162, fig. 3 (Hera and Arpolykos), here **Ills. 3–4**. Vase in the Louvre: *LIMC* 2, pl. 747, no. 381.

19. Trianti 1986, 166–68, fig. 5.

20. Trianti 1985, 116–18, pls. 75–81; Trianti 1986, 164, pls. 143–44.1–2.

21. See, e.g., Trianti 1986, 166; her chronological sequence is, however, different from mine: cf. supra, n. 1.

22. That the Parthenon west metopes represent not the Akropolis Amazonomachy but a land battle is proposed, e.g., by Stähler 1992, 87.

23. To be sure, the Ilioupersis may have been depicted already on the north metopes of the Parthenon, and it can be argued that the topic at the Argive Heraion was again suggested by the Athenian temple. Yet at the Heraion the connection with its metopal series is still remarkable, and the shift of the subject to the more important area of the gable must also be meaningful. The same comments may apply to the Amazonomachy as a topic. Besides on a small, fragmentary gable at Topolia, in Boiotia (c. 520; cf. Ridgway 1993, 300 and fig. 123), it had already been used for a late Archaic pedimental composition at Eretria, but in the context of the Deeds of Theseus. The 5th-c. pedimental sculpture attributed to the Classical Apollonion at Eretria continued that topic, with Theseus and Herakles fighting side by side (La Rocca, 1985 and 1986). An Amazonomachy has been postulated for the west gable of the Athena Nike Temple, accompanied by a Gigantomachy on the E: G. Despinis, "Ta glupta ton aetomaton tou naou tes Athenas Nikes," *ArchDelt* 29 (1974, publ. 1977) 1–24, 173–75 (German summary); more recently, M. Brouskari, "Aus dem Giebelschmuck des Athena-Nike-Tempels," and W. Ehrhardt, "Der Torso Wien I 328 und der Westgiebel des Athena-Nike-Tempels auf der Akropolis in Athen," in *Festschrift für Nikolaus Himmelmann* (*BJb* BH 47, Mainz 1989) 115–18 and 119–27 respectively. Yet we cannot tell, at the present state of the evidence, which Amazonomachy it was. Since Felten 1984, 118–31, has suggested that the north and west friezes of the Nike Temple could rather depict two encounters at Troy, we might theoretically already have such Trojan epic themes exemplified there (note, however, the objections by Stähler 1992, 75–84, who believes in a unified topic connected with the saga of the Herakleidai and an Athenian aretology). Once again, Archaic monuments may have led the way, with the battle between Achilles and Memnon perhaps illustrated by the

Architectural Sculpture on the Mainland

metopes of the Artemision at Corfu, c. 570, and a less plausible Death of Priam on the west gable (cf. Ridgway 1993, 338 fig. 126, and 280 respectively). The Siphnian Treasury at Delphi certainly showed the same epic duel over the corpse of Antilochos on the east frieze. Both pediments of the Temple of Aphaia at Aigina, at the turn into the 5th c., were also filled with battle scenes from two Trojan wars, with reference to the local heroes Telamon and Ajax, his son. Given the island's position between Attika and the Peloponnesos, this pedimental choice may have been influenced by Peloponnesian as much as by Athenian interests. See, however, a different interpretation of both gables as the saga of the Heraklidai, not connected with Troy: U. Sinn, "Aphaia und die 'Aegineten': Zur Rolle des Aphaiaheiligtums im religiösen und gesellschaftlichen Leben der Insel Aigina," *AM* 102 (1987) 131–67.

Another possible, Classical, example is the east frieze of the Hephaisteion, which Felten 1984, 57–66, identifies as Hephaistos, on Hera's bidding, fighting the River Skamander and his boulders, with which the fluvial divinity was threatening the Greeks as a reaction to Achilles' glutting his course with Trojan corpses. This interpretation, however, has not been universally accepted. The subjects of the Hephaisteion pediments are still a matter of debate and await the official publication by E. B. Harrison. At a public lecture in Athens (December 1988), she stated that she now believes the east pediment had an altar at the cutting in the center, and a subject connected with the saga of the Heraklidai; the west gable may have contained an Amazonomachy. O. Palagia has attributed to it two fragments of draped female figures that she considers Amazons: "Duo Thrausmata klassikes Glyptikes," *Archaische und klassische griechische Plastik* 2 (Mainz 1986) 86–88, pls. 109–10, 231 (German summary). She suggests, however, that the subject belonged with the rest of the sculptural program, which emphasized the deeds of Herakles and Theseus. Finally, the Ilissos Temple frieze in Athens may have dealt with a Trojan topic, but clearly with an Athenian slant: supra, Chapter 1, n. 25. The Trojan Amazonomachy would therefore seem to be a primarily Peloponnesian version of this popular theme, explainable through the participation of regional heroes in the Trojan War.

24. Yalouris 1992; see esp. 67 for the time span required by the construction, and 82–83 on the possible absolute dates, with rebuttal of different theories. For a condensed account, see also Yalouris 1986. The building inscription has been published in great detail by Burford 1969, and has been analyzed for architectural purposes by Roux 1961, 84–130. See, more briefly, Stewart 1990, 273–74, T 88. The inscription is *IG* IV² 1, 102.

25. A. C. Smith, "Athenianizing Associations in the Sculpture of the Temple of Asklepios at Epidauros," *AJA* 97 (1993) 300. The span 375–370 is that suggested by Yalouris 1992, 82–83.

26. Yalouris 1992, 13. What is probably meant is one of the smallest peripteral temples, especially in the Peloponnesos. For a table of peripteral temples of the 4th c. and later, with relative dimensions, see Knell 1983, 230; brief entries and plans of Greek temples can also be found in Schmitt 1992. The most extensive architectural analysis is by Roux 1961, 84–130.

27. Yalouris 1992, 64. Not only weapons and horse harnesses, but also ornaments, such as the diadem around the Phrygian cap of Penthesileia, and earrings, were added in metal: cat. no. 113, p. 53, pl. 42e, and cat. no. 19, p. 28, pl. 19a–b, respectively.

28. See Roux 1961, 105–6, pl. 34.1. The only earlier example of this type of sima with rampant antefixes occurs on the Delphic Tholos, on which see infra.

29. See Roux 1961, 127–28, for discussion of these coffers as listed in the building inscription; the *prosopa* are mentioned in lines 56–57; coffers without figures would have had gilded rosettes and stars, or akanthos leaves painted in encaustic technique (inscription, lines 51, 82–84, 86–87, 240–42). A possible connection between the stars and the *prosopa*, on the grounds that the latter were planets, which could be represented by masks, is dismissed by Tancke 1989 (14–16, section 2.1.2) as anachronistic. Given the presence of faces next to abstract motifs, however, a sculptural program could be suggested (according to Tancke) if both types of astral bodies (stars and planets) were involved in Asklepian cures. Whether such motifs were in gold foil appliqués or in encaustic painting is left open.

30. Posch 1991. For the dark limestone slabs, see Roux 1961, 119–23. Posch assumes that the reliefs depicted Bellerophon and Perseus, although Pausanias explicitly attributes these themes to the throne. They would have been appliqués in gold, ivory, or white marble, contrasting with the dark background. On the issue of the *typoi*, see, however, Yalouris 1992, 70–74, and Yalouris 1986, 185–86; Stewart 1990, 35–36; Todisco 1993, 57–58. All these authors translate the word as "models" and therefore attribute to Timotheos responsibility for providing the guidelines for the entire sculptural decoration of the temple. Other commentators besides Posch would, however, render the word as "reliefs" and therefore assign a much more limited role to Timotheos. For an independent discussion of the term see, e.g., Aleshire 1989 (43, 157, 234, with additional refs.), who deals with it in the context of votive offerings to the Athenian Asklepieion, some as reliefs made in one piece with their background, some as reliefs attached to small tablets, probably by means of nails. See also J. J. Pollitt, *The Ancient View of Greek Art* (Yale Publications in the History of Art 25, New Haven 1974) 272–93 and, more succinctly, his review of O. Palagia, *Euphranor*, in *AJA* 88 (1984) 419.

On the Asklepios by Thrasymedes, see Krause 1972.

31. Yalouris 1992, 68–69, on Hektoridas and the other sculptors mentioned in the building inscription. From the accounts, over 40 hands seem to have worked on the various carvings.

32. Burford 1969, 108 n. 2, suggests the alternative possibility that Hektoridas received his payment in two installments, but for a single contract. Thus the carving of the gable could have continued uninterrupted.

33. A further argument is, however, advanced by Posch 1991, 72, who stresses that the mention of the *typoi* occurs within the inscription next to that of works carried out in the workshop (*ergasterion*). This position had even led to the suggestion that Timotheos had been asked to make reliefs for the ergasterion, although it is implausible that a temporary work place would be thus embellished. Posch points out that appliqués would not have been carved *in situ*, thus explaining their order of mention. Other scholars, noting the same fact, have suggested that the *typoi* might have been sculptured metopes for the pronaos (e.g., Roux 1961, 114–15), but no remains of the porch elevation are extant, and two votive panels with Asklepios and Apollo (see infra, n. 39), occasionally considered metopes, do not have the required dimensions: Yalouris 1992, 70 and nn. 274–76.

34. It is sometimes argued that Theo[. . .] should be completed as Theodotos, presumably the same man as the architect of the entire temple (named in the building inscription), and that the sculptor of the second pediment, whose name is missing, should also be the same Theodotos, since his guarantor is the same: see, e.g., Posch 1991, 71, with additional refs. Yalouris 1992, 68, is against this theory, although he notes that Theodotos the architect, not otherwise identified, was probably a local man. It is not impossible for an architect to be also

Architectural Sculpture on the Mainland

a sculptor (see infra, on Skopas and the Athenaion at Tegea), but we then must again assume that he was the supervisor of a workforce rather than a direct participant in the carving of the pedimental and akroterial sculptures, for which he would have had little time.

35. *LIMC* 7, s.v. Penthesileia, no. 58a, pl. 242; Boardman 1995, fig. 10.2; Yalouris 1992, cat. nos. 33–35, pp. 35–41, pls. 38–43; Penthesileia is no. 34, pp. 35–38, pls. 40–41, 42c, to which head cat. no. 113 (pl. 42e) should be connected. Other groups carved from one block are also extant, but do not have the complexity and size of this central piece. Identification as the Amazon queen is suggested by the figure's prominent position in the center of the gable, by her added metal wreath, and, indirectly, by the size of her Greek opponent.

36. Achilles is identified also by Yalouris 1992, 64 and n. 214, since he is the largest male in the gable and the traditional opponent of Penthesileia; but Machaon is tentatively named only by Stewart 1990, 170; *LIMC* 7 (supra, n. 35) names Podarkes as a possible alternative to Machaon. Yalouris leaves the kneeling warrior anonymous, although admitting that both Podaleirios and his brother should occur somewhere in the composition.

37. Penthesileia: supra, n. 35. One other Amazon seems to have worn the plain Phrygian bonnet: Yalouris 1992, cat. no. 114, p. 53 pl. 44e (part of group cat. no. 36). A fragmentary pelta also survives: cat. no. 30, pp. 33–34, pl. 34c–e. For the Amazon with braided hair, see Yalouris 1992, cat. no. 39, pp. 42–44, pls. 47e–50a (Yalouris 1986, pl. 150.2). Trojan woman, kneeling in front of another: cat. no. 19, p. 28, pl. 19a–b (Yalouris 1986, pl. 153.3). On the braids, cf. supra, n. 14.

38. Priam: Yalouris 1986, 182, pl. 153.1–2; Yalouris 1992, cat. no. 16, pp. 26–27, pls. 16d–e, 17b; Todisco 1993, pl. 73; Boardman 1995, fig. 10.4; *LIMC* 7, s.v. Priamos, no. 101 pl. 407—note that this scene is unique in sculpture, except for a Hellenistic relief in Boston (no. 102).

Idol (Palladion): Yalouris 1992, cat. no. 13, p. 25, pl. 14; Boardman 1995, fig. 10.5. This image too has been discussed in the context of Archaistic statues; see references supra, n. 15 (Fullerton and Czapski).

39. Kneeling woman with heavily drilled mantle: Yalouris 1992, cat. no. 22, p. 29, pls. 21g–22. The channels are here so deep and abrupt that I once suspected later reworking. Note, however, that the same heavy use of the drill, and even the same irrational arrangement of drapery, occur on one of the two votive reliefs from Epidauros—the one depicting Asklepios, Athens NM 173: *LIMC* 2, s.v. Asklepios, no. 62, pl. 638; Boardman 1995, fig. 138 (cf. **Pl. 54**); the second relief (NM 174) is no. 61, on the same plate. See also Yalouris 1992, fig. 15 on p. 76, with discussion on p. 78, and cf. B. S. Ridgway, "The Two Reliefs from Epidauros," *AJA* 70 (1966) 217–22.

Mantled woman with crossing male leg: Yalouris 1992, cat. no. 12, pp. 24–25, pl. 13 (esp. d–f); Yalouris 1986, 181–82, pl. 152.3 (with different inv. nos.); cf. B. Ashmole and N. Yalouris, *Olympia: The Sculptures of the Temple of Zeus* (London 1967) pl. 111 (west pediment, Figure H), and pl. 81 (west, Figure E).

40. To my knowledge, only the Temple of Aphaia on Aigina had a similar temporal sequence of subjects, both equally involving Troy. Given the proximity of the island to Epidauros, possible influences cannot be entirely excluded. On that building, see, most recently, H. Bankel, *Der spätarchaische Tempel der Aphaia auf Aegina* (Berlin/New York 1993), with discussion of chronology on pp. 169–70. For a different interpretation of the pedimental subjects, see supra, n. 23 (U. Sinn).

41. Yalouris 1986, 183–84, fig. 2; Yalouris 1992, cat. no. 1, pp. 17–19, pls. 1–2; Todisco 1993, pl. 77.

42. Yalouris 1992, cat. no. 2, p. 19 and n. 39, pls. 3–5; cat. no. 4, p. 20, pl. 7 (Yalouris 1986, pl. 153.4; once also taken for male and attributed to a pediment).

43. Yalouris 1992, cat. no. 25, pp. 30–31, pls. 24–26 (Yalouris 1986, pl. 151.1); Todisco 1993, pl. 74; Boardman 1995, fig. 11.3.

44. Akroterial rider to right: Yalouris 1992, cat. no. 26, pp. 31–32, pls. 27–28; Todisco 1993, pl. 75; Boardman 1995, fig. 11.1. Akroterial rider to left: cat. no. 27, pp. 32–33, pls. 29–31; Todisco 1993, pl. 76; Boardman 1995, fig. 11.2. Fish fin on horse of cat. no. 26: Stewart 1990, 170.

Boston Amazon: Yalouris 1992, 37–39 n. 134, figs. 9–10; Ridgway 1981a, 59, 71.

45. Yalouris 1992, 37–39 n. 134; the Alba Youth (often considered a Niobid) is shown in figs. 7–8. See also Ridgway 1981a, 55H (Alba Youth) and 59, with bibl. on pp. 70–71.

46. V. Lambrinoudakis, "Architektonika glupta apo to hieron tou Maleatou Apollonos," *Acts of the First International Congress of Peloponnesian Studies* (Athens 1976–78) 1–12, pls. 1–8. A recent plan of the sanctuary is given in *Enemerotiko Deltio* (a publication of the Archaeological Society in Athens), October 1988, part 1, p. 15, fig. 2; the article, by Lambrinoudakis, reports on the latest campaigns (pp. 12–17). See also V. Lambrinoudakis, "To hiero tou Maleatou Apollonos kai e chronologia ton korinthiakon aggeion," *ASAtene* 60 (1982) 49–56, although primarily concerned with the early phases of the sanctuary and its importance for the chronology of Corinthian pottery. Yalouris 1992, 78 and nn. 320–21, comments on the Maleatas sanctuary as a 4th-c. annex of the Asklepieion, and illustrates several sculptures: figs. 21–25 on p. 79, and the head NM 4837 as fig. 26 on p. 80.

47. One other possible pedimental composition has been postulated for the Metroon at Olympia, but only a single figure has been attributed to it, and not widely accepted: cf. Ridgway 1981a, 41 and bibl. on p. 69. Somewhat improbable seems to me the connection with that temple of a terracotta fragmentary "metope" with a relief of Phrixos and the ram: W. Fuchs and B. Rudnick, "Phrixos auf dem Widder," *Boreas* 14–15 (1991/92) 45–49; cf. *LIMC* 7 s.v. Phrixos, no. 15bis. Yet A. Moustaka, *Grossplastik aus Ton in Olympia* (OlForsch 22, Berlin 1993) 150–51, no. P 8, pl. 18a–b, does not dismiss the possibility that such metopes once stood over the porches.

Several pedimental(?) and akroterial figures collected by Delivorrias 1990 show strong affinities with the Bassai sculptures, but cannot be connected with a definite building and seem datable to the end of the 5th c. One more possible item of architectural sculpture, a fragmentary **relief of a warrior** dated to the first half of the 4th c., comes from the city of Elis and is now in that museum (inv. no. Λ 337). Its metopal function is doubted by Junker 1993, 178, pl. 35.2, because no Doric structure of suitable size has been found at the site. It is, however, a large panel with upper fascia, and the relief exhibits various holes for metal attachments. The warrior is posed frontally, his mantle fluttering behind him and his shield in three-quarter view. His right arm is stretched out, to counteract the pull of a now missing figure who has grabbed him by the head. Some points of comparison with the Bassai frieze had prompted me to date the relief to the late 5th c. (Ridgway 1981a, 36 no. 2), but I would now accept it as early 4th, given the many similarities among sculptures of this phase.

48. The analogy is suggested by Roux 1988, who also attributes to this building's architect

Architectural Sculpture on the Mainland

the invention of this type of sima, and points out that at Delphi, or even in the entire Greek Mainland (with the exception of Attika), this is the first *large* monument entirely in marble (p. 297). For that author, this is the most sophisticated roof known, with an unusual double sima but a single slope (cf. *GdDs* 1991, no. 40, pp. 65–68, reconstruction drawing fig. 14 on p. 66), eventually repeated by the Lysikrates monument at much smaller scale. For architectural comments and another reconstruction drawing, see Seiler 1986, 56–71, fig. 29 on p. 60, and section fig. 30 on p. 61. A more extensive, recent discussion is by J. Bousquet, "La tholos de Delphes et les mathématiques préeuclidiennes," *BCH* 117 (1993) 285–313.

49. Marcadé 1993. See also *GdDm* 1991, 66–76, figs. 35–37. Given the uncertainty over the roofing of many tholoi, the information available for the decoration of this one is worth stressing. All reconstruction drawings (supra, n. 48), however, omit the akroteria.

50. Note that some translations of Vitruvius emend the text and render "of Phokis" rather than "of Phokaia," but the Latin reads *Phocaeus,* not *Phocensis,* and should refer to Asia Minor.

The equation between workshops and architects is made by Marcadé 1986a, 172. It is rejected by *GdDs* 1991, which stresses the Athenian tradition. The chronology there suggested is generally accepted, although Roux 1988 prefers the first two decades of the 4th c. He also believes (p. 306) that the Corinthian capitals at Delphi are earlier than at Bassai and that the Tholos offers the first example of tangential columns (they are actually partly "sunk" into the wall, showing only 17 of their 20 flutes). *GdDs* 1991, 67, seems to doubt their original existence, and hints at reused material (Laroche).

51. See, especially, Marcadé 1979 and 1986a; in the latter publication, the man restraining a horse is illustrated on pl. 145, a centaur on pl. 147.2. Also *GdDm* 1991, 66–76, figs. 27–31 (see fig. 26 for a partial reconstruction of the outer Doric frieze, fig. 27a for the rampant horse, fig. 30 for remains of centaurs). Comments on all the metopes are offered by Junker 1993, 155–57, pl. 28.2–3. See also Boardman 1995, figs. 13.1–3.

52. Note the oral discussion reported at the end of Marcadé 1986a, and parallels there cited. G. Roger Edwards points out to me that the symbol could also refer to a grave monument, and cites Kurtz and Boardman 1971, 128–29 and 240–41.

53. Marcadé 1986a, 172, for subjects and stylistic comments, and pls. 147.5–4, 148.1–2. See also *GdDm* 1991, 66–76, esp. figs. 32–33, and fig. 34 a–h for depiction of heads from both series of metopes.

54. See also the comments supra, Chapter 1, n. 34.

55. Cf. the suggestions for the viewing of the Parthenon frieze in R. Stillwell, "The Panathenaic Frieze," *Hesperia* 38 (1969) 231–41.

56. Seiler 1986, 65–67 and 71, believes the Tholos is an Athenian dedication, but, in order to make this theory fit the historical and economic circumstances, he dates the building after the Peace of Nikias (421), placing its construction in the decade 420–410. For objections to Seiler's view, see Junker 1993, 155–57.

57. This last theory is proposed by Roux 1988, 294.

58. On the architecture and the theory of the hero cenotaph, see Roux 1961, 131–200; for the theory of the chthonian Asklepios, see Seiler 1986, 72–89, with reconstruction drawing on p. 76, fig. 34, and section on p. 77, fig. 35; his table 2, on pp. 82–83, lists the construction phases and the yearly accounts of the building incription, *IG* IV2 103. On the latter, see also

Architectural Sculpture on the Mainland

Burford 1969, 63–68. See also H. Büsing, "Zur Bauplanung der Tholos von Epidauros," *AM* 102 (1987) 225–58, who points out many "quotations" from Attic architecture (p. 253). It has been noted that an altar lies on the axis of the Tholos, but its presence cannot support either the heroic cenotaph or the chthonian cult theories.

59. See, e.g., Todisco 1993, 48; on p. 27, he favors the span 365–330 for the erection of the Tholos and assumes inspiration from the Delphic one. Roux 1961, 177, states that at least 17 years intervened between the Doric and the Corinthian colonnades.

60. For general comments on the Epidauros metopes, see Junker 1993, 157. Interpretation as rosettes is traditional; that of phialai for libations is due to Roux 1961, 140–42, 179 (with list of precedents and later examples, including possibly some in bronze affixed to stone backgrounds), and 195. Connection with Magna Graecia, although primarily for the rinceaux of the sima, is advocated by M. Pfrommer, "Grossgriechischer und mittelitalischer Einfluss in der Rankenornamentik frühhellenistischer Zeit," *JdI* 97 (1982) 119–90, esp. 140 and n. 78 (with mention of a Hellenistic altar on Kea with a relief phiale) and 170.

For the Megara Hyblaia building, which included also decorated triglyphs, see, most recently, Junker 1993, 140–41 and pl. 25.2; cf. also B. A. Barletta, "An 'Ionian Sea' Style in Archaic Doric Architecture," *AJA* 94 (1990) 45–72, esp. 63 and fig. 17 on p. 64; Ridgway 1993, 355 and bibl. For the Hellenistic building, see F. A. Cooper and D. Fortenberry, "The Heroon at Messene," *AJA* 97 (1993) 337.

61. The only other series of carved metopes from Epidauros, of the mid-4th c., has now been connected with a triglyph altar—therefore not with a conventional building: see Junker 1993, 157–58 and pl. 29.1, who accepts the interpretation proposed by Ch. R. Long, *The Twelve Gods of Greece and Rome* (Leiden/New York 1987) 14 no. 2, 194–96, fig. 43. See also infra, n. 79.

62. On the Archaic temple, see Østby 1986; also M. E. Voyatzis, *ArchNews* 17 (1992) 19–25, where it is suggested that it dated from the second half of the 7th c. This early building was in turn preceded by two successive apsidal structures of the Late Geometric period: M. E. Voyatzis and E. Østby, "Current Fieldwork at the Sanctuary of Athena Alea at Tegea," *AJA* 97 (1993) 346–47.

The plan of the 4th-c. temple has been entirely reconsidered and redrawn by Norman 1984; for a section showing the interior arrangement, see her p. 182, ill. 8; for an imaginative reconstruction of the cella and its contents, see Stewart 1990, fig. 541 (plan in fig. 540). It has been repeatedly pointed out that this temple interior recalls the Apollonion at Bassai, but I find the similarity with the Asklepieion even more striking. The presence of a side door at Tegea was dictated by local cultic topography, not by a meaningless imitation of Bassai.

63. The theory about the cult images is proposed by Norman 1986, who points out that no proper underpinning was provided for them, suggesting that they were brought into the temple as an afterthought. She, however, assumes that the statues were carved by Skopas for an outside fountain while the temple was being erected. Doubts have been expressed by Marcadé 1986b, 323–27. A later (Late Hellenistic) date for these stone sculptures, which survive only in fragments and are echoed on a votive relief, has, however, been argued by Lebendis 1993. For a possible parallel situation at Bassai, see Madigan (supra, n. 4). Pausanias (8.47.1) states that the statue of Athena he saw in the Tegea temple, flanked by the Asklepios and Hygieia, was brought from the town of the Manthoureans, and was surnamed "Hippia." Cf. Stewart 1990, 285, T 113.

Architectural Sculpture on the Mainland

64. On the Tegea metopes: Stewart 1977, 30–32 nos. 27–32, pl. 23a–b; yet read also the "Addendum to p. 30f." on p. 150, where it is noted that nos. 27, 28, and perhaps also 29 may be too big for the panels, and that no. 32 (a baby torso) may also belong to a different monument, the Federal Altar (on which see infra, n. 80); p. 46 (technique); pp. 57–58 (composition); pp. 62–64 (iconography and interpretation); app. 3 on p. 138 provides a stemma of the Arkadian dynasty, with Aleos, father of Kepheus and Auge, as no. 8. Atalante is also related to Aleos through his other son, Lykourgos, her grandfather. Much of Stewart's visualization of the metopal subjects is based on earlier suggestions, since too little can be derived from the actual sculptures. On the Tegea metopes, see also the skeptical comments by Marcadé 1986b, 320–22, and, most recently, Junker 1993, 159. The appliqué technique of the Erechtheion frieze and the Tegea metopes seems to have continued in late 4th–mid-3rd-c. Taras, where many detached pieces come from funerary naiskoi: Carter, *Taras* (supra, n. 16) 14, nos. 306, 346–50, 361, 366, etc. In the Late Hellenistic period, sizable half-figures in stone were applied to walls, presumably as decoration of interior surfaces; examples recovered from the Mahdia wreck have technical parallels on Delos: see N. Marquardt, "Die Reliefköpfe," in G. Hellenkemper Salies et al., eds., *Das Wrack: Der antike Schiffsfund von Mahdia* (Bonn/Cologne 1994) 329–37.

65. On this relief, see most recently Waywell 1993; Gunter 1995, 55–56 and fig. 26; and infra, n. 74.

66. Head with lion-head cap: Stewart 1977, no. 16, pls. 13, 14a–b, with discussion of identification on p. 54; Stewart 1990, fig. 542; Todisco 1993, pl. 142; *LIMC* 4, s.v. Herakles, no. 1309 (*not* Telephos); but cf. *LIMC* 7, s.v. Telephos, no. 49; Boardman 1995, fig. 9.1 ('Telephos').

Bearded head with lion-skin: first attributed by Delivorrias 1973; Stewart 1977, pl. 47a, and n. 40 on p. 157 (considered a free-standing statue); Todisco 1993, pl. 147; *LIMC* 4, s.v. Herakles, no. 1313 (free-standing because of hole for *meniskos*). Marcadé 1986b, 320 and n. 10, finds it difficult to have two personages with a lion headdress within a single pediment, even if the form of the headdress varies. He too doubts that the bearded Herakles belongs on the gable, but mentions another fragment, preserving the end of a beard and part of a garment across both shoulders, as a possible candidate for a pedimental Herakles.

Although Stewart calls the headdress of head no. 16 a cap, I would rather see it as a helmet, with calotte rear and neckguard carved in imitation of a mane, and open jaw serving as paragnathis. Similar lion-head helmets occur on one of the metopes of the Athenian Treasury at Delphi (Herakles fighting Kyknos), the Aigina east pediment (Herakles again, although U. Sinn [supra, n. 23] would consider him Hyllos), the parapet of the Archaic Artemision at Ephesos (probably a giant), frieze no. 1 on the podium of the Nereid Monument at Xanthos (on which see infra, Chapter 3), and the Alexander Sarcophagus (Alexander).

Stewart 1977, pl. 53, gave a reconstruction of the Tegea west pediment that he then altered to add the de Bry head: A. Stewart, *Skopas in Malibu: The Head of Achilles from Tegea and Other Sculptures by Skopas in the J. Paul Getty Museum* (Malibu 1982), foldout. He has, however, now accepted that the de Bry head is not ancient: Stewart 1990, 345 (at 15.4) and fig. 545. It should be noted that Stewart 1977 lists only 32 out of a possible 150 extant fragments, as stated in his preface to the catalogue, p. 5. Yet this monograph remains the

Architectural Sculpture on the Mainland

most extensive and best-illustrated presentation of the Tegea sculptures. Marcadé 1986b offers some significant comments, and corrections to Stewart's catalogue.

The head with the lion helmet was stolen from the Tegea Museum in 1992, together with other pieces from the temple and other museum holdings; see "An Appeal by the Greek Ministry of Culture," in O. Palagia and W. Coulson, eds., *Sculpture from Arcadia and Laconia* (Oxford 1993) 271, fig. 1.

67. Anti-Spartan message: Stewart 1990, 183; counterclaim against the Macedonian royal house: Todisco 1993, 81; Stewart 1977, 66, even suggests that in both Tegean pediments, "a deity slighted is at the root of the trouble and suffering" (Artemis and Dionysos, respectively), while Athena plays an indirect role as helper of heroes. For other reconstructions of the west pediment, see Stewart 1977, 56–57, 64–65 (Picard, Dörig, and Delivorrias). Other architectural depictions of the Kalydonian Boar Hunt seem to be without specific regional or moralizing allusions: cf. supra, Chapter 1, n. 34.

68. Male heads: Stewart 1977, nos. 9–10, 16–18, 22–24, pls. 7–8, 13–16, 18–19a; boar head: no. 5, pl. 5a. Cf. Todisco 1993, pls. 143 (helmeted head no. 18), 144 (helmeted head no. 17), 145 (bare head no. 9), with additional bibl.; also Boardman 1995, fig. 9.2.

69. Cf. P. Dintsis, *Hellenistische Helme* (Rome 1986) 105–8, map 13 (illustrating the distribution of the type before the time of Alexander the Great), and Beil. 8, nos. 308–10, falling within the time bracket 400–350, nos. 312–14, c. 350–300. These examples seem closest in shape to the Tegea helmets, although Dintsis does not specifically refer to the latter. J. P. Small, "The Tarquins and Servius Tullius at Banquet," *MEFRA* 103 (1991) 247–64, esp. n. 4, stresses that costume was always contemporary in ancient art, given a lack of antiquarian knowledge of the past—but nudity and Corinthian helmets would have effectively conveyed to the viewers the impression of a time other than the present.

70. Female head (akroterial, but once considered Atalante): Stewart 1977, no. 4, pp. 12–14, pl. 4; female torso with inserted head: no. 8, p. 16, pl. 6b–c. Marcadé 1986b, 318–20, is decidedly against attributing this torso to the east pediment, not only because of technique, but also because of its smaller scale and approximate workmanship. He would also be against attributing the female head to one of the akroteria, and believes that the two female torsos considered akroterial by Stewart (infra, n. 71) may instead be sculptures in the round from the Federal Altar, on which see infra, n. 80.

71. Akroterial figures: Stewart 1977, no. 1, pp. 9–10, pls. 1–2c (cf. Todisco 1993, pl. 141; Boardman 1995, fig. 9.3); no. 3 (with himation), pp. 11–12, pl. 3; cf. reconstruction on pl. 53. Gulaki 1981, 74–78, makes the comparison with the Nikai from Side (figs. 32–34), which are published by Inan 1975, 133–35, nos. 64–65, pl. 64, but considered to be after a Hellenistic, Pergamene original of the mid-2nd c. Gulaki (p. 75) sees also a more general resemblance of the Tegea figure to a Nike from Cyrene, her figs. 30–31. For objections to an akroterial function of the two torsos, see supra, n. 70.

72. In her review of Stewart 1977, O. Palagia (*JHS* 99 [1979] 212–13) points out that a griffin illustrated by the original excavators was not included; but it is unclear whether she would consider it akroterial.

73. The quotation is from Stewart 1990, 183. Although Roman carvers could be blamed for the tamer, more vapid rendering of the heads of statues supposedly copying Skopasian originals, identifications of such originals and attributions of copies are highly debated, as

Architectural Sculpture on the Mainland

we shall discuss in Chapter 7. That the Asklepios and Hygieia within the Athenaion at Tegea may have been by a later Skopas has been suggested by Lebendis 1993: see supra, n. 63.

74. This theory, together with mention of other Hekatomnid benefactions, is proposed by Waywell 1993; cf. Gunter 1995 (supra, n. 65).

75. The major publication of the 4th-c. temple is B. H. Hill, *The Temple of Zeus at Nemea* (as presented by C. K. Williams II, Princeton 1966). An exhibition held at the Benaki Museum in Athens, after clearing and restoration work at the site by the University of California at Berkeley, resulted in a guidebook, *The Temple of Zeus at Nemea: Perspectives and Prospects* (Athens 1983), which contains useful information.

76. Hill/Williams (supra, n. 75) 29–30, state that no trace of a cult image was found east of the Corinthian colonnade, perhaps because the cella paving had been removed; they allowed, however, that no provision seems to have been made for one, and that the space west of (i.e., behind) the colonnade would have required too small a statue standing at the head of the stairway. For a section of the cella, see pl. 8; for the threshold and the doorway, see pp. 26–27.

77. See, e.g., Todisco 1993, 27.

78. For a brief review of Archaic architectural sculpture, see Ridgway 1993, 300 and 305–6 (pediments and akroteria), 400 (all forms). During the Severe period, only the Temple of Zeus at Olympia seems to represent Peloponnesian production. For the 5th c., see the surveys in Ridgway 1981a, chs. 2–4, esp. the summaries on pp. 34–35, 64, and 99–98.

79. Supra, n. 61. Since one corner triglyph is extant, it is possible to see that the frieze did not extend beyond the corner. The fragmentary remains at present consist of three relief panels and four triglyphs, but more probably existed. Reckoning from left to right, the first, cuirassed, figure would be Ares; the next figure, seated, would be Poseidon; and, on the third and best-preserved metope, Athena, receiving a helmet from Hephaistos. The goddess wears a diagonal aigis and has a shield near her feet; Hephaistos is a mantled man leaning on a staff, like those on the Parthenon east frieze, and the carving has in fact been attributed to an Attic workshop. The style would be compatible with a mid-4th-c. date, and an inscribed block from the Epidaurian sanctuary carrying a dedication to the Twelve Gods confirms both the presence of the cult and its chronology.

80. Tegea Altar: Stewart 1977, 50 (chronology), 68, 150 (cf. supra, n. 64). Cf. also the elaborate discussion in Picard 1954, 193–205, who considers the altar "federal"; the French scholar points out the very similar description given by Pausanias (8.31.3–4) for a table in Megalopolis, which stood in front of Herakles. It was decorated (presumably in relief) with two Seasons, Pan holding reed pipes, Apollo playing the lyre, and some of the same Nymphs mentioned as part of the Tegea Altar, with Neda holding the infant Zeus. Pausanias gives no chronological indication, and the foundation date of the city (369) could allow a 4th-c. date. Since the Herakles in question may have been made by Damophon, however, the table at Megalopolis may also belong to the Hellenistic period, which may strengthen a similar supposition for the Tegea Altar. Note, however, that Marcadé 1986b would attribute to the latter figures in the round, including the current akroteria of the Athenaion: cf. supra, n. 70.

"Hygieia" from Tegea, Athens, NM 3602: Todisco 1993, 136, pl. 303 (dated 310–290, therefore early Hellenistic); Boardman 1995, fig. 53; *LIMC* 5, s.v. Hygieia, p. 567, no. 221 (listed under uncertain identifications, dated third quarter of the 4th c.) and p. 571, where considered a Praxitelianizing Aphrodite; Picard 1954, with an unusual side view as fig. 89

on p. 201, and a rear view on p. 202, fig. 90, with attribution to the Federal Altar; Waywell 1993 concurs. The hair in the back is only summarily carved.

For the Priene Altar, see Ridgway 1990, 164–67 and ill. 22, with pertinent refs.

81. Tegea group: Despinis 1993; for the Conservatori group, see Eckstein 1967, and cf., more recently, the entry in the exhibition catalogue, M. Cima and E. La Rocca, eds., *Le Tranquille Dimore degli Dei: La residenza imperiale degli* horti *Lamiani* (Venice 1986) 190–91, fig. 125 (with plaster additions removed).

82. Oxford, Ashmolean Mus. 1928.530; see Picón 1993. No provenance is known. The marble seems Parian or Naxian, which would not contradict my Eretrian suggestion. On the Doric Temple of Dionysos at Eretria, see, e.g., Knell 1983, 217–18 and chart on p. 230.

A study on the relationship of akroterial subjects and temple deities is listed as a Frankfurt University dissertation in *AA* 1993, 155: M. Andres, "Akroterstudien: Untersuchungen zum Verhältnis von Tempelinhaber und Akroter." But the work, to my knowledge, is still unpublished.

83. Palatine Aura: Rome, MN 124697; most recently discussed by Picón 1993, 91–92, with extensive bibl. in n. 14; *LIMC* 3, s.v. Aurai, 53 no. 13 (dated 420). Cf. also Delivorrias 1990, 32–33 and n. 99, who, however, is primarily concerned with dissociating the piece from his stylistic group. The Greek scholar discusses also a statue auctioned at Sotheby's in 1937, and now in a private collection: 33–35, fig. 29a, and bibl. in nn. 103–6; but he is uncertain whether the piece is a Greek original (perhaps reworked) or a Roman copy. It is therefore impossible to include it here in my main text.

The replica of the Palatine Aura from Loukou was illustrated in Η Καϑημερινη, Aug. 27, 1995. Other discoveries had been announced in the same newspaper on Aug. 23, and included a copy of the so-called Pasquino group. I suspect that the latter goes back to an original made in Italy for the Romans, perhaps for the Sperlonga grotto (see Ridgway 1990, 275–81); therefore the Palatine Aura from Loukou may also copy a monument that stood on Italic soil, and may exemplify Herodes Atticus' interest in imitating the capital in the decoration of his villa. On the other hand, any statement at this early a date is entirely premature and hazardous. I am greatly indebted to Prof. Miller-Collett for knowledge of the newspaper accounts.

84. Copenhagen Aura: Ny Carlsberg Glyptotek 2432: see, most recently, Picón 1993, 93 and nn. 20–21; Todisco 1993, 56 and pl. 21 (accepted as coming from Hermione, as originally suggested by Bielefeld 1969); *LIMC* 3, s.v. Aurai, 53, no. 17, pl. 53 (tentatively considered akroterial).

Formia Nereids: Bielefeld 1969; Lattimore 1976, 51 and n. 26; *LIMC* 6, s.v. Nereides, 794, no. 106, pl. 467 (with various suggested dates and provenances mentioned, but accepted as akroterial).

LIMC s.v. Aurai: vol. 3, nos. 10–17 (under doubtful identifications).

Two more sculptures, now in Sorrento, and therefore probably Magna Graecian, have been considered akroterial: a female figure riding a hind and another female on an equine creature, probably a mule because it carries a saddle: Stähler 1985. The first has an inscribed plinth that would make it a private dedication, rather than a piece of architectural sculpture, despite the possible parallels adduced by Stähler 1985, 328–29. See also the comments in Delivorrias 1990, 38 n. 16, with additional bibl., and cf. Ridgway 1981a, 117, fig. 91; *LIMC*

Architectural Sculpture on the Mainland

2, s.v. Artemis, 674, no. 697, pl. 501 (dated second half of 4th c., and considered a dedication). Stähler 1985 discusses also, in an appendix, the Leda and the Swan, and the Aphrodite on a goose, both in the Museum of Fine Arts in Boston, which he would also define as akroterial. On the Leda, see infra, Chapter 7, under Timotheos, and, most recently, Delivorrias 1990, 35–36, nn. 108–15, who would tentatively accept its connection with the Temple of Nemesis at Rhamnous, as central akroterion.

85. Dolphin riders from the Athenian Agora: Lattimore 1976, 50–51; Ridgway 1981a, 62 n. 28 with additional bibl; *LIMC* 6 s.v. Nereides, 790–91, no. 42a (Greek original), b and c (copies in Venice and Crete), pl. 459 (beginning of the 4th c., akroteria from Temple of Ares?).

Female Figure from the Athenian Agora, S 182: Delivorrias 1990, 24 and n. 67, fig. 18 on p. 26; Ridgway 1981a, 62; D. Buitron Oliver, ed., *The Greek Miracle: Classical Sculpture from the Dawn of Democracy: The Fifth Century B.C.* (exhibition catalogue, Washington, D.C., 1992) 138–39, no. 27; *LIMC* 6, s.v. Nereides, 819, no. 483, pl. 515 (under doubtful or controversial identifications, cross-referenced to Aurai, dated c. 400).

Delphi, Athena Pronaia akroteria: Marcadé 1993, 22–24, fig. 14 (inv. nos. 8605, 8606), no earlier than the mid-4th c., and therefore too late for the Tholos, but possibly from the Doric Treasury, or, more probably, from the limestone Athenaion (as contrasted to the earlier, tufa temple). *GdDm* 1991, 75–76, figs. 36–37.

86. See S. Bevan, "Water-Birds and the Olympian Gods," *BSA* 84 (1989) 163–68, for discussion of such bird decorations.

87. Herakleion at Thebes: *LIMC* 5, s.v. Herakles, 7, no. 1710; Pausanias uses the expression ἐν τοῖς ἀετοῖς but he seems to mean on a single gable.

Asklepieion at Titane, *LIMC* 5, s.v. Herakles, 178, no. 3480 (uncertain date). Was Herakles chosen as a subject on a temple of Asklepios because he had defeated death? C. S. Salowey has suggested a strong ancient belief in Herakles' curative abilities: "Ἡρακλεῖ ἰάτρων ἀντὶ χαριζομένου: Herakles and Healing Cult in the Peloponnese," *AJA* 99 (1995) 316. The expression Pausanias uses for the Nikai is πρὸς τοῖς πέρασιν, "at the ends"; could he have meant akroteria?

88. Herakles in Athens: Travlos, 280, figs. 360–61; the reclining pose might indicate an off-center location. But see *LIMC* 4, s.v. Herakles, no. 777, where the sculpture is labeled a statuette from the sanctuary of Herakles Pankrates and is dated to the 3rd/2nd c. B.C., without mention of a possible pedimental function.

Muse from the Temple of Apollo Patroos: Ridgway 1990, 19, 236, pl. 117.

Funerary naiskos, now in the Hommel Collection in Zürich: a six-figure pediment, with the two outermost seated on stone blocks, next to two others resting a foot on stone boulders; cf. Carroll-Spillecke 1985, 16; Fleischer 1983, pl. 47.

89. See Ridgway 1990, 17–21, with additional bibl.; *GdDm* 1991, 77–84, reconstruction in foldout fig. 38, and figs. 39–45, where it is stated that these are the last great sculptured pediments in the history of Greek art, completed at the latest by 327. Boardman 1995, figs. 14.1–2.

90. On the various phases of the Kalapodi sanctuary, see, conveniently, Boardman 1993, 40–41 and fig. 24. The official report is by R. C. S. Felsch et al., "Kalapodi: Bericht über die Grabungen im Heiligtum der Artemis Elaphebolos und des Apollo vom Hyampolis 1978–

Architectural Sculpture on the Mainland

1982," *AA* 1987, 1–99, with mention of the Gigantomachy relief on p. 82, and a discussion of it by M. Salta on pp. 83–88, where its function is left uncertain. Junker 1993, 178 and pl. 35.3, lists it under the debatable examples of metopes.

91. Funerary metope in Athens, NM 1688: Junker 1993, 158; the metope, flanked by two triglyphs, comes from the vicinity of the Tower of the Winds and may have decorated a building in antis with three metopes on façade. The panel, dated by Junker to the first half of the 4th c., depicts three mourning women seated on boulders in an apparent semicircle: cf. Carroll-Spillecke 1985, 15; Fleischer 1983, pl. 48.1. Wegener 1985, 67, and 277 cat. 30, pl. 11.1, dates the panel c. 320, therefore early Hellenistic.

Sparta Amazonomachy: A. Mantis, "Dorike zophoros me Amazonomachia apo te Sparte," in *Praktika tou XII Diethnous Synedriou klasikes Archaiologias, Athenai 4–10 Sept. 1983* (Athens 1988) vol. 3, 177–84, pl. 39 and line drawings in figs. 1–3. The panels show: (1) an Amazon and a male opponent with fluttering mantle, recalling Bassai; (2) two Amazons facing left in uncertain action; (3) an Amazon to right, running alongside a galloping horse; (4) an Amazon fighting to right. The 4th-c. date is suggested by Junker 1993, 159–60, pl. 29.2. Note that Sparta is not well represented in terms of architectural sculpture; for the possibility that some terracotta panels from the Archaic period are *not* metopes but votive plaques, see Ridgway 1993, 335–36, ill. 30.

Kalydon metope: Junker 1993, 155. For the Temple of Poseidon at Molykreion, see H. Knell, "Der Artemistempel in Kalydon und der Poseidontempel in Molykreion," *AA* 1973, 448–61. Both structures are Doric, 6 × 13 with Π-shaped interior colonnade, Kalydon dated in the 360s, Molykreion somewhat earlier.

One more metope from the Peloponnesos (besides that cited supra, n. 47) can here be mentioned, although it is early Hellenistic. It is a poros panel with the myth of Perseus and Andromeda(?), and seems to come from the Temple of Zeus Soter at Messene: it was first mentioned in the "Chronique des fouilles," *BCH* 115 (1991) 864 and fig. 27 on p. 865; it is also listed by Junker 1993, 160, and dated at the earliest to the turn into the 3rd c. Its material, its subject, and its location are unusual, as well as the fact that the relief overlaps the triglyphs.

J. Bousquet, *Etudes sur le Comptes de Delphes* (BEFAR 267, Paris 1988) 51–57, argues that the accounts for the 4th-c. Temple of Apollo could be read to imply that six sculptured metopes embellished each porch, as at Olympia. Certainly a tradition of decorated panels existed at the sanctuary, and included the very predecessor of the Apollonion, the so-called Alkmeonid Temple. But nothing has been found to date of these later metopes.

92. Under the term "Greek Mainland," I here include the nearby islands, and, eventually, the Kyklades. The six decorated examples listed by Knell 1983, 230 (chart) are the Apollonion at Delphi, the Athenaia at Tegea and at Mazi, the Artemision at Kalydon, and the Asklepieion at Epidauros, with the doubtful example being the Metroon at Olympia. To be sure, we seem to have architectural sculpture without temples, and akroteria are not included in this count. In addition, Knell does not list the Argive Heraion. Add, however, one building on Paros: M. Schuller, "Der dorische Tempel des Apollon Pythios auf Paros," *AA* 1982, 245–64 and esp. fig. 10 on p. 257 (amphiprostyle with six columns or peripteral, 6 × 9, with interior colonnade) and another on the same island: K. Schnieringer, "Der dorische Tempel by Marmara auf Paros," *AA* 1982, 265–70 (amphiprostyle or peripteral, probably with six

Architectural Sculpture on the Mainland

columns on façade); both are datable to the first half of the 4th c. on formal grounds. In the second half of the 4th c., a Doric porch was also added to an earlier heroon on that island, again without sculptural decoration: A. Ohnesorg, "Der dorische Prostylos des Archilocheion auf Paros," *AA* 1982, 271–90, with reconstructed elevation as fig. 11 on p. 288.

93. On the sculptured frieze, articulated in a series of duels, see Marcadé 1969, 47–49; he thought he could distinguish a tree from the encounter with Sinis, and another composition reminded him of the episode with Skiron. See also *GdDélos* 1983, 68–69 (on how little sculpture remains from the 4th c.) and 150–51, building no. 42, where the various identifications of the structures are listed. For the most closely argued identification (Temple of Apollo, the Pythion of the accounts, enclosing the Keraton, the altar of deer horns around which Theseus and his companions danced the "Crane Dance" after returning victorious from the encounter with the Minotaur on Crete), see Roux 1979, esp. 123–24 and n. 53 for the sculptured frieze.

For several Athenian battle friezes, probably all from funerary structures datable to the last quarter of the 4th c., see Ridgway 1990, 31–33.

CHAPTER 3

Architectural Sculpture in the East (Non-Greek)

It may seem peculiar, in a book on fourth-century Greek sculpture, to devote an entire chapter to non-Greek monuments; yet two major reasons exist for doing so. The first, as already mentioned in Chapter 1, is that such monuments document the expansion of Greek artistic forms into the East well ahead of the campaigns of Alexander the Great. The second is that the East Greek cities seem to have been remarkably passive during the first half of the fourth century, at least as far as monumental architecture is concerned, and only after approximately 350 do we find truly Greek structures decorated with sculpture. This apparent gap in our sequence is usually filled in our handbooks by accounts of such buildings as the Nereid Monument at Xanthos and the Heroon at Trysa. It is important, however, to stress the non-Greek character of these works, not only to underscore the peculiar, lacunose nature of our Greek evidence (which does not come to the fore until geographic distribution is observed), but also to emphasize the difficulties of evaluating material for which virtually no texts exist (and certainly no building accounts) and which combine Greek and non-Greek themes and stylistic forms.

In Lykia, a strong tradition of sculptured heroa, pillar tombs, and stone sarcophagi existed since the late sixth century, especially at Xanthos, but virtually no monument seems datable to the span 450–400 on either historical or stylistic grounds. Yet dynastic rule, as attested by *coinage*, should have ensured the continuing need for funerary structures befitting the political figures of the time. Perhaps the lack of strong sculptural workshops in the Greek cities of Asia Minor is reflected in this apparent gap.[1] This local situation did not change perceptibly at the turn into the fourth century, but the impetus provided by the extensive building program on the Athenian Akropolis seems to have extended rather to the non-Greek territories of Anatolia, perhaps even as the result of a possible diaspora of sculptors after the final phase of the Peloponnesian War. Yet it has been pointed out that all Xanthian monuments datable to the first two decades of the new century are in local lime-

Architectural Sculpture in the East (Non-Greek)

stone and in a distinctive local style and iconography that bespeak native workmen, albeit under the influence of Greek island masters.[2]

This is not the case with the Nereid Monument, whose strong Greek features, combined with the use of (local?) marble for both sculpture and architecture, have repeatedly suggested the participation of Greek carvers. This theory, nuanced to stress East Greek or insular connections for one of the two workshops, has been confirmed by the recent official publication of the sculptures, which has also dated them toward the end of the decade 390–380, and has attributed the majestic tomb to the Dynast Arbinas (Erbbina). The detailed treatment of both iconography and style, together with the excellent line drawings and photographs, allows us to discuss the Nereid Monument extensively for the first time.[3]

THE NEREID MONUMENT OF XANTHOS

Although it looked like a Greek temple, the Nereid Monument was definitely a tomb, erected for a Dynast in a prominent location outside the city walls of Xanthos (Pl. 12, Ill. 10). Its high podium recalled the traditional Lykian pillar-monuments, but its peristyle of 4 × 6 Ionic columns and its pedimented roof were in traditional Greek idiom. A thorough architectural analysis has preceded the publication of the sculptural decoration, and, except for matters of details, it has stood the test of time.[4] Here it suffices to point out that the presence of dentils instead of a continuous frieze above the architrave, as well as the tall Ephesian column bases and the extensive use of egg-and-dart moldings, conforms to the East Greek tradition, but many other features, especially the distinctive column capitals and the elaborate doorways, recall the Athenian Erechtheion.

Plate 12

Definitely non-Greek is the use of two superimposed sculptured friezes, of uneven height, atop the podium (Pl. 13). That the architrave should be carved with figured scenes is, however, not unprecedented in Greek territory, given the comparable rendering of the Archaic Didymaion; a fourth such decorated band around the exterior of the "cella" walls may recall equally Archaic Samian and Asia Minor parallels.[5] It is the total richness of the monument which seems extraordinary, since it included painted coffers over the ptera, two carved pediments, group akroteria, and the Nereids that give it its modern name as free-standing statues in between the columns; marble lions guarded the four corners of the podium, probably at ground level,[6] and lion-head spouts ran along the (plain) lateral simas. From a distance, perhaps, the total effect resembled the Athenian Nike Temple rising on the Akropolis bastion surrounded by its carved parapet, but certainly the peripteral arrangement and the multiplication of figured friezes and statuary in the round exceeded this precedent. Not even the Delphic Tholos, with its spectacular embellishment, would have rivaled the virtually contemporary Lykian tomb, but it is important to stress the apparent increase in architectural sculpture during the first two decades of the fourth century.

Plate 13

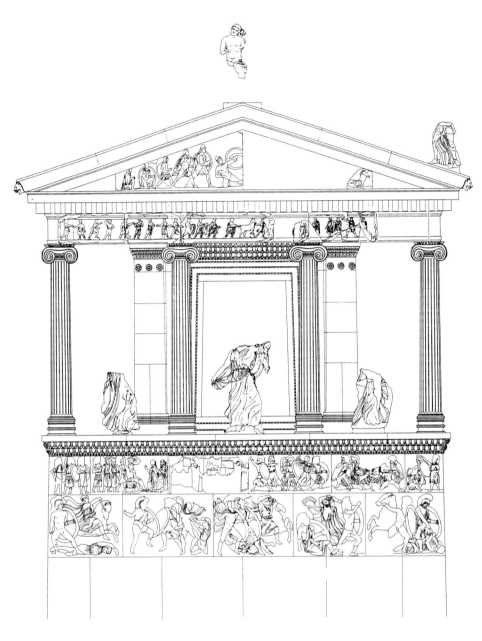

Ill. 10. Xanthos, Nereid Monument, reconstruction of west façade (after Demargne 1990)

Architectural Sculpture in the East (Non-Greek)

The Xanthian painted coffers, regrettably, are no longer sufficiently visible for interpretation, although outlines were still perceptible at the time of discovery. They included abstract and floral decoration, but also at least one female head, in three-quarter perspective view, perhaps wearing a sakkos, on a slightly concave background.[7] Traces of paint on the sculptured friezes suggest that they too would have shared a pictorial role and probably given the impression of extensive murals—an effect enhanced by the clever, if naive, perspective rendering of the besieged cities in the top podium frieze. The exceptional state of preservation of the sculpture itself, however, which makes this Xanthian monument one of the most complete examples to have survived, has allowed a total program to be postulated. The Dynast is glorified through his life exploits, which become progressively more symbolic and eventually merge with those of epic heroes and mythological figures to suggest eternal afterlife in another world.[8] This same approach, in a less graduated fashion, will form the decorative basis of most Roman Imperial sarcophagi.

To the Dynast's life cycle belongs, first and foremost, **frieze 2**, the so-called historical frieze, which crowns the podium. Although smaller than the one immediately below (a perspective arrangement in itself, to enhance the apparent height of the pedestal?), it is the most distinctive. One city under attack is depicted per side, two of them (N and E) at the beginning of their respective stretch of frieze, the two others (S and W) in the center. This unusual presence of landscape gives the viewer a sense of actual events, as if each city with its gate and towers—the one on the west façade even with a typical Lykian funerary monument within the walls (Pl. 14), the one on the north over rough terrain (or perhaps even a tumultuous river, Pl. 15)—could be recognized and named. Yet a certain amount of symbolism is also present, in that the motif of the city-siege is derived from Assyrian prototypes and need not correspond to real campaign sites. The realism of some details includes a woman in distress amidst the manned embrasures of the merlons on the city walls of the south side (Pl. 16); yet the warriors who emerge from the walls to face the attackers hold only stones in their raised right hands—missiles of some effectiveness if hurled down from high walls, but virtually useless in hand-to-hand combat. On the opposite side of the same fortress, the enemy is shown scaling the siege mound, and some soldiers have already entered an inner court and are talking to the defenders; yet within the battlements, heads turn in different directions, mostly facing each other or looking away from the danger point. Just before the siege mound, behind a saddled horse being brought into the city, a leafless tree stands alone,[9] almost a presage of the desolate landscape of the Alexander Mosaic.

Plate 14
Plate 15

Plate 16

It has been suggested that more than one episode is shown within each frieze, specifically the west, where the sequence reads (from right to left) as victory in battle, flight toward the city, and capitulation. What is even more significant is that the Dynast may appear more than once: undoubtedly when seated under the parasol indicative of his rank, while receiving the emissaries from the city; and being

Architectural Sculpture in the East (Non-Greek)

Plate 17

crowned in combat as he grasps by the hair a kneeling opponent (Pl. 17).[10] He would thus be shown twice within the same visual frame, satisfying the requirements for what has been called "continuous narrative," typical of Roman historical reliefs and traditionally held to begin no earlier than the Pergamene Telephos Frieze at least two centuries later. In each occurrence the protagonist is recognizable, not necessarily through his features but through the use of accepted iconographic motifs: the hair-pulling schema of the victor being crowned on the field of battle (again, in anticipation of Roman Imperial renderings), and the paraphernalia of his status in truce. The first image, although as early as Old Kingdom Egypt, had found major Greek expression in the Parthenon east metope with Athena defeating her giant while being crowned by Nike. The second image is more closely related to Assyrian and Persian prototypes; the Dynast may at first glance seem to be portrayed in Greek heroic semi-nudity, but his torso is instead covered by a tight-fitting garment once obviously enhanced by color and now discernible by the slight nick at the neckline.

Frieze 3, on the architrave, has a different subject on each side, although all four topics may be subsumed under the larger definition of dynastic activities and rituals. On the *east*, a hunt with participants on foot and on horseback revolves around a bear and a boar, the latter closer to the axis of the building and placed almost directly under the figure of the enthroned Dynast on the pediment. A third animal, a deer, is already dead and being carried on a man's shoulder; a riderless horse may represent a wild animal or one who has thrown his rider. It seems surprising to me that a lion should not be included, as it will be later in the iconography of Alexander the Great; but the boar is a dangerous animal, and the scene may reflect a true exploit of the ruler, albeit with a hint of a mythological allusion to Meleager and the Kalydonian beast. On the *south*, a widely spaced battle between infantry and cavalry picks up the second major theme in the life of an Oriental potentate, parallel to the hunt. The *west side* depicts a procession of men bringing in clothing and a horse, which reappears on the *north side*, the least well preserved, where prepara-

Plate 18

tions for a banquet are in progress (Pl. 18). If the animal is meant to form a visual link between two, or even three, of the sides, the west and north friezes could represent the sequence following the hunt of the east façade, and eventually leading to the cella frieze, **no. 4**, where the *north side* shows a banquet in full swing.[11] A viewer at the foot of the podium, looking up, could almost simultaneously have seen the architrave decoration and the cella top, as visitors to the Parthenon could have perceived the metopal subjects juxtaposed to those of the continuous frieze. But the connection of topics established at Xanthos seems closer than that on any Athenian monument, and perhaps comparable only to the program of the Argive Heraion.

Frieze 4, from the outer cella walls, is less well preserved but seems to belong as well to the realm of the living. The already mentioned banquet on the *north side* is

Architectural Sculpture in the East (Non-Greek)

almost complete, with men reclining together on long klinai in front of which attendants provide service. The spatial recession implied by the arrangement had already appeared on the Archaic Assos architrave, but it is here enhanced by the greater overhead space above the banqueters. Only two figures do not share their couch with others, and the one close to the center is obviously the Dynast, identifiable through his slightly larger scale, frontal face, stylized beard and hairstyle, the Persian rhyton he holds, the dog reclining under him, and the converging figures that frame the kline and draw attention to its occupant. The other singleton appears toward the right end of the frieze and cannot be readily identified; the suggestion that it may be the son and heir of the ruler seems appropriate in a dynastic monument.[12] The *west side* has a rare depiction of a sacrifice, with a procession converging toward a central altar. Only two finished blocks (BM 901a, BM 906a) and an unfinished one (BM 908) can be attributed to the *south side*, apparently showing an assembly of draped men, often compared to the Parthenon east frieze; the scene includes, once again, an unmounted horse. The poorly preserved *east façade* retains both corner blocks, each with a surprising image: a winged Victory at the left (BM 906b) and a person in lively motion, perhaps a dancer, at the right (BM 898b),[13] the intermediate block (BM 907) has some figures holding unidentifiable objects, perhaps weapons or armor, and moving in opposite directions, some toward a seated man who may again represent the Dynast. Whether or not this is the case, the presence of a personification shifts the scene from the everyday realm to a mythological/allegorical plane. It has also been suggested that the west sacrifice implies a hero cult for the deceased, being performed by his heir, or an offering to the founder of the dynasty. But I am not sure that the somewhat larger size of the Dynast at banquet, on the north side, is an index of heroization rather than a simple example of the "scale of importance" being applied to the scene.

Definitely heroic, however, is the character of **frieze 1**, on the podium (Pl. 19; cf. Pl. 13). Despite the almost conventional character of dress and armor, no clear division can be made between battling armies, and duels are not always between differentiated opponents. Some warriors exhibit Greek paraphernalia and even Greek nudity, others sport Lykian hairstyle and long chiton, three have Persian costumes and headdresses, some are on foot and some on horseback—but all of them give the impression, through familiar iconographic schemata, of belonging to an epic combat, specifically an Amazonomachy. The long hair of some combatants (typically Lykian), their clean-shaven faces, their prominent chest muscles, could indeed be misleading, were it not that their clinging and transparent garments reveal their sexual organs. The frieze has therefore been described as "quasi-historical" or as a "pseudo-Amazonomachy" and a foil to the "historical" depictions of **frieze 2**, which surmounts it. It is, however, unclear whether all four sides show a unified subject, or whether two or several heroic myths, perhaps Greek as well as local, are depicted, even if some participants stand out. Notable among the combatants are

Plate 19

the youthful horseman with a lion-skin helmet (cf. Pl. 13); the bearded warrior removing a spear from (or plunging it into?) the head of a fallen man on whom he steps; the hoplite wearing a helmet with ram's head cheekpieces; the kneeling long-haired Lykian in frontal pose, with Venus rings on his neck; and finally the Oriental wearing a Persian tiara and wielding an axe, who may represent the Dynast himself. In this case, he would be shown as a Herakles or a Theseus in a quasi-Amazonian battle. Yet all differentiation may be due to the preferences of the individual masters and their desire for variety, especially since even the three "Persians" are not singled out for special treatment, and no side is clearly victorious over another.[14] Note, however, that all the fallen combatants wear the long chiton of the non-Greek.

The Dynast recurs explicitly on the celebratory pediments, which show him first enthroned in state (this time with a bare upper torso), accompanied by his wife, children, servants, and faithful dogs (east side), and then victorious in battle, probably in the Dexileos schema, although the half of the west gable that contained his image is almost entirely missing. Both scenes could be read at the level of real-life occurrences, yet they acquire unmistakable heroic connotation through their location, which on earlier Greek temples was traditionally reserved for gods and, eventually, for heroes. But the highest and most symbolic level of meaning is achieved through the **intercolumnar statues** and the **akroteria**. The famous Nereids allude to the wedding of Peleus and Thetis, their heroic son Achilles, his final journey to the island of Leuke and, thus, to immortality.[15] The akroteria seem to reinforce this message, creating an obvious parallelism between the Greek heroes and the Dynast with his successor.

There were originally **11 Nereids** between the columns, three on each façade and five on the north side, and they have all survived in more or less complete form. The south stylobate, surprisingly, has revealed no cuttings for the plinths of the sculptures, as they occur on the other three sides, and is therefore restored without statuary complement. The official publication refers to all four sides of the monument as *côtés* or *façades* indiscriminately, but certainly the presence of the large doors on the east and west ends, together with the pedimented roof and akroterial ornaments, should identify them as the true façades, as contrasted with the "long" north and south sides, even if actual measurements are not considerably different. It has been pointed out that the north side (Ill. 11) may have had particular importance as place of access for the monument—thus perhaps a need to leave the intercolumnar spaces free; yet the opposite obtains, since it is the south side that holds no sculptures. The outer friezes seem also to lend greater emphasis to the southern view, since the besieged city of **frieze 2** is centered on that side, and the architrave carvings depict one more theme of combat.[16] By contrast, the northern city appears at the left hand (the beginning) of its frieze band and the architrave composition seems unidirectional; yet the poor preservation of the podium carvings prevents

Architectural Sculpture in the East (Non-Greek)

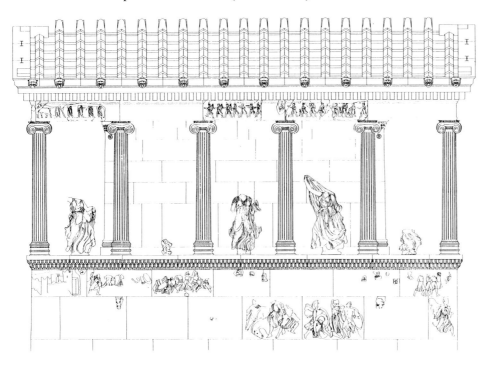

Ill. 11. Xanthos, Nereid Monument, reconstruction of north side (after Demargne 1990)

further speculation. Certainly, with a bifacial "cella" and a non-Greek monument, we may unjustifiably try to assign greater value to the east than to the west façade; in fact, at present, the west may seem the more significant of the two in terms of its sculptural message.

Identification of the intercolumnar statues is due to the seven aquatic animals recognizable at the females' feet, although some lack such attributes and others are too poorly preserved to retain them. They have been assigned to the three sides of the monument largely on the basis of their apparent direction: those on the east façade move to the right, those on the west to the left, and those on the long north side converge toward a frontal figure (BM 909, Pl. 20), singled out because of her costume—a sleeved chiton held by shoulder cords, as contrasted with the belted peploi of the other Nereids. Two more fragmentary pieces distinguish themselves from the group, one because it is a mantled male, the other because it represents a female in stationary pose, wrapped in a himation flung across her waist, like images of Aphrodite.[17] They probably depicted Peleus and Thetis, or—should the Nereid in chiton be Thetis herself—the Dynast and his wife, and their location on the building is uncertain.

With their himatia billowing behind them like sails (only BM 918 does not wear one), their floating skirts, their long, belted overfolds appropriate for lively action,

Architectural Sculpture in the East (Non-Greek)

Plates 21–22

their transparent costumes revealing a strong body, their legs wide apart in a motion pose, these Nereids are spectacular (Pls. 21–22). Their display between columns has indeed an almost theatrical effect, with the mantle functioning as a background foil.[18] Yet their location would have recalled votive statues traditionally set up within peristyles of temples, as for instance at the Temple of Zeus at Olympia, except that at Xanthos theme and chronology are unified, and the appearance is calculated for maximum impact in relation to the architectural frame. The statues are in fact slightly under lifesize, but the viewer would have tended to "read" them at human scale, thus deriving the impression that the columns themselves are taller and the structure is bigger than in reality.

Plate 23

The **akroteria** are more controversial in their interpretation. Fleeing(?) female figures at each corner (two very fragmentary, two almost entirely preserved) are distinguishable from the Nereids because of their smaller scale, but wear the same kind of peplos belted over the long apoptygma and a back mantle (Pl. 23). The central akroteria join a male and female protagonist in action poses, and are assigned to their respective façades on the basis of findspots. Thus one group with a nude male lifting a draped female almost to shoulder height is located on the east side and identified as Peleus kidnaping Thetis; the second group, with the female component preserved only as a hand behind the youthful male's head and a swag of drapery over his left thigh, is restored to the west and, because of the apparent distance between the two figures, interpreted as the initial struggle between Peleus and his future, reluctant bride. This reading of the iconography would connect the akroteria to the intercolumnar sculptures and prolong the symbolic parallelism with the Dynast and his wife, as well as its allusion to heroic immortality.[19] Yet a few problems remain.

Connection between *elements* of the sculptural program (that is, individual parts, in addition to the overarching message) is not impossible, and may occur elsewhere on the Nereid Monument, if the preparation for a banquet shown on the north architrave (**frieze 3**) in fact lead to the feasting of **frieze 4** on the north cella wall. As for the akroterial compositions, it may even be argued that the more violent, struggling group (according to present interpretation) corresponds visually to the battle on the west pediment, whereas the conclusion of the struggle occurs over the east gable celebrating family life. But is the western scene truly a confrontation? Harrison has suggested that the youth's head, rather than being grabbed, is being supported by the female hand behind it, and that therefore the two protagonists should be Herakles and Auge—the hero, drunk, emerging from the dark cave where he has been sleeping off his excesses, and the heroine, whose name carries connotations of light, helping him unaware that he will then rape her. Harrison has also pointed out that the high position of the female figure on the east side suggests she is being lifted onto a chariot, and thus the group could represent Hades and Persephone or Helen and Theseus. Despite the apparent incongruity of having an abduc-

86

Architectural Sculpture in the East (Non-Greek)

tion without progeny over the east, and a rape engendering a dynastic offspring (Telephos) over the west, both myths could be appropriate for the funerary monument of Arbinas, who put a (bearded) Herakles on his coins and may have already been assimilated to the hero in his depiction on the quasi-Amazonian frieze.

I find the Auge story too local in character to be meaningful in a Lykian context—around 380 Pergamon had not yet achieved enough renown to lend its origins wider Anatolian relevance. Identification of the supporting hand as female rests primarily on the "slender" wrist and the surviving drapery, but the latter could be appropriate also for a god or a hero, as shown by the Apollo of the Epidaurian akroterion. Could this group represent Apollo and Hyakinthos? Hermes or Apollo and the Lykian hero Sarpedon? Eos and Kephalos? Thetis and the grieving Achilles? In the second and the last hypothesis, the subject would be in keeping with the combat scene on the underlying gable and the intercolumnar sculptures, perhaps even with the east akroterion, if that indeed represents Peleus and Thetis. The definite resemblance between the Nereids and the lateral akroteria would then be more understandable. Another possibility is that the scene captures Meleager, the Great Hunter, expiring as the fire consumes the fateful log thrown into it by his enraged mother, Althaia. A play by Euripides had given the myth increased popularity by the end of the fifth century, and a South Italian krater approximately contemporary with the Xanthian monument shows the hero being supported by Deianeira and Tydeus. The subject would connect with the boar hunt of **frieze 3**, and might explain why the corner figures run toward rather than away from the apex of the gable.[20] This issue must remain open at present. More significant is the recognition that Greek epics and myths may have played an important role in the symbolic program of this non-Greek monument—a choice confirmed by the repertoire of our next example, the Heroon at Gjölbaschi-Trysa.

Style is likewise under strong Greek influence, and typical of the so-called Rich phase. Hands have been distinguished as well as two main workshops, but here it is irrelevant to dwell on attributions. A more pronounced local flavor and Oriental imagery have been perceived in **friezes 3 and 4**, as contrasted with the two podium narratives. Certainly, their composition is more widely spaced, more rhythmic, more repetitive, and thus seemingly more "provincial." Their almost cartoonlike appearance has prompted their classification as "Gattungstil," an untranslatable German term that stresses position and repetition.[21] Yet the same formal devices are employed in the drapery of all four friezes: the paired folds that I call "railroad tracks," the pincer folds that bracket frontal thighs under smoothed cloth, the peculiar wavelets—almost a Lykian or Anatolian hallmark—produced by parallel motion folds in between or behind the legs of figures in active poses. The larger scale of the podium friezes, and their better-preserved surface, allow clearer identification of these traits, but they exist in the two smaller areas as well and bespeak a common understanding of style.[22] Location may also have contributed to the different ap-

Architectural Sculpture in the East (Non-Greek)

pearance of the two sets of friezes, and it is illuminating, although anachronistic, to compare the Xanthian superstructure carvings to the narrow friezes on the architraves of Roman triumphal arches, often rendered in the so-called popular style as contrasted with the classicizing renderings of sculpture on piers, spandrels, and attic. To be sure, the emphasis on parallel lines and the repetition of similar figures on **frieze 3** have been rightly compared to the Apadana reliefs at Persepolis, but the same traits recur on **frieze 2**, where the attacking phalanx of warriors on BM 875 and 868L (cf. Boardman 1995, fig. 218.14) resembles a chain dance.

The great linearity of this Lykian style has been properly stressed and compared to Ionic works like the Charites relief from Kos dedicated by Peithanor, son of Charmios. Yet the latter is ultimately under strong Attic influence, and even the Nereid Monument sculptures betray more than a second-hand inspiration. The "stumbling horse" motif on a slab of **frieze 1** is in fact so close to the same rendering on the south frieze of the Nike Temple that the two could be confused when viewed at the unifying scale of slide projections. Other motifs have been traced to various Greek monuments, and some of the Nereids themselves, with their archaizing Knielauf poses and the birds at their feet, compare well with the Agora Nike once thought to be an akroterion for the Stoa of Zeus and with the Nike of Paionios respectively. Could the greater linearity at Xanthos be the result of copying from pattern-book *drawings* of the Attic sculptures? And is the eclectic style of the Xanthian east pediment (Archaic reminiscences, references to Attic classicism, and provincial/Oriental features) a distinctive characteristic of a mixed culture? I am reminded of the archaizing hairstyle of female heads from Halikarnassos and Priene, and of the Motya Youth, whose forceful rendering of sexual organs under clinging drapery provides perhaps the best parallel for some figures of the quasi-Amazonian frieze.[23]

Finally, some technical comments. The unfinished block BM 908 has already been mentioned; we may add that a sort of "cookie-cutter" outline is still apparent in some figures, and may bespeak a local or Asia Minor tradition. In keeping with East Greek practices also is the use of very few added elements in metal, as contrasted with Attic and even Kykladic practice. Some pieces are inserted separately, in stone, despite the small scale involved—a peculiar technique.[24]

THE HEROON AT TRYSA

Connections with Greek painting, or at least with pattern books of Greek motifs, have been so often advocated for the sculptural decoration at Gjölbaschi-Trysa that the Heroon has to be considered here, despite its non-Greek architectural form. Yet even its roughly rectangular precinct-wall with massive doorway, built around the burial structure of an unknown Lykian Dynast, has been compared with the Theseion in Athens and its painted decoration, although no remains of Theseus' resting place have as yet been safely identified.[25]

The Turkish name for the site (Gjölbaschi, or, in a more correct transliteration,

Architectural Sculpture in the East (Non-Greek)

Gölbaşı) is that of the local village near the ancient nekropolis, and it means "place on a lake," a description that no longer applies. The Greek name, Trysa, is, however, epigraphically attested and should therefore be used throughout. Yet the hyphenated form occurs in all major publications of the Heroon and therefore cannot be ignored.[26] Before the end of the last century, the limestone blocks of the temenos wall were taken to Vienna, where they have been set up in the original sequence. Regrettably, their heavy weathering makes detailed reading difficult, and photographs are often less illuminating than the published drawings. Iconography looms therefore larger in all accounts, especially because of the peculiar mixture of Greek and non-Greek subjects, some of them not sculpturally attested elsewhere. The date of the complex, based on stylistic grounds, has been placed after the Nereid Monument, around 380 or within the following decade.

In general terms, the temenos wall, averaging 3 m. in height, carried the primary decoration: two courses of continuous, superimposed relief friezes running at the top, just below the crowning moldings, around all four inner sides, with occasional scenes spanning both registers; on the outside, only the south (entrance) wall was thus embellished (Ill. 12). A massive houselike building in the approximate center of the enclosure contained the remains of the obviously important ruler, probably once identified by a now lost inscription. Fragments of decorated sarcophagi found within the precinct suggest that other members of his entourage were also buried there; a typical Lykian stone casket with high-swinging and sculptured lid stood outside, in front of the SE corner, and was inscribed with the names of Dereimis and Aischylos, probably also related to the ruler. Within the temenos, traces of other structures were noted: a possible altar in front of the north wall, which may indicate heroic cult for the dead; a later wooden construction in the NW corner, which affected the reliefs; and, in the SE corner, a temporary wooden building, probably stoa-like and ritual in purpose (funerary banquets?), which was instead carefully planned at the outset, as shown by the sculptured friezes, which in that area run one course lower, to clear the overhead roofing.[27]

The door lintel, on the outside, is decorated with four strongly projecting winged-bull protomai, of Persian inspiration, alternating with rosettes and a central gorgoneion, all obviously apotropaic in function. Below them, in a low-relief register, two pairs of husband and wife, perhaps depicting the heroized dead, sit facing each other. The outer door jambs are plain, but the wall on either side carries the double band of friezes. Standing before the entranceway, the visitors would have seen, to their left, an Amazonomachy on the upper, a Centauromachy (with Kaineus and perhaps Theseus and Hippodameia) on the lower level; to their right, a scene of city siege (probably the attack of the Seven against Thebes because of Kapaneus falling headlong from a ladder, and Amphiaraos with his chariot sinking into the ground) above the depiction of a seashore battle, with a warrior being carried on a shield toward three moored ships.

Architectural Sculpture in the East (Non-Greek)

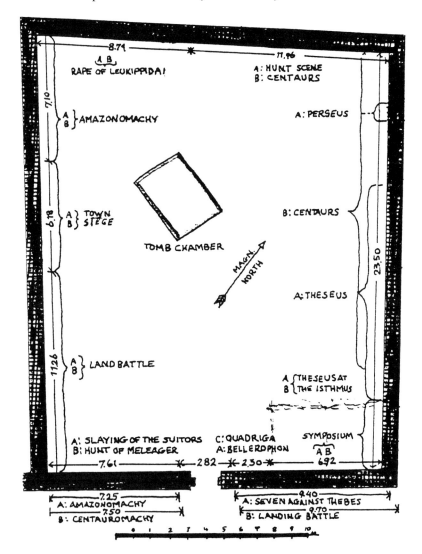

Ill. 12. Trysa, Heroon, plan (drawing K. Dimler)

The decoration of the door on the inner side is even more elaborate (Ill. 13). The lintel is carved with eight grotesque creatures dancing and playing musical instruments, their similarity to the Egyptian god Bes betraying Egyptian inspiration. On the door jambs, two almost-lifesize figures look at first like Greek kalathiskos dancers, their skirts aflutter with twirling motion; but a second glance reveals that they are male, one obviously bearded. The connection with the lintel scene is clear, and the total should allude to some Lykian ritual. Significant also is the choice

Architectural Sculpture in the East (Non-Greek)

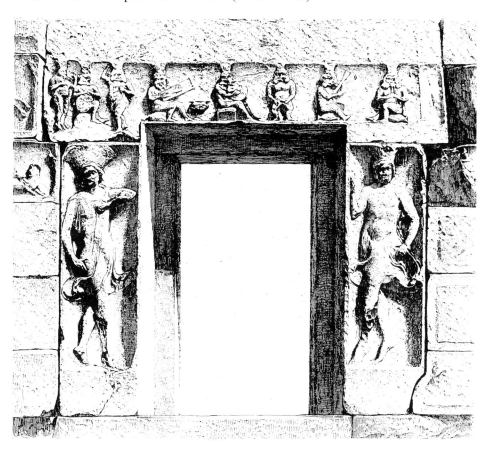

Ill. 13. Trysa, Heroon, drawing of doorway, interior side (after Benndorf and Niemann 1889)

of themes for the two friezes immediately to the right of the entering visitors: on the upper level, a youthful warrior stands in a racing quadriga next to an equally young and beardless charioteer; on the lower level, a warrior on foot carries a distressed female in his arms in what is probably a bride-kidnaping scene, while the adjacent block depicts Bellerophon on Pegasos spearing the Chimaira. The presence of the Lykian myth next to the rape episode may allude to the ancestry of the ruler, himself perhaps depicted in his chariot on the block above. The program of the entire complex would have therefore been made explicit from the start: a mixture of real-life representations and mythological narratives, with that symbolic parallelism already postulated for the Nereid Monument.[28]

In keeping with this interpretation is the apparent duplication of subjects: at various places on the four walls there are two Amazonomachies, two Centauromachies, two hunt scenes, two kidnaping scenes, two battles in front of a besieged town (Pl.

Architectural Sculpture in the East (Non-Greek)

Plate 24

24), two fights by the seashore, and deeds of two heroes—Perseus and Theseus; Bellerophon may appear emblematically rather than narratively, but the total absence of Herakles and his well-documented Labors seems surprising. Only the SE area encompassed by the temporary wooden structure has depictions appropriate to its function: a banquet, with attendants serving men reclining in pairs and dancers (both boys and girls) performing to the accompaniment of musicians (lyre and pipes). A unique scene has been identified as Odysseus killing the suitors.[29] The program has been read in the traditional manner: triumph of culture over barbarism, good over evil, victory in hunt and war, as appropriate for the ruler. Debate may linger only over the interpretation of the most famous scene, which occupies both levels of the west wall (Pls. 25a–c): a Lykian city under attack or the Greeks outside the walls of Troy?

Plates 25a–c

Whereas the representation of a city siege on the outer south wall could be easily seen as a mythological episode, because of the presence of recognizable heroes and perhaps also of Zeus, this inner depiction hovers at the narrow threshold between epic and real-life scenes.[30] If this is a Lykian city, would the ruler show his own seat under attack, with refugees escaping to safety? And why would he be portrayed in heroic semi-nudity, with a fillet on his head instead of the royal tiara? If, on the other hand, this is Troy, why would the enemy be entering through two doors within walls heavily defended by the troops inside? Troy was taken by surprise through the stratagem of the wooden horse, and Priam would not be rendered sitting in state under a (painted) parasol, overlooking the attack. The woman under a carved parasol shown on an elaborate throne at some distance from the ruler seems too young to be Hekabe, and Helen would probably not be granted the insignia of equal rank.

Given the ambivalent world of Lykian iconography, identification seems to me less important than the actual rendering of the scene. The use of both registers allows a clear division of attackers and defenders, with a sense of space and perspective unprecedented in Greek sculpture. The human figures are properly scaled in relation to the high walls, and the two postern gates are foreshortened to suggest the projection of the flanking towers. Within the walls, defenders seen frontally throw stones on the attackers, but one warrior sacrifices a ram, in what would seem a Greek military ritual, and another rallies his men, who move toward one threatened entrance in two converging and cascading lines suggesting descent from above.[31] A building with a gabled roof is rendered in three-quarter view: it has an elaborate central akroterion in Oriental style and lateral antefixes. The total effect, highly pictorial, is not marred by the joins between blocks, which are used, rather than ignored, to indicate levels and margins and to provide details. Some of them are in fact emphasized by framing ridges or turned into trees (cf. Pl. 24), adding to the rocky groundlines and the general landscape—a device applied here as well as to several other scenes within the enclosure.[32]

Architectural Sculpture in the East (Non-Greek)

Although the transition from double to single frieze and vice versa has been criticized as "not fluid," the expansion of one topic over both wall courses seems to me cleverly exploited for spatial effects, not only here but wherever employed. Note that most blocks of the precinct walls are trapezoidal rather than rectangular in shape, with a technique that may be considered typically Lykian, since it occurs in other constructions, like the tombs at Kızılbel and Karaburun, dated around 525 and 470 respectively. The elaborate painted decoration of both these burial chambers, moreover, clearly shows that a pictorial tradition mixing mythologico-epic subjects and "everyday scenes" already existed in Lykia itself, albeit probably inspired by Greek vase painting.[33] It is, therefore, the *stylistic* renderings of the Trysa friezes that suggest the use of pattern books reproducing sculptural monuments of the Greek Mainland; at the same time, several features have already been noted in the Nereid Monument and can, by 380–370, be considered part of the Lykian sculptural repertoire.

By and large, the treatment of drapery at Trysa is less flamboyant than at Xanthos, more sober. "Railroad tracks" have given way to single parallel folds, and drapery is less consistently transparent. Yet motion lines are usually present, as well as the "Lykian wavelets." Skirts have an added liveliness, suggesting spiral rather than unidirectional movement; strong undercutting and wider spacing of ridges often create a clamshell effect at the hem. Many important details were added in paint, and the loss of color together with the heavy weathering of the surface makes analysis difficult. No metal attachments or other technical additions are recorded. Among the poses, those of the Tyrannicides recur, as well as the "stumbling horse" motif, the helping of a wounded comrade, the hair-pulling fight. The woman on horseback escaping the besieged city holds her mantle around her head in the typical wind-inflated, sail-like arrangement that serves as a hieroglyph for rapid motion, despite the apparent incongruity of the signal in this relatively sedate scene. Many imperfections have, however, been noted throughout the friezes, as well as unmotivated empty spaces and figures used as fillers. Although the total program may have had a single planner, execution was probably left to individual carvers who freely juxtaposed unconnected episodes according to the availability of suitable prototypes.[34]

As a final comment, the difference in subject matter from the sculptural program of the Nereid Monument should be emphasized. In the latter, epic allusions were made through the intercolumnar figures, perhaps also the quasi-Amazonian **frieze 1**, and mythological topics appeared as akroteria; but by and large the subjects were local and pertinent to the life of the tomb owner. By contrast, there is no questioning the epic and mythological character of the Trysa themes, as well as their wide range. Even if Troy and its vicissitudes may not play as strong a role as some commentators suggest, the Killing of the Suitors implies knowledge of the Homeric poems and is all the more surprising in that no close prototype may be cited for

Architectural Sculpture in the East (Non-Greek)

this depiction.³⁵ As for the mythological scenes, Theseus lifting the rock hiding the tokens is not attested in any of the architectural-sculpture sequences of the Greek Mainland. Bellerophon on Pegasos, in gilded bronze, was the central akroterion of the Nike Temple.

THE HEROON OF PERIKLE AT LIMYRA

Perseus and Bellerophon, as traditional local heroes, are even more prominently displayed in the last Lykian funerary monument to be considered: as central akroteria of a structure that strongly resembles both the Nike Temple and the Karyatid porch of the Erechtheion (Ill. 14).

Built at the edge of a prominent terrace below the akropolis of Limyra (Lykian Zêmuri) but high above the city itself, in a dramatic setting, this tetrastyle amphiprostyle structure, oriented N–S, with possible opening to the south, uses Karyatids in place of columns, and its high podium containing the burial chamber recalls both the Athenian Akropolis bastion and the orthostat pedestal below the Erechtheion Korai. Although the Nereid Monument is also said to have served as inspiration, the comparison seems more remote, at least in the present state, when intercolumnar statues, if they existed, are no longer recoverable.³⁶

Besides akroterial sculpture and the above-mentioned Karyatids, the main decoration of the building consists of two low-relief friezes along the cella walls, each showing a procession of riders and foot soldiers moving toward the south. The frieze on the east side is very poorly preserved, as contrasted with its counterpart on the west, but they have been reconstructed as mirror-images, although what remains of the eastern blocks shows that composition, details, and execution may have differed.³⁷ Carved rosettes embellish the anta capitals of the cella and the upper zone of the two-fasciaed epistyle, just below the dentil course. Lion-head waterspouts can be restored along the lateral sima, but the pediments appear at present to have been empty of decoration, although painted scenes cannot be excluded. The building has been carefully published and described in detail, and we can therefore focus here on specific comments.

Although the Athenian Akropolis is so strongly echoed by the shape of the monument, attribution of it to the significantly named Dynast Perikle (in the Lykian spelling of the name) rests on relative evidence: the fact that Perikle's name is inscribed on many local tombs, that he minted coins in Limyra, that his known dates are compatible with the chronology of the structure, the latter determined primarily on stylistic grounds to be around 370. On the same grounds, Bruns-Özgan would lower this date to the second half of the fourth century, although even this later placement would not prevent the burial from belonging to the ruler. She points out, however, that Perikle also minted coins elsewhere, and that his name recurs within inscriptions found at other sites. One more possible argument advanced by Borchhardt, that the ruler mounting a chariot, as preserved on the Heroon

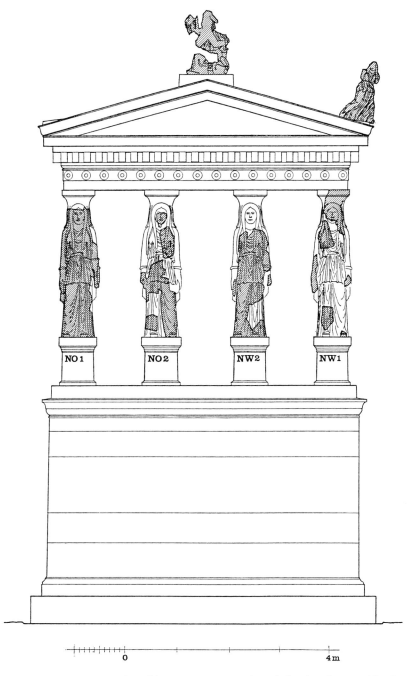

Ill. 14. Limyra, Heroon of Perikle, reconstruction of north façade (after Borchhardt 1976)

Architectural Sculpture in the East (Non-Greek)

west frieze, resembles a numismatic "portrait" of Perikle, seems to be less valid, in that the stone surface is heavily damaged and the coin type provides only relative comparison.[38]

One important point about the Limyra frieze(s) is that the central focus of the procession is said to rest on the Persian king, Artaxerxes III, a beardless man who rides a splendid horse and wears the *tiara orthè* as insignia of his rank. To be sure, the tomb owner himself would be shown at the head of the alignment, in a quadriga, gesturing dramatically back to his followers; but there is no question that the Dynast would thus appear as a vassal of the Great King and subordinate to him. This detail alone could be sufficient to support a chronology before 370–360, the approximate time of the so-called Satraps' Revolt, which tried to remove the Persian yoke and ended by replacing it with a Karian intermediary. Yet a similar tiara has not prevented identification as Arbinas for the depictions on the Nereid Monument, and debate is still open on whether the Satraps would show themselves as subservient to the Great King on their own monuments, which to me seems unlikely.[39] Persian details of attire, such as the *kandys*, do not alone identify Artaxerxes, since others exhibit them as well. One of the peculiarities of the friezes is in fact the great variety of headgear (including a petasos) and equipment among the participants, who may comprise mercenary troops. Yet a comparison with the equally differentiated horsemen of the Parthenon frieze is inescapable.

Where is this parade of mounted nobles and foot soldiers going? Although directed toward the front of the Heroon, it cannot be visualized as a funerary or ritual procession if the Dynast, wherever identified, is still depicted among the participants. Nor can it represent an actual event in the Dynast's life, not only because of its duplication but also because any historical reference, however symbolic, is lacking. As a sheer icon of political dependence, the picture seems inappropriate for the Heroon of the glorified deceased, and we have already questioned the presence of the Great King. It is perhaps more logical to assume that Perikle is twice emblematically shown as a person of military rank and political power amidst his faithful followers, without specific reference to events and places. Borchhardt believes he is setting out for war on one side, for the hunt on the other, as befits an Oriental ruler.

Other comments on the friezes are made difficult by the weathering of the limestone. How the carvings might have appeared when the original paint was preserved is shown by the tinted cast recently published. What is still obvious, however, is the sense of human mass conveyed by the superimposed levels of warriors, in an arrangement which is virtually unknown in Greek sculpture, and which recalls the Roman phalanx, as well as the Roman propensity for showing "disembodied heads" in their historical reliefs—that is, heads of figures whose bodies are totally hidden by those standing in front. This "stacked" arrangement of the troops is quite different from the repetitive files of the Nereid Monument (**frieze 2**), and certainly more effective, if less decorative. Whether it should therefore be considered more "ad-

Architectural Sculpture in the East (Non-Greek)

vanced" in chronological terms is debatable; but the concave rendering of the warriors' eyes, some of them virtually left uncarved, may also suggest that more than a decade separates the two monuments.[40]

Another stylistic trait recalling both Epidauros and Tegea can be found in the marble head of Perseus from the northern central akroterion; not only are the inner corners of the eyes shadowed by nose and brow, but also the outer corners of the lids are overlapped by the prominent eyebrow muscles, in what is usually considered a "Skopasian" mannerism. The partly open mouth exhibits pronounced drill holes at the corners. The result is an intense expression, appropriate to the dramatic moment: Perseus has beheaded Medousa and lifts her beautiful head high while striding (or flying) above the lifeless torso of the Gorgon (Ill. 15). The traditional connection between Perseus and the Persians (Herod. 7.61)[41] has been stressed, as well as

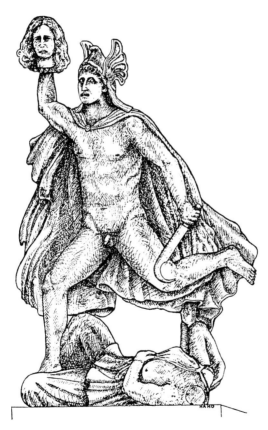

Ill. 15. Limyra, Heroon of Perikle, reconstruction of north akroterion (Perseus and Medousa) (after Borchhardt 1976)

Architectural Sculpture in the East (Non-Greek)

his astral meaning, here alluded to by his pose. It seems surprising, however, that no hint should be given of the birth of Pegasos, since the winged horse appears on the opposite gable, with Bellerophon. The link between the two akroteria would then have been explicit.

Perseus' pose, although daring, is not too different from that of some Xanthian Nereids, and uses the same stratagems for support: the beheaded monster between his legs, his ample mantle as a backdrop for his naked body. He wears the Persian tiara, perhaps to stress his Oriental connections, but he is definitely part of Greek mythology, as is his counterpart Bellerophon. The southern akroterion is, however, much more fragmentary, and the presence of the Chimaira remains uncertain, although pieces of a winged horse attest to that of Pegasos. Equally fragmentary are the lateral akroteria that have been reconstructed as Amazons on foot, although they would seem less congruous than Medousa's sisters. The epic/mythological nature of the roof ornament is nonetheless clear.

More subtle is the meaning of the eight limestone Karyatids distributed over the two façades, which have been recovered in various stages of preservation. Their calculated height is greater than that of the Erechtheion Korai, they wear a high kalathos carved in one piece with head and abacus, and they stood on tall, cylindrical bases. They were also meant to be seen primarily from below, not only because of their position on a podium, but also because of the steep approach to the Heroon from the south side. Differences are especially obvious in the rendering of the hair: mannered and linear, in "ogival canopy" pattern over the forehead, as contrasted with more detailed strands rolled up over the temples. Whether this variation corresponds to different location is uncertain, but all figures seem to have long, twisted tresses falling over the chest and along the upper arms, which are taken as a sign of youth. I would also see them as an Archaistic touch appropriate to women-supports.

The Limyra Karyatids are more heavily dressed than their Athenian counterparts. Beside the peplos and the back mantle—which is here turned into a veil, doubled, covering the head—they also wear a chiton buttoned along the arms; their peplos is belted over the overfold by a thick, rounded band. On their feet are high-soled sandals, on their arms bracelets ending in lions' heads, like Achaemenid jewelry. They hold horse-head rhyta, phialai, and perhaps mirrors. They have been identified as Horai and Charites, according to Pausanias' explanation (3.28.9) of the Karyatids on the Throne of Apollo at Amyklai, built in the late sixth century by Bathykles of Magnesia. Since that peculiar monument also carried reliefs with the Killing of the Gorgon by Perseus, and of the "Lykian monster" by Bellerophon, the comparison seems appropriate, but some scholars prefer to stress the funerary nature of both the Limyra structure and the Karyatids' attributes, which therefore weakens the identification.[42]

More than any other feature of the Heroon, these stiff creatures exemplify the translation from Greek patterns into local stylistic idioms. Although the rendering

Architectural Sculpture in the East (Non-Greek)

of their skirt distinguishes between free and weight leg, the bend at the knee would be barely noticeable were it not underlined (the word is chosen intentionally) by catenaries, which however here have almost lost their character as modeling folds and are sharp and linear, like separate layers of clothing. Over the straight leg, drapery is engraved rather than plastically expressed, and its overall appearance is rigid and opaque, without hint of the body beneath. Although long masses of cloth overhang the belt, they do not describe the rounded kolpos suggestive of the underlying abdomen that one would expect on a contemporary Greek work—nor is the effect conditioned by the belting above rather than below the overfold, as in the Erechtheion Karyatids. Perhaps the clearest contrast is provided by the treatment of the peplos over the breasts—linear and perfunctory, without the transparency (albeit incongruous) of the Athenian prototypes. The Limyra Karyatids are unthinkable as products of Greek carvers, and surprising next to the Hellenized Perseus. Thus the Limyra Heroon well expresses the range possible within a Lykian monument imitating Greek formulas.

NON-FUNERARY MONUMENTS

The above review does not include the most famous tomb/Heroon of antiquity—the Halikarnassos Maussolleion—because Greek sculptors and architects were called in to erect it, and therefore the monument must be considered among the examples of East Greek art, although geographically it stood in Karia. We shall discuss it in the next chapter.

It seems, however, surprising that all the architectural sculpture reviewed so far belongs exclusively to funerary monuments, even if all of them imply some element of heroic cult. True religious structures are not recorded, at least for the relevant period. The most important sanctuary in Lykia, the Letoon near Xanthos, had sufficiently early beginnings, but its three temples date from the Hellenistic period or later; they seem, moreover, not to have been embellished with sculpture.[43] Of the other non-Greek areas within the Anatolian peninsula, Phrygia has left no decorated buildings from the fourth century; Karia has provided several, but decoration may have been very limited. We shall mention them only briefly.

A major Karian sanctuary at Labraunda, that of Zeus Labrandeus (or Lambraundos, or Labranda, or even Stratios, according to various ancient formulas), was provided with two "androns" and a peristyle temple under the Hekatomnids, specifically Maussollos and his brother Idrieus. The androns are so named in the dedicatory inscription set on their architrave blocks, and they are thought to have been banqueting halls, presumably reserved for men. Officially called A and B by their excavators, building A is actually later than B, since it was probably dedicated by Idrieus, according to the current restoration of its dedication. Andron B can definitely be attributed to Maussollos, whose name is fully preserved. Relative dates would therefore be around 353 for the earlier, around 347 for the later structure.

Architectural Sculpture in the East (Non-Greek)

Both of them are distyle in antis, but the two Ionic columns over Asiatic bases carry a Doric entablature, with plain epistyle surmounted by a triglyph-and-metope frieze. They are therefore early examples of the mixture of the two orders that becomes more frequent during the Hellenistic period.[44]

Although their architectural idiom seems completely Greek, the lateral akroteria of Andron B consist of two bearded sphinxes of typical Persian derivation, at a time when Greece has completely abandoned the type, which was popular during the Archaic period. No suggestion has so far been made for the central akroterion. Andron A may have had metal ornaments fastened to holes pierced through the "ears" of the triglyphs and presumably hanging across the metopes, as suggested by green staining of two such holes. This observation makes us wonder how much of the embellishment of an ancient building may escape us because of its perishable nature, and whether the so-called monotonous friezes of the Hellenistic period, for instance, those with repetitive garlands, are indebted to metal prototypes. Finally, the major temple at Labraunda, an Ionic peripteral (6×8) probably initiated by Maussollos and completed by Idrieus around 350, may have carried similar bronze sculpture in its pediment, as implied by attachment holes in its tympanon blocks. This type of decoration, if contemporary with the temple and not a Roman addition, may have been the solution to the adornment of an Ionic gable, for which the shallow Ionic cornice provided little support. A fragmentary marble statue, perhaps a Nike, may have been a corner akroterion,[45] and the marble sima preserves traces of lion-head waterspouts.

From the above survey, it would seem that the Lykians were more interested in architectural sculpture than their neighbors, but the picture is slanted by the predominance of funerary monuments and by our exclusion of the one comparable Karian structure, the Maussolleion. As we shall see in Chapter 5, the North Syrian (Phoenician) Sidonians, also under Persian rule and influence, produced elaborately carved sarcophagi that exhibit a comparable mixture of Greek and non-Greek formulas and styles, but that cannot be classified as architecture, despite the templelike appearance of one of them. It should be stressed once again that no comparable funerary structure exists in Greece at this time—not even in Macedonia, where the form of government, a monarchy of alleged divine origin, could have been conducive to funerary cults—and that the nearest parallels are provided by Athenian religious monuments.

In terms of definition, the Lykian sculptures we have analyzed show basically the same characteristics on all three major monuments: their style is heavily indebted to Greek prototypes of the late fifth century, perhaps mediated through the Greek islands, but some patterns have become so standardized that they can be considered true Lykian mannerisms. Only at Limyra do we find traces of fourth-century styles, as known through Epidauros and Tegea, but they exist side by side with earlier

Architectural Sculpture in the East (Non-Greek)

forms, as indeed can be said even of as varied a repertoire as that of the Nereid Monument. Of the three Heroa, the Xanthian is the most sculptural, the Trysan the least. Although both use superimposed friezes, in a thoroughly non-Greek manner, the Xanthian registers remain distinct and different in treatment; the Trysan ones merge and separate in pictorial fashion. Although both show figures in action from behind or fully from the front, the Xanthian background seems primarily even and neutral, like the backdrop of a stage on which actors perform, and which they tend to fill to the top, whereas the Trysan figures may be steeped in atmosphere and even dwarfed by their setting. Yet these comments apply only in a general sense, to certain Trysan scenes; others are quite traditional and reflect the same conventions as at Xanthos. The Limyra friezes, with their effective massing of troops and their processional arrangement, seem to fall in between the two extremes.

Because some of the Trysan subjects are so unusual, and some, to our knowledge, are unattested in Greek sculpture, we tend to stress the possible pictorial origin of that complex. Yet motifs with undoubted sculptural pedigree recur in both the Xanthian and the Trysan program, and they may have formed part of Lykian workshop repertoires. Even the spreading of a topic over more than one course need not be connected exclusively with Greek pictorial prototypes, like the murals of the Athenian Theseion, but could be seen as a local practice connected with their own painted tombs. Exactly the same mixture of mythological and epic subjects, interspersed with possible scenes taken from daily life, have been noted in the Kızılbel tomb, which provides a significant precedent for both the Nereid Monument and the Trysa Heroon. On the other hand, Egypt and its decorative practices may have played a role as well, given also the clear evidence of the Bes-like figures above the temenos door; there, friezelike compositions usually spread over several courses, and the line between painting and relief is difficult to draw. More than at Xanthos, the Trysan program seems representative of a variety of currents, as indeed was the art of the Persian empire.

In terms of content, the great predominance of Greek heroic and epic themes in all three Heroa is remarkable, even if some myths can be connected with the Persian or the Anatolian sphere. To be sure, the lack of literary sources precludes their proper interpretation—can we safely assume that Lykians would have attributed to them the same meaning as the Greeks? Is it true that Amazons begin to acquire here, for the first time, a decidedly funerary meaning,[46] rather than continuing to convey an idea of Eastern "barbarism" and anti-maleness? It has correctly been pointed out that these elaborate burials are not simply rich resting places for the Dynasts, but also loci of heroic cult—hence the "symbolic parallelism" with Greek heroes; that the same approach will be prevalent in Roman Imperial times speaks eloquently for a basic similarity in social stimuli. Even more important, and again partly equaled by the later Roman sarcophagi, is the mixture of biographico-historical

Architectural Sculpture in the East (Non-Greek)

elements and epic themes. As is true also for Roman sarcophagi, the specific events cannot always be pinpointed, but the scenes emphasize the prowess of the deceased in both hunt and war, as two facets of the same virtue. These considerations raise the issue of patronage and directives: who determined what was to be depicted on a dynastic grave?

It seems clear that each ruler had a say in the total program of his tomb, as is most obvious at Limyra, with its references to the Periklean Akropolis. Yet we should also beware of creating a circular argument—using the similarities to attribute the Heroon to the Lykian Perikle, and then explaining the program on the basis of his name. I believe that each Lykian Dynast may have suggested which Greek heroes and myths or even which "real life" topics he wanted represented, but the individual compositions were probably left to the ability and knowledge of the local workshops. It is a measure of the difference in cultures that no master's name has come down to us, as contrasted with the Greek buildings; yet it also makes us reflect on the impact of the Roman sources in determining fame. In Lykia, the importance of the Dynast made that of the sculptor(s) entirely subordinate; yet the loss of the relevant inscriptions has meant for us the loss of secure information on the owners of these elaborate structures.

As was well put by Rodenwaldt some time ago,[47] in these Lykian complexes the style is Greek, the content is local. Although this concise statement can be nuanced and amplified, its basic validity remains. It will apply, we shall see, even to that most famous product of major Greek sculptors, the Maussolleion.

NOTES

1. See Zahle 1979, 320, who also points out that, during the early periods, almost all extant sculpture is concentrated at Xanthos, whereas after 400 examples can be found throughout Lykia—a situation that may hint at a change in power structure. A similar gap in Xanthian sculpture is noted by Childs and Demargne 1989, 390–94, who discuss the monuments attributable to the turn into the 4th c.; see also p. 385 for comments on the limited amount of East Greek sculpture during the second half of the 5th c. Stewart 1990, 171, stresses that this hiatus coincides with Athenian-Persian rivalry in south Asia Minor and with the Periklean building program. Note that Chamoux (infra, n. 3, p. 281) calls the Nereid Monument "un des ensembles de sculpture decorative les plus riches et les plus complets (peut-être le plus complet) que *l'art grec* nous ait laissés" (my emphasis). For Lykian history, see Bryce 1986; and, more summarily, Oberleitner 1994, 15–18, and chronological tables on folding plates ("Lykien zwischen Ost und West") in Borchhardt 1993a.

2. Childs and Demargne 1989, 394. It is impossible, in a book dedicated to Greek sculpture, to review all non-Greek works in mixed style, whether Lykian, Phrygian, Karian, North Syrian, or Graeco-Persian. The focus remains therefore on those monuments where Greek style and iconography can be seen to predominate, and, in this chapter, where the architecture also may conform to Greek practices. Extensive bibliography on such "mixed sculptures" can be found in Childs and Demargne 1989; add Jacobs 1987, reviewed by W. A. P.

Architectural Sculpture in the East (Non-Greek)

Childs in *Gnomon* 63 (1991) 244–47. The Inscribed Pillar Monument, important for both chronology and attribution of the Nereid Monument, is discussed by Bruns-Özgan 1987 and Childs and Demargne 1989, and will not be covered here because of its more distinctive local character.

3. Official publication: Childs and Demargne 1989; see specifically pp. 404 (chronology); 376, 395 (architect and chief sculptor, head of Workshop M I, definitely Greek, but from the islands or East Greece, and *not* Greek masters fleeing Greece); 372, 391, 398 and passim (influence from the Parthenon, and masters' knowledge of true Greek monuments). Workshop M II seems to have been local, although eventually influenced by the style of M I.

At present, the official publication has been reviewed only by French scholars: F. Chamoux, *REG* 103 (1990) 284–86; C. Delvoye, *AntCl* 59 (1990) 591–94; and, most thoroughly, J. Marcadé, *RA* 1991, 137–40. For briefer accounts of the Nereid Monument, with additional bibl., see, e.g., Demargne 1990; Fedak 1990, 66–68; Stewart 1990, 171–72, figs. 468–74; Todisco 1993, 29–32, 55–56, figs. 5–6, 20, pls. 66–71; Boardman 1995, 190–91, figs. 218.1–16. The comments by Bruns-Özgan 1987, 35–52, were written before the appearance of Childs and Demargne 1989.

For additional information about Arbinas, an inscription in his honor, and his dedication of a statue to Leto at the Lykian Letoon, see, most recently, H. Metzger et al., *Fouilles de Xanthos* 9 (Paris 1992) 155–87, with a dynastic stemma on p. 174.

4. Coupel and Demargne 1969; the location of the monument is described on pp. 27–28; it was included within the city walls only during the Hellenistic period. See reviews of the publication by R. Martin, *RA* 1971, 327–37 (who minimizes the Erechtheion influence and would rather stress connections with Building G on the Xanthian akropolis, standing on a terrace decorated by a figured frieze and topped by statues of peplophoroi), and by G. Roux, *REG* 88 (1975) 182–89 (who emphasizes a possible Bassai derivation for the four-sided corner capital, and Peloponnesian ties in general); see also Childs and Demargne 1989, 3. The structure served probably as a family chapel. The main chamber, in the "cella" atop the podium, contained marble klinai, fragments of which have been recovered; a possible burial chamber within the podium itself has been postulated on relatively scant evidence.

For the pervasive influence of the Erechtheion forms on buildings of the western satrapies of the Persian empire, see Stucky 1991, 471 and n. 36; cf. the base and anthemion necking of a column from a temple at Sidon, p. 473, figs. 11–12.

5. For convenience' sake, cf. Ridgway 1993, figured architraves: 389, 408–9 n. 9.24 (Didyma); friezes around cella walls: 384 (Myus), 390 (Samos), 404 n. 9.15.

6. W. A. P. Childs kindly tells me that the location of the four(?) lions was never fully resolved, and that positioning on the roof slope, two on either side, could also be envisioned, on possible analogy with the (later) arrangement on the Maussolleion. For illustration, see, e.g., Boardman 1995, fig. 218.2.

7. Tancke 1989, 12–14, section 2.1.1, cat. no. 1, p. 228, pl. 9.1 (head); Coupel and Demargne 1969, 93–98 and fig. 1 on p. 95 (floral ornament).

8. Childs and Demargne 1989, 257. Most of the sculptures from the Nereid Monument are in the British Museum, London; hence block inventory numbers are preceded by the notation BM. Some fragments are, however, in the Antalya Museum and at Xanthos itself. We shall refer to the various pieces according to the Childs and Demargne publication, using

Architectural Sculpture in the East (Non-Greek)

their suggested sequence of blocks, which in some cases differs from the present installation in the British Museum but is based on a thorough reevaluation of findspots and previous notations. Inventory numbers and plates refer equally to this official source, from which all our information is derived unless otherwise specified or supplemented; Arabic numbers refer to photographs, Roman numerals to line drawings.

9. City with funerary monument: BM 877, pls. 60, XXXIII. City on rough terrain (or river? my suggestion): BM 876L, pls. 65.2, XXXVII. Woman in distress: BM 869, pls. 48.1, 49.1, XXVI. Warriors sallying forth with stones: BM 869, pl. 48.3 (cf. Boardman 1995, fig. 218.12; see also 218.13–14). Warriors in court, siege mound, horse, tree: BM 878, pls. 52–53, XXVIII.

10. Childs and Demargne 1989, 266–67, for identification of sequence of events and of Dynast. Dynast being crowned in battle: BM 868C, pls. 65.1, XXXVI. Dynast under parasol: BM 879, pls. 57.2–59, XXXII (cf. Boardman 1995, fig. 218.11); the detail of the costume is most visible on pl. 59.1–2. Note that Demargne 1990, 67, repeats the official version of the interpretation, but the catalogue entry for slab BM 879 (no. 55, p. 167), by A. Dinstl (as per initials), follows the German theory that sees the Persian Great King, Artaxerxes II, in the ruler under the parasol; cf. also p. 166, no. 54.

On continuous narrative, see infra, Chapter 6 and n. 13.

11. For illustrations of **frieze 3**, see Childs and Demargne 1989, pls. 115–29, and the helpful line drawings of pls. LXXXVII–LXXXVIII; also Boardman 1995, figs. 218.8–10. The iconographic meaning of **friezes 3** and **4** is discussed by Demargne, pp. 279–91. He treats the two sequences as separate, however, and in **frieze 3**, does not seem to find significant the recurrence of the riderless horse on the west side, explaining it rather as one more offering together with the clothing (p. 282).

12. Childs and Demargne 1989, pls. 130–34, with detail of the Dynast (BM 903) on pl. 133, and of the other singleton (BM 902) on pl. 134.3; this latter personage is the only one to have a table in front of his kline. Perhaps significant is the reclining man with bare torso, contrasting with the tunics of the other banqueters: BM 898, personage no. 6; the servant in chiton and himation in front of him has tentatively been called female, but seems male to me, albeit in Greek costume as contrasted with the Oriental attire of the other attendants: pl. 130.3 (cf. Boardman 1995, fig. 218.8). Line drawings of all four sides of **frieze 4** are given on pl. LXXXIX.

Assos architrave frieze: see, e.g., Boardman 1978, fig. 216.2.

13. Sacrifice scene: Boardman 1995, fig. 218.9. Both corner blocks are shown on pl. 139. For the suggestions of heroization mentioned infra, see Childs and Demargne 1989, 287.

14. These comments are derived from the interpretation of **frieze 1** provided by Childs, in Childs and Demargne 1989, 257–63; see especially p. 258 for a table itemizing the iconographic schemata present in Greek and Asia Minor architectural sculpture during the 5th and 4th cs. For comments on the three Persians, see p. 259; for the long hair of the Lykians, p. 260. Rider with lion helmet: BM 850L, pls. 24.2, 25.1 (west side). Bearded warrior spearing fallen man: BM 854L, pl. 30.1–2 (west side). Warrior with Persian tiara (Dynast? cf. p. 262): BM 853, pl. 29 (west side). Warrior with ram's head cheekpieces: BM 860L, pl. 9 (east side). Warrior with Lykian curls and Venus rings: BM 858, pl. 16 (south side; cf. Boardman 1995, fig. 218.16); note that he appears at the center of a pyramidal schema that recalls the battering of Kaineus on the Bassai frieze, but the current impression is misleading, since a fourth warrior, poorly preserved, is also part of the composition.

Architectural Sculpture in the East (Non-Greek)

15. Pediments: Childs and Demargne 1989, pls. 140–46, LXVII–LXVIII; Boardman 1995, figs. 218.6–7. On the cult of Achilles and the island of Leuke (White Island), often equated with the Isles of the Blest, see most recently Hedreen 1991, esp. 320.

16. I am indebted to W. A. P. Childs for the suggestion that the intercolumnar statues were initially meant to go all around the building (as could be inferred from the probable beginning of a socket for a sculpture at the SW corner), but were not completed. That what was available was arranged on the two short sides and the north long one may imply particular importance for the north terrace.

17. Childs and Demargne 1989, Nereids: 119–37 (catalogue), 167–69 (location), 270–77 (iconography), pls. 78–111.4, XLI–XLIII; cf. Boardman 1995, figs. 218.4–5. Associated statues: 183–85 (catalogue), 277–79 (iconography), pls. 112 (BM 940, male), 113–14.1, 3 (BM 942, female; note that pl. 113.1 has been printed reversed). Aphrodite: see, e.g., Agora S 1882, *LIMC* 2, s.v. Aphrodite, no. 162, pl. 19; Stewart 1990, fig. 425.

18. On this subject, read the perceptive comments by Borbein 1973, 108–13. Regrettably, none of the Nereids has preserved her head. For additional stylistic comments, see also Ridgway 1981a, 225 and figs. 142–44.

19. Childs and Demargne 1989: 223–27, pls. 147–49, LXXVI, LXXVIII (central akroteria, BM 926, BM 927); 227–31, pls. 150–52, LXIX, LXXVI, LXXVIII (lateral akroteria; note that BM 919 is illustrated on pl. 151, and BM 922 on pl. 150, rather than vice versa, as indicated); 297–306 (iconographic interpretation). See also Boardman 1995, fig. 218.3. Objections to the reconstruction have been raised by both Marcadé (supra, n. 3) 140 n. 2, and Harrison 1992.

20. See, e.g., *LIMC* 6, s.v. Meleagros, pp. 414–15, and cf. *LIMC* 1, s.v. Althaia, no. 4, pl. 436, for the South Italian krater. A version known to Homer and Hesiod has Meleager killed by Apollo, which is, however, not attested iconographically until the Roman period (nos. 139–43). Imperial sarcophagi (nos. 150–55) also show Meleager on his deathbed, with a woman supporting his head, but the youth of the Xanthian akroterion seems alive.

21. See Childs and Demargne 1989, 353–54 and n. 54, with reference to the German definition and comments. "Generic style," although helpful, does not convey the meaning of appropriateness to specific location implied by the German term. The definition was first applied by Hiller 1960 to the socle frieze (hunt scenes) on the Sarcophagus of the Mourning Women from Sidon, but Fleischer 1983, 33, prefers the term *Ornamentaler Stil* and dates the inception of the genre, at the earliest, to 375; he also believes it to have originated in Asia Minor. On the Sidonian sarcophagi, see infra, Chapter 5.

22. For a definition of "railroad track folds" see Ridgway 1981a, xviii; what I call pincer folds are not normal catenaries modeling the thighs, but a rendering that accompanies full, free-flowing short skirts of figures in motion. The "Lykian wavelet" seems to be an exaggerated and fossilized derivation from the motion folds of sculptures like Figure G from the Parthenon east pediment (see, e.g., Ridgway 1981a, 226 and fig. 23), as indeed most of the above mannerisms can be said to be. That the rendering may have reached Lykia through the Greek islands is suggested, e.g., by a late 5th-c. gravestone in Rhodes depicting a seated woman, on whom, therefore, the suggestion of apparent motion is all the more incongruous: *DOG* 1977, no. 64, pl. 17; Clairmont 1993, cat. no. 1.184, p. 250 (considered Ionic, strongly Atticizing).

For examples of the various renderings on the Nereid Monument friezes, see Childs and Demargne 1989: *railroad track folds*, e.g., pls. 20.1 (BM 859, **frieze 1**), 54.1 (BM 875, **frieze**

Architectural Sculpture in the East (Non-Greek)

2), 119.2 (BM 888, **frieze 3**), 139.2 (BM 898b, **frieze 4**). *Pincer folds on frontal thighs:* e.g., pls. 9 (BM 860L), 20.1 (BM 859, **frieze 1**), 65.1 (BM 868C, **frieze 2**), 125.3 (BM 895, **frieze 3**), 133.1 (BM 903, **frieze 4**). *Lykian wavelet:* e.g., pls. 18 (BM 851), 46.1 (BM 860C, **frieze 1**), 43.1 (BM 882), 46.1 (BM 868L, **frieze 2**), 128.1 (BM 893), 129.1 (BM 886, **frieze 3**), 131.1 (BM 899, **frieze 4**).

23. Kos relief: *LIMC* 3, s.v. Charis/Charites, no. 24, pl. 153; Ridgway 1981a, 144; Childs and Demargne 1989, 387 and n. 93 with bibl., pl. 160.2. Stumbling horse, at Xanthos, BM 861, pls. 31, XV (north side); on Nike Temple, block f (south side): e.g., Harrison 1972, pl. 75.9, who suggests inspiration from the painting of the Battle of Marathon and makes the comparison with the Nereid Monument block, her pl. 76.10. If a painting is in fact behind the rendering, the idea of a pattern book is perhaps strengthened. For motifs derived from Greek monuments, cf. Childs and Demargne 1989, 258. Agora Nike S 312: Ridgway 1981a, fig. 37; Childs and Demargne 1989, 395–96. Nike of Paionios: Ridgway 1981a, fig. 84. The stylistic definition of the east pediment is by Demargne, in Childs and Demargne 1989, 365. The heads from Halikarnassos and Priene are discussed infra, Chapter 4. Motya Youth: Stewart 1990, 148, figs. 297–98 (= Boardman 1995, fig. 187); its Punic findspot continues to suggest, to me, a possible Phoenician subject by the hand of a Greek/Sicilian sculptor; for comparisons on the Nereid Monument, see, e.g., **frieze 1**, south side, BM 858 (pl. 16.1), BM 851 (pl. 18.1).

24. For technical details, see Childs and Demargne 1989, 315–19, especially the comments on the second workshop, M II, and its silhouette relief. On the so-called cookie-cutter technique as an East Greek approach since the Archaic period, see Ridgway 1993, e.g., 385 and passim (refs. in index, s.v. technique).

25. See, e.g., Childs and Demargne 1989, 263 n. 43, where the comparison with the Athenian Theseion is attributed to Homer A. Thompson (*Hesperia* 35 [1966] 42, 47 n. 8). For the suggestion of Greek patterns, perhaps even in clay or plaster, but probably as drawings, see Bruns-Özgan 1987, and her extensive discussion of the Heroon, pp. 56–81; cf. Ridgway 1981a, 9–10.

26. Still important, especially for its extensive drawings, is the book by Benndorf and Niemann 1889; most of the drawings are repeated in *EAA Suppl.: Atlante dei complessi figurati* (Rome 1973) pls. 268–75. Photographs are published by Eichler 1950. For shorter, condensed accounts, see Noll 1971; Oberleitner 1990 and 1994 (the latter with excellent color ills.); Stewart 1990, 171–72 and fig. 475; Boardman 1995, 191–92, figs. 222.1–11.

27. See the reconstruction drawing of the inner SE corner in Oberleitner 1990, 74 fig. 31 (after Benndorf and Niemann 1889), and cf. the model (p. 155, including the sarcophagus of Dereimis and Aischylos), and the plan (p. 157). Note that the precinct is not exactly rectangular, that the doorway is not centered within the south wall, and that the dynastic tomb is set obliquely within the temenos and equally off-center, perhaps to be visible through the doorway from the outside. It would have towered above the surrounding walls because of its much greater height. It has been suggested (Oberleitner 1990, 73) that only the descendants of the hero could have entered the precinct, and that the outer decoration of the entrance wall was "for the common folks."

28. This interpretation is advanced in Noll 1971, 4, and Oberleitner 1990, 76 and 156–57; the intentional pairing of subjects to be discussed infra is mentioned by the latter. The appar-

ent youthfulness of the warrior in the chariot seems surprising in a depiction of the ruler, but Lykians may have been more seldom bearded than Greeks. For the scene of Bellerophon and the Chimaira, see, e.g., *LIMC* 7, s.v. Pegasos, no. 203, pl. 166; Boardman 1995, fig. 222.3.

29. The scenes mentioned are distributed as follows ([a] indicates the upper, [b] the lower frieze, [a/b] the extension of one subject across both levels; inner surfaces are always meant unless otherwise indicated): *Amazonomachies:* (a) outer south (west) wall (left of doorway); (a/b) west wall, (last third toward north). *Centauromachies:* (b) outer south (west) wall (including bride being carried off by centaur, defended by Theseus); (b) NE corner, the theme extending over both walls (especially along the east wall, although not entirely preserved. No women appear in this battle). *Hunts:* (b) south (west) wall (Meleager's Hunt, including Atalante and Theseus swinging a club); (a) north wall (second half, to NE corner; boars, bear, panther, deer). *Kidnaping scenes:* (b) south (east) wall (warrior on foot, described supra); (a/b) north wall (first half, from NW corner, Rape of the Leukippidai from wedding feast, with each Dioskouros in a quadriga, and a distyle templelike building with high window and ridgepole antefixes). *Battles in front of besieged towns:* (a) outer south (east) wall (right of doorway; Seven against Thebes; the warrior falling headlong from a scaling ladder could just be a topos of Assyrian relief, but the presence of Amphiaraos' sinking chariot makes him Kapaneus hit by lightning and ensures identification. A veiled bearded figure seated on a rocky elevation [Zeus?] supervises the action); (a/b) west wall (center; Troy? scene to be discussed infra). *Battles by seashore:* (b) outer south (east) wall; (a/b) west wall (first third, from SW corner, four ships, a trophy, several duels). *Deeds of heroes:* (a) east wall (Perseus with the head of Medousa, and various deeds of Theseus: lifting the boulder under which his father had hidden the tokens, Minotaur, an unclear episode) and (a/b) (Theseus at the Isthmus: Skiron, Sinis); (b) south (east) wall (Bellerophon and the Chimaira). The Slaying of the Suitors occurs on the upper level of the south (west) wall (Boardman 1995, figs. 222.7, 10); given the reclining poses, the scene could be taken as a duplication of the banquet with entertainers that occupies the SE corner (a/b). G. R. Edwards points out to me that the vessels on a three-legged table seem to be lekanides, an exclusively Attic shape. The dancing and music-making that accompany the latter in turn might have a pendant in the figures around the interior face of the doorway.

Some thematic overlapping between scenes is also possible; for instance, the centaur dragging off a woman (Hippodameia?) on the outer south (west) wall could also be classified under kidnapings; and Meleager's Hunt could be added to the heroes' deeds, even if Bellerophon's adventure should be considered part of the ruler's symbolism. The complete absence of Herakles remains, however, significant, especially given the relative prominence accorded to Theseus, not a Panhellenic figure.

For a listing of subjects and their distribution, see also Borchhardt 1976, 141–43. According to his interpretation, all scenes on the west wall—the battle near the ships, the city siege, and the Amazonomachy (Achilles and Penthesileia)—take place near Troy; yet the Lykians, like the Amazons, were Troy's allies and should not have emphasized their defeat. *LIMC* 1, s.v. Achilleus (and Penthesileia), does not mention the Trysa west frieze, which is instead listed in the same volume, s.v. Amazones, no. 420, pl. 491, as an "undetermined Amazonomachy" perhaps including Theseus.

30. For a thorough discussion of this Trysa scene, as well as other cities under siege, see

Architectural Sculpture in the East (Non-Greek)

Childs 1978, esp. 31–36. Cf. Boardman 1995, figs. 222.4, 11. G. R. Edwards suggests to me that the city being attacked could be Teuthrania (*Kypria* 1) or other sites in the Troad sacked by the Greeks during their expedition, but the presence of the woman on the walls is difficult to explain.

The depiction of the Seven against Thebes is listed in *LIMC* 1, s.v. Amphiaraos, no. 39, pl. 561, although identification of the seated figure as Zeus is left open; see also *LIMC* 5, s.v. Kapaneus, no. 27, ill. on p. 956, and *LIMC* 7, s.v. Septem, no. 43, ill. on p. 740.

31. Ram sacrifice as military ritual before battle (*sphagion*): *Aspects of Ancient Greece* (Catalogue of a Loan Exhibition, Allentown 1979) 76–77, no. 35 (R. Lacy); a different interpretation, suggesting funerary and hero cult, is given by Schmidt 1975, in connection with a relief in Chalkis stylistically similar to some Trysa renderings; in her list of examples on p. 148, the Trysa scene is no. 1.

32. See the comments by Carroll-Spillecke 1985, 11–13. A more detailed discussion of all block joins (Gschwantler 1993) attributes the convention to the local masonry technique, and points out that treatment varies according to subject, but that style and composition are subordinate to the wall construction, and that only the outer south frieze was planned with special reference to the block courses: cf. the diagram of joins on p. 83. That all trees in pre-Hellenistic times were treated as leafless and dead trunks in both Lykian and Greek art (p. 79) seems to me a more questionable statement (cf., e.g., the Archaic Olive Tree Pediment on the Athenian Akropolis).

33. The criticism (lack of fluidity) is by Childs 1978, 36. On Lykian trapezoidal masonry, see Gschwantler 1993, for additional examples. The earlier tombs and their pictorial decoration have been preliminarily treated by Mellink, *AJA* 74 (1970) 251–53, pls. 59–61; 75 (1971) 246–49, pls. 50–52 (Kızılbel); *AJA* 75 (1971) 250–55, pls. 54–56; 76 (1972) 263–69, pls. 58–60 (Karaburun II). The late Archaic tomb depicts Perseus killing Medousa (from whose body spring Chrysaor and Pegasos), and probably Achilles and Troilos; daily topics include a boar hunt, a boat, and a chariot scene. Full publication is forthcoming. Comparison with Etruscan paintings has been made by Paschinger 1985; iconographic parallels for some of the Trysa figures have also been found on Etruscan relief urns.

34. For a detailed analysis of the Trysa style, together with many close-up photographs and illustrations of parallels, see Childs 1976; although his chronology is partly based on the assumption that styles develop more or less in linear fashion, his basic conclusions seem sound. See also the table of recurrent motifs in Childs and Demargne 1989, 258, which includes Trysa among the comparisons.

For apparent incongruities, see, e.g., the warrior in full armor participating in the Kalydonian Boar Hunt. Of at least five quadrigas depicted on the various friezes, four show the horses' heads in the same positions, obviously after one pattern.

35. The subject is rare even in vase painting, and in sculpture it is primarily known from Etruscan urns: see *LIMC* 6, s.v. Mnesteres II, 631–34, for general commentary and examples; the Trysa scene is no. 14, pl. 372.

36. The main publication is Borchhardt 1976, but see also the more concise account, Borchhardt 1990: a plan of Limyra is shown on p. 14, fig. 13, a view of the terrace with the podium remains on p. 76, fig. 33, and a model of the Heroon on p. 171 (cat. no. 58). A similarly synthetic account is Borchhardt 1993a. See also the comments by Bruns-Özgan

Architectural Sculpture in the East (Non-Greek)

1987, 81–91; Boardman 1995, 191, figs. 222.1–2. Two fragments from the east frieze, found too late to be incorporated in the official monograph, are published in Borchhardt 1993b; see esp. figs. 1–3 on pp. 354–55 for reconstruction drawings. Since the temenos was entered from the east, the frieze on that side was the more important of the two.

On Perikle of Limyra, see Wörrle 1993, who discusses a historical Greek inscription by the "King of the Lykians."

37. For drawings of the extant blocks and reconstructions of the two friezes, see Borchhardt 1976, folding pl. after p. 48 (west), and folding pl. after p. 64 (east). That the two friezes differ has been pointed out by Bruns-Özgan 1987, 85–86. See also Borchhardt 1993b, and supra, n. 36.

38. For chronological comments, see Bruns-Özgan 1987, esp. 90, and her doubts expressed on pp. 82–83. Borchhardt 1976, pl. 60.2–3, juxtaposes the head on the west frieze to the coin; the latter is also illustrated in Borchhardt 1990, 178, nos. 97–98 (catalogued by J. Zahle), and on pp. 11 and 51. Can this head really be a dynastic portrait?

39. This conclusion is also reached by Jacobs 1987, 71–73, who reviews this controversial issue; to my arguments, he adds that Artaxerxes III would not have been shown beardless. Subordination to the Persian king would be particularly surprising in Perikle's Heroon/monument, in that the Dynast was strongly anti-Persian and spearheaded the movement of rebellion: see Bryce 1986, 111–14. See also Childs and Demargne 1989, 264–66.

40. Tinted cast: Borchhardt 1990, 169, no. 57. "Phalanx" of troops, west side: Borchhardt 1976, pl. 20. Somewhat the same staggered rendering is exhibited by the mounted figures of the center, but note that the corresponding block on the east side (Borchhardt 1976, pl. 26; color photograph in Borchhardt 1990, 77, fig. 35) shows an almost isocephalic arrangement, with faces strictly in profile, as contrasted with the three-quarters ones on the west. For details of the eyes, see Borchhardt 1976, pl. 22.

Roman historical reliefs with "disembodied heads"; see, e.g., D. E. Strong, *Roman Imperial Sculpture* (London 1961) pls. 35 (Ara Pacis), 51 (Vicomagistri relief), 60 (Arch of Titus), 74 (one of many possible examples from the Column of Trajan).

41. This legend, based on the resemblance of the names, may have been the reason for the choice of subjects; but if political motivations are to be sought, we may recall that Medousa in Greek means "female ruler." Her beheading could theoretically allude to the Satraps' Revolt. More probably, however, the akroterion had primarily an apotropaic function, as common for representations of the myth.

Perseus: *LIMC* 4, s.v. Gorgo, Gorgones, no. 318, pl. 185 (= *LIMC* 7, s.v. Perseus, no. 150); see also the colored photographs in Borchhardt 1990: 77, fig. 36 (head); p. 140, no. 31 (entire akroterion); p. 128, no. 12 shows the one surviving lateral akroterion, Medousa's sister. See also p. 75, fig. 32, and p. 171, no. 58, for models of Bellerophon and the set of southern akroteria. Note that the central akroteria are in marble, the lateral ones in limestone.

42. Limyra Karyatids: see colored photographs in Borchhardt 1990, 76, fig. 34; p. 127, no. 10; and the model of the Heroon on p. 171. See also Schmidt 1982, 84–87, pls. 15–17, who stresses the different appearance of the Erechtheion Korai and doubts the interpretation as Horai and Charites. The respective *LIMC* entries do not in fact include the Limyra Karyatids, and the commentary s.v. Charis/Charites, *LIMC* 3, p. 202, suggests that phialai are appropriate to Nymphs but not to the Graces.

Architectural Sculpture in the East (Non-Greek)

Most recently, on the Throne at Amyklai, see Faustoferri 1993, who, however, interprets the sculptural program of the structure in terms of the early myths of Sparta, the foundation of its power, and its connections with Boiotia (see her diagram, fig. 1 on p. 160). Yet there is no doubt that the myths at Limyra had Anatolian meaning and Eastern traits.

43. On the Hellenistic temple, see, most recently, Rumscheid 1994, vol. 1, 24; vol. 2, 34–35, no. 126; and cf. no. 127 on p. 35. See also H. Metzger et al., *Fouilles de Xanthos* 9 (Paris 1992).

44. On the androne, see Hellström and Thieme 1981; Maussollos' dedication for Andron B: p. 64; Idrieus' dedication, p. 72; comments on the early mixture of Doric and Ionic, pp. 59, 74. For suggested dates, see Hellström and Thieme 1982, 46. For a more recent reference, with additional bibl., see Rumscheid 1994, vol. 1, 21–22; vol. 2, 31–32, nos. 116 (Andron A) and 117 (Andron B); Gunter 1995, 16–17.

45. Bearded sphinx akroteria of Andron B: Hellström and Thieme 1981, 68 and fig. 17; triglyph with pierced "ears" of Andron A: p. 73 and fig. 25. Gunter 1989, 92–94, mentions an eagle's head that may go with the bearded sphinxes, but she would entertain the suggestion (mentioned in "Discussion," p. 98) that the sphinxes may have flanked an altar at the eastern end of the terrace. Gunter 1995, 21–30, cat. nos. 2–3, returns to the akroterial identification; see also her cat. no. 11, pp. 37–38, for the eagle's head. Full publication of the temple, which represents an enlargement of an original building in antis, is by Hellström and Thieme 1982; possible pedimental decoration in metal, p. 36; marble lateral akroterion, p. 38 and fig. 11 on p. 37; Gunter 1995, 13–16, 35–36, cat. no. 8, and cf. cat. no. 9. See also Rumscheid 1994, vol. 2, no. 115.

Three fragments of bearded heads from Sidon have also been identified as sphinxes, thus suggesting artistic links between Karia and Phoenicia; see Stucky 1988, figs. 1–5 (drawings), pls. 36–37; Stucky 1991, 472, fig. 13.

46. See, e.g., Childs and Demargne 1989, 262 and n. 41.

47. G. Rodenwaldt, "Griechische Reliefs in Lykien," *SBBerl* 1933, 1028–55; the entire quotation reads: "Als stärker erweist sich, wenn beide Elemente in dem gleichen Werk zusammentreffen, am Orient der Gedanke, an der Antike die Gestalt."

CHAPTER 4

Architectural Sculpture in the East (Greek)

On February 6, 1991, at a colloquium at the Center for Advanced Study in the Visual Arts (Washington, D.C.), Lothar Ledderose presented his research on Mao Zedong's Mausoleum in Beijing. He pointed out how the planners placed the structure on the main axis of the city—a "spine" that runs also through the imperial palace—thus trying to give new meaning to the urban plan while enhancing the prestige of the leader's tomb through the use of past formulas. As prototypes, they used both Lenin's mausoleum in Moscow and the Lincoln Memorial in Washington, D.C., thus combining two different building types in a unique fusion that the speaker attributed to the indigenous Chinese tradition of imperial tombs. The Beijing monument, erected in record time within one year, also contained Mao's mummy (again, like Lenin's mausoleum) and his statue in marble (like the Lincoln Memorial). Ledderose added, however, that the planners of the Chinese mausoleum chose only those western elements which would be understandable within their own culture, the mummification of religious leaders in China being "traditionally taken to demonstrate that they had reached their spiritual goal in this world."[1]

It may seem irrelevant to use a virtually contemporary monument (Mao died in 1976) in a preface to a discussion of the tomb of Maussollos, the Karian ruler who died in 353 B.C. Yet the basic aspirations, solutions, and formulas are all similar: from the influence on the urban plan, to the imperialistic allusions, the combination of different architectural prototypes, and the grounding on local, and therefore locally meaningful, traditions. It is almost unnecessary to point out the use of the term "mausoleum" to connote any grandiose burial structure after the Karian prototype; this latter will instead be cited as "Maussolleion," better to conform to the inscriptional evidence for native spelling.

Famous in antiquity as one of the Seven Wonders of the World, Maussollos' tomb in Karian Halikarnassos has been equally famous in modern times because of its specific mention and description in two of the most influential ancient sources:

Architectural Sculpture in the East (Greek)

Pliny (*NH* 36.30–31) and Vitruvius (*de Arch.* 7.praef.12–13). Many theoretical reconstructions were based on these literary references, especially after the site was excavated by the British in 1856, with the consequent removal of many sculptures to the British Museum; but investigations have taken renewed impetus from the more systematic exploration by Danish archaeologists from 1966 to 1977. Results and new conjectures are being systematically published, both in periodic reports and in a special monographic series. The British Museum has also undertaken a modern presentation of the sculptures, which is still in progress. The last word has therefore yet to be spoken, and no complete agreement exists at present on matters of details; yet great strides have been made toward a complete understanding of the monument, both in its architectural form and in its sculptural embellishment. In particular, it has become clear that the structure has strong affinities with contemporary Karian and East Greek buildings, so that it can no longer be considered in isolation. The scholarly literature on the Maussolleion is vast,[2] and we shall therefore limit our comments to matters of substance—what can be known for sure *now*—rather than trying to settle points of disagreement or provide different reconstructions.

THE HALIKARNASSOS MAUSSOLLEION

The basic historical facts are fairly clear. In 377 Maussollos inherited the satrapy of Karia from his father, Hekatomnos; he was still a subject of the Great King, but around 362 he joined the Satraps' Revolt against him. Yet, by the time the turmoil ended, Maussollos had shifted allegiance, and therefore received additional powers, such as control over the Lykian cities. He also encouraged the revolt of Rhodes, Kos, and Chios against Athens (in 357), and thus exercised a strong influence over those islands. He was equally active in internal affairs. He moved the capital from Mylasa to Halikarnassos, which he enlarged through the *synoikismos* (the fusing together) of six Lelegian cities (Strab. 13.1.59). The new capital was given a new layout, probably by 362 at the latest. Although the site was previously inhabited, this new systematic planning virtually made Maussollos the second founder of the city. He also greatly embellished the powerful Karian sanctuary at Labraunda, not only donating an andron and perhaps other structures, but also initiating the enlargement and renovation of the Temple of Zeus, which was then completed by his brother Idrieus. Maussollos married his sister Artemisia, who succeeded him at his death in 353. When she also died, in 351, the next two siblings, who had also intermarried, Ada and Idrieus, took over, and continued their predecessors' policy of support to Greek cities and sanctuaries, thus receiving many honors.[3] Idrieus died in 344, and Ada saw her power usurped by the youngest Hekatomnid, her brother Pixodaros, in 340. She, however, in 334 adopted Alexander the Great, thus giving him official entry into a large part of Asia Minor; he in turn restored her rule, which was eventually supplanted by total Macedonian control. Several points of importance for the Maussolleion can be derived from this basic information.

Architectural Sculpture in the East (Greek)

The Site

According to Pliny, the splendid tomb of Maussollos was started by his devoted wife/sister Artemisia after his death, therefore after 353; it was still unfinished when Artemisia died as well, but it was completed because of the commitment of the participating Greek sculptors, who "were already of the opinion that it would be a memorial to their own glory and that of their profession." This account was taken literally, and the main disputed point in the scholarly literature was whether the Halikarnassos or the Tegea project was the earlier, since the stele with Ada, Idrieus, and Zeus Labraundos, found at the latter site, proved the connection between the two.

This issue of precedence has now been put to rest. The location of the Maussolleion within the ancient city shows clearly that the site was selected with care, not only in the virtual center of Halikarnassos, but also at the western end of the agora, whence the Maussolleion terrace was accessible through a flight of steps and a small propylon.[4] The tomb of the ruler was thus virtually equated with that of a hero *ktistes*, like Battus of Cyrene or other founders who were honored by burial in the agoras of their respective cities. We may even see a remote allusion to Herakles, the Greek hero from whom Maussollos claimed descent through a fictitious stemma of his family, since not only North Syrian, but other Eastern, and even Latin, cults connected Herakles/Melkart with the marketplace.[5] To be sure, the specific site had been previously used for other important burials, but the Maussolleion superseded all earlier purposes and became rather the Heroon of the Hekatomnid dynasty, and specifically of Maussollos. Its architecture, in fact, harked back to such buildings as the Nereid Monument at Xanthos, and, as we shall see, so did its sculptural program. Another Greek hero eulogized by the architectural decoration was Theseus, who was traditionally held as the synoikist of Attika, once again with possible allusion to his Karian counterpart.

Such mythological speculation may suffer from modern overinterpretation. There is no denying, however, that the Danish excavators, in clearing the rock-cut remains of the funerary chamber, below ground level, found extensive evidence for a ritual meal/sacrifice that would again support the theory of special honors.[6] In addition, the very fact that the vast precinct occupied a pivotal position within the urban layout shows that its presence had been envisioned from the beginning, and thus from the late 360s. In emphasizing Artemisia's devotion to her husband, whom she wanted honored by such a spectacular monument, Pliny was following the traditional Roman concept of the noble wife committed to extraordinary acts of mourning in memory of her deceased spouse.[7] In reality, Maussollos, like many an Oriental ruler, must have planned the building himself, although he could not see it completed. Probably neither did Artemisia. But it is important to stress that Pliny's account cannot be taken as a deliberate, and accurate, chronological indication.

Although Jeppesen has been instrumental in dispelling earlier notions, the element of need for a speedy completion still infiltrates some of his writings. He has

Architectural Sculpture in the East (Greek)

in fact suggested (1992, 87) that the famous Greek sculptors called upon to decorate the Maussolleion may have competed among themselves not only for artistic excellence but also for the fulfillment of their task in the shortest time. Yet a span of approximately two decades (c. 360–340) would seem adequate time, especially considering the number of workmen who were involved in the project.

The Building

Every reconstruction of the Maussolleion has followed the ancient sources, specifically Pliny, who described a rectangular plan (Ill. 16) and a colonnade surmounted by a pyramid, in its turn topped by a marble quadriga. This basic information can now be confirmed *in situ* and through the various architectural members recovered during different campaigns, including those "quarried" from 1494 to 1522 by the Knights of St. John, who reused them in the Castle of St. Peter, at the entrance to the harbor.

Above the underground funerary chamber stood a high tufa podium revetted in alternating sections of white (Asiatic) marble and dark limestone, each higher one set back in relation to the one below, thus forming a stepped arrangement. It is still uncertain how many steps existed, and how high; Jeppesen and Waywell disagree in their reconstructions (Ills. 17a–b, 18a–c) but their calculations are based primarily on the distribution onto the resulting ledges of the extant statuary in the round, which they classify differently by size, as we shall discuss below. The top of the podium was embellished by a sculptured frieze depicting an Amazonomachy, which is the best preserved of the three from the monument. It stood just below the stylobate, which supported an Ionic colonnade (9 × 11) resting on Asiatic (Ephesian) bases in turn overlying dark limestone plinths. The entablature followed the Asiatic system as well: it had three fasciae, and was topped by dentils and a sima with lion-head waterspouts; it certainly did not include a continuous, carved frieze, as was originally supposed. The marble ceiling of the pteron had coffers carved with figured scenes. The roof consisted of a marble pyramid[8] whose top step created a platform for a colossal marble chariot, fragments of which have been recovered, as well as of its horses with their metal harness. The step/base for the quadriga was decorated all around with a Centauromachy frieze. Another frieze, depicting a chariot race, probably ran at the top of the cella wall, although the presence of a room within the colonnade is still debated. It is also unclear whether such a cella, if it existed, had a stepped wall, to accommodate a series of additional statues. We can be fairly confident, however, that the many lions attested by fragments from the site stood on the steps of the pyramid—not only at the edge of the roof, but, according to Jeppesen, probably also at higher levels. Akroterial groups at the four corners of the roof have also been suggested.

This particular form of heroon derives from different architectural prototypes. It has been argued that a tradition of stepped pyramids (aristocratic burials?) existed

Architectural Sculpture in the East (Greek)

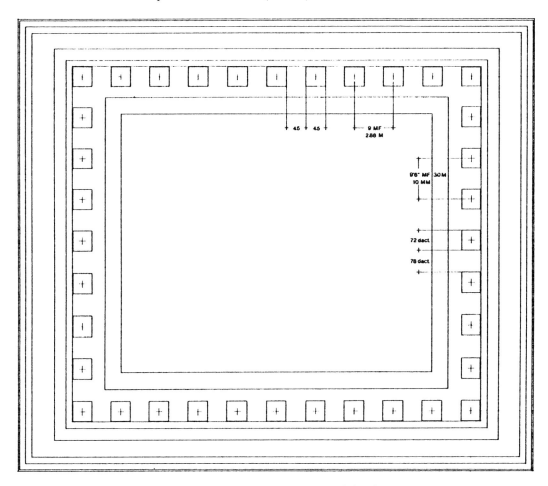

Ill. 16. Halikarnassos, Maussolleion, groundplan (by K. Jeppesen)

since the sixth century, not only in Karia but in Anatolia as a whole. Persian precedents have also been adduced, including a tomb at Taş Kule near Phokaia. The terraced ziggurats of Mesopotamia, as well as the Egyptian stepped pyramids, have also been mentioned. Yet the most immediate comparison, to my mind, remains the Nereid Monument, with its high podium surmounted by carvings, its Ionic colonnade, and its cella. The juxtaposition of dark and light stone recalls Persian and Near Eastern practices, but also, certainly, Attic and Peloponnesian monuments, especially of the fourth century. The closest architectural system, including a possible grid plan for the colonnade, seems, however, to be that of the temples of Athena at Priene and of Zeus at Labraunda, both Hekatomnid projects. The involvement, if not of the same architect, at least of the same workshop, is supported by a

Architectural Sculpture in the East (Greek)

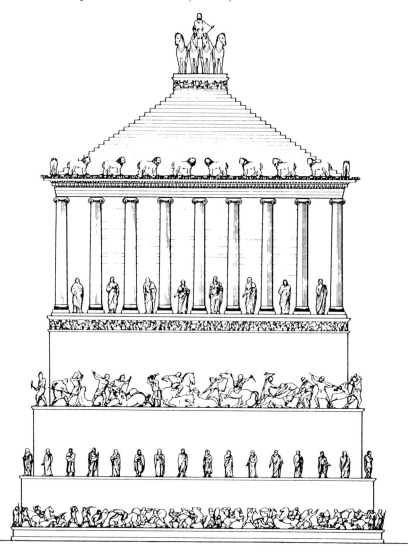

Ills. 17a–b. Halikarnassos, Maussolleion, reconstructions by G. Waywell

number of proportional and decorative details.[9] The virtual contemporaneity of all three monuments is thus confirmed, and remains in striking contrast with the different architectural idiom of the Athenaion at Tegea.

Like the Beijing Mausoleum, therefore, the Halikarnassian one combined funerary, religious, commemorative/heroic, imperial, and traditional features. The very eclecticism of the tomb finds parallels in Persian programs to convey the idea of Empire (Root 1979). This mixture is also apparent in the decorative schema of the Karian building. One final architectural comment: the templelike, colonnaded ap-

Architectural Sculpture in the East (Greek)

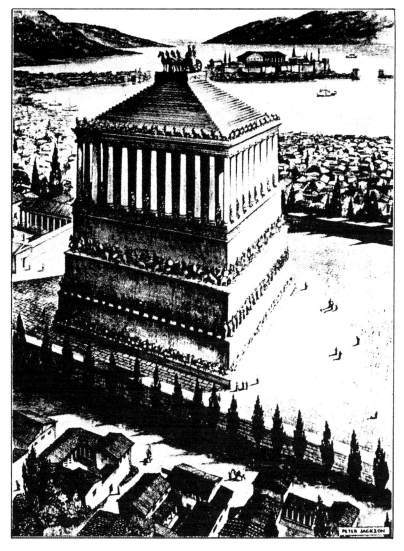

17b.

pearance of the Maussolleion inspired several subsequent funerary structures, like the one at Belevi. Yet we should beware of modern reconstructions that tend to complete the remains with even greater similarity to the precedent than warranted by actual evidence.[10]

The Sculpture
It is now finally acknowledged that it was the amount of sculpture, rather than its artistry or the fame of its markers (*pace* Pliny and Vitruvius), which contributed

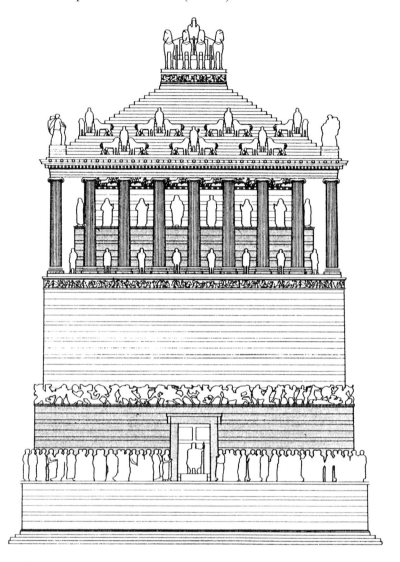

Ill. 18a. Halikarnassos, Maussolleion, east, reconstruction by K. Jeppesen

to make the Maussolleion one of the Seven Wonders of the World. The pyramid apparently floating above the colonnade also excited admiration. But certainly the Latin writers who mention the Halikarnassian structure were already acquainted with Roman Imperial tombs of comparable size, and therefore it was not an issue of magnitude per se.[11] The large quantity of statuary postulated for Hadrian's Mausoleum may imply that this feature of the Karian predecessor was particularly worthy of emulation.

Architectural Sculpture in the East (Greek)

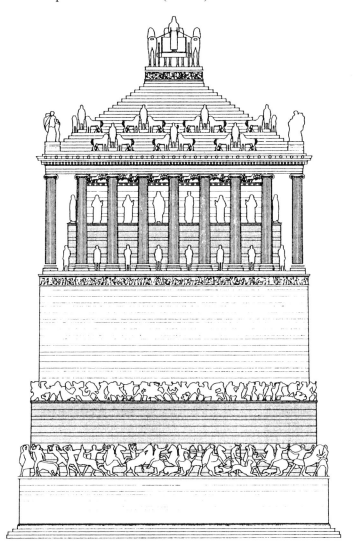

Ill. 18b. Halikarnassos, Maussolleion, west, reconstruction by K. Jeppesen

Three categories of sculpture are represented on the Maussolleion, and three major issues are connected with them. The categories are: (1) the reliefs (Amazonomachy, Centauromachy, Chariot Race friezes; the coffers); (2) the sculptures in the round (on the ledges of the podium and of the cella wall[?], in the peristyle); (3) the roof decoration (corner akroteria, lions, quadriga finial). The main issues are: (a) can the style of the four different masters mentioned by Pliny be recognized in the extant fragments? (b) what is the correct placement of the free-standing sculp-

Architectural Sculpture in the East (Greek)

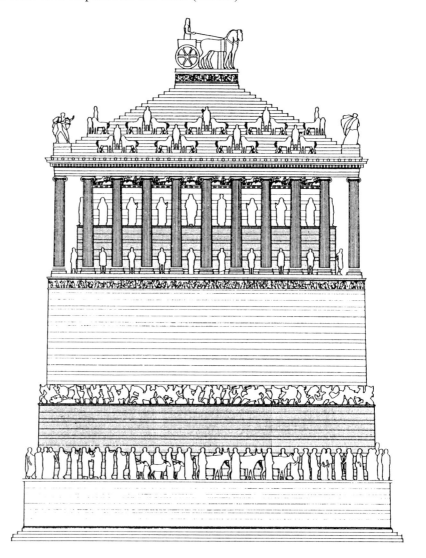

Ill. 18c. Halikarnassos, Maussolleion, south, reconstruction by K. Jeppesen

tures? and (c) was the chariot empty or occupied? Overarching all three is the greater issue of the meaning of the sculptures, which involves their relative importance.

The reliefs
When friezes are mentioned, only one of them is truly meant, because of its greater preservation (over 20 different slabs): the **Amazonomachy**, which, through the fortunate survival of a segment containing the hero, can be identified as that of

Architectural Sculpture in the East (Greek)

Herakles at Themiskyra (Pls. 26–27). Before publication of the sculpture in the round, virtually all attention had been focused on these reliefs, not so much to determine their style and sequence as to "recognize" the hands of the great sculptors said by Pliny to have worked on the Maussolleion: Skopas on the east, Bryaxis on the north, Timotheos on the south, and Leochares on the west side. Vitruvius' version, replacing Timotheos with Praxiteles, was virtually ignored. That this "attribution game" was ultimately too subjective to succeed is shown by the disparity in stylistic readings, as recently tabulated. The problem was compounded by the lack of specific provenance for most of the slabs, usually found reused in later contexts: when in 1969 a new join was discovered between two slabs, it was seen that only one scholar among many had attributed the sequence to the same hand.[12] Side-by-side collaboration is not unthinkable, as shown by the Nike Balustrade, but it is unacceptable on the Maussolleion, if Pliny is to retain his informational value.

Plates 26–27

Slab 1014, which fits neatly in a sequence of several (1013–1015, plus a more recently discovered fragment in Bodrum), has been almost consistently assigned to Skopas because of its alleged findspot on the east side, and because one spinning, seminude Amazon on it recalls the statuette of a maenad in Dresden attributed to the Parian sculptor on stylistic and literary grounds. Yet the maenad's attribution could be challenged, as we shall see in Chapter 7, and the findspot is less secure than it may seem, since the relief and its adjacent slabs were found over a later drain, where they had been reused as covers.[13]

Pliny's use of the verb *caelare* ("to engrave, to carve in relief") to characterize the work of the four great masters had given further incentive to those who saw the Amazonomachy as their main contribution. At present, however, the notion that architectural friezes, like glorified moldings, could be left to the hands of lesser carvers within the masters' workshops is gaining credence. Jeppesen has even found a block belonging to the Chariot frieze inscribed *Apollo*[...] *epo*[iei], obviously the signature of an otherwise unattested sculptor working in that area. He still believes, however, that each named master was active on a single side, thus being responsible for both relief and free-standing sculptures.[14] To this effect, he has suggested an additional emendation to the Plinian passage: *caelavere* and *caelavit* would be replaced by *celebravere* and *excelluit* respectively, thus eliminating a possible connection with the friezes alone and strengthening the more encompassing attribution. These changes, especially the first, which involves considerable restructuring of the ancient sentence, may be unnecessary if Pliny's implication of artistic competition is discounted. It seems to me more reasonable to assume that, given the magnitude of the sculptural and architectural task, those sculptors were summoned to Halikarnassos who already had an established workshop that could provide immediate contribution and ensure supplies and contacts.

To wit: *Timotheos* had been active at the Asklepieion at Epidauros, and was therefore in touch with both workmen and guarantors. If the Maussolleion was in fact

begun much earlier than Pliny suggests, the gap in time between the Epidaurian and the Karian commissions would be minimal, especially if Timotheos, as sculptural similarities make plausible, had continued to work at other Peloponnesian projects. In addition, Vitruvius (2.8.11), who seems uncertain about his sculptors, attributes to him, or to Leochares, an akrolithic statue of Ares at Halikarnassos, which may suggest the master's presence at the site before work on the Maussolleion had started.[15]

Skopas has been considered heavily influenced by Timotheos, and perhaps even trained at Epidauros. We would then need to look no further to explain his participation in the Maussolleion. Yet another, albeit tenuous, possibility exists: that he was already connected with an architectural/sculptural project on Paros, the sanctuary of Hestia, where around 360 a rectangular exedra was changed into an apse to house a statue of the goddess by Skopas later taken to Rome by Tiberius. At any rate, since Skopas was a native of the Kykladic island, and since some of the Maussolleion sculptures in the round are in Parian marble, he might have been recruited for the project on the basis of his home ties. It seems now fairly well established that the Tegean project is later than the Karian; other works attributed by the ancient sources to Skopas in Asia Minor and vicinity (at Knidos, at Ephesos, at Chryse in the Troad, and at Samothrake)[16] may be either later or earlier and serve simply to strengthen the plausibility of his involvement in the area, but rest on somewhat flimsy evidence without true archaeological support.

Leochares and *Bryaxis* are more difficult to connect with established workshops, especially the latter, who probably needs to be distinguished from the homonymous master who worked for the Seleukids and Ptolemies. The one involved with the Maussolleion seems to have been an Athenian about whom little is known, although the possibility exists that he was a Karian, given his unusual name. As for Leochares, he was certainly an Athenian, and may have provided the link for the importation of Pentelic marble, from which some of the free-standing sculptures are made. He may have been already available at the site, if he was the one who made the Halikarnassian Ares, as mentioned above; otherwise, he seems to have worked primarily in Athens, except for two highly important commissions—at Olympia (the chryselephantine portraits for the Philippeion) and Delphi (Krateros' Hunt with Alexander).[17] Yet two other masters' names are connected with the Maussolleion and deserve special attention.

Pytheos and *Satyros* are cited by Vitruvius as authors of a book on the Maussolleion, and the first man also as having written one on the Athenaion at Priene. Pliny mentions that the quadriga topping the Maussolleion was by him. Although each text gives different spellings of the name, it seems evident that a single person was intended, both sculptor and architect, as was the case for Skopas. Satyros may have been primarily a sculptor, but his involvement in the Maussolleion treatise suggests some architectural expertise as well. Significantly, Satyros was from Paros, and

Architectural Sculpture in the East (Greek)

Pytheos from Priene. On the island, whether or not Skopas was active there, at least two Doric temples (the Apollonion and the one at Marmara) and one Ionic sanctuary (of Hestia) were constructed during the first half of the fourth century. The refounding of both Priene and Halikarnassos, together with the extensive building activity at Labraunda, as well as the similarity already mentioned among structures at the three Asia Minor sites, speaks strongly in favor of either or both masters having had contacts with local manpower and workshops. Their role with the Hekatomnids is undisputed, on the evidence of inscribed bases and architectural details. It seems therefore natural that they would be called to collaborate at the Maussolleion, each perhaps contacting the sculptors and workshops with whom he was acquainted.[18] The spectacular impression the finished monument made on the ancient viewers was undoubtedly responsible, *post factum,* for the fame that accrued to the four sculptors' names most identifiable by the Roman sources; but no initial selection on the grounds of established reputation and artistry was involved, I believe, nor was there a matter of allotment per side. Although different hands may be suspected on the extant slabs of the Amazonomachy frieze, the conception appears unified and coherent. The whole vast sculptural program around the Maussolleion should therefore be visualized as a choral enterprise comparable to that of the Parthenon and, eventually, of the Pergamon Altar.

This statement seems especially valid when the **Centauromachy** frieze is considered. Its heavy weathering, fragmentary preservation, and heavy base molding with deep overhang (cavetto or cyma recta below fascia) have suggested a placement around the base for the crowning quadriga. It is hard to dispute the excavator's reasoning, but it is still tempting to visualize the Chariot Race frieze below the great marble chariot itself, almost like a time-frame depiction of its motion culminating in the final stillness.

Be that as it may, the Centauromachy is the frieze that will profit most from complete presentation, since the few published photographs make it look quite different from the Amazonomachy. If style could be safely translated into chronological terms (an especially dangerous assumption at the Maussolleion, as we shall see below), the elongated figures of this narrative would be considered almost 200 years later—an impossible proposition. We note that women are present at the fray, as well as long-haired youths, and at least one human torso is preserved to sufficient length to reveal the humped junction with the horse's rump of a centaur.[19] The complete absence of landscape does not help to localize the event, which may have here turned into pure pattern, especially considering the height at which the frieze stood and its distance from the viewers.

The **Chariot Race** frieze has been assigned to the outside of the cella wall, where it would have been hardly visible, especially if further blocked from view by statues standing between the columns and on a ledge of the wall itself, as Jeppesen suggests. Yet, of all the subjects, this is the one that most closely resembles a glorified mold-

ing, with the same motif repeated endlessly in sequence like the rolling of a cylinder seal. The idea itself goes back to the Archaic period and to some of the earliest decorated architectural terracottas, especially at home in Anatolia, albeit on religious buildings. But the meaning at Halikarnassos may have been more specific. Note that the charioteers are youthful, beardless, with intense eyes, long hair, and elongated bodies rendered even more emphatic by the sinuous movement of the long robes flying behind them.[20]

Finally, **the coffers**. Of the original 36 panels, only 24 fragments are preserved, and only 10 are even vaguely legible. The most extensive includes a figure seated on a rock, one leg visible between those of a standing male, which has been reconstructed as Theseus fighting with Skiron. Because two more panels retain parts of kneeling draped figures believed to be Amazons, and another may show the curve of a shield, usually not carried by the Athenian hero, the Deeds of Herakles have been postulated as counterpart to those of Theseus.[21] Not much can be said about pieces of legs and feet, or the top of a spear(?), except that the general quality of carving is inferior to that of the friezes: toes are not indicated, and calf muscles have no definition, possibly because of the limited visibility of such decoration.

The sculptures in the round
The evidence for the placement of statues on ledges of the podium has greatly advanced our understanding of the total monument. Although the basic architectural form could still be considered tripartite—the tall base, the colonnade, the crowning pyramid—strong horizontal accents created both by differently colored stones and by the high steps would have articulated the podium to great effect. In agreement with this apparent modular planning in sets of three, Waywell separated all freestanding sculpture into three classes, according to their size. The smallest figures are lifesize (c. 1.80 m.), the next "heroic" (c. 2.40 m. in height), and those of the third group colossal (between 2.70 and 3 m.). Newton's excavation notes show that the largest number of statuary finds was made in an area beyond the peribolos wall, over which the sculptures must have toppled from their original position. Among them, there were no lifesize examples. Waywell therefore logically concluded that three tiers existed, the lowest one—nearest to the viewer and to the precinct wall—supporting the lifesize statuary (battle between Greeks and Persians), the next one the heroic (quietly standing or interacting figures in Greek and Oriental dress), and the third one the colossal (hunt, sacrifice). In a later publication, he also considered the possibility that heroic figures could stand on the same step as the lifesize ones, although on different sides of the building. Waywell also tentatively placed colossal figures between the columns, and considered them the ancestors of the Hekatomnids, among them the famous "Maussollos" and "Artemisia" that are the best-preserved human sculptures from the site.

Jeppesen would reconstruct only two ledges to the podium, but would place one

Architectural Sculpture in the East (Greek)

more series of statues on a base around the cella walls, behind those standing between the columns. His totals (approximately 410 single figures of humans and animals, for a minimum of 375) are appreciably higher than Waywell's (approximately 314 or 330), although both scholars include the roof ornaments, to be discussed below. Although initially Jeppesen considered only two size-classes, he seems now to have accepted all three, and has even subdivided Waywell's colossal group into two subgroups: (a) containing the 3 m. tall figures, and (b) containing those 2.70 m. high. In so doing, he has separated "Artemisia" from "Maussollos," although he would place both sets around the cella. He also estimates that 148 colossal statues stood on the lower of the two steps around the podium, and 110 lifesize ones on a blue limestone ledge at the next level.[22] At this time it seems useless to speculate in detail about distribution, and only some basic points should be made.

Three "narrative" subjects seem to be represented among the sculptural fragments: a **hunt**, a **sacrifice**, and a **battle between Greeks and Orientals**, including cavalry. Animal figures from these compositions, besides horses, include a ram, a boar (pig?), a bull, which may belong with the sacrifice (an early *suovetaurilia*?), and then leopards (and a panther?), dogs, and some lions (one perhaps lying down, and a lioness?), which should go with the hunt. Obviously, the three themes recall the Nereid Monument, especially since sacrifice depictions are rare, although a procession of tribute bearers carrying some of the animals as gifts could also be visualized, and would not greatly depart from the Lykian precedent, while echoing also Assyrian and Persian motifs. Among the colossal pieces, a **seated personage** is not only tall (estimated height, if standing, c. 4 m.) but unusually deep—at c. 1.65 m., considerably more than the "Maussollos," for instance (0.68 m.). Jeppesen has therefore suggested that it stood in a special position, perhaps in front of a recessed blind door in the center of the east side, and he would visualize two processional streams of people moving toward this focus, perhaps in an audience scene; the sacrificial animals would appear on the north and south sides, directed toward the front, and the west side would show the hunt.[23] Undoubtedly, this suggestion is influenced by the Parthenon frieze, with its two parallel streams converging toward the "peplos scene," the sacrificial animals on the two long sides, and the gathering of cavalry on the west. But such a quotation would not be amiss on the Maussolleion, whether or not readily perceivable by the Karian subjects. The state of the fragments is such that these suggestions remain within the realm of speculation. Conceivably, however, the seated statue represents Maussollos, especially if given a privileged location on the podium (almost like an Egyptian nobleman in front of the false door of his tomb) and if highlighted by the compositional direction.

Another statue of difficult placement is a lifesize **Oriental squatting cross-legged** like an Egyptian scribe, who probably portrays a servant near his master. At Belevi, a similar albeit standing figure was found in the interior of the podium,

within the burial chamber, indeed like an attendant ready to respond to the requests of the deceased portrayed reclining nearby. But there is no evidence to show that the Halikarnassian piece came from a comparable location. Next to the seated colossus, if the latter in fact stood within a doorway, the servant would look not only small but off-side; and it is hard to visualize him among the Hekatomnid family members of the peristyle. The possibility remains that the piece does not belong to the Maussolleion, as was originally thought, although its motif would fit well within the program.[24]

Certainly related is a colossal **Oriental rider**, wearing tunic and trousers; because of its size, it should belong with the hunt scene, and thus may represent the tomb owner himself. Maussollos would then be shown at different spots within the sculptural program, as was suggested for the Dynast of the Nereid Monument. Yet, given the number of individual statues postulated for the composition, identification of the rider as an attendant or companion cannot be excluded, despite its spectacular appearance.[25] It is well to remember that we tend to give excessive importance to the few preserved sculptures, now that so much evidence has been lost.

Finally, the so-called **Maussollos** and **Artemisia**. These statues attracted the greatest attention since their discovery, not only because of their better preservation, but also because of their impressive drapery and distinctive features—the male with his unusual portrayal of non-Greek traits (Pl. 28), the female, despite her damaged face, with her archaizing hairstyle. So characteristic was the man's physiognomy that it sparked theories on the development of Greek portraiture, assumed to lag behind that of the East, where potentates were used to having their likenesses depicted on their coins, and had needs and aspirations different from those of the democratic Athenians. Today we make a sharper differentiation between portrait and likeness, realism per se and faithful reproduction, type and individual, although agreement is far from consistent.[26] It seems, however, established that neither the tomb owner nor his wife can be represented by the two statues in London, and, if they are ancestral figures, it is unlikely that the fourth-century sculptors could have produced true likenesses.

It was thought at one time that the "Maussollos" stood on the crowning quadriga with his wife at his side, but the idea was dismissed when it was realized that his hands could not have held the reins, and neither could hers. The added improbability of good preservation after a fall from such a high spot served to eliminate the notion. Yet one major issue still remained: were the two statues compatible with a date around 350 or were they considerably later—mid- or even Late Hellenistic?

The suggestion that the Maussolleion sculptures belonged to more than one stylistic phase had been advanced by Buschor (1950), who advocated an interruption in the execution of the work at Artemisia's death, with a resumption some 20 years later, when Alexander was adopted by Ada and gave renewed vigor to the Hekatomnid dynasty. The German scholar believed he could see evidence of such different

Architectural Sculpture in the East (Greek)

dates even in the slabs of the Amazonomachy frieze, and could defend his argument on historical grounds. In point of fact, some ancient sources speak of extensive damage to Halikarnassos at the hands of the Macedonian, and it is not inconceivable that the Maussolleion required repair after his conquest of the city. Even this theory is now obsolete, but two decades were not as drastic a gap as the two centuries envisioned first by Carpenter and then by Havelock on stylistic grounds. Their position was rebutted by Ashmole and Waywell, and effectively silenced by the new excavational evidence; yet the style of these two magnificent figures is quite unlike that of contemporary Record or votive reliefs and gravestones, which are both different in scale and form and often second-rate, or that of the watered-down Roman versions of fourth-century statuary.[27] We shall discuss style separately, not to prove a variant chronology but to highlight the forms of original Greek sculpture at midcentury.

The processional arrangements have already been compared to the Parthenon frieze, and the statues on ledges to pedimental sculptures, yet neither comparison is truly apt, because of the different depths of the figures against the background in the first case, and the lack of an enframing triangle in the second, with all the variety in poses such frame involves. A more cogent parallel is the Gigantomachy frieze of the Pergamon Altar, not as a precedent, of course, but as a clear derivation from the Maussolleion. Carter (1990, 136) has already undermined the Altar's uniqueness in terms of style, of which he sees the incipient traits at Priene and Halikarnassos, thus placing the Gigantomachy within an established tradition. Here we can stress the Maussolleion's influence in terms of architecture, and in the use of three-dimensional sculpture against a podium below (and within) a colonnade.[28]

The roof decoration
Cuttings on the steps of the pyramid and extant fragments indicate the existence of a minimum of 56 **lions** to be seen in profile with heads turned in opposite directions; rather than two single files meeting at a central axis (Waywell), they could be visualized in confronted sets of two (Jeppesen), like the griffin-lions of the Belevi Mausoleum. The Danish scholar would also restore a single human figure, of heroic scale (Class II), between the animals of each set, and, as already mentioned, would arrange the resulting tripartite groups not only along the edge of the roof, but also on the higher steps of the pyramid, to accommodate them all.[29] It is difficult to imagine who these personages flanked by lions would have been.

A more clearly mythological identity is suggested for **corner akroteria** by the presence of a male head that has always been considered an Apollo because of its hairstyle. Jeppesen would group it with the heads of a woman and a youth, and reconstruct the episode of the Killing of the Niobids. The female would therefore be Leto or the distressed mother, and the youth one of the male victims. The Apollo head seems to be of a scale intermediate between the colossal and the heroic, and

Architectural Sculpture in the East (Greek)

may be well suited to represent a god between two mortals, at roof level.[30] Presumably other such groupings existed at the remaining three corners.

Plate 29

The **crowning chariot** is extant only in fragments, but just the surviving front half of one of its magnificent horses is enough to give an idea of its impressiveness (Pl. 29). Yet why was stone chosen for it, rather than the less vulnerable, and more adaptable, shiny or gilded bronze? Did a meaning attach to medium with respect to function? Because of the weight of the marble, various precautions had to be taken: a support under the chariot floor, struts under the horses' bellies, and a carving technique that divided the animals in halves and hollowed out the surface at the join. Horse BM 1002 looks solid at the point of break, but that is because the join at mid-body was so strong that it held, the marble splitting just beyond it, at the edge of the central support. The animal's mane is parted at the crest of the neck, falling on either side of it, but it seems short, as if cut.[31] Could this be a sign of mourning, as per Greek custom, or should it be considered a Karian or Persian fashion? The answer may rest with the interpretation given to the composition.

It has been noted that the horse's mouth is open, its tongue showing through the bronze harness and once made more visible by red paint. It was therefore suggested that the horses are being held in check as if for a sudden stop. Yet the rendering may simply be expedient for the insertion of the bit, or be a realistic trait without special meaning. Much more important is the issue of whether the chariot was occupied or empty. An empty chariot could signify the death of its master, as does the horse with empty saddle that even today is led behind the bier in the funeral procession for a deceased monarch. Yet most commentators visualize Maussollos in the quadriga, accompanied by another figure—Artemisia, an unidentified charioteer, or even Nike. Those who support the ruler's equation with Herakles would see the sculpture as a symbol of his apotheosis, recalling the hero's introduction to Olympos, but certainly Persian and Assyrian, even Egyptian, imperial imagery would suffice to explain the icon. Stamatiou (1989) has stressed not only the Achaemenid, but also the Platonic symbolism of the deceased in his chariot. Once again, the issue is whether the Maussolleion program should be read in Greek or in Near Eastern terms. It is therefore necessary to review the possible meaning of the entire monument.

The Meaning
The Maussolleion was meant as the burial place of a single individual. As such it was not a dynastic tomb. Yet, insofar as it included Maussollos' ancestry in its statuary, it would have celebrated the whole Hekatomnid clan. Whether or not the Karian considered himself a faithful satrap of the Great King, Persian imperial imagery would have enhanced allusions to his own power. But he was also a Hellenized ruler, as indicated by the choice of masters, not only for his tomb but probably for other features of his new capital. Given the mixture of Greek and non-Greek fea-

Architectural Sculpture in the East (Greek)

tures of the entire complex, we have to assume that specific directives were given to the workmen.

Waywell (1980, 122), stressing the tripartite module of the building, sees the program as the fusion of three cultures—the Lykian, the Greek, the Egyptian—over which Karia was seen to exercise its supremacy. Yet the mythological content of the sculptures—Centauromachy, Amazonomachy, Deeds of Theseus and Herakles, Killing of the Niobids, even if their identification rests on varying degrees of certainty—bespeaks a strong Greek component implying emulation rather than domination. As contrasted with Perseus and Bellerophon, only the Niobids have clear Anatolian connections, and they are the least assured of the reconstructions. Herakles' expedition to Themiskyra, wherever that was supposed to be, worked against the natives and in favor of the Greek hero.[32]

Of all the subjects, the Amazonomachy may seem the most surprising, given the Athenian reading of the theme, which spelled victory by the Greeks over the Orientals. Would Maussollos have chosen a subject that stressed the defeat of his own people? The presence of both Amazonomachy and Centauromachy on the same building would have inevitably recalled the Parthenon program, yet viewers would have been required to read the images with a new content—as the deeds of two heroes, Herakles and Theseus, to whom Maussollos wanted to be compared.

To be sure, these themes had already appeared earlier on two Lykian funerary structures; yet the Nereid Monument used a quasi-Amazonomachy, not a true depiction, and at Trysa the juxtaposition of so many different subjects emphasized the epic character of the decoration, almost like a rhapsodic recital at a banquet, rather than a specific message. It has also been suggested that Amazons and centaurs in the fourth century were acquiring a funerary connotation beyond any other possible meaning, and were therefore appropriate for a tomb. The Amazonomachy, moreover, has been considered an especially suitable subject at Halikarnassos because of the Karian belief that Hippolyte's axe, taken from her by Herakles, was kept at Labraunda. Yet, once again, practical reasons should also be considered, especially in view of the limited importance of the two friezes as contrasted with the volume and visibility of the sculptures in the round. Could the two themes have been chosen (as well or primarily) because they allowed an endless number of unspecified figures, easily broken into duels or isolated groups distinguishable from a distance,[33] and suitable to fill a space exceeding 100 m. in length? The ultimate example is the Amazonomachy frieze of the Hellenistic Temple of Artemis at Magnesia, hardly more than a glorified molding because of its size and the height at which it stood: its subject was certainly appropriate to Artemis as patroness/prototype of the Amazons, yet it showed her devotees in defeat at the hands of Herakles and his companions.

The race of the Chariot frieze has been considered a symbol of aristocracy (Tancke 1990), and a metaphor for life as a whole (as the Romans imply with their

Architectural Sculpture in the East (Greek)

well-named *cursus honorum*, which translates into our modern *curriculum vitae*— the unavoidable academic CV). It could also depict funeral games at Maussollos' burial, with epic overtones, although this would be the only Homeric allusion extant from the building. In addition, the repeated similarity of the charioteers may work against this interpretation. Definitely geared to the ruler's life are the subjects of the free-standing sculptures: audience, hunt, sacrifice, battle. Like the Xanthian scenes, they need not carry specific references to historical events but function as status symbols made authoritative by their wide diffusion and comprehension, here increased by spectacular size and number. Finally, the roof lions would have translated into images of royalty and power, both Oriental and Greek, as well as apotropaic devices.

Despite the obvious precedents in the Lykian monuments already cited, what makes the Maussolleion remarkable is the *consistent* Greek appearance of its sculptures, regardless of their themes. This is therefore the last aspect we should analyze.

Technique, Iconography, and Style
One feature that seems characteristic of Greek practices is the use of metal attachments, which Lykian monuments always used sparingly, if at all. Even at Halikarnassos, added elements to the friezes are relatively few, but they exist, and not always where expected. Bronze weapons and bridles are understandable, but why insert a metal linchpin in an otherwise fully carved wheel and chariot in the Chariot frieze? By contrast, purely painted details seem much rarer, as for instance the central shield strap of a Greek stepping on an Amazon, on BM 1011. Undercutting is strong in some slabs of the Amazonomachy, nonexistent in others; in the fully preserved Centauromachy block (BM 1032), the right leg of the man seen from behind has been carved free from the background at the point where it overlaps that of the fleeing female. Note his pose, which almost duplicates that of a Greek at the left edge of slab 1020,[34] and suggests the use of standard outlines or patterns. In all three friezes, apparently, joins between slabs can run right through major figures, suggesting sequential, if not *in situ*, carving. Perhaps, as at Bassai, blocks to be decorated were preliminarily set up in the workshop in their intended order, before being transferred to the monument.

Proportions of human bodies vary not only from frieze to frieze, but also from slab to slab. Yet, in both the Chariot Race and the Centauromachy, figures fill the entire span, their heads touching the upper edge of their blocks, whereas in the Amazonomachy a sense of space and atmosphere is produced by the overhead room above the action. Some personages are rendered intentionally taller than others, and Ashmole (1972, 174) has suggested that a few Amazons, also distinguished by their different helmets, may have been the queen's bodyguard. But the distance from the top edge is respected and the effect of greater height is achieved through other devices, such as the slant of the body in motion. Oblique compositional lines

Architectural Sculpture in the East (Greek)

predominate on certain slabs, and include a pyramidal arrangement on BM 1006—two Greeks hammering down a kneeling Amazon—that recalls the iconography of Kaineus. Foreshortening, where present, is used to good effect, and poses comprise many rear views, as if the background were penetrable and the combatants could spin and move freely like actors on a stage.

Because of its better preservation, the Amazonomachy frieze lends itself to more detailed analysis, and has in fact been studied at length in various articles, although not yet in an official publication.[35] We shall therefore emphasize only variety of iconography and what can be considered specific stylistic traits of the mid-fourth century. The sculptors seem to have made a conscious effort in differentiating Amazon weaponry from the Greeks': even the women's way of holding the shield varies (with grip strings in the center but no *porpax*), as well as the shield size, although they do not carry the distinctive pelta. They usually fight with axes, but one riding backward on her mount (BM 1015) must be shooting a bow, as does one on slab 1007, probably added in paint.[36] Most of the Amazons are bare-headed, or wear a Persian cap, but some seem to have a sort of sakkos, and a few crested helmets have already been mentioned; the bare-headed ones have flaming ponytails, or long strands, or rolled hair at temples and nape. Their male opponents are usually young and clean-shaven, but a few are bearded, with elongated faces quite different from the Tegea ones. They wear Corinthian helmets with long crests, tilted back to expose the forehead in an incongruous manner, but a few sport the Attic variety (e.g., slab 1015), which hints at contemporary fashions, as will become the norm later in the century even in mythological contexts.

Costumes reveal the same wide range of renderings. Many of the Greeks are entirely nude, others have only their weapons (including the added baldric in metal); some have a short mantle rolled up around their shield arm, or fluttering from their shoulders; a few are in full attire: chitoniskos and chlamys (BM 1019) and even a cuirass (1011). Herakles on slab 1008 carries lionskin and club. An animal pelt appears also on a helmeted Amazon, so tall that she could be taken for a man in her present damaged state, which has removed the features of her frontal face; but she has a bared right breast, as do many of her companions.[37] Others have their chitoniskos carefully pinned over both shoulders, some add a rolled mantle, and a few (slab 1007) are in Oriental costume, with sleeves and trousers. A remarkable fragment shows the nude upper torso of a dying or dead Amazon—both nakedness and death unusual in this context. At Limyra, the different gear and clothing had suggested the possible presence of mercenary troops; at Halikarnassos, this possibility is excluded, and the multiplicity of costumes can be accepted as the masters' desire for variety. Perhaps certain renderings served to identify some figures, as we can acknowledge in the depiction of Herakles.[38] But in the present condition of the frieze what seems rare or unique may suffer from statistical deficiency, since we lack so many of the original slabs. Certainly, no inscribed labels were possible, as

on the Pergamon Gigantomachy or the Siphnian Treasury friezes, since they would have been invisible from ground level.

Stylistically, the garments are rendered as uniformly opaque albeit thin, modeling the underlying bodies through the patterns of the crisp folds, rather than through their omission or apparent adherence to the human forms. Mantles wave in the empty spaces between the figures with irrational course and, occasionally, somewhat mechanical articulation, almost at the level of filling ornament, but the typical Lykian wave is absent even from swirling skirts, or the pattern is overridden by true motion lines. Among facial traits, perhaps the most distinctive is the rendering of the eyes, which has often been connected with Skopas' influence: deep-set at the inner corners, overshadowed by the hanging brows, which, however, do not quite overlap the outer lid corners, as will happen at Tegea; some eyeballs are concave, some bulging and rounded, as one can expect from different carvers. Jaw lines are pronounced, especially in the male warriors, who exhibit strong neck muscles and tendons, and a lean anatomy; Carter (1990, 130) has well analyzed the rendering of the torsos and has stressed the distinctive, bowlike profile of the "transitional line between thorax and lower edge of the rib cage." The median line (*linea alba*) seems always strongly articulated. I would argue that these are typical traits of mid-fourth-century style, rather than mannerisms of specific sculptors.

As already mentioned, the Centauromachy frieze shows touches of a different style; here, I would emphasize the garments of the lone woman on BM 1032: her low-slung mantle forms a virtual ring around her, with a roll that crosses at midthigh. The curving abdomen is outlined by true transparent drapery, as I could find in none of the Amazons.[39] She seems to have longer legs, wider hips, and narrower shoulders than other female figures on the podium frieze, and is primarily responsible for the impression of a later date that the slab gives. If the Centauromachy frieze stood just below the crowning chariot, perhaps it was among the last to be executed, and its position may have allowed for more cursory rendering, or required elongated forms for optical corrections.

Where style should be analyzed in depth is in the free-standing figures, especially the so-called Maussollos and Artemisia (cf. Pl. 28). Photographs do not convey the impact these statues make on the viewer, especially because they tend to be taken at eye level, and thus cannot reproduce the intended angle of sight. His eyebrows, for instance, which form such a distinctive upswinging ridge when seen in photographs, do not look nearly as patterned on direct examination. But the face seems broader and flatter, certainly different from the Classical Greek countenance (especially in the beard hugging the prosperous double chin and the wide cheekbones), yet, at the same time, less portraitlike than is usually assumed.[40]

Ashmole (1977) has carefully pointed out damage that has flattened edges and destroyed parts now repaired in plaster. Old photographs of "Maussollos" showed him with a full head of hair, whereas only the strands on his right side are preserved

to any length. At present, the stunted ridges of his wavy locks give the impression of a matted, almost greasy hairstyle, but this would not have been the case when the carving was pristine. Yet there is no mistaking the long drill channels that separate the strands not only from each other but also from the face, with a dramatic chiaroscuro effect. Another groove has been drilled above and along the upper eyelid, emphasizing the impression of deeply set eyes but making the outer corner fully visible. A thin line edges the mustache and the upper lip, almost suggesting the cold work of a bronze statue. A horizontal depression separates the relatively low forehead into two halves, the lower one exhibiting the so-called Michelangelo bar that is typical of fourth-century styles; this treatment contrasts strongly with the truly flat forehead of "Artemisia."

"Maussollos" looks portly and thick, with unusual depth. Under the stiff tunic, his pectoral muscles are surprisingly pronounced, almost feminine; his stomach is not really bulging, but is emphasized by the mantle roll that tops the "apron" arrangement with its thickened edge. Here too, broken ridges have increased the impression of turbulent drapery, but certainly this is highly modeled cloth, with ledgelike pleats and deep straight slashes across the mass. A few minor accents are created by "press folds" that are not always rendered as thin grooves but also as slight ridges and serve to animate even the flat surfaces.[41] Most dramatic of all, indeed baroque in its effect, is the long tension fold from the bent left knee to the right ankle, with a tremendous cavity behind it. The massive thighs and powerful knees are thrust into prominence by the careful arrangement of emphatic modeling lines, without true transparency. In addition, as noted for features of the head, contours of forms are traced by deep grooves—for instance, that which separates the mantle swag from Maussollos' left thigh—and this treatment gives special definition to the body without compromising the textural integrity of the costume, which now comes into its own as an element of the composition on a par with the physical structure. To be sure, similar outlining grooves had been used on some of the Epidaurian sculptures, especially the akroteria, but they had created a peculiar dichotomy, with the body forms appearing as if uncovered or, at best, revealed through very thin drapery, while the same costume, away from the human frame, looked illogically thick and heavy. On the "Maussollos" the garments are logical and coherent—not in the sense of the intellectualized system of folds of the fifth century, which could be traced almost from beginning to end as they looped around the figure, but in the sense of textural naturalism, albeit exploited for chiaroscural effects. Another touch of realism was used for the footwear, the *trochades* attested on Greek male statues from the late fifth century into the Hellenistic period, but in a form typical during the mid-fourth century.[42]

A similar analysis can be made for the so-called Artemisia. As contrasted with the male figure, her thick-soled sandals have no plastically rendered strapwork, which must have been added in paint. Her chiton follows the patterning conventions

Architectural Sculpture in the East (Greek)

of the fifth century, but it is uniformly opaque, even over the prominent breasts, although its folds, particularly those branching off the sleeve buttons, are marked by deep drill channels. The mantle looks definitely heavier than the underlying garment, but its tension folds across the abdomen and from left hip to right ankle are considerably shallower than those on "Maussollos," without the deep pockets of the male rendering. This is partly due to the fact that she stands with her weight on her left leg, almost in mirror-image to his pose; yet the same comment can be made for the mantle roll across her waist, which, although thicker, looks less chiaroscural than his. Textural effects are nonetheless comparable, including the occasional press fold and the contouring groove along the left, outthrust hip. Her stance, with both forearms extended, as if in prayer (and thus named "the *orans* pose"), is like Ada's on the often mentioned Tegea relief to the Zeus of Labraunda, and so, probably, is her hairstyle.[43]

Given the loss of all facial features (except for the overly smooth, oval forehead), "Artemisia's" hair has attracted the greatest attention. Covered by the raised mantle in the back, it is visible only as a ledge of three rows of globular curls framing the face, in a rendering that recalls late Archaic and Archaistic coiffures. Yet nothing else looks deliberately archaizing in this impressive statue, and the existence of several other female heads of approximately the same date and from contexts also connected with the Hekatomnids has strengthened the suggestion that this particular hairstyle, probably of Persian derivation, was common at the Karian court. To be sure, Persian parallels point to male, not female, fashions, but this discrepancy may be due to the lack of ladies' depictions in Persian art. It could also be theorized that ancestral status was being implied by the old-fashioned coiffure, but if the labeled Ada at Tegea indeed wears it too, this assumption cannot hold. The scale and quality of the relief are such that minute details are impossible, but the general appearance is the same. That the headdress may be an applied ornament will be mentioned below, in connection with a head of "heroic" scale from Priene.

It should finally be pointed out that the back of both statues is more perfunctorily carved than the front; all basic forms and tension folds are rendered, but without the chiaroscuro effect of the main view. The notable depth of both figures may suggest a more dynamic arrangement than a strictly frontal alignment, but certainly not an all-round viewing. Both an intercolumnar location and a podium setting are possible, perhaps with the "Maussollos" on a different ledge from the "Artemisia." That the discrepancy in size merely reflects the physical reality of a man's height versus a woman's may be disputed on the basis of the Tegea relief, where Ada appears almost level with Idrieus.

A few heads from the Maussolleion can be more briefly acknowledged. A **female, BM 1051**, can stand for the missing features of Artemisia, and these are so generic as to dispel any impression of portraiture: oval forehead, regular eyebrow arches, large eyes with upper eyelid slightly overlapping the lower at the outer corner, in a

fifth-century mannerism. The cheeks are plain, with little modeling; the damaged mouth remains as a bow-shaped groove between the abraded lips; the chin is full and deep. The one coloristic accent, at present, is the pattern of drill holes between true snail curls. Two **male bearded heads, BM 1054 and 1055**, could not look more different. The first might be at home in the Athenian Kerameikos, on any number of grave stelai, its only unusual feature a short *anastole* on either side of a faint central part. Its eyes are large and fairly deep-set; its facial hair is regular, with short locks; its serious mouth has a short lower lip, clearly overhanging the chin; its cheeks are smooth and plain. The second head's hair and forehead are damaged, but its beard is much more impressionistic and tumultuous, its lips more even, its cheeks more modeled and almost sagging, its eyes narrower between prominent lids.[44] Finally, **the head of Apollo (BM 1058)** seems almost a cross between the two: his hair is even more chiaroscural and lively, and his lower lids are clearly rendered, as in the second head; but his protruding lower lip is short and his cheeks are fairly smooth, as in the first. His expression seems intense because of the deep-set eyes. I find it impossible to attribute any of these heads to a specific master, and can only acknowledge them in terms of the variety of forms present on the Maussolleion.

THE TEMPLE OF ATHENA AT PRIENE

The architectural similarity among the Maussolleion, the Athenaion at Priene, and the Temple of Zeus at Labraunda has already been mentioned. Investigation of the second building by the Germans is in progress and will produce a definitive publication. In the meantime, preliminary information given at a symposium in Philadelphia in April 1993 has suggested that work on the Athenaion and its architectural ornamentation continued from the fourth century to Augustan times. This observation may solve some of the difficulties scholars have raised in accepting an early Hellenistic date for the temple altar, and a Classical one for its decorated coffers. Further support comes now from renewed analysis of the akrolithic Athena in the cella.[45] Once again, we shall focus here on what is known at present and what is relevant for fourth-century sculpture.

According to Vitruvius (1.1.12), the Athenaion at Priene was built by Pytheos; the Greek master must have worked there after, or even during, his involvement at the Maussolleion, but certainly later than his presumed activity at the Temple of Zeus at Labraunda. A *terminus post quem* for the Greek building is given by the refounding of Priene, probably under Hekatomnid sponsorship, around 350. An inscription on an anta block from the east porch of the Athenaion declares that King Alexander dedicated the temple to Athena Polias, and it is generally assumed that it dates from 334, after the Battle of the Granikos—the same year in which the Macedonian was adopted by Ada and restored her to power. Yet dedication does not mean completion, as has been noted on the basis of architectural moldings that

Architectural Sculpture in the East (Greek)

betray different periods of execution. An alleged "foundation deposit" of silver tetradrachms of Orophernes of Cappadocia within the statue base had been taken as evidence that this king had donated the statue itself toward the middle of the second century, therefore implying construction protracted to that period. As we now know, work may have continued even later, but this specific chronology has been discredited on these very architectural grounds (the analysis of moldings), and the contemporaneity of statue base and statue during the fourth century means that a roof already existed over the cella, to protect the image. In addition, an architectural sketch on the underside of a wall block, which has been taken as "Pytheos' signature," has demonstrated that the roof was planned from the very beginning. Yet the strongest argument against a fourth-century roof had been based on the style of the carved coffers with which the pteron ceiling was decorated (Ill. 19). The reliefs depicting a Gigantomachy had been compared to the main frieze of the Pergamon Altar and dated to the same period, thus adding to the apparent clustering of features at mid-second century.[46] This theory can now be dismissed as well.

These carved panels had once been assigned to the Altar of Athena, rather than to the temple, because of their subject. A reconstruction had therefore placed them on a podium below the Ionic colonnade of the structure, in imitation of the alleged Pergamene prototype. Even when this location had been proved erroneous, however, a Hellenistic chronology continued to adhere to the Priene reliefs because of their "Baroque" style, supposedly influenced by the more famous Gigantomachy. The removal of fragments mistakenly added to the Athenaion panels has simplified some figures and made the Pergamene comparisons less convincing; more importantly, Carter has persuasively argued that the coffer reliefs are quite similar to the Maussolleion sculptures. His dramatic photographic juxtapositions of fragments from Priene and from Halikarnassos (Carter 1990), made possible by their presence in the same museum, should have dispelled all remaining doubts: the same hands who worked at one site must have worked at the other. In addition, isotopic analysis of the Maussolleion Amazonomachy and the Priene Gigantomachy has shown that they are made from the same Asiatic (Prokonnesian) marble.

Of the original 26 coffers, 65 fragments have been catalogued, including some found during the German excavations of 1895–98 and now in the Istanbul Museum.[47] Their construction, based on a corbeling arrangement of the framing blocks, is quite different from the carved beams of the fifth century, and can be paralleled only at the Maussolleion, which must have served as experimental prototype. The height of the relief (between 50 and 60 cm.) is exceptional, especially for coffers, with figures about one-third lifesize partly carved free of the background and standing on a base groundline. The sole precedent for action scenes in coffer reliefs is again provided by Maussollos' tomb, and the practice will not recur until the Belevi Mausoleum, in the third century, probably in imitation of the famous Karian building. That no other parallels are known would confirm the strong link between the

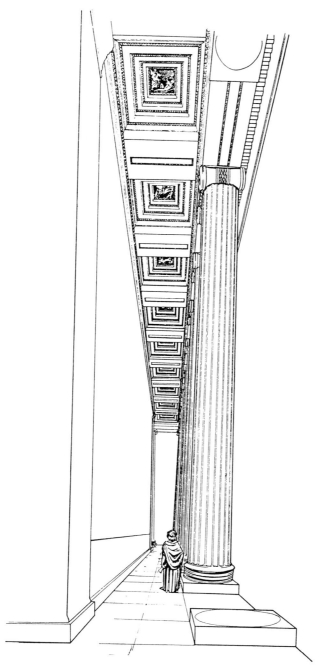

Ill. 19. Priene, Athenaion, reconstruction of pteron coffers in place (after Carter 1983)

Architectural Sculpture in the East (Greek)

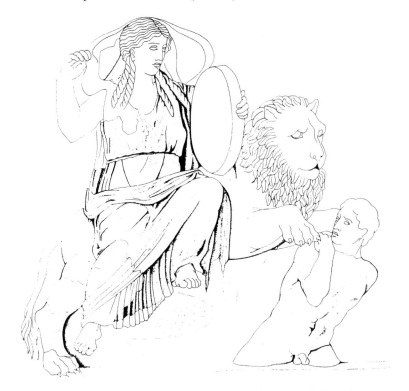

Ill. 20. Priene, Athenaion, reconstruction of coffer with Kybele and giant (after Carter 1983)

two Pythean buildings. The coffers, like metopal panels, usually include two figures (Ill. 20), a deity and a giant in combat, the latter depicted with human legs, although Athena's opponent is both winged and anguiped (cat. nos. 31–32), and another (cat. no. 55) may have smooth coils for legs. Among the giants is their mother, Ge, rising from the ground (cat. no. 27), and, more surprising, a group of fighting Amazons, at least one of them mounted (cat. nos. 9, 10, 28, 35). Carter places the Amazon coffers on the north side, toward the west end, perhaps as Herakles' opponents, and tries to explain their inclusion as a conflation of the Pheidian scenes on the shield of the Athena Parthenos. Although Parthenonian echoes would not be amiss on a building that included a replica of the Pheidian chryselephantine colossus as its cult image, I find this mixture surprising and wonder whether a total Amazonomachy should not be reconstructed over the west pteron; it would then correspond to the west metopes of the Parthenon, with the Gigantomachy occupying the east front and the two long sides.

Although Carter's stylistic comparisons are compelling for the male torsos, parallels with the Maussolleion drapery are fewer and largely limited to tool marks and

Architectural Sculpture in the East (Greek)

textural details; differences are explained on the grounds of variant subject matter, types of garments, and location on the respective buildings. Here, however, there is no need to defend a Halikarnassian connection that, in my opinion, has been sufficiently proved. The Priene coffers can therefore be analyzed for their own sake.[48] And what I find most striking is the more "Classical" rendering of folds, both motion and modeling ones, with true instances of transparent cloth. A striding goddess (cat. no. 17) seems a more advanced version, in mirror image, of Figure G from the Parthenon east pediment, and the torso of another goddess (cat. no. 26) looks almost bare, with her navel showing through her chiton and her nipples prominent under the stretched drapery, smooth almost everywhere except for a few thin ridges. Kybele on her lion (cat. no. 14, cf. Ill. 20) and Zeus (cat. no. 1), who surprisingly fights from a seated position, carry their mantles in their lap like Parthenonian deities, each thick fold long and logical, easily followed throughout its course. But on most draped figures belts are high, tied just below the breasts, emphasizing different bodily proportions, and some overfolds and mantles are flamboyant in their surprising motion (cat. nos. 18, 24). The one female head preserved with its features (cat. no. 10) exhibits strong pathos through her angled eyebrows, deep-set eyes, and open mouth; her impressionistic hair forms an old-fashioned (Severe), ogival-canopy pattern over the forehead, but her suffering expression recalls Epidauros. She has been labeled an Amazon, being pushed by the hand of an opponent who grasps her by the hair.

I would agree with Carter that high position and angle of vision determined the basic forms of these reliefs, but I am still surprised by the antiquarian touches, as it were, mixed with more current renderings. The addition of metal attachments (weapons, sandal straps, horses' reins), as well as the extensive coloring, would have made the actions clearer as well as more naturalistic but seems hardly appropriate for the location—inevitably different, because of its deeper frame, from a metopal series, which the Priene panels most resemble. This difficulty might explain why later examples of carved coffers either eschew the narrative or tend to be in lower relief, with all details carved or painted.

The Athenaion as a whole is basically sober, despite its array of architectural moldings, which include lion-head spouts against a carved rinceau. Although often hailed as a revival of the Ionic order, it is instead strongly influenced by Doric principles, including the grid system of its plan, which first appears in Anatolia at Labraunda (Temple of Zeus). Its shorter proportions (6 × 11) with deep pronaos included a shallow opisthodomos (perhaps first attested in Asia Minor at the Nereid Monument). Its entablature had dentils above the epistyle, without the area of the continuous frieze that was beginning to make its appearance in other Ionic monuments of the East and would have offered scope for sculptural decoration. Its column capitals are relatively plain, and its Asiatic bases over square plinths are unadorned. It is therefore doubly surprising to find these deep, carved coffers, which Pytheos

Architectural Sculpture in the East (Greek)

must have adapted from his experience at the Maussolleion, making their relief higher and thus pushing their decorative potential to, or beyond, the limit. In this respect, they can perhaps be compared to the Pergamon Gigantomachy, where relief figures extend beyond their natural frame to coil onto the steps and invade, as it were, the world of the living.

Before leaving Priene, we should mention an **over-lifesize female head** highlighted by Carter as a portrait of Ada, the Hekatomnid sister of Maussollos. She wears the distinctive coiffure with three rows of globular curls framing the oval forehead, the rest of her hair bound in a sakkos with a striking painted pattern. But traces of bright red paint over the curls, and their faceted appearance, have led to the suggestion that they represent the underpinning for gold foil, and that therefore the coiffure should be read as a golden toupee, probably worn by women of the Karian court. Were this the case, the old-fashioned, Archaistic hairstyle could be explained as a formal ornament, like the false braids and other additions later used by Roman women. The Priene head was meant for insertion into a separate body, of which a few pieces may survive, and the statue stood in the Athenaion cella, where all the related fragments were recovered. It was probably made around 340–333, perhaps to honor Ada for beginning work on the temple, which Alexander then dedicated. Isotopic analysis has recently shown that the Priene head is of the same Parian marble that was used for the head BM 1051 from Halikarnassos, which is in turn similar to the stone used for the akrolithic Athena within the temple. Such technical and iconographic details strengthen the links between the sites and the workshops involved in the two projects.[49]

A **bust of a girl (BM 1153)**, an adolescent, to judge from the facial features, comes from the Athena sanctuary, and wears the same type of headdress with snail curls, although these are close to the skull rather than forming a high ledge like those of the Ada; the rest of the hair is covered by a banded cap. The piece, meant for insertion into a body, has been variously dated Neronian or, more convincingly, Classical. Close comparisons to it exist in **two heads in Berlin**, also from Priene but from the cella of the Demeter sanctuary, usually dated to the late fourth century.[50] Since all these heads once belonged to complete statues, and because of their privileged location, it seems logical to ask whether they could all represent priestesses—of Athena as well as of Demeter—perhaps in the guise of Kore in the youthful case. The Archaistic hairstyle, whether real or artificial, would then be an allusion to the antiquity of the cult and the sacredness of the role. That women of the Hekatomnids were so represented suggests the possibility of an honorary priesthood for the female members of the family. Both heads in Berlin are strongly idealized, especially the larger, whose sharp eyebrows, lids, and nose ridge make me think of Roman work. But both, like the heads from the Athena sanctuary and those from Halikarnassos, combine generalized, smooth features with modeled details,

Architectural Sculpture in the East (Greek)

especially in the area of the mouth. This treatment contrasts with that of the more individualized female heads preserved from the Amazonomachy frieze at the Maussolleion, and may suggest deliberate classicizing.

OTHER ARCHITECTURAL SCULPTURE IN THE EAST

Perhaps the most important architectural undertaking in Asia Minor during the fourth century was the rebuilding of the Ephesian Artemision, destroyed by fire in 356. Another structure, significant for its sculptural decoration, was the Propylon to the Temenos at Samothrake, an island whose geographic position makes it a stepping stone between Europe and Asia. Yet both these works have been discussed elsewhere,[51] and will be here investigated only in terms of what they can contribute to the general picture.

In contrast to the Athenaion at Priene, the **Ephesian Artemision** (8/9 × 20, dipteral Ionic) is lavishly decorated and utterly anomalous in its plan and orientation (W–E). Yet both its decorative schema and its layout are strongly dependent on its Archaic predecessor and therefore cannot be considered typical of Asia Minor trends in the fourth century. Whether or not there were statues of Amazons between windows in the huge west pediment (as suggested by Trell on the basis of numismatic representations, but dubious because of scale and depth of cornice), there was certainly enough sculpture to overwhelm the viewer. We note once again that it was probably not size alone that caused the temple to be listed among the Seven Wonders of the World. The sculptural embellishment comprised both column drums and pedestals, of difficult reconstruction and placement. The latest interpretation of the reliefs (Rügler 1988) sees the first as depicting deeds of Theseus and Herakles, as well as cult scenes, and the second as portraying a Gigantomachy and a Centauromachy. Given the fragmentary state of the evidence, it is legitimate to wonder whether we tend to reconstruct the subjects with which we are most familiar. Conversely, one could argue that these subjects lent themselves best to architectural representation and were already current in Asia Minor, a battle involving centaurs having been included on the parapet of the Archaic Artemision itself. The Gigantomachy seems to be limited to religious buildings, however, whereas the Centauromachy is appropriate also for funerary structures, as shown by the tombs at Halikarnassos and Belevi. The Deeds of Theseus are perhaps more surprising, given his strong Athenian association, but by this time perhaps his fame had expanded abroad, and his cycle of adventures formed the best counterpart to that of the Panhellenic hero.

The range of dates suggested by Rügler for the sculptures goes from 340 to 310, which makes them stretch into the Hellenistic period; it should perhaps be extended a bit further, but I would agree that the material is too fragmentary to base on it an investigation of early Hellenistic sculpture in Asia Minor. Yet Rügler points out that the Artemision carvings provide the best example of a mixture of progressive

Architectural Sculpture in the East (Greek)

and retrospective stylistic traits—something we have noted in the Priene coffers, although he attributes the phenomenon to the Ephesian political climate. Rügler believes that Skopas' hand cannot be detected among the extant fragments, but that the master may have been responsible for some plans (notably those with the sea thiasos), and that his workshop (which Rügler calls Workshop B, one of three active at the building) may have gone to Ephesos after Halikarnassos, since similarities exist between the Maussolleion friezes and the Artemision drums and pedestals. Here we may note especially the texturing of cloth and the rendering of faces in the best-preserved drum, explained by Rügler not as the myth of Alkestis but as the cult of Demeter. I would, however, attribute this style to the time, rather than to one sculptor (especially since the Plinian passage mentioning Skopas [*NH* 36.95] may be corrupt), although there is nothing inherently implausible in the movement of one workshop from the Karian town to the Greek sanctuary.

The Artemision retains the standard Eastern-Ionic entablature, with dentils above the epistyle, as at Priene. The Ionic **Propylon to the Temenos at Samothrake**, however, seems to have the first example of a continuous carved frieze added between those two members. This innovation, probably patterned after Attic-Ionic fifth-century prototypes (where, nonetheless, the dentils were always omitted and carvings always included), is fundamental for the decorative potential it offers to fourth-century Ionic architecture. The date suggested by the excavators for the Samothrakian porch is 350–330—slightly ahead of the earliest examples of the combination in Greece proper: the Philippeion at Olympia (after 338), where the frieze is however uncarved, and the Monument of Lysikrates in Athens (precisely dated to 334), where the carved frieze runs above a Corinthian, not an Ionic, colonnade. In the eastern area itself, two examples need to be considered, because occasionally dated earlier than the Samothrakian porch: the **Temple of Aphrodite(?) at Messa**, on the island of Lesbos, and the Temple of Hemithea at Kastabos.

The building at Messa is poorly preserved and includes no sculpture, but it was larger than the Priene Athenaion and deserves attention for its remarkable combination of colored stones, a form of decoration in itself. A pseudodipteral with 8×14 plan, its cella walls and columns were in cream-colored volcanic liparite quarried nearby, and its sima was of white marble, but the frieze course was in red conglomerate, a breccia-like stone whose use has been compared to that of the blue limestone of the Erechtheion frieze in terms of providing contrasting accents in the entablature. Yet the Athenian building added white marble sculptures, so that the bluish background served no greater purpose than to replace the traditional paint for architectural reliefs, whereas the Messa frieze remained plain. Could it suggest that some friezes, at least in the East, had their background painted red rather than blue? This color contrast, however, continued in the interior as well, where the inner core of the cella was in reddish trachyte, including the columns in antis, with creamy liparite being used only for their capitals and bases.[52] To be sure, we miss

most of the paint that once definitely embellished even some of the plain members of Greek temples, as we are now beginning to realize, but this experimentation with different materials leads into the trends of the Hellenistic period and deserves mention. The latest suggestion would date the Messa temple to 340–320, and earlier than the Samothrakian Propylon, but the chronology of both buildings relies almost exclusively on stylistic analysis, and may reflect the desire to find the "earliest example," or to attribute an innovation to a great master, the *protoeuretes* so beloved by the ancient sources, which at Samothrake is thought to have been Skopas himself.

The Temple of Hemithea at Kastabos was an Ionic peripteral (6 × 12), apparently with Corinthian columns in the pronaos and a naiskos within the cella. It used the combination entablature, but this time the frieze course was carved with floral motifs: flame palmettes, lotus flowers, and trailing vines. Chronology is fortunately assured by a deposit of coins from the filling under the floor, the latest of which were minted by Demetrios Poliorketes in 306. The building should therefore date to 300–280.[53] It is remarkable that the decorative potential of the continuous area should have been used for just another molding-like effect, rather than for narrative purposes.

To return to the Propylon at Samothrake, the Archaistic frieze of dancing women may at first appear as "monotonous" and molding-like as the floral pattern at Kastabos, yet some variety in the figures and their musical instruments (kithara, tympanon, double pipes), and the converging directions of the procession, which imitates the pattern of the Parthenon frieze, would have dispelled the impression. Yet there is no denying that the small size of the frieze, its low relief, its modest quality, and the fact that the Propylon itself did not face any major feature within the sanctuary detract somewhat from the importance that has been given to this structure. This lies primarily in the fact that a fourth-century date is assured for an Archaistic style that some would consider possible no earlier than the mid-Hellenistic period. But the Propylon date is less firm than intimated, since little of what remains was found *in situ*, and both local and imported sherds are either uncertainly dated or too close to the suggested time span. Some scholars have argued that the proposed chronology should be lowered by 10 or 20 years, but such precise determination seems irrelevant. More significant is the fact that the column capitals had an added anthemion band that recalls Archaic examples, so that a retrospective tone seems implied by both the architecture and the sculpture, perhaps to suggest the antiquity of the cult.

Completely contemporary, however, was the style of the heads in various poses that decorated the Propylon ceiling. This type of carved coffer is quite different from the action scenes of the Maussolleion and the Priene Athenaion, and the faces looking down on the viewers have been identified as Olympian or astral divinities and heroes to increase the plausibility of the location. Yet they have also been com-

pared with the portraiture of Alexander the Great, to argue for a Macedonian connection, and with Skopasian stylistic traits, to claim Skopas' participation in the project. I would rather believe in trends common to the second half of the fourth century, and consider any resemblance to Alexander coincidental, rather than intentional and part of a Macedonian propaganda that could be anachronistic. The use of heads for coffers seems also less "advanced" than one would expect from a workshop fresh from Halikarnassos and perhaps Priene, even if architecturally more successful and reminiscent of both Epidauros and Xanthos. Whether Skopas was ever at Samothrake will be discussed in Chapter 7.

One last monument should be considered in this review: **the Lion Tomb at Knidos**. Preserved only in its lowest courses and rather sober in its reconstructed appearance, this structure is known primarily through the monumental lion couchant that surmounted it, which is now in the British Museum. It was a Doric pseudoperipteral building, with its engaged columns (4 × 4) standing on a low podium, and a pyramid crowning the roof as pedestal for the guardian animal. Its calculated height of 20 m. (probably excessive) makes it a far cry from the Maussolleion, despite its geographic and perhaps chronological proximity. Because of the pyramid and the lion, this tomb has been considered a possible prototype for the Karian building, but it was certainly not for a single individual: its square marble exterior enveloped twelve low burial chambers (*ostothekai*) radiating from a round room with a corbeled ceiling. Regrettably, no inscription can be associated with the Knidian tomb, and no suggestions have been made, except for a vague reference to the Athenian admiral Konon's victory near the site in 394, for which the monument might have served as a polyandrion. This date is the one most frequently found in the literature about the monument, but too little remains for a proper architectural analysis. The sober Doric order and the lack of other embellishment make stylistic assessment difficult, but the recumbent lion is impressive, although badly weathered. It has been compared to the beasts marking the monuments at Amphipolis and Chaironeia, but those are alert creatures, sitting like watchdogs with open mouths. The Knidos lion recalls Archaic examples from Asia Minor in its compact and massive form, and is quite different from the Maussolleion animals, especially in the drill work of his voluminous mane.[54] I would opt for a date past the mid-fourth century.

In summary, we can try to draw some general conclusions from our survey of architectural sculpture in the East, at both Greek and non-Greek sites. It seems abundantly clear that only "foreign" funerary monuments received special sculptural attention, on a lavish scale and in unorthodox positions: the Lykian burials considered in the previous chapter and the Halikarnassos Maussolleion. The Doric Lion Tomb looks surprisingly restrained by comparison, probably because it did not serve dynastic purposes. Of the temples, only the Artemision at Ephesos had extensive

Architectural Sculpture in the East (Greek)

decoration, but this seems conditioned not simply by its enormous size, which may have required extra embellishment, like a colossal statue, but also, and primarily, by its Archaic predecessor, which the fourth-century structure recalls and emulates. Indeed, the Classical version lacks the relief parapet that must have been a conspicuous feature of the sixth-century Artemision, and was probably roofed (as suggested by Vitruvius' account and by the recovery of tiles from the area), thus eliminating the possibility of inner-courtyard embellishment, as for its predecessor and at the later Didymaion. The pedimental area obtained through this roofing was certainly pierced by windows, but any sculptural addition seems problematic. The temple at Messa used color for decoration, despite the potential for sculpture offered by the continuous frieze, and the temple at Kastabos (although too late for our survey) employed a molding-like pattern, eschewing figural narrative. Finally, the Athenaion at Priene confined its sculptural decoration to its coffers, relatively few and of difficult visibility.

The Propylon to the Temenos at Samothrake may qualify also as a religious structure, but it was certainly not a temple, and is perhaps closer in purpose and form to the north porch of the Erechtheion. Its Archaistic overtone, moreover, may have demanded modes of a time past, and inspiration may have come from Athens rather than from local trends. Its carved coffers seem more in keeping with Peloponnesian than with Asia Minor practices. Compared with the Tholos at Delphi or even the Athenaion at Tegea, these East Greek buildings must have looked restrained.

One more issue remains to be considered. According to traditional assumptions and accepted chronology, Skopas worked first at the Maussolleion (360–340), then at Tegea (350–340), then at Samothrake (340–330) and Ephesos (340–310); and at least one workshop formerly active at Tegea was involved with the Temple of Zeus at Nemea (330s–320s), not to mention the workshop nexus linking Labraunda (360–350), Halikarnassos, and Priene (350–334). How can a single master, even if itinerant, have been personally involved in all these roughly contemporary projects? Just the number of statues in the round for Halikarnassos, if those received the special attention of the main sculptors, would have required a considerable amount of time, no matter how distributed among the participants and their helpers. Travel in antiquity was frequent, and the distances involved were not great, but nonetheless the means of transportation were not as speedy or convenient as in modern times. Given the many other attributions of works to Skopas, it seems best to consider this list of sites with some skepticism. I would accept that the Parian master worked at Halikarnassos and at Tegea, given the surprising connection of the Tegea relief and the "objective" mention in Pausanias, who was not trying to add fame to the Athenaion. I would doubt Skopas' presence at Ephesos and Samothrake, although I would consider it possible that some workmen from the Maussolleion found further employment at the Artemision. Priene and Labraunda probably relied on local masters, except for Pytheos. Samothrake seems to me dif-

ferent, and simply in line with fourth-century styles, but probably stemming from another source.

Stylistically, the sculptures we have considered range greatly and include both progressive and retrospective trends. In faces, idealization and pathetic expressions coexist; in drapery the motifs of the fifth century continue next to new conquests in texturing and chiaroscuro; in anatomy, a dramatic attention to forms is a prelude to Hellenistic fractioning and exaggeration. Geographically, we must recognize the unevenness of distribution, perhaps caused by the chances of survival. It is true, however, that the centers of greatest architectural activity are those that had remained more or less dormant during the second half of the fifth century: the Peloponnesos and Anatolia. Macedonia was already producing impressive tombs, but their decorative facades relied on painting rather than carving, at least until the turn into the next century. Both Magna Graecia and the Kyklades were actively building during the fourth century, but sculptural embellishment seems to have been left out—in Magna Graecia, perhaps, for lack of proper stone and because of the civic nature of the structures, but in the Kyklades certainly for personal preference. Once again, it would seem that demand promotes experimentation and progress, but that these are greater where imperialistic ambitions prevail and traditions dictate. The Parthenon, or at least Athens, may have cast a long and powerful shadow.

NOTES

1. These comments have been summarized from the Colloquium Abstract, "Mao's Mausoleum," distributed to members of CASVA in advance of the presentation.

2. The most recent account of the excavations, with latest interpretations and extensive bibliography, is Jeppesen 1992, on which many of my comments are based; also significant are Waywell 1993 and his contribution (1989) to the Uppsala 1987 symposium: *Architecture and Society in Hecatomnid Caria*. In that same volume, note Jeppesen, Pedersen, Voigtländer, and, on the friezes, Cook (all 1989). The Danish series is: *The Maussolleion of Halikarnassos: Reports from the Danish Archaeological Expedition to Bodrum* (Copenhagen); vols. 1 ("The Sacrificial Deposit," 1981), 2 ("The Written Sources," 1986), and 3. 1–2 ("The Maussolleion Terrace and Accessory Structures: Texts and Appendices" and "Catalogue," 1991) have appeared. For a good, important synthesis, with special reference to the Amazonomachy frieze, see Ashmole 1972, 147–91. A concise but helpful account of the present state of the question is Waywell 1988, which includes (107, fig. 52) a plan of the site showing the areas excavated by Newton and by the Danish expedition. The basic catalogue of the free-standing sculpture is Waywell 1978. More general mentions in Todisco 1993, 32–33; Stewart 1990, 180–82; Boardman 1995, 27–29, figs. 17–22. Other references will be given infra.

It should be noted that Jeppesen (*Sources* 1986, first section, with synopsis on pp. 110–13; repeated 1992) has suggested several emendations to the ancient texts as usually recorded; he therefore occasionally bases his interpretation of the evidence on his own readings of Pliny and Vitruvius, which will not necessarily be followed here.

Architectural Sculpture in the East (Greek)

3. For a possible honorary decree at Tegea, see supra, Chapter 2, nn. 65 and 74, with reference to Waywell 1993, where other Greek benefactions are listed. For an historical account of the Hekatomnid period, albeit with some controversial theories, see Hornblower 1982. For Hekatomnid buildings at Labraunda, see Hellström and Thieme 1982, 45–46.

4. For a recent model of the site, of the terrace with the propylon, and of the Maussolleion itself, see Jeppesen 1992, esp. pls. 27–30.

5. See, e.g., the references provided by Lauter 1971 about the role of Herakles in the marketplace, albeit in another context.

6. Jeppesen 1992, 97–98, emphatically points out that the animals deposited at the entrance to the funerary chamber were not burnt, as for a hero cult, and that the raw flesh was therefore meant for Maussollos. Note that the burial chamber is not oriented with the propylon, nor is it centered within the podium, but is shifted toward the NW corner, either to mislead possible tomb robbers or to be in closer association with the earlier burials.

7. An even more inflated account of Artemisia's actions is given by Aulus Gellius (*NA* 10.18). Cicero (*Tusc.* 3.31) says that Artemisia pined away for grief at her husband's death. See the entire discussion of the topic in *Sources* 1986, 102–9 with other ancient references.

8. Jeppesen (*Sources* 1986, 55–59) would emend the Plinian wording—*supra pteron pyramis altitudinem inferiorem aequat*—to read: *supra pteron superficies pyrae modo altitudini inferiorum accrevit*, thus implying an allusion to a funerary pyre.

9. Karian and Anatolian prototypes: Voigtländer 1989; R. Carter 1982. Persian prototypes, and tomb at Taş Kule: Cahill 1988. Mesopotamian and Egyptian precedents: Fedak 1990, 32–37; see also pp. 71–74 for discussion of the Maussolleion. Persian and Near Eastern use of light and dark: Nylander 1970, 142–43. For the Nereid Monument and the Temple of Zeus at Labraunda, see supra, Chapter 3. Comparison with the Maussolleion, and attribution to same workshop: Hellström and Thieme 1982, 55–56; Cook 1989, 40–41; Carter 1990, 132–33; Rumscheid 1994, vol. 1, 17–18, vol. 2, 21–22, no. 64, pls. 46–48. The possible prototype of the Lion Tomb at Knidos will be discussed infra. On the Athenaion at Priene as a Hekatomnid project, see infra.

10. On the Belevi Mausoleum, see, e.g., Ridgway 1990, 187–96; add a reexamination of the evidence, with different reconstruction, by W. Hoepfner, "Zum Mausoleum von Belevi," *AA* 1993, 111–23; Rumscheid 1994, vol. 1, 70–76, vol. 2, 8–9 no. 28.

11. For a chart comparing tomb structures of various heights, see *Götter, Heroen, Herrscher in Lykien* (Vienna/Munich 1990) 193; the Maussolleion, at over 50 m., is the tallest, but note the considerably larger and almost equally high Mausoleum of Augustus.

12. Table of different attributions, from 1882 to 1965: Cook 1989, 36. The join between slabs 1007–8 and 1010 (Ashmole 1969) is best illustrated in Ashmole 1972, figs. 201–2; Herakles, identifiable through club and lionskin, appears on slab 1008. Note Ashmole's comment on p. 167: "it is disconcerting that for a hundred years scholars have spent their time and ingenuity in trying to assign every slab by name."

Jeppesen 1992, 94–95, calculates that of the original length of c. 114 m., approximately 26 m. of the Amazon frieze are attested from extant fragments. For one of them found in Kos, which joins slab 1022, see Stampolidis 1987.

13. Waywell 1988, 108, on findspot; a slightly different account is given by Cook 1989, 35–36, who stresses that the reliefs were not found simultaneously but over several weeks, and had been reused in the foundations of some Turkish houses. For the slabs and the new

Architectural Sculpture in the East (Greek)

fragment in sequence, see Ashmole 1972, figs. 206–8, 211. Good illustrations of the "Skopasian" Amazon: Stewart 1990, figs. 530–31; Boardman 1995, fig. 21.1. Dresden Maenad: see, most recently, Todisco 1993, 82–83, pl. 138; this statue will be discussed with other attributions to Skopas; cf. infra, Chapter 7, n. 55.

14. As Cook 1989, 40, well states it: "Compared to the lavish quantity of free-standing sculpture, which added to the architectural impact of this extraordinary monument and contributed to its claim to be numbered among the Seven Wonders of the World, the frieze can now be seen as little more than an architectural ornament to which the accident of preservation lent for a while a repute disproportionate to its original importance." On the difficulty of attributions, see also Schiering 1975; Scheibler 1975, esp. 160 n. 7, and cf. 156 with n. 29 for refs. to authors stressing the importance of *caelare*.

For the signed block of the Chariot frieze, see Jeppesen 1992, 87, pl. 23.2. One wonders at the purpose of a signature on a block that could not be read from ground level; we either have to assume personal pride, or identification of work that required a different form of payment, or even, although less likely, a possible repair.

15. Timotheos: see supra, Chapter 2; also Stewart 1990, 274, and cf. 181, where he considers him "of uncertain nationality." Todisco 1993, 58–61, would see him as native of the Argolid. For the Vitruvian attribution, see also infra, n. 17 under Leochares.

16. Skopas trained at Epidauros: Stewart 1977, 90; Todisco 1993, 80. Parian peristyle sanctuary to Hestia: Gruben 1982, 621–83, esp. 640 fig. 13 (general, hypothetical plan), 652–56 and fig. 24 (discussion of the apse), 667–76 (discussion of building and statue). Dio Cassius (55.9) mentions that Tiberius, while in voluntary exile in Rhodes, as a private citizen, forced the Parians to sell him a statue of Hestia, which he then dedicated in the Temple of Concord. Because of the element of coercion, it is assumed that the image was important, either because it served a cult purpose or because of its authorship. Pliny's listing of a Hestia by Skopas in the Horti Serviliani (*NH* 36.25) was connected by Lippold with the Tiberian purchase, and is accepted by Gruben, who believes the sculptor was thus active in Paros c. 360, although almost 20–40 years later than the refurbishing of the sanctuary (pp. 674, 676–77).

Maussolleion statuary (Head BM 1051) in Parian marble: Carter 1990, 134; see also infra, n. 49. Literary sources on Skopas' activity in the eastern area: Stewart 1977, 127–33; Stewart 1990, 284–86.

17. Bryaxis of Athens: Stewart 1990, 282, but cf. 181, where the possibility that he was a Karian is mentioned; Todisco 1993, 88–91, where the name is considered Karian, and the younger Bryaxis seen as the grandchild or son of the elder; the Hekatomnid statues ("Maussollos" and "Artemisia") are attributed to him.

Leochares: Stewart 1990, 282–84; Todisco 1993, 103–7. The attribution of the Ares statue is based on Vitruvius (2.8.11), whose text, however, twice reads "Teleochares." Jeppesen (*Sources* 1986, 82–83) would emend the passage so extensively that two statues would be cited: one of Artemisia in the sanctuary of Ares, and one of Maussollos, akrolithic and colossal, by either Leochares or Timotheos. On the sculptor, see also infra, Chapter 7.

Maussolleion free-standing statues in Pentelic marble: Carter 1990, 133; S. Walker's abstract cited by Carter, *AJA* 91 (1987) 313, does not go into detail beyond mentioning the Asiatic marble. At the conference on sculpture from Karia and the Dodekannesos held in London in 1993 it was, however, stated that the Amazonomachy frieze is in Prokonnesian marble (ref. P. G. Bilde).

Architectural Sculpture in the East (Greek)

18. Pytheos and Satyros: Carter 1990, esp. 132–33; Cook 1989, esp. 40–41; Hellström and Thieme 1982, 56. Brief mentions also in Waywell 1993; Todisco 1993, 32, 45; and Stewart 1990, 180–81. Note that the last (p. 182) still finds it "exceedingly tempting to allot the principal role" at the Maussolleion to Skopas because of stylistic similarities with Tegea and because "in antiquity he far outshone the other three"—a statement based primarily on the frequency of ancient mentions and an inflated list of attributed Roman "copies."

The long period of construction of the Athenaion at Priene will be considered infra. For the buildings on Paros, see refs. supra, n. 16, and Chapter 2, n. 92.

19. See *AntDenk* 2.2, pl. 18; all Maussolleion slabs and fragments as drawn in *AntDenk* are reproduced in *EAA Suppl.: Atlante dei complessi figurati* (Rome 1973) pls. 204–10, with the Centauromachy on pls. 208–9. One good photograph in Ashmole 1972, 164 fig. 188 (slab BM 1032). Note his comment (p. 164): "one has a feeling, very rare in Greek reliefs but not uncommon in Roman, that the figure has been sliced in half and placed against the background." Jeppesen 1992, 94–95, does not include the Centauromachy frieze in his outline review of the sculptures on the Maussolleion (nos. 1–11)

20. Jeppesen 1992, 94–95 (no. 6) estimates that c. 36 m. of the frieze length can be inferred from the extant fragments, out of a possible total length of c. 82 m. Proportionately, therefore, this frieze would be better preserved than the Amazonomachy. Nine charioteers were already known, and another has now come to light, as well as additional fragments. Although comparison with the great quadriga is tempting, note that the wheels on the frieze have only four spokes, as contrasted with the much larger and six-spoked wheels of the freestanding chariot. For good photographs, see Ashmole 1972, figs. 182, 185–87 and comments on pp. 159–62; he believed that the frieze ran around the inside of the cella, a suggestion repeated by Stewart 1990 and Todisco 1993. Note, however, that the best-preserved charioteer (Ashmole, fig. 187, slab 1037) was reconstructed from two unrelated fragments: Cook 1976, 53 no. 8, pl. 7e; Boardman 1995, fig. 22.

On Archaic chariot friezes and "monotonous" terracotta revetments, see, e.g., Ridgway 1993, 377–84, with refs., to which add: M. Mertens-Horn, "Die archaische Baufriese aus Metapont," *RM* 99 (1992) 1–122. For later meanings, see Tancke 1990.

21. Tancke 1989, 18–22, section 2.2.1, cat. nos. 3.1–10 on pp. 229–32, pls. 10–19. Her reading seems accepted by Jeppesen 1992, 86. Waywell 1988, 120, mentions only the Deeds of Theseus. Technical and sculptural comments also in Carter 1983, 59–70.

22. Waywell's theories are expressed most extensively in his 1987 catalogue, but have been somewhat refined by further publications of the new architectural finds. See therefore his discussions and reconstructions in Waywell 1980, 1988 (esp. 109–13, for Newton's excavations, and 120), and 1989 (acceptance of lifesize and heroic figures on different sides of building; question on presence of statues between columns, and if so, which). Jeppesen's most recent publication is 1992, with tabulation of all sculptures and distributions on pp. 94–95 (entries 1–11); each entry includes number of extant fragments and postulated totals. For other comments on the sculptures, see also pp. 79–85, and the models, pls. 19–32.

It would seem reasonable to place the lifesize figures closest to the viewers, and the progressively larger ones higher up on the monument, to ensure proper visibility. On the other hand, the opposite may work to greater effect, the psychology of vision suggesting to the viewers equal size diminished by the enormous height of the building, as on the Nereid Monument.

Architectural Sculpture in the East (Greek)

23. Seated figure, BM 1047: Waywell 1978, 44–45, 108–10, no. 33, pl. 17; Todisco 1993, pl. 166; Jeppesen 1992, 80 (depth), 95 (comparison with the Parthenon frieze), pls. 27.2, 29.1, 30. Note that Waywell 1978 records a depth of only 1.12 m., but Jeppesen may estimate the original dimension (before breaks?). The figure sits on a cushioned stool with support under the seat; its legs were bare below the mantle, with traces of footwear. Would the tomb owner have been shown on a throne?

24. Squatting Oriental (scribe), Izmir Museum 506: Waywell 1980, 8–10 and bibl. on p. 11, figs. 7–8 (perhaps within tomb chamber); 1989, 30, figs. 13–14 (on podium, perhaps next to seated figure). This statue is not catalogued in Waywell 1978, because it is not in London; it was, however, found in 1918 within Bodrum Castle, and at first was not connected with the Maussolleion, although Waywell believes it is from that monument. If so, it would be the only human figure spared from the lime kilns by the Knights.

Belevi servant: Ridgway 1990, 193–95 with refs., pl. 86; deceased, pl. 88.

25. Oriental rider, BM 1045: Waywell 1978, 110–12, no. 34 (plus seven fragments probably belonging to the horse), pl. 8; Stewart 1990, fig. 527; Boardman 1995, fig. 18.3. Note that traces of a painted saddle could be seen when the piece was first found. For a panther (BM 1095) belonging to the hunt, see Waywell 1978, 173–74, no. 371; Stewart 1990, fig. 528; Todisco 1993, pl. 172.

26. See, e.g., definitions and discussion in Ridgway 1990, 79, 109–11, with refs.; on a more general level, Stewart 1990, 78–81. For a more traditional view, see Ashmole 1977, 17–18 and n. 28; and cf. his n. 17 (p. 16) for variant identifications of the two statues.

"Maussollos," BM 1000: Waywell 1978, 68–70, 83–84, 97–103, no. 26, pls. 13–15; Stewart 1990, 181, figs. 535–36; Todisco 1993, pl. 165. The figure held a scabbard (with sword?) in the left hand, probably a phiale in the lowered right. Its head, carved separately, was joined to the body by the mortise and tenon technique, as were the heads of several other statues from the Maussolleion.

"Artemisia," BM 1001: Waywell 1978, 70–72, 83–84, 103–5, no. 27, pl. 13; Stewart 1990, fig. 535; Todisco 1993, pl. 163. Her head is carved in one piece with the body. Both figures are shown together in Boardman 1995, fig. 19.

27. Buschor 1950 extended his comments to the Amazonomachy slabs: see, e.g., the chart provided by Cook 1989, 36, where the "second series" advocated by the German scholar is indicated by lowercase letters (slabs 109, 119, 122). Ancient sources mentioning damage to Halikarnassos include Strabo, Arrian, and Diodorus Siculus; they are collected and discussed by Luttrell in *Sources* 1986, 127–29.

Carpenter 1960, 214–16, would date the "Maussollos" c. 150, the "Artemisia" c. 100, because the baroque emphasis of the male drapery is toned down in the female's; other works from the Maussolleion assigned by him to the "Pergamene" style are the Oriental rider, BM 1045, and the head of Apollo, BM 1058, now assigned to the roof decoration. Havelock 1971 adds to Carpenter's stylistic points. Ashmole 1977 strongly opposes both points of view, and he is certainly correct in rejecting for sculpture a stylistic and cultural evolution comparable to biological evolution (p. 14). But his citations of 4th-c. reliefs serve primarily to confirm iconography, and other comparisons may be somewhat weakened by current knowledge (e.g., the Alexander head Akr. 1331 [Todisco 1993, pl. 223] is now considered a Roman copy rather than an original). Waywell and Jeppesen can argue instead from excavational evidence.

28. This similarity was pointed out orally by G. Ferrari Pinney when the first reconstruc-

Architectural Sculpture in the East (Greek)

tions of the Maussolleion podium appeared. It is made even more apparent by the most recent reconstruction of the Pergamene monument: W. Hoepfner, "Zu den grossen Altären von Magnesia und Pergamon," *AA* 1989, 601–34, esp. 619–34, fig. 33 on p. 632.

29. Lions: Jeppesen 1992, 81–82, 94–95, nos. 9–10 (cf. no. 4). For the best-preserved lion (BM 1075), see Waywell 1978, 180–81, no. 401; Stewart 1990, fig. 537; Todisco 1993, pl. 171; Boardman 1995, fig. 18.2.

30. Apollo, BM 1058: Waywell 1978, 118–19, no. 48 (probably Class II, but larger because god), pl. 22; Stewart 1990, fig. 525; Todisco 1993, pl. 169; Jeppesen 1992, 81–82. The long strands raised over the forehead suggest a bow-knot hairstyle, which becomes popular only in the Hellenistic period, but incipient forms of the coiffure can be found, e.g., on the Apollo of the Mantineia base (Todisco 1993, pl. 289), and not enough is preserved on the Halikarnassos head to reconstruct the fashion exactly; Waywell describes it as having also a bun or topknot above the nape. His description is repeated in *LIMC* 2, s.v. Apollon, no. 569. On the bow-knot hairstyle, see Ridgway 1990, 93 and 107 n. 43.

31. Horse BM 1075: Waywell 1978, 85–86, no. 1, pls. 5–6; nos. 1–23 include all fragments of the team, nos. 24–25 catalogue the chariot; an Asiatic breed is suggested on pp. 67–68; a reconstruction drawing of the chariot is on p. 17, fig. 2 (also Waywell 1988, 115, fig. 58). The six-spoked, oversize wheel (carved in two pieces?) is in keeping with Persian practices. The horses' legs, as far as can be judged from the fragments, are straight, and therefore no motion was implied for the chariot, yet Waywell 1978, 85, reads the horses' musculature and facial features as indicating the end of "a tremendous exertion." The forelock of the well-preserved head is rendered in loose, flowing strands over the forehead, and not in the high, knotted Persian fashion. I would therefore tend to read the shorn mane in Greek terms. Note that the horses of the Amazonomachy frieze have shorter, crew-cut manes, albeit with long forelocks blown back by their motion. Horses in "real life" scenes on the Limyra and Xanthos heroa seem to have the same crew-cut mane. Waywell 1978, 22, queries whether the tails of the Maussolleion team might have been clipped to show mourning; cf. his pp. 21–25 for a thorough discussion of possible occupants of the chariot and related meanings. It may be useful to recall how important the imagery of the bronze chariot crowning a triumphal arch will become for the Romans.

A saddled but riderless horse may have been part of the funerary imagery in Anatolia; note the animal being led by an attendant on the outer frieze of Heroon G at Xanthos, c. 460: H. Metzger and P. Coupel, *Fouilles de Xanthos 2: L'acropole lycienne* (Paris 1963) pl. 38.2. A similar horse, in the round, has now been found at the Limyra Ptolemaion, c. 270: G. Stanzl, in "Grabungen und Forschungen in Limyra, 5: Die Ausgrabungen am Ptolemaion 1984–1990," *ÖJh* 61 (1991/92) Beibl. cols. 151–60, fig. 12.

For photographs of the best-preserved horse, see also Stewart 1990, fig. 538; Todisco 1993, pl. 170; Boardman 1995, fig. 18.1.

32. That the Athenian point of view, at least, had not changed in this respect may be shown by Isokrates' address to Philip II. After the Peace of Philokrates had been negotiated between Macedonia and Athens (in 346), the orator exhorted the king to lead an expedition against Persia on the strength of his descent from Herakles (which would make all the Greeks follow him), and in view of the successes achieved by the hero against the barbarians: Isokrates to Philip, paras. 105–14, cf. Connor 1966, 84–85.

33. To these considerations, Ashmole 1972, 164–65, adds the contrast of colors—"the

white bodies of the Amazons against the brown bodies of the Greeks"—and the appropriateness of the subject of warrior women for a country that had produced two such queens, both named Artemisia. Here again, however, the outcome of the mythical battle would have contrasted with the allusion.

34. The two can be most readily compared in Ashmole 1972, figs. 188 (Centauromachy) and 194 (Amazonomachy) respectively. The damaged surface of the first does not retain the muscular detail visible in the second, but the pose is the same. That Greek on slab 1020, however, wears his hair like the second man on the Centauromachy slab, who moves in profile to the right.

35. A detailed publication by Brian Cook is forthcoming. Note that several fragments once erroneously added to the frieze when it reached the British Museum have now been removed: Cook 1976. The Amazonomachy slab once in Genoa (BM 1022) has not only had its top molding chiseled off, but it may have been slightly recut and overcleaned: Ashmole 1972, 168, fig. 191. Slabs 1014, 1006 ("Kaineus" motif), 1020 (overlarge, helmeted Amazon), 1022, 1015 (Amazon riding backward) are illustrated in Boardman 1995, figs. 21.1–5.

36. Cook 1976, 52, no. 2, pl. 6d, points out an erroneous addition to the arms of the shooting Amazon on slab 1007, and suggests a painted bow because of the lack of attachment holes for a metal one.

37. On this figure, see the comments by Ashmole 1972, 170–73, fig. 194: he admits the ambiguity of its sex, but "on balance" decides in favor of an Amazon, albeit a special one. He also points out how the pelt visible on one side becomes a garment when it passes behind the figure's back to emerge on the other side. The dying, nude Amazon is Ashmole's fig. 220 with description on p. 191; cf. Stewart 1990, fig. 534.

38. Ashmole 1969, after discovering that 1008 and 1010 form a single, very long slab, has suggested that the nude warrior seen from the rear, fighting a mounted Amazon, next to Herakles, could be Theseus, although he acknowledges the difficulty of having two Amazon queens. He even advances the possibility that each side of the Maussolleion depicted a different Amazonomachy, thus envisaging one with Penthesileia. The Attic helmet of the "Theseus" is distinctive, but it is not the only one on the frieze; nor is his complete nudity unique. I am therefore hesitant about this identification.

39. By true transparency I mean here what I defined in Ridgway 1981a, xviii: "the effect obtained by carving very few ridges over an entire surface, so as to give the impression that the cloth adheres almost entirely to the body. The sculptor can then model the figure as if it were naked, adding a fold or two at wide intervals [or along the *contour* of the anatomical feature to be revealed] to betray the presence of the dress."

40. These comments, as well as some on the friezes, are based on notes taken by me in front of the sculptures during a visit to the British Museum some years ago, and therefore reflect personal impressions and observations rather than published descriptions, unless otherwise indicated.

41. On press folds at the Maussolleion (and at Priene), see Carter 1990, 132; in general, Ridgway 1990, 219 and n. 12 on p. 240 with bibl. For a far more speculative interpretation in the context of Egyptian art, see now P. A. Bochi, "Ancient Egyptian Art at the Walters Art Gallery," in *Center 14: Record of Activities and Research Reports June 1993–May 1994* (CASVA, National Gallery of Art, Washington, D.C., 1994) 45–47. In studying an ivory

Architectural Sculpture in the East (Greek)

statuette of a man with trapezoidal apron (Baltimore, Walters Art Gallery 71.509, 12th Dynasty, 1991–1783 B.C.; fig. on p. 46), she notes its pattern of alternating single and double lines, considers them press folds, and believes that, "more than an allusion to fashion and socioeconomic status," they are "a visual metaphor for religious beliefs" and aspirations for the afterlife. Although Egyptian influence is often advocated on the Maussolleion, it is doubtful that such specific concepts could have survived the changes in time and location; but the suggestion is worth considering.

42. Morrow 1985, 84–85, pl. 60. Many shod feet exist among the Maussolleion sculptures; Morrow lists six wearing *trochades* and 12 wearing *krepides* (pp. 73–75). Note, however, that in this case a date for the shoe form is strongly suggested by the structure rather than vice versa: n. 1 on pp. 203–4. The shape originated on the Greek Mainland and was probably carried over to East Greece through the islands.

43. On the *orans* pose, see Ashmole 1977, 18–19 and n. 32; he also compares Artemisia's and Ada's hairstyles on p. 19 and pl. 8.1–3 with a good close-up of the latter, on which see also infra, n. 49.

44. Female head BM 1051: Waywell 1978, 106–7, no. 30, pl. 16; Todisco 1993, pl. 164. Note that its back is covered by a cap, and that its curls are articulated by spiral incisions, as contrasted with the globular masses of "Artemisia." See also infra, n. 49, for comparison with the head from Priene.

Male head BM 1054: Waywell 1978, 115–16, no. 45, pl. 20 (with comments on its classicizing form); Stewart 1990, fig. 526; Todisco 1993, pl. 168; Boardman 1995, fig. 20.

Male head BM 1055: Waywell 1978, 117–18, no. 47, pl. 22; Todisco 1993, pl. 167. The top of the head, although partly damaged, was also separately attached.

45. My information is derived from W. Koenigs' lecture, "The Temple of Athena at Priene: Doric Design in Ionic Appearance," delivered on April 3, 1993, at the Second Williams Symposium on Classical Architecture sponsored by the University of Pennsylvania. Publication of the papers from the symposium is forthcoming. I am indebted to Prof. Koenigs for discussing the chronology of the Athenaion with me. See also his similar statement cited by M. J. Mellink, "Archaeology in Anatolia," *AJA* 97 (1993) 126–27. Note that the Athenaion was rededicated by the *demos* to Athena Polias and Augustus some time after 27 B.C.: Carter 1983, 41; Rumscheid 1994, vol. 1, 42–45, with discussion of the chronological issue, vol. 2, 69–71, no. 293.

For the architectural similarities among the three buildings, see supra, nn. 9, 18, and Chapter 3, n. 44.

On the 3rd-c. altar of the Athenaion, see Ridgway 1990, 164–67, with bibl. in n. 16 on pp. 202–3; note esp. the review of Carter 1983 by R. Fleischer, *Gnomon* 57 (1985) 344–52, in favor of the traditional mid-2nd-c. date. The review by R. R. R. Smith, *JHS* 105 (1985) 233–34, is more favorable to Carter's chronology. The Priene Altar, as now reconstructed (with high-relief figures on a podium behind Ionic columns; cf. Ridgway 1990, 165 ill. 22), may well imitate the Maussolleion cella arrangement, although influence from the Sarcophagus of the Mourning Women (to be discussed infra, Chapter 5; cf. **Pls. 47a–b**) is also possible. A late 4th-c. date preceding the creation of Eutychides' Tyche for the iconography of a Muse sitting with legs crossed (as it appears on the altar) is now supported by S. I. Rotroff, "Building a Hellenistic Chronology," in J. P. Uhlenbrock, ed., *The Coroplast's Art: Terracottas*

of the Hellenistic World (New Paltz, N.Y., 1990) 22–30, esp. 27–28 and fig. 17 on p. 29. A terracotta figurine in that rare pose was recovered from a Kerameikos building collapsed before 310, as reported by U. Knigge in *AA* 1980, 263–65 (fig. 14 on p. 264) and *AA* 1981, 385–89.

Traces of fire on the marble feet of the akrolithic Athena Parthenos in the Athenaion have been noted by Carter 1990, 135; these correspond to blackening on slabs and moldings assigned to the base for the cult statue, with which they must be contemporary, and which belong to "phase one" of the temple construction. He therefore would now reject the traditional mid-2nd-c. chronology for the Athena. The 4th-c. date for the image is accepted by Weber 1993, 83–99, esp. 97–99, with the suggestion that the statue was sponsored by Alexander the Great after the Battle of the Granikos.

46. See discussion of the Prienian chronology in Carter 1990; he addresses there recent revisionist theories on the founding of the city and the temple, and therefore supplements and supersedes Carter 1983, 25–38 and 231–37 (on coin deposit, statue, and base). See also comments and bibl. supra, n. 45, esp. Rumscheid. Carter 1983 remains, however, the fundamental publication of the Priene coffers (history of scholarship on the reliefs on pp. 38–40); additional stylistic comments in Carter 1979 and 1990, the latter with specific comparison to the Maussolleion sculptures, and summary of previous theories on pp. 129–30. His position is supported by Cook 1989. For Pytheos' sketch, see Koenigs 1983, 165–68, 176 fig. 1, pl. 44.1. The fragmentary block cannot be assigned to a definite place within the temple.

47. Two additional fragments (cat. nos. 66 and 67) share the same subject but are in a different marble and may belong to a Roman monument; this is an important conclusion, since these better-preserved pieces have been occasionally illustrated as representative for the entire complex of relief coffers. For a tabulation of fragments and tentative identification, with possible stylistic clustering, see Carter 1983, 83, table G; his diagram H on p. 89 gives a hypothetical arrangement of the entire peristyle ceiling. All catalogue numbers given henceforth, as well as all basic information, are from that publication unless otherwise specified. Note that Koenigs 1983, 157–59, would place stone coffers also on the opisthodomos, thus calculating a total of 29.

Tancke 1989, 30–41, section 2.3.2, cat. nos. 6.1–55 on pp. 243–61, pls. 25–30, not only lists fewer fragments but retains the 2nd-c. date (second quarter) and considers valid all comparisons with the Pergamon Altar. One of her reasons for the later date is the height of the Priene reliefs, yet she can list no other example of similar narrative coffers during the Hellenistic period, except for the Belevi Mausoleum (her section 2.3.1 on pp. 25–30, cat. nos. 5.1–21 on pp. 234–42, pls. 22–24), which is rather influenced by both Halikarnassos and Priene.

48. This type of comparative stylistic analysis is limited to Carter 1990; the various catalogue descriptions in Carter 1983 are quite autonomous (although possible similarities with other monuments are mentioned) and highly informative. Less helpful, because subordinate to the goals of creating stylistic clusters and grouping anatomical and drapery renderings, are the synthesizing comments in Carter 1983, 77–81.

49. Head BM 1151, from Priene: Carter 1983, 271–76, cat. no. 85, pls. 39, 40a–b, 47a, d, and color frontispiece; the description includes the suggestion of the gold headdress, which he calls *tettix* and compares to Greek renderings but I would leave unnamed. Wooden and

Architectural Sculpture in the East (Greek)

gilded *tettiges* are listed among the gifts offered at the Athenian Asklepieion: for a commentary considering them ear pieces, see Aleshire 1989, 154 (inventory III, lines 20–21); I owe this reference to S. G. Miller-Collett. G. R. Edwards has called my attention to a gold hairpiece called *stlengis* and considered typical of the North Pontic region: D. Williams and J. Ogden, eds., *Greek Gold: Jewelry of the Classical World* (New York 1994) 185, no. 119; cf. also p. 205, no. 135 for female head pendants (Io) wearing a *stlengis* over the forehead.

Drapery fragments have also been connected with the head in London: Carter 1983, 315–18, cat. nos. 126–30, and drawing of painted patterns on p. 275, fig. 29. The information on the marble type, with additional comments, is given in Carter 1990, 134. Kreikenbom 1992, 7–8, discusses this head in the context of the earliest colossal images of mortals made by Greeks, and would date it either before 340 or after 333 (cf. cat. no. I.3, pp. 116–17). Although the "Maussollos" and "Artemisia" would predate the Priene piece, their size may have been dictated by the building complex in which they stood (cf. pp. 115–16, cat. nos. I.1, I.2a–g); Karian nationality may also have been a factor.

50. Bust of young girl, BM 1153: Carter 1983, 276–78, cat. no. 86, pls. 40c–e, 47b; the Neronian dating is due to Rosenbaum (ref. in Carter), the Classical to Waywell and Carter, who include comparisons with the two heads in Berlin: Blümel 1966, 86–87, nos. 104 (inv. 1536) and 105 (inv. 1535), figs. 138–41; note that both have pierced earlobes, for the insertion of metal earrings. The Berlin heads are also illustrated in Todisco 1993, pls. 189–90. Carter suggests that the girl from the Athena sanctuary, at small lifesize scale, could represent a maiden in the service of Athena, but the presence of similar works (Berlin no. 104 being also a statuette, and no. 105 being half-lifesize) from the cella of the Demeter sanctuary makes me think of possible priestesses.

51. Samothrake Propylon: Ridgway 1990, 26–28, 63 n. 10; Ridgway 1993, 454, 455, 467–68 n. 21, and 469 n. 27. Add: Tancke 1989, 22–25, section 2.2.2, and cat. 4.1–7 on pp. 232–34, pl. 20, on the relief coffers. Stewart 1990, 285–86, relates Lehmann's attribution to Skopas, apparently with approval, whereas Todisco 1993, 85, doubts that Skopas was the maker of cult images at Samothrake (on which see infra, Chapter 7, n. 50), and does not mention the Propylon, perhaps discounting the presence of the master on the island.

Ephesos Artemision: Ridgway 1990, 28–30, 63–64 nn. 11–13, with bibl. Add: Stewart 1990, 195, 204 (workshop connection with the Athenaion at Ilion); Boardman 1995, 29–30, figs. 23.1–4. Trell 1988 gives an account of the later history of the temple and is a strong advocate for the pedimental Amazons: see her fig. 45 on p. 91 for Roman Imperial coins showing the temple façade, and fig. 49 on p. 99 for a Salvador Dali painting of the temple after the numismatic representations. Rügler 1988 is reviewed by U. Muss, *Gnomon* 62 (1990) 61–65, who seems to doubt his contention that the pedestals supported the carved column drums (despite correspondence of dowel-hole patterns), and chides him for dismissing all too hastily the possibility that the Smintheion in the Troad offers a strong parallel for carved drums directly below the capitals. Note that some of the figures from the column drums seem to wear trousered Persian dress, again in possible imitation of subjects from the Archaic Artemision. New fragments from both pedestals and carved drums: Büyükkolancı 1993, 100–4, cat. nos. 4–6.

52. The Temple at Messa was originally published by R. Koldewey, *Die antiken Baureste der Insel Lesbos* (Berlin 1890), but received little attention. It was extensively discussed by

Architectural Sculpture in the East (Greek)

Plommer 1981, who reproduced Koldewey's drawings (elevation: fig. 1 on p. 180; detail of entablature, fig. 2 on p. 181) and suggested that it was built around 400 (p. 184). Other scholars had proposed dates ranging from c. 300 to as late as 170, because of a possible connection with Hermogenes, given the pseudodipteral plan. The latest opinion is by Rumscheid 1994, vol. 1, 59–70; vol. 2, 43, no. 148, pls. 94–96. The author considers it the first example of the continuous frieze above the epistyle and below egg-and-dart and dentils (he dates the Samothrakian propylon to 330), but points out (vol. 1, pp. 65–66) that Temple D at Metapontion, in South Italy, had already achieved the combination frieze/dentils in the first half of the 5th c., another example of the innovative tendencies of outlying Greek areas. My description of the colored stones at Messa is derived from both Plommer 1981, 180, and Rumscheid 1994, vol. 1, 69. The comparison with the Erechtheion frieze was first made by Koldewey and is repeated by Plommer 1981, 184.

53. Temple of Hemithea at Kastabos: the main publication is Cook and Plommer 1966; most recently, see Rumscheid 1994, vol. 1, 19; vol. 2, 24–25 no. 78, pls. 52–53.

54. Lion Tomb from headland near Knidos: Waywell 1980, 5–7, with a reconstructed drawing by R. P. Pullan as fig. 3 on p. 6; he estimates a height of "over 40 feet," c. 12.20 m. (well below the traditional estimate of 18.60 m.). An approximate height of 20 m. is suggested by the comparative chart of heroa on p. 193 of *Götter, Heroen, Herrscher in Lykien* (supra, n. 11). Fedak 1990, 76–78, figs. 85–89, prefers a late 4th- or early 3rd-c. date. Rumscheid 1994, vol. 1, 20; vol. 2, 28 no. 92, pl. 60, dates "390s (?)." A. W. Lawrence, *Greek Architecture* (London 1957) 196, mentions 11, rather than 12, radiating burial chambers within the Lion Tomb, and adds that a lekythos found inside is of a type apparently just a bit later than 350, but he gives no specific source for his information. He states that all burials must have been simultaneous, since there is no doorway, and takes the location as indicative of a naval battle.

The Athenian polyandrion suggestion is tentatively repeated by Todisco 1993, pl. 175; but compare the Knidos beast with the conveniently illustrated lion of Amphipolis (360/59–340–330) on pl. 176, and that of Chaironeia (after 338) on pl. 177, both of them extensively overrestored, and contrast with the Maussolleion lion on pl. 171. Lion tombs and monuments are briefly discussed by Rice 1993, 248–53 and nn. (her pl. 4a shows the promontory with the remains of the Lion Tomb); I owe this ref. to T. Brogan. Note the inserted eyes of the Knidian lion, which must have added to its impressiveness.

CHAPTER 5

Original Reliefs

Funerary

The largest surviving category of fourth-century originals consists of various types of reliefs, and here for the first time in our survey we find Athens amply represented, with a series of gravestones that began shortly before the last quarter of the previous century and gained increased momentum until production was abruptly stopped in 317 by the anti-luxury decree of Demetrios of Phaleron.[1] Side by side with the funerary, votive reliefs also appeared, but in lesser quantity; finally, a third category comprises the so-called Record (or Document) Reliefs—the figured panels that were occasionally carved as the headings of official documents set up by the state for a variety of public purposes. Of the three groups, the last is the best dated because the accompanying inscriptions give the archonship, and therefore the year, of promulgation. Yet the fragmentary state of many such stelai has either separated text from picture or eliminated the chronological information, so that dates are not always as secure as we might wish. Other problems connected with Document Reliefs shall be mentioned later; it seems best to start with the category that offers the amplest evidence, and therefore the greatest opportunity for a relative chronology and for stylistic observations: that of the grave monuments.[2] To be sure, the same sculptors who carved funerary stelai were probably often asked to make votive reliefs, so that the separation of these two categories may seem arbitrary. Yet attribution of extant works to specific hands and workshops is controversial and usually considered too subjective to be valid. We shall attempt some comments in the next chapter.

It has been recently estimated that the entire Attic production of memorials (from c. 430 to 317) has survived in over 2,000 examples, including more than 100 found outside Attika proper.[3] By contrast, numbers from other parts of the Greek world are far smaller, and only two areas, Thessaly and Boiotia, can be said to have had a sustained output. The East Greeks, however, contributed some examples, and

Reliefs: Funerary

the non-Greek, Eastern, sphere has also yielded numerous sarcophagi among which the Sidonian exhibit a strong Greek stylistic component. We shall discuss these works separately, after the Attic ones. It should also be stressed that not all funerary monuments consisted of relief work, but some either were or comprised also sculpture in the round. Many such statues have been divorced from their context by the circumstances of their find, so that firm classification is often impossible, but a few can be mentioned, as we shall see.[4]

ATTIC FUNERARY SCULPTURE

As free-standing statues should be considered, for instance, the music-making **sirens** of Dexileos' precinct, which were discussed at the beginning of this volume (cf. Ill.1). Yet even in this case we cannot be sure of their date, since they may not have been set up simultaneously with the horseman's gravestone, and virtually no other monument from the fourth century gives us the chronological link that Dexileos' death during a historical encounter provides. In a period when Attika seems to have built few temples, and fewer buildings with architectural sculpture, we lack terms of comparison for the funerary reliefs, and sculptures in the round are either known solely through later copies or floating in time without safe determination.

One distinctive form of grave monument in the round is represented by the **stone vessels** set up as markers or as secondary decoration over Attic tombs, most likely in imitation of ceramic forms used earlier as grave goods and offerings or as part of funerary rites. Shape analysis could therefore provide an auxiliary clue to chronology beside the stylistic assessment of their painted or relief decoration. Yet even such vessels are relatively few, not all of them carry figured scenes,[5] and these latter, when included, are often of inferior quality as compared with the larger gravestones, so that chronological connections are hard to establish. Taken per se, these stone vases can, however, be very impressive, as exemplified, for instance, by a huge ribbed *cauldron with griffin protomai*, held aloft by large akanthos leaves and palmettes, now in the Athens National Museum. The vase itself recalls the bronze cauldrons of the Orientalizing period, some four centuries earlier, thus establishing a link with the epic traditions of the heroic age; the akanthos and palmettes carry funerary connotations, as well as the idea of rebirth and regeneration implied by vegetation cycles; the griffins probably have apotropaic function, as appropriate for a grave. The total monument is a tour-de-force of marble carving, and its height alone would have made it conspicuous amidst the other tomb monuments.[6]

More common among stone vases are two shapes derived from the ceramic repertoire: the *lekythos* and the *loutrophoros*. The former was a traditional offering, placed both on and within graves, that underwent a gradual monumentalization even in its terracotta form, through the class of the so-called Huge White Lekythoi with funerary painted scenes.[7] From them, it was but a small step to the marble

Reliefs: Funerary

version, probably already in vogue, which was always greatly embellished by paint, even when it carried relief figures. The loutrophoros was a ritual vessel, meant to carry the water for the bridal bath; its stone translation, either as amphora (with two handles, Pl. 30) or as hydria (with three handles), has been taken as an allusion to the unmarried status of the deceased whose tomb the marble vase marked, the amphora type being reserved for males and the hydria one for females. In view of the larger numbers of loutrophoros-amphoras, some of them attestedly for men in their prime or even elderly, as compared with the loutrophoros-hydriai, it had been argued that only young maidens were commemorated by the latter, because, beyond a certain age, a woman was no longer expected to marry, whereas no such chronological limitations existed for men; yet this theory seems not to have received general acceptance.[8] It also remains unclear what the use of a vessel shape involved in marriage rites was meant to symbolize; the lack of marriage on earth, marriage in Hades for the women, or simply the last important rite of passage, with death comparable to marriage in this respect, have all been suggested.

Plate 30

The **symbolic aspect** of funerary iconography is one of the major points of interest in most recent discussions of tomb monuments. That vase shapes carried specific significance seems a logical inference; yet no clear message comes to us from the very few stone *amphoras of Panathenaic shape* that have survived. Although it would be easy to assume that the deceased whose grave was marked by this type of memorial had been a victor in the Panathenaic games, this inference is not supported by the scenes carved on two examples from Marathon, of which only brief mentions have been made so far. Although differing in details, each exhibits two groups of two adult figures (one vase adding a child), and each includes the depiction of a bearded priest holding a knife, which creates a link between both works, although in neither can the priest be clearly identified as the deceased.[9] Did these vessels mark the family plot of an official involved in the religious aspect of the Panathenaic festival, so that the implicit emphasis of the relief scenes is on the priestly role rather than on the athletic competitions? And was this distinction important enough to be expressed by the chosen shape, although neither amphora may have marked the priest's tomb? Moreover, what should we make of the figureless vases of similar shape?[10]

One more type of vessel, only recently identified by Clairmont, is represented by a fragmentary *oinochoe* decorated with figures against a "patterned" background—that is, a decorative motif spread over the entire body of the vase, in this case consisting of vertical ribbing surmounted by a guilloche, in imitation of black-glazed ware (or vice versa?). Perhaps this shape should also be considered ritual, suggesting the pouring of libations. It is impossible to tell, however, whether this offering would allude to the funerary rites, the tendance of the tomb, a cult of the dead,[11] or the lifetime function of the deceased in the service of a deity.

There has been much discussion of **heroization of the dead** in tomb iconogra-

Reliefs: Funerary

phy. The tendency, perhaps encouraged by the romantic views of the nineteenth century, has been to interpret nudity or semi-nudity, frontality, special furnishings (e.g., thrones with sculptured armrest supports [Pl. 31], footstools), and large scale as signs of special honor paid to the persons commemorated by figured monuments. To be sure, epitaphs and Greek literary sources speak of the dead as being "bigger and better" than the living, and ancient oracles supposedly encouraged cities to take counsel with the dead, as founts of inspiration and wisdom if not of material protection.[12] The political exploitation of heroes and the emphasis on the recovery of hero bones are well-known events of the Classical period, and the earlier (Archaic) practice of placing over-lifesize statues of kouroi over graves has been taken as indication that heroizing notions existed even for the dead sons of aristocratic families in Attika.[13] Yet it has been correctly pointed out that each phase developed its own viewpoint, and that we cannot extrapolate from one to the next. In particular, Clairmont has strongly argued that heroization in Attic gravestones during the Classical period was limited to warriors who died in battle for the public good, and that even nudity connoted nothing more than pleasure in the fairness of the male body, albeit without the underlying notion of absolute beauty or the pursuit of its achievement, as demonstrated by the different anatomical renderings on the tombstones. To be sure, deceased warriors are usually shown clothed or in full armor (Pls. 32–33), but it is not clear to me, then, what elements would have signified heightened, heroic status to the viewers. I would agree that we have overstressed the concept of heroization in our interpretation of funerary iconography, but I would not go so far as to reject every possibility outside the military sphere; it seems likely to me that each monument could convey a variety of messages according to the level of understanding of its spectators through time, often beyond (or even regardless of) the specific intentions of its commissioner or its maker.[14]

It may be significant that **iconography** seems to vary according to the shape of the tomb marker itself. Schmaltz (1970) has pointed out that warriors and battle scenes seem to predominate on relief lekythoi, and that women appear in formulas quite different from those used on contemporary stelai. He also noted that the early marble lekythoi carried three- or even four-figured compositions—at a time when traditional Attic gravestones were still limited to two personages—only to reduce the number of their figures after approximately 370, as stelai increased theirs. Finally, he considered the apparent carelessness in details, the sketchiness in the rendering of garments, the progressive rarity of inscribed names, as indications that after 350 such stone lekythoi no longer served as primary tomb markers, but rather as subsidiary, flanking decoration for **naiskos stelai** or other forms of grave monuments.[15] During the second half of the fourth century, in fact, the most popular type of funerary sculpture was undoubtedly the elaborate, multi-figured stele (cf. Pl. 34) in very high relief, or virtually in the round, within an architectural, ever-deepening frame.

Reliefs: Funerary

Was the frame itself a form of heroization, as the name "naiskos stele" would imply? When the relief slab is topped by a pediment supported by antae (cf. Pl. 31), the human figures appearing within this architectural setting would have conveyed the impression of cult images within a small temple, of which several existed in Athens.[16] Yet such figures seldom faced forward, and profile poses, excluding the spectator, would have implied "narrative" rather than hieratic presence. It has been pointed out that persons assisting or surrounding the deceased should be understood as still alive, and therefore unsuited for the heroizing shelter of a naiskos, had this been the intention of the frame, which should rather be read as an excerpt from domestic architecture.[17]

Once again, I am not entirely convinced by the argument, since live worshipers and attendants would have visited the true, religious naiskoi, and, on the gravestones, difference in size would have sufficed to clarify the role of each image. But an intermediate position is probably closer to the mark: a frame that was already familiar to carvers from the sphere of votive reliefs and non-Attic funerary stelai (where juxtaposition of the living and the dead had an earlier history)[18] was adopted for the Classical Athenian tombstones, both for the protection of the relief and for its implications of permanence and status. Even if heroization was not intended, respect for the dead was certainly a consideration that might have been instrumental in suggesting the naiskos-like arrangement. And a gable provided additional space for (painted?) decoration and for subsidiary symbolism in the form of akroteria.

It is significant, in fact, that even gravestones topped by what looks like the lateral section of a roof, complete with tiles and antefixes (cf. Pl. 41), often add akroterial shapes that clash incongruously with the side-view depiction of the entablature. These "lateral" frames have been specifically connected with domestic architecture, offering, as it were, a glimpse inside the courtyard or the portico of the deceased's home. Yet it is equally difficult to understand why scenes of family unity, female adornment, athletic activity, even childbirth, should take place against the same background, which would in turn allude to interior and exterior space, as the case may be. The rendering becomes even more illogical when transferred to the relief panels of stone vessels, in a superimposition of symbols, and it is easier to see such sima roofs as conventional framing devices that may have lost an original, more specific meaning.[19]

In **compositional** terms, the naiskos stelai can be said to become progressively deeper, their relief figures higher and more numerous, from the second half of the fourth century onward, suggesting a semicircular arrangement through a staggering of planes. The narrow antae turn into veritable side-walls that may even carry their own subsidiary decoration, usually in very low relief, and the entire frame may be added separately around the carved slab, or figures may be sculptured in the round and set up within the shelter of the "naiskos." Yet this is not always

Reliefs: Funerary

the case, and in some instances the added frame may be relatively shallow although the multi-figured composition is quite high, as in a classicizing stele in New York (Pl. 35);[20] individual taste or the specifications of the burial plot may have dictated the format.

Plate 35

Another consideration influencing the composition was the changing concept of the individual and the family through time.[21] As the polis and its population expanded, a person came to be defined not only by his (rarely her, at first) civic context, but also, gradually, by his—and definitely her—familial relationships, as the focus shifted from outward activity to personal values. The change can be observed in a variety of fields: in the theater, from the lofty tragedy and the politically satirical Old Comedy to the Middle and New Comedy, concerned with love, greed, and personal feelings; in literature, from historiography to biography and oratory; in religion, from Olympian worship to the healing cults and the protecting heroes; in art, from the generic votive offering to the honorary statue of a family member or the "portrait" of initiates and devotees. In the realm of funerary monuments, this process of internalization (for want of a better term) can also be followed as a broad, general iconographic trend. Thus the Archaic period put its emphasis on the single figure, especially the prematurely dead, shown in isolation and characterized by costume or qualifying objects, such as a cuirass, a discus, or an aryballos. The revival of gravestones in the late fifth century again stressed the individual, but now occasionally accompanied by subsidiary figures that served an attributive function—not yet that of a mourning chorus expressing the family's feelings, but that of the providers (the carriers) of the attributes: an attendant offering a jewel box, a small servant carrying athletic equipment, a child suggesting a family man or woman. Finally, in the fourth century, with the flowering of Attic gravestones, this progression found its clearest expression.

In action stelai, like that of Dexileos (cf. Pl. 1), narrative suggested the event as well as the quality (valor) of the deceased, and his familial connections found expression in the monument's inclusion within a family plot, surrounded by other grave markers for his siblings. Although the single figure never disappeared from the funerary repertoire, eventually (especially during the second half of the century) the deceased came to be depicted in a wider family context, often stressing his or her link with the living through the handshake motif, while relatives and attendants received enough characterization to denote the hierarchical position of each within the group. They also served as mute and restrained commentary on the human loss and the collective grief—a task that was first given to fantastic figures like the mourning or musical sirens, or to free-standing statuary of servants in dejected poses that would have flanked the main stele depicting the deceased.[22] With time, this gathering of people within one frame came occasionally to be used as memorial for each of them, as they too died, and their names were all inscribed on the architrave, so that, in such cases, it is often difficult to determine who had been

Reliefs: Funerary

the primary recipient of this funerary offering, especially when the names do not exactly correspond, in gender and number, to the figures included on the stele.[23] This issue deserves special discussion, since it is clearly connected with the problem of whether fourth-century gravestones were specifically commissioned or were ready-made, stock-piled monuments to be bought on short notice, as a sudden death occurred.

To be sure, **economic considerations** must have played a significant role in the acquisition of grave reliefs, yet it is perhaps erroneous to assume that only the propertied and hoplite classes had access to good funerary sculptures.[24] To judge from today's practices in poor Mediterranean villages, even families with restricted financial means make considerable sacrifices to provide their dead with an elaborate memorial or a lavish funeral, in order to keep up appearances with their neighbors and to project the image of proper grief and respect for their deceased relatives, especially when familial ties are close. In fourth-century Athens, funerary expenditures may have shifted from ostentatious funeral rites, costly shrouds and burial clothing, or abundant grave gifts—impermanent and eventually invisible tributes—to increasingly elaborate tomb markers that were in perennial display and attracted public attention, set up, as they often were, along major arteries of traffic, either in Athens or in its demes. Such lavish dispersal of wealth must have prompted Demetrios of Phaleron's anti-luxury decree, and thus the virtual disappearance of monumental gravestones after 317. Yet, to be sure, throughout the fourth century, the smaller shafts with sunken relief-panels, the non-figured slabs with carved rosettes and inscriptions, the mediocre carvings on stelai perpetuating stock types that survive in large numbers, must have been readily available for the less affluent clientele. Does it follow that all good-quality monuments, especially those with over-lifesize figures, added metal ornaments, and elaborate frames, were specific commissions? Given the fact that at least one year would be required for a master and his apprentices to carve large gravestones,[25] can we assume that families were willing to leave the new graves unmarked for such a length of time?

Scholarly positions range from a complete assurance that all major tombstones were commissioned to the opposite belief that only a rare few were, with several intermediate views and opinions. Among the arguments advanced to support the ready-made theory, particular relevance is given to two of them: the fact that it is often difficult, on present evidence, to determine which figure within a group is meant to represent the deceased, and the recognition that tombstones, like most Classical epitaphs, say little about the dead and portray the same generic concepts—all men are wise and brave, good family members and citizens; all women are endowed with *sophrosyne, arete,* and all the virtues.[26] We shall discuss these points separately.

Irrelevant in single- or even, often, in double-figured compositions, **identification of the dead** becomes an acute issue in group representations; yet, had a stele

been expressly ordered for a specific death, there should be no doubt as to the person being commemorated. The problem received thorough attention in the first influential monograph in English to look beyond the stylistic and chronological classification of gravestones: K. Friis Johansen's *Attic Grave Reliefs of the Classical Period* (Copenhagen 1951). Acknowledging the difficulty of such determination, Friis Johansen proposed that the deceased should be recognized through outward signs of importance and respect: for instance, the seated position among standing figures, the more elaborate type of seat when more than one such is depicted, the direction of gazes focusing on a specific personage, the greater size, the heroizing "citations." We have already mentioned the potential meaning of the throne or the *klismos* with footstool. Yet subsequent studies have shown that a seated position within a group, although denoting special status, is not always indicative of the deceased, but simply of ranking within the family unit. As for gazes, the loss of painted details makes this determination difficult, as stressed by Clairmont.[27]

Yet gaze was considered a major clue by Himmelmann, in his 1956 monograph on the Ilissos stele—not the mournful glance of the living directed toward the dead, but the apparently vacant stare of the dead, which isolates them from their surroundings. Although the author acknowledged that connection was the central theme of Classical gravestones, he believed that such connection was broken by death, which transferred the deceased into a heroic sphere different from the mortal. We have already mentioned, however, that heroic nudity and the very concept of heroization have been doubted and challenged.[28]

Those who maintain that gravestones, even large ones, were prepared in advance suggest that details may have been left unfinished, to be filled in as requested by the potential buyer; thus, the traits of old age were superficially added (in the forms of crow's feet and wrinkles) to a standing woman on a stele in Athens that had originally depicted her with the same costume and head proportions as the seated female in front of her.[29] In cases where the inscribed names do not correspond to the persons depicted, the assumption that the buyer settled for the ready-made relief closest to his intentions and his family composition seems particularly plausible. This explanation applies not only to the larger monuments, but also to the smaller stelai and relief stone vessels, which, however, could certainly have been prepared as blanks, to be speedily completed on request.

The **generic message** of the monuments is the second valid argument in favor of prefabrication. Obviously, the dead had to be commemorated under the best possible light, and therefore certain desirable virtues that could apply to anyone were emphasized. Specificity is rare, the circumstances of death are seldom described, and, when they are, they are again generalized: a warrior dies fighting, a woman in childbirth—occurrences that require no individualizing details. Even scenes that may appear to depict daily-life events have now been read in symbolic and generic terms.[30] The frequent use of stock figures—such as the young boy with his toys (Pl.

Reliefs: Funerary

36), the young girl with her girded costume, the young woman with an attendant, the young man with athletic equipment—implies that such topics were in great demand, as infant mortality was high and age was a relative concept.

To be sure, as we shall see below, **age groups** can be determined on gravestones, on the basis of hairstyles and dress, especially for single or primary figures. But bereaved fathers and mothers may not have insisted on a precise chronological depiction with the same punctiliousness as an archaeological classifier. It has been pointed out, moreover, that the same person may be represented younger or older on different monuments regardless of chronological sequence, but rather according to the pattern of relationship. For instance, Prokleides is shown as old on the grave relief for his son, but on the *later* stone lekythos for his father he appears as a middle-aged man shaking hands with an elder. It has therefore been convincingly argued that depictions of age have primarily hierarchical values within family groups, and that traits of old age are "narrative" rather than representational.[31] No desire for true portraiture existed, and stock scenes emphasizing traditional family ties could have served many purposes.

Can the high quality of many stelai be reconciled with the concept of stockpiling? In other words, were major **masters** involved in the production of funerary monuments, and, if so, would they have been willing to conform to traditional patterns or would they have expressed their originality through new conceptions and compositions? Here, again, answers may vary according to individual understanding, some scholars believing that wealthy patrons could afford to hire the best sculptors available, while others think of grave stelai as the "anonymous product of an impersonal craft."[32] Undoubtedly, the artistic production of the time must have influenced the gravestone carvers, who "cited" these statues in their own works. This is why Attic gravestones are so important for our perception of fourth-century sculpture, as we shall discuss below with reference to style. But I am personally convinced that no major sculptor had the time, or perhaps even the inclination, to produce grave reliefs—certainly not Skopas and Lysippos, whose very presence in Athens may be doubted, but not even Praxiteles or his father, Kephisodotos, although their workshop may easily have accepted such commissions. At best, Praxiteles might have made some funerary sculptures in the round, but even Pausanias' attribution of a soldier standing near a horse on a tomb just outside the city gate need not be taken at face value.[33]

Clairmont believes that the "step-motherly treatment" given to Attic gravestones by survey books on Greek sculpture is due to the fact that no great names can be safely associated with them. Yet this is not strictly true, especially for those of us who place little reliance on the "attribution game," and for scholars like Picard and Vierneisel-Schlörb, who have devoted many pages to the subject.[34] The difficulty lies primarily in the sheer quantity of material, and the relative impossibility of creating a reliable chronological framework. It should be also noted, however,

Plate 36

Reliefs: Funerary

that the Classical period experienced a reversal of what had been established Archaic practices. During the sixth century, in fact, more sculptors' signatures appeared on funerary than on votive monuments, whereas none of the extant fourth-century gravestones carries a master's name, despite the frequently inscribed epitaphs and labels. I would agree that some gravestones stand out as "masterpieces," both compositionally and stylistically, and may have set the pattern for imitative renderings by other hands; I would also accept that a few (although not necessarily always the biggest or the best) were specifically commissioned.[35] But I still tend to see most of the funerary production as a "service craft" made available reasonably in advance of demand.

One final point, before embarking on a discussion of style: no funerary monument seems to have been made in bronze; all extant pieces are in marble and, outside Attika, occasionally in limestone, but the use of metal is limited to a few additions, like weapons and jewelry. It is obvious that cost alone could not have been responsible for this choice of medium, since elaborate, multi-figured gravestones would have been as expensive as a bronze memorial that could be cast from established (arche)types or models. That the goldlike, shiny surface of a metal statue might have suggested improper heroization is belied by the practice of honorary and athletic sculptures in bronze, nor would the sheer number of highly reflecting surfaces in one spot have been disturbing to the sight, since equal frequency existed in sanctuaries and marketplaces. Not even commemorative monuments for fallen warriors, like that for the Theban dead at Chaironeia (Pl. 37), were made in bronze, thus strongly suggesting that stone alone was considered appropriate for funerary purposes throughout Greece. This observation would in turn cast doubt on the tentative funerary identification of works known only through marble Roman copies but supposedly copying Greek bronze originals, like the fifth-century Hermes Ludovisi type.[36]

In terms of **style**, however, many Attic gravestones can rank on a par with the best architectural sculpture from elsewhere, and are often of better quality, probably because available for closer scrutiny, while providing a more continuous sequence. We do not find in them the thoroughly revealing drapery and short, fluttering costumes of Amazons and Nereids, because inappropriate to the subjects of the reliefs, but we see the same carving mannerisms and peculiar renderings, such as the extensive use of the drill creating "illogical" folds and the bunching of cloth into "rosettes" that was noted in the Epidaurian pedimental figures and will recur, in more disjointed fashion, in early Hellenistic sculptures.[37] A certain "retardataire" element is suggested by the continuing influence of Polykleitan anatomical forms and stances, but in general male figures look elongated and slimmer, unless muffled in heavy mantles and stooping to suggest old age. We have already alluded to occasional classicizing traits; even a touch of archaism is provided by an exceptional female head wearing a polos, on a fragmentary pedimented stele listed by Clairmont

Reliefs: Funerary

as Attic, but strongly reminiscent of Boiotian renderings—her highly patterned hair waves run parallel in a series of closely spaced rows like those of the kalathiskos dancers on the Delphic Akanthos Column.[38]

To highlight the changes from fifth- to fourth-century renderings, comparison between the famous **Hegeso stele in Athens** and the **gravestone of Mnesarete in Munich** (Pls. 38–39) may be helpful.[39] The composition is the same: a young woman seated to left, fronted by a standing girl facing right. Both stelai are topped by a (now) empty pediment with floral akroteria, supported by antae, but the upper frame of the relief in Munich is lower and the stele narrower, thus suggesting the lighter entablatures and slenderer forms of fourth-century architecture. Exceptionally, however, there is also more relative space above the two women's heads, which gives a sense of atmosphere to the composition, as compared with the less noticeable background of the Hegeso relief. Approximately contemporary imitations of the basic scene, as well as later ones, tend to crowd the bodies within the frame and may entirely abolish the overhead space, with a trend that increases with time, especially in multi-figured arrangements.

Plates 38–39

Hegeso sits on a backed chair (a *klismos*), wears her mantle, veil-like, over her head, and lifts a now invisible trinket from the box that the attendant holds for her. Both the remarkably thin-looking mantle behind her face and the object in her hands would have relied on added paint for visibility, with a pictorial (layered) effect in keeping with the low projection of the entire relief. By contrast, Mnesarete's stele emphasizes volume and sculptural qualities. There is greater overlap between the two figures, yet also greater isolation, since no physical object links them. The standing girl clasps her empty hands in front of her; the deceased's left hand, entirely wrapped in the mantle, rests on her lap, while her right hand pulls forward the edge of this garment that lies over her shoulder. Both heads are bowed, as if focusing on something approximately level with Mnesarete's knees, but nothing is there, nor could anything have been rendered in paint, and the effect is therefore one of sadness and meditation.

Mnesarete sits on a stool, so that she overlaps the anta with her body—not just the back of her seat, as Hegeso does. The spatial effect is enhanced by the attendant, who also projects above the level of the frame, thus creating an even stronger impression of high relief. Note the truer profile rendering of Mnesarete's upper torso, the clear outline of her buttocks, the three-dimensional effect of her leg position, which is the reverse of Hegeso's. A "rosette" marks the catch of the mantle behind her left knee, and drill channels slash the himation tip on her lap. Note also the peculiar use of triangular depressions—one on her back, near the nape, another overlying the muffled left hand—which replace the fifth-century swirls and mannerisms of Hegeso's. The attendant's stance is solid and immovable, like a karyatid's, with long, straight folds anchoring her to the groundline. The lines of her body have been subordinated to this effect, eliminating the modeling folds and the catch

Reliefs: Funerary

at the bent knee of the previous generation. Yet what the Munich relief has lost in elegance and grace it has gained in effect and meaning. This could not be mistaken for a daily-life scene, no matter what its original symbolic value was.

An epitaph engraved over the architrave tells us that Mnesarete is mourned by her husband and siblings, her mother and her child; that she was virtuous, and now occupies Persephone's bedchamber (*thalamos*). None of her family relationships are expressed by the relief, although it can still be debated whether the attendant, with her uncovered, curly hair, is a servant or a companion. Only Mnesarete's gesture of pulling forth her mantle may suggest matronly status.

What this same composition becomes toward the end of the gravestone series is shown by the **stele of Kallisto**, in Athens (Pl. 40).[40] Now the pediment projects like a shelf, but the antae are thoroughly subordinate to the human figures. The attendant is on the right, the deceased on the left side of the relief, in strong diagonal pose. But both women face forward, with that new relationship between monument and spectator that develops in the second half of the fourth century, and are therefore entirely isolated from each other. The box being opened by the maid is almost a fossilized attribute embedded in an apparently irrelevant gesture—the coiffed servant is actually looking away from it, to her left and into the distance. The matron's pull of the mantle is closer to the bridal *anakalypsis,* and the cloth has real substance; her forehead is distinctly triangular, with hair piled up high in the center, according to new fashions. The effect is static, theatrical, confrontational, but not especially mournful. Yet these judgments are relative and subjective, as we read the scene with our modern eyes.

Hairstyles and head covers have been viewed as indicators of age group and status. Short hair may have been cropped to suggest mourning, but may also indicate a slave; a sakkos together with a long-sleeved tunic should signify a servant. But short and curly hair often characterizes a woman of advanced age, whose strands are no longer abundant enough to be tied in a bun. Braids or long ponytails are considered typical of maidens, melon coiffures are said to be rare, women in their prime wear their hair parted in the middle over the forehead and combed back into a roll encircling the nape or the entire head.[41] These distinctions are probably correctly interpreted, yet fashions, I believe, also played a role. The relative rarity of the melon coiffure may thus be an indication of late date, and so should be the triangular framing of the forehead combined with the high piling of the hair in the center (cf. Pl. 34).

An example of the latter occurs on the **stele of Archestrate in Athens**.[42] To the traditional composition of deceased seated to left, facing a maiden holding a box, has been added, in between the two, a child who holds a bird above the seated woman's lap. Archestrate has the high hairstyle; the child wears a braid. The former betrays her advanced style also in the rendering of her contoured, thick-soled sandals, the slashing pleats of her mantle, and the distinctive way in which the garment

Reliefs: Funerary

outlines her left breast, not through transparency but through the course of its folds, which recalls two of the Mantineia Muses. Yet the chiton slipping off her right shoulder is a fifth-century mannerism that stands as a strange antiquarian reminiscence.[43] A similar composition in which the central child has been replaced by another figure, now mostly missing (probably an older man), appears on a stele in Boston that also exhibits the *Melonenfrisur* with encircling back braid.[44]

Short hair rendered as a series of large snail curls complements sagging cheeks and stooping shoulders on a seated woman shaking hands with a standing man on a **relief in Philadelphia**, while an old man in the center looks on (Pl. 41); inscriptions name Krinylla, daughter of Stratios; Naukles, son of Naukrates; and Naukrates, son of Naukles. It has been suggested that the deceased is Naukrates, shaking hands with his mother in the presence of his father; since he is already a mature man, his parents had to be shown as older.[45] As elderly women wear their hair short, so elderly men wear theirs long, always without a fillet to emphasize its unruliness. Increased characterization occurs after c. 350; no longer superficial wrinkles but hollow cheeks, double chin lines, and prominent veins convey the effects of age, together with mantles that envelop the entire body and rise over the nape, for protection against the elderly's perennial feeling of cold. Feet are usually kept flat on the ground, muffled in covered shoes; shoulders are bent, and staffs are often used for support. Yet, without hints of the ravages and ailments of advanced age so prominent in Hellenistic genre sculptures, such stereotypical depictions are dignified and sympathetic. They correspond to the bulging abdomens, chubby legs and arms, and large heads with full cheeks that portray children on stelai.

Plate 41

In **chronological terms**, Pfisterer-Haas has distinguished three compositional types for the elderly female. The earliest and most enduring (till the end of the gravestone series) shows the old woman seated in the foreground, usually because of the death of a grown child, as on the Philadelphia stele, with the father standing in the background in a less prominent position. The other two types begin approximately at mid-century: the old woman stands in the foreground left, but leaves the place of honor to the seated deceased, usually a daughter dead in childbirth, who occupies half the relief space; or she stands in the background, as a commentary on the scene in front of her. Yet, in whatever other combinations she may occur, the old woman is never the person being commemorated—unless, as in the case of a priestess, her longevity is being stressed as a positive trait of long service to the divinity.

A comparable typological progression has been suggested for representations of young girls wearing the back mantle (Pls. 42–43).[46] The fashion may indicate a specific age bracket or unmarried status; it is found on the Erechtheion Karyatids, and on some of the women in procession on the Parthenon east frieze. At first the garment hangs straight, but by mid-century it is shown fluttering against the background, and the wearer pulls it with one hand, as if steadying it while in mo-

Plates 42–43

tion. Yet, on stelai, this suggestion of activity is belied by the static pose of the body. A third type, toward the end of the series, has the deceased holding the mantle with both hands. Given the repetition of the image, it has been suggested that a famous statue of Artemis or Athena was cited, but the internal progression of the rendering, if correctly perceived, may belie the existence of a specific prototype. Perhaps, in conjunction with the chest straps securing the peplos or chiton around the body, the fluttering back mantle was simply meant to convey the liveliness of a young and vigorous girl—a connotation appropriate to action divinities as well, and as such to be found in their renderings without further implications.

Plate 44

Chronological progression may be noted in the texturing of cloth, specifically the use of press folds. They begin in the course of the second quarter of the fourth century, as shown, for instance, on a stele in Philadelphia (Pl. 44), and another in New York.[47] Since this rendering is found also on the "Maussollos" from Halikarnassos, the two chronologies (in Athens and Karia) reinforce each other and attest to the diffusion of this intriguing sculptural detail. Dating hints can also be derived from the shapes of footwear, in particular the contouring of the soles of sandals, most often worn by women on gravestones, which however tend to follow patterns already known from the fifth century. Projecting fillets ornamenting such soles seem to appear around 350, although they continue into the Hellenistic period. Cylindrical side loops occur on the soles of one of the most stylistically advanced stelai, but since the fashion does not become popular until the middle of the second century, some redating of this "early" example may be advisable.[48]

NON-ATTIC FUNERARY SCULPTURE

Boiotian Stelai
Despite its proximity to Attika, Boiotia attains some originality in its funerary art, in terms of technique, medium, composition, and subject matter. Three major groups of reliefs can be typologically isolated, with differing chronological ranges that make only one of them pertinent for this survey.[49] **The first type**, supposedly beginning at Thebes in the late fourth century, but only in the Hellenistic period at Tanagra, is a series of (mostly Doric) pedimented entablatures with floral or animal carvings of some elegance that probably topped a high pillar set on the funerary mound; the architrave is usually engraved with the deceased's name, and the material is a golden poros that occasionally retains traces of stucco, although one marble example has now been found. The **second type** is a tightly connected series of warrior gravestones in dark limestone more closely related to painting than to carving. The main figure is in fact rendered in outline, with inner details marked by engraving and/or paint, against a slightly lower and somewhat roughened background. Surprisingly, the warriors appear within a landscape marked by sloping terrain and clumps of grass, and the space around them is again suggestive of an

Reliefs: Funerary

open-air environment. The basic composition is so similar, and the technique so unusual, that a common cause for commemoration has been proposed: the Battle of Delion in 424, which would place all "Black Stelai" in the last quarter of the fifth century. This limited time span has now been extended downward, into the first two decades of the fourth century, but the fashion seems to have ceased with the end of its workshop. Finally, the **third type** comprises more traditional gravestones in high relief, primarily in marble, occasionally within a surrounding architectural frame, like the Attic examples. They probably began earlier than the Athenian series, as a continuation of the Archaic stelai, but seem to have died out by the end of the fourth century.

Never as numerous or as sophisticated as the Attic counterparts, the Boiotian reliefs are, however, more distinctive in subject matter. Besides the men on horseback or standing near their mount, they illustrate solitary hunters with their dogs in a rocky landscape (Pl. 45), a priestess holding up the statuette of a deity, and family groups, which are made unusual by the fact that the seated woman (the deceased?) wears a divine crown (the polos) and, in one case, the back of her *klismos* is surmounted by a sphinx. Rather than indicative of fashion in headdresses and furniture, these details seem to imply heroization. Yet too few such Boiotian monuments survive from the fourth century to analyze stylistic and iconographic development. It can only be stated that their style is not openly "provincial," although it may lag somewhat behind contemporary renderings in Athens.[50]

Plate 45

Thessalian Gravestones
More definitely "provincial," or at least distinctive and often Severizing, is the style of Thessalian funerary monuments. The main discussion of this regional production is by now approximately 30 years old, and new finds have enriched the local museums. In particular, a stele commemorating a warrior who died at the Battle of Tanagra in 457 has clearly shown the conservative tendencies of the area, not simply in sculptural style but also in script and letter forms. Had the event in which the deceased met his fate not been mentioned, both the relief and the inscription would have been considered much earlier.[51]

Other gravestones to be added to the initial corpus demonstrate the originality of the Thessalian repertoire; two of them, in fact, show a woman suckling a baby, a subject unrepresented among Attic stelai.[52] Despite the popularity of the kourotrophos motif in Greek art, mother figures are usually depicted holding babies in their arms, but not actually breast-feeding them, perhaps under the influence of the traditional Athenian restraint. Northern Greece seems to go its own way, as shown by its early adoption of two-figure compositions, frontal poses, and disproportionately small secondary personages, not as true attendants but as children, in more intimate familial poses. Imitation of Athenian styles is more perceptible in the fourth than in the fifth century, yet a certain linearity in the rendering of hair-

Reliefs: Funerary

styles and, often, folds (Pl. 46), bespeaks Thessalian preferences and mannerisms. Regional traits are apparent in some items of costume, such as the support under the women's mantle that makes it stand erect over the forehead, or the Macedonian kausia, and a peculiar cap for men that, in one instance, seems to accompany markings of old age.[53] This series is perhaps most interesting for documenting the slow spread of the "High Classical" style of Athens, which makes its impact felt on iconography (e.g., the dexiosis motif, the attendant with jewelry box) more than on actual renderings of anatomy and drapery. It could be argued that gravestones were produced for the middle or lower classes and should therefore not be considered representative of the best Thessalian sculpture; yet often quality is good, albeit conservative, and the area was fractioned into poleis under local rulers who seem to have promoted the arts and the existence of local workshops.

Lakonian Reliefs

This particular group of monuments has always been in limbo, interpretation oscillating between purely votive and purely funerary. Recent studies, especially in the light of terracotta plaques from established sanctuary contexts, have shown that what may in fact have originated as a form of votive relief for hero figures was generic enough to have been dedicated to different cults at various locations, and was eventually turned into funerary, with the addition of mourning poses and amplification into "Funerary Banquet" formulas. Here, too, provincial traits have made purely stylistic assessment difficult, and chronology remains tentative. Another recently discussed series of Lakonian stelai from Sparta and environs, decorated with diversified and exuberant floral forms in low relief, and beginning around the middle of the fourth century, presents a similar ambiguity. Although most likely funerary, given the life and rebirth symbolism implicit in vegetation, these slabs have no safe excavational context, and therefore a votive/heroic connotation cannot be excluded, especially since one relief, as suggested, may include a representation of Leda's egg, and vegetal attributes are appropriate for Helen.[54]

Tarentine Reliefs

A more definite heroizing connotation exists in Tarentine funerary art, which, however, primarily consists of naiskoi, often decorated with elaborate architectural sculpture in soft stone. Some of these naiskoi held marble statues of the deceased, as suggested by a few extant fragments and by depictions on contemporary vases. But stelai must also have been used, albeit rarely, as attested by a marble example of specific interest because said to be under Northern Greek influence. The upward tapering slab is framed by antae and probably once had a gabled top. A warrior (characterized by spear, shield, and sword) is depicted in Polykleitan pose, a mantle around his left arm, and a fillet in his hair. He props his left elbow on a rock, which surprisingly seems to disappear behind the right anta; yet a "window" on the upper

Reliefs: Funerary

left corner shows the head of a horse, as if opening from the interior outward onto a courtyard. Other surprising elements are a helmet in the background, and the fact that the youth seems to be giving a fruit (a pomegranate?) to a rearing snake. The helmet shape and the similarity to hero reliefs have suggested a connection with the visit of Alexander the Molossian to Taras and a date in the second third of the fourth century.[55]

East Greek Stelai

The corpus compiled by Pfuhl and Möbius lists at least 41 examples datable to the fourth century, even without counting a group of Greek-Oriental gravestones. This high total gives the impression that the use of gravestones was widespread during the late Classical period; yet further analysis shows that the area under review is wide indeed, including Rhodes, Lesbos (Mytilene), Samos, and other islands, as well as Rhodosto (Rhedesto) in Thrace. The true flourishing of East Greek gravestones occurs during the Hellenistic period, especially in the environs of Smyrna, when Athenian influence seems to wane and a more distinctive format is established.[56]

In general terms, fourth-century stelai are often Atticizing, with a few provincial renderings. Distinctive is the trend to show men and youths seated, even if alone, as contrasted with Attic formulas, but the standing youth also occurs, often accompanied by a dog or a bird. Women may be seated or standing, and one remarkable example of the latter pose, from Rhodes and now in Munich, shows the deceased in almost frontal stance, right hand raised, palm forward, near the head, in an unusual gesture—mourning, salutation, veneration? Her peplos has an overly long kolpos reaching to just above her knees, but the distinctive "rosette" appears at the catch of the mantle where her left arm bends, thus demonstrating the spread of this mannerism.[57]

SIDONIAN SARCOPHAGI

Only the sarcophagi from the Phoenician nekropolis of Sidon can be treated in this section. The Lykian sarcophagi, although numerous, are in a more definite Eastern style and shape, as well as iconography. But the Sidonian caskets traditionally rank as products of Greek workmanship and deserve full attention, especially now that they have each received monographic treatment.[58]

Debate continues over the proper chronological sequence and attribution of the four decorated chests found in the Royal Nekropolis and now in the Istanbul Archaeological Museum. Several caskets were found in the various chambers, but only four exhibited figural decoration in Greek style. Of these, the Alexander Sarcophagus definitely belongs after 323, and as such is part of Hellenistic sculpture. The so-called Satrap Sarcophagus had traditionally been assigned to the fifth century, earlier than the so-called Lykian Sarcophagus, which recalls the Parthenon in its style. Yet new debate keeps shifting the sequence, some scholars dating the Satrap casket

Reliefs: Funerary

after the Lykian; thus the latter would fall around 410–400 (if attributed to Abdeshmoun) or 400–386/5 (if given to Ba'ane), and the Satrap's around 386/5–372, belonging to Ba'alshillem II. Even some who support this king's attribution would, however, date the Satrap Sarcophagus around 400, with the Lykian Sarcophagus near 430.[59] It is clear that these determinations are based primarily on the chronology of the Sidonian kings, and not on the style of the monuments, whereas I would find it possible that some of the non-figured caskets served for the royal burials, while the "Greek" ones housed other family members.

A recent monograph has now considered all Phoenician sarcophagi from the point of view of typology, iconography, and style, reaching very different conclusions. According to Ferron (1993), the Satrap Sarcophagus comes first, around 420 or slightly later, the Lykian one falls in the second decade of the fourth century (but not after 380). These divergences of opinion would not matter greatly were it not for the dating of the one casket of specific concern here: the so-called **Mourning Women Sarcophagus** (Pls. 47a–b), which Ferron narrowly places between 360 and 355 (thus during the period of Persian supremacy), attributing its manufacture and iconographic program to the same indigenous Phoenician workshop that produced the so-called Tribune of Eshmoun.[60]

Plates 47a–b

Fleischer (1983) has instead connected the casket with Straton I (the Phoenician Abdashtart), who ruled from approximately 375/4 to 361/58. The uncertainty of the second date is due to the imprecise chronology of the Satraps' Revolt against the Great King—when the Satraps failed, Straton's wife killed him and then committed suicide. Fleischer believes, however, that the commission for the sculptured chest had been given during the ruler's lifetime to a single master who carried out his work without pressure. On the basis of style, architectural details, and iconography, moreover, this master carver is assumed to be an Athenian, although participation of local (Hellenized) Phoenicians or Greeks from elsewhere is not excluded. This scenario would, however, place the Mourning Women Sarcophagus squarely during the second quarter of the fourth century, in contrast with Ferron, whose lower chronology would seem more plausible to me on stylistic grounds. Yet, admittedly, it is impossible to date ancient sculpture with such precision, especially when the monument belongs to an eclectic tradition.

The chest is shaped like an Ionic peripteral temple, but with pilasters at the four corners and low screen walls between the columns, against which heavily dressed female figures lean or sit. Parallels for such balustrades have been sought, for instance, in the late Archaic Temple F at Selinous, but the difference in time and area makes the comparison irrelevant. Fleischer additionally suggests that the parapet running along the pedimental slopes at the short ends and the eaves of the roof on the long sides is not in imitation of early monumental architecture like the Archaic Artemision at Ephesos, but is simply a background needed to support the relief figures. These depict the *ekphora*, the funeral transport of the body, here accompa-

Reliefs: Funerary

nied exclusively by men in Oriental costumes worn with one bared breast in sign of mourning. By contrast, the female figures appearing between the columns wear Greek dress. Finally, a low socle below the peristyle portrays the hunting of various animals in an almost miniaturistic style. Like that of the Hunt on the Nereid Monument (Chapter 3), this rendering has been defined as "Gattungstil," and insofar as the term indicates a specific position subordinate to the rest of the decoration, the definition may apply. Fleischer prefers to call it "Ornamentaler Stil," and indeed the effect is that of a repetitive sculptured molding, equivalent to the vine wreath running at entablature level on all four sides of the Alexander Sarcophagus. Ferron, however, connects the frieze with all other hunt scenes on Phoenician caskets and wants to see in it a symbolic partnership of the deceased and the Divine Hunter (the Sun Psychopompos) against the funerary deities.[61]

An important point stressed by Fleischer is that no element of the decoration on the Mourning Women Sarcophagus specifically refers to the ruler, his life, and his deeds. No inscription exists. No figure is singled out in the hunt, and even the ekphora is anonymous, without royal symbols, and twice repeated, each long side being alike. Mourners appear both in the intercolumnia and within the two gables, but they are not characterized as superhuman, whether heroic or mythological.[62] With their bare feet and standard costumes (chitons, peploi, himatia), the women look like visitors to a sanctuary, and only their pensive poses and angled eyebrows imply an element of sorrow. Were we not accustomed to Attic stelai, we might not even detect it in some of them. To be sure, their location recalls the Nereids of the Xanthian monument, but what a difference in actions, silhouette effects, transparency, and types of garments! The figures would have definitely stood out more emphatically when the original blue color of their background was preserved, and many other touches of paint would have imparted a lifelike appearance, but no illusionistic effects have been noted, as present, for instance, in the later Alexander Sarcophagus.[63]

For all their Greek appearance, these women follow Oriental customs in that one on each long side holds a tympanon. Music traditionally accompanies mourning, although here the instruments are not being played; in Greece, however, pipes would have been used instead. The mourners appear frozen, as if on a stage—once again, a trait shared by Attic gravestone—but they are carefully keyed to the surrounding architecture, so that on the short "façades" the free leg of the end mourner is always on the outer side. Stylistically, their garments look opaque, linear, with unobtrusive drill work despite the frequent roll of the mantle at the waist. Himatia are worn relatively short, creating horizontal accents against the lower garment and sectioning the figure into visual segments; one woman wears her mantle over a very long kolpos, another's wrap forms a frontal "apron." Faces are full, with triangular foreheads and concave eyes.[64]

Truly Eastern traits can be found rather on the Hunt frieze. Leafless trees are

Reliefs: Funerary

scattered throughout the otherwise empty background, recalling the treatment of block joints at Trysa but here without that justification. Fluttering mantles fill spaces with movement, but they appear stylized and artificial. A few examples of the "Lykian wave" occur, as well as the so-called ivy-leaf motif—the ivy-shaped arrangement of the skirt over a protruding frontal thigh, with flattened center and ogival contour folds curling into a wavelet in the center of the hem.[65]

In most general terms, this sarcophagus conforms to that mixture of non-Greek conception and Greek execution that we have noted in other Eastern monuments. Yet, after the tumultuous renderings of the Lykian Sarcophagus, the Oriental flavor of the Satrap Sarcophagus, and before the excited action of the Alexander Sarcophagus, the Sarcophagus of the Mourning Women (*pace* Ferron) seems to me to stand alone and virtually unexpected. Should we question the high date, it could be considered influenced by the Halikarnassos Maussolleion, where the ancestral figures of the top level would have produced a similar effect. Likewise, the casket could be compared to the altar of the Athenaion at Priene, with its somewhat static Muses between Ionic columns, but again chronology prevents it. If this is truly the product of Athenian masters, their contribution must have exercised a check on the more expressive and emotional art of the Greek islands and the non-Greek cultures of Asia Minor, which supposedly produced or influenced the other Sidonian chests and the Lykian monuments.

Perhaps the most notable conclusion to be drawn from this survey is the pervasive impact of the Attic gravestones on other funerary monuments. Although occasionally subjects and renderings found distinctive regional expressions, formats and motifs seem to have spread out more or less uniformly from the Athenian center, especially with regard to the naiskos frame, the dexiosis motif, and the "rosette" mannerism. Although Attic stelai may have lagged behind the output of other centers during the "empty" span of the fifth century (c. 490–430), they soon took a leading role when production resumed, and remain the single most abundant testimony of fourth-century original sculpture. Stelai never found fertile ground in Magna Graecia, and were never so numerous elsewhere in Greece, but when they occurred, they acknowledged the influence of the Attic series, either through actual imports or through imitations from pattern books. Traveling masters may also have helped diffuse some types and styles. The sculptured sarcophagus remains a non-Greek tradition, at home in the Eastern regions.

Stylistically, the Attic gravestones confirm the progression suggested by other sculptural evidence. Different styles can coexist, but a gradual change is also noticeable—from a preference for transparent drapery and calligraphic mannerisms to a more realistic, opaque, and chiaroscural texturing of garments, which, during the second quarter of the fourth century, begins to include press folds. "Rosettes" of cloth appear at pressure points, and drill work deeply penetrates mantle rolls and

Reliefs: Funerary

skirts. Iconographically, a change seems to set in around 350, with more types, more numerous groups, and a heightened sense of relationship. Hairstyles begin to include new renderings (the high pile above the forehead, the melon coiffure), sole shapes add contouring ridges, and old age is depicted realistically but sympathetically. Frames become ever deeper, with the figures within looking increasingly like sculpture in the round. Frontality and an apparent relationship with the onlooker are traits of the end of the Attic series. Symbolism and idealization are the distinctive characteristics of the entire production.

NOTES

1. For a recent discussion and translation of the Ciceronian passage mentioning this decree, and the type of Attic funerary monument allowed after that date, see R. H. W. Stichel, "*Columella-Mensa-Labellum:* Zur Form der Attischen Grabmäler im Luxusgesetz des Demetrios von Phaleron," *AA* 1992, 433–40.

2. Bibliography on grave monuments is extensive, comprising some corpora by types and regions, monographs, museum catalogues, and articles on specific issues or single monuments; many of them will be cited when relevant. On Attic funerary stelai, Clairmont 1993 represents now the most up-to-date and best-illustrated treatment of the subject, although not all monuments cited could be photographed (some are reproduced from old drawings), and some photographs are not of high quality. Many of the issues treated in my chapter are discussed in Clairmont's Introductory volume, and my comments are often based on his statements, although I am not always in agreement with his views; his pp. 230–67 give summaries of the most significant publications for the period 1893–1992, including a few works of forthcoming appearance. Clairmont 1993 has been reviewed by J. Bergemann, *Gnomon* 67 (1995) 532–41. A Supplementary Volume (1995) has not yet reached American libraries.

More general but significant studies of funerary monuments and customs are Kurtz and Boardman 1971, Schmaltz 1983, and, for Attika, Stupperich 1977 and 1994. For a semiotic approach to the classification and interpretation of Attic gravestones, see Dallas 1992, who is, however, more concerned with establishing a computerized research system than with suggesting results. On funerary tables (*trapezai*), see Scholl 1994. On social issues, see Morris 1992, esp. ch. 5 on Classical grave markers, and its review by R. Garland, *Gnomon* 67 (1995) 245–47. I have not consulted Ch. Breuer, *Relief und Epigramme griechischer Privatgrabmäler: Zeugnisse bürgerlichen Selbverständnisses vom 4. bis 2. Jahrhundert v. Chr.* (Vienna 1995).

3. These estimates are derived from Clairmont 1993, Intro. vol., 64 and 242; see also 73–80, for his definition of Atticizing tombstones. In *DOG* 1977, cat. nos. 80–99 (among nos. 32–101 dated to the Classical period) are considered Attic or strongly Atticizing, although found in Asia Minor or the neighboring islands, and Attic influence is mentioned for several other stelai. For Attic grave reliefs of the 5th c., see, e.g., Ridgway 1981a, 128–30, 144–49, 152–54, nos. 3 and 6.

4. Some statues in the round with possible funerary purpose will be discussed in Chapter 9. One more cemetery is known to have existed from shortly after 426 to the 5th or 6th c.

Reliefs: Funerary

a.c.: that on the island of Rheneia, which serviced the sacred island of Delos. Yet Couilloud 1974 mentions that most stelai date from the Hellenistic and subsequent periods; two that can be dated to the 4th c. on epigraphic grounds (her nos. 378 and 415) carry only an inscription; others are impossible to date. Even the Hellenistic gravestones seem to be under Attic influence, although some derive inspiration from Eastern sources.

5. Clairmont 1993, Intro. vol., 43, reckons that several hundred lekythoi and over 150 loutrophoroi carried figured scenes in relief; he includes not only free-standing stone vessels but also those carved on stelai, which comprise the unique occurrence of a volute krater, his cat. no. 3.335, with handles supported by eagles with widespread wings. He does not, however, discuss stone vases *without* figured scenes, so that total numbers, for our purposes, should be considered higher. Basic works dealing with such vessels are Schmaltz 1970 (lekythoi) and Kokula 1984 (loutrophoroi); additional bibl. in Clairmont 1993, who repeatedly stresses the lack of profile drawings of such vessels, which would help their dating. He also mentions (pp. 71–72) that some of them are what he calls "white elephants," that is, works exhibiting a dichotomy in style, so that the relief scene on a stone vase, for instance, appears later than the shape, and may have been added after some time. Although reworking of an earlier monument is not impossible, one wonders whether a "conservative" or earlier shape may have been chosen for antiquarian, symbolic reasons.

Note that the only two Attic amphiglypha known to Clairmont 1993 (Intro. vol., 46) are stelai showing a hand-shaking scene on one side, and a vessel in low relief on the other: cat. nos. 2.671 (Feodosia Mus., lekythos on reverse) and 2.331c (present location unknown, loutrophoros on reverse; not illustrated, but see drawing in Conze 1890, vol. 1, 168, no. 787). To be sure, Clairmont's catalogue includes only grave monuments with human figures, and therefore does not consider amphiglypha with animals, but these are also rare (cf., e.g., Athens NM 3709, a late 5th-c. amphiglyphon with a lion and a lioness, Woysch-Méautis 1982, 133, no. 357, pl. 60). One wonders whether the vessels carved on the reverse of a figured scene were meant to symbolize social status, grave gift, or tomb marker proper.

This question has some bearing on another category of gravestones. Not only were lekythoi and loutrophoroi also depicted as the main image on (low-) relief stelai, but groups of smaller vases around a central, larger vessel—the tomb monument proper—could be rendered as well, almost in a compendium of appropriate funerary offerings, or as a "still-life" rendering of a burial plot: cf. Stupperich 1978; Dehl 1981; Boardman 1995, fig. 132; Kokula 1984, 61–66, cat. G1–24, pp. 165–70, pls. 10–12. According to this last source, this form of stele begins in the late 5th c., and continues into the early 4th, but is only rarely seen later. It almost represents a transition from the "real life" tomb with gifts as shown on the white-ground lekythoi and the grave marked with an elaborate funerary monument.

These depictions are significant for the issue of whether actual tomb monuments were ever depicted on gravestones, with the deceased standing next to them: see Clairmont 1993, Intro. vol., 98. One such representation may be Athens NM 1863, his cat. no. 1.431/2.431c, p. 369, although Clairmont believes the loutrophoros/hydria beside the maiden (Hagnostrate, daughter of Theodotos) simply symbolizes her unmarried status at death. Note, however, that the relief vessel depicts the same Hagnostrate (labeled) shaking hands with a beardless man labeled Theodoros. Regardless of whether he is her brother or fiancé, the scene seems to me indicative of a true tomb marker.

Reliefs: Funerary

6. Athens NM 3619–3620 (griffin protomai restored in plaster, but on safe evidence), total height 1.82 m., dated c. 340: S. Karouzou, *ArchDelt* 19.1 (1964) 13–15, pls. 10–11; Karouzou 1968, 123; Kurtz and Boardman 1971, 129, pl. 29; Boardman 1995, fig. 134 (height given as "about 1.60," date as "about 350"). A similar vessel (c. 400) adorned the geison of the so-called Monument at the Third Boundary Stone in the Kerameikos: Willemsen 1977, 148–50, pls. 55.5 and 61; cf. Knigge 1988, 162–64; see also infra, n. 10, for a stone amphora of Panathenaic shape from the same grave.

7. For the Group of the Huge Lekythoi, see *ARV*², 1390; cf. also F. Brommer, "Eine Lekythos in Madrid," *MM* 10 (1969) 155–71, who states that the height of these vessels ranges from 0.68 to 1.10 m.

8. Kokula 1984, 143–44, 148–49, suggests that 4th-c. Athenian men were reluctant to marry, thus explaining the disproportion in the numbers of unmarried men (graves marked by loutrophoros-amphoras) versus those of unmarried women (graves marked by l.-hydriai). She had already mentioned this theory in her dissertation (*Marmorlutrophoren,* Cologne 1974, 187). Clairmont 1993, in his summary of her views (Intro. vol., 260), states that her position is not generally accepted.

Kokula 1984, 107 n. 72, lists only two possible exceptions to her assignment of loutrophoros-amphoras to men: her cat. L 99, pl. 29 (inscribed "Lysippe"), and one plain piece in relief on a pedimented stele in New York, MM 57.151 (*BMMA* 16 [1957/58] 191), whose painted inscription, "Eukleia," is by her considered uncertain. She seems to imply that practices may have changed after the decree by Demetrios of Phaleron.

9. *ArchDelt* 29 (1973–74), Chronika 64, pl. 67b; *JHS-AR* 1979–80, 17 fig. 30. Clairmont 1993, Intro. vol., 45, calls these vases "pasticci," meaning that they carry two separate groups standing back to back without unified iconography (definition on p. 94); he lists them (vol. 4, 144–46) as cat. nos. 4.781–782, which, according to his classification system, means a four-figure composition with child datable to the first quarter of the 4th c.; yet the vessel shape would suggest the second half. Clairmont 1993, vol. 4, 131, seems to imply that the priest is shown as the deceased on at least the amphora including the child (4.781).

Because of the priestly image, both vessels are listed by Mantis 1990, 87, nos. 16–17, and discussion on p. 91; he does not specifically attribute either of them to the priest's grave, but only to the same family plot, and dates amphora BE 31 (standing priest, inscribed Theogenes, greeting mantled male figure inscribed Theoxenos Probalinthios; standing woman facing seated woman, with only remnants of inscriptions) after the mid-4th c.; he dates amphora BE 30 (standing priest facing standing woman with child, seated woman shaking hands with standing bearded man) to the third quarter. Mantis can suggest no reason for the selection of the shape, which does not seem supported by the iconography of the relief figures; the priestly male on the Parthenon east frieze (slab V, Figure 34; Mantis 1990, 84–85, 94–95, pl. 34a) is usually identified as the priest of Poseidon-Erechtheus, not officially involved with the Panathenaia. Yet priests must have performed the animal sacrifices (the hekatomb) required by the festival.

Clairmont 1993, Intro. vol., 266–67, mentions that a forthcoming monograph by A. Scholl (*Die attischen Bildfeldstelen des 4. Jhs. v. Chr.: Untersuchungen zu den kleinformatigen Grabreliefs in spätklassischen Athen,* of which he was given a copy in advance of publication) points out that priests and priestesses are found exclusively on stelai of distinctive

Reliefs: Funerary

format: a plain shaft topped by a small recessed panel carrying the figured scene; yet Clairmont cites his own cat. no. 1.334 (pp. 319–20, the stele Kerameikos Museum P 1131, with a woman holding a hydria) as an exception, and several others are listed by Mantis 1990, e.g., 49–50 (priestesses), 85–87 (priests).

10. A plain amphora of Panathenaic shape is reconstructed as standing over the state monument "at the Third Boundary Stone" in the Athenian Kerameikos: Willemsen 1977, 140–41, pl. 60; Knigge 1988, 163 fig. 159. At the time of her writing, Knigge stated that the construction had not been entirely cleared, but that its impressive size and location suggested official sponsorship by the city (this view seems shared by Stupperich 1994, 94 with bibl. in n. 20). Pottery from a sarcophagus behind the monument gives a date at the turn into the 4th c. Two marble hounds stood guard at the ends. See also supra, n. 6.

For another such plain amphora, although considerably later, in the University Museum of the University of Pennsylvania (MS 3447), see G. R. Edwards, *Hesperia* 26 (1957) 323, n. 6, pl. 87; yet its purpose was votive. This vessel was in fact excavated with seven others at the sanctuary of Diana Nemorensis at Nemi, Italy, as reported in *NSc* 1895, 425–29, nos. 1–8, figs. 2–4. All eight vases (four of them griffin cauldrons, also in the University Museum) seem to have been made by a single workshop, since they were dedicated as a group by a certain Chio, according to the inscriptions (d.d. = *donum dedit*). Three of them, amphoras also of Panathenaic shape, carry relief decoration, and may be noted here because of their intrinsic interest, although they probably date around the middle of the 2nd c. or a bit earlier, on the basis of their shape. They are now in Copenhagen, Ny Carlsberg Glyptotek: see *Billedtavler til kataloget over Antike Kunstvaerken* (1907) pl. 38; F. Poulsen, *Catalogue of Greek Sculpture in the Ny Carlsberg Glyptotek* (1951) 356–57, nos. 506–7 with additional refs. and a dating "presumably" in the 1st c. A.C. Their subjects could be appropriate also for funerary purposes. These (repeated on both sides) are: griffins attacking a deer; two satyrs holding grape bunches on either side of a large krater and pushing each other away from it; and two-horse racing (a satyr and a naked "putto," each leading also an unmounted horse) galloping toward the scaffolding with seven eggs meant to mark the racing laps in a circus (three laps still to go). These signals, according to Livy 41.27.6, were not introduced until 174 B.C. (cf. J. H. Humphrey, *Roman Circuses: Arenas for Chariot Racing* [London 1986] 260–62), and are thus not incompatible with the 2nd-c. dating of the marble amphoras. For this chronology, for knowledge and all pertinent bibl. on these marble vessels, as well as for extensive discussion on them, I am fully indebted to Prof. Edwards.

The Nemi amphoras are also briefly cited by D. Grassinger, *Römische Marmorkratere* (Mainz 1991) 220, exkursus I, nos. EI: 1A–C, with additional mentions listed on pp. 234–35 under "Kopenhagen" and "Philadelphia"; she dates the vessels in the early Augustan period (or the third quarter of the 1st c. B.C.). In an even briefer mention, they are dated to the 1st c. *after* Christ by H.-U. Cain and O. Dräger, "Die sogenannten neuattischen Werkstätten," in G. Hellenkemper Salies, et al., eds., *Das Wrack: Der antike Schiffsfund vom Mahdia* (Cologne 1994) vol. 2, 820. A full publication, within the context of the Nemi sanctuary, is being prepared by P. Guldager Bilde.

11. Patterned oinochoe: Peiraieus Mus. 3636: Clairmont 1993, Intro. vol., 45, cat. no. 4.410, pp. 87–88. For another stone oinochoe bearing a figured panel, but votive in function, see Chapter 6, under Banquet (*Totenmahl*) Reliefs.

Reliefs: Funerary

For a discussion of the tendance of tombs and the cult of the dead although focused on ancestors and heroes of an earlier period, but with many citations of recent bibl. see Antonaccio 1994, esp. 391.

12. See, e.g., Arist., *of the Soul*, as quoted in Plut., *A Letter to Apollonius* 27: "those who have become our betters and superiors." For oracles and other mentions of burials within public buildings, see, e.g., Paus. 1.43.2–3 (Megara); Pol. 8.30 (Taras); Herod 5.67 (Sikyon).

13. See, e.g., Stewart 1990, 110, for the kouroi, and 49–51 for general tendencies in funerary art.

14. See Clairmont 1993, Intro. vol., 98 (on thrones), 137–59 (on nudity), esp. 145. But note, for instance, the woman on a fragmentary stele dated to the beginning of the 4th c. (Athens NM 3891, Schmaltz 1983, 221, pl. 9), whose voluptuous body, leaning pose (against a loutrophoros-hydria), and transparent drapery slipping off her shoulders clearly recall images of Aphrodite. Clairmont 1993, cat. 1.182, p. 249, in discussing the same stele, rejects the implication as incompatible with Greek religious beliefs at the end of the 5th c., although becoming popular "much later." At issue here is whether well-known images of divinities, as statue types, could be "cited" on Attic gravestones as part of an accepted vocabulary of signs producing mental associations in the viewers. This process of *intertextuality* and multiple connotations is explored for the so-called Hermes Richelieu/Hermes of Andros type, which, when used to represent the deceased, would have brought to mind not only the statue and the god, but also the latter's function as psychopompos: Dallas 1992, 255–56, q.v. also for further comments on the many levels of connotation of nudity. A strong advocacy of "ideal nudity" is found in Himmelmann 1990, but cf. T. Hölscher's review of the book, *Gnomon* 65 (1993) 519–28. *Essays on Nudity in Antiquity in Memory of Otto Brendel* (*Source: Notes in the History of Art* 12.2 [Winter 1993]) discusses the concept in the context of other ancient cultures, but the section on the Greek (by B. Cohen) focuses on women in vase painting.

For over lifesize scale as a possible sign of heroization, see, e.g., the mid-4th-c. stele from Acharnai in New York, MM 48.11.4 (Richter 1954, no. 79, pls. 64, 79c; Clairmont 1993, cat. no. 2.277, pp. 204–5). The deceased is seated on a throne with armrest supported by a crouching sphinx; she wears a diadem or wreath on her head (which Clairmont considers instead a form of hairstyle), and had earrings added in metal. Greater size may also be suggested by the diminutive scale of accompanying figures; this convention, popular on East Greek stelai of the Hellenistic period, may have started in the 4th c.—cf. a stele in Princeton, Ridgway 1994, 24–27 no. 6 (here **Pl. 42**).

For an "exceptional" stele of a naked warrior in attack position, see the gravestone of Silanion, son of Aristodemos, in the Athenian Akropolis storerooms, Clairmont 1993, cat. no. 1.361, pp. 336–37. The relief slab is framed by antae and topped by a sima roof, on which see infra. Stupperich 1994, 95 and n. 35, lists stelai with warriors storming forward but without enemy. An intriguing gravestone with two warriors was found in South Russia and is now in the Pushkin Museum, Moscow (here **Pl. 33**): Clairmont 1993, cat. no. 2.354, pp. 355–56 (considered Atticizing); cf. also Knauer 1992, 392–99, with fig. 11 on p. 393; Stupperich 1994, 96 and figs. 4–5 on p. 97, thinks a public burial may be involved. My thoughts on this monument (possible connection with a heroon of Achilles?) will be published by the Russian authorities as one in a group of essays on the stele.

Reliefs: Funerary

Schmaltz 1983, 220–22, in discussing heroization, considers meaningful clues also such items as the Corinthian helmet (although I am not convinced it was no longer current at the time and was therefore an anachronistic, retrospective allusion), and the footstool, not used as part of daily life. On a certain type of throne as a sign of heroization, see Cain 1989, esp. 95.

15. Schmaltz 1970, 116; see also Clairmont 1993, Intro vol., 250–51, for a summary of Schmaltz's viewpoints. Some conclusions are repeated in Schmaltz 1983, passim (see summary in Clairmont 1993, 256–57).

16. See, e.g., Travlos, fig. 202 on p. 151, for several examples; cf. also L. Beschi, "Contributi di topografia ateniese," *ASAtene* 45/46 (1967/68) 524 fig. 9, for his reconstruction of the naiskos of Aphrodite Pandemos (early Hellenistic), reproduced in E. Simon, *Festivals of Attica* (Madison 1983) 49 fig. 7. See also the comments by Borbein 1973, 104–8, who compares sculptures in naiskoi to family groups.

17. For discussion of the various forms of frame and decoration, see Clairmont 1993, Intro. vol., 38–46, who refutes any heroizing intent and gives additional refs. to authors who support his position. By contrast, Weber 1990, 62–65, section 1.3.1, pls. 29–32, figs. 107–17, is certain that an architectural frame is indeed meant to suggest "naiskos" and therefore heroization, and she uses votive and Document Reliefs as confirmation of her theory.

One more possible reason for rejecting the heroizing interpretation is the fact that early naiskos stelai are quite shallow, with figures overlapping the antae; yet the same point could be made against the domestic interpretation, since the house would then provide only a backdrop to what should be indoor scenes. See also below.

18. See, e.g., two stelai from Sinope, dated c. 450: Ridgway 1970, 97–98, figs. 133–34; *DOG* 1977, 17, nos. 23–24, pl. 6; Hiller 1975, 165–66, Cat. O 20–21 (with additional refs. to text discussion), pl. 12.1–2. One stele is framed by Ionic columns and surmounted by a dentil course; the other has a pedimented top with a large central akroterion (painted palmette); both reliefs show the deceased as a seated woman facing (living) attendants.

19. Roof simas with antefixes are discussed by Clairmont 1993, Intro. vol., 39–40, who also points out that only this variant was transferred to a few stone vessels. He sees the architectural abbreviation as domestic because some reliefs imply interior scenes: e.g., his cat. 2.457, a sunken panel with a woman on a bed assisted by another (childbirth). For scenes of family unity, see, e.g., Clairmont 1993, cat. nos. 3.383, 3.383c, 3.384, 3.384c, and passim. For an athletic scene, see the stele of Sostratos, New York, MM 08.258.41, Richter 1954, no. 85 pl. 69a; Clairmont 1993, cat. 1.825, pp. 453–54: the roof sima carries also a central siren within a triangular frame, and cut-out relief sphinxes as lateral "akroteria." Another such is the stele of Aristion, Athens NM 4487: Boardman 1995, fig. 126. Cf. also a stele (whereabouts unknown) combining the sima rendering with a pediment, corresponding in part to the wings of a central akroterial siren, and with doves as lateral akroteria against a solid background: Clairmont 1993, cat. no. 3.880, p. 493. One more peculiar rendering, on a stele in New York (of Philte, daughter of a man from Sounion: MM 65.11.11; Clairmont 1993, cat. no. 3.905, p. 504), has a central siren and profile lateral sphinxes, but these rest on a smooth fascia above the architrave, without any specific architectural feature. It seems obvious that great freedom in framing existed, and that architectural citations were irregular, irrationally combined, and aesthetically/symbolically chosen.

Reliefs: Funerary

For the sima rendering on a stone lekythos in Eleusis, see, e.g., Clairmont 1993, cat. 4.755, pp. 140–41 (the so-called roof structure is however unclear in the illustration). See also Boardman 1995, fig. 131 (lekythos of Aristomache, Athens, Kerameikos, on site). I would suggest that the reason behind the choice of the "sima roof" on stone vases is its similarity to simple horizontal moldings appropriate to frame sunken panels—note, in fact, that "a-kroteria" are eliminated from such renderings, as contrasted with their use on stelai. A pedimented frame on a lekythos or loutrophoros would have clashed with the vessel shape.

That these sima roofs cannot literally be read as side views of a building is suggested by the fact that several of them are supported by antae; see, e.g., the stele of Alexos, Athens NM 2574, Ridgway 1990, 33–34 and ill. 12; Clairmont 1993, cat. no. 4.471, pp. 121–22, dated within the bracket 350–300 (the antae are restored, but the inscribed, three-fasciaed Ionic epistyle surmounted by dentils is fully preserved, both on facade and on the return sides; note the corner antefixes!).

Note that several *votive* and *Document* reliefs, some earlier than the gravestones, exhibit the same lateral-sima framing, together with action scenes, although some of them depict only divinities and personifications (e.g., Athens, NM 1403, fragmentary, with frontal Kore/Artemis[?], shortly after 420: *EA* 1241, *LIMC* 2, s.v. Artemis, no. 508; Athens NM 1467, treaty between Athens and Kerkyra, dated 376/5, Meyer 1989b, 280, no. A 51, pl. 16.2), and some include worshipers (e.g, Athens NM 1332, mid-4th-c., to Asklepios and healing divinities: *LIMC* 2, s.v. Asklepios, no. 313 [entablature cropped in illustration], Neumann 1979, 73 pl. 47a). These types of monuments will be discussed in Chapter 6.

20. Semicircular effect: Schmaltz 1983, 201–4.

Clairmont 1993 gives several examples (his cat. nos. 4, 5, 6, 9, 16, 17, 18, 22, 23) of side-walls with low relief decoration, which have, however, been found separate from the back wall and cannot therefore be visualized as complete monuments. Figures carved separately to be placed within naiskoi: see, e.g., New York, MM 44.11.2/3, Richter 1954, no. 94, pls. 76–77; Ridgway 1990, 35, 65 n. 22; Clairmont 1993, cat. no. 1.971, pp. 513–14 (dated to bracket 350–300). See also Hamiaux 1992, nos. 210 (Ma 4505), 211 (Ma 3076), 212 (Ma 648), pp. 202–5 for female figures, and no. 214 (Ma 3067), pp. 208–9, for an ephebic figure, all with roughly finished backs that suggest inclusion within funerary naiskoi.

High-relief slab with shallow frame suggested by anathyrosis of the short sides: New York, MM 11.100.2; Richter 1954, no. 83, pls. 67–68a-d; Clairmont 1993, cat. no. 3.846, pp. 475–76 (here **Pl. 35**). The monument has been dated c. 360 (and Clairmont would connect it with the sculptor Kephisodotos), but it seems classicizing to me (the man's face looks like a herm, his pose with tall staff recalls Zeus, the veiled matron standing behind him resembles a Hera, her child's stiff appearance suggests a karyatid) and could probably be later. The standing woman facing the seated man once wore a wreath added in metal, but Clairmont, although considering her the deceased, sees in this ornament no heroizing connotations. Both adult women also once had metal earrings.

21. Some of the concepts expressed in the following section are derived from a variety of sources; see, in particular, Schmaltz 1983, especially 214–20; Himmelmann 1956; and, to some extent, Clairmont 1993, especially, in his Intro. vol., the essay by Geneviève Hoffmann, and her summarizing comment (p. 179): "L'aspect novateur des scènes de groupe du IVe siècle ne fut pas d'inventer l'immortalité par la descendance et la *philia* dans la famille, mais

Reliefs: Funerary

d'évaluer ces valeurs, déjà chantés dans l'oeuvre homérique, comme primordiales dans le cercle de la parenté et dans la communauté civique, et cette évaluation prend sens dans le contexte du temps et par la conscience qu'avaient les citoyens de leur identité." Schmaltz 1983, 214, makes two significant observations: that athletes and maidens are never shown in the handshake motif, so common in other contexts, and that although the athlete, during the second half of the 4th c., can appear surrounded by family members, he is not in physical contact with them. For other discussions of the handshake motif, see Clairmont 1993, Intro. vol., 115; Pemberton 1989; and, in a context wider than funerary, extending to Etruscan and Roman examples, Davies 1985, esp. 628–30.

For general, synthetic comments on the intellectual climate of the 4th c., see Todisco 1993, 25–26.

22. For two mirror-image servants from Menidi, now in Berlin, see Blümel 1966, 44–45, no. 45 (K13a–b), figs. 62–69; Boardman 1995, fig. 117; and cf. an attendant in Athens, NM 825, Clairmont 1993, cat. no. 7, p. 9. Flanking figures could also portray other types, not always with the same function. See, for instance, the matching lions guarding the family plot of Dionysios of Kollytos in the Athenian Kerameikos (NM 803–804): Clairmont, 1993, cat. no. 3a–b, pp. 6–7; Knigge 1988, 125 (123–26 for the whole precinct); Boardman 1995, fig. 112.3; the less obvious panthers in Munich: Vierneisel-Schlörb 1988, 140–43, nos. 24–25, pls. 54–57; or the Skythian archers accompanying, presumably, a warrior's grave, Athens NM 823–24, Ridgway 1992, 273–75, nn. 18, 21; Clairmont 1993, cat. no. 20a–b, p. 23; Boardman 1995, fig. 118.

23. These inscriptions are discussed by Clairmont 1993, Intro. vol., 119–21, who, however, stresses that multiple stelai have also been found for members of the same family who died at different times, and that only a few gravestones show, through a more advanced or different lettering, that some names were added later. As an example, see Prokleides' stele, Athens NM 737, infra, n. 31.

24. For this opinion, see, e.g., Clairmont 1993, Intro. vol., 66–72, esp. 71–72 for his belief that the "hierarchy of classes in socio-economic terms is fully reflected" in the range of Attic gravestones.

25. For estimates on the expense and length of time required to set up gravestones, see Schmaltz 1983, 136–48. Waywell 1978, 81, calculates one year for a lifesize sculpture in the round by a skilled carver; stelai, even multi-figured, being in relief, might have required less time, but many were virtually in the round, and some had over-lifesize scale. Yet this consideration is valid only in cases of unexpected deaths. As M. Fullerton pointed out to me, nothing prevented heads of family from ordering appropriate funerary monuments for themselves and their relatives well ahead of need; this anticipated commission may have even dictated the lack of emphasis on a single figure that makes us suspect stock production.

26. This second statement is taken from G. Daux, review of Clairmont's *Gravestone and Epigram* (Mainz 1970), *BCH* 96 (1972) 503–66, specifically p. 505.

Once again, M. Fullerton comments that, whether commissioned or prefabricated, stelai were carved according to a relatively limited stock repertoire. Moreover, given the ancient emphasis on concepts and symbols, it is illogical for us to assume a "family-portrait" mentality for which there is virtually no evidence in Classical Greece. He concludes that the question of prefabrication versus commission may be an artificial issue.

Reliefs: Funerary

27. For a summary of Friis Johansen's book, see Clairmont 1993, Intro. vol., 242–43; see also 122–29, for comments on glances. The point on the seated pose is stressed by Pfisterer-Haas 1990, with regard to older women, and by Meyer 1989a for older men. Elderly women seated in the foreground represent the earliest form of such portrayals (Pfisterer-Haas's Type 1), beginning early in the 4th c. and continuing to the end; they usually depict the mothers of the prematurely dead, and are given seat and location as a position of honor for the *mater familias*, with the father in a less prominent spot. The same comments apply to older men, when they are the main character on a stele, without necessarily being the deceased. Meyer 1989a, 79, makes, however, the important point that whereas women on gravestones, both old and young, may be shown seated because the pose is typical of their domestic activities, few men are thus depicted whose sitting is *not* based on their advanced age.

28. Supra, n. 14. For commentary and reservations about Himmelmann's (1956) concepts, see Schmaltz 1983, 206–9, and, more critical, Clairmont 1993, Intro. vol., 130–36 (on the concept of the deceased), 137–59 (on nudity and idealization), 243–44 (on Ilissos Stele monograph). Ilissos Stele, Athens NM 869: e.g., Boardman 1995, fig. 124.

29. Pfisterer-Haas 1990, 192, pl. 37.1, makes this suggestion for the stele Athens NM 1953 = Clairmont 1993, cat. no. 3.439a, pp. 367–68 (deceased left uncertain). Old women (like children) supposedly are characterized by larger heads in proportion to their bodies.

30. This statement applies specifically to the frequent depiction of a woman adorning herself from a jewel box held by an attendant in front of her. Usually read as an allusion to the last setting out, or even as a future bride (of Hades?) putting on her finery, the subject has now been interpreted as an allusion to the qualities desirable in a woman, who should be *eukosmos*, well appointed: J. Reilly, "The Imagery of Female Adornment on Ancient Athenian Grave Reliefs" (Ph.D. dissertation, Bryn Mawr College, 1992), and "Adornment as the Image of Virtue on Athenian Funerary Reliefs," in *Abstracts 1994* (82nd Annual Conference, CAA, New York, February 16–19) 177. Reilly's arguments are convincing, but a bridal allusion cannot be entirely excluded, given the multi-layered meanings of Greek art. For the connection between death and marriage, see, most recently, Connelly 1996, 62–63 and n. 66.

For discussion of scenes of death in childbirth, compared to the death of warriors, see Vedder 1988. A stele too late (330–320) to be properly considered here, but intriguing for its subject, has been discussed by A. Scholl, "Das 'Charonrelief' im Kerameikos," *JdI* 108 (1993) 353–73, in terms of an ambivalent message mixing the symbolic and aristocratic allusion to a funerary banquet with a realistic portrayal of a *metoikos* in Skythian costume within a transport boat, to suggest the owner's profession as a merchant (*naukleros*). I am not sure I agree; even the fur mantle could be appropriate for Charon, who would need a transport boat to ferry the souls. The juxtaposition of a boat to a laden table remains nonetheless peculiar. The relief, Athens, Kerameikos Mus. P 692, is listed in *LIMC* 3, s.v. Charon, no. 57, pl. 173, under "Uncertain Representations"; it is not included in Clairmont 1993.

31. Age groups and terminology have been established by Clairmont 1993, Intro. vol., 19–29, and summarized on p. 24, although he states that age is usually specified only for young and very old people (p. 25). He also (pp. 30–37) analyzes costume as indicative of age, primarily for women. On pp. 261–62 he summarizes the Ph.D. dissertation for Oxford University by C. Dallas, "The Significance of Costume on Classical Attic Grave Stelai: A Statistical Analysis" (1987), but criticizes it for establishing too many age groups.

Reliefs: Funerary

For Prokleides and his monuments, see Clairmont 1993, cat. nos. 2.418, pp. 513–14 (lekythos for Sostratos, father of Prokleides, in Reading, Pa.), and 3.460, pp. 394–96 (naiskos stele for Prokleides, Athens NM 737 = Boardman 1995, fig. 123). He prefers somewhat different identifications from Meyer 1989a, 71–72, who gives the main analysis from the viewpoint of old age, with additional examples. See also her p. 57, where she points out that on a stone lekythos from Myrrhinous, c. 380–370, Thokritos shaking hands with Philte is depicted with a bald forehead to indicate he is her father, but on a later lekythos from the same grave plot, he shows no trace of baldness as he shakes hands with another man. Again, Clairmont, cat. nos. 2.234, pp. 173–74 (lekythos, Brauron Mus. BE 35), and 3.267, pp. 110–11 (lekythos, Brauron Mus. BE 37), has somewhat different interpretations.

Pfisterer-Haas 1990, 194, makes the distinction between narrative and representative with regard to old-age traits. This consideration may affect our assumption that only premature deaths were commemorated by most Attic monuments. Both Meyer and Pfisterer-Haas agree that a change in the typology of gravestones occurs around 380–370 (360 for Pfisterer-Haas), leading to experimentation, and eventually, in the second half of the 4th c., to a positive rendering of old age for hierarchical purposes, whereas earlier such depictions had a mostly negative connotation.

32. The quotation is from Carpenter 1960, v, where it refers to Greek sculpture in general. Clairmont 1993, Intro. vol., 152, considers "hardly questionable" that Lysippos and Skopas, although not mentioned in this connection by any ancient source, must have been involved in the making of gravestones. Other authors are less positive: see, e.g., Schmaltz 1983, 123–36, esp. 130. Frel 1969, in determining hands according to the Morellian (Beazleyan) method, ventured no well-known names and implied craft specialization; his attributions are discussed by Clairmont 1993, Intro. vol., 100–107, and cross-referenced to his own entries on pp. 108–9.

33. Paus. 1.2.3; the passage, although surely referring to a tomb, is, however, ambiguous, leaving unclear whether the horse and the soldier standing near it were in relief or in the round. Schmaltz 1983, 129–30, assumes that the style of the figures looked "Praxitelean" and therefore prompted Pausanias' statement. Corso 1988, 140, 142–44 and nn. 873–79, accepts the work as a youthful effort, when the master was accepting commissions from private individuals, rather than from the state. Pliny (*NH* 36.20) mentions that there were statues by Praxiteles "at Athens in the Ceramicus." But this expression usually means the Agora, where in fact statue bases signed by the master have been found: cf. Corso 1988, 90 and nn. 458–63. The "crying matron" of Pliny, *NH* 34.70 (Corso 1988, 86 and n. 410), may not be by Praxiteles, and at any rate would not be a funerary statue because in bronze (see infra, n. 36). No sources cite works by Skopas in Athens, and the master's many activities in the Peloponnesos and in Karia make it unlikely that he would have stopped in Attika to make gravestones. As for Lysippos, he is said to have made a portrait of Sokrates that was kept in the Pompeion, and a satyr, which Pliny (*NH* 34.64) says was "in Athens." The expression may imply that it was originally elsewhere, and Lysippos' authorship for the Pompeion statue is only Diog. Laert. 2.43—a 3rd-c. A.C. source that may have sought a famous authorship for an important subject no longer extant in the original, given the destruction of the building in 86 B.C. Note also the discussion of other difficulties with that text in Vierneisel-Schlörb 1979, 318 n. 4, who, however, accepts that Lysippos made the original of portrait

Reliefs: Funerary

Type B, on stylistic grounds. For further analysis of attributions, see also infra, Chapters 7–8, on major masters.

34. Clairmont 1993, Intro. vol., 181; see his pp. 180–90 for a discussion of the tombstones in the context of 4th-c. sculpture. One entire section of C. Picard, *Manuel d'archéologie grècque: La sculpture* (vol. 4.2, Paris 1963) is devoted to gravestones, and so is a large section of Vierneisel-Schlörb 1988. Schmaltz 1983, 129, mentions the lack of signed gravestones. For Archaic practices, see Ridgway 1993, 427–30.

35. Such pioneering masterpieces are called *primae ideae* by Clairmont 1993, Intro. vol., 69–71, 95–97; they would all have been commissioned.

36. On the media used for funerary sculpture, see Schmaltz 1983, esp. 66–69, for comments on the lack of bronze and its possible causes. Kurtz and Boardman 1971, 240, believe that some free-standing funerary statues in bronze were erected outside Attika during the Hellenistic period, on the basis of preserved epitaphs that they cite on p. 263 (e.g., a statue of a charging horseman; a warrior with raised shield), but none is extant. At that time, commemorative (honorary) monuments from the campaigns of Alexander the Great may have provided the impetus. For the Hermes Ludovisi and its connection with the funerary monument for the dead at the Battle of Koroneia (suggested by S. Karousou), see Ridgway 1981a, 216–17 no. 4, with additional refs. Lion of Chaironeia: Boardman 1995, fig. 135 (p. 118: either "for the victorious Macedonians or for the Theban Sacred Band, which was wiped out").

37. See, e.g., the Themis of Rhamnous, Ridgway 1990, 55–57, esp. 56. Note, however, that on the Themis, the rendering seems divorced from the course of the mantle folds across the body, whereas on gravestones the bunches form at points of pressure created by an arm held at the waist or by the edge of a seat pressing against the body, and are therefore more logical. For such "rosettes" on gravestones, see, e.g., Clairmont 1993, cat. no. 2.300, pp. 245–46 (Athens NM 726) = Stewart 1990, fig. 478. The single example multiplies into three on Clairmont 1993, cat. no. 2.294a, pp. 238–39 (the stele of Pheidylla, daughter of Aresias of Alopeke, found in 1965, listed as "Third Ephoria M672").

38. Archaizing head: Clairmont 1993, cat. 2.282 (therefore dated c. 400–375), p. 215; once in the Brummer collection but listed as of unknown present location. The "polos" has been called a bridal crown, but the same headdress appears on several Boiotian gravestones (see below), including the supposedly 5th-c. stele of Amphotto, Athens NM 739, which has a comparable hair rendering: Friis Johansen 1951 (supra, n. 27) 135 and fig. 68 on p. 134; Schild-Xenidou 1972, 10–11, K 10. For the Delphic Akanthos Column, see Ridgway 1990, 22–26, pl. 4; Boardman 1995, fig. 15.

For classicizing renderings, see supra, n. 20.

For Polykleitan forms and poses, see, e.g., Clairmont 1993, cat. no. 2.330, pp. 294–95 (London, BM 1825.7–13.1), Couilloud 1974, 153, no. 286, pl. 54; this stele has several intriguing features that deserve close scrutiny, such as the folded mantle being both carried and seemingly worn by the young attendant, and the drill holes for earrings on both male figures. Note that the general Polykleitan appearance is accompanied by a triangular arrangement of eyes and brows, which indicates a date no earlier than 375. The stele supposedly comes from Delos, another anomaly.

Given the coexistence of these various stylistic trends, all further comments on the stylis-

Reliefs: Funerary

tic development of gravestones should be understood solely in generic terms. Dexileos' stele provides the only external fixed point in the sequence; whatever other prosopographic connections can be made by Clairmont 1993, Intro. vol., 12–18, relate to the end of the 5th c.

39. Hegeso Stele (Athens NM 3624): Clairmont 1993, cat. no. 2.150, pp. 95–98; Ridgway 1981a, 146–48, fig. 107; usually dated c. 410, also according to Clairmont's chronological cataloguing, this stele has occasionally been attributed to the early 4th c. I continue to believe that it represents 5th-c. style, regardless of the exact decade in which it was made.

Mnesarete Stele (Munich, GL 491): Clairmont 1993, cat. no. 2.286, pp. 221–24; Vierneisel-Schlörb 1988, 19–25 no. 4, pls. 6–10, with excellent photographic details, dated c. 380.

40. Stele of Kallisto, (daughter?) of Philokrates, from Konthyle, Athens NM 732: Clairmont 1993, cat. no. 2.431 (i.e., c. 350–300), pp. 544–45; I would date it c. 330–320. No relevance seems to attach to the fact that the position of seated and standing figure on the relief has been reversed from the "Hegeso schema." On the theatricality of 4th-c. gravestones, see Borbein 1973, 178–82.

41. For these distinctions, see Clairmont 1993, Intro. vol., 35–36. On the melon coiffure (usually cited with the German term *Melonenfrisur*), see Ridgway 1990, 130, with additional refs. For hair high over the forehead (almost suggestive of a theatrical *onkos*), see also the Themis of Rhamnous (supra, n. 37). An unusual braid occurs on the deceased athlete of the Stele of Sostratos in New York (supra, n. 19), who is said to be placing a wreath on his head, although I believe the rendering to indicate a hairstyle. A bronze statue (1.14 m. high) of a nude boy combines a braid with a melon coiffure: D. K. Hill, *Catalogue of the Classical Bronze Sculpture in the Walters Art Gallery* (Baltimore 1948) 3, no. 1, pl. 1; the piece is called eclectic.

42. Stele of Archestrate, Athens NM 722: Clairmont 1993, cat. no. 2.820 (i.e., c. 375–350), p. 708; for her sandal shape, see Morrow 1985, 205 n. 8, where a date in the second quarter of the 4th c. is accepted. For the Mantineia Base comparisons, see, e.g., Todisco 1993, pl. 289b (Muse with double pipes) and c (Muse with kithara). For another high hairstyle, see, e.g., the stele Berlin 738, Clairmont 1993, cat. no. 3.419, pp. 332–33 = Stewart 1990, fig. 515.

43. A more definite allusion to late 5th-c. prototypes appears on the so-called *telauges mnema*, the stele (Athens NM 3716) made famous by Ch. Karousos' article: Clairmont 1993, cat. no. 3.284, pp. 120–21, with all refs. = Stewart 1990, fig. 479. Despite the undoubtedly high quality of the relief, I find disturbing the clear dichotomy between the excessively transparent chiton covering the deceased's upper torso and the tormented bunch of mantle folds crossing her lap. This rendering is obviously a manifestation of the "Rich Style" comparable to the Epidaurian west akroteria, but it seems out of place on a funerary monument. Note, however, the variation on the theme of deceased-with-attendant-and-maid, which makes me think the piece might be later than c. 375—the deceased sits almost frontally, with legs in diagonal position to right, at the center of the stele; a heavily draped companion holding a box is visible behind her left leg and lowered arm, while a small servant with sakkos looks almost tucked away below her raised right arm.

44. Boston, MFA 1979.510: Clairmont 1993, cat. no. 3.446, p. 376. The rendering of the drapery seems perfunctory.

45. Philadelphia, University Museum MS 5470: Clairmont 1993, cat. no. 3.409, pp. 312–

Reliefs: Funerary

13. Comments on the parents' ages are made by Pfisterer-Haas 1990, 185, pl. 32.2, and Meyer 1989a, 62. The following statements on old age are taken primarily from these two sources.

46. Roccos 1986, 405–34, esp. 424–28 for the meaning on stelai, and 411 for the suggestion that the garment indicates premarital status. For the second rendering, cf., e.g., a stele in Princeton, Roccos 1986, 410, 484, cat. no. 159, pl. 74; Ridgway 1994, 24–27, no. 6. For a figure in the round, see Ridgway 1972, 43–44, no. 15, ill. pp. 162–63 (**pl. 43** in this volume). Roccos 1995 expands on her comments with specific reference to the Parthenon frieze and the office of *Kanephoros;* on votive and funerary reliefs, see her pp. 663–65. I cannot entirely follow the logic of her argument for identification.

47. Philadelphia stele, University Museum MS 5675: Clairmont 1993, cat. no. 2.307, pp. 254–55. Stele of Philte, in New York: see supra, n. 19.

48. Morrow 1985, 70–89 on 4th-c. footwear, specifically 70–73 on sandals, and 89 (summary); cf. her figs. 1 (g–h) on p. 155, and 6–7 on pp. 160–61, for outline drawings from several examples of soles on gravestones. The stele with side cylinders is Athens NM 1005: Clairmont 1993, cat. no. 8, pp. 9–10.

49. The so-called temple entablatures are discussed by Fraser and Rönne 1957, who consider them the product of a conservative community, and date them primarily on epigraphic grounds. See also Demakopoulou and Konsola 1981, 75–77, nos. 60–61, with mention of the one marble example and the setting; Kurtz and Boardman 1971, 233, pl. 56, call them the T-type and believe them to copy a simpler wooden plaque on a post. Carved decoration, besides purely architectural elements, may consist of three kinds: (1) symbols connected with the funerary tradition (e.g., sirens, vases); (2) symbols rare in the Hellenistic funerary tradition but common in Hellenistic art (e.g., Tritons, dolphins); (3) depictions of tumulus and stele, found only on entablatures from Thebes.

The Black Stelai have been most recently considered by T. Milbank in his unpublished 1993 M.A. thesis for Bryn Mawr College: "Shielded Meanings: A Study of Shield Decoration (Exterior Relief and Interior)," 123–26, and cat. nos. SI 07–10 on pp. 187–89. Four of the warriors' shields, in fact, are decorated on the inner face with Bellerophon on Pegasos fighting the Chimaira. To the previously known seven examples, he has added one more, unpublished, on the art market. See also Schild-Xenidou 1972, 176–78, K 43–48; and Demakopoulou and Konsola 1981, 74, where the stelai are said to continue during the first two decades of the 4th c. Yet the similarity of the renderings is striking.

For a general survey and catalogue of Boiotian reliefs, see Schild-Xenidou 1972, with somewhat conservative chronology; she deals with the 4th c. on pp. 178–87, but some of her late 5th-c. attributions have now been lowered to the following period.

50. Frontal, cuirassed warrior standing near a horse that he held with metal bridles (as per attachment holes), on a slab framed on the upper and the right edges and a (missing) slab abutting it on the left, Thebes Mus. 35: Demakopoulou and Konsola 1981, 42 and fig. 7 on p. 40 (dated early 4th c.); Schild-Xenidou 1972, 22–23, K 22 (dated last quarter 5th c.). The most extensive description is Heimberg 1973, 22–26, no. 3, pl. 3b, who suggests the possibility that the relief may be votive. Given, however, the preference for man-and-horse gravestones in 5th-c. Boiotia, the theory seems unlikely.

Hunters with dog(s): Thebes Mus. 33, from Thespiai; Demakopoulou and Konsola 1981,

Reliefs: Funerary

73–74, fig. 25 (first half 4th c.); Schild-Xenidou 1972, 56, K 64 (second quarter 4th c.). Vierneisel-Schlörb 1988 dates the Thebes stele "not before 350" in discussing a comparable gravestone in Munich, GL 492, her no. 7, pp. 34–39, pls. 15–17 (first half 4th c.); see esp. her n. 5, where the origin of the Munich relief, variously considered Attic or Boiotian, is debated. The Munich stele is not included by Clairmont 1993, not even among the Atticizing monuments: see his vol. 6 (indexes), 78–79, list of such memorials (AB = Attic-Boiotian; ATh = Attic–Thessalian; AN = Attic–Northern Greek, etc.). I would agree that it is Boiotian.

Priestess holding statue of deity (stele of Polyxena, in Berlin, late 5th c.): Mantis 1990, 67, pl. 28a; Ridgway 1981a, 148, fig. 108.

Family scene, woman wearing polos with sphinx on *klismos* back (Thebes Mus. 42): Schild-Xenidou 1972, 57, K 65; Demakopoulou and Konsola 1981, 73. Note that the child stands upright on the woman's lap, and the male confronting them is nude except for a mantle appearing on his left shoulder and between his legs—a surprising iconography. Schild-Xenidou 1972, 116, discusses the polos, which occurs on four of her catalogued gravestones, and considers it appropriate not only for divinities but also for girls and matrons. In her section headed "Meaning" (pp. 138–51), she does not stress heroization, although at times she seems to imply it; see, however, Bell 1981, 81–82, where a divine meaning is supported.

For other 4th-c. gravestones in the Thebes Museum, see Demakopoulou and Konsola 1981, 41, no. 242, pl. 6 (limestone); p. 73, nos. 131, 43; p. 77, nos. 39, 40 (marble).

51. To my knowledge, this monument, found in 1977 and exhibited in the Larisa Museum, has been mentioned only in K. I. Gallis, "He Larisa apokaluptei ton archaio kosmo tes," *Politeia* 6 (1982) 51–55; I owe this reference to J. McK. Camp. The warrior commemorated by the stele is Theotimos, son of Menyllos. The corpus of Thessalian grave reliefs is Biesantz 1965, to which add, e.g., two early 4th-c. stelai from Amphipolis: Hamiaux 1992, 244–45, nos. 260–61 (Ma 3582, Ma 800). See also infra, n. 52.

52. One nursing-mother stele is published in A. Batziou-Efstathiou, "Two New Grave Stelae of Larisa Museum," *AAA* 14 (1981) 47–53 (in Greek, with English summary on pp. 53–54), fig. 1 on p. 48. On the motif, its popularity in Italic territory, and its rarity in Greek art, see L. Bonfante, "Dedicated Mothers," in *Popular Religion* (Visible Religion vol. 3, Leiden 1984) 1–17, esp. 3, and ead., "Votive Terracotta Figures of Mothers and Children," in J. Swaddling, ed., *Italian Iron Age Artefacts in the British Museum* (London 1986) 195–20, esp. 198 and n. 73. Is this a daily-life motif, or an allusion to divinity? This second possibility is postulated on the basis of unquestionable images of nursing goddesses, such as Aphrodite nursing Eros, Kybele nursing Attis, and, in Italy, Juno nursing Hercules.

53. On headdresses, see Biesantz 1965, 78–80; mantle peak: nos. K 7 (pl. 2), K 10 (pl. 22); kausia: no. K 56 (pl. 23); man's cap: K 57 (pl. 22). Some debate exists over the form of the kausia; see, most recently, C. Paliadeli-Saatsoglou, "Aspects of Ancient Macedonian Costume," *JHS* 113 (1993) 122–49, esp. 122–42, on the basis of the Vergina painting from the Great Tumulus. On pls. 1–4 she illustrates some Macedonian gravestones from the same mound, but Macedonian stelai are not well enough known to attempt a review of them in this chapter.

54. On Spartan reliefs, see, most recently, Salapata 1993; Hibler 1993; Ridgway 1993, 242–43. For a list of sculptors active in Lakonia during the Archaic and Classical periods, see

Reliefs: Funerary

p. 269 in O. Palagia and W. Coulson, eds., *Sculpture from Arcadia and Laconia* (Oxbow Monographs 30, Oxford 1993). The floral stelai, which continue into the early Hellenistic period, are discussed by Delivorrias 1993b; cf. p. 213 for a chronological and funerary assessment, p. 215 for a possible votive meaning; the stele with the presumed Leda's egg is his fig. 1.

55. Most Tarentine funerary art is to be dated to the Hellenistic period; see, recently, Ridgway 1990, 180–85, and 218 for the marble fragments from statuary in the round = Carter 1973. The relief stele is published by Geyer 1989, whence my information is derived.

56. See *DOG* 1977: the Classical stelai comprise nos. 32–101, but since they are arranged typologically, some entries refer to 5th-c. monuments; nos. 73–77 are Greek-Oriental items, nos. 80–99 are Attic or strongly Atticizing. See also Clairmont 1993, loc. cit. supra, n. 50. On 3rd-c. East Greek gravestones, see also Ridgway 1990, 357–59, and 361–68, for examples from Rhodes and other islands.

57. Stele Munich GL 482: *DOG* 1977, no. 50, pl. 13; Vierneisel-Schlörb 1988, 26–29, no. 5, pls. 11–12 (c. 370).

58. On the Lykian sarcophagi, see, e.g., P. Demargne, *Tombes, maisons, tombes rupestres et sarcophages: Fouilles de Xanthos* 5 (Paris 1974) and, id., "Le décor des sarcophages de Xanthos: réalité, mythes, symboles," *CRAI* 1973, 262–69.

The monographs on the four Sidonian sarcophagi are: I. Kleemann, *Der Satrapensarkophag aus Sidon* (*IstForsch* 20, 1958); B. Schmidt-Dounas, *Der lykische Sarkophag aus Sidon* (*IstMitt-BH* 30, 1985); Fleischer 1983 (Mourning Women); V. von Graeve, *Der Alexandersarkophag und seine Werkstatt* (*IstForsch* 28, 1970). See also Hitzl 1991, 177, cat. 16 (Satrap Sarcophagus, dated last quarter 5th c.); 178, cat. 17 (Lykian, 390–385); 179–80, cat. 18 (Mourning Women, between 367 and 361 or 358); 181, cat. 19 (Alexander, between 322 and 312). Illustrations: Boardman 1995, figs. 225 (Satrap, about 420), 226. 1–2 (Lykian, about 380), 227 (Mourning Women, about 360), 228. 1–3 (Alexander, about 315).

59. For a plan of the Sidonian nekropolis, indicating the findspot of each casket, see, most recently, Ridgway 1990, 41, ill. 16, and pp. 37–45 on the Alexander Sarcophagus; for chronology see esp. p. 66 n. 27. Dating of the Satrap Sarcophagus to 386–372 is due to Fleischer 1983, 6; a date c. 400 is by H. Gabelmann, "Die Inhaber des lykischen und Satrapen-Sarkophages," *AA* 1982, 493–95. I have discussed the Satrap Sarcophagus as Lingering Severe in Ridgway 1970, 98–99, the Lykian in Ridgway 1981a, 149–51.

60. Ferron 1993, 250–61 on chronology, esp. 257–59 for the Mourning Women Sarcophagus; see p. 256 for the Satrap and p. 257 for the Lykian Sarcophagus. The Alexander Sarcophagus is there dated 317–312: pp. 259–60. On the Tribune of Eshmoun and its stylistic connections, see infra, Chapter 6. For general comments on the sculptural influence of Greece in Phoenicia, see, most recently, J. Boardman, *The Diffusion of Classical Art in Antiquity* (Princeton 1994) 53–58. See also A. H. Borbein's review of Fleischer 1983 in *BJb* 187 (1987) 714–18.

61. The hunt includes boars, panthers, deer, several riderless horses and many dogs, but only one bear, with a selection of animals again corresponding to the Nereid Monument frieze (and the Vergina painting on the attic of the so-called Tomb of Philip II). One episode, with two men in Oriental costume attacking a deer, closely resembles the same theme on the Alexander Sarcophagus, implying perhaps continuity of patterns and workshops. For an

Reliefs: Funerary

early discussion of the socle frieze on the Mourning Women Sarcophagus, see Hiller 1960. Fleischer 1983 describes it on pp. 33–34, pls. 12–17; Ferron 1993, as part of the general interpretation of the sarcophagus, on pp. 307–10, pls. 53–57. Note that even the ekphora is interpreted by Ferron in mythological terms: the trip to the Kingdom of the Dead. For its details, see the better illustrations in Fleischer 1983, pls. 36–39.

62. Could this apparent anonymity reflect manufacture under Persian rule? Greek models would then have been used because of their availability to the workshop, rather than because of their programmatic meaning. Yet, once again, Ferron 1993, 307–10, reads the gables as depiction of an Ugaritic myth of divine loss; the Mourning Women in the intercolumniations are considered guardian deities lamenting the death. Although an approach at interpretation based on local customs and beliefs, and in the light of local precedents, seems highly positive, I cannot agree with its conclusions, given the strong Greek flavor of this specific work. The very architectural frame of the casket, including a tiled roof, is based on Greek, not local, forms, and the mourning women are *not* dressed in Phoenician fashion, in contrast to the members of the ekphora. Boardman 1994 (supra, n. 60) 57, comments that "easterners did not take their grief so calmly." Is it realistic to expect that the same iconographic message persisted through several centuries, when the area was being subjected to so many extraneous influences?

Note that a woman on Gable C (Fleischer 1983, pl. 42) wears her chiton slipped off her left shoulder—a Greek mannerism. The gables are not entirely filled with figures, as in the Alexander Sarcophagus, and the rocky ground in the center looks more like a convenient device to create a triangular composition than like an element of the story. The men on the parapet above the pediments use the sloping cornice as a prop for their poses, in a strange mixture of "real" and "unreal."

63. On polychromy, see Fleischer 1983, 60, who points out that the architectural details picked out in paint conform to Greek monumental practices. He makes no mention of metal attachments. Note the corner akroterial sphinxes with poloi, the central anthemia, the lion-head waterspouts of the lateral sima.

64. Women holding tympana (A 5 and B 2): Fleischer 1983, pls. 22 and 25 respectively. Woman with long overfold, short mantle (A 3): pl. 20; note the long fold outlining the free leg, as in some Halikarnassos sculptures. Woman with apron mantle (C 3): pl. 32. Some women wear a fillet just below the hairline, over the forehead: see, e.g., pls. 22 (A 5), 24 (B 1), 29 (B 6). Drill work is most evident in the vertical folds of the lower chiton; one "rosette" appears on A 3. For the short sides, see pls. 6–7.

65. Lykian wave, on profile figures: e.g., Fleischer 1983, pl. 16 (C 7, 12, 14, 16); ivy-leaf motif: e.g., pls. 12 (A 2, 8), 13 (A 23), 15 (B 15, 18), with the clearest rendering perhaps on B 23, pl. 15.

CHAPTER 6

Original Reliefs

Votive, Mythological, Document

There seems to be a strict correlation between funerary and votive reliefs, at least in Attika. The latter continued to be made, albeit sparingly, during the period (c. 490–430) when gravestones apparently were not, but the real flourishing of the form began with the resumption of funerary sculpture and ended almost entirely around 300, shortly after the anti-luxury decree had forbidden the carving of expensive stelai. Simultaneously, Attic motifs and stylistic forms spread outside Athens and its environs, first around 400, at the end of the great Athenian building program, and then again at the end of the fourth century. It has therefore been logically assumed that votive reliefs were produced, as a sort of sideline, by the same workshops that provided architectural sculptures first, and then, at the height of their production, mostly gravestones.[1] Indeed, comparisons have been attempted between votive and funerary reliefs, with specific identification of hands, and at least one parallel has been found between heads from the Argive Heraion metopes and those on a votive panel in Copenhagen.[2]

Somewhat the same chronological outline can be followed for Attic Document Reliefs, which begin around 430 and taper out around 300, to reappear briefly in the late second century; the non-Attic examples, proportionately limited, date from the mid-fourth century onward. Although the stylistic development of these figured headings for decrees, both official and "specific," has been found to conform in general terms to that of grave stelai, only in the early phases of production can the works be attributed to the same ateliers. In the course of the fourth century, however, increased dissimilarity among the Document Reliefs themselves has suggested specialized carvers, especially since the primary purpose of such monuments was the recording of often lengthy inscriptions, rather than the display of the figured panels. The virtual disappearance of Document Reliefs after 300 is therefore to be ascribed to the changed political condition in Athens, rather than to lack of expert sculptors.[3]

Reliefs: Votive, Mythological, Document

The category of mythological reliefs is far more nebulous and, to my knowledge, has not been treated as a unit.[4] Both Document and votive reliefs, to be sure, depict divinities and heroes, and, as such, could be considered mythological; yet I limit my definition to those panels that narrate episodes about the gods. These could be outright votive reliefs, like one in the Athens National Museum that portrays the miraculous birth of Asklepios; or they could be bases, like the Mantineia slabs with the story of Apollo and Marsyas.[5] In some cases, lines are difficult to draw between categories, as in the case of votive pinakes showing the dances of the Nymphs, or the healing intervention of Asklepios or Amphiaraos. In other cases, the original reliefs are lost and can only be visualized through literary descriptions (for example, Pausanias on the deeds of Perseus and Bellerophon on the throne of Asklepios at Epidauros) or through alleged echoes in the so-called Neo-Attic reliefs (such as the delivery of the baby Dionysos to the Nymphs of Nysa, postulated by Edwards for the base of the chryselephantine statue in the Temple of Dionysos at Athens). We shall attempt a sampling of the various types.

VOTIVE RELIEFS

The briefest definition of a votive relief is that of a carved panel donated either as a thank-offering or as a request for favors.[6] But whereas gravestones had the specific purpose of depicting the deceased, a votive relief did not necessarily have to represent the divinity involved, the donor, or the circumstances that led to the dedication. As an example of the first type (no deity), one may cite the many reliefs found in Greek Asklepieia and other healing sanctuaries, which depict neither patient nor doctor but only parts of the human body—the so-called anatomical votives (Pl. 48).[7] The second category (no donor) is represented by images of the deity or deities alone, or even in group with other divinities, but without human votaries. As for the third type, we may note how relatively few items show the healing in progress, a victorious event in athletic competitions, or a battle encounter that the dedicant survived. By and large, the typical votive relief of the fourth century portrays a group of worshipers, often leading sacrificial animals or making gestures of adoration, confronting one or more divinities, clearly differentiated from the humans by their larger size.

But a relief was not the only form available to request a favor or express gratitude. Gifts of garments, armor, jewels, animal sacrifices, fruit and grains, or, to return to the artistic realm, terracotta or bronze figurines in a variety of shapes seem to have been equally appropriate—in fact, some were required by the specific cult, like that of Artemis Brauronia, who received clothing connected with women in childbirth.[8]

Even within the sphere of the dedicatory panel, other options were possible. As we learn from inventories recovered from various sanctuaries, terracotta or wooden painted plaques, metal reliefs attached to a separate background, and reliefs entirely of bronze, silver, or gold were often given, but are today largely untraceable because

Reliefs: Votive, Mythological, Document

of their perishable or precious nature.[9] Yet their influence was felt on the more standard stone production, which often included pictorial elements proper to painted panels and usually absent from other categories of the genre, such as architectural or funerary relief.

This painterly component of votive panels could take different forms.[10] Details of the individual figures could, for instance, be added in paint, such as items of the costumes, weapons, scepters, or various attributes—a practice that, however, obtained also on gravestones. Or spatial differentiation could be achieved through an alternation of high- and low-relief images, the latter partly hidden through overlapping or shown as if emerging from the panel frame; this technique began in the late fifth century, although it became more popular after 400. But the most revealing pictorial element may seem to us the inclusion of landscape features in the composition, either clearly expressed in stone through relief groundlines, rocky frames, and architectural items, or presumably added in paint in the large overhead spaces that make the worshipers appear as if steeped in the atmosphere. Such renderings do occur in architectural sculpture, but on non-Greek territory, as is the case for the Trysa friezes, which are also considered under strong influence from monumental painting. In Greece proper, both funerary and architectural reliefs eschew any but the most basic of topical allusions—the occasional background tree, the rock on which a foot can be conveniently propped, the few undulations symbolizing the sea.[11] But votive reliefs are so frequently embellished with such settings that a special category can be defined, with its own meanings and motivations.

Landscape Reliefs
Perhaps the simplest form within this class—if understood as comprising any form of topographical indication—consists of reliefs including **architectural elements**. A step in that direction was probably provided by the need to supply not only a frame but also some kind of projecting top border to shield the sculpture from weathering. In the Archaic period we have at least a few votive reliefs crowned by a pediment, although more elaborate framing devices, including antae, seem to appear only later, and the lateral sima with antefixes, already discussed in connection with gravestones, makes a frequent appearance only toward the end of the fifth century.[12] Neumann sees in this last rendering the intentional representation of a stoa, as a meeting ground between gods and men, and it is quite possible that this meaning accrued to it with time; but I suspect that the feature originally had a purely practical function, intensified by cross-currents with funerary art.

That no literal depiction of a building was intended may be suggested by a votive relief from the Amphiaraion at Oropos (Pl. 49), where a large pair of apotropaic eyes appears among the lateral antefixes of the top border.[13] Within the space framed by antae, the donor, Archinos, is shown twice, or perhaps even three times, in an unexpected anticipation of Roman continuous narrative: first, at the extreme right,

Plate 49

Reliefs: Votive, Mythological, Document

as worshiper, standing in a posture of adoration; then, in center field, lying asleep on a kline while a snake touches his right shoulder; and finally standing near a much larger figure—probably Amphiaraos, because of his Archaistic curls, rather than a local priest—who is attending to his damaged arm. This last scene could be interpreted as Archinos confronting the healing hero in his dream, and therefore not as a true duplication of the donor in a physical and temporal sense; yet no such explanation is possible for the standing worshiper, thus requiring a reading of the images in chronological sequence.

But the most important feature of this relief, from the point of view of our concern with architectural definition, is the large plaque on a pedestal rendered in low relief as rising behind the couch on which Archinos reclines. It should probably be read as the very dedication made by the grateful worshiper, and in fact its format reflects that of the carved stone panel, which terminates in a tenon meant for insertion into a tall shaft. We cannot tell at present whether any scene was indicated in paint on the plaque within the relief, but the rendering certainly suggests the open setting of the Oropos temenos, thus contradicting the apparent location of the kline within a stoa. Nor can the total picture be read as if "photographed" from the interior looking out, since the top frame depicts the eaves of the roof. It seems best to avoid too logical a reading of Archinos' relief, in favor of a syncretic explanation in keeping with Greek narrative tendencies. Thus, the upper frame would be the one appropriate for votive reliefs, the apotropaic eyes would not need a literal interpretation, and the panel within the panel would then acquire identifying value, signifying sacred space.

That this last suggestion is viable is supported by the many votive plaques in which a similar low-relief pinax appears, sometimes incongruously under an antefix-frame, as for instance in another panel from Oropos, showing a chariot with bearded charioteer and "apobates" moving at full speed in front of such a votive monument. Other examples occur within clear open-air settings, as suggested by the rocky ground and the remnants of a realistic tree trunk on a fragmentary votive relief in Delphi, perhaps still belonging to the late fifth century. Finally, others include a more elaborate transition between post and panel, and the latter is carved with divine figures, thus verifying the sacred meaning of the signifier. It is worth noting that, at least in one case clearly datable to the fourth century, the gods appearing on such a "background" panel are Apollo, Leto, and Artemis, rendered in Archaistic style, whereas the primary relief (now fragmentary), which comes from the Asklepieion at Corinth, probably showed the healing god and Hygieia in contemporary fashion.[14] Thus the connection between Asklepios and Apollo, known through mythology and cult, is confirmed iconographically, as an oblique compliment to the recipient as well as a topographical indication.

If the lateral sima on antae is primarily a framing device, and the panel on a post mainly signifies "sanctuary," there is no mistaking, however, the inclusion of actual

Reliefs: Votive, Mythological, Document

architectural structures within some reliefs themselves, not just as part of their border. Some votive plaques to Herakles show him next to a tetrastylon, which has been linked to a special form of cult building for the hero and a specific festival in his honor; and fifth-century votives had already included images of Athena and other personages in a naiskos.[15] But the most striking rendering occurs perhaps in a late fourth-century relief to Asklepios (Athens NM 1377, Pl. 50).[16] Carved from a single block, but with its upper border on two levels, the relief juxtaposes the divinities within their own shrine, at right angle to the worshipers approaching from the right under a lower segment of a roof, which in this case, with its own two antae, indeed conveys the impression of a stoa abutting the taller naiskos. Architectural differentiation is therefore obtained not only through illusionistic but also through plastic means, with the front surface of the panel breaking into the viewer's space like a projecting wing inviting entrance into the sacred enclosure. This participatory approach, this implied interaction between spectacle and spectator, is also observable in late fourth-century gravestones with their deeper frames, semicircular compositions, or figures looking out as if to reach into the world of the living, the most typical example of which is perhaps Aristonautes' Stele.[17] Most remarkable in the Asklepios panel, however, is the further gradation of planes, with figures carved in very low relief on the short sides of the slab, and a rear surface so carefully smoothed that it was probably meant to receive a painted decoration, perhaps even an additional scene.

A second form of landscape relief, which we may call the **cave type**, also involves the framing border, here rendered as a rocky ledge, but adds an uneven background to the carved figures within, so that the impression of a grotto is conveyed (Pl. 51). This compositional device is typical of votive reliefs to the Nymphs, creatures of nature often personifying or inhabiting springs and mountains, but it can also be used for other gods, occasionally in theriomorphic form. Edwards has pointed out that the two earliest Nymph reliefs to use the cave frame include no worshipers, and thus the setting cannot symbolize just a meeting place between rustic divinities and men (as Neumann has suggested for the stoa-like frame). Yet Van Straten has shown that, with time, the mouth of the cave that bounds both groups comes to separate them, keeping the gods in and the men out, in accordance with a general tendency of the late fourth century and early Hellenistic period that sees the divinities as progressively more aloof and removed from their worshipers.[18]

Edwards has given several explanations for the use of the cave frame: not only is a grotto the natural habitat of such creatures as Pan and Acheloos, who often accompany the Nymphs, but it is also the place where deities of fertility and promise rise up from the underworld. Finally, the baby Dionysos was reared by the Nymphs of Nysa in their cave, when Hermes delivered him to them for safekeeping. For Edwards, this is the paramount reason why reliefs to the Nymphs, in the second half of the fourth century, changed their framing device from a linear/architectural for-

Reliefs: Votive, Mythological, Document

mat to a rocky border: the impetus was provided by a major monument depicting the Dionysos story, which then served as inspiration for all future votive production. Such a major monument, according to Edwards, can be reconstructed with additional help from Neo-Attic works; it probably decorated the new base for the chryselephantine statue of Dionysos Eleutherios made by Alkamenes around 430, which in the mid-fourth century must have been moved to the new temple of the god near the Athenian Theater, where it was seen by Pausanias (1.20.2).

To be sure, the recurrence of specific types within the series of votive Nymph reliefs, and the change from a purely processional or dancing appearance to a narrative scene, might seem to imply the creation of a specific and influential prototype, but I hesitate in accepting the elaborate mythological frieze reconstructed by Edwards for the statue base. In addition, his inclusion of Theban and Attic characters prompts him to read political allusions into the composition, and thus makes him set its date within the aftermath of the Battle of Chaironeia (338). As a consequence, most of his catalogued items receive a date lower than perhaps necessary, although Edwards acknowledges the general "revitalization" (not a revival) of votive production after the mid-fourth century.[19] For the purposes of our survey, such fine chronological and political distinctions are unnecessary, and only some general observations can be made on the basis of Edwards' thorough study.

One important point is the transformation in the appearance of Acheloos, the river god who often accompanies the Nymphs. Shown at first as a human-faced bull protome that seems to disappear behind one of the framing edges, around the mid-fourth century Acheloos is rendered as a disembodied head or mask carved in low relief onto the rocky border of the panels. He is therefore no longer an acknowledged participant or spectator to the action, but an apotropaic device protecting the sacred space while also symbolizing its watery component (cf. Pl. 51).[20] Comparison with the large eyes on the roof of Archinos' relief comes to mind, again not as a descriptive feature of a true locale, but as an added prophylactic element in keeping with the superstitious (or naively pious) sphere of votive art.

The cavelike frame may have originated as part of a narrative context, yet not all such Nymph reliefs include the divine infant. The best-preserved rendering of the myth is the outstanding plaque dedicated by Neoptolemos of Melite, a friend of Lykourgos, which Edwards uses as a focal point for his reconstruction, and where the baby Dionysos appears as a bundle of clothes in the center. But an equally good and approximately contemporary, or even slightly later, offering by Agathemeros omits the narrative and includes within the cave both the worshiper and his attendant *oinochoos* pouring a libation into his master's kantharos. To be sure, distinctive gestures and poses of individual divine participants (e.g., the seated Nymph lifting the edge of her mantle as if to receive something on her lap; the leaning Nymph with hand on hip) could by that time have become allusive and readable even without explicit formulation of the delivery scene,[21] but I wonder whether another ex-

Reliefs: Votive, Mythological, Document

planation for the introduction of the cave frame is also possible.

Some reliefs with a rocky border were obviously meant to be displayed on tall pedestals, as indicated by their stone tenons, often carrying the dedicatory inscriptions. But the many, now empty, rock-cut niches surrounding many Attic sanctuaries (on the north slope of the Akropolis, or on the road to Eleusis, to name just two areas) were also intended to house votive offerings, some of which were undoubtedly reliefs in either stone or terracotta. Seen in place, against their natural setting, such panels would have automatically acquired a rocky frame, which could eventually have been rendered as part of the very plaque, to blend, as it were, with its containing niche.[22] Thus, as we argued above for the lateral-roof border, multiple explanations are possible. A pictorial origin in wooden pinakes and a symbolic meaning for the cave as a meeting place cannot be discounted; influence from monumental paintings or famous cult-statue bases can also be postulated, even in the absence of material evidence. Yet the cave-frame reliefs could also be viewed as the plastic translation of a natural setting typical of popular offerings.

A third category of landscape reliefs, incorporating **natural features** within the composition, is more difficult to define. The Neoptolemos relief mentioned above, for instance, besides its rocky border includes a rough background hollowed out of the block to suggest the uneven ground of a cave, on which figures sit at different levels, while others lean against apparent outcrops. This same leaning pose can be introduced at the very edge of the composition, so that the personages, usually divine, appear to prop themselves against the cavelike border (as in Agathemeros' dedication); or a tree is substituted for the rock in an outdoor setting.[23] In other instances, it is impossible to tell what was meant by the particular rendering, which once would obviously have been clarified by paint. This is the case with a fragmentary relief in New York (Pl. 52), which might be funerary rather than votive, but which seems to depict an actual event on the battlefield.[24]

Plate 52

The small panel is now topped by a plain border, but it may originally have been set in a more elaborate frame. The bottom ledge is carved to give the impression of an uneven, rough terrain, and a great deal of overhead space suggests an open-air environment. But the most peculiar feature is an undulating shape defined by two parallel lines, in very low relief, which descends vertically from the top to disappear behind the raised shield and left arm of a youthful warrior who is kneeling on the ground under the pressure of an opponent's knee. It seems improbable that the vertical feature may represent a tree, since its wavy contours are too regular; yet it could not depict water, since such a naive perspective would be out of place in this well-carved and well-conceived sculpture. The three warriors appearing on the preserved fragment have been described as wearing piloi or pointed helmets; a closer look has convinced me that at least the fallen man (probably a corpse) and the soldier fleeing to right wear soft Oriental caps with long side flaps and pointed tips. The scene should therefore depict an encounter between Greeks and Easterners,

perhaps Lykians, as had already been proposed on the basis of the kneeling warrior's long hair. That battles could traditionally be shown against a picturesque—and pictorial—background, perhaps under the influence of monumental painting, is suggested by fifth-century renderings like the famous Albani Relief and the Pythodoros dedication at Eleusis, the latter definitely votive because of its inscription.[25] Should the New York relief also be a thank-offering, it would represent one of the rare occasions in which the reason for the gift was made explicit by its content.

As a last example of a landscape relief, an unusual fragmentary plaque from the Athenian Asklepieion may be mentioned, although it straddles the fine line between the votive and the mythological sphere (Pl. 53).[26] The poorly preserved portion has been read as a depiction of Asklepios' magical birth and nurturing, according to the Epidaurian version of his legend; if this interpretation is correct, the natural features of the composition may be as much symbolic as descriptive. The breast-shaped mountain (nipple included) would be a visual pun on the name of Mount Titthion, where the baby was abandoned, not simply a setting for his discovery; and the towering palm tree, far from depicting local flora, would allude to Artemis and Apollo, especially the latter, who was Asklepios' divine father.

On the basis of all the examples cited, therefore, it seems logical to conclude that landscape elements in Greek reliefs had multiple functions (including that of framing devices), but that primary among them was a specific allusive purpose; thus pictorial traits were never used in purely decorative form, although foreshortening, spatial and plane regression, and color may have considerably added to the painterly effect.

Banquet (Totenmahl) *Reliefs*
A second category of votive reliefs can be isolated, but the topic has been discussed well and at length in specialized articles and monographs; therefore only a brief account need be included here.[27] Although the type begins in the late Archaic period, it achieved its greatest popularity in the fourth century, and the basic schema—a reclining male, a female seated at the foot of the kline, a table laden with food, an attendant *oinochoos*—becomes increasingly elaborate with time, especially during the Hellenistic phase and in East Greek territory, with the inclusion of personifications, armor or other objects shown as wall hangings, and "windows" opening up as architectural features in the background to reveal horse's heads and humans.[28] Yet it is important to point out that similar motifs, albeit in disjointed fashion, already appear around 400 on the so-called Telemachos Relief, a votive monument from the Athenian Asklepieion, of significance not only because it was copied in antiquity, but also because of its extensive inclusion of landscape elements.[29]

In its early manifestations, and then again in Hellenistic times, the type of the *Totenmahl,* as implied by its German name, can carry funerary connotations, and is often used on gravestones. Yet, during the fourth century, Banquet Reliefs seem

Reliefs: Votive, Mythological, Document

more definitely votive, since they include worshipers, at considerably smaller scale than the reclining honorand and his female companion, and the occasional sacrificial animal. Although some gods can sporadically be recognized, identification of the recipient is usually impossible, and even inscriptions frequently refer to "the Hero" without further specification.[30] The divine nature of the banqueter is sometimes emphasized by his wearing the polos, but considerable variety in his rendering points to multiple identities: the man can be bearded or beardless, fully or semi-draped, holding a rhyton or a phiale, with or without an accompanying (chthonian) snake. Findspots suggest that such reliefs were set up in a variety of sanctuaries, according to need. This last statement brings up the issue of production, as raised earlier for gravestones. Were votive reliefs, of any kind, *made on commission* or were they *mass produced?*

The very wide geographic distribution of the Banquet type would indeed seem to imply generic patterns and standard manufacture. Heroes, by their very nature, had a "normal" lifespan, as contrasted with a deity, who could be conceived as eternally, and attributively, young or perennially mature. Thus variety in the age rendering of the reclining banqueter might not have affected sales, regardless of the intended recipient. To be sure, the larger and better works were probably specifically ordered, and the inclusion of unusual traits or figures within the basic composition would seem to suggest a direct commission. Yet, even the presence and number of worshipers need not be taken as signs of ad hoc carving, as confirmed by several votive reliefs, of different types, carrying dedicatory inscriptions. The issue may therefore be better discussed on a wider level, to involve all types of votive reliefs.

A plaque in the Brauron Museum may serve as evidence for the existence of stock pieces, perhaps available on the spot where dedications to Artemis were to be reasonably expected. It depicts the goddess, wearing a belted peplos and a tall hairstyle, and holding phiale and bow. Behind her stands a deer. An altar separates the deity from a line of approaching devotees: a male slave holding a bull ready for sacrifice, then four men alternating with five women, including a servant carrying a tall *kiste* on her head, and four children (two girls and probably two boys). Yet the inscription mentions only one dedicant, Aristonike, wife of Antiphates, and the worshiper closest to Artemis (who should be the primary votary) is definitely a man. We may also wonder at the perfect distribution of genders, which extends to the children depicted as miniature copies of the adults, since it seems to recur, with minor variations, in other similar reliefs. Yet the Brauron panel is a work of good quality: note the irregular alternation of the figures, with some facing outward to break the monotony of the file, and gradually diminishing in height, as if for a perspective arrangement suggesting recession into the distance. By contrast, Artemis towers over the humans, filling the entire space from top frame to bottom. Her costume, with its straight hem at the overfold, looks old-fashioned and has been called classicizing.[31]

As mentioned, this type of family group, comprising several men and women

Reliefs: Votive, Mythological, Document

and often two or three children, occurs with great frequency on votive reliefs, although at times it is the woman who leads the procession. The arrangement of the above-mentioned Brauron plaque cannot therefore be taken as a form of gender discrimination or hierarchical subordination. Nor is the presence or absence of women and children, or their order in the file, determined by the recipient of the offering, since they are also included in votives to Asklepios and Hygieia, and to Demeter and Kore.[32] Van Straten has underscored the paradox implied in the fact that increasing individuality in fourth-century religion—as indicated by the choice of "more intimate" patrons, sought among the healing deities and the fertility goddesses—is counterbalanced by a lack of individuality in the votive depictions, which are private but not individual, even when only one dedicant is mentioned by the inscription.[33] Yet I suspect that the apparent similarity and anonymity of such family groups on reliefs may have a different (or concurrent) explanation and could be taken as evidence of sculptural prefabrication.

Two corollaries may be added to this tentative conclusion. The first is that earlier times, which favored ad hoc commissions, allowed for a greater focus on the donor in votive plaques, as was occasionally true for gravestones: see, for instance, the late Archaic "Potter's Relief" from the Athenian Akropolis, or even the early Classical depiction of a jeweler(?) in direct contact with Athena, from the same findspot.[34] Anonymity and mass-production therefore seem to go hand-in-hand, as a fourth-century phenomenon. The second corollary is the acknowledgment of a new emphasis on family groups—the citizens as defined by their intimate relationships—which again was noted in funerary reliefs from mid-century onward. **Children** are now depicted as an important part of the family nucleus, not because their status has changed or parental affection has increased, but because their attributive and defining function has been recognized. That their depiction is faulty, in that they are shown as shrunken adults, does not diminish the value of their inclusion, which belies the common misconception that the Greeks, as contrasted to the Romans, did not portray children in their monuments.[35]

Olga Palagia has made the important observation that only one relief (the so-called Athena and the Pig Sacrifice), which she would date still within the Archaic period, ever shows the goddess with a family; the parents would be bringing their two sons (and a daughter) to the Akropolis to introduce them to Athena during the festival of the Apatouria. This apparent singularity seems remarkable, since the festival continued to be part of the Athenian religious calendar through the ages. I had already suggested that the plaque is Archaistic, rather than Archaic, and therefore placed it after 480. It seems unlikely, however, that its date could be lowered further, into the fourth century, although Archaistic renderings are well attested for that period. Yet the uniqueness of this panel cannot be explained with a change in the concept of Athena.[36]

Were there divinities, therefore, to whom it was inappropriate to bring children?

Reliefs: Votive, Mythological, Document

This is a difficult question that cannot be explored outside a chronological frame, if the inclusion of progeny in compositions begins in the fourth century. Moreover, answers are conditioned by the chance of the finds and the number of extant monuments. The largest quantity of all votive reliefs known at present was dedicated to Asklepios and Hygieia, followed in popularity by Demeter and Kore,[37] and then by Artemis at specific sites. The Nymphs and Acheloos, as previously discussed, also received frequent offerings, and Herakles was relatively popular. But the latter, and other deities, tend to be shown with few worshipers, or even in isolation, like Kybele in her naiskos. This goddess, of course, was particularly important in Asia Minor, and her reliefs may thus respond to different conventions, although her cult, as Meter, spread to Attika in the late fifth century, when her shrine was established in the Peiraieus.[38]

On the one hand, therefore, the answer to our question may be affirmative—children were included only in special cases. On the other hand, the argument itself may be entirely circular, since the fewer reliefs offered to less popular deities may have required specific commissions, and therefore resulted in distinctive composition.[39] One such case is illustrated by a mid-fourth-century votive relief to a newly created god, Attis. It has in fact been argued that the name in Phrygia originally referred to a cult official of the Mother, not to a mythological person, and that only later was a story provided to account for a more important, independent role. Attis may therefore have entered Greek cult as the main attendant of the mother goddess, for whom a **specific iconography** had to be devised. This was found in the traditional depiction of Oriental garb, as used, for instance, in representations of Paris, the Trojan prince, and Attis appears so dressed in what may be one of his earliest occurrences in Greek art, firmly identified by the accompanying inscription: the above-mentioned votive plaque from the Peiraieus, now in Berlin. Roller attributes Attis' acceptance as a god in Greece to ignorance of Phrygian cult practices and to a basic need for help from a maternal deity whose companion he was thought to be.[40]

This Athenian interest in **foreign cults** is not a novelty of the fourth century. The previous century had already witnessed the worship of (Zeus) Ammon, (Dionysos) Sabazios, and (Artemis) Bendis (significantly provided with cult places in the main harbor of Athens, the Peiraieus), but these alien divinities, despite their "outlandish" attributes, could be assimilated to local ones and thus obtain easy acceptance.[41] The innovation of the fourth century consists in a greater need for special protection and personal assistance that may have resulted in a more encompassing pantheon and even in the personification of abstract concepts, such as Iakchos and Hymenaios, and especially Tyche.[42]

Two final comments should be made on votive reliefs, whether commissioned or mass-produced. The first is that we should recognize their use of the **scale of importance**. Egyptian art, with its emphasis on Pharaoh and/or the deceased made

to appear much larger than surrounding figures, has always seemed to us abstract and intellectual, as contrasted with the more naturalistic renderings of the Greeks. Even the depictions of the Hellenic divinities are perceived as different from the Oriental ones in that they are so fully anthropomorphized as to be virtually indistinguishable from humans. Admittedly, a few examples of imbalance in scale existed in the Archaic period, but not many in Attika, and certainly not in later periods—or so we thought. Yet this survey of votive reliefs has shown that at the very peak of the Classical phase, during the fourth century, humans could be shown as considerably smaller than the gods, and younger persons as smaller than adults, not simply because of their relative age, but also because of their ranking. A significant example is in fact provided by a votive relief to Demeter, in which a file of seven ephebes follows two taller men who stand closest to the altar and the goddess; the virtual isocephaly of the youths is intentional, despite the variety of their poses.[43] Even the attendants who hold the sacrificial animals are always pictured as improbably small—not because of their actual age, but because of their inferior status.

My second comment concerns these very attendants, or rather the **depictions of sacrifice**. Animal victims had already appeared on the Parthenon frieze, but without a specific allusion to their destination, almost as a sequel to the cavalry horses. On votive reliefs, the intended sacrifice is made explicit by the proximity of the altar or the deity to whom the offering is made; yet not once, to my knowledge, is the actual killing depicted, or is the animal readied for the stunning blow or the cutting knife. The contrast with Roman reliefs is all the more significant in that the traditional sacrificial pattern was supposedly derived by the Romans from an alleged Greek monumental painting, in turn inspired by vase painting representations. Should this hypothesis remain valid, it would underscore the difference in subjects and iconography between the various forms of Greek visual expression.[44]

MYTHOLOGICAL RELIEFS

This category may be important, paradoxically, because of its scarce representation, which contrasts with the relatively more abundant examples of this genre in the preceding and following centuries. Stories about the gods, or at least depictions of the gods in contexts that suggest something about their essence, a primary event in their "lives," or one of their deeds, definitely occur in votive reliefs of the sixth and fifth centuries: scenes of Aphrodite emerging from the sea, or traveling over the waves in a chariot drawn by Erotes; Herakles carrying the Erymanthian boar, capturing the apples of the Hesperides, or with Theseus in the Underworld; Athena fighting in the Gigantomachy; Kore being kidnaped by Hades.[45] During the Hellenistic phase, elements of narrative reappear. To mention just a few, there is Herakles being initiated into the Mysteries at Agrai, the Hero Hippalkmos on horseback fighting a wild bull, Dionysos visiting Ikarios, Artemis at an altar accompanied by two satyrs(!), which may suggest associations and stories now lost.[46] Why, therefore, should the fourth century be so devoid of action scenes?

Reliefs: Votive, Mythological, Document

The obvious answer would be that fourth-century worshipers were primarily concerned with obtaining specific, personal favors, and therefore wanted to represent themselves in front of the divinity, as a reminder. Yet human spectators could always have been included at the edges of narrative contexts, and personal conditions would not have noticeably changed during the Hellenistic period, when the many battles and individual hardships should only have made the need for favors more acute. Perhaps the answer lies in the progressive distancing of the deities from the faithful, at least in iconographic terms, as Van Straten has suggested; but a better answer is perhaps provided by the apparent demise of the Attic votive relief after 300, as contrasted with the diffusion of the practice to other areas. As always, we should be wary of drawing general conclusions from Athenian examples alone, since Attika does not represent the rest of the Greek world. Yet even this inference, which might explain the resumption of mythological reliefs outside Attika during the Hellenistic period, does not address the issue of the changes *during the fourth century*. The different, non-narrative character of Attic reliefs as contrasted with their predecessors *within the same area* is therefore worth noting.

A few examples can nonetheless be considered "mythological" votives, and I shall here mention them briefly. The fragmentary plaque from the Athenian Asklepieion probably depicting the Birth of Asklepios, previously discussed among the examples of landscape reliefs, can certainly be included here as well, and so can the Neoptolemos Relief with the delivery of the infant Dionysos to the Nymphs of Nysa. All representations of Asklepios and other healing heroes attending to humans could be considered action scenes. Less obvious but possible inclusions are some votive offerings to Demeter and Kore that comprise Triptolemos in his winged chariot, and therefore may be said to contain narrative elements, as allusion to the mission entrusted to him by the goddesses.[47] This is the theme most often represented in votives to the Eleusinian deities, as contrasted with the actual kidnaping of Kore, which is very rare. Peschlow-Bindokat has noted a number of changes in fourth-century reliefs, as contrasted with those of the earlier century: the Mother now often sits on the *kiste* while the Daughter stands; age differentiation is introduced, and not only through the type of costume worn, but with other subtle hints. In addition, Kore exhibits new ways of draping her mantle. Finally, there is greater distance between the two, who previously were shown in close contact; now they stand in isolation, like two statues, their attention focused on the worshipers who are almost always included in the scenes.[48]

A few votive reliefs show Aphrodite riding a goat or next to a ladder; these are allusions to her nature as Ourania, and are therefore what the Germans would call *Daseinsbilder*, a sort of representation of the essence of the god. Many of these works are fragmentary and difficult to date, but given the rarity of the type, they should be mentioned here.[49]

True mythological narration is found only outside the sphere of votive reliefs, primarily on temple bases. Most of these are now lost, and I am not convinced that

Reliefs: Votive, Mythological, Document

Neo-Attic reliefs allow us to reconstruct them with confidence. A few are extant, although mostly datable toward the end of the period under consideration. Some comments should, however, be made about the so-called Mantineia Base, given its importance in the literature in connection with Praxiteles. In addition, two related structures will be considered because of the specific issues they raise: the so-called Altar of Asklepios from Epidauros and the "Tribune of Eshmoun" in Sidon.

A passage in Pausanias (8.9.1) has been crucial in our discussions of the **Mantineia Base**. In entering the city, he describes a strange temple divided in the middle by a wall; one section seems to be dedicated to Asklepios, another to Leto and her children. He attributes the "agalmata" to Praxiteles and mentions that their base is carved with a Muse and Marsyas playing the pipes. Three marble slabs, discovered at Mantineia in 1887 as part of the paving of a Byzantine church, depict the contest between Marsyas and Apollo in the presence of a Skythian slave and six Muses; they were therefore considered confirmation of Pausanias' statement (with slight emendation of his text) and attributed to the Athenian master. Subsequent studies have nuanced this attribution, giving the reliefs to his workshop, but they are now unanimous in seeing them as the pedestal for Praxiteles' divine statues. The Letoon has not yet been found.[50]

Since Pausanias' attribution of the Hermes at Olympia to Praxiteles has now been challenged, there is no reason to give complete credence to his other identifications, even if there is nothing inherently implausible in the idea that Praxiteles might have made statues for Mantineia. But it is the base that is here in question. "A Muse and Marsyas playing the pipes" may not sound like an accurate description of the poignant scene between the satyr and Apollo, but it is sufficiently close, and Muses do not appear frequently enough in fourth-century reliefs to suggest that a different monument was intended. There are, however, some peculiarities that have prompted different interpretations of the Mantineia find.

A main objection is that the three slabs do not combine into a plausible base to support three statues at normal or over-lifesize scale. If **slab A** with Apollo and Marsyas is placed in the center, with **B** and **C** (the slab with a Muse seated on a rock, and the slab including a Muse with the kithara, respectively) at right angles to it, forming the short sides of a rectangle, the resulting enclosed surface would seem too small. If all three slabs are combined in a linear arrangement, again with **A** in the center and **B** and **C** aligned with it on either side, the base might be long enough, but it is surprising that the two end pieces show no return to connect with the (blank?) short side.[51] The same kind of structural objection can be raised with any other arrangement, even if a missing slab is postulated to bring the Muses' number to the traditional nine, and regardless of symmetry.[52] Statue bases formed by orthostats do in fact exist, but show technical features that exploit the thickness of the slab to produce a return face, thus eliminating central joins, or carry no carved decoration. At any rate, no join seems to fall exactly at the corner, which

Reliefs: Votive, Mythological, Document

would virtually require a canted or diagonal surface to meet the adjacent slab.[53] If indeed the Mantineia plaques once formed the revetment for a cult-statue base, I would suggest that they were recut to their present form, or even reused as a base from a different original arrangement.

Other objections are less compelling. The subject matter of the reliefs, for instance, seems to have little in common with other Classical bases (as far as we know them), or at best to have emphasized Apollo's exploits. A missing slab might have carried a pendant scene with Artemis, but Leto would have been excluded, although the temple may have been primarily for her. Muses, moreover, are appropriate for Apollo, but hardly for the two goddesses. The reliefs were not found in context and therefore any suggestion must be considered purely speculative. Yet traditional interpretations carry great weight because of their potential for our understanding of Praxitelean patterns and style.

One theory, proposed by Svoronos, was that the slabs, with their clear musical content, formed the decoration of a *bema* for competitors in musical agones in the Mantineia theater, on the strong argument that a fragment of the reliefs was found in that area.[54] No such bema as the one Svoronos reconstructs has ever been archaeologically attested, and a decoration for the *scaenae frons* of the theater, although an attractive alternative, seems anachronistically too early by at least 200 years.[55] Except for some early suggestions, nobody recently has disputed a fourth-century date for the reliefs, although imperfections and iconographic details have been used to advocate execution by a workshop rather than a master. In particular, Linfert-Reich has hypothesized that the composition (without Marsyas and the Skythian slave, but with the three "Moirai" copied by the Neo-Attic Madrid Puteal) was first used for a round altar in Athens, and was then adapted for the statue base in Mantineia by workmen who might have followed Praxiteles there. The Marsyas would have been patterned after action figures like the Hermes on the Echelos/Basile Relief, and the Apollo after an original seated-Muse type, thus explaining Pausanias' misunderstanding of the scene.[56] I find this suggestion unconvincing. The Apollo wears not only the long-sleeved costume of the singer, with which his function of kitharoidos is usually underscored in the fourth century, but also high-soled sandals, typical of actors and quite different from the apparently soft shoes worn by the Muses on the other slabs. I also am impressed with Svoronos' observation that on each slab the central figure is static, as if listening, while the flanking personages are characterized by musical instruments or are singing (the Muse with the scroll on **slab C**), as if three separate but comparable competitions were shown.[57]

Stewart (1990, 177) has commented that the Mantineia Base develops the "detached style of narration popular with Pheidias's pupils," by which I take him to mean the apparent lack of interaction among the figures, as well as the wide space both between them and overhead. Yet the one extant base that can be connected with Agorakritos' workshop exhibits considerably more interaction and closer spac-

Reliefs: Votive, Mythological, Document

ing, especially with respect to the top border. The clear scansion of the Mantineia reliefs, to my mind, recalls nothing else so much as the frieze on the Lysikrates Monument, of approximately contemporary date.[58] To be sure, the very small band carrying the story of Dionysos and the Pirates was to be seen at considerable distance from ground level, and therefore spacing was essential for clarity. The larger size of the Mantineia slabs suggests instead a different placement; yet their subject seems more in keeping with a choragic monument than with a cult image or images. I wonder, therefore, whether the reliefs were first employed to support a tripod or even a commemorative statue, and were then cut free from their original blocks (for ease in transport and reuse, which would explain their peculiar format) and set up within the Letoon, where they were seen by Pausanias.

Alternatively, we could imagine that no connection exists, despite the apparent similarity of the subject, between the statue base described in the second century A.C. and the Mantineia reliefs. In that case, the findspot of a fragment within the theater might confirm a choragic purpose, perhaps as a balustrade around a specific spot or trophy. The subject of the play would have been the contest of Apollo and Marsyas, and the Muses would have composed the chorus—just as, in the Lysikrates Monument, satyrs play the chorus to Dionysos and the pirates. The Marsyas figure, with his unstable stance, looks more like a dancer than a player, and may reflect an actor's pose.[59] Should this hypothesis be correct, no connection would exist between the Mantineia reliefs and Praxiteles or his workshop.

Although this conclusion may appear excessively negative, the value of the "base" for stylistic studies remains considerable. We would only have lost its connection with a "great master" but not eliminated its importance as a sampler of female costumes and hairstyles in the second half of the fourth century. A date around 330–320, as advocated by some scholars,[60] seems a bit low, especially in comparison with the Sarcophagus of the Mourning Women, or even some of the Attic gravestones discussed in Chapter 5, and I would prefer to place the Mantineia reliefs one or two decades earlier; yet such chronological precision is rendered more difficult by the Arkadian location, as contrasted with the possible Attic inspiration behind the motifs.

Perhaps the most distinctive trait in the female costumes is the emphasis given to the upper edge of the mantle, in its various forms: circling the neck and shoulder, thus stressing volume and penetration into the background; crossing between the breasts, so as to outline one of them with tension folds; rolled up above waist level, thus producing a short "skirt" and two horizontal accents, one major and one minor; flung across the lap of the seated Muse with a surprising flutter of folds caught as if in motion. Little textural distinction occurs between chiton and himation, and the buttoned sleeves have almost turned into pure pattern. An occasional deep fold, whether in the upper or the lower garment, tries to recover the outline of the body whenever the composition tends to muffle it, yet occasionally the effect is almost

Reliefs: Votive, Mythological, Document

the opposite, as in the seated Muse with the lute (over the left leg). By contrast, the hands of two figures, wrapped in the mantle, are hinted at with convincing transparency. I can find only one incipient "rosette": in the central figure on **slab C**, and I am not even sure that the motif was intended.

The three Muses' heads on slab 217 (**C**) are damaged beyond analysis, but those on slab 216 (**A**) show three hairstyles important for chronological correlations, given their simultaneous occurrence: the high peak over the forehead as part of a hair roll, the melon coiffure encircled by braids, and a high chignon—all patterns attested through grave reliefs, but perhaps indicative of different ages for the wearers.

The second monument to be discussed cannot be considered mythological in terms of narration, but it is related to the Mantineia Base by its equally puzzling nature, and it is greatly important for its stylistic mixture: the so-called **Epidauros Altar** (Athens NM 1425). The relief block has also been variously described as a base, a balustrade, or an architectural member.[61] As preserved at present, it is a thick slab with figures on three sides (although the female on one return face is in lower relief than the images on the front) and, on the fourth, traces of attachment to an ashlar core; we shall call it **block A**. A similar block recomposed from two joining fragments (here called **block B**) may represent the back panel of the same monument, since it carries three figures in as high relief as those of the front. This additional find seems to have been disregarded by most commentators, perhaps because of its poor preservation, and (except for Rupp 1974) I find no mention of it after the original publication in 1911; yet its figures were thought at the time to support Svoronos' earlier suggestion that the entire work depicted the Twelve Gods, with Zeus and Hera on the front face of **block A**. These identifications are now apparently rejected in favor of Asklepios and perhaps Hygieia, yet a corollary identification—that of the side personage as Hebe—has apparently been retained although no true justification for it now exists.[62]

The front face of **block A** shows a bearded male figure seated on a throne to left, his sandaled feet on a low stool. His upper torso is bare, his himation being wrapped only around his hips and legs and flung over the left armrest; his right arm is raised, holding a staff or other similar object probably once rendered only in paint. In the center of the panel, a female figure stands frontally, her head now broken off. She wears a peplos with low kolpos and a himation wrapped around her head and shoulder, which forms a roll at her waist and a short apron in front; she holds its edge at face level with her right, at hip level with her left hand. At the (viewer's) left edge of the front panel is a Nike in flamboyant drapery; she is almost entirely broken off, because she was carved in high relief at the very corner, like a ship's figurehead, her wings extended on either side, so that her right one appears only on the return face of **A** and its tip would have continued on the adjacent block. Her wind-blown skirt and the ends of her fluttering chlamys are spread against the background on

either side, in tubular folds. Her peculiar position at the corner recalls a comparable treatment on at least one of the pedestals from the Artemision at Ephesos, and suggests an invitation to the viewer to walk around the monument to look at additional elements of the composition. By contrast, the female on the opposite return face (thus behind the enthroned male) is carved entirely on the short side of the block, moving toward the front. Although also wearing a scarflike chlamys swaying out with her motion, this figure is in pure Archaistic style, clad in chiton and long diagonal himation with swinging tips, zigzags, and swallow-tail folds. Her face is damaged, but she has long tresses falling on her chest; in her right hand she holds an oinochoe. She has thus been called Hebe, walking to attend to Zeus; yet the enthroned male is more likely to be Asklepios, especially given the provenance of the block. The central figure, with her matronly gesture, does not fit Hygieia's iconography, although she is usually so identified. She could, however, be Epione, Asklepios' wife, especially in an Epidaurian context. Svoronos argued that she was Hera, in the context of an assembly of the Twelve Gods.

If fragment **B** truly forms the rear panel of this same monument, three more figures would be added to the composition. They are regrettably damaged, and even their sex is not always clear. The central, frontal image is definitely female, clad in chiton and himation; she is flanked on either side by a heavily draped personage moving outward—probably a female at her left, a male at her right. All heads are missing, and action is much less emphatic than with the Nike; yet long, curving motion folds characterize the outer "female" and a triangular "apron" is discernible on the mantle of the "male" figure. In an assembly of the Olympians, the central woman could be Demeter, perhaps between Poseidon and Kore.

Given the exposed clamps on the present top surface of **block A**, one more stone course must be postulated, as crowning member, slightly set back from the edges according to faint weathering lines (Rupp). If the monument was a statue base, this upper block would have received cuttings for it; if an altar, it would have served as the sacrificial table, perhaps with barriers at the short ends. It is harder to visualize the relief(s) as part of an architectural frieze, yet the only pertinent comparison for the corner Nike (the Ephesos pedestal) is in fact architectural, although as support for a column. The carving on one return face of **block A**, in lower relief than on the front, demands for it either a rear or a side position, according to parallels on votive and funerary stelai; the imposing appearance of the enthroned figure and the movement toward him of the oinochoe-holding female may imply that the main surface of **block A** was the front. **Block B** could theoretically have joined it at right angles, next to the Nike, but not enough room seems available for the Victory's wing tip and for a pendant figure at the other corner, nor do the extant images on **block B**, regardless of their weathered condition, look imposing enough to have been the true front of the monument. In all possible cases, even disregarding the evidence of **block B**, the restored structure remains unusual. Even more surprising

Reliefs: Votive, Mythological, Document

is the use of a figure in Archaistic style next to others in contemporary, Classical form.

Because of that figure, various dates have been suggested for the Epidauros "base," ranging from the fourth to the first century, the lower chronologies placing the relief among the eclectic manifestations of Neo-Attic art. Yet even obvious juxtapositions of images derived from different periods achieved at least the semblance of a unified composition, as contrasted with the abrupt change of the Epidaurian relief.[63] In addition, the Archaistic "Hebe" finds its best parallel on Panathenaic amphoras of the second half of the fourth century, and this date is supported by the style of the other images, although the flamboyant Nike could be as early as the akroteria of the Asklepieion. The Zeus/Asklepios can be compared to one of the two panels once thought to be metopes from that temple (Pl. 54).[64] In final summary, we have to admit that neither the meaning of the Archaistic figure nor the purpose or form of the monument itself can be readily understood. We should simply acknowledge its important evidence for Archaistic trends in fourth-century sculpture.

Plate 54

The third work to be considered in some detail is the so-called **Tribune of Eshmoun from Sidon** (Pls. 55 a–c), although I have already dealt with it briefly elsewhere and no new excavational information has become available. Yet the monument is particularly relevant in this context because it touches upon several facets of our previous discussion: its shape is unusual and unexplained, comparable to the Epidaurian base; its findspot reinforces the picture of Greek stylistic influence (or even workshop presence) in Phoenicia; and its decoration incorporates images derived from the Athenian repertoire, which has prompted suggestions that its official dating within the second half of the fourth century should be lowered considerably, making it a Neo-Attic rather than a Classical work. I shall therefore review the arguments advanced in recent publications, although unable to come to conclusions of my own, since I have never seen the sculpture. It should be admitted, however, that neither have many of the commentators, given the location of the site and the protective brick covering now built around the "Tribune" in the Beirut Museum.[65]

Plates 55a–c

Its excavator, M. Dunand, found it in 1963, within a sanctuary dedicated to Eshmoun, a local divinity who in the third century became equated with Asklepios. Other sculptures from that site range greatly in time and cannot provide a safe chronological underpinning for the Tribune. There are only a few pieces of possible fourth-century date, most of them fragmentary and of small scale; on the other hand, only two "copies" of alleged Greek types have been found, although "a mass of statuettes and statues was set up in Hellenistic time."[66]

The Tribune stood atop a socle of limestone blocks reveted with marble plaques that rested against a retaining wall for a canalization. Alterations and additions of limestone blocks around this original socle were made at an unspecified time. The dating of the reliefs has been based on their style and on a surrounding ash layer that contained black-glaze sherds. Yet this evidence seems inconclusive, so that style

Reliefs: Votive, Mythological, Document

has remained the primary criterion. The name "Tribune" has also been retained, although the purpose of the monument is still undetermined. It has the appearance of an altar in antis, being carved from a single large block of Pentelic(?) marble whose upper half has been hollowed out, making it Π-shaped; decoration in relief, in two superimposed registers, covers the three outer faces and—at the upper level only—the short returns on the fourth (rear) side.

The block is framed by a series of carved moldings at top and bottom, with additional moldings at mid-height forming the division between the two registers. On the fourth side, only the moldings crowning the figured "antae" have been rendered in relief; the others are plain. Whether they were left uncarved because of the block's intended function (perhaps, originally, as an altar) or because they were invisible once in position is one of the unsolved questions; another is whether the Tribune was found in its original location or was moved there from elsewhere, with a corresponding change in use. It has been suggested that the relief front, as found, served as a balustrade to separate whatever stood inside it (either human beings or divine images) from the viewers assembled in the semicircular area that fronted the Tribune and its pedestal. Damage to the outer corners of both antae on the rear face has been attributed to the possible removal of bronze grilles, which might imply reemployment. Also problematic is the means of access to the upper level of the platform, within the "balustrade."

The composition of both registers is symmetrical, on either side of an invisible central axis, so that no figure is given excessive prominence. Yet the upper frieze (18 personages, including two charioteers) has been read as a glorification of Apollo surrounded by other divinities, whereas the lower frieze would be in honor of Dionysos, because of the presence of his thiasos (18 females, one male, and one satyr) and despite the presumed absence of the god of wine himself. According to the official publication, the upper register's left half (spectator's point of view), moving from the center outward, depicts a standing Apollo playing the kithara and an enthroned Leto being crowned by a standing Artemis. Behind her stands an unidentified "matronly goddess" in peplos and himation; the edge of the front is marked by a damaged figure of Eros, recognizable through his wing tips. This sequence is balanced on the other half by a standing Athena, an enthroned Zeus, and a standing Hera. The female figure next to Hera is probably Amphitrite, because the partly effaced male facing her at the edge has his right foot propped up on a rock—a stance considered distinctive of Poseidon. Turning the corner, a female figure seated on a block has been tentatively identified as Dione, the peplophoros standing next to her as Aphrodite. A charioteer (Selene?) drives a quadriga at full gallop toward the end of this short side, and the (SE) anta face has a priestess facing left toward an altar. On the opposite short side, turning the corner from Eros, the enthroned female and standing peplophoros are considered Demeter and Persephone; the charioteer is perhaps Helios, and the SW anta face has an unidentified peplophoros. Note,

Reliefs: Votive, Mythological, Document

however, that "Demeter" sits to the right, thus leading the viewer's eye toward the front, whereas her counterpart on the parallel short side looks in the opposite direction; both chariots move toward the rear of the monument.

The lower register is again divided into two sections meeting at the central axis; the short sides, however, seem to move in the same centripetal direction, except for the very first figure (reading from left to right)—a mantled female who dances left toward the edge of the frieze. She is also singled out by the larger space between her and the next figure, a young satyr in three-quarter rear view, who is linked to the next dancer by the scarflike chlamys draped around his upper thighs, which she pulls toward her. The remaining two dancers on this side and the next three figures on the front hold hands in a chain terminating with a kithara player, who in turn stands behind a pipe player, probably also female. She is confronted (on the other side of the invisible central axis) by a youthful male in heavy garb (a young Dionysos, as advocated by some?) who leads by the hand a chain of three linked dancers. A fourth, at the edge of the front, stands stationary and facing, entirely wrapped in her mantle. On the parallel short side, five females are absorbed in their own revels, each an independent figure pirouetting in a flurry of drapery. It is this entire group of figures that has given rise to contrasting chronologies.

All commentators agree that they derive from Attic prototypes, and that some of them recur on attested Neo-Attic works, like the marble krater of the so-called Pisa type, whose earliest known examples were found in the Mahdia shipwreck. Three of the dancers (M, N, O at Sidon) are even shown in exactly the same order on both the krater and the Tribune, and it seems certain that the two relief vases now in Tunisia were made shortly before their transport foundered, probably around 100. Yet Grassinger, who has analyzed the marble vessels within their own Neo-Attic context, seems to think that there are true differences between the "Roman" carving of the kraters and the "Greek" rendering of the Tribune, thus supporting a chronology in the second half of the fourth century for the latter. Edwards, in his study of the Nymph reliefs, came to the opposite conclusion, disputing some of the comparisons suggested in the original publication, and arguing that the way in which the Tribune combined figures from different prototypes spoke in favor of a date around 100.[67]

Given the fact that both diverging conclusions are based on thorough knowledge of Neo-Attic monuments, I find it difficult to take a position. I must admit that the similarity between the Pisa-krater maenads and the Tribune dancers seems to me less compelling than stated by Grassinger, but I would side with her and Edwards in dissociating stylistically the Tribune from the Sarcophagus of the Mourning Women (cf. Pls. 47a–b), although the official chronology would place the former only a few decades later than the latter (Stucky 1993a, 44). Yet, as Stucky correctly emphasizes (1993a, 48), the Greek style of the Tribune has enormous bearing on the "Hellenization" of Sidon during the period of Persian domination, and removes

Reliefs: Votive, Mythological, Document

the sarcophagi from their apparent isolation. Whether the parallelism Apollo-Dionysos expressed by the superimposed friezes should be read in the light of Delphic practices, and whether the other divine identifications should be considered valid in a Phoenician milieu (especially since Eshmoun/Asklepios seems not to be included in the divine assembly) are issues that I am not qualified to debate. I shall only add a few comments on style.

The two charioteers of the Tribune recall the Halikarnassos Maussolleion frieze with a similar subject, although the horses themselves are quite dissimilar. Yet the contours of the racing drivers could easily have been derived from pattern books without specific chronological significance. The peplophoroi of the upper frieze have distinctive fifth-century traits, not only imitating the Erechtheion Karyatids, but also looking back to some Severe prototypes in the regular catenaries between the breasts. Equally Classical are the looping folds across Zeus' legs. To judge from photographs, all draped figures on the Tribune convey a highly decorative and linear effect, occasionally emphasized by deep contouring grooves, as contrasted with the plainer, more massive, and opaque rendering of the Mourning Women on the Royal sarcophagus. Whether these stylistic differences can be confidently translated into chronological terms, I do not know, but I suspect they are more likely to reflect different workshop practices or hands.

The apparent eclecticism of the Tribune is not per se an indication of Late Hellenistic date. As Edwards has shown, Attic Nymph reliefs continue to repeat for decades, and even in the so-called Neo-Attic phase, patterns originating shortly after the mid-fourth century;[68] a comparable mixture of motifs and styles has been found in the Trysa reliefs, which presumably made use of pattern books copying both monumental and vase paintings as well as sculptural works. As the Epidauros base demonstrates, different styles could coexist on the same monument, for whatever iconographic or religious reason. It would therefore seem reasonable to assume that imitative practices could occur at any time after the creation of a specific prototype, with the motif itself transmitted and probably transformed through its reproduction in different media. It is therefore unnecessary to confine all Classical imitations to a narrowly defined "Neo-Attic" period. As the geographic restriction has been demonstrated inadequate, so should the chronological one now be discarded, in favor of a much longer, uninterrupted stretch through Classical, Hellenistic, and Roman times, as advocated by Fullerton.[69] To be sure, the enormous demand for "luxury objects" and the shift toward decoration promoted by the Roman art markets during the last century B.C. made for a quicker pace of production, and for a consequent increase in both creativity and imitation, but these latter features had existed even before, especially away from the diffusion center of masters and motifs that was Classical Athens.

A consequence of this conclusion is to highlight the dangers inherent in reconstructing lost Classical monuments through Neo-Attic renderings. Several mono-

Reliefs: Votive, Mythological, Document

graphs in recent years have attempted to do so, with varying results; but all of them started from the premise that such prototypes existed and were recoverable with sufficient study. Fullerton believes instead that "prototypes" served only as general sources, perpetuated and mediated, but also altered, through various times and media. We shall therefore await his contribution before writing a chapter on Classical reliefs known only through Roman copies.

DOCUMENT RELIEFS

These figured *en-têtes* of decrees were given greater importance by earlier commentators because the firm dates of their inscriptions were considered meaningful clues for the development of sculptural styles in general. More recent studies have formulated the problems connected with this belief: (1) very few texts and reliefs have been preserved intact with their dates, which in many cases are the result of conjectures; a firm chronology is therefore a potential rather than a fact; (2) cities and personifications in these Document Reliefs may echo specific statues that are considered representative of the parties involved in the decree; iconography can therefore be chronologically distant from the time of issue; (3) many of these reliefs are second-rate works with no true aesthetic value; others are of necessity simplified compositions because of their small scale; finally, as pointed out above, precedence may have been given to carvers who could transcribe lengthy texts, rather than to those who could produce good-quality figures. Given these strictures, and the existence of well-researched recent work on this class of monuments, only few comments need be made here.[70]

Document Reliefs use the same framing devices as the votive and funerary stelai: lateral antae, plain or pedimented tops, even tiled roof eaves with antefixes. They too have been taken as indications of shrines or canopies,[71] but they are probably conventions derived from the other two categories. The reliefs are usually carved in one piece with the decrees, but, albeit rarely, when the inscription is particularly long, they may occur on a separate slab, the join placed at some distance from the figured panel, between lines of text. An unusually large example, dated c. 342 and honoring the exiled Molossian king Arybbas, carries two reliefs: an upper panel topped by antefixes, with a three-quarter-view rendering of a chariot to right between antae, and a lower panel, between sections of text, also showing a chariot, as well as a rider, in motion to left.[72]

According to Meyer, most extant Document Reliefs belong to the last six decades of the fourth century. Earlier examples with reliable dates after 400 show that they cannot be compared stylistically to other dated monuments and that their development cannot be followed as closely as that of the fifth-century items, especially in terms of the relationship of the figures to the relief ground (Meyer 1989b, 52). Yet, in more general terms, a tendency toward deeper frames and greater depth effects can be noted, with costumes serving to emphasize bodies and ponderation. Around

Reliefs: Votive, Mythological, Document

mid-century, this rendering of volume increases, with the mantle roll across the waist making its appearance. Eventually, around 340–330, figures, moving within a wider space, assume an almost conical shape, with broader base and high girding; garments react to the body's movement not as a unified whole but in individual motifs, according to an additive formula (Meyer 1989b, 68).

Although divinities are often chosen to represent cities, personifications such as Demos (the people), Boule (the Council), Demokratia (Democracy), and Eutaxia (Good Order) also appear.[73] Humans are at times shown, at smaller scale, next to deities or tribal heroes, in some cases as worshipers. I particularly want to mention a poorly preserved Document Relief recovered from the Mahdia shipwreck, which, within a pedimented frame, depicts the (Egyptian) god Ammon, enthroned in front of an altar, being approached by two devotees. It is firmly dated to 363/2 and was probably set up in Ammon's sanctuary in the Peiraieus, but it is even more important for its ultimate findspot, which suggests that, two centuries later, it was considered worth exporting, probably to Italy. The possibility that it was used as ballast has been minimized in the latest publication,[74] thus leading to the hypothesis that its value for the Roman market consisted in its being an "antique." In view of the indifferent quality of the carved panel, I wonder whether, in this particular case, the attraction may not have been the depiction of Ammon, given the Egyptomania current in the Italic cities in the Late Hellenistic period.

Specific mention should also be made of three newly published Document Reliefs from the Athenian Agora because of their unusual iconography involving Athena.[75] The first shows her with five female figures apparently engaged in construction activities, since one of them uses a fulcrum to lift a block; given the smaller but not diminutive size of these females, Lawton suggests they may be Nymphs, perhaps heading an early fourth-century building account for a fountain. A second, fragmentary, carving, of the mid-fourth century, deserves attention because the goddess holds the edge of her back mantle at her right side, with a gesture that is common on gravestones but unique on Document Reliefs; derivation of the motif from the Erechtheion Karyatids is proposed. Finally, one more panel shows a stiff, slightly Archaistic Athena (a statue?) holding up an aphlaston with her right hand; painted additions (a face on the rounded top of the ship's prow, the rim of the shield held by Athena's lowered left hand) are probable; a second, now missing, figure may have portrayed the victorious trierarch or a winner in a naval competition for whom the honorary decree was probably inscribed, in the third quarter of the fourth century.

A recent study of Athena types on Attic votive offerings has investigated the question of image derivation also with respect to Document Reliefs, and has come to the conclusion that representations in the minor arts may have been more influential than major works by master sculptors. Cult statues, by their very nature, appeared in isolation, whereas figures on reliefs interacted with others in a narrative context; therefore changes in pose combined with the simplification in costumes

Reliefs: Votive, Mythological, Document

demanded by the reduced scale further to remove the imitation from its source.[76] Of the many Athena types that have been attributed to Classical Athens, only the Parthenos and the so-called Ince Athena recur on such reliefs, yet the latter type has not even been connected to a specific name or monument.[77] Surprisingly, types that have been made famous by either modern or ancient writers, or through the number of extant Roman copies, like the Promachos, the Velletri Athena, and those that are traditionally considered the Lemnia and the Myronian, are admittedly absent from these reliefs, yet the explanation given—that their costumes were too complex for adequate reproduction—does not satisfy. We should review our information on these works, and be more open-minded about what constituted importance and recognition in ancient times.

Summarizing the lengthy review of both funerary and votive reliefs that we have attempted in the present and the previous chapter, two issues need briefly to be considered: (1) what traits of style can be connected with what we conceptualize as the production of the major masters? and (2) what caused the apparent spurt in the production of all reliefs around 350?

The first issue is undoubtedly related to that of prototypes, as just explored for the Document Reliefs, and is capable of different answers, Clairmont (1993) and Neumann (1979) voting in favor of major influence from famous sculptures, and Mangold (1993) looking to the minor arts. I would side with the latter. In casting a general glance across the entire production, I can still see a strong Polykleitan influence in terms of poses and contrapposto, although not necessarily in proportions and facial features. The so-called Praxitelean poses, with off-balance or leaning stances, seem much rarer, and S-curve bodies or sfumato anatomy are equally scarce. Toward the end of our period (c. 330), stronger expression of emotions could be connected with what is usually considered Skopasian pathos, but I happen to believe that this is a common trait of sculpture around 350. Xenophon, in his *Memorabilia* (3. 10. 6) reproduces a dialogue between Sokrates and an unknown sculptor, Kleiton, that has occasionally been taken as a veiled allusion to Polykleitos.[78] Yet the passage in which the philosopher makes the sculptor acknowledge that it is important to render the inner feelings of his subject through external means cannot possibly be dated within the context of Sokrates' and Polykleitos' lives—at least, to judge from what we know of fifth-century art. It is more likely that (like Platonic dialogues) Xenophon's passage reflects the thinking current at his own time, around 380, and in Athens. At this time, the pedimental sculptures from the Asklepieion at Epidauros are indeed exhibiting emotions of various kinds through outward physical traits; but Athens does not seem to translate philosophical thinking into stone until about the mid-century. I do not believe that Skopas was responsible for this development, and would rather credit the more personalized tone of art, and of the whole culture, at that time.

Once the Mantineia Base is divorced from Praxiteles, there is no reason to associ-

Reliefs: Votive, Mythological, Document

ate specific drapery and coiffure developments with his name. Admittedly, large-scale statuary may have been innovative in these respects, but we can no longer capture the evidence through the world of Roman "copies." Note, moreover, what little impact the Knidia appears to have had on Athenian production. Conversely, funerary and votive reliefs seem to have an inner stylistic coherence that speaks for an internal development within the genre, with changes promoted by widespread experimentation. At the same time, I would acknowledge the concomitant presence of different stylistic currents: Archaistic, classicizing, eclectic, as well as a major basic trend focusing on drapery as a subject in itself, and not purely as a means of conveying motion and richness of forms.

Why this development seems to quicken after mid-century may be a related matter. If we discard, or simply downplay, the presence of influential major monuments by famous masters, there is no need to correlate, for instance, the Nymph reliefs with the new statue base (by Praxiteles?) for the Dionyseion in Athens, or the complexity of gravestones with the production of Euphranor and Lysippos. It may be significant, for instance, that some of the more elaborate funerary monuments were erected at Rhamnous, away from Athens where Praxiteles' activity was probably centered. Economic conditions, the rise of a strong commercial bourgeoisie, and a stable government in the city may have been the controlling factors. In particular, the sound financial control exercised by Euboulos of Probalynthos in the years before and after the Peace of Philokrates (346)—even more than Lykourgos' activity in Athens (338–322)—may have given rise to increased demand for skilled makers of public monuments, with favorable repercussions in the realm of private offerings, whether votive or funerary. Yet it is useless to try to correlate political and historical events with artistic activity, and once again we have to note how productive the middle classes in Athens could be in times of unrest and Macedonian threats.[79]

NOTES

1. For a recent discussion of this phenomenon and the "sideline" theory, see Van Straten 1993, 253. Edwards 1985, 265, states that "only beginning in the third quarter of the 4th c. can we speak of a votive relief industry which is comparable to the mass production of grave reliefs," but this view may be influenced by his chronological assessment of stylistic development in Athens.

2. Votive relief in Copenhagen, Ny Carlsberg Glyptotek 197: Neumann 1979, 43–44, pl. 24a–b, with comparison on pl. 24c; the author stresses also (pp. 64–65) the strong influence exerted on votive reliefs by the Parthenon and the east frieze of the Nike Temple, although Edwards 1985, n. 145 on p. 139, suggests that the arrangement of the figures on the temple frieze—a gathering of gods on either side of a central deity—was in its turn inspired by a cult-statue base. For an Athenian maker of gravestones migrating to Rhodes at the end of the 5th c., see J. Frel, "The Krito Sculptor," *AAA* 3 (1970) 367–71, and, with additions, Edwards 1985, 257–60. See also Edwards, 256–67, for comments on the spread of the Attic tradition of votive reliefs. Other comparisons with gravestones in Clairmont 1993, Intro. vol., 182–83, and passim.

Reliefs: Votive, Mythological, Document

3. This development is outlined by Meyer 1989b, esp. 74–75; for comparison with gravestones, see 75–79; for discussion of workshops, see 222. According to her catalogue (and cf. her statement on p. 63), the largest number of Document Reliefs belongs to the last six decades of the 4th c., although quality is not as good as that of their predecessors. Only four items (her catalogue C 1–4, pp. 315–16) are datable to the late 2nd c.; cat. N 1–24 (pp. 316–22) are non-Attic. The term "specific" is not quite appropriate, but it is used here to indicate those decrees meant to be set up in outlying demes, rather than in Athens proper, or in individual sanctuaries, or even in specialized locations, such as theaters or harbors.

4. Hausmann 1960, 45–56, devotes an entire section to mythological reliefs, but his examples come from the 5th c. or from the Hellenistic period. The former include the so-called Three-figure Reliefs, the Great Eleusinian Relief, one side of the Kephissos Relief, with Echelos carrying off Basile, and depictions from the epic poems, as found in Melian reliefs. It seems remarkable to me that the exploits of Herakles are almost never the subject of votive reliefs. Groupings of gods are studied by Güntner 1994, but with little emphasis on mythology, since affiliations seem to be determined by similar functions or type of life and cult; only a few gatherings of "independent" deities may carry meaning.

5. The monuments cited are discussed infra. In a Ph.D. dissertation for Bryn Mawr College (1996), Angeliki Kosmopoulou collects all figured bases.

6. My general comments are largely derived from Hausmann 1960, Neumann 1979, Edwards 1985, Aleshire 1989, Van Straten 1993; see also Ridgway 1981a, 128–44, 152 no. 1; and now Boardman 1995, 131–33.

Helpful studies on votive reliefs to specific divinities are Peschlow-Bindokat 1972 (Demeter and Kore: 117–27 for 4th-c. reliefs, and 151–56, nos. R17–R69, for their catalogue listing), Isler 1970 (Acheloos), Naumann 1983 (Kybele), Mangold 1993 (Athena), Tagalidou 1993 (Herakles), Vikela 1994 (Pankrates), and from 1981 to the time of writing, the various entries in the *LIMC*. I understand that C. Lawton is preparing a volume in the *Athenian Agora* series on the votive reliefs from that excavation. See also infra, n. 36.

7. For a discussion of anatomical votives, albeit in Etruria but with reference to Greek parallels, see J. M. Turfa, "Anatomical Votives and Italian Medical Traditions," in R. D. De Puma and J. P. Small, eds., *Murlo and the Etruscans: Art and Society in Ancient Etruria* (Madison 1994) 224–40, esp. 225 and passim. It is important to note that this practice continues today at many Orthodox and Catholic sanctuaries, as, for instance, the grotto of St. Rosalia on Mt. Pellegrino, near Palermo, Italy (here **Pl. 48**). This type of silver, therefore precious, votive plaque is also attested in antiquity: see infra.

A peculiar votive relief, variously said to come from the Athenian Asklepieion or from the south slope of the Akropolis, displays severed anatomical parts but was seemingly dedicated to Herakles, perhaps as a healing god: Athens, Akr. 7232, Tagalidou 1993, 80–81, 191–92, cat. no. 8, pl. 3.1; *LIMC* 4, s.v. Herakles, no. 1386, pl. 535. A standing Herakles with club and an empty cornucopia receives the homage of a naked female who kneels in front of him; an upper torso to the waist, a lower torso down to the knees, two arms, and two legs complete the picture. Tagalidou describes the kneeling woman as wearing a long dress, but I cannot detect it. It has been noted (*LIMC*) that the disjointed body parts make a complete female body; Tagalidou takes them to be *typoi* or anatomical votives hanging on a wall, but it should also be stressed that the upper torso, which includes the head, bears a strong resemblance to the kneeling worshiper, and that both the thighs of the lower torso and the "severed" legs

appear in the kneeling position. The dedicant therefore may be shown twice, once as *disiecta membra* and once as a complete, living person. Herakles is one of the few divinities to whom it is proper to kneel: cf. F. Van Straten, "Did the Greeks Kneel before Their Gods?," *BABesch* 49 (1974) 159–89.

8. For such donations, see T. Linders, *Studies in the Treasure Records of Artemis Brauronia Found in Athens* (Stockholm 1972). A great variety of offerings is listed in the inventories for the Athenian Asklepieion published by Aleshire 1989; of the nine inscriptions she cites, nos. I–III range from c. 350 to 329/8, and are therefore pertinent to this chapter.

9. For this type of offering, see Aleshire 1989, 234, commentary to inventory IV, line 75, with additional references. She distinguishes between τύπος πρὸς πινακίωι (a relief attached to a small tablet, probably by means of nails) and τύπος ἐμ πινακίωι (a relief made in one piece with its background). For actual metal examples, from a shrine of Demeter, see E. Tsimbides-Pentazos, "The Archaeological Collection at Alexandroupolis," *AAA* 1 (1978) 51–52, figs. 3–4; A. K. Babritsa, "Anaskaphe Mesembria Thrakes," *Prakt.* 1973, 77–79, pls. 92–95. For general comments, see Van Straten 1993, 257–58.

10. For a more general treatment of this theme, see Ridgway 1983, citing examples from architectural and funeral, as well as votive, monuments.

11. Some gravestones eventually introduce more extended landscape elements, but apparently not before the 2nd c. See, e.g., two stelai from Rheneia, now in the Mykonos Museum: Couilloud 1974, 83–84, no. 58, pl. 13 (seated woman and standing man with flowering tree in the background), and p. 104, no. 110, pl. 28 (figures in two registers, those at the upper level seated on rocky ground). By that time, architectural reliefs as well use similar landscape features (e.g., the Telephos frieze).

12. Archaic votive reliefs with pedimented top: e.g., Athens, Akr. 121 to Hermes and the Graces (Neumann 1979, pl. 14a); Potter's Relief, Akr. 1332 (top frame largely restored; Neumann 1979, pl. 15a); note also the many reliefs to Kybele that include the divinity within her own naiskos: Naumann 1983, cat. nos. 37 (pl. 12), 40 (pl. 13), 42–43 (pl. 14), 48–49 (pl. 16). Severe relief with antae: Funerary Banquet from Thasos, Istanbul Arch. Mus. 1947 (Neumann 1979, pl. 21). Neumann 1979, 9–11, derives the development of a pedimented top from the palmette finials of Attic gravestones; but see, contra, his reviewers: *AJA* 85 (1981) 346–47 (C. M. Edwards), and *ArtB* 63 (1981) 674–75 (B. S. Ridgway). For the stoa as meeting ground of divinities and humans, especially in the cult of Asklepios, see Neumann 1979, 50–51. Weber 1990, 48–49 (sections 5.4.1–2) objects to the stoa interpretation because of the lack of columns, and takes all renderings of a lateral sima with antefixes to represent a stone translation of a baldacchino, whether in votive or record reliefs, as well as on gravestones.

13. Athens NM 3369: Van Straten 1976, 4 and fig. 10 (discussed together with several other examples of cures, and votive reliefs, involving sleep and dream-state); Neumann 1979, pl. 28; *LIMC* 1, s.v. Amphiaraos, no. 63, pl. 564 (which, however, crops off the top frame; dated first half of the 4th c.); Boardman 1995, fig. 142. I have here accepted the *LIMC* description (I. Krauskopf), but another interpretation (Karouzou 1968, 149–50, and *Ethniko Mouseio, Genikos Odegos* [Athens 1979] 74) would see a priest in the man manipulating Archinos' shoulder, and the already healed donor at right, dedicating the plaque in the background; it would thus read the scene sequentially from left to right. In either case, this relief

Reliefs: Votive, Mythological, Document

would satisfy the requirements for continuous narrative, as recently discussed by Froning 1988, esp. 171, following F. Wickhoff's original definition (in *Die Wiener Genesis*, 1895). See also supra, Chapter 3 and n. 10.

Note that the pedestal supporting the plaque within the relief was continued solely in paint below the level of the kline. The *LIMC* description refers to Archinos as bearded in all his three appearances, but he is definitely shown consistently beardless, as kindly verified for me by A. Kosmopoulou. It is remarkable, therefore, that the offering was made by a youth rather than by a grown man.

14. Relief with chariot in Berlin: *LIMC* 1, s.v. Amphiaraos, no. 67, pl. 566 (= Blümel 1966, K 80, p. 72, no. 85), dated to the beginning of the 4th c.; note that here too the lower part of the background pedestal has been omitted below the horses' leg, perhaps to be rendered in paint.

Relief in Delphi, from Sanctuary of Apollo: Zagdoun 1977, 23–27 no. 4 and fig. 15 on p. 24; the male divinity confronted by a worshiper is here interpreted as Dionysos and the accompanying animal as a panther, although its resemblance to a dog is stressed; I wonder if the god depicted is Apollo, or perhaps even Asklepios.

Relief in Corinth, S 2567: Zagdoun 1977, fig. 16 on p. 24; Ridgway 1981b, 427 and n. 21, pl. 91.d. Restoration of the entire composition is made possible by the similarity of the Corinth pedestaled capital to another on a relief from the Athenian Asklepieion (Athens NM 2557: Svoronos 1908, pl. 171) showing a seated Asklepios and a standing Hygieia leaning on the votive pillar. Yet another such panel showed an Archaistic rendering of the Three Graces: Rome, Mus. Naz. 393, E. Schmidt, *Archaistische Kunst in Griechenland und Rom* (Munich 1922) pl. 19.3. The Archaistic style used for some of these background pinakes would seem to strengthen the connotations of greater antiquity and sanctity as compared with the reliefs on which they appear.

Zagdoun 1977, 26 n. 4, lists all the examples of such "background plaques" known to her, ranging from the late 5th c. to the Roman period, some of them belonging to the so-called Visit to Ikarios type. Add a fragmentary relief in the Volo Museum, of early Hellenistic date: Ridgway 1983, 204 fig. 13.17, 205; K. Schefold in text to BrBr 785b (Munich 1939) 22–23, fig. 2 on p. 21. Add also Side B of the Telemachos Relief, according to the newly added fragment: infra, n. 29.

15. Reliefs to Herakles within tetrastylon: Tagalidou 1993, 19–49, discusses the issue at some length, citing previous opinions. Out of 52 reliefs to Herakles in her catalogue, from the late Archaic to the Late Hellenistic period, 10 include the structure and come from different sanctuaries in Athens, but also from Boiotia, perhaps Messenia, Andros, and Eretria. She connects the tetrastylon with a sanctuary of Herakles Alexikakos in Melite (an Attic deme) and the festival of the Oinisteria, celebrated by a phratry in honor of the hero together with Hermes during the month Pyanopsion. The same issue, with less definite conclusions, is discussed in *LIMC* 4, s.v. Herakles, 801–2, 805 (the possibility of the worship of Herakles *en akridi* at Eleusis is mentioned). Weber 1990, 47–48 (section 5.3.2), asserts that the structure shown is a baldacchino, but catalogues only two examples: p. 162, B98–99, pl. 20.80–81 (Tagalidou 1993, nos. 32 and 21 respectively).

The reliefs pertinent to our concerns are: Tagalidou 1993, cat. no. 3, pl. 2.1 (Athens, Akr. 2586; on p. 43 said to be possible pendant to cat. no. 45); no. 18, pl. 10.1 (Athens NM 1404;

Reliefs: Votive, Mythological, Document

LIMC 4, s.v. Herakles, no. 1377); no. 21, pl. 12.1 (NM 2723; *LIMC*, no. 760); no. 32, pl. 12.2 (Boston, MFA 96.696, probably from Athens; *LIMC*, no. 1378, pl. 534; Boardman 1995, fig. 144); no. 38, pl. 13.2 (Rome, Mus. Barracco 1114; *LIMC*, no. 1380, pl. 534); no. 39, pl. 16 (Venice, Mus. Arch. 100, probably from Athens; reworked in Renaissance; *LIMC*, no. 1375, pl. 534); no. 40 (now lost); no. 42 (Thebes Mus. 48; Schild-Xenidou 1972, 48–49, K 53); no. 45, pl. 20 (Naples, Mus. Naz. 6734, from Andros; *LIMC*, no. 1376, pl. 534); no. 46, pl. 19.1 (Eretria Mus. 631; *LIMC* no. 1379). Tagalidou 1993, 20–21 n. 80, includes a long list of vases on which the same tetrapylon appears.

Relief with Athena in naiskos (recomposed from many fragments), Athens, Akr. 4734 + 2605 + 2447: Neumann 1979, pl. 37a; B. S. Ridgway, "Images of Athena on the Akropolis," in J. Neils, *Goddess and Polis: The Panathenaic Festival in Ancient Athens* (Hanover, N.H., and Princeton, N.J., 1992) 119–42, esp. 135–37, fig. 87 on p. 136.

Relief with unknown personage within naiskos (so-called Torlonia Relief): Ridgway 1981a, 136–37, fig. 100; Ridgway 1983, 202, fig. 13.12; E. Simon, "Kephalos," in *Studiengenossenfest 1990 des Kronberg-Gymnasiums, Aschaffenburg am Main* (1990) 67–83, esp. 73–77; see also *LIMC* 2, s.v. Asklepios, no. 101; *LIMC* 5, s.v. Hippolytos I, no. 124; and *LIMC* 6, s.v. Kephalos, no. 33, for discussion of the Torlonia Relief with bibl. and different interpretations.

16. Relief to Asklepios, Athens NM 1377 (from Athenian Asklepieion): Ridgway 1983, 194–97, figs. 13.4a–b; Neumann 1979, pl. 29; *LIMC* 2, s.v. Asklepios, no. 201, pl. 650; Van Straten 1993, 251; Boardman 1995, fig. 147. Because of the "independent" stoa sheltering the worshipers, Karouzou 1979 has suggested that other reliefs exhibiting ample overhead space above the human figures were once completed in paint to indicate a similar building. Although this possibility should not be discounted a priori, I suspect that the apparent spatial differentiation is unintentional, caused by the need to make the deity much larger than the votaries. See also infra, comments on scale of importance.

Another votive relief to the healing gods (Rome, Cap. Mus. 617, from unknown findspot) shows Hygieia resting her right elbow on a pillar and Asklepios seated against an architectural background that includes a hanging curtain, but the rendering is much less dramatic than that of the Athenian plaque. For the piece in Rome, see *LIMC* 2, s.v. Asklepios, no. 73, pl. 640 (dated "c. 300 (?)").

17. Aristonautes' Stele, Athens NM 738: see Ridgway 1992.

18. The most comprehensive study of Nymph reliefs at present is Edwards 1985; for his explanation of the cave (on which see also infra), see 59, 62–63. See also Güntner 1994, 10–25, and 117–28, cat. A1–54, pls. 1–12. Van Straten 1993, 251–52, mentions both union and separation of men and gods by means of caves; his ref. (252 n. 13) is to a relief of Zeus Meilichios as a snake, Athens NM 3329. See also, e.g., a Boiotian relief with snake in cave facing worshipers (c. 375). Blümel 1966, 65, no. 74 (K 92), fig. 111. Another example of a rocky frame is in the Louvre (Ma 751): Hamiaux 1992, 220, no. 231. The fragmentary relief shows a monumental Hekate(?) reaching the grotto's ceiling with her polos. She stands frontally near an altar, holding two torches, and being approached by three diminutive female worshipers. A small Pan sits cross-legged, playing the syrinx, at a higher level within the cave, which seems supported by a central pier(?).

19. For revitalization rather than revival, see Edwards 1985, 264. For his reconstruction drawing of the hypothetical base, see pl. 53, with summary of deductions on pp. 107–10. The

Reliefs: Votive, Mythological, Document

base would have shown the delivery of the baby Dionysos to the Nymphs of Nysa; note, however, that no cave is included in the reconstruction, and the only element of landscape is a flowering tree inferred from Neo-Attic reliefs. There would also have been allusions (through the inclusion of Ino, Athamas, Agave, Autonoe, Leandros) to the Theban saga of the god, made popular in Athens by the playwrights. Dionysos' rejection by Thebes would have been contraposed to his acceptance by the Athenians through the presence of Praxithea and her daughters, the Erechtheids. The major Athenian master available to create such an important composition after 338 would have been Praxiteles. On Alkamenes' statue, see supra, Chapter 2, n. 2. A different reconstruction of its base, in 5th-c. style—Dionysos' Birth from Zeus' thigh, flanked by the so-called Kallimachean Maenads—is suggested by L.-A. Touchette, *The Dancing Maenad Reliefs: Continuity and Change in Roman Copies* (London 1995) 25–30 and pl. 4.

Edwards' chronology of all Nymph reliefs, argued primarily on stylistic grounds, breaks down as follows (my count is based on his catalogue, and joins Attic finds to those from outside Attika, but considered under Attic influence): only 1 example (dedicated by Archandros, Athens NM 1329; Travlos 142, fig. 192) for the period 410–400; 4 = 410–390 (incl. the Xenokrateia and Echelos/Kephissos reliefs); 3 = 390–380 (incl. Kos relief to the Charites); 6 = 380–370. The next sequence comes after a gap: 6 = 340–330; 10 = 330–320; 11 = 320–310, and then the largest group, with less defined chronology: 22 = 320–300; 11 = 310–290. This calculation yields a total of 14 reliefs for the period 410–370, as contrasted with a total of 60 for the span 340–290. Additional items dated from the 3rd c. to the Early Imperial period total 38. I suspect that the gap between 370 and 340 is simply apparent, being due to our imprecision in dating Classical reliefs by style. A more even chronological distribution would still emphasize an increase in production after 350, a "logical" breakpoint for the introduction of the cave motif. Note that a very few Nymph reliefs use an architectural frame even after 340–330 (by Edwards' reckoning): Athens NM 4465 (Edwards' no. 20; Neumann 1979, pl. 30b), and NM 1459 (Edwards' no. 57; *EA* 1244), although this latter exhibits different divinities in the foreground (probably Zeus Philios, Agathe Tyche, and another unidentified personage), with the Nymphs and Hermes appearing on the upper part of the relief, behind a wavy contour that may represent the hill of Mounichia.

20. The apotropaic effect of the disembodied head seems less efficacious when Acheloos appears in profile, as in a relief to the Nymphs dedicated by Eukles, from the Vari cave, Athens NM 2012 (here **Pl. 51;** Edwards 1985, no. 29; *LIMC* 1, s.v. Acheloos, no. 179). Note that several other diminutive images, in very low relief, are carved against the rocky frame (Pan, a hunter, possibly the mythical Kynnes, his dog, and various deer's heads), thus increasing the pictorialism of the panel. For a good photograph, see Palagia 1980, fig. 3.

Edwards 1985, 67, points out that Acheloos is again rendered in protome form by the end of the 4th c., but seems affected by the intermediate formula: he is carved into the rocky border, and his head is disproportionately large for the forepart.

21. Neoptolemos' votive relief, Athens, Agora Mus. I 7154: Edwards 1985, 56 (considered the first with cave frame) and pp. 419–37, no. 14; Neumann 1979, pl. 31a; *LIMC* 2, s.v. Artemis, no. 1280, pl. 551 (dated c. 340–330, on prosopographic grounds); Boardman 1995, fig. 146; best description, detailed photographs, and chronological discussion in H. A. Thompson, "Dionysos among the Nymphs in Athens and in Rome," *JWalt* 36 (1977) 73–84.

Agathemeros' votive relief, Athens NM 4466: Neumann 1979, pl. 31b.

Reliefs: Votive, Mythological, Document

For another example of similar poses without narration, see also, e.g., the relief from the Vari cave mentioned supra, n. 20.

22. Note that several of the Nymph reliefs were in fact found in caves, and that, as Edwards 1985 points out (53–58 and chart 1 on pl. 52), the earliest renderings of the cave have a scooped-out background, as well as a rocky border, in contrast with later renderings, where the figures within the rocky frame are arranged against a flat backdrop, as if on a stage. The earlier, trough-like arrangement would have been particularly well suited to a niche, and in fact some reliefs have a semicircular, rather than a rectangular, contour: see, e.g., Edwards 1985, cat. nos. 14, 15, 23, 34, 38, 40, and cf. *LIMC* 1, s.v. Acheloos, nos. 173 (pl. 36), 176–78 (pl. 37), 184 (pl. 39), 187.

For examples of dedications in rock-cut niches, as shown by early Hellenistic terracottas, see R. M. Ammerman, "The Religious Context of Hellenistic Terracotta Figurines," in J. P. Uhlenbrock, ed., *The Coroplast's Art: Greek Terracottas of the Hellenistic World* (New Paltz, N.Y., 1990) 42–43, figs. 32–33 (the piece in fig. 32 is from Myrina; that in fig. 33 from a spring sanctuary of Pan and the Nymphs at Grotta Caruso, Lokroi Epizephyroi).

A study of the rock-cut niches on the north slope of the Athenian Akropolis is included in K. T. Glowacki, "Topics Concerning the North Slope of the Athenian Akropolis" (Ph. D. dissertation, Bryn Mawr College, 1991) 79–86, fig. 18, and catalogue on pp. 87–90. The catalogue lists 92 niches apart from those in the caves of Apollo and Pan. At least 102 niches appear in Cave B and on the spur separating it from Cave C, and at least 12 more are in Cave D (although not all of the latter may be ancient).

23. See, e.g., the votive relief to Asklepios and Hygieia (from the Athenian Asklepieion), Athens NM 1333: Neumann 1979, pls. 30a, 45b; *LIMC* 2, s.v. Asklepios, no. 66, pl. 639 (dated after 350); or the later composition from the same findspot, Athens NM 1335: Neumann 1979, pl. 45a; *LIMC* 2, s.v. Asklepios, no. 96, pl. 643 (dated after 350). In one example, Louvre Ma 755 (= Neumann 1979, pl. 44b; *LIMC* 2, s.v. Asklepios, no. 64, pl. 639, dated after 350, and *LIMC* 5, s.v. Hygieia, no. 32; Hamiaux 1992, 218, no. 227), an unusual disc on a pier provides support for the leaning Hygieia. A similar composition appears on a fragmentary relief from the Athenian Asklepieion, Athens NM 1330: *LIMC* 2, s.v. Asklepios, no. 63, pl. 638 (dated c. 350). Since no discs from the Classical period are preserved in the archaeological record, our evidence for votive dedications is obviously incomplete.

24. New York, MM 29.47: Richter 1954, 55, no. 81, pl. 66a; Ridgway 1983, 201–2, fig. 13.11 (dated c. 390–380); for a more detailed description and discussion, see also G. F. Pinney and B. S. Ridgway, eds., *Aspects of Ancient Greece* (Allentown Art Museum Loan Exhibition Catalogue, Allentown, Pa., 1979) 152–53, no. 74. Not all photographs show a good detail of the background; see, however, BrBr 646d. The relief is at present exhibited within the room with funerary reliefs and considered an official commemoration; yet see infra, n. 25, for an example of a battle scene as part of a votive relief. Stupperich 1994, 95 and n. 37, seems inclined to see the New York panel as part of a state burial because its alleged findspot in Rome would make its situation analogous to that of the Albani Relief. Yet votive reliefs were also taken there in antiquity: see U. S. Kuntz, "Griechische Reliefs aus Rom und Umgebung," in G. Hellenkemper Salies et al., eds., *Das Wrack: Der antike Schiffsfund von Mahdia* (Bonn/Cologne 1994) 889–99.

25. Albani Relief: see, e.g., Ridgway 1981a, 144–45, figs. 104–5. Pythodoros dedication,

Reliefs: Votive, Mythological, Document

Eleusis Museum 51: Ridgway 1981a, 135, fig. 99; Ridgway 1983, 201 and n. 26, fig. 13.10 (conveniently illustrated next to the New York relief). Both works are datable to the late 5th c. I keep changing my mind about the undulating shape in the New York panel, which I once thought (*Aspects of Ancient Greece,* supra, n. 24) could be caused by veins and imperfections in the stone. I am now convinced it is a deliberate rendering, although I am no closer to suggesting an explanation for it. The helmets are described as piloi by Richter (supra, n. 24). The suggestion of a Lykian battle was made by T. Hölscher, *Griechische Historienbilder des 5. und 4. Jahrhunderts v. Chr.* (Würzburg 1973) 107–8, pl. 9.2, although he admitted that not many encounters between Athenians and Lykians could be listed for the period: cf. his n. 563 on pp. 263–64. He therefore stressed the non-Greek, ethnic characterization of both enemy and locale (a mountainous terrain) to suggest a distant land at the fringes of the Greek world; but he followed Richter's description of the headdresses. He also left open the issue of whether the relief was part of a funerary state monument or a votive offering.

26. Birth of Asklepios, from the Athenian Asklepieion, Athens NM 1351: Ridgway 1983, 203–4, fig. 13.15; *LIMC* 2, s.v. Artemis, no. 1279, pl. 550; cf. s.v. Asklepios, no. 5 (dated c. 350). Edwards 1985, 709, dates it late 4th c. Van Straten 1976, 8, suggests the alternative interpretation of "a picture of a vision seen in a dream by the dedicator."

A most remarkable relief from Thespiai (Athens NM 1455) shows Mount Helikon personified as a wild man emerging from a mountain top, but it may count as an example of anthropomorphism rather than as one including landscape elements: *LIMC* 4, s.v. Helikon I, no. 1 pl. 360 (dated to the 3rd c. on uncertain grounds).

27. The most extensive compilation with thorough discussion of all aspects of such reliefs is by Thönges-Stringaris 1965. On the motif in general, see B. Fehr, *Orientalische und griechische Gelage* (Bonn 1971); Dentzer 1982. Additional, more recent references to the general motif in Ridgway 1993, 213, nn. 5.40–41. The latest discussion at the time of writing is that of two Banquet Reliefs from the Mahdia shipwreck, by G. Bauchhenß, "Die klassischen Reliefs," in *Das Wrack* 1994 (supra, n. 24) 375–80, esp. 375–77, figs. 1–2.

28. Several such reliefs are listed and illustrated in *DOG* 1979; for refs. and brief discussion, see Ridgway 1990, 358, 360. That windows with horses and humans, in a complex arrangement, begin in the early Hellenistic period is mentioned by Thönges-Stringaris 1965, 43. The greatest popularity of the type is, however, achieved during what she calls the middle period (from c. 400 to c. 300–280), with over 150 examples: cf. pp. 13–15 and n. 61; Dentzer 1982, 346, dates the great majority of Attic Banquet Reliefs between 350 and 300.

29. Telemachos Relief: fragments have been recognized in Athens, London, Padua, and Verona. For early accounts and bibl., see, e.g., Ridgway 1981a, 136; Ridgway 1983, 198–201, figs. 13.6–7. All previous reconstructions are now superseded by more recent studies: L. Beschi, "Il rilievo di Telemaco ricompletato," *AAA* 6 (1982) 31–43, and id., "Rilievi attici del Museo Maffeiano," *Nuovi Studi Maffeiani* (Verona 1983) 13–32, with a new arrangement. Cf. also Lawton 1992, 242–43, n. 13.

Subjects different from the typical adoration scenes may have been allowed on bracket capitals topping tall stands, below the votive plaque proper, as in the Telemachos Relief. For a remarkable example from the Athenian Agora (I 7396; second quarter 4th c.), showing five males at work in the cobbler Dionysios' shop, see J. McK. Camp, *The Athenian Agora* (London 1986) 147 fig. 126, or *The Athenian Agora: A Guide to the Excavation and Museum*

(ASCSA, 4th rev. ed., 1990) 211–13, fig. 134. A good photograph is published in N. Himmelmann, *Realistische Themen in der griechischen Kunst der archaischen und klassischen Zeit* (*JdI-EH* 28, Berlin 1994) fig. 14 on p. 31; on p. 29 Himmelmann comments on the location of the "realistic" scene, and on the costumes of the men, which, however, to me seem no different from those of the citizens. The dedication is to the Hero Kallistephanos, and therefore the (now missing) votive plaque might have shown a Banquet scene. The intimation to erect the offering was given in a dream.

Another peculiar monument classified among the Banquet Reliefs is a votive stone oinochoe in the Louvre: Ma 3229: Hamiaux 1992, 228, no. 241. The vase, said to be from Athens, is plain, with a recessed panel centered on the body that includes only two figures: a reclining man with right arm raised over his head, and a woman unusually standing, rather than sitting, at the foot of the kline.

30. They occasionally refer to "the founding hero" or "the benevolent hero," but without naming him. On the various identifications of the banqueter, see Thönges-Stringaris 1965, 48–54. Among the deities to whom such reliefs are dedicated, she lists Dionysos, Agathe Tyche, the Mother of the Gods, Zeus Philios (cf. Boardman 1995, fig. 148), an unnamed *theos* and *thea*, and Zeuxippos (presumably an underworld divinity). For illustration of a dedication to this last entity, in Corinth (S 1024 bis), see Ridgway 1981b, 427–28, pl. 91.f; for an example including the god Hermes (S 1200), see pl. 91.e. Other deities appearing as bystanders in Banquet Reliefs are Asklepios and Hygieia, Kybele, Herakles, Demeter and Kore: Thönges-Stringaris 1965, 91, nos. 153–56.

31. Relief Brauron Mus. 1151 (5): *LIMC* 2, s.v. Artemis, no. 974, pl. 518 (dated c. 330); Van Straten 1993, 249 fig. 1; Neumann 1979, pl. 40b and p. 63 for the classicizing definition, n. 51 for reference to attributions to Kephisodotos and Praxiteles. The choice of costume may, of course, imply a specific, youthful age, which, in the case of the goddess, cannot be suggested by relative size. Note, for instance, the adolescent girl in the relief to the healing gods, Athens NM 1333 (supra, n. 23; good detail in Neumann 1979, pl. 45b), who has the same static appearance as the child on the gravestone in New York (MM 11.100.2; supra, Chapter 5 n. 20), despite the addition of the lively back mantle. Another similar girl appears, less obviously, on NM 1377 (supra, n. 16). Yet there is no denying the classicizing effect of the costume.

On the Brauron relief, the deer accompanying Artemis is also rendered in pictorial fashion, since the rear of its body does not reappear, as it logically should, behind the goddess.

32. For a woman leading her family, see, e.g., another relief to Artemis, also in Brauron, Mus. 1153 (32, 32a): Neumann 1979, pl. 38b; *LIMC* 2, s.v. Artemis, no. 673, pl. 499. Although children are to be expected in votives dedicated at that sanctuary, because of its specific cult, they occur also in reliefs to Asklepios and Hygieia: see, e.g., Athens NM 1333 (supra, n. 23), and NM 1377 (supra, n. 16). For children in votives to Demeter and Kore, see, e.g., Eleusis Mus. 5061, *LIMC* 4, s.v. Demeter (out of alphabetical order), no. 379, pl. 589; BrBr 548b.

A cursory review shows that children appear also on reliefs to Herakles (cf., e.g., *LIMC* 4, s.v., no. 1383 and ill. on p. 803; no. 1388, pl. 535. The relief in Venice mentioned supra n. 15 [*LIMC*, no. 1375] was dedicated by a father and son, but the latter looks like a youth rather than a child); and to Apollo (cf., e.g., *LIMC* 2, s.v. Apollon, no. 956, pl. 267). The two small attendants, a boy and a girl, often carved in low relief at the sides of Kybele's naiskos,

Reliefs: Votive, Mythological, Document

are taken by Naumann 1983, 186–87 (37 examples listed, cf. pls. 26.2, 27.2), to be divine rather than human, although she acknowledges that accompanying deities are never shown so small elsewhere. For a (Hellenistic) relief to Kybele and Attis dedicated by a mother and daughter, see infra, n. 38.

33. Van Straten 1993, 261; on p. 262, and in the contrast between his figs. 29 and 30, he emphasizes the distinction between communal and private cult as reflected in the relative frequency of various species of sacrificial animals.

34. Potter Relief (Akr. 1332) and Jeweler(?) Relief (Akr. 577): see, conveniently, Neumann 1979, pls. 15a, 19a respectively, and cf. his discussion of donors on pp. 69–75.

35. A staple of slide quizzes for introductory courses on ancient art is indeed the contraposition of the Ara Pacis procession to the Parthenon frieze, which ignores the many children depicted, where appropriate, on the Parthenon west pediment.

For the inclusion of children in votive reliefs to various deities, see supra, n. 32; also infra, n. 36. For the participation of children in Attic religious life, see, e.g., Golden 1990, 30–32, 41–50, 76–79.

36. Athena and Pig Sacrifice: Akr. 148, conveniently illustrated in Neumann 1979, pl. 18a; on p. 38 he compares it to the painted Pitsa tablet (his pl. 12a); yet the smaller figures on the pinax—the pipes- and lyre-player and the attendant bringing the sacrificial animal—have special functions within the ritual and therefore need not be considered members of the family. The height difference among the other figures is not sufficiently great to distinguish adults and children. For other references to the Akropolis relief, see, e.g., Ridgway 1993, 451 and bibl. on pp. 465–66, nn. 11.14–16. Palagia's comments were made at the 1993 Annual Meeting of the Archaeological Institute of America: see her Abstract, "Votive Reliefs of Athena from the Early Years of the Democracy," *AJA* 98 (1994) 284. On the Apatouria, see, e.g., H. W. Parke, *Festivals of the Athenians* (Ithaca 1977) 88–92; it was a communal, rather than a state celebration, since it was organized by the *phratriai*, and it marked family occasions, like births, entrance into manhood, and marriages.

That images of children may have been appropriate dedications to Athena (or, at least, on the Akropolis) is moreover suggested by the fact that a 4th-c. inventory drawn by the Treasurers of the goddess lists a high percentage of bronze statues of children intended to be melted down: Harris 1992, esp. 643. It is therefore dangerous to draw conclusions based exclusively on the extant finds. Moreover, at least two 4th-c. reliefs (Athens, Akr. 3003 + 2413 + 2515; Akr. 3007) show Athena receiving a line of worshipers who definitely include women and (the former) a servant with a *kiste,* although their fragmentary state prevents us from verifying the possible presence of children: Mangold 1993, cat. nos. 27–28, pl. 7.1–2 respectively. I understand that Prof. Palagia is compiling a catalogue of Athena reliefs from the Akropolis.

37. This statement is made by Peschlow-Bindokat 1972, 117; Edwards 1985, 263 and 283 n. 28, who wants to stress the increase after mid-century, points out that the German scholar lists 14 reliefs from c. 430 through the mid-4th c., of which only three or possibly four fall after 400, but as many as 37 from the second half, 22 of which come from Eleusis. In general, the most frequent recipients of votive offerings are what H. W. Pleket has called the "assisting deities," in H. S. Versnel, ed., *Faith, Hope and Worship* (Leiden 1981) 155, 166, 176.

38. Yet note that Meter was considered helpful in childbirth, as suggested by votive inscriptions from the Peiraieus. The subject has been most recently treated by Roller 1994,

Reliefs: Votive, Mythological, Document

esp. 257 with nn. 73–76, who conveniently illustrates (pl. 56b; cf. p. 258) a relief to Meter and Attis in Venice given by a mother and daughter, who both appear at the edge of the panel. The young girl, however, looks almost like an attendant, and the background details indicate a Hellenistic (early 2nd-c.) date for the carving. Naumann 1983, cat. 553, pl. 40.2, and commentary on pp. 242–43, discards the possibility that this panel was originally a pendant to the Herakles reliefs now also in Venice (supra, nn. 15 and 32), because the latter is over 100 years earlier, although the two may have been connected later; for the theory, see A. Linfert, "Zu zwei Reliefs," *AA* 1966, 497–501, with photomontage as fig. 4 on p. 499. See also Güntner 1994, 26–33, 128–36, cat. B1–48, pls. 13–16.

39. A cursory review of the *LIMC* yields very few votive depictions (especially in isolation) of Aphrodite, Ares, Dionysos, Hera, and even Apollo, who is, however, more frequently shown together with other deities. Admittedly, our picture may be biased by the poor quality or fragmentary condition of many reliefs, which are therefore not mentioned or illustrated.

40. Berlin, Staatliche Museen 1612: Roller 1994, pl. 55a; Naumann 1983, no. 552, pl. 40.1 (dated end 4th/early 3rd c.). On the relief, Attis appears together with Angdistis (as per inscription), but that is another form of Kybele. Roller makes the additional point that Kybele's worship in Greece was transformed from an official, state cult to a private one, in keeping with 4th-c. tendencies. She mentions other examples of titles, or even mystery-cult cries (like Iakchos) that were personified as the names of foreign or minor divinities.

41. Such attributes are, for instance, the ram's horns of Ammon, the magical hand of Sabazios, the nebris of Bendis—yet they had all existed in different contexts: horns for river gods and Pan, nebrides for maenads, gestures for other deities. On Ammon (imported from Egypt), see *LIMC* 1, s.v., pp. 666–89. On Bendis (imported from Thrace), see *LIMC* 3, s.v., pp. 95–97, and cf. *LIMC* 2, s.v. Artemis, nos. 915–41. On Sabazios (either Phrygian or Thracian), see *EAA* 6, s.v. Sabazio, pp. 1042–44 (with uncertain Greek iconography).

42. For Iakchos and Hymenaios, see *LIMC* 5, pp. 612–14, and 583–85 respectively; see also Clinton 1992, 64–71 and cat. pp. 136–38 for Iakchos in sculpture. On Tyche and her cult in the 4th c., see, most recently, S. B. Matheson, "The Goddess Tyche," and O. Palagia, "Tyche at Sparta," in S. B. Matheson et al., *An Obsession with Fortune: Tyche in Greek and Roman Art* (New Haven 1994) 19–33 and 65–75, respectively.

43. Relief to Demeter, Paris, Louvre Ma 756: Hausmann 1960, 67 fig. 36; *LIMC* 4, s.v. Demeter (out of alphabetical order), no. 27, pl. 564 (dated 340–330); Hamiaux 1992, 216, no. 224 (dated second half 4th c.). Demeter stands on the other side of the altar, holding phiale and a long vegetable stem; the offering is a goat. Note also the closely similar relief to Bendis, from the Peiraieus: London, BM 2155, *LIMC* 3, s.v. Bendis, no. 3, pl. 73; here the eight youths are, however, rendered almost at the same scale as the two adults.

I would stress that even the Parthenon frieze displays a comparable scale of importance, in that the seated gods on the east side, were they to stand, would appear considerably larger than the surrounding humans—a consideration that makes me continue to believe that the so-called Eponymous Heroes should instead be identified as marshals and other Athenian citizens of mortal rank. On this issue, see, most recently, I. Jenkins, *The Parthenon Frieze* (London/Austin, 1994) 23, 77, 80–81—an important work because of the new numbering of the frieze plaques; also Connelly 1996, 68 ("generic elders"), albeit within the context of a mythological reading of the frieze.

Reliefs: Votive, Mythological, Document

I have been unable to consult H. Rauscher, *Anisokephalie: Ursache und Bedeutung der Grössvariierung von Figuren in der griechischen Bildkomposition* (Vienna 1971), which may make some of the same points.

44. Several examples of sacrificial animals in votive reliefs have already been mentioned; for a rapid review, see Neumann 1979, pls. 29, 30a, 38b, 40b, and 44b. I have not seen F. T. Van Straten, **Hiera Kala**: *Images of Sacrifice in Archaic and Classical Greece* (Leiden 1995). This detail is seldom shown in 5th-c. votive reliefs. But cf. the large rendering (in the round) on the Halikarnassos Maussolleion (Chapter 4), and on the west side of the small **frieze 4** on the cella wall of the Nereid Monument at Xanthos (Chapter 3). The ram sacrifice at Trysa may carry a mythological meaning.

For the monumental prototype (a 4th-c. painting by Pausias that Pliny, *NH* 35.126, saw in the Porticus of Pompey in Rome), see O. Brendel, "Immolatio Boum," *RM* 45 (1930) 196–226, esp. 215–19. Brendel would see the relief to Herakles in the Barracco Museum (supra, n. 15, *LIMC* 4, no. 1380, pl. 534) as providing an almost contemporary echo of the painting, in that the bull is shown on bent knee; he identifies as Theseus the youth standing in front of the animal, but this interpretation has not found much acceptance. He also collects earlier examples of the kneeling-bull theme in Greek vase painting, and thus considers it an established topos leading to Pausias' work.

45. The examples here mentioned can easily be found under the respective deities in the various volumes of the *LIMC* (Aphrodite emerging from the sea is the controversial Ludovisi Throne). Some scenes (Aphrodite in a chariot over the waves; the kidnaping of Kore) appear primarily on terracotta pinakes from Magna Graecia, but these are still valid as votive reliefs. See also supra, n. 4: Hausmann 1960. He adds some scenes from the epic in Melian reliefs (e.g., his fig. 27 on p. 53), although he admits (p. 55) that their recipients were the dead, and not the gods. To me, this funerary function excludes the Melian terracotta plaques from consideration. It is, of course, unnecessary to mention the many episodes appearing in architectural sculpture, which is by nature narrative, and continues to illustrate action even during the 4th c.

46. For these examples, see, conveniently, Hausmann 1960, 80, 82 fig. 47 (Herakles and the Mysteries, Athens NM 1778); 81, 84 fig. 49 (hero Hippalkmos, relief in Thessaloniki); 82–87, figs. 52–53 (Artemis and satyrs, in bronze, on Delos, A 1719; see, more recently, Ridgway 1990, 319–20, pl. 158). For the Visit to Ikarios, see supra, n. 14, and, most recently, Pochmarski 1990, 97–108, with catalogue on pp. 297–301 (R1–32); D. Grassinger, "Die Marmorkratere," in *Das Wrack* 1994 (supra, n. 24) 259–83, esp. 274–75 and n. 24 (both authors date the prototype to the second half of the 2nd c.). Note also a definitely votive (stone) relief from Thessaly with Penelope at the loom and Odysseus having his feet washed by his aged nurse (Athens NM 1914): Hausmann 1960, 52–54, fig. 26; Biesantz 1965, L 57 on p. 32, and comments on pp. 144, 148, pl. 80; *LIMC* 4, s.v. Eurykleia, no. 7, and cf. nos. 8–9, pl. 52 for the same subject in Melian reliefs; *LIMC* 7, s.v. Penelope, no. 19, pl. 228, and cf. no. 20, pl. 228 (Melian relief).

47. Birth of Asklepios Relief: supra, n. 26; Neoptolemos Relief (baby Dionysos to Nymphs): supra, n. 21. Reliefs with Triptolemos on winged chariot: e.g., Eleusis Mus. 5061 (supra, n. 32); Louvre, Ma 759, Hamiaux 1992, 217, no. 225 (dated second half 4th c.).

48. Mission of Triptolemos most often represented episode: *LIMC* 4 (within Addenda),

Reliefs: Votive, Mythological, Document

s.v. Demeter, p. 890; kidnaping of Kore rare: p. 889. Changes in 4th-c. depictions: Peschlow-Bindokat 1972, 118–20 (see also supra, n. 6). On the iconography of Triptolemos and his position in the Eleusinian Mysteries, see Clinton 1992, 39–55 and passim.

49. Aphrodite reliefs with ladder and goat: Edwards 1984, although note that many of his examples occur on vases. See also E. Mitropoulou, *Aphrodite auf der Ziege* (Athens 1973). It is difficult to determine whether reliefs of the dancing Nymphs being led by Hermes should be considered Daseinbilder or narrative scenes; I have discussed them under "Landscape Reliefs" for obvious reasons. Similarly, depictions of Herakles and the tetrastylon, or even Banquet Reliefs, could fall within the category of Daseinbilder.

50. Mantineia Base, Athens NM 215–217: Stewart 1990, 277–79, T 94, figs. 492–94 (he mentions that Praxiteles may have died before 326, but that the figures on the base, although by his workshop, reveal the master's own portrait style [p. 177]); Todisco 1993, 73, pl. 289 (he makes the strange statement that the Leto, Apollo, and Artemis might have been made by Praxiteles at various times during his career; the base is the product of a workshop still within the master's sphere, c. 330–320); Corso 1988, 141 (text) and 164–69 (he attempts to visualize the free-standing statues, and accepts the base as part of the commission). See also Ridgway 1990, 106 n. 3.39, 253 and 270 n. 7.15, pls. 132a–c; *LIMC* 6, s.v. Mousa, Mousai, no. 106 (= Marsyas I, no. 24); Boardman 1995, figs. 28.1–3. The main report on the discovery is by G. Fougères, "Bas-reliefs de Mantinée," *BCH* 12 (1888) 105–28; the most extensive discussion is Svoronos 1908, 179–236, who summarizes earlier positions, including some against a Praxitelean connection.

Pausanias mentions that the statue of Asklepios was by Alkamenes, and that Praxiteles made his images three generations after him. This statement raises important questions about cult images and their role in temples, and perhaps even about the correctness of Pausanias' attributions. On the cults of the deities mentioned at Mantineia, see M. Jost, *Sanctuaires et cultes d'Arcadie* (Études Peloponnesiennes 9, Paris 1985) 124–25, 491–93.

51. All three slabs are 0.97 m. high; **slab A** is 1.38 m. long, the other two are 1.36 m.; their thickness is 0.08 m. They were found face down, so that their backs had been rubbed smooth by the feet of the faithful. Fougères (supra, n. 50) mentions that each panel has three cuttings (two at the back of the upper edge, one on the left corner of the bottom edge) but does not specify distances from the carved faces, or possible uses; he, however, excludes the possibility of lateral clamping, and thus arrangement in a continuous frieze or balustrade. Yet if the blocks were cut down from their original thickness, clamp holes to laterally adjacent blocks or even to backers may have been eliminated. On p. 123 he notes that the head of the central figure on **slab C** had been found in isolation, three weeks before discovery of the slabs, in the stoa near the theater.

52. We may have an exaggerated conception of the Greeks' love for symmetrical arrangement, but the structural arguments remain valid. A two-slab front (**A** next to either **B** or **C**) would demand another relief slab for the second short side, but it seems unlikely that the scene containing Apollo would have been accompanied by three Muses, with three more Muses on each short side (note that the seated Muse on **slab B** faces in the same direction as the Apollo, and therefore would not form a good compositional closure); or that Muses only (**B** + **C**) would have been shown on the front, with Apollo (**A**) relegated to one side. Earlier studies have usually postulated a missing slab, frequently restored as containing the three Moirai appearing on the Neo-Attic Madrid Puteal (see, e.g., Svoronos 1908, 190, fig.

Reliefs: Votive, Mythological, Document

119 [cited with disapproval], Linfert-Reich 1971, drawings on p. 37; Papachatzis 1980, 205 with ill.); Svoronos 1908, figs. 134–35 on pp. 207–8, would even include the scene with Zeus and Athena from the same puteal, although not to form a statue base. See infra.

53. See, e.g., the pedestal for the Erechtheion Karyatids, which, although not a true base, has been compared to one in its effect: Jacob-Felsch 1969, 54. The decorated base of the statue of Nemesis at Rhamnous is formed by two large blocks juxtaposed back-to-back, so that the joins fall in the center of the two short sides. Only the front and short sides were decorated with reliefs; the back was blank. The center area was partly hollowed out and filled with rubble; the top surface was a separate step of dark blue-gray stone strongly projecting above the relief slabs and carrying the cutting for the statue's plinth. See Lapatin 1992, esp. 108, fig. 1 on p. 109, and pl. 27, which conveniently juxtaposes the original fragments to the Neo-Attic Stockholm slab that may copy them but adds overhead space.

Jacob-Felsch 1969, who discusses orthostat bases (53–54, 65–66), accepts the Mantineia reliefs as representative of the type with top and bottom moldings carved in one with the main slab (66; cf. cat. no. 84 on p. 182), but she admits that the sequence of the panels is debated, and shows a different conformation of a typical orthostat base on her folding chart. According to her own listing, the type seems to be quite rare. Svoronos 1908, 190, mentions an observation by W. Dörpfeld: **slab A** at the (viewer's) right edge must have formed a right angle with the left edge of **slab B**, which in turn formed a right angle with **slab C** (thus, this last would have been aligned parallel, rather than adjacent, to **slab A**). This arrangement was posited on the basis of the different spacing of the figures from either edge on each slab, but does not seem to have been supported on structural grounds.

54. See supra, n. 51 (head from **slab C**). Svoronos 1908, 192, points out that the Byzantine church where the slabs were found is quite a distance from the gate through which Pausanias entered the city (and therefore was not built over the pagan temple), and is in turn far from the theater in the city's center. It would have made no sense to carry a small fragment chiseled off from the slabs at the time of reuse (as the heads of the other two figures were, although not recovered) to an area where it served no purpose, as contrasted with leaving a fragment behind when the large and heavy slabs were moved from their original location—the theater—to the Byzantine church to serve as paving. Svoronos (p. 201) bases his argument in favor of a bema on a passage of Polybios (4.20) that stresses the importance of musical contests for the Arkadians; they were held annually in the theater. He also believes that the Mantineia slabs are "copies" for which he advocates a date no earlier than the mid-3rd c., but possibly 50 to 100 years later (p. 215). His impression that the reliefs were copied is partly due to his observations on poor carving: the left arm of the Skythian slave was originally placed too high, and was then corrected (a "pentimento"); the contour of Marsyas' right upper arm shows a peculiar lack of muscle; and other details (p. 187). Svoronos' arguments and suggestions are not all equally strong and may be overlooked, although some observations seem on target and make this text still important.

55. The earliest relief decoration for a stage front may occur at Pergamon, around the middle of the 2nd c.; for a recent discussion of the development of such ornamentation, see M. C. Sturgeon's review of M. Fuchs (*Untersuchungen zur Ausstattung römischer Theater in Italien und den Westprovinzen des Imperium Romanum* [Mainz 1987]) in *BJb* 189 (1989) 639–43.

56. Linfert-Reich 1971, 32–33: Pausanias was not mistaken, because the "Apollo" looks

Reliefs: Votive, Mythological, Document

like a Muse. This type of argument was already familiar to Svoronos (1908, 186), who found it impossible that Pausanias would have misunderstood the significance of the Skythian executioner, given the popularity of the story. Marsyas after Echelos/Basile Relief: Linfert-Reich 1971, 34 (for the relief, Athens NM 1783, see, e.g., Ridgway 1981a, pl. 98); round altar as prototype: p. 38. She also adds that the Muses on the base copy prototypes in the round that were originally not created as Muses but had other identities.

57. Apollo appears in a similar costume, and with distinctive (classicizing) long locks on several 4th-c. votive reliefs and statues in the round: see, e.g., Palagia 1980, figs. 6–17, 18, 28, 54.

Svoronos 1908, 191, 195–96, believes that the central female figures on **slabs B** and **C** are Mnemosyne and Hymnia respectively, the latter an old Arkadian deity later assimilated to Artemis. He suggests that all three slabs represent independent contests with central "judge," juxtaposing one type of music to another; the Muses would therefore be not four of the traditional nine, but Muses of music. Although such identifications may be questionable, the effect of the scenes may have been read correctly.

58. Some 4th-c. relief bases do in fact use wide spacing between and above figures, but they seem too late for any connection with Pheidias' pupils; see, e.g., London, BM 789 (from Sigeion): *DOG* 1977, 34, no. 86, pl. 21; Clairmont 1993, no. 12, pp. 15–17, and cf. no. 15 (Peiraieus Mus. 3364), pp. 19–20. Outside the funerary realm, a similar composition, although fragmentary, has been recovered from Neo-Attic replicas: see Xenokles' relief base, on the Athenian Akropolis (Ridgway 1984a, 57, pls. 69–70), which, perhaps significantly, seems to be connected with performances (pyrrhic dancing).

Lysikrates Monument: see, e.g., Ridgway 1990, 15–18, ills. 1–3, pl. 1; Todisco 1993, 28, fig. 4; Boardman 1995, fig. 16; a complete publication of the frieze has now appeared: W. Ehrhardt, "Der Fries des Lysikratesmonuments," *AntP* 22 (1993) 7–67, pls. 1–19.

The theater at Mantineia seems to have been built in the 5th c., restored in the 4th and again in Roman times.

59. The Mantineia Marsyas recalls also the so-called Marsyas of Myron, and, to some extent, the bronze figure of the satyr from Patras in London, BM 1557: *LIMC* 6, s.v. Marsyas I, no. 11, pl. 184, and no. 15 respectively. The position of the arms has been altered to accommodate the piping action, but the tiptoe stance, especially of the right leg, has been retained. In this case, the workshop that made the reliefs might have used pattern books collecting a variety of models. For other slabs that may have served to decorate a choragic tripod base, from the Theater of Dionysos, see Athens NM 259–260, and, from a similar monument, NM 2667: *LIMC* 5, s.v. Horai, nos. 9–11, pls. 344–45 (all dated at the end of the 1st c.); Karouzou 1968, 191–92.

A special case is a three-sided base in Athens, NM 1463, found east of the Akropolis, between the Monument of Lysikrates and the Theater of Dionysos, and usually dated mid-4th c. It shows a heavily draped Dionysos, apparently beardless but with long Archaistic curls (side A) and two Nikai (sides B and C), and is now known also in an Imperial replica in Basel: Berger 1983, pl. 24. A mid-2nd-c. square base for a tripod, still in the Athenian theater, carries an inscription (*IG* II/III² 3089; cf. Corso 1988, 25–27, no. 13) mentioning that Praxiteles had considered appropriate to dedicate Bromios (Dionysos) and Nike under two tripods (ὑπὸ τρίποσιν), on the occasion of famous contests of actors (κλεινοῖς ἐν ἀγῶσι

Reliefs: Votive, Mythological, Document

τεχνιτῶν). The reliefs on the triangular base have therefore been taken to echo or copy Praxiteles' dedications: Karouzou 1968, 158 (Nike B after the Parthenon east frieze; Dionysos and Nike C after Praxitelean prototypes); *LIMC* 3, s.v. Dionysos, no. 88, pl. 302; *LIMC* 6, s.v. Nike, no. 227, pl. 579 (= Basel replica); Todisco 1993, 135, pl. 288, with additional bibl.; Boardman 1995, fig. 152. Indeed, the peculiar ledge under each relief figure gives the impression of a statue in the round with its own base, and Praxiteles' work has been visualized as free-standing: cf. *LIMC* 3, s.v. Dionysos, nos. 601–2. Corso 1988, 25–27, believes instead that the very base NM 1463 is Praxiteles' offering, which must have therefore supported two tripods, since its date agrees with the master's career. But the shape of the pedestal cannot be reconciled with two objects, even if its connection with the tripod is unclear: see Amandry 1976, 40, for a description of the top surface, in the context of a discussion of three-sided bases with concave panels (pp. 37–44), which range from the 4th c. to Imperial times. Only Jung 1986 has suggested that the base is a Neo-Attic work. Corso makes, however, the important point that Praxiteles' connection with actors' competitions implies wealth and the paying of choragic liturgy, as we know was true for his sons (but see infra, Chapter 7 n. 59).

On recent discoveries in the Street of Tripods, see the contributions to W. Coulson et al., eds., *The Archaeology of Athens and Attica under the Democracy* (Oxbow Monograph 37, Oxford 1994) by P. G. Kalligas (25–30), A. Choremis-Spetzieri (31–42, plan fig. 2 on p. 33), and K. N. Kazamiakis (43–44).

60. M. Maas and J. M. Snyder, *Stringed Instruments of Ancient Greece* (New Haven 1989) 185, would date the lute held by the seated Muse on **slab B** to the period of, or after, Alexander's conquests, c. 330–320. I owe this reference to G. S. Merker. See also Boardman 1995, fig. 28 ("about 330").

61. Athens NM 1425 (**block A**): found in 1886, c. 50 m. from the east façade of the Temple of Asklepios at Epidauros. It has a low bottom fascia and is crowned by four sets of moldings, which make the top length of the block 1.092 m., with a top width of 0.273 m.; total height, 0.621. The most extensive discussion is Svoronos 1908, 418–24. **Block B**: found in 1911 built into a wall c. 20 m. from the NE corner of the Temple of Asklepios, but mentioned only by the initial publication: Ch. A. Giamalides, "Alla plevra ek tou bomou ton dodeka theon en Epidavro," *ArchEph* 1911, cols. 174–77. Broken on all four sides, max. p. l.: c. 0.690 m., max. p. h.: 0.535 m., max. th. at bottom: 0.230 m. These dimensions and other technical comments are taken from Rupp 1974, 213–19, cat. no. 98; he considers the pieces to come from an altar of his Type V D, with solid ashlar construction for the foundations and the superstructure. Slightly different measurements are given (only for **block A**) by Jacob-Felsch 1969, 182, cat. 86, where the piece is considered an example of orthostat base with top and bottom moldings in one piece (cf. her p. 66); another block would have been placed on top. According to Rupp's personal observations (p. 214), "the rear face is worked in order to abut against three other blocks" with a broad band of finer finish around all edges and, in the center, "an almost square area that is slightly higher than the remainder of the face." On the top surface of the block are "three Π-shaped clamps which correspond to the three areas on the rear face, as do the three rectangular dowel holes in the bottom surface." **Block B** has lost all traces of the top moldings, and retains only a bit of the bottom fascia; the relief has approximately the same height as the figures on **block A**, and should thus be

Reliefs: Votive, Mythological, Document

the rear face of the monument; its own back is roughly finished, with a higher band of anathyrosis at the bottom and no cuttings for dowels.

Block A has been called: a base in the original excavation report, by Jacob-Felsch (supra) and by Zagdoun 1989, 166, cat. no. 58; an altar by Svoronos 1908 (with reconstruction drawing as fig. 211 on p. 423), Giamalides (supra), and Rupp 1974, although the last author acknowledges (p. 302) that "the use of relief sculpture to decorate an altar of this small size and shape is unique in a late fourth century altar"; a balustrade or architectural member by Karouzou 1968, 101; an architectural relief in *LIMC* 2, s.v. Asklepios, no. 90, pl. 642.

62. See, e.g., *LIMC* 4, s.v. Hebe, no. 25. **Block B** is discussed by Rupp 1974, who, however, cannot give its inventory number (the one tentatively suggested belongs to a different monument).

63. See, e.g., the so-called Pisa krater, most recently discussed in the context of the Mahdia finds by Grassinger (supra, n. 46), and, in the same publication (*Das Wrack* 1994, supra, n. 24), by H.-U. Cain and O. Dräger, "Die sogenannten neuattischen Werkstätten," 809–29. The only—remote—association I can make is with the Archaistic figures on panels depicted within votive reliefs to Asklepios: supra, n. 14.

64. For this relief, Athens NM 173, see supra, Chapter 2, n. 39, and cf. *LIMC* 2, s.v. Asklepios, no. 62, pl. 638. For the various dates suggested for the Epidaurian base and its comparison with Panathenaic amphoras, see Zagdoun 1989, 166. A comparison of the Archaistic "Hebe" with the dancers from the Samothrake Propylon (supra, Chapter 4, n. 51) was used to argue the possibility that those Archaistic figures moved toward a central section of the frieze in 4th-c. style: Lehmann 1982, 312 and n. 20. Although this theory has not found general acceptance, the similarity between the Samothrakian and the Epidaurian rendering is clear.

65. Tribune of Eshmoun: Ridgway 1990, 168–69 and bibl. on 203 n. 18. The official publication is Stucky 1984; the figures of the upper frieze are given sequential numbers, those of the lower, letters of the alphabet, reading from extreme left to extreme right. Additional comments, rebuttals to reviewers, and placement within a wider local context: Stucky 1993a, 41–49, and 109–10, cat. no. 247, pls. 58–61 (p. 42 n. 290 mentions the protective covering around the reliefs). See also Stucky 1991, fig. 16, with emphasis on the diffusion of Greek culture to Phoenicia during the 4th c., and Stucky 1993b, pl. 46. The sanctuary of Eshmoun seems to have been in use from the 6th c. B.C. to the 4th c. A.C. (it eventually included an early Byzantine church), at the end of which it was destroyed. During the Classical period, it seems to have been under special protection of the Sidonian kings, who had founded and built it up (Stucky 1993a, 46 and nn. 326–27; p. 47 for the Hellenistic correlation Asklepios-Eshmoun). To Stucky's bibl., add Edwards 1985, 243–55 (appendix), who argued for the Tribune a date in the second half of the 2nd c. (c. 100). For more recent expressions of adherence to the 4th-c. date, see, e.g., Grassinger 1994 (supra, n. 46) 274 and n. 27. See also *LIMC* 4, s.v. Eshmoun, p. 24; Boardman 1995, fig. 229 ("about 340").

66. Stucky 1993a, 29. The two established types are the Dionysos Jacobsen and the Hygieia Broadland (p. 52). The most numerous sculptures are the so-called Temple Boys, including girls: a total of at least 101 items (p. 29 n. 197), comprising some imports from Cyprus; style and votive inscriptions suggest that local production began in the late 5th/early 4th c. I am not sure, however, that the boy's head (close-up fig. 20, p. 480, in Stucky 1991) belongs to the second half of the 5th c.; its modeled forehead would suggest a later dating.

Reliefs: Votive, Mythological, Document

67. Stucky 1993a reiterates his initial dating; Grassinger 1994 (supra, n. 46) supports him; for her date of the Pisa type, see p. 275, and cf. the drawing (rolled out) of the decoration, fig. 9 on p. 266; her initial correlation was made in *Römische Marmorkratere* (Mainz 1991) 59, nn. 25–27 (pp. 58–62 for the total discussion of the Pisa krater type), pp. 110–13; cf. Stucky 1993a, 45 and n. 317. Edwards' findings, in brief summary (his pp. 249–50), are as follows: **Dancer A** is loosely taken from a late 4th-c. mantle dancer; **Dancer C** is related to Neo-Attic types copying the 5th-c. Nike Parapet; **Dancers F, G, H** copy a late Classical triad of dancers; **Musicians I, K** are transformations of late 5th-c. types; **Dancers M, N** copy a late Classical group; **Dancer O** transforms the 5th-c. "Aglauros"; **Dancers R, S, U** are loosely patterned after late 4th-c. mantle dancers; **Dancer T** is a transformation of the 5th-c. krotalist dancer/maenad.

68. See, e.g., *LIMC* 1, s.v. Aglauros, Herse, Pandrosos, nos. 44 (Nymphs–Mantle Dancers) and 45 (Neo-Attic reliefs), with commentary on p. 296 (U. Kron).

69. See M. D. Fullerton, "The Problem of Prototype in Neo-Attic Relief Sculpture," in *Abstracts 1994* (82nd Annual Conference, CAA, New York, February 16–19) 11–12. A comprehensive study of Neo-Attic art by Fullerton is in progress. See also Touchette 1995 (supra, n. 19).

70. For earlier commentators, see, primarily, R. Binnebössel, *Studien zu den attischen Urkundenreliefs* (Kaldenkirchen 1932); cf. also Hausmann 1960, 41–44; Ridgway 1981a, 128 and bibl. on p. 155. Ridgway 1990, 71 n. 44, lists some examples dated after 330 that include particular effects. C. Lawton, *Attic Document Reliefs of the Classical and Hellenistic Periods* (Oxford 1995) has just appeared and could not be taken into account here. My comments on stylistic evolution are based on Meyer 1989b. See also Boardman 1995, 132–33, figs. 149–51.

71. Cf. Weber 1990, 49, section 5.4.2 (baldacchino); pp. 65–66, section I.3.2 (naiskos); cat. pp. 164–65, B 104 (NM 1467, dated 375/4), pl. 23.86, and B 105 (NM 1471, dated 347/6), pl. 23.87. Also the item from Mahdia mentioned infra has been taken to suggest a temple.

72. Athens NM 2948 + Epig. Mus. 13291: Lawton 1992, esp. 241 and pl. 63a–b; in its original state, the slab is estimated to have been c. 4 m. high. Meyer 1989b treats the two fragments separately: cat. A 90, p. 291, pl. 29.1 (EM 13297 [sic]), and cat. A 118, p. 299, pl. 29.2 (NM 2948).

73. See, most recently, C. Lawton, "Representations of Athenian Democracy in Attic Document Reliefs," in J. Ober and C. W. Hedrick, eds., *The Birth of Democracy: An Exhibition Celebrating the 2500th Anniversary of Democracy* (Washington, D.C., 1993) 12–16. Cf. also Palagia 1994; Boardman 1995, fig. 150.

74. Tunis, Bardo Mus. C 1201: Bauchhenß (supra, n. 27) 378–79, and G. Petzl, "Die griechischen Inschriften," in the same volume, pp. 381–86; another supposition is that this and three additional reliefs from the same context were used as fillers for voids, to stabilize the cargo. Cf. also Meyer 1989b, 282, cat. A 57; *LIMC* 1, s.v. Ammon, no. 14.

75. Lawton 1995; the first relief is her no. 1 (S 2495), pl. 35a; the second is her no. 2 (S 2311), pl. 36a; the third is her no. 4 (S 366), pl. 36b–c. I thank Prof. G. R. Edwards for alerting me to this article. Note the "Corrigendum" in *Hesperia* 64 (1995) 178, taken into account in my text.

76. Mangold 1993, esp. 52–53; document reliefs are included within the 64 items in the catalogue. My comments on the Athena types most frequently used are based on this same

Reliefs: Votive, Mythological, Document

source. The author notes (p. 54) that renderings of Athena on Document and votive reliefs may also be influenced by 5th-c. Artemis or Aphrodite types, when appropriate.

77. Athena Ince: see, e.g., Todisco 1993, pl. 9, where the prototype is dated c. 400 and attributed to the School of Alkamenes, in imitation of the Parthenos. A somewhat lower date is probably closer to the mark. For additional bibl., see, e.g., Ridgway 1994, 53–56, no. 15 (A.-M. Knoblauch).

78. For a recent mention of this passage, although from a different point of view, see Stewart 1990, 83. J. J. Pollitt, *The Art of Ancient Greece: Sources and Documents* (Cambridge 1990) 155–56, relates the preceding passage in Xenophon, when Sokrates makes the painter Parrhasios acknowledge a similar need to depict human feelings as well as appearances. Note, however, that the emotions to be expressed sculpturally are the competitiveness of the athlete and the elation of victory, not the agony of defeat; "pathos" seems not yet in vogue.

79. For a picture of Athens just before and during the time of Lykourgos, see F. M. Mitchell, "Lykourgan Athens: 338–322," in *Lectures in Memory of L. T. Semple: Second Series, 1956–1970* (Cincinnati 1973) 165–214, esp. 191–93, although some identifications of buildings cited within the Athenian Agora have since changed.

CHAPTER 7

The Issue of the Great Masters

Only Greek originals of the fourth century have been considered so far. We enter now the dangerous waters of the realm of Roman copies, where setting the proper course is difficult indeed. Recent publications (Stewart 1990, Todisco 1993) and monographs (e.g., *Lisippo* 1995)[1] have dealt at some length with individual masters and attributions; we can therefore concentrate here on points of specific importance, without attempting a complete survey of sculptors' oeuvres.

Our evaluation of Roman copies has changed considerably in recent years—from a position of complete dependence on them, in the assurance that they could help us recapture the lost masterpieces of the Greek past, to a position of healthy skepticism based on the realization that Roman patronage and taste may have encouraged not only considerable changes in the copying of a specific prototype but also variations and new compositions in retrospective styles. Current research in this field is opening up different vistas, and historiographic studies are helping by pointing out the cultural premises and biases of earlier scholars, which in turn conditioned their interpretations and attributions. To be sure, old theories die hard, and opinions even on major monuments are far from having reached consensus; but fresh ground is being broken, new methods are being tried, greater open-mindedness is exercised, and this ferment of ideas bodes well for the future.[2]

THE ANCIENT SOURCES

Our traditional approach to Greek sculpture was based on excessive reliance on the ancient sources, often without proper discrimination. Confident that Pliny had derived much of his art-historical information from the writings of earlier, practicing Greek artists, we had tended to overlook Pliny's intended focus on natural history, as well as his innate tendency to organize and classify, often providing cause-and-effect connections where none existed, or seeking to establish the origins of certain practices by naming a "first inventor" whose name and times could not possibly allow verification.[3] An added problem is the fact that Pliny did not often mention the ethnics or patronymics of the sculptors he listed, nor did he always

distinguish among homonymous masters. The results of this lack of clarity are still evident in today's scholarship.

Other writers of the Roman period must also be consulted with a precise understanding of their purpose. Thus, rhetoricians and orators like Quintilian and Cicero, who strived for special effects, should be read in context, rather than excerpted, keeping in mind the essential question: *cui bono?* Plutarch's *Parallel Lives* should be understood within the moralizing and pedagogical terms of their compilation by a person who was indeed a Greek but one steeped in Roman practices and ways of thinking. Poets in particular should be used with caution, since their own art took precedence over accuracy of information; whether writing in Greek or Latin, their primary purpose was the composition of an effective poem, not the transmission of art-historical knowledge, as attested, for instance, by many hyperbolic epigrams in the *Anthologia Palatina*. It is amazing to realize how often quotations from Lucian come from his *Philopseudes*, a work about a congenital liar who is therefore not expected to be telling the truth, even if engaged in an apparent dialogue with a friend.[4] Other poets, like Statius and Martial, meant not only to satirize and ridicule, but—even more misleadingly—to flatter their patrons beyond measure. They were all, moreover, men of their own times, and therefore open to the misunderstandings and misattributions of a Roman culture centuries removed from the Greek originals.

Pausanias, despite his second-century (Antonine) date, is an entirely different source of information, since he tended to read and transcribe inscriptions as he saw them in his various travels; his accuracy has been confirmed in several cases. He too, however, could confuse a younger with an older master, and occasionally relied on local traditions rather than on personal verification. Whenever he used the expression "as they say" or something comparable, we should assume that he did not have first-hand evidence, and therefore his statement should be taken with caution.

Much more reliable knowledge can be derived from extant signatures of sculptors, although they appear on statue bases rather than on the sculptures themselves, at least for the Classical period. Traces left by the original monument on these signed pedestals can also help reconstruct, if not the style, at least the medium and the stance of the lost work, and recent research has tended to assign increasing importance to such material testimony. Yet problems exist even within this more objective category of evidence, and should be briefly mentioned.

The most obvious difficulty is that not all monuments were signed, and most inscribed bases give no indication of the sculptors; extensive studies have been unable to detect patterns behind the presence or absence of signatures, except to note their relative insignificance and lack of correlation with the importance of the commission.[5] In addition, statue bases were among the most easily usable blocks in antiquity, and are often found fragmentary, out of context, reemployed for different purposes. In many cases, a partially preserved sculptor's signature has been recon-

The Issue of the Great Masters

structed on the basis of likely mentions or allusions in literary sources, and the resulting arguments tend to be circular.[6] Even when base and signature are intact, installation traces may show that the original monument was removed and occasionally replaced by a different one, or the inscription itself was recarved and altered. In the best of circumstances—a fully signed monolithic pedestal, or at least one with top surface preserved—a base for a marble statue reveals only the most general outlines of the composition through the cavity prepared for the insertion of the plinth on its top surface. A base for a bronze monument is more explicit, but even its cuttings, corresponding to the points of adherence of metal to stone, can be puzzling and unclear, especially if different from standard footprints. Finally, inscriptions are notoriously difficult to date, and epigraphists tend to assign wide ranges to letter forms, specifically during the fourth century. Unless prosopographic or historical indications help connect the monument to known individuals and events, epigraphic evidence remains vague. Some cases are more difficult than others, since even well-dated Olympic victors seem to have set up their statues only many years after their attested victory, either because three achievements were necessary to obtain statuary honors, or because finances did not allow immediate commemoration—hence the current debate over whether several athletic monuments were made by the famous Polykleitos in the fifth century, or by Polykleitos the Younger in the fourth.[7]

Despite these strictures, signed bases should remain our most reliable source of information. It is therefore striking to note how many masters are known only through epigraphic evidence that finds no echo in the ancient writers. A cursory review of fourth-century masters attested *solely* by their signatures has revealed 19 Athenians (or at least, in the absence of ethnics, masters who worked in Athens), two Peloponnesians, two Megarians, two Boiotians, two Thessalians, one Parian, and four Rhodians.[8] It should be stressed that these numbers refer to commissions for statuary in the round, not to architectural works that could be subcontracted to relatively obscure carvers. Conversely, no signatures of the famous Skopas are extant, despite his widespread activity outside his home territory, which should have demanded ethnic identification abroad. We have three bases signed by Sostratos son of Euphranor, but none carrying the name of his more famous father. Even Timotheos, for all his alleged reputation, has left no inscribed monument, although his activity is attested through the next-best form of evidence—building accounts. If other names from the same type of document were included, however, the totals listed above would be higher.

It has been generally accepted, on the basis of the ancient accounts, that the four sculptors who worked at the Halikarnassos Maussolleion had been called there because of their established fame. I have suggested instead that the availability of trained manpower and established workshops may have been the primary reason behind the invitation. This theory may be supported by the evidence from the large

The Issue of the Great Masters

sculptural dedications set up in Delphi and Olympia, which comprised a great number of bronze statues. A name—*Antiphanes of Argos*—recurs at Delphi like a leitmotif, and deserves further consideration.[9]

Ancient sources mention the sculptor as a second-generation member of the School of Polykleitos; his master was Periklytos, and he in turn was the teacher of Kleon of Sikyon. But his activity can be best traced at Apollo's sanctuary, through some fairly well dated monuments that attest his activity from the last two decades of the fifth to approximately the middle of the fourth century. After 414 he is said to have made a Trojan Horse commemorating the victory of the Argives over the Spartans; after the Spartan success at the Battle of Aigospotamoi (405/4) he collaborated on the Lysander Dedication (also known, inaccurately, as the Monument of the Navarchoi); after 370/69 he worked with others at the Arkadians' dedication, set up for their participation in the Thebans' victories over Sparta; but he is the sole sculptor epigraphically attested on the monument of the Kings of Argos (also erroneously named), celebrating the Argive contribution to the new foundation of Messene in 369. Since only one half of the semicircular base for this last commission seems to have held statues in antiquity (ten, of bronze), it has been occasionally suggested that the work was not completed; yet optical considerations may have prompted the unusual arrangement, to make the statues immediately visible to the visitors climbing the Sacred Way—one more example of the theatrical effects prevalent in the fourth century.

From the above list, it would seem that Antiphanes spent most of his active life in Delphi, indiscriminately accepting commissions from both allies and enemies of his home town, and willing to commemorate both victories and defeats of some of his clients. This neutrality strongly speaks in favor of a sculptural workshop based at the sanctuary and prepared to satisfy the demands of Apollo's devotees regardless of nationality; a similar situation may have obtained during the Archaic period. More intriguing is an analysis of the ethnics represented in the two commissions that required a large number of statues. The **Lysander Monument**, with approximately 40 bronze figures, was produced by Antiphanes of Argos together with Athanodoros and Dameas of Kleitor in Arkadia; Alypos, Patrokles, and Kanachos of Sikyon; Theokosmos of Megara; Pison of Kalaureia; and Teisandros, not otherwise identified. The first five of Antiphanes' collaborators (all Arkadians and Sikyonians) belong to the School of Polykleitos and may therefore be assumed to have been called in by a fellow pupil; but Pison was said to have been a pupil of the Athenian Kritios (Paus. 6.3.5), and even Theokosmos of Megara supposedly worked with Pheidias (Paus. 1.40.4., although here he says λέγουσιν). A breakdown of the type of statue executed by the various masters does not seem to correspond to special skills, for instance, in the making of human versus divine images, and collaboration may imply simply the need for many hands.

The second monument, the **Arkadian Dedication**, with nine figures, is a less

The Issue of the Great Masters

clear-cut case, in that Antiphanes' collaborators, as mentioned by Pausanias (10.9.5–6), are all thought to belong to the Polykleitan School: Daidalos of Sikyon, Pausanias of Apollonia, and Samolas of Arkadia. Yet only the first named has a clear connection through his father and teacher Patrokles, who worked on the Lysander Dedication; the others' association is inferred through their Delphic collaboration. It is also noteworthy that, of the masters listed for both monuments, only Daidalos has received some tentative attributions of works known through Roman copies; the others are completely unknown. A Dioskouros from Baiae (Todisco 1993, pl. 36) has been connected with Antiphanes solely because of its subject (which the master executed for the Spartan group) and its Polykleitan appearance—it is, I believe, a Roman adaptation of Classical forms, as suggested by the (severizing) long hair strands framing the face. The head of a strategos in the Capitoline Museum (Todisco 1993, pl. 35) has been identified as Lysander on the strength of its portraitlike quality; yet the mannered pincer-locks over the forehead and especially his decorated helmet may warrant interpretation as a classicizing Mars.

Even accepting a sustained connection of the sanctuary with the Polykleitan School, only Antiphanes of Argos is represented with any consistency at Delphi; the other named sculptors make a single appearance. They may therefore have been recruited only when the local foundry was unable to supply the requested number of statues within a specified time. But how could masters routinely working at some remove from one another, even if connected through a hypothetical link to Polykleitos, produce sculptures that would look stylistically compatible on a single base? How could Antiphanes himself collaborate first with the father (Patrokles), then with the son (Daidalos) after an approximately 30-year interval? Would stylistic developments have made the difference in generations obvious? Note, moreover, that Antiphanes was presumably involved in two simultaneous commissions, since both the Arkadian and the Argive dedications fall shortly after 369.

We can only conclude that such numerous groups were executed by various hands from generic models that could be altered in minor details to provide a semblance of differentiation from figure to figure, without requiring special creative imagination.[10] Armor, attributes, hairstyles, but especially context and interaction, together with the labeled bases, would have provided identification. The viewer, impressed by the sheer number and size of the dedications, would not have looked for those traces of personal style that we take for granted today. A similar picture is suggested by the imprints on the surviving bases: the bronze figures seem to have been paratactically aligned, some of them in the typical Polykleitan stance with left leg trailing and right leg advanced, bearing the weight; but some markings suggest a reversal of the pose, and others even show both feet flat on the ground. The compositional features so typical of the fifth-century master may therefore have been modified or rejected by his followers.

What, therefore, constitutes a *School?* Only two clear instances are mentioned

The Issue of the Great Masters

by the ancient sources: the School of Polykleitos and that of Lysippos, although the Sikyonian master is said to have had no known teacher himself, except the Doryphoros of Polykleitos. But Skopas and Praxiteles may have come from a family of sculptors; the latter certainly trained his own children to continue his trade; and large workshops based on extended family connections are known for the Hellenistic period.[11] We should therefore attempt some definitions of concepts such as "School," "workshop," and "family."

I suspect that "School" simply means a direct connection of apprenticeship in which a master sculptor (whether carver or bronze-caster) teaches the basic tenets of the trade, either to immediate family members or to artisans from other areas who have come to learn proportioning, finishing, the use of piece-molds, the ability to work with various tools to obtain specific results. From this point of view, I imagine that this kind of connection was not substantially different for other forms of ancient activities, be they pottery-making, painting, leather-working, and other such skills. A shoemaker would train other shoemakers, a jeweler other jewelers, in the same way a mother might train a daughter to spin and weave, or to cook. Sources of the Roman period like Pliny and Pausanias, I surmise, may have placed greater emphasis than warranted on the master-pupil relationship simply to provide approximate chronological referents for periods so far removed from their own, not to indicate stylistic affiliation. Some sculptors may have achieved a certain reputation, and have thus attracted more apprentices than others, but I doubt that in antiquity the same situation obtained that we know to have prevailed in Renaissance Florence, for instance, where the pupil actually paid the teacher to work under his guidance. Wages would have been paid to Greek apprentices, and slaves would have been employed for the more menial tasks.[12]

Whether this direct instruction inevitably resulted in similarity of styles is impossible to tell. Had stylistic originality been the mark of specific schools, we would not have the evidence of a base signed by Lysippos and Polykleitos (III?) at Thebes (Todisco 1993, 47 fig. 14), nor would we hear of the collaboration of a Praxitelean (Kephisodotos II) and a Lysippan (Euthykrates), as mentioned by Tatian (Stewart 1990, 296, T 136). Thus, participation in a single commission need not imply a workshop connection, if workshop is understood as School. If, however, workshop means simply the physical establishment in which a work is being produced, then subcontracted sculptors may easily have worked side by side with others, either as apprentices or as equal partners, as was probably the case at the great sanctuaries, where masters from different areas congregated to use the available facilities.

Even within the concept of School and workshop, we should accept the fact that trainees and trainers alike might have felt the influence of neighboring ateliers, if, for example, they resided in the Athenian Kerameikos. In Hellenistic Rhodes, we may have evidence that a workshop worked in a variety of styles, since Menodotos of Tyre together with [. . .]phon of Rhodes produced the Archaic-looking Piombino

The Issue of the Great Masters

Apollo, as well as portraits of athletes in first-century fashion.[13] The issue could also be raised of how sculptors could have created a School if they were frequently traveling, as it is assumed for Skopas and Lysippos. This may, however, be a moot question, since inscriptions seem to attest that sculptors moved relatively seldom, and tended to stay within a circumscribed area not far from their home base.[14] We have already noted some evidence of this practice in discussing Peloponnesian architectural sculpture (Chapter 2).

Oeuvres of masters and their peregrinations have been reconstructed, as mentioned above, primarily on the basis of literary sources. We shall here consider briefly what can be accepted as reliable evidence, with a minimalist and perhaps hypercritical but safe approach. At the same time, I must acknowledge a certain ambivalence in my analysis, in that some works seem more acceptable to me than others, as possible replicas of fourth-century originals, *on stylistic grounds*. This ambiguity of positions will be addressed in my "Conclusions."

THE SCULPTORS

Naukydes

Since the School of Polykleitos has been cited above, we may begin our survey with one of its members, either a nephew or a more distant relative of the better-known master. Like Antiphanes of Argos, Naukydes began his activity in the fifth century, but we cannot be sure how far it stretched into the following; yet he is significant enough to be considered here. Inscriptions attest that he was the son of Patrokles of Sikyon, and thus probably brother of Polykleitos II, but we cannot ascertain his ultimate connection with the Argive head of the "School." Naukydes is known to have made several statues of athletes at Olympia (Paus. 6.6.2; 6.8.4; 6.9.3); the chryselephantine Hebe at the Argive Heraion (see supra, Chapter 2); a bronze Hekate in Argos (Paus. 2.22.7), with a sphere of action that seems concentrated in the Peloponnesos and does not—surprisingly—include Delphi, despite his father's participation in the Lysander Monument. Yet a signed statue base was found on the Athenian Akropolis. Pliny (*NH* 34.80) praises Naukydes for his Hermes, a diskobolos, and a figure of a man sacrificing a ram.[15] Only the discus-thrower is universally accepted as identifiable in Roman copies, and should detain us briefly.

If this attribution is correct, the pose of the **Diskobolos**, as best represented by the replica in the Capitoline (Pls. 56–57), marks a definite departure from that of the Doryphoros. Although the left leg still supports most of the weight and the right is slightly bent at the knee, the latter is placed diagonally forward, rather than trailing, and opens up the composition laterally. Torsion is expressed in the uneven length of the shoulder contours, which emphasize the slight upward shift of the right humerus. Yet the discus hangs at the youth's left side, so that if the Greek term used by Pliny is to be taken literally, this type, for all its transitory stance, is

Plates 56–57

The Issue of the Great Masters

not a discus-thrower, but a discus-carrier (diskophoros), or at best an athlete preparing to throw.[16] Incipient motion is in fact suggested by his toes, especially those of the right foot (missing in the Capitoline replica, but known through other copies), which seem to grip the ground. Body proportions appear stocky, with the rounded head somewhat small for the torso, although more recently found replicas are said to be slenderer[17]—another instance of copyists altering a possible model to suit contemporary taste, which therefore casts doubt on the entire practice of *Kopienkritik*.

The similarity between the Diskobolos and the Ares Borghese has been repeatedly mentioned; yet for all their Polykleitan affinities, the two are different. As Linfert properly stresses, the forward right leg of the Ares is straight, not bent; nonetheless, the lateral opening of his composition cannot be denied, and the inclination of his head is comparable to that of the athlete. I would accept that the Ares is a classicizing creation after Polykleitan prototypes,[18] and that the Capitoline Diskobolos (as representative of the specific type) goes back to an early fourth-century original. That such an original was by Naukydes is, however, uncertain. Although both Linfert and Todisco mention that the Diskobolos' stance is attested by the markings on the base for the Rhodian boxer Eukles' statue at Olympia, signed by the master (Todisco, 1993, fig. 12 on p. 46), to me those footprints look parallel, rather than at an angle. The artistic innovation of the Capitoline Diskobolos type rests *not* on the advanced right foot, but on the spatial penetration suggested by the oblique placement of the forward leg, which forecasts such late fourth-century creations as the Lateran Sophokles (Todisco 1993, pl. 293) and the Naples Aischines (Todisco 1993, pl. 300), or the early third-century Demosthenes (Ridgway 1990, pl. 107).

A few stylistic comments. The Capitoline Diskobolos' face has a modulated forehead that relies on modeling, rather than on engraved lines, to separate the bulging muscles over the nose and eyes (the so-called Michelangelo bar) from the upper portion of the brow. This rendering, here concentrated around the central axis, increases progressively in volume with time, culminating in the prominent frowns of the "Maussollos" or the Agelaos and the Agias (Todisco 1993, pls. 240–41). The Diskobolos' hair is distinctive; its comma locks are quite short, without the orderly concentric arrangement typical of Polykleitan heads, and look as if brushed back with a sweaty hand. This naturalistic treatment, if not due to the copyist, separates this head type from others that may look similar but have a more calligraphic, classicizing arrangement of curls over the forehead. Regardless of its maker, the Diskobolos original was an impressive work of the first quarter of the fourth century.

Timotheos
This master has received more than usual attention because of his connection with the Maussolleion, which implied great fame, and his participation at Epidauros,

The Issue of the Great Masters

which has been read to mean overall control of the sculptural program for the Asklepieion. This literary and epigraphic evidence has led to the belief that original works by his hand are extant, both from the Peloponnesian and from the Karian site; this may be the case, but the situation is less clear than it may seem. As already discussed, the Maussolleion attributions were based on the various slabs of the Amazonomachy frieze, yet these are probably not by the head masters but by the "workshops." Of the sculptures in the round, nothing resembles the Epidaurian style, our only basis for establishing possible links. At the Peloponnesian sanctuary, Timotheos did not have the leading role, given the correct translation of the term *typoi*. We know, however, that he made one set of akroteria, although we are not told over which façade. It has been suggested and tentatively accepted (Stewart 1990, 274) that those over the front are more in keeping with the style of the east pediment, and should therefore be by a single master (as contrasted with the west side, where pediment and akroteria were contracted for by two different sculptors, and in fact seem to show stylistic differences). But even this reasonable observation would give Timotheos responsibility for making at least the models for the east gable, which we believe not to be the case. What remains is therefore a general conception of a style that may have been prevalent at the time, rather than the hallmark of a specific sculptor—a style of flamboyant drapery that can simultaneously be both heavy and transparent; a mannerism of deep grooves that follow contours of limbs and torsos; a trend toward deeply set eyes and soulful expressions; finally, and most important, an incipient element of torsion, as present in the central akroterial Nike ("Epione") on the west side.

On these grounds, two works, although not mentioned by any literary or epigraphic source, are consistently attributed to Timotheos: the so-called Hygieia from Epidauros, a Greek original, and the Leda with the Swan, known through well over 20 replicas and variants from Hellenistic and Roman times. The first can be briefly discussed; the second presents a more complex situation.

The **Hygieia from Epidauros** (Todisco 1993, pl. 82) is a headless, under-lifesize marble work that closely resembles all the akroterial sculptures from the Asklepieion.[19] With her raised left thigh and her cascading mantle swag, she echoes the position and costume of the eastern Apollo struggling with Koronis; with her chiton pinned only over her right shoulder, she repeats the diagonal accent and the unveiled torso (albeit reversed) of the NW corner Aura; the riding figure at the opposite (SW) corner has the same catch of folds at the bent left knee as that at the Hygieia's right. Transparency is extreme, and mantle and chiton play against each other in creating contrasting effects, yet flamboyance is muted; technical virtuosity is great, and marble curtains are thin to the breaking point. That she is the Goddess of Health has been argued on the basis of her findspot, as well as of the snake on the rock that props up her foot, which was perhaps shown rising toward the object (a *kiste*?) once held over her left knee. Although her contour looks more eloquent

in right profile, the frontal view is necessary to reveal the snake (at least in its present, damaged state) and looks satisfactory. If this Hygieia is not by Timotheos, it should at least be a product of the same artistic circle active on the Asklepieion, and contemporary with its architectural sculptures. Note that the goddess is both a mythological figure, daughter of Asklepios, and a personification, in keeping with the abstract tendencies of the fourth century.

Iconographically, it should be stressed, this Hygieia is unique,[20] not only because of her pose, but also because of her excessively revealing costume. Other Hygieia types traditionally dated to the fourth century, whether in the round or on votive reliefs, are more heavily clothed, less seductive. In fact, the Epidauros statue seems a pendant to the **Leda**, although the latter is known only through later replicas and her iconographic schema goes back to fifth-century prototypes.[21]

Equally under-lifesize, the Leda's body (Todisco 1993, pl. 84) is more explicitly revealed, as she rises from a rocky perch to defend the small, seemingly harmless swan in her lap from a threatening, albeit invisible, eagle. This type of composition—a single-figure group, as it were—which requires the viewers not only to know the story but also to supply in their own mind the missing element that completes the narrative—is especially popular in the Late Hellenistic period, but it can be found, in incipient form, in such late fourth-century grave reliefs as that of Aristonautes.[22] It may suggest for the Leda a date lower than the decade 370–360 usually assigned to the missing original. The classicizing head with its ogival forehead (at least in the Capitoline replica) may either confirm a later chronology or hint at Roman contamination.

Stylistically the Leda fits in well with the Epidaurian sculptures, making allowance for the Roman transliterations. Her mantle is perhaps richer, its omega folds more mannered, its selvedge more decorative than realistic, in that it borders the entire cloth, rather than just its vertical edges. One wonders whether the original might have been in bronze,[23] since the rock-support against which Leda leans (or from which she has just risen) contrasts with the stool under her left foot, which suggests an indoor setting.[24] Yet a swan chased by an eagle within a domestic enclosure would be improbable; so, which is the intrusive element, if the two props are mutually exclusive? The fifth-century prototype, more coherently, has no rock, and rests one foot on a step or block; but it is also less elaborate and its costume is only an unpinned peplos, not chiton and himation. The fourth-century Leda raises her mantle high, creating a thin shell of marble which would require carving virtuosity—or the stability of bronze. But the Nike of Paionios shows a similarly daring rendering, and one of the Xanthian Nereids makes a comparable, if reversed, gesture (Todisco 1993, pl. 71; London, BM 910).

Attribution of the Leda to Timotheos can be made on those same stylistic grounds advocated for the Hygieia; yet a peculiar reasoning is at the root of the theory. In the 1840s, Jahn suggested that the Leda's composition—a human being

The Issue of the Great Masters

and an animal in an amorous context—was comparable to the **Ganymede and the Eagle** of Zeus described by Pliny (*NH* 34.79) as a bronze by Leochares, and traditionally identified in the marble version of a table support in the Vatican (Pl. 58).[25] Because both Leochares and Timotheos had worked on the Maussolleion, Jahn assumed a master-pupil connection between the two, with the (attested) Ganymede inspiring the approximately contemporary (albeit unattested) Leda. Eventually, on the evidence from Epidauros, the theory was reversed; inspiration from one composition to the other was retained, but on the grounds that Timotheos, as an older master, was Leochares' teacher. This suggestion is still repeated by some modern sources,[26] yet I would propose a different reading of the evidence.

Plate 58

The Ganymede in the Vatican is probably after a Hellenistic pictorial prototype, unconnected with Leochares;[27] at any rate, the relationship between animal and human is entirely different in this group, since the eagle is formidable, no sexual allusion is evident (although implicit in the myth), and all elements of the composition are included, thus requiring no imagination. The presence of both Leochares and Timotheos at Halikarnassos was probably due to their availability, not to a theoretical pedagogic relationship. There is therefore no proof that the Leda original was by Timotheos, although style makes it plausible; I would, however, prefer a somewhat later date for the theatrical prototype. Iconographically, the Leda goes back to earlier renderings, but then her formula continues to be used unchanged through the centuries, until the Roman period provides a more sexually explicit version, with a naked Leda standing against a much larger swan.[28] The popularity of the "Timothean" Leda should be attributed to its subject rather than to the fame of its master. From this point of view, one indeed wonders whether the homosexual allusions of the Ganymede theme were being intentionally counterbalanced by the heterosexual emphasis of the Leda, Zeus appearing in both cases in bird form, but with different interests.[29] At Pergamon, a replica of the Leda may have stood in one of the niches of the stoa in the Athena Precinct. If so, it may have created a pendant to the scene of Herakles freeing Prometheus from the eagle devouring his liver, and been part of a series of themes with human/animal interaction.[30]

One final comment: I find it a surprising coincidence that both the "Timothean" Leda and the Epidaurian Penthesileia should have an (Athenian?) predecessor in fifth-century works at present in the Boston Museum of Fine Arts (see Chapter 2, n. 44). I certainly do not mean to imply that the sculptures in Boston are forgeries—they are excellent Greek originals; I am simply wondering about this peculiar connection, and the role these two pieces played in antiquity.

A summary statement on Timotheos must admit that the master's persona remains elusive. We do not even know his proper ethnic, since the available sources do not mention it. Suggestions that he is an Athenian or an islander trained in Attika are based on his style, supposedly related to the Nike Balustrade; he is more likely to be a Peloponnesian, a local man who did not need to be identified in the

The Issue of the Great Masters

building accounts of his own town.³¹ We might have some originals by his hand at Epidauros, but we do not know exactly which. He certainly worked there in the 370s, and perhaps at nearby Troizen, where Pausanias (2.32.4) says an Asklepios was made by him; he was probably active at some of the earlier building projects in the Peloponnesos, perhaps as preliminary training leading to the Asklepieion commission. He cannot have been very famous, by our standards, since even Pliny (*NH* 34.91) cannot list his (bronze) works beyond a generic "armed men, hunters, and people making sacrificial offerings." His participation in the Maussolleion program cannot be verified, although his seems more plausible than the alternate name suggested (Praxiteles); if he was there, he might have made the **akrolithic Ares** otherwise given to Leochares. All other attributions to him are unprovable; the Artemis taken to Rome (Pliny, *NH* 36.32) cannot be recognized on the Sorrento Base, a purely Roman work.³² On the basis of the sources, he would have worked not only in marble, as attested at Epidauros, but also in bronze, and perhaps in the akrolithic technique.

Leochares of Athens

Equally versatile was Leochares, who definitely worked in bronze as well as, supposedly, in gold-and-ivory at Olympia, and, at the Maussolleion, in marble.³³ The akrolithic Ares at Halikarnassos, already mentioned in connection with Timotheos, is not surely by him, nor can we be sure whether the Athenian was responsible solely for the marble parts or for the entire construction—affinities between the akrolithic and the chryselephantine techniques may appear to strengthen the attribution, but the argument is ultimately circular. In fact, extant evidence, consisting of an unusually high number of signed bases, would define Leochares primarily as a maker of bronze statues. These stood in Athens and environs (the Peiraieus, Oropos, Eleusis), and suggest that the master specialized in private dedications, both on the Akropolis (including the Athenian Asklepieion) and the Agora.

For a group of six bronze figures representing the family of Pandaites of Potamos, set up on the Akropolis, Leochares collaborated with Sthennis; usually placed at mid-century, this dedication has now been lowered to 330 or later, since the donor was born around 351. A statue of Isokrates was dedicated at Eleusis by the general Timotheos,³⁴ who was exiled in 356/5; the commission should therefore have been given before that date and, together with earlier monuments in Athens, may have established Leochares' ability (and availability?) to portray individuals and types. Yet he must have been fairly young when he went to Halikarnassos (c. 360–350), since he continued working until after 320, when Krateros died, as the votive inscription in Delphi records that the latter did not see the completion of the **"Alexander's Hunt"** dedicated by his son.³⁵ It has been suggested that Leochares too may have died before finishing his task, which was then given to Lysippos. Yet I

would see nothing unusual in the collaboration of two bronze sculptors on a single multi-figured monument; on the other hand, Lysippos' name may have been associated with the Delphic commission in later times, simply because of Alexander's presence within the group.

Work at the Maussolleion may have earned Leochares a call to Olympia, where he is said to have made the chryselephantine statues of Philip II and his family, beginning after 338 (Paus. 5.20.9). In turn, this Macedonian commission may have led to the Delphic job. But, except for his one trip across the sea to Karia, Leochares the Athenian seems to have remained at home, the excursions to the two Panhellenic sanctuaries, if verifiable, being special ventures. Attributions have tried to expand his sphere of action, but they are tenuous at best. Perhaps the most persistent, because of its authoritative proponent, is that he made the **Demeter of Knidos** (cf. Pls. 79a–c); but this suggestion was advanced on the basis of a stylistic comparison with the **Akropolis Alexander** (Todisco 1993, pl. 223), initially thought to be an original but now recognized as a Roman copy. In turn, the Akropolis Alexander was connected to Leochares primarily because of his apparent youth, and the fact that this age bracket corresponded theoretically to Alexander's appearance at the time of the Philippeion chryselephantine portraits, before the Macedonian had reputedly chosen Lysippos as the only sculptor entitled to portray him. This chain of assumptions has been weakened in almost all its links, and I have discussed it elsewhere.[36] Here it can therefore simply be discounted.

Other recurrent mentions are the already considered Ganymede and the Eagle (too late a composition for this master), and, because of alleged similarity to it, the **Belvedere Apollo**, which is also likely to be a Hellenistic rather than a fourth-century creation; in turn, the Apollo's split motion has prompted attribution of the **Artemis of Versailles** type.[37] Although these specific sculptures should be excluded from Leochares' oeuvre, the master is known to have made images of divinities—not just the bronze Zeus Brontaios later taken to Rome (Pliny, *NH* 34.79), which may or may not be a correct attribution, but also, on the witness of Pausanias, at least one of the Apollo statues that stood in front of the temple of that god in the Athenian Agora (1.3.4); a Zeus and Demos in the Peiraieus (1.1.3); and another Zeus on the Akropolis (1.24.4). Material evidence (statue bases) is limited, however, to private dedications.

If we exclude the attributed masterpieces, Leochares' early output and range do not seem to make him comparable to a Skopas or a Lysippos.[38] The question therefore arises whether his alleged fame was responsible for earning him the Maussolleion commission or, rather, whether it has been assumed that he was famous *because* he worked there. As mentioned above, it seems probable that it was the Halikarnassos connection that earned him the (undoubtedly prestigious, but chronologically later) Philippeion and Krateros commissions—just as *Satyros* may have

The Issue of the Great Masters

been asked to make the statues of Ada and Idrieus at Delphi because he too had been involved with Maussollos' tomb.[39] Once again, we must admit that fame is a relative concept, somewhat in the eyes of the beholder.

Bryaxis

The same comments could be made for this master, the fourth to have been connected with the Maussolleion. His case is made more difficult by the fact that a later Bryaxis is credited with several works, the most famous of which may have been a Sarapis for Alexandria; it is therefore impossible to distinguish, without proper chronological indications, which sculptures could have been made by a man active around 360 and which by a master commissioned by Alexander's successors.[40] Despite his foreign-sounding name, the one sure evidence for a Bryaxis comes from Athens: a signed base for a bronze tripod found in the Athenian Agora (Todisco 1993, pl. 156). It represents the dedication of a father and two sons who had won in the *anthippasia*, a cavalry competition by tribes (*phylai*). The letter forms, datable at mid-fourth century, ensure that the signature is that of the Maussolleion sculptor, but the reliefs on three sides of the base are so insignificant as hardly to warrant a claim of authorship. They give a monotonous rendering of the same scene—a horseman moving toward a tall tripod—with minimal variations and inversion of direction.[41] If the base was carved by an apprentice, as likely, would Bryaxis have signed his name for making the bronze trophy that stood above it? Or was the master advertising the availability of his workshop for private dedications?

On the principle of proximate activity, we could accept for this Bryaxis the Asklepios and Hygieia seen by Pausanias (1.40.6) at Megara. But if this sculptor indeed went to Halikarnassos, he may have also made five colossal bronze divinities for nearby Rhodes (Pliny, *NH* 34.42), a marble Dionysos at Knidos (*NH* 36.22), and a Zeus, an Apollo and lions at Patara, in Lykia (Clem. of Al., *Protr.* 4.47). On the other hand, an Apollo at Daphne (founded after 300)[42] and a portrait of the city's founder, Seleukos (Pliny, *NH* 34.73), as well as the Alexandrian Sarapis, are likely to be by the younger master. Yet, by the same geographic principle, all works in Asia Minor and Rhodes could be attributed to the Hellenistic (Karian?) Bryaxis— the ancient sources are too laconic to provide adequate cause to decide. On strictly logical grounds, it could even be argued that it was the intensive activity of the younger Bryaxis in Rhodes, Asia Minor, Syria, and Egypt that led to the later (and fictitious, as well as anachronistic) association of his name with the most important Classical monument of his homeland.

Should the ancient accounts be correct, and did the Athenian Bryaxis work at the Maussolleion, he may have been assigned the task on the basis of his acquaintance with his compatriot Leochares, perhaps through a workshop connection. "Fame" may have accrued to his name *post factum*, rather than being the reason behind his

The Issue of the Great Masters

participation. Once again, the oeuvre of the master remains nebulous, and none of the attempted attributions has any real foundation.

We have stated it repeatedly, but the point bears reconsideration. A summary statement about the celebrated sculptors who were active at Maussollos' tomb should acknowledge the relative obscurity of three out of four (perhaps even all four) of the named participants; only then can we read the sources with objectivity and realize that both Pliny (*NH* 36.30–31) and Vitruvius (7.*praef*.12–13) hint at the same conclusion. The first states that, after Artemisia died, the masters continued working, "having already decided that it would be a monument both to their own glory and to that of their art." The second claims that "the outstanding excellence of their art created a reputation *for the work* [my emphasis] that caused it to be classed among the Seven Wonders of the World." Nowhere, except in modern commentaries, is it said that these four masters were chosen because of their *established* reputation. The free-standing statues from the Maussolleion are excellent examples of mid-fourth-century Greek sculpture, but no attribution to individuals is possible, since the distinctive(?) styles of the individuals themselves can no longer be captured on present evidence. They should, in turn, provide no ground for hypothetical identifications, beyond a chronological assessment.

Skopas

Can this Parian master be considered at the same level as his three Halikarnassian co-workers? At first consideration, he would seem to be the giant that stands out from the mass, the one artistic personality that can be recaptured with some confidence. Once again, however, doubts can be raised. In addition, more than one master by that name is attested in antiquity, thus complicating the picture sketched by the literary sources, which do not distinguish among them.[43]

Pliny (*NH* 34.49) gives Skopas' *floruit* in the 90th Olympiad (420), together with Myron, Pythagoras, and Polykleitos—thus sculptors undoubtedly belonging to the early and mid-fifth century; most commentators therefore believe that this reference is to an earlier master, perhaps the famous sculptor's grandfather. Note, moreover, that this Plinian mention comes within his book on bronzes, yet the fourth-century Skopas is usually given only one bronze statue: an Aphrodite Pandemos, riding a goat, in Elis (Paus. 6.25.1). Because a master of the first century B.C. signs in Delos as Aristandros son of Skopas, it has been assumed that such names would alternate within the same family of sculptors, thus producing the following approximate stemma.

The Skopas of Pliny's *floruit* would be at the head of the sequence (*Skopas I*). His son *Aristandros* would be the master from Paros who made a bronze statue of a woman with a lyre (presumably a personification of Sparta) that stood under one

of the tripods dedicated at Amyklai after Aigospotamoi, therefore after 405/4 (Paus. 3.18.8). He was a contemporary of Polykleitos II, who also worked at Amyklai and made an Aphrodite for the same commemoration.[44] *Skopas II*, who worked at Halikarnassos, would be Aristandros' son, although no bases or signatures by him are extant, and no source gives his patronymic. His only datable activity is connected with the Maussolleion (360–350) and Tegea (350–340), but a life span from approximately 395–390 to 330–325 is assumed (Todisco 1993, 79). As already discussed, he collaborated with Leochares, Bryaxis, and Timotheos; at Megara he may have worked with Praxiteles, since he added a Pothos, Eros, and Himeros, to Praxiteles' Peitho and Paregoros, around an (Archaic?) ivory Aphrodite (Paus. 1.43.6). For Argos, in the temple of Hekate, he may have made a marble image of the goddess that stood next to bronze ones by Polykleitos (II?) and Naukydes (Paus. 2.22.7), but proximity need not imply collaboration or even contemporaneity, in this case. If he had a son *Aristandros*, he would have been the second by that name, perhaps alive still early in the third century, but we need to stretch lifespans or add other personages, to reach a *Skopas III* in the second century,[45] who was the father of that *Aristandros (III?)* who, during the first century, signed at Delos as son of a Skopas, all three times under the signature of Agasias son of Menophilos of Ephesos, two of them on bases for honorary statues of Romans, erected by the Greek and Roman merchants of the islands. In all three cases, Aristandros' name is accompanied by the verbal form *epeskeuasen* (from ἐπισκευάζειν), which has been translated as "repaired," and the Parian has therefore been credited with restoring monuments overturned during the Mithridatic War and the sack of 88.[46] A *Skopas IV* (active around 100?) would have made the reclining Hercules in Rome that may be connected with the inscribed base, and is therefore identifiable with the *Scopas Minor* mentioned by one ancient source.[47]

This hypothetical and at times illogical genealogy serves only two purposes: to confirm that some works listed by the sources as being by the fourth-century Skopas may belong to a homonymous (*S. minor*) master (whether the third or the fourth by that name), and to explore the possible roots of the Parian sculptor, if indeed the Aristandros active at Amyklai was his father. As noted above, the Spartan dedication was in bronze, yet all but one of Skopas' attributed works are in marble. Is it too far-fetched, therefore, to assume that the Aphrodite Pandemos for Elis, also in bronze, was by Aristandros' father, the first Skopas listed by Pliny among the bronze-casters? Pliny's *floruit* in 420 may be erroneous, yet a divine image riding an animal, in bronze, is perfectly conceivable within the last quarter of the fifth century, given the examples in stone (certainly a *lectio difficilior*) extant from that period;[48] indeed, the iconography of a female seated sidesaddle on a mount was known since the Geometric period, as attested by small bronzes.

Both Skopas I and Aristandros I would have been active in the Peloponnesos, albeit retaining their Parian nationality. This fact could be read to support a possible

The Issue of the Great Masters

apprenticeship of Skopas II at Epidauros, as some suggest, yet one would also expect continued training in bronze-casting with grandfather and father. On the other hand, a Parian Skopas (a different branch of the same family?) may have been active at the Temple of Hestia on the island (see supra, Chapter 4), and may thus have been connected with architectural enterprises that could earn him commissions at Halikarnassos and then at Tegea. A picture would emerge of a master indeed trained primarily to carve in the Parian stone of his home, and moving within a relatively limited geographic sphere—perhaps, after Tegea, working at Argos (Hekate) and at Gortys of Arkadia (Asklepios and Hygieia); eventually, at Thebes (Artemis, Athena Pronaos), Megara (Pothos, Eros, Himeros), and Sikyon (Herakles). But this is a highly hypothetical list, based entirely on Pausanias, who, at least for the Theban Athena, relies on others' opinion (λέγεται).

Significantly enough, the attributions more consistently made to the Classical Skopas on the basis of Roman copies draw little from even this reduced list—and I have left out other mentioned works at Samothrake, Chryse, Knidos, and Ephesos because of their improbable or overlapping chronology. If, after the Maussolleion, Skopas went to Tegea, he is unlikely to have returned to Asia Minor for additional commissions. The most popular identification of modern scholarship is the Pothos type, as represented by over 40 copies. Another frequent attribution is that of the Meleager type, even more often replicated in antiquity than the Pothos. I have discussed both statue types elsewhere.[49] I shall therefore limit myself here to a mention of the reasons why such attributions are made, and why they seem implausible, or at least unsupportable, to me.

Two ancient references to a **Pothos** by Skopas exist: one by Pausanias visiting Megara, and one by Pliny (*NH* 36.25), who adds that Aphrodite and Pothos are worshiped in Samothrake with extremely sacred ceremonies. The usual interpretation of the Latin passage has been most recently challenged by Todisco, who reads the comment as an aside on the cult of the two deities rather than as an indication of location for Skopas' statues. The Skopasian Pothos listed by Pliny would therefore be the same as the one in Megara seen by Pausanias in a group with two statues by Praxiteles. Other scholars support a duplicate rendering, but there is no agreement as to which of them is the type traditionally identified in the Roman replicas (Pls. 59–60).[50]

That Praxitelean and Skopasian works could be placed together at Megara need not imply similarity of style. Yet Stewart has repeatedly commented on the frequency with which the ancient sources join the names of these two artists, at times expressing doubts about attributing sculptures to one or the other. We should admit that we know nothing definite about the style of either; what we think we know would most definitely separate the two oeuvres, Praxiteles being the master of grace, languor, and sfumato, Skopas the conveyor of pathos, action, and torsion. Yet no ancient source uses the word *pathos* in connection with the Parian sculptor, and

The Issue of the Great Masters

this modern assumption is based on the Tegea heads, misleadingly alleged as primary testimony of Skopas' style. The production of the two artists could easily have been less dissimilar than we think, but Pliny's notions of rivalry may simply connote contemporaneity.[51]

Pothos is a personification of yearning, often interpreted as erotic desire. But so are Himeros and Eros; indeed Pausanias (1.43.6) wonders if there is any distinction in their function. Pothos should therefore be Eros-like; yet only one reversed (and erect, rather than leaning) replica, from the theater at Ferento, shows the type winged. It has been argued that the wings have been omitted from the marble copies because of the difficulties, static and technical, of rendering them in stone; yet the Ferento statue belies the assumption, as do the Nike of Paionios, the Epidaurian akroteria, and other marble renderings of winged creatures. Slots for separately carved wings are also found on some stone sculptures; moreover, one would have expected complete replicas in bronze and terracotta to exist, as is the case for other famous Classical creations, yet none is extant, to my knowledge. The gems reproducing a comparable type show it in fact winged, but also with androgynous traits much more pronounced than in the full-scale versions.[52]

If the copied original stood in Samothrake, why was the Aphrodite (probably seated or, if standing, colossal, against whom the Pothos may have been leaning) never duplicated? If it stood in Megara, why was Pothos singled out over Eros and Himeros? What, in the statuary type, ensures its identification as Pothos? Indeed, before Furtwängler's suggestion, it was known as Apollo with the goose. And why do we have no identifiable copies of the Praxitelean personifications that stood with the Skopasian trio? Since the comparison between the Pothos head type and the Tegea sculptures, as we have repeatedly stressed, is based on erroneous premises, and since certain stylistic traits (e.g., the rendering of the eyes) were common to the advanced fourth century, I continue to doubt that the prototype of the Capitoline statue was the Pothos by Skopas, and would accept its excessively slanted pose (which could easily have been rectified by the Romans if the composition was excerpted from a greater whole)[53] as typical of a non-Classical date.

No ancient source at all mentions a **Meleager** by Skopas. Identification of a specific athletic type (Todisco 1993, pl. 151) is based on the Roman copies using a boar's head as support, but it is remarkable how few of them do so; moreover, this potential attribute does not consistently appear on the same side of the human figure in the various replicas, thus suggesting that it was not present in the original. Since boar-hunts were popular, in both Greek and Roman times, this type of sculptural strut could have been appropriate for a generic or princely hunter, as well as for the mythological hero. A second supporting argument stresses the similarity between the Roman copies and the head from a Late Hellenistic tondo at Kalydon that decorated the heroon of a local personage, Leon. Since Meleager's famous exploit was the killing of the Kalydonian boar, the connection is valid, but several tondos seem to

The Issue of the Great Masters

have been adapted from preexisting statues in the round, and a suitably generic type may have been co-opted to fit the requirements of the program, relying on context for identification; in addition, the specific "Meleager" bust is heavily restored and its resemblance to the statuary type is vague at best. Finally, attribution to Skopas rests solely on the relative rarity of the subject, which was, however, represented on the Tegea pediment, and on a vague stylistic affinity between the architectural sculptures and the Roman copies. The Tegea subject was chosen, as we have seen, for purely local reasons, and the Meleager on the gable would have been portrayed in violent action. There would have been no cause for Skopas (the architect) to produce, at some later time, an isolated figure in the round in a static pose. As for the stylistic traits, we have already stated that they are shared by many other fourth-century works, and cannot validate attribution.[54]

Two more works find, however, mention in the ancient literature, and should be briefly examined: the **Maenad**, and the **Marine Thiasos**. The first is known only through a statuette replica in Dresden (h. 0.45 m.), a single exemplar in the round that would seem to belie the alleged fame of the work in antiquity (Pl. 61). The usual grounds have been advanced for a Skopasian attribution: its deeply set eyes, wide head and neck resemble the Tegea heads; its fluttering garment exposes the body in a manner comparable to an Amazon on a slab from the Halikarnassos Amazonomachy frieze traditionally given to Skopas; and the Greek sources speak of a frenzied maenad by Skopas.[55] Of these three arguments, two can be easily dismissed: the Tegea heads, as repeatedly noted, cannot represent Skopasian style; and the Maussolleion slab was probably not by Skopas' hand, although the Maenad has been used to support its attribution, with perfect circularity. The ancient sources are three: an epigram in the *Anthologia Planudea*, one in the *Anthologia Palatina*, and one by Kallistratos. The first two are very brief and do not describe the work, although they mention the Parian master; the third one is quite long and states that the figure holds a slain goat in one hand.

Yet there are no traces of such an animal on the Dresden statuette. What had been taken as scars from the broken-off kid on the girl's left shoulder are rather the ends of her loose curls (Ills. 21a–d). An early suggestion (by Six) that the maenad therefore held the animal with her right hand is made improbable by the lack of traces on that side, since the arm, originally lowered, would probably have been carved with its burden adhering to the body, in one piece, given the small scale of the marble figure. A second suggestion, by Lorenz, would give the Dresden Bacchant a tympanon in the raised left arm, which would explain the heavy doweling of the separately carved limb, demanded by the difficult position; her right hand would have swung free in the dance. Support for this reconstruction is sought in works of the minor arts, specifically a rendering on Terra Sigillata sherds. Yet, despite the discrepancy between Kallistratos' description and the Maenad as reconstructed, Lorenz would still assign it to Skopas, simply assuming that the master

Plate 61

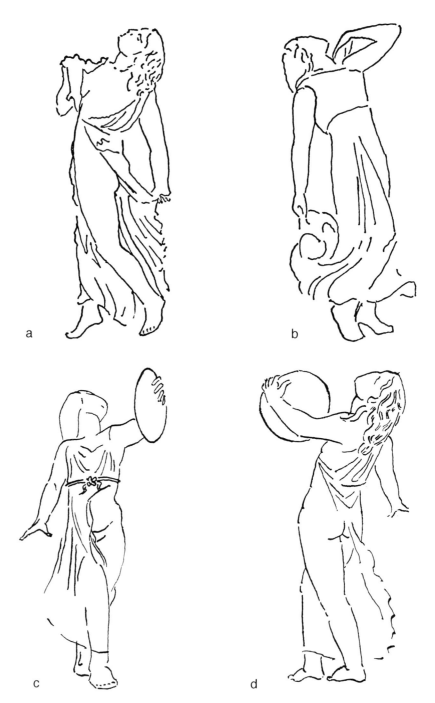

Ills. 21a–d. Dresden Maenad, reconstructions by: (a) G. Treu; (b) J. Six; (c–d) T. Lorenz

The Issue of the Great Masters

carved two such frenzied images. I do not believe in unnecessary duplication of ancient works. A maenad as a sculptural subject could as easily have been made by the Classical Skopas as by one of the later masters with the same name, but once the detail of the slain goat is eliminated, there is no way of proving the connection. Presumed echoes of the Dresden type in Terra Sigillata pottery and Neo-Attic reliefs are neither sufficiently close nor early enough to validate a fourth-century date, and Bacchic subjects, although especially popular in the Late Hellenistic period, seem to have enjoyed continuous favor since the advanced fifth century.

The **Marine Thiasos** presents similar problems. It is only mentioned by Pliny (*NH* 36.26), who does not specify whether it was a work in the round or in relief. It apparently included Achilles, although commentators believe that it represented Poseidon's cortege, rather than the conveyance of the hero's soul or of his weapons. At one time it was suggested that the marine frieze from the so-called Ara of Domitius Ahenobarbus was the very work by Skopas, albeit the Younger, but this hypothesis has not found much favor. The Bithynian origin of a Skopasian group in the round was based on the related theory that the "Ara" was in fact a pedestal supporting the statues taken as booty by Ahenobarbus, who was governor of Bithynia around 40–35; but the connection of the "Ara" reliefs with the first-century Ahenobarbus has now been questioned, and therefore any indication of the original location of the marine group is lacking. The latest discussions leave it open whether the ensemble was by the Classical Skopas or by his Late Hellenistic successor. Arguments based on the presumed poses of Nereids within the group are inevitably tenuous, since no trace of the original remains—if novel for the fourth century, they are considered the (unprovable) invention of a major master; if paralleled in later reliefs and in the minor arts, they may actually confirm a late translation into three-dimensional renderings, in the period that tended to draw inspiration from such sources. A Triton in Berlin, considered a Greek original, and a Roman torso of a Nereid in Ostia have been connected with the Classical Skopas and his Marine Thiasos, but the basis for the attribution—similarity to the Tegea heads and, for the Nereid, the Dresden Maenad—is again questionable.[56] It seems useless to me to engage in this type of shadow-boxing in trying to recover a completely elusive ancient monument.

By eliminating a Bithynian commission, we have further reduced the number of Skopas' works in the East. While at Halikarnassos, he may well have made a Dionysos and an Athena for Knidos, mentioned by Pliny (*NH* 36.22) together with a Dionysos by Bryaxis, but we cannot be sure that the latter was the mid-fourth-century master, and Skopas was probably too busy at the Maussolleion for additional tasks. At Ephesos, besides the improbable contribution to the Artemision, he is supposed to have made a Leto with the Nymph Ortygia holding the Divine Twins (Strab. 14.1.20); the same objection would apply to this work, known through this single mention. A double mention survives for his Apollo Smintheus at Chryse,

The Issue of the Great Masters

in the Troad (Strab. 13.1.48; Eust. 34.16), although the second source suggests that the Parian made only the mouse under the statue's foot, not the divine image. The temple presently at the site is a monumental complex of second-century date. Recovered fragments of the cult statue show it to be colossal (right leg, 1.13 m. long), therefore probably made ad hoc for the Hellenistic setting. Numismatic representations from the area give different renderings. Whether more than one sculpture existed, or whether the Hellenistic one was by another Skopas (or even wrongly attributed), is difficult to tell. Given the revival of cults in Asia Minor, especially in the Troad, after Alexander's campaigns, it is tempting to assume that the second was the case.[57]

Skopas' fame, for Pliny, seems to have rested primarily on the Marine Thiasos. Yet if this and the other works cited by the Roman author are to be attributed to the later sculptor, little remains on which to base a judgment of Skopas' greatness. To argue that Pliny would not have praised so highly monuments of non-Classical date is impossible, since the writer often mentions with favor even contemporary sculptures. Poetic praises of the Maenad are literary hyperboles, and the lost piece is undatable. Others are single mentions without elaboration. Skopas' activity at the Maussolleion must have given him a reputation comparable to that of the other masters called there, at least in the eyes of the ancient. His work at Tegea, as architect, hints at versatility; his making of divine images, although perhaps no longer recoverable in Roman copies, suggests skill in carving marble. But he never worked for Olympia or Delphi, and no pupil of his is ever mentioned by ancient sources, although his successors may have continued in his profession. Inflated or confused ancient lists and modern attributions have contributed to make of Skopas one of the primary figures of fourth-century sculpture, but a more realistic assessment should admit the scarce reliability of our fabrications, and our current inability to recover his style.[58]

Kephisodotos and Praxiteles

Since Skopas and Praxiteles were repeatedly connected by the sources, we should deal with the latter next; yet his work cannot be disjoined from that of Kephisodotos, since a master-pupil relationship has traditionally been assumed for the two. Because one of Praxiteles' sons carried the same name, Kephisodotos has been considered Praxiteles' father. Another suggestion would make him his father-in-law instead, and would eliminate for Praxiteles an inherited sculptural tradition. In addition, the presumed wealth of Praxiteles' family, attested by the official records of heavy liturgies paid by a Kephisodotos son of a Praxiteles, has been challenged, on what seem solid grounds. We would then have two families, approximately contemporary, with recurrent similar names, but not necessarily, or at least not obviously, related.[59] Since sculptors were not usually wealthy by profession, and no ancient source alludes to Praxiteles' affluence, the suggestion seems valid.

The Issue of the Great Masters

There is no question, however, that two sculptors named Kephisodotos existed, as well as more than two named Praxiteles.[60] We are here concerned only with Kephisodotos the Elder, a late fifth-/early fourth-century master, and the fourth-century Praxiteles, the homonymous artists belonging primarily to the Hellenistic period.

Kephisodotos is one of the few sculptors of whom we possess a securely identifiable work, albeit through Roman copies and echoes in the minor arts. The ancient sources give him a rather limited sphere of activity: at Megalopolis, in collaboration with the Athenian Xenophon (a group in Pentelic marble with a seated Zeus Soter flanked by a personification of the city and by Artemis Soteira: Paus. 8.30.10); on Mount Helikon, again in a collaborative effort (three Muses, in a group of nine for which Strongylion and Olympiosthenes each contributed three: Paus. 9.30.1);[61] perhaps at the Peiraieus (although Pliny, *NH* 34.74, says Kephisodoros); perhaps a dedication to Athena Pronaia at Delphi (Marcadé 1953); and certainly in Athens, with the Eirene and Ploutos (Paus. 1.8.2; 9.16.1–2). Pliny (*NH* 34.87) gives him also "a man declaiming in public with his hand upraised," and a bronze Hermes holding the infant Dionysos, but without mentioning a specific location. This picture does not look prepossessing—a journeyman called in when a multi-figured group was needed?—yet the commission for the Eirene must have been important, since the group stood in the Athenian Agora and carried great symbolism. Note, however, that once again what we consider a major monument must have escaped the compilers of the art-historical treatises consulted by Pliny.

The **Eirene and Ploutos** have been recognized in marble copies (Pl. 62), as well as on Panathenaic amphoras of great significance because precisely datable through the inscribed archon's name, Kallimedes, to the year 360/59.[62] It has been convincingly argued that the image was placed on the columns flanking the Archaistic Athena on the vases because it had just recently been erected (after the peace with Sparta of 362?) and was thus immediately recognizable and meaningful. Another date at times proposed for the group, after 374/3, is connected with the establishment of the official cult of Peace in Athens (albeit mentioned only by late sources), and perhaps the Panhellenic peace of 371. Pliny's *floruit* for Kephisodotos (*NH* 34.50; 102nd Olympiad = 372) may or may not be a supporting indication. Given the short span of time involved in these alternative dates, the issue is not worth debating.

That the monument was in bronze has been confirmed by the recognition of plaster fragments of the Ploutos at Baiae, within the cache that seems to contain only casts of objects originally in metal.[63] The original stood next to statues of Lykourgos, Kallias, and Amphiaraos, and was therefore in a prominent position. The message of prosperity (Ploutos = Wealth) through peace took precedence over mythological accuracy, which would have demanded Ploutos as son of Demeter rather than Eirene. But similar messages were being made around Greece: Pausanias

Plate 62

The Issue of the Great Masters

(9.16.1–2) records in Thebes a statue of Tyche (Fortune) holding Ploutos ("as if she were his mother or nurse"), by Xenophon and Kallistonikos (a local man). Since Xenophon, an Athenian, had collaborated with Kephisodotos at Megalopolis, his own work may have been inspired by the Eirene. She, too, conveys the impression of being the infant's mother, yet, as correctly noted (Todisco 1993), her glance is lost in space and does not meet the child's, with the "absentmindedness" typical of fourth-century statues, which often seem lost in thought in the middle of an action. We shall return to this point with the Knidia. The stance, however, is completely natural for a woman carrying a baby on her outswung hip, although Eirene can only be a kourotrophos, nurturing but not generating wealth—the message is even more poignant than usually acknowledged.

The Panathenaic amphoras help restore the bronze group. Eirene and Ploutos wore leafy wreaths; she held a tall scepter, he a cornucopia with fruits. She wore a heavy peplos with voluminous kolpos and apoptygma curving over the rounded abdomen; her mantle, although draped only over the shoulders, is considered different from the shoulder-pinned back mantle of figures of action and young girls;[64] yet I cannot imagine how else it would stay in place unless fastened on both sides. The impression is thoroughly matronly, and commentators have emphasized the composition's relative width, as contrasted with the slenderer appearance of, say, the otherwise solid Erechtheion Karyatids. Yet comparison with fifth-century works is compelling and has been taken as a sign of conservatism in an elderly master; others have seen rather a deliberate quotation of "the good old times" when Athens was prosperous and politically important, with all the modifications and spatial adjustments to be expected in a fourth-century work. I believe the depiction of the traditional (and, by then, out of current use) peplos was not simply in imitation of Demeter or in evocation of the past, but also a deliberately old-fashioned choice because the wearer was a personification, not a human being—a distinction especially important since Kephisodotos' group was standing next to honorary statues. Even Eirene's hair, loosely spread over the shoulders in spiraling curls, seems to me "classicizing" rather than Classical. That a retrospective trend was present in fourth-century sculpture has already been pointed out in connection with reliefs, and will be mentioned again (e.g., Apollo Patroos in Chapter 9).

No fragments of the Eirene have been recognized among the Baiae casts, and it may be significant that only the child was represented there. Different figures could in fact be adapted to the kourotrophos role, and this imagery seems to have been especially popular in the fourth century, in keeping with what we have already noted in votive and funerary sculptures. We may briefly mention here a few more works with comparable motifs.

The bronze **Hermes and Dionysos** by Kephisodotos is, I believe, no longer recoverable, despite attempts to combine a youthful body in Madrid with a child over a herm in the Athenian Agora, both of Roman date. The group from the theater at

The Issue of the Great Masters

Minturnae (Pl. 63) is certainly a Roman creation. Depictions of various males holding infants have been collected by Aileen Ajootian around an Imperial trapezophoron recently found at Corinth, and cover a great range of personages, from Hermes with Arkas or Dionysos, in various poses, to satyrs and silenoi, presumably holding the god of wine, several of them probably belonging to our period, at least in prototype. In addition to the Tyche by Xenophon and Kallistonikos, the baby Ploutos is held by Eubouleus in two late fourth-century reliefs from the Athenian Agora probably inspired by Kephisodotos' group, bringing back the concept within the Eleusinian sphere. A heroic child, perhaps Erichthonios in the arms of an Aglaurid, has survived in an original fragment from the south slope of the Akropolis, where it was built into a later wall. Finally, a statue of Rhea handing Kronos a stone wrapped in swaddling clothes, attributed by Pausanias (9.2.7) to Praxiteles, stood in the Temple of Hera Teleia at Plataia, but I doubt that the original can be visualized through a fragmentary Roman copy in Bracciano, Castello Corsini-Odescalchi, which, because of the fawn-skin wrapped around her waist, should probably depict a maenad or nymph.[65] This flurry of representations must be meaningful, although I would not venture an explanation for its occurrence at this time.

Plate 63

Kephisodotos' kourotrophoi have been used to support attribution to *Praxiteles* of the **Hermes with the infant Dionysos** at Olympia (Pls. 64–65). Yet recent literature is finally beginning to acknowledge that this work, at least in the version that has come down to us, must date from the Hellenistic period.[66] I would not even consider it a Hellenistic replica of a fourth-century Praxitelean creation, since the elongated body type and the sfumato rendering seem in keeping with later traits. Once we discount Pausanias' attribution to the famous master of that specific sculpture (seen by him in the position where it was found: 5.17.3), no other reason exists for retaining the connection—certainly the extant base provides no signature or added inscription, as we might have expected. The only other work safely given to the Athenian is the Knidian Aphrodite, and nothing in that figure, albeit seen exclusively through Roman copies, suggests the same stylistic qualities that have been noted in the Hermes: grace, off-balance pose, blurring of anatomical details and facial features, impressionistic contrast of hair and skin, naturalistic treatment of drapery. Nor do the ancient references describe Praxiteles' style in clear enough terms to allow for further attributions. Regrettably, our entire approach in fleshing out the master's oeuvre has been based on presumed similarities to the Hermes among the iconographic types listed by the sources; the results are numerous but unsound, and the modern literature is equally voluminous but misleading.

Plates 64–65

A **male figure in Elis**, in Pentelic marble, found in a context of the first century, has received less attention than it deserves, yet its resemblance to the Hermes is striking, and extends to the heavy traces of tool marks on its back, which may then be taken as a workshop practice when the proposed setting of a statue was known

The Issue of the Great Masters

in advance. Headless and virtually armless (but the right arm was lowered, as shown by the shoulder), it is preserved down to the left ankle, with the right leg broken off just below the knee; its missing footwear can therefore provide no additional comparison. Like the Hermes, however, this youthful male rests his weight on the right leg and leans strongly to his left, yet no traces of struts exist on the torso or along the thigh. Its pubic hair shows drill holes, but modeling conveys fleshy hints at the groin and the right armpit. Naturalistic drapery is flung over the left shoulder, as in the Hermes of Andros type (Todisco 1993, pl. 285), and the figure probably stood in isolation, without the child. A certain body type was therefore adapted to different compositions, as we would expect in the Late Hellenistic period.[67] I would retain such a date for both the Elis and the Olympia figures, at best to be assigned to a later Praxiteles, but without postulating unprovable imitation of the fourth-century master.

A great many works have been ascribed to the famous sculptor by the ancient sources,[68] and their distribution is wider than for Kephisodotos I. Besides several statues in Athens, both in bronze and marble, Praxiteles' oeuvre seems to have been represented at Delphi, in Boiotia (at Lebadeia, Leuktra, Plataia, Thespiai, perhaps Thebes), in Phokis (at Antikyra), repeatedly at Megara and perhaps at Eleusis, and, in the Peloponnesos, at Argos, Mantineia and Elis. In the East, some of his works stood at Knidos, Kos, Karian Alexandria(?), perhaps at Halikarnassos and Ephesos, and Parion (Mysia), the colony by the Sea of Marmora; a possible signature of his was found at Olbia on the Black Sea and one on Delos. Counting these two, two more from Athens, and one from Leuktra, five signatures of Praxiteles are extant,[69] yet they occur in conjunction with statues of individuals, as personal dedications, quite different from the divine subjects mentioned by the ancient authors. It could be argued that authorship of private commissions needed to be advertised for commercial purposes, whereas it would have been improper to boast of making sacred images. But it is then possible that some attributions, passed down simply by word of mouth, were improperly remembered, or even consciously misrepresented once the master's reputation had become established. As was the case for Skopas, moreover, confusion among homonymous sculptors may be suspected, to account for a production that seems vast for a single person, even if helped by sons and pupils. This consideration is especially valid for the many works taken to Rome or listed as being there, several of which, given their subjects (Bonus Eventus, Bona Fortuna, Maenads, Thyiads, Karyatids, and Silenoi) are likely to be by a Hellenistic master, or even by the well-attested Pasiteles, with an understandable confusion in transcription.[70]

What can we accept from the above list? Activity in Athens and Boiotia is documented; at Megara and Delphi, it is highly probable. A trip East, to make the Aphrodite of Knidos, is assured—Praxiteles must have carved it in place, given the delicacy and the specifics of the composition. The anecdote (Pliny, *NH* 36.20) that

The Issue of the Great Masters

he went around peddling his two prefabricated Aphrodites is surely to be dismissed. Whether from Knidos he traveled to Ephesos, Parion, and Olbia is uncertain; Karian Alexandria seems too late a foundation, and there must have been a tendency in antiquity to ascribe to Praxiteles any likely Aphrodite statue. Praxiteles' intervention at the Maussolleion, mentioned only by Vitruvius, I believe should be disregarded; the reference was perhaps prompted exclusively by the late notion that the most famous masters were present at Halikarnassos.

It is impossible to review here all works attributed to Praxiteles by modern scholarship, and recent publications on the master are now available. I shall therefore limit myself to comments and updates, primarily to express my own opinions on a vast and very difficult subject.

The **Aphrodite Knidia** (Pl. 66) is the most assured identification, and the most revolutionary. Yet it has been distorted and misrepresented by later commentators, as recently reviewed in the important historiographical study by Havelock (1995). She rightly stresses that nineteenth-century concepts have influenced our understanding of the statue, introducing a voyeuristic element of "Aphrodite being surprised at her bath" that is supported neither by ancient sources nor by the visual evidence. No mythological episode, like that of Artemis and Aktaion, is related about the Goddess of Love, nor is the statue shown as startled by an intruder or shielding her body: her head is not sharply turned, her glance is vaguely directed out and downward, her hand only hovers in front of her pubes. It looks as if, in the process of lifting her mantle or dropping it on the water-jar, Aphrodite forgot what she was doing and paused in mid-motion to follow her wandering thoughts, with an absentmindedness and aloofness present in other divine images of the time. The goddess is depicted as an epiphany, not in an unexpected glimpse, and in "heroic nudity" as unconscious and glorious—and as attributive—as that of the male gods. I am completely convinced that the gesture of her right hand is meant to point to, not to hide, her womb, emphasizing her fertility and complementing the action of her left hand.

Havelock believes that, as an attribute, the hydria implies Aphrodite's powers, "her fertility, her unending freshness and youth."[71] An additional meaning is, however, possible. In an unpublished essay, Gregory Leftwich some years ago stressed that in Greek literature of the fifth and fourth centuries, the womb is described as a jar. In addition, medical knowledge of the time emphasized the physiological differences between men and women in terms of the degree of moisture present in the human body, which was thought to be greater for females than for males. Not only was the uterus, understood as the receptacle for a variety of fluids, explained as an inverted jug by various gynecological writings in the Hippokratic corpus; the opening of the uterus/jar in rape or intercourse was also likened to the breaching of a city wall, for which similar terms were used. One of them, the word *kredemnon*, had in fact several meanings: a head covering, hence the lid of a vessel, or, in the

The Issue of the Great Masters

plural, the battlements that crown a fortification. Thus the Knidia's gesture of removing drapery from a hydria could be read as a sexual reference comparable to her pointing to her genitals.[72]

The hydria itself takes several forms in the various replicas of the Knidia, and it has been argued that the elegant decoration on the vessel of the most famous copy in the Vatican (the Colonna Aphrodite) should be considered a Hellenistic elaboration. Thus a more reliable version of the original would be an Aphrodite in Munich, who (in alarm?) pulls her drapery closer to her body from a smaller and simpler jar (Pl. 67). A rebuttal of this theory, by various authors, acknowledges that the Colonna vessel is unconventional and without direct parallels, but ascribes its invention to a major artist. As already mentioned, various ancient passages and anecdotes refer to famous sculptors producing silverware and other luxury objects, yet they are all likely to be later fabrications without foundation.[73] Given the Roman copyists' penchant for varying insignificant details of their models, I would not exclude the possibility that the original fourth-century hydria was further embellished by the carver of the Colonna replica, but I would take the vertical fall of the drapery itself as a true reflection of the prototype.

Plate 67

The Munich replica of the Knidia is therefore likely to be a later interpretation, in keeping with the many variations on the Praxitelean theme produced in the Late Hellenistic period. Havelock makes this point forcefully: the Knidia was not immediately popular. Understood and understandable within the geographic context of its specific commission, where images of the naked Astarte pointing to her reproductive organs were common, her fame spread later, when we find her reflection in the minor arts, and when the taste of the time was ready to view a nude Aphrodite in different terms. Another important point made by Havelock is the subtle impact of the inferences we have drawn about Praxiteles' alleged affair with the courtesan Phryne, who is thought to have posed for the Aphrodite. I believe that no woman was specifically copied for what is, in fact, an over-lifesize image of the goddess; anecdotes about the love relationship between an artist and his model have been repeated at all times and are all likely to be fabrications.[74] That Phryne commissioned certain works from Praxiteles is probably true, but she may have been, by then, fairly advanced in age and simply another of his customers.

Havelock argues convincingly another major issue: that the linear development from a transparently dressed to a semi-nude to a completely divested Aphrodite is a modern construct based on a puritanical modesty that demanded a gradual adjustment to the concept of a naked goddess. It is becoming increasingly apparent that logical progression, either in style or in iconography, finds no real support in the monumental evidence from Greece. I would thus continue in my supposition that the **Aphrodite of Arles** (Todisco 1993, pl. 111) is a Late Hellenistic creation, intentionally recalling the Knidia in head type, despite recent reiterations of an early date for the original, attributed to the young Praxiteles.[75]

The Issue of the Great Masters

If the total composition was not imitated and copied until two centuries later, one element of the Knidia was, however, immediately influential: the head, with its oval face, triangular forehead, crinkly strands pulled back straight from the temples, eyes with raised lower lid lending them a dreamy or slightly myopic expression. This facial rendering, with minor variations, predominates among late fourth-century females and was used almost throughout antiquity. We are less well informed about Praxitelean male faces. I continue to be uneasy about the effeminate appearance, slender forms, and peculiar activity of the **Apollo Sauroktonos** (Todisco 1993, pl. 126), which to me seem more in keeping with later concepts and renderings. The specific hairstyle recurs in the Hypnos, of undoubted Hellenistic or later date, and the meaning of the lizard may escape us, although usually explained as a playful or metaphorical substitute for the formidable Python.[76]

A totally different impression is produced by the **Apollo Lykeios** (Todisco 1993, pl. 205), whose well-developed body belies the childish braid over the center of the forehead. This hairstyle has been used to link the statue to the reorganization of the Athenian Ephebeia between 335 and 330, since youths entering military service ritually cut their hair—yet the Apollo, as *pais* (albeit overgrown), would represent a stage well *before* such initiation! Recent discussion has focused not so much on the dating of the prototype (which seems difficult to pin down, given the variations in scale and rendering of the various replicas), but especially on the gesture itself, which appears just as frequently in connection with Dionysos, perhaps even earlier than for Apollo. Explanation of it as a sign of drunkenness would apply only to the God of Wine; for Apollo, it may mean divine epiphany. To be sure, the two deities became almost interchangeable in the late fourth century, both iconographically and perhaps conceptually, but I still have some difficulty assigning the Lykeios type to Praxiteles, since resemblance to the Olympia Hermes is the major argument for doing so.[77]

Two **satyrs** are traditionally attributed to Praxiteles, although the ancient sources are unclear about their number. Pliny (*NH* 34.69) lists among the master's bronze works a satyr so famous that he was called *periboëtos* ("the notorious"); it was perhaps in group with a Dionysos and an image of Drunkenness.[78] Pausanias (1.20.1–2) speaks of a famous satyr by Praxiteles (which could be the one mentioned by Pliny) as part of a choragic monument in the Street of Tripods, and then refers to another in the Temple of Dionysos, but does not specify its authorship. Nonetheless, two types are singled out by current scholarship, and their considerable differences are minimized by assuming that one was made very early in Praxiteles' career, the other very late. I find it hard to believe that the same man might have made both, especially in a period that stressed continuity over originality. It should also be noted that these are the first satyrs in the round of which we have notice, after the Marsyas by Myron one century earlier—and the Myronian was a specific personage, involved in a specific event. This fourth-century shift in subject matter for

The Issue of the Great Masters

public statuary—the depiction of a nonhuman "species" outside a narrative or allegorical context—has been taken as a sign of an era moving away from traditional religion and concentrating on minor mythological figures and personifications. Yet I believe that other reasons may have come into play, which deserve further study. To ascribe the new prominence of satyr-statuary to a special interest in the theater disregards the fact that drama and Dionysiac festivals were as popular in the fifth as in the fourth century. It is also important to compare the appearance of fourth-century satyrs attested on dated original works.

To judge from the Lysikrates Monument (precisely datable to 334), satyrs were visualized as wild, muscular creatures with beards and long tails, wearing animal skins. A Document Relief of the year 313/2 (or earlier), depicting a youthful Dionysos with attendant, shows a smaller and younger satyr, but he too is clearly characterized as nonhuman by forehead horns, long ears, wild hair, and a tail. Rather young, but with distinctive pug noses and prominent tails, are also the two satyrs flanking Artemis on a late third-century bronze plaque on Delos. A young and "humanized" satyr, with chlamys on his back, wreath on his head, and a short tail, is depicted by a terracotta figurine from a deposit on the south slope of the Akropolis clearly dated by its contents to the end of the third and the first quarter of the second century, but even this figure has small horns on its forehead. Satyr children had not attracted Athenian attention, even in vase painting, since the mid-fifth-century rendering by the Methyse Painter.[79] It is therefore surprising to find that one of the satyr types attributed to Praxiteles is almost entirely human, to the point that some replicas omit its (short) tail; were it not for its inconspicuous pointed ears, the figure could simply be taken for a wreathed youth.

This is the so-called **Pouring Satyr** (Todisco 1993, pl. 101), very popular in Roman times, when it was even adapted to a fountain; its human qualities are so pronounced that comparison has been made with young slaves serving their masters. Similarity with the Marathon Youth makes me suspect that this satyr as well could be a Hellenistic or Roman creation, transposed from a two-dimensional rendering, such as the many Banquet Reliefs with young *oinochoos*, and adapted to current taste.[80] Very different is the **Leaning Satyr** (**Anapauomenos**, Todisco 1993, pl. 135), with his mane of hair that recalls river gods (or even portraits of Alexander the Great), and the dramatic slash of the panther skin across his torso, to emphasize his slanting pose.[81] Although youthful and handsome, this satyr is clearly not human, as shown by its more prominent pointed ears and wider nose. Its feet are not almost parallel, as in the Pouring Satyr, but virtually one behind the other, thus creating a truly unstable pose that demands the tree-trunk support. This stance recurs in late fourth-century grave reliefs and in some statues in the round attributed to Lysippos, but it is different from that of the Sauroktonos: the latter appears as if in incipient motion, his long legs flowing into the attenuated torso; the satyr is fully relaxed, legs almost crossed, supporting a more robust, wider body. Praxitelean authorship can neither be confirmed nor disproved on any of the above

The Issue of the Great Masters

grounds; the extreme popularity of the type, even at reduced scale (over a hundred reproductions known), simply suggests its appeal for the Roman clientele.

In summary, what can be said about these masters? Of Praxiteles, we can visualize the Knidia; of Kephisodotos, the Eirene and Ploutos. Skopas, Leochares, Timotheos, and Bryaxis are less clearly connected with extant works, or, at least, not clearly enough to warrant attempts at further attributions. Naukydes lives in Polykleitos' shadow; Antiphanes of Argos, for all his attested activity in connection with major monuments at Delphi, receives no true credit in ancient sources and gets lost in collaborative enterprises. Fame seems a relative and late concept. It accrued to the sculptors who worked at the Halikarnassos Maussolleion because of the novelty and richness of the structure itself. It invested Praxiteles because the "originality" of his Aphrodite became appreciated in Late Hellenistic times. Many sculptures may have become well known because taken to Rome—or because forgeries in sculptors' names were created for the Romans. It has been suggested that artisans started claiming some distinction, or at least some knowledge of reality and "truth," during the course of the fourth century.[82] This may well be the case, but the evidence at hand does not suggest, to my mind, qualities of originality and aesthetic genius such as have been attributed by modern scholarship to the "big names." To be sure, the level of sculptural competence must have been extremely high, and commissions frequent, but within the parameters of tradition and extended practice.

One major name is missing from this chapter: that of Lysippos. The Sikyonian master will be discussed next, as a special case, and a final section will deal with other extant fourth-century originals in the round.

NOTES

1. A book edited by O. Palagia and J. J. Pollitt, *Personal Styles in Greek Sculpture* (Yale Studies 30, Cambridge University Press) is forthcoming. Ridgway 1990, 73–97, discusses Lysippos, Skopas, Praxiteles, Leochares, and Bryaxis, and should be consulted in conjunction with this chapter. Brief comments in Boardman 1995, 52–58. On Skopas, Timotheos, Leochares, and Bryaxis, see also supra, Chapters 2 and 4.

2. Besides Ridgway 1984a, see also J.-P. Niemeier, *Kopien und Nachahmungen im Hellenismus: Ein Beitrag zum Klassizismus des 2. und frühen 1. Jhs. v. Chr.* (Bonn 1985). More recent interest in Roman copying practices is attested by several monographs, articles, and symposia; see comments in B. S. Ridgway, "The Study of Classical Sculpture at the End of the 20th Century," *AJA* 98 (1994) 759–72. Add W. Geominy, "Der Schiffsfund von Mahdia und seine Bedeutung für die antike Kunstgeschichte," in G. Hellenkemper Salies et al., eds., *Das Wrack: Der antike Schiffsfund von Mahdia* (Cologne 1994) 927–42, with reference to contributions by various authors evaluating pertinent objects within the cargo. Note also the balanced comments by Stewart 1990, 19–22 (the ancient sources), 24–27 (the monuments), 239 (on connoisseurship). For 18th- and 19th-c. cultural biases, see, e.g., Havelock 1995, 20–26, 40–54.

3. For a recent assessment of this source, see Isager 1991, and its review by A. A. Donohue in *Bryn Mawr Classical Review* 3.3 (1992) 192–97.

The Issue of the Great Masters

4. See the appropriate comments by Stewart 1990, 275, with regard to the statue of Pellichos by Demetrios of Alopeke mentioned in *Philops.* 18. For a more general outlook, see also T. P. Wiseman, "Lying Historians: Seven Types of Mendacity," in C. Gill and T. P. Wiseman, eds., *Lies and Fiction in the Ancient World* (Austin 1993) 122–46. On Plutarch's *Parallel Lives*, see R. Lamberton, "Plutarch, Hadrian, and the Project of an Athenocentric Greece," Abstract, *AJA* 99 (1995) 349–50.

5. See, e.g., Goodlett 1989, 10.

6. See, e.g., *IG* II² 3453, the supposed base for the statue of Lysimache by the same Demetrios of Alopeke (supra, n. 4), where both the name of the subject and that of the master have been restored: Mantis 1990, 70–71.

7. For several examples of such victors' statues, including reused and reinscribed bases, see, e.g., Ridgway 1995b.

8. These totals have been culled from Todisco 1993, 41–50, and Goodlett 1989; they should not be considered final, since some masters' signatures may belong to the late 4th c., although I have omitted from my count six or more inscribed bases dated c. 300. I have also excluded names known from signed bases if they are even merely listed by any ancient author (e.g., Sthennis; Sostratos, son of Euphranor). The names behind my numbers, in approximate chronological order, are as follows: *Athenians:* Aleuas, son of Kreon; Strabax; Nikomachos; Euboulides I; Pandios; Oinades and Epichares; Stratonides; Ephedros; Philistides; Sositheos; Ariston and Xanthias; Exekestos; Aristopeithes; Theoxenos; Polymnestor and Kenchramos; [Symen]os. *Peloponnesians:* Nikodamos of Menalos; Polykles of Argos. *Megarians:* Apelleas; Kallikles, son of Eunikos. *Boiotians:* Polynikos and Straton of Thebes. *Thessalians:* Herakleidas and Hippokrates of Atrax. *Parians:* Alkippos. *Rhodians:* Aristonidas, son of Mnasitimos; Pheidias of Rhodes; Ergophilos; Onetorides.

9. Antiphanes of Argos: Todisco 1993, 47 (chronology), 48–50 and figs. 15–18 (various monuments, with drawing of bases); *GoDs* 1991, 104–6, no. 105 (Arkadian dedication), 108–10, no. 109 (Lysander's monument), 114–15, no. 113, and fig. 38 on p. 112 (hemicycle of Kings of Argos); Stewart 1990, 168–69, 272, T 85 (Paus. 10.9.7–11); Goodlett 1989, 15–17 (on collaboration with other sculptors); Borbein 1973, 60–72 (monuments on curved bases, Kings of Argos), 72–84 (monuments on rectangular bases, Lysander Dedication).

10. It could be argued that Antiphanes, as "contractor," might have made models for the entire group, but it is more likely that such models existed as part of a bronze workshop repertoire: C. C. Mattusch has advocated a similar procedure for other multi-figured monuments, such as the Eponymous Heroes in the Athenian Agora: "The Eponymous Heroes: The Idea of Sculptural Groups," in W. Coulson et al., eds., *The Archaeology of Athens under the Democracy* (Oxbow Monograph 37, Oxford 1994) 73–81, esp. 80; see now also Mattusch 1996, ch. 2. A comparable arrangement seems to have prevailed also in the case of marble statues, to judge from the considerably later (c. 333) Daochos Monument at Delphi: Ridgway 1990, 46–49.

Mark Fullerton has suggested to me that sculptors sharing a base or a dedication need not always have collaborated in our sense of the term, since statues could be commissioned independently and then be erected together. Our understanding of a statuary group as a coherent unit rather than an agglomeration may be a modern construct.

11. *School of Polykleitos:* According to Pliny (*NH* 34, 50), it comprised Argeios, Asopo-

The Issue of the Great Masters

doros, Alexis, Aristeides, Phrynon, Deinon, Athenodoros, and Dameas of Kleitor; the Latin author also mentions that the 95th Olympiad marked the *floruit* of Naukydes and his father, Patrokles, relatives of Polykleitos; Daidalos and Polykleitos the Younger may also have been sons of Patrokles. Thus the names in this second list are family members, rather than simply pupils of the more famous master. Other names are culled from Pausanias' account of the Lysander Dedication. For these relationships, see, e.g., Todisco 1993, 45–55, with stemma on p. 46, closely following Linfert 1990; Stewart 1990, 168–69. Goodlett 1989, 87–91, in fig. 1 tabulates graphically, and somewhat differently, the relationships among the students of Kanachos and Aristokles, and their connection with Polykleitos and his School.

School of Lysippos: Although the names derive from various ancient sources, the main lists are in Pliny, *NH* 34.41, 66–67, 80, 83; they can be broken down into family members (Lysippos' brother Lysistratos, Lysippos' sons Laippos [or Daippos], Boedas, and Euthykrates), and pupils (Eutychides, Phanis, Chares, Teisikrates, and Xenokrates), over different generations. See, e.g., Todisco 1993, 139–43; Stewart 1990, 200–201, 297–300.

That Lysippos had no known master is mentioned by Pliny, *NH* 34.61, on the authority of Douris of Samos (c. 340–260); that he looked to the Doryphoros of Polykleitos as his teacher is asserted by Cicero, *Brutus* 296. For an ironic reading of Lysippos' statement, see J. M. Hurwit, in W. G. Moon, ed., *Polykleitos, the Doryphoros, and Tradition* (Madison 1995) 3, with n. 1 on p. 15 (cf. Ridgway 1995b, 197 n. 29), and, more thoroughly, A. Stewart, ibid. 257–58. On the anecdotal character of claims of masters' autodidactism, see Kris and Kurz 1979, 14–26, with specific reference to Lysippos.

On the family of Praxiteles, see Goodlett 1989, 169–76; she accepts that Kephisodotos I was probably Praxiteles' father-in-law, rather than his father; Praxiteles' sons are Kephisodotos II and Timarchos. He may also have had one pupil, Papylos (Pliny, *NH* 36.33–34).

Hellenistic workshops: Goodlett 1989, 21–27; also, ead., "Rhodian Sculpture Workshops," *AJA* 95 (1991) 669–81, esp. 681, for her definition of a sculptural atelier, which may comprise persons of different origins. On a more general level, see also Burford 1972, 78–80, 82–91, and, for the Archaic period, Viviers 1992, 21–51. Cf. Paus. 6.10.5 for an inscription by Eutelidas and Chrysothemis of Argos, who made statues of the father and grandfather of Theopompos the wrestler, "learning the art from men before them."

12. See Goodlett 1989, 24–25; as she points out, conditions vary from area to area. In Athens, foreigners were forbidden to own property, and thus few pupils would have come from outside.

Kris and Kurz 1979, 19, argue that the history of Greek artists arranged by lists of pupils was modeled on the similar pattern in use for the philosophical schools, where indeed the importance of the teacher would have been paramount.

13. This point is made by Goodlett 1991 (supra, n. 11) 677–78, although she considers the Piombino Apollo Archaistic rather than a forgery of an Archaic type.

14. Cf. Goodlett 1989, 19.

15. Naukydes: Goodlett 1989, 88–91, believes there were two sculptors by that name, one the brother of Polykleitos I; the other, the son of Patrokles. I follow here the authors who believe in only one Naukydes, since evidence for an earlier one seems to me tenuous.

Todisco 1993, 53–54; Stewart 1990, 169, 272–73, fig. 442. Linfert 1990, 266–78, discusses also Naukydes' circle. He stresses that the first identification of the Diskobolos (by E. Q.

The Issue of the Great Masters

Visconti, in 1839) was based on the replica now in the Vatican, whose nonpertinent head led to connecting it with Alkamenes, an association supported by the Diskobolos' pose, which resembled that of the Ares Borghese, already attributed to the Athenian master. The discovery in 1910 of the replica now in the Capitoline Museum with pertinent head allowed a proper placement of the Diskobolos within the Polykleitan School, and suggested connections with the similar heads on the Hermes Pitti and the Hermes from Troizen carrying a ram by his side (Boardman 1995, fig. 32). This sequence of statues seems to correspond so well to Pliny's list (taking the Troizen Hermes to be "the person sacrificing a ram") that Linfert accepts attribution of all three sculptures to Naukydes (cf. his figs. 133, 135, 139 [Capitoline Diskobolos], 136 [Hermes Pitti], and 137, 138a–b, 141a–b [Hermes from Troizen]). This same position seems supported by Todisco 1993, pls. 46 (Hermes from Troizen), 47 (Capitoline Diskobolos), 50 (Hermes Pitti).

Yet all three works are marbles of the Roman period after presumed Greek bronze originals. Given the penchants of copyists for changing heads at will, no assurance can be placed on this similarity; stances are certainly quite different, the two Hermes types being traditional variants on the Doryphoros. Moreover, the Troizen Hermes uses his ram as support, albeit appropriately, and may thus not be "*immolante arietem*," as suggested by Pliny. If the type is indeed a kriophoros, as Linfert seems to accept, the god should appear as protector rather than as killer of the animal. The winged hat and winged hairstyle of the two Hermes types are clear elements of Roman iconography and cast further doubts on the attribution.

16. Linfert 1990, 604, suggests that the athlete is visualizing the goal of the toss, yet his head is inclined, looking downward, and he would have to shift the discus from his left to his right hand. As in the case of the more famous Diskobolos by Myron, I find that poses need not be chosen for their realism, but for their aesthetic value, provided their meaning is explicit.

17. Linfert 1990, 603–5, mentioned within the entry on cat. no. 128, the Diskobolos replica restored by Cavaceppi. The Capitoline and two additional ones are said to be so close as to suggest contemporaneous manufacture, in Flavian times.

18. Linfert 1990, 272, goes so far as to call the Ares anti-Polykleitan, and the Diskobolos re-Polykleitan, with Naukydes reacting to Alkamenes' creation, which he could have known through his activity in Athens. I now prefer a classicizing Ares (contrast Ridgway 1981a, 178 and n. 36). A visit to the Louvre in 1995 allowed me to view replicas of the Ares and the Diskobolos virtually opposite each other. The former looked to me more static and frontal, the latter showed different musculature, greater flexibility through its bent knees, and greater torsion, with the left toes grabbing the plinth, in clear contrast to those of the right foot.

The suggestion that the Ares is an Augustan creation has been made by K. Hartswick, "The Ares Borghese Reconsidered," *RA* 1990, 227–83. Note that doubts about identification and attribution had already been expressed by Ph. Bruneau—cf. *LIMC* 2, s.v. Ares, no. 23, pl. 360, and Commentary to I B, pp. 489–90. If the type is not an Ares, connection with Alkamenes is undermined. See also Bruneau's response to Hartswick, "Le rajeunissement de l'Arès Borghese," *BCH* 117 (1993) 401–5, where he deplores the scholarly tendency to cling to part of a theory even when other parts are proven erroneous.

19. Hygieia from Epidauros: Athens NM 299, h. 0.90 m.; Boardman 1995, fig. 52; *LIMC*

The Issue of the Great Masters

5, s.v. Hygieia, no. 20, pl. 382 (dated c. 370); Yalouris 1992, 76–77, figs. 16–18, and cf. n. 293 on pp. 72–73. For reference to the Epidauros akroteria, see Chapter 2; they are conveniently illustrated by Todisco 1993, pls. 75 (NW akroterion), 76 (SW akroterion), 77 (central east akroterion, Apollo).

20. See the commentary (by F. Croissant) in *LIMC* 5, s.v. Hygieia, pp. 568–72, where it is pointed out (p. 570) that the small Epidaurian figure (accepted as a product of Timotheos' workshop) remains strangely isolated—as shown by all other illustrated types. It is, however, also stressed that Asklepios' daughter lacks a true iconography, probably because of her nonmythological character, and that she therefore tends to merge visually with other female images of the second classicism. On the contrary, Delivorrias 1991, 150 and n. 40, fig. 31, does not accept identification of the Epidaurian statue as Hygieia, because of the alluring treatment of her costume.

21. Leda: see, e.g., Todisco 1993, pl. 84 (replica in Rome, Cap. Mus.), with additional bibl.; *LIMC* 6, s.v. Leda, no. 6a–f, pl. 108 (Timothean prototype, c. 360; replicas of Hellenistic date, except for 6a, the Capitoline statue, considered Hadrianic), no. 7, pl. 108 (Late Hellenistic variant in Mantua), no. 73a–i, pls. 119–20 (Roman copies); Yalouris 1992, 70 and nn. 270, 272 (agreeing with attribution), 72 and nn. 292–93 (see esp. pp. 69–74, 75–81 for Yalouris' evaluation of Timotheos' style and possible works by him); Bol 1992, 170–73, no. 315, pls. 110–15; Vierneisel-Schlörb 1979, 248–51, no. 24, figs. 114–18 (dated 380–370); Boardman 1995, fig. 91 ("about 320"). An analysis of the various replicas, for the purposes of *Kopienkritik*, is provided by Rieche 1973; see also Dierichs 1990 for representations of the theme on gems, but with comments on sculpture.

For a marble 5th-c. prototype (Boston, MFA 04.14), see Todisco 1993, pl. 17; Ridgway 1981a, 67, no. 7, figs. 41–42; Delivorrias 1990, 35–36 and nn. 108–15, figs. 30a–b (considered Attic, central akroterion flanked by peplophoros in Louvre [his fig. 13], probably from Rhamnous); *LIMC* 6, s.v. Leda, no. 5, pl. 108 (dated c. 410–400). Cf. also supra, Chapter 2, n. 84 (Stähler 1985). Note that the subject of Leda and the Swan does not appear iconographically until c. 400: *LIMC* commentary (L. Kahil), pp. 245–46. Could the importance of the newly erected Nemesis at Rhamnous have promoted the representation? Or was the myth made popular by Euripides' *Helena* (produced c. 412)? See esp. vv. 16–22. That the "Timothean" Leda need not have been a votive offering at Rhamnous is stated by Bol 1992, 171.

22. On single-figure groups (*Einfigurengruppen*), see Ridgway 1990, 322 and refs. in n. 16. For Aristonautes' Stele, see Ridgway 1992. See infra, n. 24, for further discussion on the meaning of Leda's pose.

23. The continuous selvedge of the Capitoline replica is seen by Rieche 1973, 39, as an intentional ornamental enrichment, not as a misunderstanding of the copyist; on p. 46 she notes that Furtwängler suggested the original may have been in bronze, but she prefers a marble prototype.

24. This stool appears in almost all replicas, so it cannot be considered an addition by individual copyists. Rieche 1973, 49–50, believes that the rock supporting Leda in the copies would have been a throne in the original, or part of its architectural setting within a niche, because of the complementary footstool. This theory is accepted by Dierichs 1990, 39, because a gem (type 1.2) shows Leda near a round altar (taken to be a glyptic transmutation of the original throne), and the sculptural variant in Mantua (pl. 6. 1; cf. *LIMC* no. 7, supra

n. 21) has a tree stump as support. These arguments do not seem compelling to me. The Mantua version, moreover, reverses the direction of the action, eliminates Leda's chiton, and shows her right foot raised and off its plinth, in a more momentary pose than the "Timothean" type, as if Leda were still in motion. Bol 1992, 172, considers the stool one more example of the ambivalence in expression of the composition: the long ponytail over Leda's shoulders is typical of young maidens, like Athena and Artemis, yet her forms are full and matronly; it is uncertain whether Leda is rising from her rock or sinking back onto it; and the rock hints at outdoors, while the stool suggests a more intimate interior setting.

25. Vatican Ganymede: Todisco 1993, 104–5, pl. 219; Boardman 1995, fig. 29; *LIMC* 4, s.v. Ganymedes, no. 251, pl. 95 (dated Antonine); cf. no. 200 for the ref. to Pliny (*NH* 34.79) describing Leochares' creation. The attribution is still accepted in more recent treatment: Stephanidou-Tiveriou 1993, 130–31, nos. 136–37 on pp. 283–84, pls. 71–72. The first of these two trapezophora, in Thessalonika, is considered probably closer to Leochares' original than the Vatican version; yet note that the eagle's claws are firmly placed on Ganymede's bare flesh, although Pliny's (rare) description explicitly mentions that the bird "refrains from injuring the boy with its claws, even through his clothing." (Several other trapezophora with Ganymede have the eagle standing next to him, nos. 119–35.)

26. O. Jahn's theory is cited by F. Winter, "Zu den Skulpturen von Epidauros," *AM* 19 (1894) 157–62, esp. 161; he, however, believes (p. 162) that the Leda is earlier and led to Leochares' creation of the Ganymede. This position finds a positive echo, e.g., in Vierneisel-Schlörb 1979, 249; more nuanced, but comparable, is Todisco's opinion (1993, 105).

27. K. M. Phillips, Jr., "Subject and Technique in Hellenistic-Roman Mosaics: A Ganymede Mosaic from Sicily," *ArtB* 42 (1960) 243–62, esp. 260, fig. 23 for the Vatican trapezophoron. The mid-3rd-c. date of the Morgantina mosaic, which had been tentatively lowered by more recent studies, has been reaffirmed by B. Tsakirgis, "The Decorated Pavements of Morgantina I: The Mosaics," *AJA* 93 (1989) 395–416, who has examined the Ganymede panel within the wider context of mosaic floors at the site. Distinction has been made between the apprehension and the abduction motif in Ganymede/eagle iconography, the Morgantina mosaic belonging to the first, the Vatican group to the second type, but it is uncertain whether these are aesthetic or chronological differentiations: cf. *LIMC* 4, s.v. Ganymedes, commentary on p. 168 (H. Sichtermann); the Morgantina mosaic is no. 170, pl. 88.

28. The type of the standing Leda with large swan may go back to the Hellenistic period: cf. *LIMC* 6, s.v. Leda, nos. 15–16, pl. 110, two reliefs, the first one said to be from Argos and either a 3rd-c. original or a copy thereof. Nonetheless, it is the Roman period that popularizes this composition (Type C), in a variety of media: cf. nos. 76–97, and esp. no. 96, pl. 122, for a sculptural group in the round, in Venice; commentary on p. 246. This seems to be the only type rendered in Attic trapezophora: Stephanidou-Tiveriou 1993, 131–39, nos. 138–43 on pp. 284–86, pls. 73–76.

29. In her *LIMC* commentary (supra, n. 21), L. Kahil stresses the correlation between Leda and Aphrodite, especially in the gesture, also popular among terracottas, primarily Boiotian, from the end of the 5th to the 3rd c.; see nos. 8–14 on pl. 109 for coroplastic examples, some in different compositions. See also Delivorrias 1991, 147–50 (with the Leda as fig. 30), on the unveiling of shoulder and chest in the iconography of mythological characters illustrating the amorous adventures of the Olympians. Bol 1992, 172, accepts a bridal

The Issue of the Great Masters

connotation in the opening of the mantle. One wonders whether it was the eroticism of the Leda group that excluded it from description (and attribution) in the ancient sources, despite its obvious popularity, as Bol 1992, 171, seems to note with surprise.

30. Pergamon Leda: *LIMC* 6, s.v. Leda, no. 6c; Rieche 1973, 25 no. 8, pls. 10, 30a, 31a, 33a; with discussion on pp. 30–31. This replica is smaller than all others (c. 0.80 versus 1.40 m.), and shows minor variations from the norm. It is particularly important because of its (assured?) mid-Hellenistic dating (c. 160, albeit on stylistic grounds only). Bol 1992, 173, n. 14, adds in fact D. Kreikenbom's suggestion that the motif may have originated in painting and have been turned into sculpture during the Late Hellenistic period of preference for one-sided (*einansichtige*) compositions, which would still be compatible with its retrospective 4th-c. style. Closely comparable Pompeian paintings, thought to be derived from the sculptural type, could actually have inspired it. Bol notes indeed that stylistic similarity with Timotheos' works holds only from the front. Yet that several viewpoints of the "Timothean" Leda are satisfactory (even if not all-around viewing) seems to me to militate against the "flat" definition.

Pergamon, Freeing of Prometheus: *LIMC* 7, s.v. Prometheus, no. 73, pl. 427.

31. On Timotheos' local origin, see Yalouris 1992, 78, and cf. p. 76 and n. 308 for refs. to others who consider him an Athenian and a pupil of Agorakritos. Vierneisel-Schlörb 1979, 250, repeats her original opinion (infra, n. 32) that he may have been a Parian trained in Attika.

32. On the Halikarnassos Ares, see supra, Chapter 4, nn. 15 and 17. The most extensive series of attributions to Timotheos is B. Schlörb, *Timotheos* (*JdI-EH* 22, Berlin 1965), now largely superseded because of the new reconstructions of the Epidaurian sculptures; more recently, see Todisco 1993, 58–61. On the Sorrento base as a Roman monument, see Roccos 1989; also Flashar 1992, 41–43 (more receptive to a 4th-c. echo, although finding no parallel in extant sculpture); Todisco 1993, 61, pl. 137.

33. Besides supra, Chapter 4, n. 17, see Stewart 1990, 282–84, with discussion of chronology on p. 283; Todisco 1993, 103–7.

34. On the dating of Pandaites, see Todisco 1993, 104. Although the information about the Eleusis dedication is given by Plutarch, *Isokr.* 27, it may be accepted because the entire inscription on the statue is cited, and even the precise location of the monument.

35. The dedication is inscribed on the rear wall of the niche in Delphi. See the transcription in Stewart 1990, 290–91, T 123, and cf. his p. 283, on Leochares' chronology. See also *GdDs* 1991, 225–27, no. 540 (dated 320–300); Völcker-Janssen 1993, 117–32 (on the political message of the dedication); *Lisippo* 1995, 172–73, and cf. 174–75, nos. 4.22. 1–3 for alleged echoes of the monument in later works. I suspect that too much reliance has been placed on the base from Messene (e.g., Boardman 1995, fig. 154) to reconstruct the appearance of the Hunt, thus somewhat distorting the political interpretation.

Attribution of the group to Leochares and Lysippos is made by Plutarch (*Alex.* 40.5) and Pliny (*NH* 34.63). Pausanias does not describe the monument, and Völcker-Janssen, 120 n. 16, suggests that it was no longer extant by the time of his visit, given the traces of Imperial reworking to the niche. See also infra, Chapter 8, passim, and n. 9.

36. Alexander's head on the Athenian Akropolis: Boardman 1995, fig. 111; Ridgway 1990, 135 and n. 52, with supporting bibl., pl. 69a–b; cf. also pp. 113–14. Both this attribution and

The Issue of the Great Masters

that of the Demeter of Knidos are tentatively accepted (sphere of Leochares) by Todisco 1993, 104, 106–7, pls. 223 and 221 respectively; and by Stewart 1990, 284, and figs. 560 and 571–72 respectively. Stewart is more cautious in his recent book, *Faces of Power: Alexander's Image and Hellenistic Politics* (Berkeley 1993) 106–13. He seems to waver between considering the Akropolis head an original or a copy (cf. pp. 108, 111, caption to fig. 5), but objects to the connection with Leochares' chryselephantine statues on practical grounds (p. 109), and believes in a bronze group of Philip and Alexander standing in Athens, by the same workshop that made the Akropolis marble, although no further information is available.

The first and influential proponent of the Leocharean connection: Ashmole 1951, who, however, began his chain of attributions by comparing both works with some of the Amazonomachy frieze slabs supposedly by Leochares. On the Demeter of Knidos, see infra, Chapter 9.

37. See arguments and additional bibl. in Ridgway 1990, 93–95. Todisco 1993, 105–6, pls. 226–28, seems to oscillate between a Hellenistic chronology for the Apollo (and the Artemis) and a possible resemblance of the god to some of the Maussolleion sculptures in the round—whose authorship cannot, however, be ascertained. Boardman 1995, fig. 64, labels the Apollo "copy of original of late 4th/early 3rd c.?"

38. Note Stewart's comments (1990, 283): "a complementary figure to Praxiteles, albeit at a rather lesser level of achievement," etc. Yet he cannot escape a final positive judgment (p. 284): "a sculptor who is compositionally daring yet in other respects costively conservative," albeit prefaced by a cautious "If all this is not fantasy."

39. Information on Satyros is so meager that he will not be discussed further; see supra, Chapter 4 and n. 18; cf. Cook 1989, 40–41, and Todisco 1993, 45, 90 with pl. 188 (tentative identification of a Roman female figure as copy of the Ada by Satyros). For the base in Delphi, see Marcadé 1953, 93; Todisco 1993, fig. 10 on p. 41.

40. See Stewart 1990, 282–83 for the Athenian Bryaxis, 300–301 for the homonymous Hellenistic master who made the Sarapis; cf. also Ridgway 1990, 95–97, and supra, Chapter 4, n. 17, with additional refs.

41. Signed base, Athens NM 1733: see, most recently, *Mind and Body* 1989, 320–21, no. 205; Boardman 1995, fig. 31. Todisco 1993, pl. 156. The base supported a short column that in turn was crowned by the tripod. On the rear of the base (the undecorated side), an inscription mentions the names of three phylarchs who were victorious in the contest: Deimanetos son of Demeas of Paiania; Demeas son of Demainetos of Paiania; Demosthenes son of Demainetos of Paiania. A second inscription in smaller letters gives the master's name, without ethnic ("Bryaxis epoiesen"). It is stated that this, the only signed work by Bryaxis, was made in the mid-4th c., before the sculptor went to Halikarnassos, but this sequence of events would push the date of the base at least to before 360. The podium for the base, still *in situ*, was found near the start of the *dromos* traversing the Athenian agora, just north of the Stoa of Zeus and just behind the South end of the Stoa Basileios: see H. A. Thompson and R. E. Wycherley, *The Athenian Agora* 14: *The Agora of Athens* (Princeton 1972) 95 and n. 72, 223 and nn. 26, 29. The mock battles of the anthippasia were held in the hippodrome, although the victors' monuments were set up in the Agora near the Herms, where the cavalry display began: E. Vanderpool, "Victories in the Anthippasia," *Hesperia* 43 (1974) 311–13.

42. For a discussion of this statue, see A. Linfert, "Der Apollon von Daphne des Bryaxis,"

The Issue of the Great Masters

DM 1 (1983) 165–73; cf. Ridgway 1990, 266 and n. 34. Flashar 1992, 70–77, seems to accept attribution to the Athenian Bryaxis who worked at the Maussolleion "in his youth."

43. For my previous views on Skopas, see my review of Stewart 1977, *Classical Outlook* 57 (1980) 114–15, and Ridgway 1990, 82–90; see also supra, Chapters 2 and 4. The most extensive work remains Stewart 1977; his "Introduction," and especially his six points outlining the shortcomings of the literary evidence (pp. 2–3), are worth a second reading. See also Stewart 1990, 182–85, 284–86; Todisco 1993, 79–88. Arias 1952 contains both ancient sources and a critical bibl. up to 1950, with commentary.

A monograph distinguishing between the various sculptors named Skopas is announced as forthcoming by O. Palagia: American School of Classical Studies at Athens, *Newsletter* 35 (Spring 1995) 4 (summary of a lecture delivered on Nov. 15, 1994). On these homonymous masters, see also *NSc* 1895, 458–60; Mingazzini 1971; and Coarelli 1968.

44. The Amyklai Aphrodite has recently been identified in the so-called Hera Borghese type: Delivorrias 1991, 153–57, and, *in extenso*, Delivorrias 1993a and 1995, who believes, however, that it was made by the famous Polykleitos.

45. Some dispute exists about the placement of this master within the 2nd c. (see also infra, n. 47). Mingazzini 1971 would give him the Maenad and the Ostia Nereid, which he dates c. 200–170 because of their torsional motion. Lebendis 1993 (supra, Chapter 2, n. 63) attributes to him the cult images of Asklepios and Hygieia at Tegea, which she places in the late 2nd/early 1st c.; the beardless Asklepios (as shown on the Tegea relief that copied the statues in the round) would recall the one made by the Classical Skopas for Gortys of Arkadia (Paus. 8.28.1), and would thus be a classicizing imitation in keeping with the retrospective tendencies of the period. Note that Pausanias specifies that the Tegea Asklepios and Hygieia were in Pentelic, thus making attribution to the 4th-c. Skopas surprising—but he says the same for the Gortys group, which Lebendis would accept as Classical. One wonders how Pausanias could distinguish the type of marble so easily, and why he would even mention it.

46. Stewart 1977, 135, nos. 50–52; Marcadé 1957, 23 (Aristandros son of Skopas of Paros), and 10, pls. 27. 1–3 (Agasias son of Menophilos of Ephesos). The French scholar states explicitly that the two sculptors are neither contemporary nor collaborating, yet the letter size and the ductus seem to give equal importance to both signatures. I wonder whether a repairer would have his name inscribed with as much prominence as that of the maker of the monuments. Could a technical function be implied by the verb (such as "installed" or "prepared"), thus indicating the type of collaboration that the Hellenistic period witnessed between makers and casters of bronze statues?

47. This master is recorded as *Scopas minor* by one Latin inscription (*CIL* 6.33936; cf. Stewart 1977, 135, section C, no. 49) on a statuary base for a (Hercules) Olivarius, but this is not a true signature, only one of the *tituli* added in late Imperial times to the plinths of preexisting sculptures: *NSc* (supra n. 43); cf. *LIMC* 4, s.v. Herakles, no. 1065, with added bibl.

Commentators disagree on whether S. Minor was the third or the fourth by that name. He may have been responsible for most of the works listed by Pliny (*NH* 36.25–26) as being in Rome, which indeed do not appear in any other listing of Skopasian works. These are: a colossal seated Ares in the Temple of Brutus Callaecus, which was *vowed* in 138 (cf. Ridgway 1990, 84; Todisco 1993, 88), the Apollo Palatinus (probably not from Rhamnous, since only

The Issue of the Great Masters

a late source [Stewart 1977, 128, no. 8 = *Notitia: descriptio urbis Romae,* Regio X] calls it *Rhamnusius,* which could be an epithet rather than an indication of provenance; cf. Roccos 1989, 573 and nn. 9–10, and the tenuous reasons for the suggested provenance mentioned in *LIMC* 2, s.v. Apollon/Apollo, no. 8, pp. 367–68; but see also, in support, Flashar 1992, 40–46, who would date the Apollo shortly before 360), the naked Aphrodite (whose lack of clothing suggests indeed a Late Hellenistic date; see infra, discussion of the Knidia), the Marine Thiasos (see infra), and the Kanephoros, although perhaps not the Hestia, if it was the one bought by Tiberius on Paros (cf. supra, Chapter 4, n. 16). Mingazzini 1971 would attribute to him also the Pothos, which he would place c. 100. The attribution of the Pothos to Skopas Minor is considered likely by Coarelli 1968, 337 n. 175 (see infra, n. 50); cf. his discussion of this master, pp. 325–37, and pp. 364–65 on Pliny's confusion between the two sculptors.

The Hercules in the Capitoline (Mus. Chiaramonti 733) is illustrated by Mingazzini 1971, 82, fig. 13, but its connection with the base of Hercules Olivarius in not certain; Mingazzini, however, considers it stylistically close to the Pothos. Other theories by Mingazzini 1971 are less credible: he would accept the east pediment at Tegea as being by Skopas major, but considers the west pediment a possible gift from Pergamon, not only because of its subject matter, but also because the extant heads show "Pergamene pathos."

Note that in the entire genealogy outlined in my text, only the Aristandros son of Skopas active in Delos (A. III?) and, in some fashion, the Skopas in Rome (*minor*) are epigraphically attested. Aristandros I is mentioned by Pausanias, and Skopas (II?) by various sources; it is uncertain whether Skopas I is meant in some passages by Pliny and other authors.

48. The suggestion of a 5th-c. Skopas corresponding to Pliny's *floruit* has already been made by Mingazzini 1971, who would give to that master the two Semnai (Furies) in Athens, since the third one in the group, according to a Scholion in Aischines (*In Tima.* 188: Stewart 1977, 130, no. 23; cf. also p. 129, no. 22, Clem. of Al., *Protr.*4. 41), was by Kalamis. The two sculptors would then have worked simultaneously, rather than one century apart. On the other hand, Kalamis' own chronology is controversial, and there may have been a 4th-c. master by that name: cf. infra, Chapter 9.

For marble figures riding animals, see, e.g., supra, Chapter 2, n. 84 (esp. Stähler 1985), and Chapter 6, n. 49. For possible reproductions of the Aphrodite Pandemos of Elis, see Stewart 1977, list on p. 141, and pl. 33a (bronze mirror-case in Paris); *LIMC* 2, s.v. Aphrodite, no. 976 and fig. on p. 100 (coin of Elis, Hadrian to Caracalla), and cf. no. 975 for notice of the group in Elis, nos. 947–76, pls. 93–95, for other types of the goddess riding a goat/ram.

49. Stewart 1990, 184, gives the number of replicas of the Pothos type; the total comprises at least 17 statues, in various states of preservation, as well as statuettes and disembodied heads, and several depictions on gems. For my previous discussion, see Ridgway 1990, 87–89.

50. Todisco 1993, 85; his reading of the passage is entirely plausible. A Samothrakian stage has been advocated for Skopas also on the basis of the sculptures in the Propylon to the Temenos (both coffers and frieze), thus ascribing to the master an archaizing interest. As already mentioned (supra, Chapter 4 and n. 51), these are stylistic trends of the late 4th c. and are not specifically attributable to a single master. The argument in favor of Skopas' activity at Samothrake originates with the Plinian mention of the Pothos, and it is therefore circular.

The Issue of the Great Masters

Note that some Plinian manuscripts read "pothon et phetontem" or even "phetontem" alone: Stewart 1977, 127, no. 4 and n. 1 on p. 135. In his earlier publication, Stewart accepted the presence at Samothrake of a mirror-image Phaeton, which he identified in a torso from Salamis (his pl. 45b) and another in Rome (cf. his list of copies of Phaeton, p. 146, section H, and discussion on pp. 109–10); he was then inclined to consider the Capitoline Pothos type as a replica of the Samothrakian work. He leaves the issue open in Stewart 1990, 184, and has eliminated Phaeton from the Plinian passage: p. 285, T 112. Cf. *LIMC* 7, s.v. Phaeton II, no. 3, p. 355 (considered hypothetical).

51. The only ancient text to use the word πάθος in connection with Skopas is Kallistratos' description of his maenad (Stewart 1977, 131, no. 31.3), but this is a poetic interpretation, not a stylistic assessment of the work. For Skopas' Praxitelean connections (according to Stewart 1977, 3, accounting for one-fifth of all references to the Parian master in ancient literature), see Stewart 1990, 184, 285–86, esp. 286, where he admits that we cannot be sure that the Pothos, his "most Praxitelean of subjects," was typical.

Note that Pliny (*NH* 36.25) makes Skopas a rival not only of Praxiteles, but also of his son Kephisodotos, who to us may seem a less influential master. In early Imperial times, many famous Classical sculptors (including Skopas) were erroneously thought to have produced also silverware: cf. Stewart 1977, 134, no. 42 (= Martial, 4.39.1–3). It is therefore obvious that no clear notions existed as to the style and oeuvres of Greek masters.

On the styles of the two masters as presently conceived—although without proper basis—see Childs 1994, 46: "le style doux et enjoué, un peu sucré, que l'on appelle praxitélien, ou le style de masses volumineuses, mouvementé, et un peu dur, qui est associé au nom de Scopas."

52. Cf. *LIMC* 7, s.v. Pothos, section B ("P. of Skopas"), nos. 12–26; no. 24, pl. 396 is the Ferento replica, no. 26 (same pl.) a ringstone in Munich (the other gem cited, no. 25, is now lost). Heinz 1982, 309, in studying the gems, points out the change (e.g., the thyrsos in place of a torch) that brought both Pothos and Aphrodite into the Dionysiac sphere, probably during the Augustan period, which would explain the popularity of the sculptural replicas; their prototype is, however, dated c. 310 and is left unattributed.

The sculptural copy considered best is in the Conservatori Museum, *LIMC* 7, s.v. Pothos, no. 14, pl. 395; Todisco 1993, pl. 150; Boardman 1995, fig. 34 (with question mark).

53. Stewart 1993, 184, accepts that the Pothos was excerpted, and that he leaned against Aphrodite, either at Megara or at Samothrake. Yet the Megara statue, being of ivory and of earlier date, would hardly have accommodated and supported an addition. Lattimore 1987 believes more plausibly that the Pothos type reflects the Samothrakian figure, but, as we have seen, Skopas' work on the island may be questioned.

54. Statuary type: Stewart 1977, 104–7, with lists of (31) replicas on pp. 142–44, additions and corrections on p. 151; Stewart 1990, 185, fig. 549; Todisco 1993, 87 (not so much because of its stylistic similarity to other attributed works, but because of its "new pathos"), pl. 151; *LIMC* 6, s.v. Meleagros, no. 3, pl. 208, with comments on the ("oddly") infrequent appearance of the boar's head ("no hint on who created the type"). Boardman 1995, fig. 80, illustrates the "Hellenistic version" in Cambridge, Mass.

On the "generic hunter" theory, see Fink 1969. For an illustration of a Late Imperial (3rd-c.) example, see, e.g., a statue in the Villa Doria Pamphili, Rome, with the body of the

The Issue of the Great Masters

Polykleitan Doryphoros, a portrait head, and a boar's head at the bottom of a tree-trunk support: *AntP* 1 (1962) pls. 13–15. On the Kalydon busts, see P. C. Bol, "Die Marmorbüsten aus dem Heroon von Kalydon in Agrinion, Archäologisches Museum Inv. Nr. 28–36," *AntP* 19 (1988) 35–46, esp. no. 8 (inv. 34), 37–38, pl. 27a–b. Other pertinent bibl. is cited in Ridgway 1990, 104 nn. 26–27.

55. Dresden Maenad: Todisco 1993, 82–83, pl. 138; Stewart 1977, 91–93, 130–31, nos. 29–31 (testimonia), 140–42, section B (list of replicas); Stewart 1990, 184, 286, T. 114, fig. 547, and cf. p. 19, where Kallistratos' praises are defined as "extravagances." For the comparable Maussolleion slab, BM 1014, see, e.g., Ashmole 1972, figs. 207, 212; Boardman 1995, fig. 21.1; cf. supra, Chapter 4, n. 13.

A fragment in Burgos, preserved from the hips down to the low base, is considered a second replica of the Dresden Maenad: Luzón 1978, 283–85, pl. 68. It is, however, very close to a figure on a Neo-Attic round altar that holds a large tympanon, as in Lorenz's restoration. The Skopasian attribution cannot therefore be sustained. In addition, the preserved height of the Burgos fragment, including the base, is 0.42 m.; its scale is therefore considerably larger than that of the Dresden figure.

Two major discussions of the Dresden figure are Six 1918 and Lorenz 1968; the former (p. 42 n. 5) believes that Kallistratos may not even have seen the original statue but worked from a previous literary description. See his fig. 1 on p. 40 for the Terra Sigillata maenad (albeit reversed) that prompted Six's reconstruction with goat in the lowered arm. See also Lorenz 1968, fig. 5 on p. 56, for other Terra Sigillata examples; his own reconstruction is given as fig. 6 on p. 57. See also supra, n. 45, for attribution of the Dresden Maenad to Skopas III, c. 200–170.

56. For latest discussions, see Todisco 1993, 88: he hesitates between attribution to Skopas Major or Minor, but cf. captions to pls. 154 (Grimani Triton) and 155 (Ostia Nereid), tentatively connected with the 4th-c. sculptor. See also *LIMC* 6, s.v. Nereides, no. 338 (= Achilleus, no. 533, with bibl.), on the lost Skopasian group, no. 423, pls. 506–7, on the "Ara of Domitius Ahenobarbus." For the latter, see now Kuttner 1993 (base for a votive group set up by the Marcus Antonius who was killed by Marius in 87; the marine reliefs are *spolia*). The theory that the reliefs are the actual Skopasian work is by Mingazzini 1971, 79–81; refuted by Stewart 1977, 99–101 and n. 56 on p. 170. A 4th-c. date based on minor-art renderings and on echoes in monuments on Delos and Tinos is advocated by Picard 1988; but see Ridgway 1990, 174 (insufficiently skeptical of the Bithynian provenance, but with added bibl.). On the Late Hellenistic tendency to derive inspiration from two-dimensional prototypes, see, e.g., N. Himmelmann, "Mahdia und Antikythera," in *Das Wrack* (supra, n. 2) 849–55, esp. 853.

57. Temple of Apollo Smintheus: Ridgway 1990, 158 and bibl. on 201 n. 9. The fragments of the cult image are mentioned by M. J. Mellink, "Newsletter from Asia Minor," *AJA* 86 (1982) 573. Commentators who believe in a 4th-c. statue assume that an earlier temple preceded the 2nd-c. structure, or that the Apollo by Skopas stood in an open-air temenos (e.g., Lehmann 1982). Yet a third source on the legendary discovery of the cult image (Menand. Rhet. Περὶ Σμινθιακοῦ = Arias 1952, 74–75, T 18) suggests the presence of a statue that could have fallen from the sky—therefore very ancient (cf. Lehmann 1982, 261 n. 254). More than one statue of Apollo might have been housed in the Hellenistic temple.

The Issue of the Great Masters

The problem of the numismatic representations is complex. Arias 1952, 110–11 (M 6), pl. 6. 19–20, prefers as the Skopasian a naked type with raised foot and laurel branch. Lehmann 1982, 258–61, selects the coins with an Archaistic draped image holding a bow (cf. her fig. 213 on p. 260), in keeping with what she considers Archaistic tendencies in the famous Skopas. Flashar 1992, 46–49, stresses the consistency of numismatic representations of this long-robed Apollo from c. 310 B.C. to the 3rd c. A.C., which is too great to be independent of a cult image. Acknowledging, however, the Archaistic traits, he leaves open the question whether it was made in the 5th or the 4th c. He also cannot suggest echoes of it in actual sculpture.

The issue is discussed in some depth by A. A. Donohue, **Xoana** *and the Origins of Greek Sculpture* (Atlanta 1988) 80–81 and n. 194, because Strabo (13.1.48) calls Skopas' work a *xoanon* (cf. her transcription of the passage, p. 441, no. 345). She concludes, however, that the writer uses the term generically, to indicate a statue; there is, moreover, no direct evidence that Strabo knew the Troad from personal observation (p. 81, n. 195). Cf. also *LIMC* 2, s.v. Apollon, no. 378, pl. 213 (various coins) and comments on pp. 231–32. On Chryse, see the account in *PECS*, 846–47, s.v. Smintheion (where no trace of an early temple is cited, although one is assumed to have existed).

58. Stewart 1990, 64, states: "Skopas was the century's most sought-after entrepreneur in his field," and indeed he appears in present scholarship as a prodigious traveler. Overlapping chronologies should considerably reduce the listing of his works. Note that several other attributions made by Pliny are considered uncertain by any standard: the Niobids in Rome, the Janus pater, and an Eros with a thunderbolt, supposedly a portrait of Alkibiades (*NH* 36. 28 = Stewart 1977, 133, nos. 37–39).

Images of divinities: Palagia 1984 argues that the Hope Herakles type, usually identified as the statue made for Sikyon, is probably a Roman pastiche inspired by an earlier prototype.

59. Goodlett 1989, 169–76, on the sons of Praxiteles (Kephisodotos the Elder as father-in-law: p. 172). Differentiation between the families: the wealthy Kephisodotos is known through his demotic, Sybrides, but Kephisodotos the Younger never signs with his demotic; the trierarchies of K. Sybrides would have been early in the life of the sculptor, yet such duties were usually exacted later in a man's life. Praxiteles himself is thought to have been well off because related (via Kephisodotos' sister) to the general Phokion, but the latter was of modest means and unlikely to have profited from his first wife. The alleged love affair between the sculptor and Phryne need not imply affluence, not only for the reasons stated by Goodlett, but also because, presumably, she commissioned works from him, and moreover the entire anecdote is likely to be fabricated: see infra. Goodlett stresses (p. 176) that Kephisodotos Sybrides was richer than most Athenians, in a special class, which makes it unlikely that he would have continued to exercise a menial profession.

For a scholar in favor of Praxitelean wealth, see, e.g., Lauter 1980; cf. Corso 1988, 25–27.

60. For Kephisodotos I and II, see, e.g., Marcadé 1953, 52–53, and cf. 89, for the signature of Praxiteles II on a base for a bronze statue at Delphi (first half of the 3rd c.). For various sculptors named Praxiteles, see Corso 1988, 15: besides the 4th-c. master, he lists one in the first half of the 3rd c., one in the second half of the 1st c., and one in the first half of the 1st c. A.C. As in the case of Skopas, some ancient authors may have inevitably confused the works of these homonymous artists.

The Issue of the Great Masters

61. The same passage attributes to Kephisodotos a second group of nine Muses, but Marcadé 1953, 52 n. 3, suggests that they are by Kephisodotos II. Todisco 1993, 63, would give Kephisodotos II also the Megalopolis group, because of the city's foundation in 371.

62. Because of the importance of this identification, discussions of Kephisodotos the sculptor usually coincide with those of the sculpture. See, e.g., Todisco 1993, 63–65, pl. 96; Stewart 1990, 173–74, 275–76, figs. 485–87; *LIMC* 3, s.v. Eirene, nos. 4–5 (coin and gem), 6a–f (amphoras from Eretria), 7 (amphora from Eleusis), 8 (sculpture), on pl. 541; cf. *LIMC* 7, s.v. Ploutos, p. 418; Boardman 1995, fig. 24. Surprisingly, cults of personifications and abstract concepts were established almost at the same time in Rome: cf. T. Hölscher, "Die Anfänge römischer Repräsentationskunst," *RM* 85 (1978) 315–57, esp. 349, where it is, however, pointed out that such concepts focused on human qualities, achievable by individuals.

Representations of the Eirene/Ploutos on the six amphoras and two fragments from Eleusis have been treated extensively by Eschbach 1986, 58–70, esp. 66–70, pls. 17–18 (and the sculpture on pl. 19); he divides the painted renderings into three groups, and illustrates them with sketches (group A, K 36–41, figs. 36–41; group B, K 42, figs. 42–43; group C, K 43–45, figs. 44–48) on pp. 62–63. Six additional amphoras (three more are not pertinent to this issue) found at Eretria in 1969 and 1976, are published by Valavanes 1991, pls. 41, 42, 51, 57, 137a (K 1–6), and the Eirene statue is discussed on pp. 110–12 (cf. English summary on pp. 339–46). This author supports a date shortly before 360 for the erection of the sculpture. Note that the rendering appears on no other vase but Panathenaic amphoras.

63. Landwehr 1985, 103–4, no. 63, group XI, pl. 60. She mentions dates for some of the Roman copies: the replica in Naples, from Cumae, and the one in New York are Julio-Claudian, that in Munich is Hadrianic/Antonine. Note, in fact, the peculiar waves of hair that overlap the upper edge of the fillet (detail in Todisco 1993, pl. 96): they recall renderings of the Antinoos Mondragone type and seem a typical Hadrianic mannerism. Such waves could not have been visible in the original, had they existed, because of the wreath obscuring them.

64. The statement is briefly made by Roccos 1991, 399 n. 8; the difference may consist in the length of the mantle.

65. Hermes/Dionysos by Kephisodotos: Todisco 1993, 63, pls. 91–92. The Hermes from Minturnae, albeit discredited, has been discussed in the context of the Kephisodotean controversy by Inan 1975, 65–72, no. 19 (a youthful Hermes leaning on a herm).

Trapezophoron from Corinth: to be published by A. Ajootian; see her Abstract, "Hermes Kourotrophos," *AJA* 98 (1994) 334, where Hermes is said to have carried, as children: Arkas, Aristaios, Asklepios, the Dioskouroi, Erichthonios, Herakles, Ion, and even Oidipous.

Eubouleus: Clinton 1992, 56–57, cat. no. 1, p. 135, fig. 9 (Agora S 1251 = *LIMC* 4, s.v. Demeter, no. 413, pl. 594), cat. no. 2, p. 135, fig. 10 (Agora S 1646 = *LIMC*, no. 414, same pl.); dated to the last decades of the 4th c.

Erichthonios held by an Aglaurid (Athens NM 2202): Neumann 1964 with discussion of ways of holding children in statuary; *LIMC* 1, s.v. Aglauros, Herse, Pandrosos, no. 28, pl. 213, dated 340–330 (under uncertain identifications) with added bibl.; an alternative suggestion makes it a votive offering to Ge Kourotrophos (not listed under Erechtheus/Erichthonios, in addenda to vol. 4, pp. 932–33).

Rhea by Praxiteles: the identification of the torso in Italy is proposed by Hafner 1988,

The Issue of the Great Masters

who does not mention the nebris, but see his fig. 1 on p. 64, which clearly shows the animal's head in profile to right, just below the woman's right breast, and a tip of the skin below the "child." The suggested comparison with the Imperial "Ara Capitolina" (his fig. 2 on p. 65) validates neither the pose (static versus the obvious rapid motion of the torso) nor the costume (himation wrapped around the waist; no skin). Hafner's suggestion is, however, accepted by Corso 1988, 171, and, more tentatively, by *LIMC* 7, s.v. Rhea, no. 10, and Ara Capitolina, no. 9 (= *LIMC* 6, s.v. Kronos, no. 23, pl. 66, A.D. 160), with comments on p. 631.

66. On Praxiteles, the most extensive treatment is now Corso 1988; his vols. 2 and 3, published in 1990 and 1992 respectively, discuss the sources from A.D. 175 to the 13th c., and are therefore irrelevant to our purposes. See also Todisco 1993, 65–79 (activity dated 370–330); Stewart 1990, 176–79, 277–81; Ridgway 1990, 90–93. In the forthcoming book edited by Palagia and Pollitt (supra, n. 1), the section on Praxiteles is by A. Ajootian.

On the Hermes of Olympia, besides the literature cited in Ridgway 1990, 105 n. 34, see Ridgway 1984a, 42–43, 85–86 and nn. 29–34 on p. 93. Boardman 1995, fig. 25 (Hellenistic copy). Todisco 1993, 75, pl. 129, believes the statue is a Neo-Attic, fairly faithful version of a Praxitelean 4th-c. original, probably in marble, chronologically close to the Aberdeen head (his pl. 128); he also suggests that Pausanias may have been using inscriptional evidence. Stewart 1990, 177, notes the similarity of the Aberdeen head (his fig. 496) to the Hermes, but acknowledges the latter as a Hellenistic work by an imitator, perhaps a descendant, although its head, and "even the entire composition, may derive more-or-less directly" from the famous Praxiteles. He discusses the statue on p. 198 as a derivative work by Praxiteles' family. I had initially accepted the Aberdeen head as comparable to that of the Hermes, but I am now less sure.

The controversy on whether the Hermes was an original by the great Praxiteles or a Roman copy replacing it used to be fierce, and engendered a copious literature. Antonssohn 1937 claimed that the Olympia marble was originally a satyr, reworked to turn it into Hermes; although his theory is no longer current, his comments on recuttings and tool marks (e.g., pp. 17–23) are worth reading.

Other works at times considered Praxitelean originals are the Mantineia Base on which see supra, Chapter 6, nn. 50–60, and the tripod base Athens NM 1463, on which see Chapter 6, n. 59. The Eubouleus from Eleusis (Athens NM 181) is attributed on the basis of an inscribed but headless bust in Rome (Corso 1988, inscriptional evidence no. 17; Clinton 1992, 136, cat. no. 14; *LIMC* 4, s.v. Eubouleus, no. 1), but the connection seems invalid: Ridgway 1990, 117, with bibl. in n. 17 on p. 140. Add Clinton 1992, 57–58, 135–36, cat. nos. 4–14; *LIMC*, s.v. Eubouleus, no. 3, p. 44 (under uncertain identifications). Stewart 1990, 177, 279, accepts it, with some reservation; Todisco 1993, 67, considers it conceivable ("opinabile"), but cf. pp. 95–96 and pl. 204, where it is ascribed to Euphranor (as Triptolemos?; see also infra, n. 77); Boardman 1995, fig. 73 (Triptolemos?). The Marathon Youth, to be discussed in Chapter 9, is tentatively included by both Stewart and Todisco among originals at least of Praxiteles' School, but perhaps unnecessarily. Both these last works are in fact compared to the Olympia Hermes.

67. Elis torso: E. Andreou, "O Hermes tes Elidos," *ArchDelt* 31.1 (1976, publ. 1980) 260–64, with French summary on p. 365, pls. 58–59a; the statue is said to be slightly over-lifesize (pres. h., 1.36m.); cf. p. 260 for description of back. The degree of finish, which retains tool

The Issue of the Great Masters

marks and rough surfaces, is different from the perfunctory but relatively smooth carving of the back in many 4th-c. originals. See also Ridgway 1984a, 42–43, 85–86 with nn. 29–34 on p. 93. My comments derive from visual inspection of the statue in 1988.

68. Corso 1988, 13, notes that Praxiteles' name is mentioned by 117 ancient sources, 20 of which are epigraphic and 97 literary, from the 4th c. B.C. to the 13th c. A.C. This total makes Praxiteles third in renown, after Pheidias (at least 165 sources) and Lysippos (127 sources), with Polykleitos a distant fourth (over 64 sources). If, however, only the mentions of Praxiteles as maker of divine subjects are selected (as against the more general references to sculpture), the master ranks second after Pheidias. Note that Corso counts each author as a single item regardless of how many passages in his work cite the sculptor; thus, all of Pliny's mentions are given under no. 38 (pp. 75–112, with commentary), and all of Pausanias' under no. 61 (pp. 140–85).

69. Corso 1988 lists seven signatures contemporary with Praxiteles' lifetime (nos. 1–7 on pp. 15–21), and 13 posthumous inscriptions, including patronymics and allusive references (nos. 8–20, pp. 21–32). Yet, of the seven, I would accept only nos. 2 (Agora base for statues of Spoudias and Kleiokrateia = Marcadé 1957, 115, pl. 44.1–2, "before 361?"), 4 (Olbia Pontica = Marcadé, 115v, c. 350), 6 (base from Leuktra, in Thebes Museum, for statue of Thrasimachos, son of Charmidas, dedicated by Archias, son of Thrasimachos, and Wanaxareta, daughter of Charmidas = Marcadé 116, c. 325), and 7 (Agora base for statue of Archippe, daughter of Kleogenes, dedicated by her mother, Archippe, daughter of Kouphagoros = Marcadé 116v, pl. 45, third quarter 4th c., "after return from Asia"). See also Marcadé's commentary, 119–22 (v).

Corso's no. 1 is the presumed Praxiteles' signature on the base of the Akanthos Column in Delphi, which that author has confirmed by personal inspection (see his long n. 2 on pp. 34–35); but cf. Ridgway 1990, 22–26; Todisco 1993, 137–38, pl. 305; in support, see J. de Waele, *RA* 1993, 123–27, esp. 127 (review of C. Vatin, *Monuments Votives de Delphes*). Corso's no. 3 is the Delian base, which Marcadé 1957, 114, mentions as a work possibly made by the master either going or coming from the East, but which seems to me doubtful. Corso's no. 5 is the letter Π inscribed on some of the lions from the Halikarnassos Maussolleion, which he claims stands for Praxiteles; three others, marked with Λ, would be by Leochares. But Π could also stand for Pytheos, and moreover there is no assurance that these are more than masons' marks to help in the assembly of the sculptures.

70. See, e.g., the comments in Ridgway 1984a, 21 and n. 53; cf. also Donderer 1988. Note that Pliny, *NH* 34.69, gives to Praxiteles the bronze group of the Tyrannicides that was taken by the Persians in 480 and returned to Athens in early Hellenistic times, with obvious chronological and stylistic confusion, either his own or his sources'. Praxitelean faked signatures are mentioned by Phaedrus (*Fab.* 5. prol. 4–7), cited by Stewart 1990, 230. A copy of Praxiteles' Eros for Thespiai was made by the Athenian Menodoros in Imperial times: Paus. 9.27.3–5.

71. Havelock 1995, 36; see her pp. 20–27 for the origin of the theory on the Knidia's bathing (by J. J. Bernoulli, in 1873). To Praxiteles and his contemporaries, however, the statue must have been a dignified religious image. Misunderstanding of the Knidia's meaning continues to mar current studies: see, e.g., N. Salomon, "Making a World of Difference: Gender, Asymmetry, and the Greek Nude," Abstract, *AJA* 99 (1995) 304, for a completely conven-

The Issue of the Great Masters

tional view and a misguided attempt to differentiate between Greek attitudes toward the male and the female nude. On the Knidia, in general, see *LIMC* 2, s.v. Aphrodite, pp. 49–52, nos. 391–408, pls. 36–38; for proportional measurements, see Berger 1992, 140–45, no. 30, ills. on pp. 256–59.

72. I have taken most of these references from the unpublished project proposal that Dr. Leftwich kindly sent me in 1989, and which unfortunately he is no longer researching or planning to publish. He acknowledged inspiration on the Knidia from E. B. Harrison, but should be given full credit for the medical slant of these convincing ideas, which are now being investigated by others, as ancient medicine begins to play a greater role in feminist and classical studies. Dr. Leftwich could also cite in manuscript a pertinent article that has now appeared: Hanson 1990. For interaction between physicians and sculptors, see also Métraux 1995. See also section 2, "Containers and Textiles as Metaphors for Women," in E. D. Reeder, ed., *Pandora: Women in Classical Greece* (Princeton 1995) 195–99, esp. 197, where the suggestion that the hydria of the Knidia refers to the goddess's body is again attributed to Prof. Harrison.

73. Colonna Aphrodite as Hellenistic version: Pfrommer 1985. Rebuttal: Von Steuben 1989; the specific discussion of the hydria is by C. Reinsberg, "Zur Hydria der Typus Colonna," 555–57. On anecdotes about minor arts by major masters, see also infra, Chapter 8.

Aphrodite Colonna: see, e.g., Havelock 1995, fig. 1; Todisco 1993, pl. 113; *LIMC* 2, s.v. Aphrodite, no. 391, pl. 36; Boardman 1995, fig. 26.

Munich Aphrodite ("Braschi"): *LIMC*, no. 399, pl. 37; Todisco 1993, pl. 115.

74. On the "aftermath" of the Knidia, see Havelock 1995, 64–67, 69–101; on Phryne (possibly two hetairai by that name), see her pp. 42–49. Todisco 1993, 70, believes the stories of courtesans posing for Praxiteles. On fabricated anecdotes about romantic ties between artists and models, see Kris and Kurz 1979, 40–41, 116–20.

75. Against linear development by Bernoulli: Havelock 1995, 20–21; additional comments on other authors' theories, 90, 95, 98 (on Aphrodite of Arles). For the latter, see Todisco 1993, 70, pl. 111 (Thespiai Aphrodite?) and cf. p. 71, pl. 110, Arles head, connected with body of Aphrodite Richelieu (pl. 109; Kos Aphrodite?). See also Lauter 1988 (head in Athens = naked Phryne), and Delivorrias 1991, 147 and nn. 35–36, figs. 27–28. For my theory, see Ridgway 1976.

The Capua Aphrodite, as an "early" semi-draped type, has been attributed variously to Skopas, Lysippos, or Praxiteles, and considered a 4th-c. prototype for the Roman Victory of Brescia; see, e.g., Ridgway 1990, 89–90. H. Knell, "Die Aphrodite von Capua und ihre Repliken," *AntP* 22 (1993) 117–39, now proposes a late 4th-early 3rd-c. date for the original, which, however, cannot be proven. See, nonetheless, comments (p. 131) on the artistic situation after Alexander's death, when, it is stated, no work seems dependent on a single school or tradition—an assessment with which I would agree, given the mixture of styles prevalent at that time.

76. Apollo Sauroktonos: Todisco 1993, fig. 26 on p. 66, pls. 126–27; Ridgway 1990, 105 n. 35 (with bibl.); Boardman 1995, fig. 27; *LIMC* 2, s.v. Apollon: no. 18, pl. 183 (variation with column, within temple, on coin of Mysian Apollonia), no. 81, pl. 190 (sculptural type); also s.v. Apollon/Apollo, no. 53 (comments on distribution of replicas on pp. 378–79), pl. 302; and cf. *LIMC* 3, s.v. Eros, no. 80, pl. 614, for a sculptural variation on the theme that trans-

The Issue of the Great Masters

forms the figure by the addition of wings, as was done for the "Pothos" type. For measurements and comparisons to the Polykleitan "Kanon," see Berger 1992, 133–39, no. 29, ills. on pp. 250–55.

For the Hypnos, see *LIMC* 5, s.v. Hypnos/Somnus (Hypnos will be treated in the *LIMC* Suppl.), nos. 42 (marble in Madrid) and 43 (bronze head in British Museum), pl. 408, and commentary on p. 607, where the iconography of the young Somnus is said to follow the Hypnos by Skopas(!). See also, extensively, Mattusch 1996, 151–61, who considers it inappropriate "to assign a single Hypnos to a single artist, or to search for a particular date for such a statue."

Childs 1994, 47 and n. 80, objects to the idea of the Sauroktonos as a parody and prefers to see it as a metaphor—the killing of the Python is no more difficult for the god of vengeance than killing a lizard is for an ephebe. Todisco 1993, 74, sees it as an erotic reference to prepubescent love, and notes that lizards were highly sought after for their alleged anti-aphrodisiac qualities. At any rate, Pliny's attribution to Praxiteles (*NH* 34.70) comes right after his assignment to the master of Antenor's Tyrannicides (supra, n. 70), therefore at least among jumbled notes. The other source to describe the composition, Martial 14.172, refers to a youth (not to Apollo) and makes no mention of Praxiteles as the maker of this small dinner gift.

77. Apollo Lykeios: *LIMC* 2, s.v. Apollon, no. 39, pp. 193–94 (attribution to Praxiteles uncertain, but original dated mid-4th c.), pls. 184–85; cf. no. 17, pl. 183 (terracotta from Jerash), no. 196, pl. 199 (Roman transformation into kitharoidos); see also s.v. Apollon/Apollo, no. 54, pl. 302, pp. 379–80. For a replica at reduced scale in Munich, see Fuchs 1992, no. 32, and bibl. on the type on p. 221 n. 9. Boardman 1995, fig. 65 ("about 320"). Todisco 1993, 99–101, fig. 30 on p. 100, pls. 205–7, assigned to Euphranor, although on questionable grounds. (Euphranor will be discussed infra, Chapter 9.) To the bibl. in Ridgway 1990, 105 n. 36, add Schröder 1989, 11–12 (over 200 representations of Apollo and Dionysos in the pose), 13 (Dionysos shown with this gesture before Apollo, on a South Italian bell krater), 27–34 (on the meaning of the gesture, esp. for the Lykeios, 29–30). The earliest terracottas to reproduce the pose occur in Asia Minor at the end of the 3rd c., and continue into Augustan times. See also V. J. Hutchinson's review of Schröder in *JRA* 4 (1991) 222–30, esp. 225–26.

The pose is further discussed in a Dionysiac context by Pochmarski 1990, 196–201, 225, 390, who, however, dates the Apollo Lykeios to the Late Hellenistic period. See V. J. Hutchinson's review in *JRA* 5 (1992) 294–96. See also *LIMC* 3, s.v. Dionysos, no. 200, pl. 320 (change made in Praxitelean circles, but, more probably, Roman reinvention), no. 278, pl. 325 (Dionysos leaning on satyr, in Lykeios pose, with variations nos. 279–80, pls. 325–26).

78. This passage is corrupt, and "Drunkenness" is an emendation; see a discussion of previous literature and theories in Pochmarski 1990, 196, who, however, rejects the possibility that the Praxitelean composition was a drunken Dionysos supported by a satyr. One more satyr by Praxiteles, in Parian marble, is mentioned by Pausanias (1.43.5) next to an earlier image of Dionysos at Megara, but modern literature does not consider it, perhaps on the assumption that the other two known types must derive from bronze originals.

79. Lysikrates Monument: good detailed photos in *AntP* 22, pls. 1–19 (cf. supra, Chapter 6, n. 58); Boardman 1995, fig. 16.

The Issue of the Great Masters

Document Relief: Meyer 1989b, 305, A 141, pl. 44.2 (Athens Epig. Mus. 13262; the Deme Aixone [Kekropis] honors Anteas and Philoxenides for their fine choregia; dated 313/2); cf. *LIMC* 3, s.v. Dionysos, no. 854, pl. 403 (dated either 340/39 or 313/2). Connection with the theater is indicated by five comic masks engraved on the upper fascia. This relief could plausibly echo the Dionysos and satyr in Athens.

Bronze relief plaque in Delos: *LIMC* 2, s.v. Artemis, no. 1027, pl. 525; Ridgway 1990, 319–20, pl. 158, and pp. 313–24 on other early Hellenistic satyrs.

Terracotta satyr (inv. 1957-ΝΑΠ-308) from Deposit 1957-C 33: mentioned in N. Vogeikoff, "Hellenistic Pottery from the South Slope of the Athenian Akropolis" (Ph.D. dissertation, Bryn Mawr College, 1993) 127, pls. 246–47.

For a family of satyrs, see the volute krater by the Methyse Painter in Minneapolis: J. M. Padgett, "An Attic Red-Figure Volute Krater," *Minneapolis Institute of Arts Bulletin* 66 (1983–86, publ. 1991) 67–77.

80. Pouring Satyr: Boardman 1995, fig. 71; Berger 1992, 128–33, no. 28 (discussed together with the Leaning Satyr), ills. on pp. 248–50; proportionally, these Praxitelean attributions are considered closest to the Westmacott Athlete and the Dresden Youth; fig. 158 on p. 128 shows a Funerary Banquet Relief in Basel with *oinochoos* in the satyr's pose. Todisco 1993, 67–68 (comparison with human slaves on p. 68), pls. 101–2, dated c. 370; it is said to copy the statue from the Street of Tripods, but without supporting evidence; the pouring pose would make it better suited for the satyr in group with Dionysos, as in the Document Relief mentioned in the previous note. See additional bibl. in Ridgway 1990, 105 n. 37.

81. Leaning (or Resting) Satyr: Boardman 1995, fig. 70; Berger 1992 (loc. cit., n. 80); Todisco 1993, 76–77, pls. 135–36, dated c. 335–330, identified as the Periboëtos, but perhaps also from a choragic monument, because of the theatrical mask added by a copyist to the replica in Munich (pl. 136). See, with further bibl., Ridgway 1990, 91 and n. 38. For replicas at reduced scale, and many important observations, see Bartman 1992, 51–101 (with no definite attribution to a master).

82. Childs 1994, 53 and n. 101; see also p. 55 and n. 105 for Plato's lack of interest in the masters of his own time, according to the frequency of names cited in his texts. See also E. Perry, "Artistic Forgery in the Early Roman Empire," Abstract, *AJA* 99 (1995) 346.

CHAPTER 8

Lysippos
A Case Study

The previous chapter dealt with specific sculptors who are known to have lived in the fourth century—with one major omission. Lysippos of Sikyon, perhaps the most famous of them, was deliberately left for separate treatment. Recent literature has devoted more than the usual attention to his oeuvre, with the result that a complete sequence of the events in his life has been worked out, and a large number of attributions have been made, giving the illusion that we can indeed recapture both the style and many of the creations of this admittedly most prolific artist. In particular, one scholar, Paolo Moreno, has contributed some 52 articles, monographs, and books dealing with Lysippos either directly or indirectly, and is considered at present the authority on this subject.[1] I find myself once again in the position of having to doubt much that has been attributed to the sculptor. I shall therefore try to outline at first what can be considered factual information; I shall then take up one particular case, that of the Herakles Epitrapezios, and I shall discuss it in greater depth than any of my previous entries, to show how different interpretations of the same evidence are possible.

The Signed Bases
No original by Lysippos is preserved. Signed bases do not fully coincide with the literary sources or Pausanias' accounts, but are important for chronological purposes. In fact, a base at **Delphi**, for a statue of the Theban general Pelopidas, dedicated by the Thessalians, should perhaps be dated after 364 (when the Boiotian died) but probably before 362 (the end of the Theban hegemony), from which it has been argued that Lysippos was born shortly after 390. The beginning of a patronymic, Lys[. . .], within the inscription implies a recurrence of the root Lys- in family names (Lysippos' brother was called Lysistratos) that may be connected with the Sikyonian cult of Dionysos Lysios, suggesting a religious initiation for its members,

Lysippos

yet this remains speculation. Speculative also is the reconstruction of the main points of the master's life on the basis of brief mentions in the literary sources, many of which are anecdotal or have been overinterpreted.[2]

Perhaps earlier than the Pelopidas monument was the statue for a general set up at **Akraiphia (Boiotia)**; the signed base was found in 1992 and is attributed to the span 372–362 on the same historical grounds. It may have been the work that earned Lysippos the Pelopidas commission.[3]

An even earlier beginning of Lysippos' career has been inferred from a bronze plaque (probably once affixed to a stone base) at **Olympia** commemorating the chariot-racing victories of Troilos of Elis when he was judge of the events in 372. But the inscription includes no signature, and authorship of the statue is derived from Pausanias (6.1.4–5). This information may be correct, but cannot be proven. That Lysippos worked at Olympia is, however, suggested also by the extant base for a statue of Poulydamas of Skotoussa (Todisco 1993, pl. 246), a fifth-century Thessalian athlete, which Pausanias (6.5.1) again attributes to the Sikyonian master. The reliefs on three sides of the pedestal illustrate some of the deeds of the gigantic man who was invited to the Persian court and is thus shown performing in front of the Great King. But no inscription confirms the Lysippan connection, and the base reliefs, at best, are workshop products. That the statue supported by the pedestal could be visualized through the help of the bronze Seated Boxer in the Terme seems to me untenable. Given the much earlier lifespan of Poulydamas and the advanced style of the base (especially of the female figures on the front face), a date in the 330s for the dedication sounds plausible.[4]

More tangible is the evidence of Lysippos' presence at **Thebes**, where his statue of the boy athlete Korveidas stood on the same base as one of Timokles by a Polykleitos; which of the homonymous masters made the latter is disputed. Moreno and Todisco prefer Polykleitos III, on the assumption that the monument was erected after the reconstruction of the city promoted by Kassander, in 316. Edwards notes that Timokles was a contemporary of Korveidas, who achieved his victories in 342 and 338, and, with Marcadé and Stewart, would therefore prefer Polykleitos II and a date before the destruction of Thebes by Alexander in 335. More important, from a stylistic point of view, is that two statues by different masters could appear side by side, although in different positions: that by Lysippos, according to the imprints, stood almost parallel to the front, with one foot perhaps raised on a support, and almost at a right angle to the more frontally posed Timokles. Since, moreover, anathyrosis is visible on one short side of the base, the extant block was probably part of a longer monument, comprising other sculptures. Once again, we note the contribution of several sculptors to multi-figured monuments, as attested at Delphi. The Sikyonian origin of both masters could explain the collaboration.[5]

Lysippos made at least two monuments for **Corinth**. The top surface of one base is damaged just where the fastening points of the statue would be, and only the

master's signature remains on the front; a lengthier text would, however, have been written on a bronze plaque (like that of Troilos at Olympia), for which a special cutting was provided on the stone. The second base is better preserved, but again no dedicatory inscription appears beyond Lysippos' name and part of the verb, and here no provisions were made for metal additions. It has been suggested that the person represented was a slightly over-lifesize athlete with his weight on the left foot, and the right foot forward and to the side, in a pose comparable to that of the Hermes Richelieu (cf. Pl. 82). The athletic subject is inferred from the findspot of the pedestal, close to the race track; a date around 340 or the early 330s is based on a comparison with another base found at Corinth that may have supported a monument honoring Timoleon.[6]

A signed base at **Thermon (Aitolia)** presents a problem, in that the person being commemorated is a Paidias who may have been hieromnemos in 265/4. Yet Marcadé believes that the letters of Lysippos' signature appear earlier than the dedicatory inscription, and the base may therefore have been reused. Another base, at **Lindos (Rhodes)** has only part of the master's name preserved, but his association with the island seems confirmed by Pliny (*NH* 34.63), who mentions a chariot of the Sun made by him. Moreno would like to connect the signed base with Alexander's dedications to Athena after the Battle of Arbela (331–330), as listed in the Lindian Chronicles; yet epigraphists tend to date Lysippos' signature to the late fourth century, therefore probably after Alexander's death.[7] I believe that we have overplayed Lysippos' connection with the Macedonian ruler as well as the political allegiances of ancient masters. As we have seen with Antiphanes of Argos, sculptors executed commissions for warring parties and even for enemies of their own city of origin, without apparent qualms. Chares of Lindos, who made the Rhodian Colossus, was said to be a pupil of Lysippos, and therefore a Lysippan stage on the island can be accepted, regardless of Alexander's movements.

The latest preserved signature occurs on a base for a bronze statue dedicated by Theramenes at **Megara**. Marcadé places it at the end of the fourth century, and it would thus seem to mark the closing of the master's career. Yet it is commonly believed that the sculptor ended his life at Taras, while completing his two colossal works: the Herakles and the Zeus. This information, however, comes from a late source (Niketas Choniates, *de signis Constantinopolitanis* 5), and the text could be interpreted somewhat differently. The Herakles seems to have been taken to Constantinopolis; the Zeus was transferred to Rome in 209 by Q. Fabius Maximus (Verrucosus; Pliny, *NH* 34.40).[8] Nothing tangible has been found in Taras to attest to Lysippos' presence.

Other inscriptions carrying Lysippos' name cannot be considered true signatures, and may not be trustworthy. One, now lost but once in Rome, accompanied a portrait of King Seleukos, and would have lengthened the master's activity to 306 at least, when the Diadochos assumed the royal title: it is now believed apocryphal, or

Lysippos

referring to a Lysippos II. More reliable is the nineteenth-century transcription of a (lost) inscription in **Pharsalos (Thessaly)** on the base for a statue of Agias, the fifth-century athlete who was an ancestor of Daochos II. This is not the place to enter into a discussion of the relationship between the Delphic *marble* monument and the Lysippan bronze in Thessaly, which I have debated elsewhere. Lysippos' return to Delphi toward the end of his career is, however, supported by his alleged contribution to the Krateros Hunt, together with or after Leochares.[9]

Unconnected with a specific place, but firmly associated with the Herakles Farnese Type is the ΛΥΣΙΠΠΟΥ ΕΡΓΟΝ written in Imperial times on the rock support of a replica from Rome, now in Florence (Palazzo Pitti). Because of minor differences in stance and arrangement of the lionskin, three different prototypes of a resting Herakles have been connected with the Sikyonian master, supposedly created at various moments of his career, but the initial attribution is due to this inscription, which, like many later Roman labels, may or may not be accurate. Lysippos is said to have created so many works (1,500, according to Pliny, *NH* 34.37) that he obviously may have repeated some of his conceptions in slightly variant forms, altering either size (from small to large and vice versa) or details. Yet such variations could also be attributed to Roman copyists, who responded to the different demands and tastes of their clients, without necessarily going back to a different original in each case. Given this impasse, this point is not worth arguing, to my mind, but one issue may require clarification. I had accepted the possibility that the Farnese Type (Pl. 68) reproduced an original once standing in the Sikyonian agora, on the basis of a silver tetradrachm of Demetrios Poliorketes that included the Herakles image as symbol and had been assigned to the Sikyonian mint. Later studies have challenged this attribution, and an authoritative numismatic publication has recently labeled the coin Corinthian and dated it c. 310–290; yet the same coin has been used to suggest that the sculptural prototype stood at Argos. I would now question a literal reading of such numismatic representations, which do not necessarily reproduce monuments standing in the city that minted the issue; the true value of the coin, therefore, would consist in the chronological confirmation that such a Herakles type had been created before the end of the fourth century.[10]

Plate 68

If we then review the above evidence, it would seem that Lysippos was active at the major sanctuaries first (Olympia and Delphi), for athletic and commemorative statues. He may have been called to either place on the strength of his connections with the Sikyonian members of the Polykleitan School, or he may have received his first commission at Akraiphia (after which he was asked to make the Pelopidas?). Conversely, he may have established a certain reputation by working for the Thessalians at Delphi, which may have prompted the Pharsalos commission (then, rather than at the time of the Delphic Daochos Monument, as usually assumed). After this spurt of activity in the 360s, his other attested works seem to cluster in the 330s and later; at Thebes and Corinth he made athletic statues; we cannot tell what

Lysippos

(if anything) he made for Thermon and Lindos, but he returned to private dedications at Megara. If his participation in the Krateros Hunt could be securely established (at present, it is only based on Plutarch's and Pliny's mentions), he could receive major Macedonian commissions around 315, but it is difficult to trace his life beyond this point.

From this list, Lysippos emerges primarily as the maker of athletic statues or male subjects. To be sure, some of these works commemorated figures of the past (like the Poulydamas and the Agias), or victorious generals (the Pelopidas and the general at Akraiphia, perhaps even the Korveidas, if he fell at Chaironeia) and as such should be considered official monuments rather than private dedications. But a comparison with Praxiteles, whose signed bases attest to the making of female votive figures, may highlight the contrast. If, moreover, we take into account the mentions in the literary sources, the range of both subjects and locales expands considerably; yet, even accepting all attributions, however tenuous, only two female subjects emerge: the Muses for Megara and the poetess Praxilla later taken to Rome, the latter mentioned in a text that inspires little confidence.[11]

Geographically, Lysippos' activity (again, to judge purely from the preserved signatures) seems more limited than that of the other fourth-century masters. Except for an apparent overseas trip to Rhodes, he may have remained within Greece, with relatively short, albeit repeated, stays in the Peloponnesos (Corinth, Olympia), and perhaps longer ones in Boiotia, Thessaly, Aitolia, Delphi, and Megara. This picture is so different from that culled from the ancient authors, and especially from the much more complex one current in modern literature, that it requires further examination.

The Locales of Lysippo
I take this title from the 1995 exhibition catalogue on Lysippos, where it is used for an essay reviewing the historical background of the sites at which Lysippan presence is postulated.[12] Besides the findspots of the signed bases, as I have listed them above, the following places are named, in the relative chronological order of the first alleged activity by Lysippos at each of them: Sikyon, Argos, Pella, Mieza, Thespiai, Helikon, Dion, Lampsakos (in the Propontis), Ephesos, Myndos (in Karia), Sagalassos, Sidon, Alexandria (Egypt), Tyre (Phoenicia), Rhodes, Kos, Kassandreia (in the Chalkidike), Athens, Alyzia (Akarnania), Taras (South Italy). These are 20 sites, to which the previously discussed seven (or nine) attested by the signed bases should be added, for a grand total of almost 30 different locations. The geographic range covers many of the areas of Alexander's campaigns along the Mediterranean shores, as well as several places in Macedonia, additional ones in Northern Greece, and eventually Italy, making Lysippos an even better traveled sculptor than his contemporaries. But can this picture be believed?

Lysippos

Once again, I shall select here those sites where Lysippos' activity is fairly plausible, giving my reasons for the choice. I shall follow the order of the list above, although a proper chronological sequence may not be fully respected by the works I can accept.

Sikyon is not only the master's birthplace (as verified by the Akraiphian base), but also probably the setting for the *Kairos* (the Opportune Moment), if we can believe the epigram by Poseidippos, and the mention by Kallistratos. It has been suggested that two versions of this peculiar personification existed: one made for King Alexander at Pella, the other in the sculptor's native town. But both ancient texts can be read to imply the same location, and the fact that a fragmentary relief from the Athenian Akropolis corresponds to the two well-known replicas of the motif (in Trau [Trogir], Dalmatia [Todisco 1993, pl. 268], and in Turin) may weigh in favor of Sikyon rather than the farther Macedonian city.[13] That the composition is known only through reliefs, never through sculptures in the round, might be due to the difficulty of posing a marble figure on tiptoes, but it remains surprising that no bronze statuette should have repeated it, to our knowledge. The Hypnos, for instance, would seem equally difficult to balance, yet it was duplicated. Given the uncertainty of preservation, however, no conclusion can be derived from this apparent lack.

Thespiai housed an Eros by Lysippos, as well as one by Praxiteles; this is known on the testimony of Pausanias (9.27.3) and seems confirmed by the type of a bow-holding, winged child known through a large number of replicas (Todisco 1993, pl. 247). Obviously, the piece was copied because its subject appealed to the Romans, rather than for its aesthetic qualities, since any effect of three-dimensionality inherent in the original is often lost in the flattened Roman copies meant for one-sided viewing. The true meaning of the Eros' action is still debated, but C. M. Edwards is offering a new interpretation that would confirm Lysippos' experimentation with momentary poses.[14] It seems remarkable that the apparently more famous Praxitelean Eros, which stood in the same location, and was even taken to Rome (twice?), eventually destroyed by fire, and replaced at the sanctuary by a duplicate (by Menodoros), should have been copied much less, at least to judge by modern attributions.

Dion was a sacred city of the Macedonians, and was therefore chosen by Alexander for the dedication of a major bronze group depicting 25 of his comrades who had fallen at the Battle of the River Granikos in 334. Made by Lysippos, it is said to have depicted each figure in realistic terms, although it is unlikely that true likenesses were possible or even attempted. Probably enough differentiation was introduced among the components to give the impression of individuality. Alexander may have been included, but it is uncertain whether defeated enemies were also represented, fallen under the horsemen's mounts. The group was taken to Rome by Q. Caecilius Metellus in 148 (Pliny, *NH* 34.64), and stood in a prominent location,

Lysippos

within the Porticus Octaviae, where it might have been copied and imitated. Attempts to identify some of the figures, especially Alexander, in reproductions are, however, questionable.[15]

I would not doubt that Lysippos created the original group, and consider this commission the main evidence of the master's connection with the Macedonian court. I do doubt, nonetheless, that he followed Alexander through his campaigns, and suspect that his fame as Alexander's court sculptor is due to the later sources. Lysippos could certainly have made other portraits of the great conqueror, but it is unnecessary to postulate that he knew Alexander from childhood, on the basis of Pliny's brief mention (*NH* 34.63).[16] If the master could portray Agias and Poulydamas almost a century after their exploits, and represent "realistically" the *hetairoi* who fell at the Granikos, he could certainly have made a "retrospective" portrait of Alexander young, when the fame of the Macedonian warranted such commemorations. On the same grounds, I would reject any association between Lysippos and Aristotle, and all hypotheses about Lysippos' early presence at Pella and Mieza (Alexander's "school"), based on no ancient source or material evidence.

Ancient sources, albeit few, attest to Lysippos' activity in **Athens**. Pliny (*NH* 34.65) cites a satyr there that has occasionally been equated with the Silenos holding the Baby Dionysos; the attribution may be correct on stylistic grounds, but it is certainly not provable through the one laconic mention. The portrait of Sokrates in the Pompeion is said by a late source (Diog. Laert. 2.43) to have been by Lysippos, but the pedestal for it, if correctly identified, gives no confirmation. The attribution to the Sikyonian of the Sokrates Type B is based purely on style. Other monuments (Aisopos and the Seven Sages, Aristotle) are even more nebulous or unattested, and accepted as Lysippos' works because of his alleged political contacts (Kassander, Demetrios of Phaleron). Since Athens had a prosperous copying industry, which may have made replicas of Lysippan creations, once could also assume that others of his monuments stood there (e.g., the Sandalbinder, since an unfinished copy was found on the Akropolis; cf. Pl. 72), but no confirmation can be found in the ancient sources.[17]

Finally, **Taras**. Since Roman authors are explicit in assigning to Lysippos these two colossal images, one of which was taken to Rome when the city was first opening up to an interest in Greek sculpture, I assume the attribution to the Sikyonian sculptor can be retained. I do not imagine that the Herakles was chosen because of the fame of its maker, but rather because its size made it remarkable and valuable booty, and also because Herakles was as significant for the Romans as for the Greeks.[18] It seems surprising, however, that Lysippos would undertake such sizable commissions toward the end of his life, when he must have been quite old. Even visualizing him at the head of a large workshop would not explain his interest in traveling to Magna Graecia to engage in a difficult task. The decision would appear more sensible had the colossi been made toward the middle of Lysippos' career,

Lysippos

when we seem to draw a blank for the years around 350 (too early for Alexander), and when Taras would have been prosperous enough to afford the cost. At any rate, the scale of the two images made later reproductions impossible unless so reduced in size as to be insignificant for our purposes.

What has been added to Lysippos' geographic range with this second round of attributions based on literary sources? Sikyon, Thespiai, and Athens fall within the previously sketched picture, the first as Lysippos' birthplace, the second as part of Boiotia, where his presence was already attested, the third understandable not only in terms of its importance but also because of its proximity to Megara, where one of the signed bases was found. Taras in Magna Graecia is a notable extension, made more remarkable by the fact that no other sculptor of the fourth century is known to have gone to Italy. The Spartan affiliation of the town does not elucidate matters, since Lysippos does not seem to have previously worked in Lakonia.[19] He has occasionally been suggested as the maker of Timoleon's monument, yet that connection would at best have linked him to Syracuse rather than to Taras. Dion is a most important addition, however, as already mentioned, because it confirms a Macedonian contact.

All other sites listed by Moreno are hypothetical, derived from Alexander's presumed itinerary. Monuments have been reconstructed from mentions in the literary sources that do not specify places of origin—for instance, the "Alexander with the Spear," supposedly for Ephesos, whereas that statue might have been made for almost any other location and may even be an "archaeological chimaera," as some would maintain.[20] Sidon is included as the site of the actual lion hunt of Alexander with Krateros—as if Lysippos needed to have been present at the event to record its details later in the Delphic monument. Tyre is mentioned because of Alexander's interest in the cult of Melkart-Herakles, and Lysippos' supposed preference for depictions of the hero. Coins and medallions, usually of Imperial times, have been used to hypothesize the existence of groups that no ancient author describes, and which, because of Alexander's participation, have been given to Lysippos. These are modern speculations on which it is dangerous to build the artist's biography.

One more ancient source should be considered, however, because it is archaeologically verifiable. Athenaios (*Deipn.* 11.784) states that Lysippos designed a special kind of jar for Kassander when that general founded **Kassandreia** at the site of an earlier city, Poteidaia, in 316. According to that account, the sculptor, "having brought together many vessels of various kinds and taken something of the pattern from each, made his own individual form." The new shape would have served to advertise the famous Mendeian wine, which had been exported widely for some time. This information has been used to support Lysippos' connection with the Macedonians even after Alexander's death, and to lower the date of some of his works, allegedly commissioned because of Kassander's patronage. Todisco aptly noted the similarity between this passage and the story told about Zeuxis (Cic., *de*

Lysippos

invent. 2.1.1.), who supposedly derived inspiration from the five most beautiful women of Kroton to create the painting of his Helen of Troy. Yet he still accepted the validity of the Lysippos-Kassander association, while doubting the process described for the making of the vase. It is clear that the eclectic approach is a topos of ancient rhetoric, based on conceptions of beauty and perfection that cannot reside in a single person or object. What has not been noted, however, is that Virginia Grace has been able to establish a firm chronological sequence of Mendeian amphoras, and a clear evolution of the shape, from stouter to thinner. No sudden change in shape was recorded, although the American scholar, aware of the ancient anecdote, paid particular attention to the possibility. Moreover, these transport vessels became quite scarce after the fourth century, suggesting that wine production was no longer a major factor in the city's economy during the Hellenistic period.[21]

It could still be assumed that Athenaios' story, although fictitious, reflects something about Lysippos' activity. Yet even this supposition falls when it is realized that authors of the Roman period often believed that major sculptors were responsible for silverware and various types of containers—a notion that is not attested by any contemporary source. Myron, Pheidias, Praxiteles, Skopas, are all cited by the Roman poets as makers of vessels and engravers, perhaps because, in Pliny's time, sculptors often engaged in such activity.[22] Given this practice in Roman times, local beliefs about earlier Greek masters may not have seemed out of place. Yet they should be dismissed, together with the Lysippan anecdote.

But the jar for Kassander has also been invoked by modern scholars as an example showing that Lysippos—the maker of colossi—did not disdain to focus his attention on small and relatively insignificant objects. On such grounds, they have strengthened the claim of Lysippan authorship for the Herakles Epitrapezios. I would like to make this particular attribution the subject of a case study in our reading of the ancient sources.

THE HERAKLES EPITRAPEZIOS

This sculpture has received much attention, recently, but always within the framework of a Lysippan connection.[23] It seems to me, however, that its message of drinking and merry-making is much more appropriate within a Roman than within a Greek context, which therefore makes it more likely as a creation meant for a Roman clientele and passed off as a legitimate antique.

The Ancient Sources

Only three texts mention this piece: Martial's *Epigrams* 9.43 and 44, and Statius' *Silvae* 4.6. The last poem bears the title *Hercules Epitrapezios Novi Vindici*, also paraphrased in the preface to Book 4, thus giving rise to the epithet for the sculptural type. Both poets describe the piece—the first briefly, the second at great length and with digressions: a one-foot-tall bronze Herakles sitting on a stone covered by

Lysippos

the lionskin, his face upturned, holding a club in his left, a cup in his right hand. The second epigram by Martial verifies the attribution mentioned in the other two works by transcribing the inscription on the base of the figure: "ΛΥΣΙΠΠΟΥ *lego, Phidiae putavi*"—"I read 'of Lysippos,' I had believed 'of Pheidias.'" This statement should immediately alert the reader about the intended flattery, perhaps even the irony, in the poet's words, because he could not have mistaken for Pheidian a composition created a century later. But he pretends to ask his host who made that admirable Herakles, and then, when chided about his knowledge of Greek, reads the inscription himself, perhaps as proof of his learning. Genuine Lysippan signatures are never in the genitive, as everyone has acknowledged. In addition, the elaborate pedigree attributed by both poets to the statuette sounds highly improbable: owned first by Alexander the Great, the bronze would have passed into the hands of the Carthaginian Hannibal, then into those of the Roman Sulla, eventually to end in the house of the learned Novius Vindex, apparently much more to the god's liking. Acknowledging the difficulty of this line of transmission, scholars have usually assumed that Novius Vindex owned a copy, not the Lysippan original, but have remained firm in ascribing the prototype to the Sikyonian master, on the strength of the alleged inscription.

I would not doubt that such an inscription existed. Yet the formula as given recalls, at best, the *tituli* apposed in the third Imperial century to much larger statues whose attribution was only surmised—not only like that found on the Resting Herakles in the Pitti Palace mentioned above, but also, and much less reliably, like those on the two Dioscuri of Montecavallo: *opus Phidiae, opus Praxitelis*—despite the obvious similarity between the two pieces, which militates against separate authorship, let alone Classical ones.[24] Given the first-century A.C. dating of Martial and Statius, who were both in Rome under the Flavians, this explanation cannot apply to Vindex's Epitrapezios. A different copyists' practice is attested by another replica of the Lysippan Resting Herakles: the Farnese statue in Naples (see Pl. 68), once in the Baths of Caracalla and most likely made for that specific setting, is signed in the nominative (with *epoiei*) by Glykon of Athens, with no mention of Lysippos. Even more revealing, because only in excerpted form and closer in time to the two poets, is the bronze herm of the Doryphoros from the Villa of the Papyri at Herculaneum, signed in the same manner by the first-century sculptor Apollonios, son of Archias, the Athenian. His claim of authorship implies that knowledge of the original maker of the full statue—Polykleitos—was either taken for granted or considered irrelevant, Apollonios wishing to advertise his own skill in copying or, more probably, his ability to do so through his possession of appropriate casts from the Greek original. Had Vindex's Herakles been a bona-fide copy, we would have expected his maker's name, not that of his creator. A third possibility is that the "signature" on the Epitrapezios was a forgery, placed on the piece to give it a fame (and a price?) it would not otherwise have commanded.

Lysippos

Confirmation of this practice can be found in other ancient sources; one frequently cited is Phaedrus (*Fab.* 5, prol.), a freedman of Augustus, who acknowledges his self-serving use of Aisopos' name in his text, like some artists of his generation who write "Praxiteles" on their own marbles, "Myron" on their own silverwork, and "Zeuxis" on their own paintings, in order to obtain a greater price.[25] Other passages (and possible instances of forgery) could be mentioned. But once this alternative interpretation is accepted, there is no reason to believe that the "original" Herakles Epitrapezios was nonetheless by the fourth-century Lysippos.

Other clues to this conclusion can be found in Statius' and Martial's words. Although apparently writing independently, it is clear that both of them had been told the same story, perhaps during the same dinner party at Vindex's home.[26] Not only do they repeat exactly the same chain of transmission of the Epitrapezios from one famous owner to the other; both also add a brief comment about the fact that Herakles the hero, in his lifetime, stayed at the home of gentle/thrifty Molorchus. It is an allusion to a story (not well known in Greece although popular in Rome),[27] according to which Herakles, on his way to confront the Nemeian Lion, spent a night with a humble shepherd of Kleonai whose son had been killed by the beast, promising to return if he succeeded in his task. He did in fact do so; Molorchus then founded the nearby city of Molorchia and planted the Nemeian wood. This episode adds nothing glorious to the hero's fame; likewise, Molorchus' mention adds nothing of interest to the Epitrapezios' story. We may therefore assume that it was brought to the poets' attention by their very host, to suggest, with false modesty, that it was not preposterous for him to own an object with such a distinguished pedigree, since Herakles himself was known to have accepted humble hospitality when alive.

Novius Vindex was then the only—subjective, and obviously partial—source of information for both poets. Yet the vicissitudes of his bronze, and the words used to describe them, have been read as chronological clues for Lysippos' creation. First of all, the very authorship of the object was considered plausible in light of Lysippos' association with Alexander, and the latter's claimed descent from Herakles. Secondly, it was assumed that the Macedonian commissioned the piece before his destruction of Thebes, in 335, because Statius says (v. 70) that, of all his deeds, Alexander sought pardon only for his Theban triumph (*Thebanos tantum excusasse triumphos*). Yet the statement in context may be read as a generic assessment of what the monarch considered his glorious deeds, only one of which he regretted. Should the verses be taken literally, and should it be assumed that Alexander indeed confided his triumphs and disappointments to the specific statuette presiding over his convivial tables, the poet surely had no way of knowing at what time in his life Alexander might have deplored his Theban excesses—it could easily have been a retrospective consideration. This can only be a literary embellishment, inspired by

Lysippos

the climate of philhellenism promoted by Statius' host. Nor should supporting chronological value be given to Statius' assertion that the Herakles accompanied Alexander in all his travels, East and West (v. 61, *fertur comitem occasus secum portabat et ortus*), especially since he candidly acknowledges that this is hearsay information.[28]

What should rather be derived from the poems, besides the general description, is what the writers consider the festive appearance of the bronze. Although poetic embellishment could also be suspected, at least their reading of the piece must have been in keeping with its use by their host. So Martial speaks of Herakles' "left hand aglow with strength, his right with wine" (9.43.4: *cuius laeva calet robore, dextra mero*). Statius is more verbose: he makes it clear that the object is an ornament for the table (*gestamina mensae*), not a wrathful likeness unsuited to the gaiety of the feast (*nec torva effigies epulisque aliena remissis*); cheering the banquet as if rejoicing from his heart (*veluti de pectore gaudens, hortatur mensas*), the Herakles holds in one hand his brother's "tipsy goblet" (*marcentia pocula*). The statuette, to be sure, is in turn portrayed as merry at Alexander's table (*laetis mensis*) until the time when the monarch drank the fatal poison, then in sorrow while accompanying Hannibal drenched in Italian blood, finally again an adornment for the *convivia* of fierce Sulla. But these variant moods attributed to the inanimate bronze would still confirm the positive meaning of the object on Novius Vindex's table (*genius tutelaque mensae*).

This is the final clue provided by the poets: the Herakles is an embellishment for a dining room, something to be placed *on* a table. With that meaning, the term *epitrapezios*, although rare, occurs for the first time in Theophrastos (*de lapid.* 42), a contemporary of Lysippos.[29] In the sense of *at* the table, it does not appear until late antiquity. In connection with Herakles, it is used only by Statius. Correctly understanding the value of the epithet, scholars have debated whether or not Lysippos—capable of producing enormous sculptures—would have made something small, even if for Alexander. Not only was the Kassandreia jar brought into the argument, but also the fact that the master delighted in contradictions—for instance, portraying the Resting Herakles so muscular yet so tired—and might have enjoyed creating a small-scale Herakles who looked instead powerful beyond measure, "a huge god in a small bronze" (Mart. 9.43.2: *exiguo magnus in aere deus*). It is clear that this line of reasoning rests on a sequence of assumptions and attributions, some of them unprovable, others even unlikely.

The Evidence of the Monuments
Apparent confirmation of scholars' doubts was provided in 1960, when a colossal, fragmentary Herakles in marble was found at Alba Fucens, in the Abruzzi (now in the Chieti Museum). The statue held a phiale in its left hand, and rested its right

Lysippos

on an upright club, thus reversing the pose of the poetic descriptions. Because the colossus was discovered within a specially appointed room with columns, on the axis of a larger complex flanked by porticos, it was suggested that the entire structure was a banquet hall, and the room a shrine for Herakles, visualized as presiding at the banquets.[30] The term *epitrapezios* was therefore read in its later meaning, and a different chain of events was proposed: Lysippos would have made a colossal Herakles "at the table," feasting as if in Olympos, or at the end of his labors; the objects at reduced scale might have been made either earlier as models or later as variants and replicas, the first of them by Lysippos himself for Alexander.

The various arguments for or against this interpretation have been well summarized by Bartman, and others could be added. Although some scholars continue to accept the Alba Fucens marble as a possible copy of the Lysippan Epitrapezios, several considerations militate against it. Not only is the complex in which the statue was found unsuited for banquets; it is also much better suited for a meat market or *macellum*. A statue of Herakles would be quite appropriate there, since in Italy the hero was associated with the protection of trade. Through his role as the killer of monsters, he was considered (with Minerva) as the bringer of civilization to wild places; he was therefore connected with colonization—and Alba Fucens was a Roman colony founded in 303. The cult of Herakles was among the earliest in Rome, celebrated at the Ara Maxima in the Forum Boarium, allegedly established by Phoenician traders; Herakles' Italic myths included his fight with the brigand Cacus, over a cattle issue, thus strengthening his association with such animals.[31] Finally, and to my mind this is the most important point, the Alba Fucens statue conveys an entirely different message from the Epitrapezios described by the poets.

With a club under his right palm, the marble hero looks ready for action—as contrasted with the nonbelligerent pose of Vindex's bronze, who casually uses the club as support on his left side. In addition, the vessel the colossus holds in his left hand seems to me to be a phiale, not the base of a drinking cup.[32] He is therefore ready to receive libations, as appropriate in a cult setting, and again in contrast to the merry drinking of the "Lysippan" bronze. The reversal of hands in the holding of attributes is not a harmless variation, as sometimes assumed: it is a major and intentional change. At gigantic scale, moreover, the Herakles is bound to look intimidating—certainly not merry. The somber head looks straight forward and downward, toward the approaching worshipers. I would also agree with Bartman that the beard of this large image is too symmetrically arranged to correspond to a Greek prototype; I have checked many fourth-century bearded heads, and no original sported a clear central part to its strands. This symmetry seems to me a typical Roman preference and would confirm that the Alba Fucens is a Roman creation of the Late Republic, only vaguely inspired by Classical prototypes.[33] The same comment applies to the marble head in Lucera, also supposedly copying the Lysippan original.

Lysippos

Most of the statuettes traditionally associated with the Epitrapezios because of size and pose, whether in bronze or marble (Pls. 69–70), seem to show the same divided beard whenever the pertinent head is preserved. This feature, together with other details, leads me to believe that this particular type of drinking Herakles meant for the table is indeed a Roman creation as well.

Plates 69–70

To be sure, seated Herakles types existed since the Classical period. Lysippos may have made the colossal one for Taras (although sitting on a basket, to allude to the Labor of the Augean Stables), and Spartan tetradrachms, as early as 260–210, show as device the muscular hero on a rock, with one leg sharply bent back, the other forward and relaxed, holding a club with the right hand and an uncertain object in the left.[34] We would therefore expect the motif to have been used, in various forms. But 21 replicas have now been collected as more or less faithful reproductions of the original Epitrapezios, through correspondence of attributes and approximate size. Reversal in the leg position or the head turn is accepted as irrelevant copyist's liberty; indeed, the intended message remains unchanged. Two of the bronzes, however, shift cup and club as well, and may thus reflect a different prototype, or rely on the small scale and the intended position (on a table) to fulfill their function.

Bartman accepts that considerable variation exists within the four extant bronzes (surprisingly few for a bronze original), but within her catalogue of the more numerous marble replicas she isolates 11 items, her "London Group," that seem more homogeneous in details and approximate height, all clustering around 0.45 m. An additional five stone statuettes are considered closely similar except in orientation.[35] Styles are, however, different in all, each betraying its time of manufacture. I wonder about such fluctuations, since at the small scale of the pieces, even a few centimeters make a difference, and attribution to a specific master is usually justified on grounds of style, nebulous as the Lysippan style may be. Finally, Vindex's Epitrapezios is the only piece for which a precise description exist; if we accept variations in the pose, we have lost contact with the supposed prototype, and our *Kopienkritik* is bound to be influenced by personal notions. Indeed, Todisco and Moreno consider the best replica to be a 0.17 m. high bronze in Vienna, which Bartman (cat. no. 21) labels unusual for the sharp turn of its head and the reversal of its attributes. The considerable diminution in height (from the "foot" of the presumed Lysippan original) may also be significant. It would seem as if the collected images are variations on a *motif* rather than on a specific creation.

One could legitimately ask how a treasured object in the possession of a famous man (be he Alexander, Hannibal, or Sulla—even Vindex, for that matter) could be copied, let alone accurately. An obvious answer, for those who believe in a Classical prototype, would be that Lysippos had made more than one version of the piece, so that those that were left behind by Alexander could have given rise to the replicas. Yet it seems peculiar that the original (to judge from the consistency of the replicas on this point) should have depicted Herakles old and bearded, since Alexander, on

his own coinage and perhaps even his portraits, promoted the image of the youthful, beardless Herakles. Moreover, dates and distribution of the extant figurines are peculiar.[36] The earliest seems to be a marble statuette from the Agora of the Italians on Delos, dated on provenance and style to the late second or early first century. A similar figure from the same island is so badly mutilated that identification must remain uncertain. A limestone version, from the Palace of Sennacherib at Nineveh, now in the British Museum, might be thought to result from Alexander's conquests, and a *terminus ante quem* of A.D. 50 could be suggested by the destruction of the palace; yet the date of the statue is given as the second century A.C. in the *LIMC*, and I would agree, on stylistic and epigraphic grounds. The other items catalogued by Bartman are mostly of Imperial date. Whenever provenance is known, they represent quite a geographic range: one from Athens (her no. 1) is missing all four limbs and the head, so that its attributes are in doubt; one or two may come from Asia Minor (nos. 10, 18), two are from North Africa (no. 2, Cherchel; no. 3, Cyrene), one from Roman Germany (no. 20, Jagsthausen); five are probably from Italy, one of them, a terracotta, having been found in a Roman house at Sinalunga.[37] The best of these (perhaps still Late Republican) is a rather large bronze (est. h. 0.75 m.) from the peristyle of the so-called Villa del Sarno, near Pompeii (cf. Pl. 69); excavation accounts mention that it was placed in a prominent location at the north end of the garden, fully visible from the triclinium (Ill. 22), and surrounded by sculptures with Dionysiac subjects. A wreath on the bronze head enhances the impression of a convivial Herakles. The relatively large number of the stone replicas, as contrasted with the surprisingly few bronzes, suggests a more frequent use within gardens or on the marble tables of Roman villas, especially since their dimensions are consistently larger than the one Roman foot of the presumed original.

The Evidence of the Context
Given the varied chronology of the replicas, their mostly uncertain provenance, their range of variations (which makes me doubt their derivation from a single prototype, as mentioned above), the term "context" can be used here in only one of its many accepted meanings: the ambiance suitable for a drinking Herakles.

In Greek times, the hero was considered a great eater, not necessarily a great drinker. Pindar and other sources call him *bouphagos*, capable of eating two oxen at one time, and prodigious appetite is often mentioned as typical of athletes.[38] Wine was nonetheless appropriate for him: the wise centaur Pholos had been given by Dionysos a special pithos of the liquid, just for Herakles' passing by on his way to Erymanthos and the Boar, although Pholos hesitated to open it, since the fragrance would attract his wilder companions—as in fact it did, and it provoked a fight. Wine was considered harmful if not used in moderation, as uncivilized creatures tended to do. Drunkenness had caused the attack on the Lapith women at Peirithoos' wedding feast and the ensuing Centauromachy. And wine could be used to enfeeble and deceive, within a system of exploitation and transgression—as when Odysseus

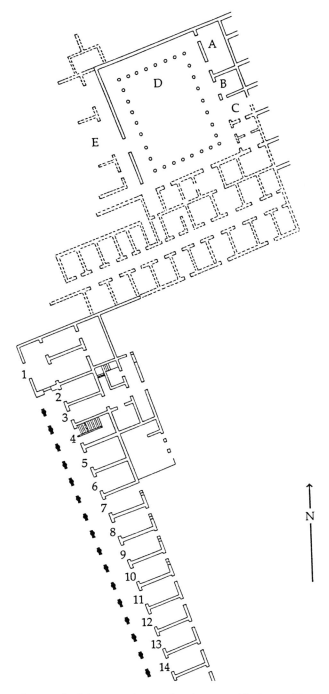

Ill. 22. Villa del Sarno, plan, with indication of findspot of bronze Herakles at *D* (after R. Winkes, *Roman Paintings and Mosaics*, Catalogue of the Classical Collection, Rhode Island School of Design [Providence 1982])

Lysippos

blinded Polyphemos, Hephaistos was brought back to Olympos against his will, or Apollo tricked the Fates into allowing Admetos to have someone else die in his place.[39] A drinking Herakles could indeed be dangerous: not only did he rape Auge while intoxicated, but he also may have killed some of the *oinochoi* who served him at human banquets—the significantly named Kyathos, son of Architeles, while the hero was banqueting with Oineus; or, on another occasion, a young kinsman of Oineus (differently named by the sources: Eunomos, Eurynomos, Ennomos, Chairias, or Archias), perhaps accidentally.[40]

Yet Herakles, at least in Greek times, seems usually to have drunk in moderation. One major episode of excess is traditionally quoted from Greek sources: the hero's speech in Euripides' *Alkestis* (vv. 782–89), when he stresses the need to live for the day, and seems to be in his cups. Yet this apparently rowdy behavior is a necessary foil for the atmosphere of mourning permeating Admetos' house after Alkestis' death, heightening the contrast between the host's loss, which the spectators know, and the unaware guest's social transgression. When Herakles finally learns who has died, he sobers up immediately—too fast, even for a hero, to have been truly inebriated—and springs into lucid action, with no ill effects from his indulgences. The intended emphasis is therefore not on drunkenness but on light-hearted cheerfulness.

Iconographically, the Greek Herakles is a dignified symposiast, either as a member of the Olympians or, while reclining in civilized Greek fashion, alone or as a host to other gods. An iconography of the drunken Herakles, by contrast, is said not to be attested before the Middle Hellenistic phase, and the true association of the hero with wine belongs to the Roman period. At that time, Herakles is frequently depicted as part of Dionysos' entourage, and even in competition with him, in drinking contests. This imagery seems to stem from an Italic tradition, which also connected drinking cups with Herakles, either for libations and dedications to the hero/god or as a form of decoration, placing his head in a central medallion.[41]

Italic as well may be the fashion of drinking and dining while sitting, rather than reclining. Bartman makes a point of the seated pose in trying to disprove the notion that the Alba Fucens Herakles is "at the table," but I believe the issue is pertinent even to the Epitrapezios motif.[42] Not only did Romans occasionally sit while dining—a fashion they may have adopted from the Etruscans—but their tables were different from the narrow three-legged stands placed next to Greek klinai, and may have happily carried a statuette meant to encourage drinking. The entire Roman approach to the pleasures of the table was different from the Greeks' and is worth exploring.

That the Romans were good eaters is known through several texts; now it has been pointed out that many more allusions to food exist in sources where they had not been detected, with a persistent depiction of a society at the dinner table. Drink-

ing practices may have also changed from Hellenistic to Roman times. Whereas the Classical Greeks mixed their wine with water in large kraters, from which the diluted liquid was then distributed into the drinkers' cups, the Romans seem to have discontinued this convention, preferring to indicate, on an individual basis, how much water (whether hot or cold) they wanted in their wine. The large mixing bowl, as a functional shape, may have disappeared as early as the Hellenistic period, to be henceforth used as an iconographic symbol for a container—of wine poured directly into it from amphoras, or even of water alone. Some banqueters may have indulged in undiluted drinking, encouraged to "live it up" by their host and by a variety of other allusions, such as the presence of skeletons at the table, represented on their own silver cups (as shown by the famous examples from Boscoreale) or in other forms. This insistence on the brevity of life and the importance of enjoying its pleasures is not just a Greek, Epicurean, concept but was present also in Egypt, and was particularly popular in Rome during the first century before and after Christ.[43] It is within this context that we should visualize a "Herakles Epitrapezios" holding out his own cup in cheerful drinking.

The Later Contaminations
It has been pointed out that the "Lysippan" Epitrapezios was the inspiration for a series of variants and imitations in later times, in keeping with different needs and climates. In one case the type is transformed into a Silenos; in another, into a youthful Herakles with lionskin on his shoulder; in yet a third, by conflation with the Farnese type, into a Herakles supporting himself on a club propped under his arm, rather than held by the left hand. The Villa del Sarno find is supposed to have served a private cult, and so is another, in tufa, from Rome.[44] Given these variations, how legitimate is it to read a specific meaning in the Roman reproductions, and thus to argue against a Lysippan original, on the basis of "context"?

We go back to the original grounds for the attribution: the poems by Martial and Statius. The context of the particular piece they describe is certainly that of a Roman house, where the piece is kept on the dining table, not in a special case, as a collector's item. The inscription assigning the bronze to Lysippos is read for us by the poets' eyes, and is the main evidence in favor of a Greek prototype. Yet, as previously noted, replicas do not agree among themselves, whether stylistically or in terms of size. To select one example over another as closer to the Lysippan model is a personal judgment—indeed, the Vienna bronze preferred by Moreno is, by his own dating, an Antonine product, which Bartman considers a variant of the original. On present evidence, to disentangle the intricate web of connections and alterations represented by the extant sculptures seems a Herculean task. But if we remain within the realm of the literary sources, I believe that a "Roman" reading is as plausible as, or even much more likely than, a Greek one.

Lysippos

To be sure, all the evidence collected above is circumstantial, and open to different interpretations. Nonetheless, I am still convinced that no attribution to a major master can be made on the testimony of two sycophantic poets, who aim only at flattering their credulous patron[45] at a time when forgeries of genuine antiques seem to have been common.

STYLISTIC ATTRIBUTIONS TO LYSIPPOS

As already mentioned, a number of sculptural types have been given to Lysippos on purely stylistic grounds, without support of either ancient descriptions or epigraphic evidence. How many of these can be legitimately included in a Lysippan corpus? Or, to approach the issue in a more comprehensive way, what would I accept as Lysippan within the world of replicas and echoes, whether attested or unattested through the ancient authors? I shall divide my choices into three groups: Group I comprises works, as known through later copies, plausibly assigned to Lysippos; Group II: works, either originals or copies, plausibly assigned to the fourth century; Group III: works, either originals or copies, implausibly assigned to Lysippos because probably later than the fourth century.

The testimony of Pliny (*NH* 34.65), although derived second-hand from other sources of dubious objectivity, suggests that Lysippos made figures slenderer, with smaller heads than those of his predecessors, thus imparting his bodies an apparent greater height. He is also supposed to have altered the "square" stance used by earlier sculptors, although "*quadratas staturas*" is a loaded definition. If, however, we read these words in terms of what we see represented in *original* Greek sculpture of the late fourth century, we do note a greater elongation of the bodies, a proportionately smaller, rounder rendering of heads, and a trend toward unstable poses. To be sure, such traits are mostly to be observed on gravestones and reliefs, and thus represent primarily Attic fashions, rather than "Sikyonian" or "Lysippan." But, given the interaction among sculptors, and the diffusion of styles, we can accept these general conclusions, whether or not we believe that Lysippos himself spent some time in Athens. It should be stressed, however, that these traits appear toward the end of the fourth century, almost all past the 331 date set conventionally as the inception of the Hellenistic phase. If there is anything we can recover of Lysippos, therefore, it would be his work during the last decades of his activity.

Group I

Perhaps the first acceptable attribution is the **Kairos**. Here too we seem dependent on poetic descriptions and references, but at least they are closer in time to the original creation. The type is so bizarre, however, and so in keeping with the allegorical trends of the period, that we may tentatively include it among Lysippan works. Note, nonetheless, that the Romans could turn the image into their own conception of Tempus by providing it with a beard.[46] The lack of reproductions in

Lysippos

the round prevents closer observations about Lysippan style, but the pose is certainly unstable and momentary.

On the same static grounds we can tentatively accept the **Eros** as identified through certain Roman copies: the bent knees, the obvious torsion, the momentary pose speak in favor of a fourth-century attribution, perhaps to Lysippos.[47] The number of replicas is, however, irrelevant as a supporting argument, as stated above, since it can be disproved by the next attributions.

I do not doubt that Lysippos made more than one "portrait" of **Alexander**; yet in this case *Kopienkritik* cannot be exercised, since all assigned works exist in single replicas (including the badly damaged Azara Herm and its "copy"). Statuettes, as we have seen, usually reflect their time of manufacture, and cannot be used as valid grounds for stylistic comments, even when identification as Alexander is not debated, as it mostly is. Cavalry encounters under the Macedonians and the Romans were widespread enough that triumphant-rider types could be produced without directly copying the Granikos Monument. Indeed, some poses are attested from previous centuries, even within mythological contexts, such as Centauromachies and Amazonomachies.

Group II

Other attributions seem to me plausible, even provable, as fourth-century works, but not necessarily as Lysippan: the Agias, the Silenos holding the Baby Dionysos, the Herakles Farnese Type, the Apoxyomenos.

The **Agias** has been well analyzed and illustrated.[48] It is indeed an original, well-dated, single statue with no replicas, and its dependence on the Pharsalos bronze by Lysippos can only be surmised, not even properly defended. Its smaller head and elongated body (although not quite as slender as those of other members of the Daochos Monument) would fit well within a Lysippan scheme of proportions, but it also corresponds to fourth-century trends of the 330s. The same can be said about its intense expression, deeply set eyes, and bulging forehead, which can be compared with similar (individual) features in works assigned to Skopas and Praxiteles. Its stance is more stable than one would expect in a Lysippan creation, although perhaps determined by the figure's position within a group.

The **Silenos holding the Baby Dionysos** (Smith 1991, fig. 149) is a more difficult case. Unstable pose and association with a child would fit within the climate of the late fourth century; yet this is a time when satyr statues are few, if any, after a long hiatus, and it is difficult to visualize this specific piece within a proper context—the Theater of Dionysos? a choragic monument? a Dionysiac sanctuary? I am today perhaps more inclined to consider it Classical/early Hellenistic than I was previously, but I should still express my reservations.[49]

The **Resting Herakles** (**Farnese Type**; cf. Pl. 68) has the torsional pose and unstable balance typical of the late fourth century.[50] Its head is relatively small in

proportion to the huge, muscular body, and its psychological content would be in keeping with late Classical/early Hellenistic trends. I cannot be sure that the original was by Lysippos, but it was certainly an influential work that set the "physiognomic" traits of all future Herakles portraits. After its creation, the bearded, mature Herakles would primarily be visualized with the features of the Farnese type. In addition, its composition virtually requires that the spectator move around the entire figure, to capture its complete meaning when the Apples of the Hesperides, held behind Herakles' back, finally come into view. As such, it is a spectacular example of the three-dimensionality that could be achieved by its time, although frontal aspects of the sculpture, at least to judge from the copies, were also aesthetically valid. The type also represents a departure from previous compositions that needed supporting figures or architectural contexts to tell a story; here a single figure embodies the entire narrative for the informed viewer, through well-placed clues. Numismatic evidence suggests that the motif, at least, was known since the turn into the third century.

Finally, the **Apoxyomenos** (Todisco 1993, pl. 274). It is the most consistent attribution to Lysippos, despite the lack of a full description in the one ancient source that mentions it: Pliny's *NH* 34.62 (*destringens se, apoxyomenos*).[51] The motif goes back to the fifth century, and is attested in later times. The statue itself, although known in very few replicas, is impressive in its subtle rotation on its central axis, its penetration of forward space, its shifting pose, its elongated legs that make the head seem even more remotely small. Whether it is truly by Lysippos I could not say, but its dating toward the end of the fourth century (c. 320) seems correct, although an original setting in Asia Minor may be hard to defend.

Group III
Many more attributions to Lysippos—even more than those included in *Lisippo* 1995, somewhat restrained by the limitations of a text keyed to objects in an exhibition—have been made through the years, some with greater plausibility than others. Recently, it has been forcefully argued that an original by the very hand of the master exists in the so-called **Getty Youth** (Todisco 1993, pl. 311), although no specific context can be produced for a statue allegedly found underwater, off the Adriatic coast of Italy. I would continue to doubt, not only the attribution, but even the accepted dating, which could perhaps be lowered to the Late Hellenistic period.[52]

The **Berlin Athlete** (Todisco 1993, pl. 309) represents a comparable situation: attributed by some to Lysippos, by others to his pupils, it could easily be one of those athletic statues created for the Romans after vaguely Classical models.[53] The head type recurs in several other compositions, and may be part of that Lysippan revival postulated toward the end of the second/early first century on the strength of the Borghese Warrior. Other examples, also once attributed to Lysippos, are the bronze **Seated Hermes** from the Villa of the Papyri at Herculaneum, and the two

Lysippos

Bronze Runners from the same findspot, now clearly (and, to my mind, convincingly) seen as Roman creations for their specific location.[54]

Perhaps the most impressive among the various attributions is one more athletic figure, often called the **Sandalbinder**, although its action represents the untying, rather than the tying, of the sandal. The relatively recent discovery of two replicas of the type, in Side and Perge (Pl. 71), has extended the range of the reproductions to Asia Minor, albeit in Roman times. Certainly, the type itself was known in Italy in the Late Republican period, when the body was used for honorary portrait statues. We have already mentioned the unfinished torso in Athens (Pl. 72), which has given rise to theories that the original, at least there, might have depicted Theseus. A literary reference, albeit late, has been used to connect the original with a statue of Hermes *tying* his sandals, in Constantinople; the Perge replica, clearly meant to depict Hermes, may support this identification. Yet Roman copyists could easily adapt and conflate types, as we have seen, and it is impossible to achieve certainty.[55] In particular, the pose with only the right hand lowered, the other arm resting on the raised right knee, makes it clear that the strings of the sandal are being loosened, and therefore Hermes cannot be preparing himself to run his father's errand, as described by Christodoros. A Hermes in Leptis Magna has not received sufficient attention in this context. He too rests his left foot on a turtle, like the Perge replica, but the raised leg and generally similar pose have been used to support a baby, thus creating a Dionysophoros type—one more example of the inventiveness of "copyists" of Roman times.[55]

Attribution to Lysippos is postulated solely on stylistic grounds: the head, which resembles that of other athletes, equally given to the master; the propped foot, again considered typical, on comparison with some alleged portraits of Alexander the Great no longer ascribed to the Sikyonian, or the equally dubious attribution of the Poseidon (Lateran Type); the alleged three-dimensionality of the pose. This last point is perhaps the most significant. I had argued long ago that the composition was Late Hellenistic because of its inherent flatness, which made side views unsatisfactory and almost incomprehensible; I therefore ranked the statue with others that appeared to translate into versions in the round motifs originally rendered only in relief or painting.[56] The Asia Minor replicas seem to be more torsional, with greater penetration into space; in particular, the presence of a neck strut has suggested that they were meant to be seen from a three-quarter angle, rather than in profile, since from an oblique viewpoint the strut becomes invisible. Yet the profile view is the one that produces what I call "the eloquent silhouette," the one that makes the action most clearly understandable; the two-dimensional motif, in fact, exists in this form at least since the time of the Parthenon frieze. I suspect that struts were of no concern to viewers of the Roman period—witness the tremendous supports for the arms of the Vatican Apoxyomenos, which to a modern observer appear to spoil the composition, and which no angle of vision could hide. Even the Perge

statue, moreover, from certain angles, presents a very narrow aspect, almost two-dimensional. Had the piece been conceived as a truly three-dimensional work, from no viewpoint should a lack of compositional depth be perceivable; contrast, for instance, the "Lysippan" Eros type, which, despite its deliberate flattening by copyists, conveys its torsional movement through its basic pose. At present, therefore, I retain my original position in favor of a Late Hellenistic date for the "Sandalbinder."

Incipient movement and torsion are considered such basic characteristics of Lysippan art that one last attribution should here be mentioned, to be disproved: the lifesize **Bronze Ram** in Palermo, once one of a pair in ancient Syracuse.[57] Originally assigned to Lysippos, its date has now been lowered to the early third century and the Lysippan School, on the assumption that it once adorned Agathokles' palace in the Sicilian city. Yet the rendering of its eyes, with clear lunate depressions for the pupils and engraved irises, unmistakably places the object no earlier than the Hadrianic period, and quite probably some 50 years later.

In summary, from this analysis Lysippos—the third member in the famous trilogy of fourth-century sculptural geniuses—has emerged as shadowy as Skopas and Praxiteles, with the difference that *none* of the works examined can be attributed to him with the certainty of Praxiteles' Knidia. The Apoxyomenos, if indeed by him, would give him innovations presaging the developments of the Hellenistic period, as in fact are to be expected in a late fourth-century work. The Resting Herakles, again, if correctly attributed, would expand his range to include exaggerated renderings with psychological, narrative content. The Kairos would testify to Lysippos' interest in allegory and the bizarre. Yet there are no common stylistic denominators among the three works, from which to derive a general impression of the master's manner, and all three may date from late in his career. What his early style was like, we do not know, but he began his sculptural activity at the Panhellenic sanctuaries, and seems to have accepted private commissions at various stages of his life. From the signed bases, he appears to have been a sculptor of men, open to collaboration with other masters, and working exclusively in bronze, thus specializing to an extent perhaps unusual in his time and again indicative of things to come.

There is no question that Lysippos was a prolific sculptor,[58] that some of his sculptures were colossal; and that he worked for the greatest man of his time—although perhaps less extensively than has been assumed—which ensured his fame for posterity, especially as the creator of the Hellenistic-ruler portrait type. On these grounds, he can be considered the quintessential fourth-century master, opening the doors to the next phase. But he was also steeped in tradition, and some of his compositions seem to have been based on previous themes and motifs, while some of his renderings, if correctly attributed, he had in common with other sculptors of his time.

Lysippos

NOTES

1. The bibliography in *Lisippo* 1995 (pp. 509–10) lists 51 entries by Moreno. As the most recent expression of Moreno's opinion, this vast catalogue of an exhibition held in Rome during Spring 1995, although compiled in collaboration with various authors, represents his 52nd, and will be cited throughout in preference to Moreno's previous publications. When other contributors to the catalogue are cited, their names will be mentioned. Numbers preceded by 3 refer to locations; those preceded by 4, to works attributed to Lysippos; those with 6, to antecedents and later echoes; additional numbers in parentheses refer to individual items within the general categories of objects displayed in the exhibition.

Other recent treatments of Lysippos are Todisco 1993, 112–31; Ridgway 1990, 73–82, 113, and passim; Stewart 1990, 187–91, 289–94, and passim. In the forthcoming volume edited by O. Palagia and J. J. Pollitt, *Personal Styles in Greek Sculpture* (Yale Studies 30, Cambridge University Press), the essay on Lysippos is by the late Charles M. Edwards, whose manuscript I was able to read ahead of publication, thanks to the kindness of Prof. J. J. Pollitt.

2. See *Lisippo* 1995, 18–25; religious affiliation is mentioned on p. 19; for the Pelopidas Monument, see pp. 48–49, no. 4.2(1), with illustrations, or Marcadé 1953, 66v, who believes the general may have been still alive when the statue was set up, thus moving its date to around 369.

On the anecdotal value of Pliny's information on Lysippos, see refs. in Chapter 7 n. 11; Kris and Kurz 1979 mention Lysippos repeatedly as exemplifying the types of stories that can develop around an artist.

3. A preliminary announcement, by newspapers, is reported in *JHS-AR* 39 (1993) 35; see also *Lisippo* 1995, 32, and 42, no. 3.24.

4. Bronze plaque for Troilos: *Lisippo* 1995, 47, no. 4.1(1); Marcadé 1953, 71v–72. Poulydamas base: 91–93, no. 4.12(1); see also pp. 94–97, nos. 4.12(2–3), for marble heads (Copenhagen, Ny Carlsberg; Florence, Uffizi) possibly copying the original bronze; pp. 97–102, no. 4.13(1), and echoes on a coin and gem, 4.13(2–3), for the Terme Boxer (which I continue to consider Late Hellenistic); pp. 319 for Roman adaptations of the possible type. The date is advocated on the basis of the Thessalian ascendancy under Daochos II, who erected a family monument with ancestral winners at Delphi. Skotoussa was destroyed by Jason of Pherai in 367 and was abandoned in 321; it was therefore in no position to commemorate its champion. Yet private individuals also set up statues of their ancestors: cf. supra, Chapter 7, n. 11 (Pausanias) and n. 34 (Leochares, family of Pandaites).

For the reliefs on the Olympia base, see also Todisco 1993, 116, pl. 246. The most extensive description is Marcadé 1987, where the base is considered a rather conservative workshop product and the "exotic details" are defined as superficial.

Pausanias mentions other works by Lysippos at Olympia, but they cannot be verified through extant evidence, and are therefore omitted from discussion; at any rate, the master's activity at the sanctuary is attested(?) by the two works cited. The other Olympia attributions are: Paus. 6.2.1 (Philandridas of Stratos, Akarnania, or more probably his son, winner in 368; Xenarches' name seems to be intrusive, moved from the next sentence into a corrupt text, according to Marcadé 1953, 72 n. 3); 6.17.3 (Kallikrates of Magnesia, winner in 344 and 340); 6.14.12 (Pites of Abdera, mercenary commander, c. 323, two statues); 6.4.6–7 (Cheilon of Patras, after either 338 or 322—cf. Stewart 1990, 290, T 122). It would therefore

Lysippos

appear that Lysippos, if indeed he made all these dedications, worked at Olympia, at intervals, from c. 372 to c. 322—a considerable span of time.

5. For a cautionary note on "collaboration," however, see supra, Chapter 7, n. 10.

Korveidas Base, at Thebes: Todisco 1993, 47 and fig. 14, 127; *Lisippo* 1995, 218–19, no. 4.32(1) (drawing and photo), with comments on the left side of the base, and the possible connection with an additional inscription, now lost, that would suggest a commemoration of youths fallen at Chaironeia. It is unclear, however, whether all the athletes represented had died, or simply the son of Diogeiton to whom the lost inscription refers. See also Marcadé 1953, 66v–67v; Stewart 1990, 290. For C. M. Edwards' opinion, see supra, n. 1. Note that Polykleitos II, although said to be "of Argos" in Todisco's stemma (p. 46) is, however, brother of Daidalos "of Sikyon."

I am not entirely sure that Lysippos' Korveidas rested his right foot on a support. The hypothesis has been made on the basis of the imprint on the pedestal, larger than a footprint and somewhat undetermined in shape. Note, however, that the imprints for the Timokles are also wider than the footprints themselves and equally formless; perhaps the markings on the surface are due to the removal, rather than to the installation of the two bronzes. I wonder, moreover, whether a pose with legs so close together is compatible with a raised foot.

6. Corinth bases: Marcadé 1953, 69 (found 1901), 69r–v (found 1903); dated "second half of the 4th c." For the second base, see also *Lisippo* 1995, 57–58, no. 4.5(1), where the athlete is said to be lifesize, and the pose is compared to that of the Getty bronze or the Berlin Athlete (nos. 4.10[1] and 4.34[1] respectively). The comparison with that of the Hermes Richelieu (for which see, e.g., Todisco 1993, pl. 53; attributed to a pupil of Naukydes?) is by C. M. Edwards (supra, n. 1), and seems more valid. The similarity of the letter forms to those on the monument for Timoleon was noted first by J. H. Kent, "The Victory Monument of Timoleon at Corinth," *Hesperia* 22 (1952) 9–18, esp. 17 n. 25, where the commemoration is connected with a victory in Sicily of 341; the parallel is accepted by both Moreno (*Lisippo* 1995) and Edwards. See also J. H. Kent, *Corinth* 8.3: *The Inscriptions* (1966) 78, no. 23.

Lucian (*Zeus trag.* 9) mentions a Poseidon made by Lysippos for the Corinthians, but this may mean the city proper as well as its two harbors or even its territory. The usual attribution of the Lateran Poseidon Type is repeated by *Lisippo* 1995, 220–25, no. 4.33, and hesitantly supported by Todisco 1993, 127, pl. 277; but I would side with Bartman 1992, 102–46, who derives the large replicas from an initially small prototype extant in several versions and unrelated to Lysippos. See also Ridgway 1990, 125–26 and further bibl. in n. 39.

7. Thermon base: Marcadé 1953, 68v (with dedicatory inscription dated to end of 3rd c.); *Lisippo* 1995, 41 (where Lysippos' work is attributed to the time of his [alleged] return to Sikyon after Alexander's death, 323–317); cf. also p. 24. Lindos base: Marcadé, 68v; *Lisippo* 1995, 179, no. 4.25(1), and cf. pp. 40 and 180, no. 4.26, for the Chariot of the Sun.

8. Megara base: Marcadé 1953, 69v–70; note that the verb is in the imperfect tense (*epoiei*) rather than the more common aorist (*epoiese*), another possible indication of late date. Paus. 1.43.6 mentions statues of Zeus and the Muses at Megara by Lysippos; cf. *Lisippo* 1995, 43.

Taras colossi: *Lisippo* 1995, 25, 44–45, 278–88, nos. 4.40(1–3) (Zeus), 4.41(1–11) (Herakles); for Niketas' passage, see also Stewart 1990, 292, T 129, and cf. T 126 (Pliny, *NH* 34.40, on the Zeus; both the Zeus and the Herakles are mentioned by Strabo, 6.278). A full discussion in Dörig 1957. Taras Herakles: Boardman 1995, fig. 40 (a possible echo).

Lysippos

9. Portrait of Seleukos: Marcadé 1953, 70r; Todisco 1993, 113. It has been suggested that the bronze Getty Youth may be a portrait of the young Seleukos as a victorious athlete, but this may not correspond to the inscription, and the identification is uncertain; see, however, *Lisippo* 1995, 68–73, no. 4.10(1), with echoes as nos. 4.10(2–12).

Pharsalos inscription and Delphi Daochos Monument: *Lisippo* 1995, 81, no. 4.11; for discussion of three figures on the Delphic monument, see pp. 82–85, nos. 4.11(1–3), and echoes of them as nos. 4.11(4–8). The statuette from the Antikythera wreck (Athens NM 13399), no. 4.11(5), is said to be unlikely to have been made specifically for the Italian market (as I had suggested), because of its heavy marble base. Yet confirmation of my position comes from the recent realization that two marble cylinders, closely resembling the Antikythera pedestal but originally published as weights, are instead the bases for some (clearly late) bronze statuettes from the Mahdia shipwreck: C. C. Mattusch, reporting on a 1995 Bonn Symposium, *Minerva* 6.3 (May–June 1995) 4. On the Daochos Monument, see also Todisco 1993, 114–16, figs. 34–35, pls. 237–43; Ridgway 1990, 46–49, with bibl.; a good discussion, by C. M. Edwards (supra n. 1) is forthcoming. On the Pharsalos inscription see also Marcadé 1953, 67v–68r.

Krateros Hunt, at Delphi: see Chapter 7 (under Leochares) and n. 35 for the literary references; cf. Todisco 1993, 123–25, figs. 36–37; *Lisippo* 1995, 172–75, nos. 4.22(1–3). Lysippos would then seem to have been working at both Olympia and Delphi from his early days to the end of his career. The date of the Krateros Hunt is, however, disputed: see Völcker-Janssen 1993, 121 and n. 19, who points out that the ancient sources do not mention the threat to Alexander and his rescue by Krateros.

10. Resting Herakles: various groupings have been attempted by Vermeule 1975 and Krull 1985; see now *Lisippo* 1995, Types Argo (no. 4.4, named after a replica in that city, pp. 51–56), Antikythera-Sulmona (no. 4.14, after the provenance of two replicas, pp. 103–10), and Farnese-Pitti (no. 4.36, pp. 242–50, original probably in Athens). Note that the Argos replica is under-lifesize, with a preserved height of 1.17 m., rather than the 1.71 m. stated in the text to no. 4.4(2), p. 52. See also Todisco 1993, 122–23, pls. 269 (Argos replica, with correct height), 271 (Antikythera replica), 272 (Farnese, in Naples), 273 (Pitti). For the inscription on the Florence replica, see Marcadé 1953, 70v. Boardman 1995, fig. 37 (Naples copy).

O. Palagia, in *LIMC* 4, s.v. Herakles, pp. 762–65, lists all these replicas under chronological headings; thus, the Antikythera statue is no. 699, pl. 492 (under "Marble statuary of the 1st c. B.C."); under "Marble Statuary of the Roman Period," she lists nos. 702 (Farnese replica), 703 (Pitti replica), and 704 (Argos replica, dated late 2nd c. A.C.), all illustrated on pl. 493. Only three variants of the type are mentioned, on the basis of changed poses and attributes: A (with right hand on hip), B (with lionskin on head), and C (with ivy wreath), nos. 727–37, pl. 495.

An under-lifesize marble example, interesting for its provenance (Naupaktos), is said to be either a 3rd-c. original or a Roman copy: Gogos 1993. From illustrations, it seems to me Roman.

On the variations within Lysippos' works, and his technique, see *Lisippo* 1995, 46, with other ancient refs.

The tetradrachm of Demetrios Poliorketes is given to Argos in *Lisippo*, 51, no. 4.4(1), but

Lysippos

to Corinth by M. J. Price, *The Coinage in the Name of Alexander the Great and Philip Arrhidaeus* (British Museum Catalogue, vol. I, Zurich/London 1991) 155–57, no. 680. I owe this ref. and other pertinent numismatic information to the kindness of Prof. Carmen Arnold-Biucchi; see also her 1995 comments (p. 227) on the independence of die-engravers. My previous position was stated in Ridgway 1984a, 73.

11. Praxilla: Tatian, *Contra Graecos* 33 = Stewart 1990, 296, T 136. *Lisippo* 1995, 208–15, equates that source with Pliny, *NH* 34.63, who mentions a drunken flute-player girl by Lysippos, and identifies the work in a type, of which the best known replica, although headless, is the so-called Berlin Dancer: no. 4.31(1) (**Pl. 73**). The head is, however, preserved in a bronze statuette that may confirm the fluting action: K. D. Shapiro (Lapatin), "The Berlin Dancer Completed: A Bronze Auletris in Santa Barbara," *AJA* 92 (1988) 509–27. Although the torsional movement of the figure could be in keeping with a late 4th-c. date, the composition could also be fully Hellenistic or later, and the consistently under-lifesize format seems improbable for a portrait.

Plate 73

12. *Lisippo* 1995, 31–45 ("Luoghi di Lisippo" by P. Moreno).

13. Kairos: Poseidippos, *Anth. Pal.* 16.275 (= Stewart 1990, 292, T 127) states that the statue stood in front of "the doors, as a lesson." It may therefore have been a way for the sculptor to advertise his skill, if the doors were his. Moreno, in *Lisippo* 1995, 190–95, no. 4.28(1–5), points out that Poseidippos, a near contemporary of Lysippos, was from Pella, and would have seen the work in his own town. Kallistratos (*Eikones* 6), however, although a late source (4th c. A.C.) mentions that Lysippos made the Kairos "for the Sikyonians." The Trogir relief has been dated by Cambi 1988 to the end of the 4th–beginning of the 3rd c., by Moreno to the 1st c., and the same date is given to the Akropolis relief. The Turin relief is Imperial (2nd c.). See also Todisco 1993, 112 fig. 33, pp. 121–22, pls. 267–68. On the Hypnos, see supra, Chapter 7, n. 76.

Pausanias (2.9.6; 2.9.8) mentions a Zeus and a Herakles by Lysippos in Sikyon.

14. Eros: Döhl 1968; Ridgway 1990, 99 n. 6, with bibl.; Todisco 1993, 116–17, pl. 247; *Lisippo* 1995, 111–29, nos. 4.15(1–12). For Edwards' work, see supra, n. 1. Pausanias gives information on the Praxitelean Eros in the same passage where he speaks of the Lysippan. For possible attributions, see, e.g., Todisco 1993, 68, pl. 103; the Centocelle type, given to Praxiteles by some commentators, is assigned by him to Euphranor: 93, pl. 197. Some modern authors would even give to Praxiteles the Lysippan Eros type.

15. The ancient sources on the Granikos Monument, and all possible echoes of it, are collected by Calcani 1989; see, however, my review of her book, *JRA* 4 (1991) 206–9. For the other main source beside Pliny (Vell. Pat. 1.11.3–4), see Stewart 1990, 290, T 121. See also *Lisippo* 1995, 148–56, nos. 4.18(1–4). On the "realism" of the *hetairoi*, Todisco 1993, 118, gives an interpretation similar to mine.

16. For my doubts on this score, see Ridgway 1990, 113–14 with n. 12, and 139 n. 14, for the suggestion that Lysippos could not have followed Alexander to Asia; this point of view, although somewhat more nuanced, seems shared by Todisco 1993, 113 ("not beyond the cities of the Asia Minor coast"), and by Stewart 1990, 190; on p. 291, he states that attempts to divide Lysippan chronology into Asian and Tarentine phases are "futile without further evidence."

Lysippos

Pliny's phrasing, *a pueritia eius* (scil. Alexander's), should refer to the range of the portraits, rather than to the time when they were made.

For comments on the slant in the ancient sources, see A. A. Donohue, "Winckelmann's History of Art and Polyclitus," in W. G. Moon, ed., *Polykleitos, the Doryphoros, and Tradition* (Madison 1995) 327–53. She stresses Pliny's emphasis on Lysippos' connection with Alexander. "The bias that accounts for the elevation of Lysippus seems to be his association not with Sicyon, but with Alexander" (p. 343). She then explains the importance of this association in terms of ancient conceptions of art history and of the conditions under which art could flourish.

17. Works in Athens: Silenos with Baby Dionysos: *Lisippo* 1995, 251–55, nos. 4.37(1–5); Sokrates: 256–65, nos. 4.38(1–8); Sandalbinder on Athenian Akropolis: 232, no. 4.35(1). For evidence of an Athenian copying industry since at least Late Hellenistic times, we can cite, e.g., the finds from the Mahdia shipwreck, the Neo-Attic reliefs from the Peiraieus copying the Athena Parthenos' shield, and several unfinished works from the Athenian Agora. See also J.-P. Niemeier, *Kopien und Nachahmungen im Hellenismus: Ein Beitrag zum Klassizismus des 2. und frühen 1. Jhs. v. Chr.* (Bonn 1985) for additional refs.

A few other sites are indeed mentioned by ancient authors in connection with Lysippan works: Argos (Zeus Nemeios; Paus. 2.20.3); Helikon (Dionysos; Paus. 9. 30.1); Lampsakos (a fallen Lion; Strabo 13.590); Myndos (Eros; emended text of Kedrenos = Stewart 1990, 292, T 128); Alyzia (Herakles' Labors; Strab. 10.459); and Kassandreia. This last will be discussed infra. I omit the others because they are not entirely reliable, or, at least, the works listed are not recoverable. They are all discussed extensively in *Lisippo* 1995. For a presumed signature at Kos (on the base of a child's statue for Timoxenos, son of Timoxenos), see Marcadé 1953, 76, pl. 13.3, where the text is read as *Lysippos ho ne[os]* and attributed to Lysippos II (fourth quarter of the 3rd c.); cf. Stewart 1990, 291 (no. 45, dated c. 300). It could be accepted by Moreno because he lowers Lysippos' chronology to the very end of the century.

18. Taras works: some of the ancient sources are cited supra, n. 8; for discussion, see esp. Dörig 1957. For the plundering criteria of the Romans, see Ridgway 1984a, chs. 2–3, passim. For the special prosperity of Taras just before 350, under the learned Archytas, see, e.g., J. C. Carter, *The Sculpture of Taras* (Philadelphia 1975) 8; his historical summary points out the war-torn conditions of the city in the second half of the 4th c.

19. Even the Spartan origin of possible Lysippan imitations does not strengthen the connection. Dörig 1957, 39–42, figs. 18–21, considers an over-lifesize marble head in Sparta to be earlier but approximately contemporary with the Tarentine Herakles, by a student of Lysippos. In *BCH* 95 (1971) 882–83, figs. 171–72, the same opinion is expressed, but *LIMC* 4, s.v. Herakles, no. 1312, pl. 530, dates the head to the 3rd c., perhaps from a type appearing on Spartan coins nos. 947 (seated Herakles; see infra, n. 34) and 194 (tetrobol, head of H., pl. 457, dated 219–196). *Lisippo* 1995, 286, no. 4.41(7), accepts the 3rd-c. dating, but connects the head with the Tarentine Herakles, on the strength of the cutting for a separate attachment on the beard, supposed to be the resting point for the raised hand; yet the comparisons proposed with bronze statuettes show the hand to be held somewhat to the side, whereas the Spartan head's cutting is centered on the feature—a rather improbable position for a resting pose?

Lysippos

20. The citation is from R. R. R. Smith, *Hellenistic Royal Portraits* (Oxford 1988) 62. For the alleged type, see Boardman 1995, fig. 38.

21. Kassandreia: see *Lisippo* 1995, 41–42. See Todisco 1993, 127 for the Zeuxis anecdote, and the statement that a working relationship between Kassander and Lysippos must have existed, even "se la realizzazione del vaso potrebbe anche essere frutto di fantasia."

The information about Virginia Grace's study of the Mendeian amphoras was given to me orally (Nov. 1994) by Dr. Carolyn G. Koehler, who worked long and closely with the late Dr. Grace. I thank her warmly for this help. Elizabeth L. Will also provided expert advice, mentioning that if a certain change is at all noticeable in Mendeian amphoras, it occurred in the 5th c.

For eclecticism, albeit of a different nature, as mentioned in ancient sources, see also *Rhetor. ad Herennium*, 4.6.9, where the juxtaposition of sculptural elements by various masters (Myronian head, Praxitelean arms, Polykleitan chest) is, however, cited as an example not to be followed. For a recent discussion of the passage, see, e.g., Corso 1988, 52, no. 18; cf. Ridgway 1984a, 84. Lucian's approach (*Imagines* 4–6) to the making of his Panthea reflects the same eclectic mentality. For the persistence of this topos, see also Kris and Kurz 1979, 43–44.

22. Pliny, *NH* 35.156; cf. also 33.130, 33.154–57, and Pomp. Porph., *ad Sat.* 1.3.90, for refs. to artists who seem to have been both engravers and makers of statues in the first century. To be sure, there is nothing inherently implausible in the notion that the same metalworking workshop could have produced items ranging from large statues to vessels, given the fact that ancient masters were primarily craftsmen and artisans rather than "artists" in the modern sense. On the other hand, whatever information is available comes from the Roman period and within unreliable contexts.

For the mention of major Classical masters as silversmiths, see, e.g., Martial, *Epig.* 4.39 (Myron, Praxiteles, Skopas, Pheidias, in that order), 3.35 (Pheidian engraved fish—"add water, they shall swim"), 6.92 (Myron's snakes engraved in a cup), 10.87 vv. 15–16 (Pheidias as engraver). Cf. also Theokritos, 5th *Idyll*, vv. 104–5 (Praxiteles as maker of vessels, although used in ironic sense: cf. Corso 1988, 44–45, no. 5). See also E. Perry, "Artistic Forgery in the Early Roman Empire," Abstract, *AJA* 99 (1995) 346, for possible forgeries involving the signature of the silversmith Mys; I am grateful to Dr. Perry for sending me a copy of her text.

23. See especially Bartman 1992, 147–86, app. 1 on pp. 191–92. Also *Lisippo* 1995, 140–47, no. 4.17; Stewart 1990, 293, no. 13, T 130; *LIMC* 4, s.v. Herakles, "H. Epitrapezios," pp. 774–76, nos. 957–83. I have already expressed some of my thoughts on the Herakles in my review of Bartman 1992: *BJb* 194 (1994) 628–33.

24. For a discussion of this "signature," see Corso 1988, 30, no. 18.

Zadoks-Jitta 1987a, 97, suggests that Vindex himself may have added the label to his Epitrapezios, since he was considered an expert "in giving back their maker to unsigned statues." She believes that Sulla may have commissioned the original, because the statesmen and generals of c. 100 B.C. were influenced by the Stoic conception of Herakles, whom they venerated as a "shiny example."

25. On this passage, see, e.g., Stewart 1990, 230. Some commentators would emend "Myron" into "Mys," but unnecessarily, since, as noted supra, n. 22, in the early Imperial period Myron was thought to have made silver vessels.

Lysippos

26. Bartman 1992, 148 n. 3, compares the expressions used by the two poets, but leaves it uncertain whether the striking similarities derive from the authors' presumed rivalry or from the same set of instructions by Vindex. She transcribes Martial's first epigram in its entirety, and provides helpful critical commentary (pp. 147–50), although still believing in a possible Lysippan creation of the prototype. See esp. her n. 9 (pp. 149–50) for other claims of famous previous ownership for ancient objects.

27. See, e.g., Verg. *Georg.* 3.19; Ael. *Var. Hist.* 4.5; Serv. s.v.

28. These speculations are made by Moreno, for instance, in his *Vita e arte di Lisippo* (Milan 1987) 73–79; he repeats them in *Lisippo* 1995, 140–42. These chronological inferences are accepted by Todisco 1993, 117–18.

29. *Lisippo* 1995, 141; at greater length, Bartman 1992, 151–52, esp. n. 15 for the use of the epithet by Statius in the preface to Book 4.

30. The main publication is Visscher 1962, and cf. also 1963. The vast size of the Alba Fucens marble is best conveyed by the preserved height of the head: 0.46 m. For interpretation of the Alba complex as a *macellum*, see Lauter 1971. For discussion of the issue, see Bartman 1992, 152–57. See also *LIMC* 4, s.v. Herakles, "Alba Fucens Type" on p. 776, specifically no. 986, pl. 512, where the colossus is considered a contamination of a composition originally with the Apples of the Hesperides, rather than a vessel. The marble Lucera head, mentioned infra as a possible replica at large scale of the Epitrapezios (it is 0.36 m. high), is illustrated in *Lisippo* 1995, 143–45, no. 4.17(1); *LIMC* 4, s.v. Herakles, no. 973, pl. 511 (accepted as replica of the Epitrapezios); the once inserted eyes would be in keeping with Late Republican cult images (c. 100). Alba Fucens seems to have enjoyed its greatest prosperity after 89 B.C.

That the Alba Fucens Herakles may reflect Lysippos' colossal conception, from which the small "epitrapezioi" derive, is accepted, e.g., by V. Harward, "Greek Domestic Sculpture and the Origins of Private Art Patronage" (Ph.D. dissertation, Harvard University, 1982) 28–30; cf. 26–30 for other anecdotes about Alexander's patronage, which he would discount in this case.

31. Ara Maxima: see, e.g., F. Coarelli, *Il Foro Boario: Dalle origini alla fine della Repubblica* (Rome 1988) 61–77, and, on the origins of the Forum Boarium, 107–9. Cacus: for literary references, see *LIMC* 3, s.v. Cacus, 177–78 (e.g., Verg. *Aen.* 8, 190–267); also *LIMC* 5, s.v. Herakles/Hercle, p. 249, section 26.

32. Bartman 1992, 153, states that the Alba Fucens figure holds the base of a drinking cup, but Visscher 1962, 16 (pl. 8.13) mentions only "un objet de forme circulaire" and seems to accept the possibility of a libation phiale in his discussion on the inversion of attributes, pp. 48–53.

33. To be sure, beards with a central part appear on undoubted Greek originals as early as the 2nd c. B.C.—for instance, on some of the heads from the Pergamon Gigantomachy and the Telephos frieze, and on the Poseidon of Melos; but by that date Roman influence cannot be discounted, and the rendering is certainly much more popular in later times.

34. See, e.g., Kraay and Hirmer, 1966, 345, nos. 521 (dated 260–210) and 522 (coins of King Nabis, dated 207–192 = *LIMC* 4, s.v. Herakles, no. 947), pl. 161. Cf. also supra, nn. 8 and 19.

35. Bartman 1992, 158; the 11 marble members of her London Group are her cat. nos. 3,

Lysippos

5, 7, 9, 12, 13, 14, 15, 17, 18, 19; in n. 45 she adds that two other (uncatalogued) versions may belong. Her five "variants" are her cat. nos. 1, 2, 4, 6, 11. On the same page, she asks an important question: "how much iconographic variation can be tolerated within a replica series without compromising its typological integrity?" Answers are bound to vary among scholars. On the heights of her London group (some are estimated), see her pp. 163–64 and nn. 54–57; on the stylistic diversities, her p. 161. Note that Moreno believes the Vienna bronze, his no. 4.17(2), to be the closest to the original, whereas Bartman (185–86, cat no. 21, figs. 79–80) states that it reverses the position of the attributes and of the legs; cf. *LIMC* 4, s.v. Herakles, no. 976, pl. 511 (dated simply "Roman").

The paucity of the bronze replicas of the Epitrapezios type becomes more obvious when compared with Bartman's second case study: the Lateran Poseidon type, of which 24 bronze statuettes survive out of a total of 34 catalogued items.

36. The point that Lysippos would not have depicted Herakles as an old man for Alexander is made also by Zadoks-Jitta 1987b, albeit in the context of the Farnese Type, which she dates to the first quarter of the 1st c. B.C., as modification of a *youthful* Lysippan original.

Date and distribution of extant examples. Delos statuette (A 206): Bartman 1992, 174, cat. no. 5, fig. 93 (est. h. 0.575 m.); *LIMC* 4, s.v. Herakles, no. 963, pl. 510 ("c. 100 B.C."). Sculptures from Delos are traditionally dated before the sack of 88 or the pirates' attack of 69; the Agora of the Italians seems to have been built around 120. The second Delos statuette (A 4163) is Bartman's no. 6, fig. 94 (est. h. 0.589 m.); for her reservations on identification, see her p. 175; cf. *LIMC* 4, no. 963 (mentioned with the previous piece). Bartman (156 n. 41) does not include in her catalogue the marble in New York, MM 11.55, sometimes considered an Epitrapezios. S. Ensoli, in *Lisippo* 1995, 350, no. 6.9(1) (dated 3rd c. B.C.), calls it a conflation of the Epitrapezios and the Farnese Herakles, since the club is propped under the hero's left armpit. *LIMC* 4, no. 942, pl. 508, lists it under the echoes of the Tarentine Herakles by Lysippos.

London, BM 1726, from Sennacherib's Palace in Nineveh: Bartman 1992, 181, cat. no. 15, figs. 90–91 (est. h. 0.527 m.); *LIMC* 4, no. 974, pl. 511. The plinth of the limestone figure is signed by the sculptor on the proper right side (*Diogenes epoiei*) and has a votive inscription (by Sarapiodoros, son of Artemidoros) on the front.

37. Athens replica (NM 4830): Bartman 1992, 171–72, no. 1; *LIMC* 4, no. 967, pl. 510.

Five items from Italy: Bartman 1992, nos. 8 (terracotta from Sinalunga, in Florence, dated possibly 2nd c. B.C., surprisingly 0.47 m. high; cf. p. 165 n. 62), 11 (once in Lanuvium), 16 (Naples Museum, bronze from Villa del Sarno; here **Pl. 68**), 17 (said to be from Gabii), 19 (from a Roman collection). The Naples bronze (figs. 76–77; Boardman 1995, fig. 41; *LIMC* 4, s.v. Herakles, no. 975—considered a 1st-c. A.C. variant because of the higher position of the club) is said (Bartman, p. 157) to have been turned into a Herakles Bibax by the addition of an ivy wreath; he also lacks the lionskin, but the bronze was found without its original rocky seat, on which the skin might have been carved (rather than being rendered in bronze), given the possibility of painting it.

38. Various ancient sources are quoted by Jeppesen 1992, 98 and nn. 200–205. See also Paus. 5.5.4, where Herakles' competition with Lepreos is recounted. It seems to have involved drinking a great deal of *water*, as well as eating an ox. Verbanck-Piérard 1992, 97–98

and n. 58, comments on the unfair criticism of Herakles' "shocking behavior" in alimentary consumption; he *must* be excessive, because he is exceptional.

39. Herakles and Pholos: Apoll. 2.5.4; Diod. Sic. 4.12. Banquet of Peirithoos: for the ancient sources, although surprisingly much later than the visual representations (e.g., Apoll. *Epit.* 1.21; Diod. Sic. 4.70; Hyginus, *Fab.* 33), see *LIMC* 7, s.v. Peirithoos, 232–33. Odysseus and Polyphemos: Homer, *Odys.* 9.346–70, with the blinding recounted in vv. 375–400. Return of Hephaistos: e.g., Alkaios, Fr. 349 (Lobel-Page ed.), with additional detail known through the visual arts; cf. J. D. Beazley, *The Development of Attic Black Figure* (Berkeley/Los Angeles 1951) 31. Apollo and the Fates: Aischylos, *Eum.* 723ff.

40. For Kyathos' death, at Phlious, see Paus. 2.13.8; this killing may have happened involuntarily, or because the boy used for the hands water meant for the feet, or because Herakles did not like the wine he was served. Athenaios mentioned that Eunomos' death occurred accidentally; but Herakles seems to have been exiled for killing the boy, who had splashed water on the hero's legs. For the ancient sources (e.g., Diod. Sic. 4.36.2; Apoll. 2.7.6.; Schol. on Sophokles, *Trach.* 39), and the various accounts, see *LIMC* 6, s.v. Kyathos, 150–51, where two different episodes may have been conflated into one. These myths have been interpreted as allusions to rites of initiation from boyhood into adulthood, and as signs of Herakles' association with young men preparing for manhood: Bremmer 1990, 141.

Even Auge's episode may be read with a positive connotation, since it was used as a legitimate topic for temple decoration (as discussed supra, Chapter 2), and it ensured important progeny; on the ancient sources, see *LIMC* 3, s.v. Auge, 45–46.

A. Foley, *Argolid 800–600 B.C.* (Göteborg 1988) 127, cites a (c. 600) inscription from Tiryns regulating wine drinking at the sanctuary of Herakles, but this information could be understood in several ways, either supporting or denying Herakles' own propensity for drinking.

41. Herakles as symposiast (with kantharos and club): *LIMC* 4, s.v. Herakles, pp. 177–79, nos. 1008–65 (esp. 1017–57), pls. 513–18; Herakles intoxicated: pp. 770–71, nos. 875–87, pl. 504, with chronological statement. Herakles as part of the Dionysiac thiasos, *LIMC* 5, s.v. Herakles, pp. 157–60, nos. 3246–91, pls. 146–49; esp. common in Roman times: p. 160, section headed "Roman." The Greek section lists primarily representations on South Italian vases, perhaps significantly. For a mosaic pavement from Antioch with the Drinking Contest of Dionysos and Herakles, see Dunbabin 1993, 121 fig. 4.

On the Italic tradition (in Sabellan-Oscan territory) for Hercules Bibax, see, e.g., A. Di Niro, *Il Culto di Ercole tra i Sanniti, Pentri e Frentani* (Salerno 1977) 57–60; C. Grella, "Ercole Bibax: Un bronzetto della Collezione Zigarelli nel Museo Irpino di Avellino," *Rassegna Storica Irpina* 3–4 (1991) 279–86 (for a photocopy of this article I am greatly indebted to Dr. Guy Hedreen).

A Campanian form is called by scholars "Heraklesschale" because it bears a central stamp showing Hercules: J.-P. Morel, *Ceramique à vernis noir du Forum Romain et au Palatin* (Paris 1965) 94–95. Calenian bowls engraved with the letter *H* (for Hercules): J.-P. Morel, "Artisanat et colonisation dans l'Italie romaine aux IVe et IIIe siècles av. J.C.," *DialArch* ser. 2.6 (1988) 49–63, esp. 57–59.

Dr. A. M. Nicgorski has kindly alerted me to a passage in Athenaios, *Deipn.* 11.500A,

Lysippos

mentioning a type of Boiotian skyphos called Herakleotic, allegedly because used by the hero during his campaigns, but also because "upon their handles there is the so-called Herakles knot." She, in turn (in her 1995 Ph.D. dissertation for North Carolina University), has connected this passage with several ancient references to Alexander's having died after (or *not* after) drinking from a huge "skyphos Herakleos": Plut. *Alex.* 75; Diod. 17.117.1–2; Ephippos of O!ynthos (*apud* Athen. 10.434 A–B). She has identified this type of skyphos as beginning in the late 5th c., increasing in popularity in the late 4th and early 3rd cs., perhaps as a result of Alexander's use of this six-quart cup with Herakles-knot handle. I am not sure whether this evidence suggests Herakles' abnormal drinking capacity or simply means that the special knot was used as a form of appropriate (good-luck) decoration. It is understandable that Alexander might have liked this type of goblet, given his alleged connection with Herakles. I am greatly indebted to Dr. Nicgorski for this information.

Certain types of drinking vessels (usually in precious materials) seem to have carried specific names: e.g., the *Therikleia*, after the Corinthian potter Therikles, who invented the shape (Cic. *in Verrem* 2.4.38); and the *Mentourges*, from a glass-worker named Mentor (Schol. on Lucian, *Lexiphanes* 7).

Note that Herakles' head also decorates some of the volute of the Derveni Krater (to be discussed in Chapter 9), with (ultimate?) funerary function.

42. Bartman 1992, 154 and n. 31; she considers the seated banquet of the Kazanlak Tomb a provincial and anomalous example. For Etruscan practices, see, however, A. S. Tuck, "The Etruscan Seated Banquet: Villanova Ritual and Etruscan Iconography," *AJA* 98 (1994) 617–28. Differences between Greek symposia and Etruscan/Roman banquets are emphasized by J. P. Small, "Eat, Drink, and Be Merry: Etruscan Banquets," in R. D. De Puma and J. P. Small, eds., *Murlo and the Etruscans: Art and Society in Ancient Etruria* (Madison 1994) 85–94. For different forms of Roman dining, see K. M. Dunbabin, "Triclinium and Stibadium," in W. J. Slater, *Dining in a Classical Context* (Ann Arbor 1991) 121–48.

That a Lysippan Herakles at a banquet (his apotheosis) should be reclining (*cubans*) is a point made by Zadoks-Jitta 1987a, who believes that the "Epitrapezios type" as we have it derives from a Late Hellenistic model like the Belvedere Torso.

43. On the importance of food for the Romans, see E. Gowers, *The Loaded Table: Representations of Food in Roman Literature* (Oxford 1993). On Roman drinking customs, see D'Arms 1995. For the use of wine and water at the Roman convivium, as well as the statement on the krater as nonspecific container, see Dunbabin 1993; and cf. Dunbabin 1986, for the use of skeletons at banquets. For the disappearance of the krater from an official (public) set of vessels in Athens, see S. I. Rotroff, "The Missing Krater and the Hellenistic Symposium," Abstract, *AJA* 97 (1993) 340–41. G. R. Edwards kindly tells me that he had noted the same phenomenon in studying the pottery of Hellenistic Corinth, but that the terracotta mixers, in Hellenistic times, may have been replaced by more luxurious metal kraters that would have been looted or melted, leaving no trace.

44. See the discussion of the Epitrapezio, in the section on "Fortuna di Lisippo" (second part), by S. Ensoli, in *Lisippo* 1995, 347–51, no. 6.9. The Silenos Epitrapezios (a statue in the Lady Lever Art Gallery, Port Sunlight) is fig. 1 on p. 384 (and cf. no. 6.14[1] on pp. 386–87—a largely modern pastiche, closer, to my mind, to philosopher types than to the Epitrapezios); the youthful Herakles (a bronze in Basel) is fig. 3 on p. 349; the contamination with the

Lysippos

Farnese type is the New York Herakles (supra, n. 36). The sacral character of two other examples is mentioned on p. 349. For the Villa del Sarno find, see supra, n. 37; its findspot outdoors, within the peristyle (**Ill. 22**), together with other "decorative" sculpture, lessens the sacral function, although *some* religious meaning should never be divorced from ancient sculpture. See also Berger 1987 for other variations and "contamination" with Hercules Invictus.

45. Onians 1990, esp. 7–8, discusses the use of flattery under the Flavians, in keeping with Quintilian's instructions in his *Institutio Oratoria*, and with specific reference to Martial and Statius.

46. Kairos: see supra, n. 13; cf. *Lisippo* 1995, 190–95, no. 4.28, and, for the Roman transformations, pp. 395–97, no. 6.16 and fig. 1, for a lost relief once in Florence (S. Ensoli).

47. Eros: supra, n. 14. For the later echoes of the composition (which could confirm a Classical date, since they occur first in Hellenistic terracottas), see S. Ensoli, in *Lisippo* 1995, 388–94, no. 6.15. Note that no. 6.15(4) (a statue in Cyrene, from the Trajanic Baths, p. 394), once considered among the best replicas of the type, is here labeled a variant because of its lack of wings—yet this argument is never made for the so-called Pothos of Skopas (supra, Chapter 7)!

48. Agias: supra, n. 9. For a good analysis, see esp. Stewart 1978, Boardman 1995, fig. 36.

49. Silenos/Baby Dionysos: supra, n. 17; for my earlier opinion, see Ridgway 1990, 80.

50. Farnese (Resting) Herakles: supra, n. 10. The pose is well known from Attic gravestones and coins.

51. Apoxyomenos: see, e.g., *Lisippo* 1995, 196–205, no. 4.29 (with chronology and hypothetical origin), (P. Liverani), 321–25, no. 6.5(1–6) for precedents and later echoes (C. Parisi Presicce); Todisco 1993, 126–27, pl. 274; Stewart 1990, 187, fig. 554; Boardman 1995, fig. 35.

52. Getty Youth: supra n. 9; see also Ridgway 1990, 57, pls. 33a–d; Todisco 1993, 140, pl. 311 (c. 300, School of Lysippos). In favor of a Lysippan original: A. Viacava, *L'atleta di Fano* (Studia Archaeologica 74, Rome 1994). For a Classical, rather than Late Hellenistic, chronology, on stylistic grounds, see M. Söldner, "Der sogennante Agon," in G. Hellenkemper Salies et al., eds., *Das Wrack: Der antike Schiffsfund von Mahdia* (Cologne 1994) 399–429, esp. 418–19, with n. 98 on p. 427. Yet the provenance of the Getty Youth from a possible wreck along the coast of Italy may speak in favor of a statue made for the Roman market, rather than an antique.

53. Berlin Athlete: *Lisippo* 1995, 226–27, no. 4.34(1) [with other heads, nos. 4.34 (2–3)], attributed to Lysippos; Todisco 1993, 140, pl. 309 (attributed to Lysippos' pupil).

54. Bronze Runners from Herculaneum (Naples, NM 5626–5627): P. G. Warden and D. G. Romano, "The Course of Glory: Greek Art in a Roman Context at the Villa of the Papyri at Herculaneum," *Art History* 17 (1994) 228–54; note the similarity to two marble youths from Velletri, 236–37, fig. 28 and bibl. on p. 251, n. 40; Helbig[4], no. 1518; Todisco 1993, pl. 48 (Polykleitan School). For the Lysippan attribution of the bronze runners, see, e.g., M. R. Wojcik, *La Villa dei Papiri ad Ercolano* (Rome 1986) 108–11, nos. D2, D4, pls. 57–58 (dated last quarter of the 4th c.); even the bronze Drunken Satyr (her no. D3, pl. 59) is considered in the Lysippan tradition of the 3rd c.

Bronze seated Hermes from the same Villa (Naples, NM 5625): Boardman 1995, fig. 79; *Lisippo* 1995, 404, no. 6.18, accepted as a Campanian product (as originally argued by

Lysippos

L. Beschi, *I bronzetti romani di Montorio Veronese* [Venice 1962] 47–48), but still said to be after a prototype of the 2nd c., in turn related to a Lysippan creation: pp. 13–39, no. 4.16 (1–6), which I would doubt on comparable grounds.

55. Sandalbinder (often called "Jason"): supra, n. 17; *Lisippo* 1995, 230–41, no. 4.35(1–10), pp. 405–8, no. 6.19 (C. Parisi Presicce) on the later echoes. Todisco 1993, 127, pl. 276, considers the type "among the vaguest attributions to Lysippos." The ancient source is Christodoros, *Anth. Pal.* 2.297–302; his description makes no mention of a sculptor (*contra* my 1990 statement). The Perge statue is extensively treated by Inan 1993; see her p. 114 for discussion of the neck strut and the intended viewpoint, her pl. 36a for a two-dimensional, unsatisfactory view. I would prefer the view on her pl. 35b, as contrasted with her "best," pl. 34. My position, as stated originally (Ridgway 1964), is repeated in Ridgway 1990, 81–82; cf. nn. 13–15 on pp. 101–2, for additional bibl. and opinions, including attribution to Lysippos' pupils. A study of struts in Roman times, by M. B. Hollinshead, is being prepared for publication and seems to confirm my points.

Leptis Magna Hermes, from the Hadrianic Baths: R. Bianchi Bandinelli et al., *Leptis Magna* (Verona 1964) pl. 155. I cannot find this statue in the *LIMC*, either under Dionysos' infancy or under Hermes. Todisco 1993, 94, mentions it briefly as a replica of a bronze prototype possibly by the Polykleitan School (Naukydes?).

56. For the theory of two-dimensional compositions converted into statuary in the round during Late Hellenistic times, see, e.g., N. Himmelmann, "Mahdia and Antikythera" in *Das Wrack* (supra, n. 52).

57. See, e.g., N. Bonacasa and E. Joly, "L'Ellenismo e la tradizione ellenistica," in *Sikanie. Storia e civiltà della Sicilia greca* vol. 8 (Milan 1985) 292–93, fig. 340 on p. 299, with good eye detail. On the techniques for rendering eyes in bronze, see G. Lahusen and E. Formigli, "Der Augustus von Meroë und die Augen der römischen Bronzebildnisse," *AA* 1993, 655–74, esp. 667–69. A Roman Imperial date for the ram, albeit too early (Julio-Claudian) in my opinion, has now been argued by Wilson 1990, app. 2, 343–46, with nn. on pp. 421–22. Wilson provides the most extensive description of the bronze to date, an outline of its later history, and the suggestion that a marble ram in the Torlonia collection may be a 2nd-c. copy (his p. 345, fig. 290). He also points out (n. 4) that Lysippos' alleged reputation as a great maker of animals is primarily based on a poem in the *Gr. Anth.* (9.777) referring to a bronze horse, and that the fallen lion of Lampsakos is the only other animal sculpture by Lysippos mentioned by an ancient source.

58. Boardman 1995, 22, mentions that Lysippos was alleged to have made 1,500 works, according to the number of gold coins—one for each creation—that he had put away; but he calls it "a silly story."

CHAPTER 9

Random Harvest

This is a chapter of odds and ends—monuments that do not fall naturally under specific headings or cannot easily be grouped into categories, yet that deserve to be considered in any review of fourth-century sculpture. To be sure, some could be claimed as specific attributions to named masters, and others be reviewed in geographic sequence, but none of these arrangements is entirely satisfactory. For convenience' sake, I shall include some of these "floating" sculptures under thematic groupings, but I want to stress the arbitrariness of my approach, and justify it with the need for a broader theoretical vision of the art of this period. Inevitably, Roman copies will be considered together with attested originals, although preference will be given to the latter whenever possible. The usual difficulties in dealing with works actually executed during the Roman period should be kept in mind.

STATUES OF THE GODS

One of the most common statements about fourth-century sculpture is that it represents a clear departure from previous iconography in the depiction of the gods. Whereas the fifth century endowed each image with grandeur and dignity—the Olympian Zeus and Athena Parthenos by Pheidias, the Nemesis by Agorakritos, to name a few—the period between 400 and 331 allegedly rejuvenated older gods, treated them as languorous and effeminate, stressed the anecdotal, and included the unusual, focusing, in addition, on minor and foreign rather than on Olympian divinities. This picture, as we have already seen, is partly based on Roman copies and tentative attributions, which may not belong within the period, like the Apollo Sauroktonos, the Lykeios, various Eros and satyr types, and the Hermes of Olympia. Other works that definitely belong—like the Knidia—are open to different interpretations. Finally, others, such as a clearly young and beardless but still athletic Herakles, a traditionally mature Asklepios, Artemis, and Demeter and Kore, are known primarily through votive reliefs, where the very nature of the monument stresses the narrative and the anecdotal. Yet a few remain to be reviewed in this context.

Random Harvest

Athena

She is perhaps the divinity exhibiting the most intriguing shifts in iconography, certainly the more easily considered because better represented, probably because of her association with Athens. In the fifth century she appears primarily as a goddess of action, her peplos belted over the overfold, her aigis short and unencumbering, her helmet elaborate and antiquarian. In the fourth century, she seems to change her costume to a voluminous chiton and himation, or she wears her peplos loose, unbelted or belted under the overfold, with a smaller aigis occasionally slipping down. One unusual type shows her apparently wearing the himation alone, like a man. Toward the end of the period, a classicizing trend brings back the peplos with belted overfold but adds a fluttering back mantle. Her expression is no longer aloof but can hint at pathos or other emotions. Only one of these statues may have come down to us as a Greek original—the bronze **Athena from the Peiraieus** (Pls. 74a–c)—and even this one is disputed, since a marble replica of it exists in the so-called **Mattei Athena** in the Louvre, and an echo in a torso in Corinth. We shall discuss it first, and review the others only briefly.

Plates 74a–c

The Peiraieus statue,[1] considered an original or a good reproduction of a type created around 350–340, has been attributed to Euphranor by Palagia, followed by Todisco, who would, however, give to the same master also the larger Artemis of the two found in the same cache, as suggested by Dontas. Regardless of stylistic affinities, there is a certain technical resemblance between the two, especially in the flat, steep central fold anchoring each figure to its base (with a true tenon), that makes us regret the lack of a full publication and thorough chemical analysis of the Peiraieus finds, which might help answer some questions. Iconographically, the Athena is remarkable. She wears a peplos without underlying chiton, in contrast to the many examples on contemporary gravestones and reliefs. Although a belt is visible from the rear, where the overfold has been pulled up to the shoulders, the front view gives the impression of a completely loose garment because of the vertical and oblique course of the drapery folds. The apoptygma, moreover, has a triangular outline caused by the lifting of the cloth in the rear, which recalls the mantle apron of a fifth-century type, the Velletri Athena. Were the bronze Athena to let the apoptygma fall down over her back, the overfold in front would return to its horizontal course but appear unusually long, as if the garment were overlarge or the goddess still young. The hair gathered in a ponytail, albeit hidden under the lifted apoptygma, may be a further hint of youthfulness, characteristic of other fourth-century images of the goddess. Her body, however, looks fully developed, and her face is mature, if somewhat "sweet."

Several points are important about the Peiraieus bronze. (1) If this is an original work, buried at the harbor just prior to shipment, during the sack of Sulla in 86, how could it have been repeated in marble during the second century A.C.—the date of the Mattei replica? To be sure, the Louvre copy slightly changes the composition

by eliminating the belt and by turning the outstretched right arm into a more casual hand-on-hip pose. Yet static and iconographic reasons may underlie such changes, and there is no question that the marble repeats the same type as the bronze. Probably, as already suggested, bronze molds or plaster casts were kept in foundries and made available for more than one replica at a time; thus other examples of the Peiraieus Athena may have existed prior to its burial, and may have served as inspiration for marble copies. Finally, the date of the cache may not be as early as the Sullan catastrophe, in which case the bronze Athena itself may be a Roman replica of a fourth-century original. I would support this third solution.

(2) What is the iconographic message of the Peiraieus bronze? The apoptygma lifted over the shoulders is usually a way of covering the head or of ensuring protection, especially from flying arrows. It is used in this second fashion by the fifth-century Niobid in Copenhagen, and by one of the bronze peplophoroi (Danaids? Dancers?) from the Villa of the Papyri that has a marble replica in the Gardner Museum in Boston (Pl. 75)—both of them severizing works of Augustan times. In both instances, the horizontal course of the garment over the front is illogical and unconvincing, as it is in other figures depicted in more static poses.[2] In the bronze Athena, the arrangement is completely correct, as can be demonstrated by anyone willing to try on a peplos, but it cannot imply religious reverence, since the goddess's head is already covered. The suggestion that this is a purely aesthetic device, meant to parallel the diagonal aigis, fails to explain why the aigis should be worn diagonally (since other arrangements are possible). Moreover, no gesture or unusual rendering in Greek iconography should ever be considered "purely decorative." In a culture that relied so heavily on sign language for its communication, every *semeion* must have been meaningful. That the goddess needs protection is belied by her calm pose and her formidable equipment. In addition to the helmet, in fact, she once supported a spear (where a flattened area appears along her left forearm) and a shield in rest position, by her left foot. Fragments of the shield, with a chariot-race decoration, were found with the statue but are not yet published.

(3) Not only was the shield decorated (echoes of the Parthenos and the Promachos!), but also the helmet. Perhaps it too was an allusion to the more complex headdresses of earlier times. Owls on the visor, griffins on the calotte, and a snake as a crest holder recall the "familiars" of the Parthenos. It is suggested that the Athena held a Nike or an owl on the extended right hand. I would prefer a phiale, for the illogical reason that the other bronzes found in the Peiraieus cache, albeit of different dates, all seem to make the same ritual gesture, although the fragile vessels are now missing. Despite the fact that the bronze Athena is in virtually the same stance as the Pheidian chryselephantine colossus, there is torsion in her body, since her right side moves forward, in keeping with the turn and slight inclination of her head in the same direction, and her right hip is prominent under the voluminous garment. Note how the vertical fold originating from the bent left knee has lost the

appearance of serving as a support for the free leg, by bending as it reaches the ground. Yet, in rear view, a long fold runs from belt to left knee, with a modeling mannerism typical of the late fifth century (cf., e.g., the attendant on the Hegeso stele). The deep drapery valleys visible in front view do not recur in the marble replica, but are consonant with the apparent heaviness of the cloth that completely hides the weight leg, again in contrast with the Mattei Athena's revealed right foot. On the other hand, the apoptygma exhibits one vertical fold, originating below the right breast, that appears to reflect a major pleat of the underlying cloth, which in fact emerges just below the edge of the overfold and continues to the ground: an early instance of drapery-through-drapery?

The Velletri Athena, although surely datable to the late fifth century, wears a himation wrapped around her body, over her peplos. The next iconographic step seems to be provided by two more Athena types that wear a chiton under the himation, and that have been traditionally dated at the very end of the fifth or the turn into the fourth century.

The **Athena Giustiniani** (Todisco 1993, pl. 10) is a massive figure with spear and Corinthian helmet, but no shield.[3] Her snake coils at her right side, although its tail reappears near her left foot, after crossing behind her. The mantle is worn in man's fashion: draped over the left shoulder, then looped across the front under her right arm, and flung back on the left to hang steeply down over her left breast. The chiton itself has a distinctive overfold that extends along the right arm, almost like the apoptygma of a peplos, but characterized by closely spaced folds that contrast with the wider expanses of the heavier mantle; both manage to conceal the underlying female forms by using straight, rather than contouring, lines. This is much more voluminous attire than that of the Nemesis of Rhamnous, although comprising the same two garments worn in similar fashion, and it makes me wonder whether the original of the Athena is a Roman creation in classicizing mode, rather than a work after a true Greek prototype of the turn of the century. The solemnity and massiveness of the figure, as well as the less combative formula, would be appropriate for a Roman Minerva. The aigis also looks unusual, with its apparently diagonal course but with a scalloped neckline that abandons any pretense at naturalism. Except for a replica from Ephesos, all copies seem to have been found in Italy; a head in Athens need not belong to that body type; one head is at colossal scale.

The **Athena Albani** (Todisco 1993, pl. 13) wears the same voluminous chiton, but her mantle is differently draped, and perhaps longer.[4] Folded double, it is pinned only over the right shoulder, passing under the left arm, almost in Archaistic fashion; the resulting diagonal accent across the chest is, however, toned down by the capelike aigis fastened in the center by a gorgoneion. The headdress is a wolf cap, unprecedented and unrepeated (and unlike that of the giant from the Mazi pediment), which further removes military overtones from the image and introduces

cultic elements. Although this very beautiful Athena has sometimes been identified as the Itonia by Agorakritos, I would again consider a Roman origin for it, especially given the lack of replicas.

One more Athena, the **Farnese Type** (Todisco 1993, pl. 14), has been connected with the Albani as a derivative creation, and dated within the same span of time.[5] The slight variation in the folding of the mantle (here with a shorter upper layer) is, however, sufficient to create a somewhat different impression, less archaizing. By contrast, the heavy Attic helmet with raised cheekpieces and the long curls outlining the neck are old-fashioned reminiscences of the Parthenos. The aigis almost completely hides the upper edge of the mantle, and the chiton seems thinner and more restrained than in the previous two types. Once again, I feel uncertain about the proper artistic placing of this Athena, except to note that her attire would continue the line of the noncombative types.

More in keeping with fourth-century renderings is the so-called **Athena Vescovali** (Todisco 1993, pl. 123), who wears her mantle wrapped tightly below her breasts, with a rolled upper edge and short overfold, thus closely resembling one of the Muses on the Mantineia Base.[6] This similarity has often prompted attribution of the Athena original to Praxiteles, but without firm foundation, given the uncertain position of the base itself; yet it should secure for the three-dimensional prototype a dating around 340. The bronze **Athena of Arezzo** has been considered a variant of the Vescovali type that enjoyed some popularity in the Roman/South Italian area, to judge from the distribution of the replicas. Her aigis is a stiff and irregular collar; her Corinthian helmet is the only sign of her warlike character, reduced to single identifying attribute now that the costume can no longer serve the same purpose. The steep fold descending from the left knee is more rigid than that of the Peiraieus bronze, although this should be a later rendering.

A different and striking image is the **Rospigliosi Athena Type**, enveloped in a long mantle that almost completely hides her lower garment.[7] In some replicas, the himation almost seems the only item worn by the goddess, since it leaves exposed her feet and ankles (Pl. 76), as in a male figure; in other copies, a long, thin chiton is apparent below the hem of the mantle, in more feminine fashion. It is difficult to decide which version is closer to the prototype, since a case can be made for either, on morphological grounds. The "chitonless" type, or, rather, that clothing Athena with an all-but-invisible chitoniskos, although unusual and striking, would openly stress the masculine character of the goddess; the type with the more traditional long chiton would still be remarkable because the upward tilt of Athena's head lends it a pathetic effect, and seems to continue the diagonal thrust of the folds covering the long expanse of the mantle. In both cases, however, the anatomical features of the female body are entirely subordinate to the rendering of the costume, which enhances the already elongated proportions. The Athena's aigis, with its stiff upper border, gives the impression of a cuirass worn under the himation; its metallic char-

Plate 76

acter is emphasized in some replicas by a star motif over its surface, rather than the usual scales. With both feet flat on the ground, her long spear seemingly supporting her, her muffled left hand on her hip, her plain Corinthian helmet tilted back, to me the goddess looks like a relaxed and lonely soldier on sentry duty. Others prefer to read her pose as one of concentration and intellectual activity, especially because of her upward glance. Attribution to Timotheos (because the head tilt recalls the Leda's) seems belied by proportions more typical of the late fourth century, if not already Hellenistic; a Skopasian connection is not justified by the "pathetic" head rendering.

More closely datable around 340–330 is the prototype of an Athena at present called the **Areopagos House Type**, from the findspot of one of its Roman replicas.[8] Its peplos has a horizontal hem to the longish overfold tied by a straight belt; its leathery aigis is vestlike and ample, fastened in the center by a gorgoneion—a costume that would justify a fifth-century date. But this Athena exhibits deep lateral kolpoi to her apoptygma, and adds not only a chiton under the peplos, as we commonly see on fourth-century gravestones, but also, more tellingly, a shoulder-pinned back mantle that, although its vertical edges are broken in this replica, has the potential of adding movement to the static pose. This rendering is obvious on Greek reliefs reproducing the same type, and in other Roman copies that preserve the fluttering contours of the backdrop garment. Proportions are also somewhat elongated, and texturing is introduced in the rendering of the peplos. All examples of the type, both two- and three-dimensional, have been assembled by Roccos, whose suggested chronology is underpinned by several Document Reliefs, one of them firmly dated to 334/3. All her evidence comes from Athens, primarily from the Agora, except for a statuette now in Florence. The type is therefore of interest as a sure Attic product (whether an Athena Phratria or Archegetis, as attested by Athenian cults), and as indication of a strong classicizing current in the sculpture of the second half of the fourth century. We have already noted such traits on gravestones, and shall comment again on other statuary in the round that exemplifies them.

Equally retrospective is our final example, the **Athena from Castra Praetoria** in Rome (Todisco 1993, pl. 217), a colossal image known through this single replica now in the Conservatori Museum.[9] It wears the same type of peplos with belted overfold, but her mantle (a chlaina) is rolled tight and worn like a shawl, cascading with a mass of folds over her left shoulder. Her **V**-shaped aigis is collarlike, without central division, although the gorgoneion remains in place like an ornamental badge. Her arms and attributes are lost, but a metal dowel on her left hip was probably for the attachment of a shield, hanging from her arm, and she may have had a spear in her right. She is therefore the most warlike depiction so far reviewed. Yet she is also attuned to her times: the highly textured cloth creates unnatural curves over the ankles, which deflect the steep vertical folds. The elongated proportions,

and the echoes of the type on a Document Relief dated to the last quarter of the fourth century, have suggested an early Hellenistic date for the prototype, although the uncertainty of statements based on a single copy in the round should be emphasized.

In summary, even taking into account only what can be safely considered Greek evidence, Athena appears to change her attire during the fourth century, in favor of more feminine, less bellicose clothing and poses—yet, ironically, her womanly appearance seems lessened, made less obvious; weapons, when present, lean nonchalantly against her body or are used for apparent support, almost like scepters, and even her helmet seems a vestigial attribute rather than a functional head protector. Toward the end of the phase, she returns to her traditional costume and perhaps a more heavily armed appearance, but with added details that betray their more recent date. Yet the classicizing trend is notable, since it recurs in other deities. We cannot pinpoint the location and authorship of many of these Athena types, but echoes on Attic reliefs suggest for some an Athenian creation.

One more point remains to be discussed. Several Classical Athenas, under their helmet, wear the Oriental tiara, primarily visible as the bent-up flaps over the temples. This feature has been thoroughly investigated by Knauer, who has pinpointed its appearance to the time after the Persian invasion of Attika and the subsequent Athenian victory; in the glorious years of the fifth century, the reminder seems appropriate and understandable.[10] Yet, on present evidence, it seems to have been occasionally retained during the fourth century, when Athens was no longer a political power, and Athena was a less warlike image. The feature recurs on the large-scale Peiraieus and Mattei statues, and even on the Giustiniani type, although it seems absent in the Rospigliosi and Vescovali types. Moreover, if the simplified renderings of the votive and Document reliefs can be trusted, Athena's helmet there seems to rest directly on her head, without the Persian flaps. Why was this foreign element retained for some images and not for others? Was its meaning lost, and was the tiara considered no more than a convenient lining for the metal helmet? Or, rather, were some head types interchangeable, and reproducing earlier molds used for convenience' sake? Roman copyists may have not understood the initial message of the tiara, or may have used it regardless in their works, although Greek originals of the fourth century had probably abandoned it. If this argument is plausible, it would confirm that the Peiraieus bronze is a copy and not an original, and that the Giustiniani type is a Roman creation. But a more thorough study of all replicas is necessary before drawing such far-reaching conclusions.

Artemis
Several types known only through Roman copies have been attributed to the fourth century, and the Peiraieus cache has yielded two more that have not, so far, been

matched in other replicas. Except for the so-called Artemis of Versailles, which I continue to consider Hellenistic, representations tend to favor a long-clad image, ill-suited for the hunt, although traditionally equipped with quiver and occasionally shown in motion. The short-skirted huntress seems to be typical of the Hellenistic phase.[11]

The **Larger Artemis from the Peiraieus** (Todisco 1993, pl. 213) has already been mentioned with the Athena, together with an attribution to Euphranor.[12] It is she, this time, rather than her sister, who wears the peplos with belted apoptygma, which echoes fifth-century styles in its horizontal hem; but the belt consists of the quiver strap with an additional cross-band; together, they emphasize her breasts, although the opaque, heavy garment hides her body effectively. The trailing left leg and the wide hips do little to reveal the contrapposto stance, and the deep valleys separating the wide, steep folds of the skirt do not manage to recover the underlying anatomical forms, as they do, for instance, in the Maussollos. The mussed effect of the surface is in keeping with fourth-century interests in textures, but the total work looks somewhat ungainly, an impression perhaps enhanced by the smallish head on an overly large, unarticulated neck. The teeth, said to be in white marble, are not really visible between the slightly parted lips. The melon hairstyle would suggest a date around 330, if this too is an original rather than a copy. The right hand held a phiale, the left probably a bow, once again subordinating attributes to cult.

The **Smaller Artemis from the Peiraieus** is more graceful, more feminine; were it not for her quiver strap (beautifully inlaid in silver with a maeander and dot pattern), from the front she could be taken for a young girl rather than a deity.[13] This figure remains virtually unpublished; the small cylinders on her sandals would suggest a Hellenistic date, but the latest listing places it still within the third quarter of the fourth century, a date in keeping with her hairstyle—a mass of curls piled up toward the back of her head. Her long peplos with belted overfold, at any rate, makes her equally unsuited for hunting, but she adds a mantle rolled up and falling forward from her left shoulder, passing under the belt, to end below the hem of the apoptygma, with an interesting contrast of horizontals and verticals. She too may have held a phiale.

These two bronze statues of Artemis, each in its own way, can be considered classicizing, at least in general patterns of garments and pose—only texturing elements, coiffures, and perhaps proportions support a fourth-century date. Definitely more than classicizing—outright archaizing—is an original marble statuette of **Delian Artemis from the Delion on Paros**.[14] It was dedicated by Areis, son of Teisenor, as mentioned in an inscription that validates a date within the second quarter of the fourth century; it is therefore a private offering, although its hieratic pose and costume may reflect a local cult image. It has also been argued, however, that she is a simplified fourth-century version of the Archaistic three-bodied Hekate

made by Alkamenes in the previous generation. To be sure, the belted apoptygma of her peplos ends with a straight hem rather than in a swallow-tail pattern. But her polos, covered by a back veil, and her long curls falling over her breasts convey an Archaic impression, which is enhanced by the undifferentiated folds of the skirt over the rigid legs held close together.

I detect an almost archaizing pattern also in the most distinctive type of all: that of the **Artemis of Gabii** (Pl. 77), after the Roman marble found at that site.[15] The young girl is perhaps the closest to our conception of a huntress, since she has twice belted up her chiton with ample sleeves, so as to leave her lower legs exposed. She is in the act of pinning a chlamys (or, according to another definition, a *diplax*) over her right shoulder, so that the gesture of her right arm resembles her more familiar pose of removing an arrow from a quiver, but here no weapons characterize the image. The strong vertical accent created by the unfastened chlamys on the axis of the body—against which collide the horizontal lines of belt (and right sleeve), kolpos, and hem of the chiton—recalls such archaizing drapery as that of the so-called Pergamon Dancer or the Miletos Karyatid, or even of figures of Isis and her priestesses. There is, on the Artemis, the same effect of drooping cloth articulated around a central axis, although here somewhat asymmetrically and without the zigzags and omega folds so distinctive of Archaistic works. The total style is Classical, to be sure, or even early Hellenistic, but an underlying pattern also exists, although, to my knowledge, not previously observed.

Plate 77

Because of her attention to her costume, this Artemis has been equated with one of the two cult images at Brauron mentioned by the inventories, to which offerings of garments were traditional, and in turn with a statue by Praxiteles seen by Pausanias (1.23.7) in the Akropolis Brauronion. Yet we do not know whether the same ritual of donating clothing to the childbirth goddess prevailed in Athens, since it has been shown that the inventories found on the Akropolis simply copied those kept at Brauron, and do not imply similarity of offerings. The only Praxitelean feature about the Gabii Artemis is her head type, although more youthful than the Knidia's; yet, as we have seen, the latter's influence was pervasive on later works, and cannot confirm authorship. Another noteworthy feature of this Artemis is the chiton sleeve slipping off her left shoulder, an alluring unveiling perhaps justified by the heaviness of the gathered material and the pose itself, but strongly reminiscent of Aphrodite and fifth-century renderings. Is this young Artemis an imaginative transposition in the round of the seated goddess linking arms with Aphrodite on the Parthenon east frieze? Regardless of attributions and interpretations, this is one of the most successful compositions, which bespeaks a creative master; but it remains without discernible echoes in other works, whether in relief or in the round.

Other types of Artemis are more traditionally fourth-century, in proportions and costume. The so-called **Dresden Artemis** (Todisco 1993, pl. 105) has also been

attributed to Praxiteles primarily on the basis of her head, although the only statue retaining it in its original form is the name piece.[16] The long, unbelted apoptygma of her peplos emphasizes vertical accents with a strong central panel of folds, but a diagonal strap once again enhances the left breast. With her right arm raised, the goddess seems about to remove an arrow from her quiver, although in the marble replica she holds her bow at her side, in a resting pose. To me, this work seems of little import, at least in its Roman translation. It is closely echoed by another, the so-called **Munich-Braschi Type** (Todisco 1993, pl. 107), which adds a chiton under the peplos and lowers the right arm; I would consider both renderings so similar as to be interchangeable. To be sure, an ancient master could repeat himself with little variation, but so could a Roman copyist using a single classical prototype or even no specific model at all. It has also been pointed out that most replicas of the Dresden type come from Rome and environs. The general appearance of both would fit within the fourth century, and a hint of torsional motion in the Dresden Artemis may confirm the chronology, but adds little to the iconography.

More original—and with a wider distribution that includes North Africa, Asia Minor, and Greece—is the so-called **Colonna Artemis** (Todisco 1993, pl. 64), which some would date to the fourth century, although others prefer to place it in the Hellenistic period.[17] Certainly, the appearance of rapid motion to her left would place this Artemis together with the Versailles type, but she looks in the direction of her movement and wears the peplos with long apoptygma like the two previous types. The quiver strap contours her left breast and creates a large kolpos on that side, but on the whole the accent of the apoptygma is horizontal rather than vertical, in contrast to the Dresden and Munich types, because of the pronounced and mannered catenaries that span the abdominal area. In addition, the Colonna's seemingly ampler upper body contrasts with the attenuated physique and the upward taper—from outthrust hip to narrow shoulders—of the other two. A hint of drapery-through-drapery over the torso, and the collision course of folds on either side of the strap, would confirm, to my mind, a Hellenistic chronology for the Colonna type. The classicizing catenaries are in keeping with the classicizing head, with its excessively angular hairline.

It should perhaps be acknowledged that the long-clad Artemis is the image that appears traditionally on contemporary votive reliefs—partly because the cultic figure is different from the hunter, partly because the latter seems of more interest to the Hellenistic period, which favors the anecdotal. The "fluttering back mantle" so often worn by young girls depicted on gravestones of the latter half of the fourth century, which had been theoretically derived from a well-known statue of Artemis, is surprisingly not attested for her images in the round.[18] In the late third-century bronze relief from Delos already mentioned (Chapter 7, n. 79), Artemis, although apparently engaged in a ritual action at an altar, wears the same shortened garment

as the Gabii Type, but note her rolled mantle, which provides a colorful break below her breasts, and her tall hunting boots, quite different from the sandals of the "Praxitelean" type. In the Classical period, as far as I can see, sculptors remain conservative in their depictions of Apollo's sister—just another long-skirted goddess with a purely attributive bow or quiver, as she was portrayed in the round since the Archaic period—yet we should rather stress the increased frequency of her statuary appearance, as contrasted with her relative rarity in the fifth century, and the classicizing as well as the archaizing traits in some of her renderings, which begin to conflate her iconography with that of Athena and Hekate.

Aphrodite

The reverse situation obtains for this divinity: the fifth century is filled with images of the Love Goddess; the fourth century is dominated by the Knidia. Since I consider the Arles Aphrodite a Late Hellenistic creation, I find it hard to present other instances of fourth-century originals or prototypes besides the so-called **Epidauros Aphrodite** (Pl. 78).

Plate 78

This attractive composition, known in at least two replicas, has been variously dated from c. 400 to c. 365.[19] Those who want it part of the Polykleitan School have suggested that it copies the Aphrodite made by Polykleitos the Younger (II) for Amyklai, after the victory of 405, since its date is too low for Polykleitos the Elder; but this argument is somewhat circular, and other identifications have been advanced for the Amyklai dedication. Certainly, the Epidauros figure (of such quality that it was once thought to be a Greek original) retains many of the traits of late fifth-century style, such as the ribbon drapery of her chiton, the modeling lines of her himation, the "slipped strap" mannerism unveiling her right breast and echoing, in mirror-image, the so-called Aphrodite of Naples/Frejus. A balancing counterdiagonal is created by the sword-strap crossing her chest from right shoulder to left hip, and disappearing under the vertical fall of the himation. The head, with its almost wiglike cap of hair, cannot go too far down into the fourth century. The arming theme could be read as an anecdotal reference to Ares and Aphrodite's mythological involvement, but also as a more serious, philosophical recognition of the needs generated by war. At present, I can only tentatively acknowledge a chronology shortly after 400 for the prototype, not necessarily in bronze.

This dearth of images seems all the more remarkable, given the many mentions of Aphrodite statues in our literary sources—by Praxiteles, by Skopas, by other masters. Either they were not copied, or we are unable to recognize them among the mass of Roman statuary. It should be stressed that "Aphrodisian" traits, such as the unveiling of one shoulder already mentioned for the Artemis of Gabii, appear in the late Classical iconography of other divinities, some of them unrelated to Aphrodite, as, for instance, Kore and Hera—again, if correctly identified. Perhaps

the fourth century blurred the lines among goddesses, just as iconographic borders were crossed between Dionysos and Apollo. We shall see once again this fraternal resemblance, as well as similarities between Aphrodite and Ariadne, on the Derveni Krater, to be discussed below.

Demeter (and Kore)

The Eleusinian divinities, popular in votive reliefs, are not as frequent in major sculpture in the round. Yet—like the Delian Artemis on Paros—they have survived in an unusually large number of original marble statuettes (perhaps imitating large-scale prototypes) that were dedicated at Greek sanctuaries, primarily on Crete and Kos, but with a few examples also from Eleusis. They are traditionally rendered as peplophoroi similar to the Eirene by Kephisodotos, with ample hips and rounded kolpoi, with back mantle occasionally drawn over the head, or with scarflike himatia. Their identity can be provided by attributes such as torches, or by proximity to each other, but it is mostly based on dedicatory inscriptions and provenance. At large scale, we have primarily Roman copies of uncertain identity because of variations in attributes and context, like the (already Hellenistic and perhaps non-divine) Large and Small Herculanensis, wrapped in their more "modern" voluminous mantles.[20] Only a few monuments need be mentioned here, because of their special nature.

Plates 79a–c The **Demeter of Knidos** (Pls. 79a–c) has caused some controversy because Carpenter advocated for it a Late Hellenistic date based on its smooth, classicizing face, impressionistic hair rendering, old-fashioned way of sitting, and coloristic drapery.[21] On autopsy, I have convinced myself that the statue is probably correctly dated to the late fourth century, although I would agree that it has several retrospective traits. But these are in keeping with the tendencies of the time, as are the more progressive, impressionistic features. Attribution to Leochares, however, as proposed by Ashmole, seems to me based on faulty premises and indefensible on present knowledge.

The stunted impression the statue gives, especially with its right-angled lap, is partly due to damage, which has removed the front legs of the throne and the figure's knees; the back of the throne was not to be seen, with the upper part attached separately, and therefore the sculpture would have rested against a wall, although it is uncertain whether another figure stood next to it. In profile view, a footstool can still be noted, carved in low relief, but present breaks make the position of the feet difficult to visualize, especially for the slightly advanced right one. The figure itself looks different from each side, appearing almost sunk into her cushion when viewed from proper right. As is well known, the head, inserted separately, is made from a better kind of Parian marble than the body, but the join between the two, at present, is far from perfect. Coarse drill channels separate the hair from face and neck, and even groups of strands from strands, with an attempt at a spiraling effect;

the rendering of the coiffure on the proper right side is clearly more coloristic and detailed than that on the left, in keeping with the slight turn of the head in that direction. The deeply set eyes and the slightly parted mouth do not, however, convey that sense of sorrow that most commentators want to read in the figure. To me, the goddess's expression looks bland and almost vacant. Somewhat similar is the head of a Grimani statuette in Venice that repeats the same veiled type. Much better, by comparison, is the voluminous mantle, which, in its twisting upper folds and tension ledges from chest to arm and across the abdomen, recalls in more textured fashion the draping of the Aischines type or of some statues of Kore known only through Roman replicas. Nonetheless, and despite its over-lifesize scale, this was probably not a first-rate work, even when paint and lack of damage had it in pristine condition. Its importance for fourth-century sculpture lies in the fact that it came from an Ionic city and a Greek sanctuary, given the fact that we have relatively few free-standing pieces extant from Greek Asia Minor.

Equally scarce is the sculptural evidence from Magna Graecia. It seems therefore important to mention a group of large **terracotta busts** from Sicily and South Italy, probably depicting Demeter and Kore, not only because of their size and elaboration, but also because of the conservative tendencies they represent.[22] The historical picture is perhaps clearer for Sicily, which seems independent from the mainland. The extensive destruction wrought by the Carthaginians on the south coast of the island at the end of the fifth century brought to a virtual halt artistic production in many Greek towns, except perhaps at Syracuse, where the tradition of making such terracotta busts may have been kept alive. Recovery did not take place until approximately 350, or even later, according to those who connect a renewal of urban life with the victories by Timoleon in the 340s and early 330s. At that time, some scholars hypothesize, coroplasts went back to fifth-century models, partly because they were the only ones available, surviving among the ruins, and partly because they felt the need to reconnect themselves to their more prosperous past. Others find this explanation too simplistic, and opt for a more global vision that takes into account similar classicizing trends in contemporary coinage and vase painting. To be sure, a revival of interest in the cult of Persephone and the greater economic prosperity of the end of the fourth century contributed to this renewed terracotta production; and Syracuse may have provided molds and examples. But I also believe that it was only then that the true Classical style of Perikleian Athens penetrated into the outlying areas and was fully accepted, as contrasted with the Severe style that had dominated most of the earlier years. This stylistic conservatism, aided and abetted by the use of molds that could be used for generations, makes many of these terracotta busts hard to date, and some may in fact have been placed too early.

It is impossible here to single out specific examples; therefore, only general points will be made. Most of these busts are lifesize or just slightly smaller, but some from Akragas are over-lifesize, and all are truly monumental in appearance. Faces are

carefully molded, retaining throughout the Classical phase a continuous line flowing from brow to nose, which in Mainland Greece and Ionia is rare after the Archaic period. They often have massive chins and heavy-lidded eyes that recall Severe renderings; but the hair, usually added free-hand, lends itself to being "modernized" in complicated coiffures. The back of the head can be unarticulated. So is the bust itself, especially in Sicily: the shoulders are simplified, the arms are not separated from the torso or even indicated at all, and the bust terminates just below(?) the undifferentiated breasts. The form began in the late Archaic period and continued into the mid-Hellenistic phase, at various sites, prominent among which is Syracuse; but equally important examples have been found at Gela, Morgantina, Akragas, and, in South Italy, at Taras, Paestum, Ruvo, and Lokroi. They come from various contexts, including domestic, and, because of their lack of distinctive attributes (except for a few South Italian examples with piglets), they are difficult to identify with certainty; but they seem primarily associated with the cult of Demeter and Kore, especially the latter in her role as Persephone—most appropriate for Sicily where, according to some versions, Kore was kidnaped by Hades near the Lake of Pergusa.

The decoration of these busts is significant. Many of the heads wear a tall polos; when its sides taper downward, some scholars would see in it a *kalathos* or a *modius*, a fruit or a grain basket, a proper symbol for goddesses presiding over the fertility of the fields. The ears are often pierced for the insertion of metal earrings, and all features were once brightly enhanced by color. The dress, probably a chiton, is often rendered as purple, of specific meaning in the cult of the Two Goddesses; moreover, the front of the bust may be painted with elaborate figured scenes, which include the very Rape of Persephone, and preparations for the wedding. They should be counted among the examples of ancient monumental painting, although they probably imitate elaborately woven clothes.

Apollo
Only certain male divinities seem popular in the fourth century, and of these Apollo is perhaps the most prominent. Iconographically, the youthful, naked type, ultimately derived from the Archaic kouros, continues in various forms, although I have already expressed my reservations about the Lykeios and the Sauroktonos as Praxitelean attributions, or even as fourth-century creations. A new type appears around 350: the heavily robed kitharoidos wearing a peplos belted over the overfold. A study by Flashar has traced the origin of the type, and, briefly, that of the peplos as worn by male and female personages. For Apollo, he sees a possible first example in the "Rhamnousios," which he would accept as a Skopasian work, despite the fact that no traces of an Apollo cult have been found so far in that Attic deme.[23] He attributes the lack of echoes in contemporary Greek votive or Document reliefs, or even in statuary in the round, to the peripheral location of Rhamnous—an argu-

ment, to my mind, weakened by the fame of the local statue of Nemesis by Agorakritos, and by the prosperity exemplified by the impressive funerary monuments of the fourth century. Yet it is this shadowy Apollo that Flashar invokes as the forerunner for a major Greek original: the **"Apollo Patroos" from the Athenian Agora** (Pls. 80a–b).

Plates 80a–b

This over-lifesize marble image has been extensively published and beautifully photographed by Alison Frantz.[24] The type was repeated in Greek votive reliefs, and in Greek and Roman copies in the round at reduced scale, which therefore can support the theory that the original was a well-known (and thus recognizable) cult image. Because of its findspot within the Metroon of the Athenian Agora, at a relatively short distance (20 m.) from a temple of Apollo, the sculpture has been identified as the Patroos by Euphranor seen by Pausanias (1.3.4). We would therefore have in this piece that rarest of Greek statues: an original cult image by a famous artist, with secure provenance and mention in an ancient literary source. Why has it not rated a separate discussion within the oeuvre of this sculptor, in the previous chapter on the great masters? My reasons are twofold: I do not believe that Euphranor's works and style are recoverable, and I have some lingering doubts as to the correct identification of the Agora statue, although I no longer question its late fourth-century date.

Euphranor appealed to Roman writers because he was both a sculptor and a painter, as well as the author of treatises on proportions and colors; but Pliny (*NH* 34.77–78) lists him in his book on bronzes, and most of his works seem to have been in that medium. Although he too made τύποι, according to Pliny (*NH* 35.128), these are probably reliefs rather than architectural models, and all other allusions to his stone carving in the ancient sources are vague and general in context. One wonders whether a cult image of Apollo by him would have been in bronze, given the fact that temple statues in that medium are attested at least for the Hephaisteion.[25] Pausanias does not specify what the material of the Patroos was, but the possibility remains, since casting molds for kouros statues have been found near the Archaic phase of the Agora Apollonion. If the first images for the earliest temple were in bronze, the tradition may have continued for the later phases.

Fragments of at least another marble kitharoidos were recovered nearby, and Pausanias mentions that two more images of Apollo, besides that by Euphranor, stood "in front of the temple," one by Leochares, and one by Kalamis, called Alexikakos. Flashar has advanced the intriguing supposition that all three statues were part of a single (Lykourgan) program, taking Kalamis to be the second master by that name, and therefore making all three sculptors contemporary. He argues that the Agora "Patroos," because of the dimensions of its plinth, could not have stood on either of the two bases (actually, hypothesized benches) flanking the cella door, which probably supported the other two images, and that an "Alexikakos" is likely to have been a naked type with a bow, thus making the recovered kithara fragments

part of Leochares' statue, perhaps a Pythios. He justifies the rendering of the "Patroos" as a kitharoidos as well on the basis of literary sources associating him with music, and of his function as *archegetes*. He finally suggests that the specific garb of the peplos with belted apoptygma is not so much retrospective as it is a deliberate allusion to Athena, meant to connect the two divinities protecting the city. He stresses, in fact, that Euphranor's Apollo, with his long hair and female costume, must have conveyed a definite feminine impression to the ancient viewers.

This explanation, taken together with the classicizing trends already noted in the fourth century, is the most acceptable of those that have been advanced so far to justify the use of Apollo's multi-layered costume. His peplos was in fact worn not only with a back mantle, but also, to judge from almost contemporary reliefs and statuettes, over the long-sleeved tunic of the actor/musician. Yet an altar of the first century A.C., dedicated to Agathe Tyche and to Apollo Patroos (as well as Pythios, Klarios, Panionian, and other epithets), carries a relief image of a naked god in a pose recalling the Sauroktonos.[26] The Patroos/Pythios iconography was therefore not fully established as a kitharoidos, to judge from this depiction.

Whether or not the Agora statue is by Euphranor, it provides insufficient basis to reconstruct the master's style. We have already mentioned that both the Peiraieus bronze Athena and the larger Artemis from the same cache have been attributed to the sculptor on stylistic grounds; yet neither of them displays the coloristic effects of the marble image, nor are they as "retrospective" in style. The Athena is basically a fourth-century type; the Artemis is more classicizing, but her proportions are in keeping with the later date. The Apollo looks high-waisted and pyramidal in composition, but this is an erroneous impression due to the missing head and arms, which have broken off with part of the torso. All other attributions to Euphranor suggested by various authors seem to me equally implausible, or at least unprovable.

As for the Apollo itself, it is undoubtedly a masterpiece, acting as a virtual touchstone for all other examples of textured drapery that have been cited as parallels to prove its fourth-century dating: draped figures from the Daochos Monument, on the Ephesos column drum, on Attic gravestones. The fine lines criss-crossing the stone surface form a graphic counterpart to the modeled depressions animating the garment, especially the overfold below the belt. The play of light and shadow over the drapery is at its best when viewed in full daylight; not even the indirect natural lighting of its present position within the lower colonnade of the Stoa of Attalos does it full justice.[27] There is virtually no sense of volume under the cloth, and certainly no hint of the weight leg despite the deep valleys interspersed with the flat folds of the skirt. By contrast, the massive right thigh, outlined by deep cuttings, as in the Maussollos, is quite prominent and seems impossibly long. A peculiar "reminiscence" of fifth-century modeling folds occurs on the outer side of the bent knee, but the pattern of addorsed catenaries meant to convey the roundness of thigh

and calf has been given an extra flourish that virtually dispels the effect. That the Apollo had long hair is shown by the few long curls falling over the left breast and by the wavy strands on the perfunctorily carved back. The head was probably turned toward his right, despite the presence of the kithara on the left hip. Whether the right hand held a plectrum or a phiale is impossible to tell, and may partly depend on the true function of the image.

Zeus, Hermes, Dionysos, Asklepios
Other male divinities can be more briefly discussed. I know of no specific statue of Zeus, although some—for instance, by Leochares—were seen by Pausanias (supra, Chapter 7), or even of Poseidon, since I accept the small-scale origin of the so-called Lateran type. There are several types of Hermes, especially the **Hermes Andros/Farnese** (Pl. 81) and the **Richelieu Type** (Pl. 82).[28] The first is, however, so close to the Hermes of Olympia that it may be a variation of the same type. The second is more distinctive, especially because of the consistent manner in which the replicas render the mantle bunched over the left shoulder, and because the stance shows both feet on the ground, the right slightly advanced, although the left leg supports the weight. This type has been derived from two previous renderings of the god (the so-called Troizen and Pitti/Berlin Types, with trailing-foot stance), but this suggestion has been based primarily on the facial features and a general Polykleitan appearance, with a linear development that seems no longer plausible, although slight variations on a theme, from generation to generation, remain possible. Given the strong influence of Polykleitan style on later athletic statues, down to the Late Hellenistic period, I find attributions and precise chronology difficult to defend, as long as we are dealing with Roman copies, where contamination and variation are likely, and head types are easily interchanged. Only the Richelieu Hermes seems to me to go back to a specific model, given the regularity of the mantle arrangement (a V-shape plunging into two concentric U-shapes, with a flap underneath enveloping the top of the left arm); but I would not venture a guess as to the date of such a model, although granting a general mid-fourth-century appearance. How often statues of Hermes could be adapted for later portraits has been demonstrated by Maderna; even the Hermes of Andros, despite its idealized features, comes from a funerary context, where it served to suggest immortality for the deceased.

Plate 81
Plate 82

Dionysos is either rendered as youthful, naked, long-limbed, and Apolline, as we shall see on the Derveni Krater, or, in a surprising rendering, old and long-bearded, muffled in a voluminous mantle: the so-called **Sardanapalos Type** (Todisco 1993, pl. 296). I have discussed this type elsewhere and can only add here a few comments.[29] Were it not for its appearance on a three-sided relief base from the Streets of the Tripods in Athens, which is generally considered a fourth-century original, this elderly Dionysos could easily be dated to the Late Hellenistic period, when it appears on a variety of reliefs, including two of the marble kraters from the Mahdia

shipwreck. The replicas in the round are all Imperial, but include one from Corinth and one (reduced in size) from Crete. The latter in particular may suggest that the original was a cult image inspiring dedications in statuette format, on the evidence of the images given to Demeter and Kore. The type combines the textured costume and the slashing horizontal accent of the mantle overfold with a herm-like head and an immovable stance, despite the apparently free right leg. This immobility cannot be simply attributed to hieratic conservatism or cultic purposes, but seems a feature of style. If truly late fourth century, this work exemplifies once again how some sculptors were ready to forgo the experiments and achievements with ponderation and torsion not only of their predecessors, but also of their contemporaries. That the Sardanapalos type has been assigned to the Praxitelean School suggests that little reliance can be placed on the master's supposed preference for off-balanced poses and rejuvenated deities, and would reveal an archaizing streak.

Asklepios makes his appearance at the end of the fifth century, when his cult is introduced in Athens, and is shown on many votive reliefs, as we have discussed above. A type in the round, the **Asklepios Giustini** (Todisco 1993, pl. 157), recalls the Dionysos Sardanapalos in the horizontal flap of the mantle where it crosses the upper body, although smaller and combined with a bare chest.[30] The head may vary, from beardless and youthful to bearded and traditional, even with *anastole*. A recent study has attempted basic groupings of the replicas, accounting for variants and elaborations of the prototype, each group depending from a model with its own chronology ranging from the early to the late fourth century, and including a last group (IV) in the latter half of the second century, which combines a fourth-century body with a fifth-century head. I find such subtleties difficult to follow with assurance, but would be inclined to believe in a fourth-century original for the initial type, which recurs on votive reliefs. The most distinctive feature of this Asklepios is the drapery: a single himation stretched tight across the body, with very few folds determined by tension alternating with smooth expanses adhering to the flesh at salient points to reveal the underlying anatomy, but also with abstract patterns, such as the large V-shape originating from both knees and reaching the hem of the garment.

STATUES OF PERSONIFICATIONS

We have already discussed the Eirene and Ploutos (Chapter 7), and the anthropomorphization of ritual titles and cries like Attis and Iakchos (Chapter 6, nn. 40, 42), especially in votive reliefs. Similarly, Document Reliefs show the Demos and Demokratia, as well as other abstract concepts connected with government (Chapter 6, n. 73). Hygieia, although a personification of health, has a quasi-mythological persona as daughter of Asklepios, and we have considered one possible representation in the round (Chapter 7, nn. 19–20); another, the beautiful **Hygieia Hope**, (Todisco 1993, pl. 54), certainly goes back to a fourth-century prototype, but seems

Random Harvest

a typical draped woman with crinkly chiton and himation, turned into a goddess by the addition of a long snake across her body.[31] I therefore hesitate in accepting the identification of other suggested types, when attributes are missing. Nike, the personification of Victory, was popular since the Archaic period, and well represented by marble originals of the fifth century. During the fourth, however, we have no extant examples in the round except for akroterial figures, despite the evidence for some bronze renderings (e.g., within the Arkadian dedication at Delphi, Chapter 7, n. 9), and a few depictions on reliefs. On the three-sided base mentioned above, the Nikai are as heavily dressed as the Dionysos, with chiton and himation, and could be taken for mortal women, were it not for their large wings. Nothing in their stately drapery suggests the potential for flight so obvious in the fluttering garments of their architectural counterparts.

One final item needs mention because the issue of its identification has recently been reopened, and the theory that it represented Demokratia has now been changed in favor of Tyche: the colossal **female torso Agora S 2370** (Todisco 1993, pl. 304).[32] I have already discussed this statue elsewhere, and shall therefore limit myself to a few comments. The first, and most important, is that the very uncertainty over the proper reading of this impressive image confirms how anonymous female statuary could be, in the absence of proper attributes. The second is on the interest in texturing, once again attested by original sculptures, especially in the rendering of the crinkly chiton.

In general conclusion, there seems to be, in vogue throughout the fourth century, a type of female figure wearing thin chiton and heavy himation that can be adapted to a variety of identities by the judicious addition of specific attributes. The mantle is sometimes draped with a series of tension folds across and around the breasts that often result in a horizontal flap, like an overfold, over the upper left arm (see, e.g., Todisco 1993, pls. 286–87); this mannerism recurs in the draping of some male figures, and continues into the next century. The female chiton sleeves are buttoned, rather than sewn, as they are on male images. As we have seen, such female statues may depict Muses, Kore, Hygieia, Nike, and any number of youthful minor deities and personifications. Major goddesses (including the relatively young Artemis and Athena) are more frequently shown wearing the heavy peplos, whether belted over the apoptygma (for figures of action) or with loose overfold above a curving kolpos. This fashion is a definite sign of conservatism, either to convey a sense of greater antiquity or to recall specific prototypes of the previous century, even when the texturing of the cloth is in keeping with recent artistic discoveries.

ATHLETIC STATUARY

Some depictions of youthful gods, in particular those of Hermes, display a developed anatomy that could qualify them to be ranked among the athletes; indeed, as we have seen, some statue types, like the Sandalbinder (Chapter 8) may be turned

into the divine messenger by the addition of a kerykeion or a Dionysos child—or, according to some authors, can be demoted to human level by the removal of the attributes. In some cases, the loss of such clues may affect our understanding of the image. In others, actions and poses are more revealing. We have already discussed the Diskobolos attributed to Naukydes and the Apoxyomenos traditionally assigned to Lysippos. Here we shall mention those monuments that best qualify as athletes, and whose attribution to a specific master has not achieved consensus. We should begin, however, with a general comment.

Through Pausanias and other ancient sources we learn of many victors' statues set up in the major sanctuaries and often made by well-known sculptors. Yet virtually none of these sculptures, especially from the fourth century, have been identified in Roman copies. The reason for this state of affairs is probably twofold: (1) statues within Panhellenic temene were not allowed to be copied; and (2) statues were usually copied not because of the reputation of their makers or their aesthetic value, but because of the suitability of their theme to Roman interests and contexts. I would therefore surmise that any athletic image not explicitly representative of a sport or not exhibiting an action pose would be omitted from reproduction, except perhaps as a convenient torso or head type. The consequences for our knowledge of Greek styles are disturbing, especially in light of the so-called Lysippan revival of the Late Hellenistic period, when many athletic creations were given elongated proportions and slender bodies that recall Lysippan formulas but were in fact in keeping with current Roman taste. We should specifically reflect on our current understanding of male fourth-century naked statues, all of which can basically be divided under three headings: (a) a Polykleitan group, usually assigned to the master's School, that repeats the chiastic stance, and often the ponderation with a trailing foot, while exhibiting a robust physique with prominent anatomical definitions, especially in the torso; (b) a Praxitelean group, with slender bodies, blurred, almost effeminate or adolescent anatomy, and possibly off-balance poses; and (c) a Lysippan group, with smaller, rounded heads on taller, athletic bodies, possibly in torsional poses, or at least implying potential shifts in stance and impending motion. Considering the number of masters working during the fourth century, our classifications seem limited indeed, even when we acknowledge the alleged influence of major artistic figures. In this respect, it is perhaps significant that Skopas—a major master by current consensus—should have been assigned two statuary types that belong to two of the above-mentioned groupings: the Pothos, with Praxitelean traits, and the Meleager, in the Polykleitan tradition.

To postpone the problem of Roman copies, we shall begin this review with an undoubted Greek work: the bronze **Youth from the Antikythera Wreck** (Pls. 83a–d).[33] Discovered at the turn into this century, this over-lifesize athlete has been various called a Perseus holding the head of Medousa, the Paris by Euphranor, or simply a Ball Player. His stance is in the Polykleitan tradition, albeit with a wider

Plates 83a–d

distance between feet (the trailing right barely touches the ground), and so is his anatomy, with prominent hip muscles and ample ribcage. The peculiar shifting of the median line (*linea alba*) away from the navel may be due to the extensive damage suffered by the abdominal region and the consequent restoration, but (although anatomically inaccurate) it is also in response to the shift of compositional direction toward the raised right arm. Palagia (1980, 11) has made the important observation that the Youth's limbs are shorter on the contracted (left) side; the prominent right arm is therefore made more emphatic by size, as well as by its position, not only away from the body, but definitely forward, penetrating space. By the same token, however, the Youth's rounded head may have looked proportionately smaller atop the powerful body, in keeping with Lysippan canons. It is one of those remarkable faces that look round from the front, oval from the sides, and its profile is surprisingly similar to the Hermes of Olympia. The Youth's "Michelangelo bar" over the eyes is not highly developed; his hair is wispy and unruly, creating a broken outline to the head. An anatomical study of the statue's veins and tendons would be welcome, given our uncertainty about such renderings on the basis of Roman copies.

The date usually given to the Antikythera Youth has ranged from c. 360 to c. 330, thus influencing, to some extent, possible attributions. The Youth's powerful back can be positively compared with that of the Apoxyomenos, although the latter is known only in marble versions of later date, and Bol believes the rendering is typical for athletic statues during the third quarter of the fourth century. The missing attributes might have helped chronology as well as identification, but only two comments can be made about them: (1) the object held in the right hand must have been small, possibly rounded, since it touched both the higher two (index and middle) fingers and the two lower ones (thumb and fifth finger), as shown by attachment scars; (2) the object held in the left hand, in my opinion, had a smaller diameter than suggested by the curled fingers in front view, since, from the back, the palm of the hand reveals a small internal projection, meant to support whatever was being held, which could not have been bigger than, say, an arrow. The suggestion that the Youth be restored as a ball player with a "hockey stick" in his left, like one of the athletes on the Archaic statue base in Athens, is therefore untenable.[34]

The contents of the Antikythera Wreck are not helpful for the Youth's chronology, unless we think of it as a Late Hellenistic recast of an earlier (fourth-century) monument—a possibility that Bol considers but tends to discard on the basis of the Youth's hair rendering.[35] The ship probably foundered just before the middle of the first century, as confirmed by investigations carried out in 1976 with the help of Jacques Cousteau, which recovered 36 late cistophoric silver coins, including Pergamene tetradrachms, one of which is specifically dated 85–76, and two Ephesian bronze coins that can be dated 70–60. This relatively large amount of Asia Minor currency may suggest that the main cargo was coming from Pergamon.

Some of the pieces on board were definitely made shortly before the catastrophe,

as proven by several classicizing athletic statuettes; although at least one of them has been considered Lysippan, I believe that the sloping contour of its shoulders and its undefined musculature, as well as its typical stance with relaxed leg forward so beloved by classicizing masters, and the type of marble base confirm the late manufacture of the piece.[36] In addition, the cargo included a marble copy of the Herakles Farnese type (e.g., Todisco 1993, pl. 271), as well as several epic groups in marble, of clear Hellenistic style. On the other hand, that other fourth-century bronze sculpture was also on board is proven by the so-called Philosopher and his companions, whose feet (five examples preserved) wear a type of sandal (*trochades*) morphologically still datable around 340. These statues will be discussed infra, in the section on portraits. The over-lifesize scale of the Antikythera Youth (1.96 m.) may prevent identification as a victor's statue, yet the Agias, 2 m. high, shows that ancestors could be glorified with super-human size or that—much less probably—previous rules no longer applied to late fourth-century statues of athletic competitors. The impressive physique of the Youth (who is, after all, mature enough to have pubic hair) makes me prefer identification as a young Herakles, which would be more in keeping with the tendencies of the time and more of interest to the intended Roman customers, or even a Hermes, but the case cannot be proven on present evidence.

Among the Roman copies, the so-called **Oil-Pourer** Type has perhaps the best chance of reflecting an actual fourth-century prototype—the issue is, which one? Todisco, in fact, can list four different examples, each supposedly copying a different model, with a chronological range from c. 420 to c. 350. The gesture of collecting oil on the left hand with the arm bent against the body, while the raised right arm pours the liquid from above, is known from vase paintings and reliefs since the late Archaic period, and we may be dealing with a late transposition of a pictorial motif into the third dimension. Of Todisco's types, I would discard the first one (pl. 29, Petworth House) as a later elaboration of Polykleitan forms, especially given the adolescent head, so often used for classicizing creations.[37] Equally classicizing, and ill-served by its restorations, is, I believe, the Vatican copy of the third type (Todisco 1993, 54, pl. 60). Its torso recalls off-balance poses despite its unresponsive legs and head. The other two types have had a longer life in the literature, and are sufficiently different to be bona-fide contenders: the **Pitti Oil-Pourer** and the **Munich Oil-Pourer** (Todisco, pls. 49 and 63 respectively).

The first of them is a powerful but not a very successful work, to judge from the Roman copies. Its anatomy is at the well-developed level of the Doryphoros, with clear Polykleitan traits and chiastic renderings; yet the free leg is forward and the pose is completely frontal. The right arm is raised only slightly above the level of its shoulder and has little effect on the stance; the head is inclined forward and looks neither at the pouring nor at the receiving hand—which, incidentally, does not seem properly positioned to receive the liquid, perhaps because of the static

constraints of a marble translation. The head is a late fifth-century type recalling the "Diomedes" (Todisco, pl. 1), but with a more pronounced division of the forehead into two halves, less by modeling than by linear means.

The second, the Munich type, is more successful: the right arm (although not preserved) was held considerably higher than in the previous composition, to judge from the anatomical reaction; the left shoulder is forward, the head is more clearly inclined and following the action. Best of all, both knees appear slightly flexed, although the left leg still supports most of the body weight; as in Naukydes' Diskobolos, or the "Lysippan" Eros, one has the impression that the youth is rotating on his axis and may shift his pose. Musculature is well rendered but attenuated without being effeminate, the difference in the pectoral muscles created by the raised arm is effectively conveyed. Like the Apoxyomenos cleaning himself after his athletic efforts, this Oil-Pourer exemplifies a moment outside the context proper—in this case, preliminary to action. This emphasis away from a specific sport, with the issue of victory or defeat left unsolved or unproposed, seems typical of the fourth century as we understand it at present. It should also be noted that all four Oil-Pourer types, regardless of their time of creation and individual height differences, can be considered lifesize and within definite human range.

The bronze **Marathon Youth** (Pls. 84a–c) is best discussed in this context because of his pose and the claim that it represents an ephebe victorious in the palaistra, on the basis of the leaf- or horn-shaped ornament of his head-fillet, although his adolescent body does not immediately convey the impression of an athlete.[38] I confess that I feel greatly ambivalent about this most graceful and appealing statue. On the one hand, it seems to embody Praxitelean forms at their best—in the current conception of the master's style; on the other, it is a typical servant statue such as we find in Pompeian houses, not only because of its pose and missing implements, but also because of his attenuated anatomy and size (1.30 m.).

Plates 84a–c

The bronze was found underwater, in the Bay of Marathon, but without a specific wreck context. Additional search by a French-Greek team in 1976 could find no traces of a likely transport vessel, and a new idea begins to find its way into print—that the statue may have adorned Herodes Atticus' villa at the site, in the middle of the second century A.C. But was the statue an "antique" of the fourth century, reused and perhaps modified, with arms replaced, to serve a functional purpose (as a tray-bearer or a lamp holder), or was it a creation of the Imperial period imitating earlier styles? That this second solution is not impossible is shown by the bronze statue of a youth in the Toledo Museum, which had been assigned to the School of Polykleitos, or, if later, to the Augustan period because of its fidelity to Classical forms, whereas technical details have now shown that it is probably no earlier than the late second or early third century A.C.[39]

The Marathon Youth has not yet received a modern technical analysis; that both upper arms show breaks, albeit at different levels, is not incompatible with casting

practices, and the different location of the joins may be due to the relative position and weight each arm had to support. A connection between object held and raised arm would be compositionally most pleasing: it would create a continuous flow, from planted weight leg on the left, across the torso, to the raised right arm, and from there, in front of the body, back to the forward left arm and diagonally down to the ground again through the trailing right leg. Not only would such a link make the rhythm obvious, it would also create space in front of the figure, thus adding to it a spatial penetration at present denied by the fully frontal alignment of the Youth's torso. Yet the inclined head does not look in the direction of the object on the left arm, but has the absent-minded glance to mid-air typical of fourth-century statues. The position of the raised right hand belies the possibility of a pouring gesture, yet it is remarkable how similar the Marathon Youth is to the so-called Pouring Satyr usually attributed to Praxiteles—or, except for the shift in the weight leg, to the Hermes of Olympia. This often noted similarity had resulted in the attribution of the bronze statue to the Athenian master himself, or, more recently, to his School, although some commentators consider it somewhat less than a masterpiece. Such quality judgments are traditionally so influenced by our personal conceptions of styles and attributions that they are best disregarded. But some objective considerations can be made.

As already mentioned (Chapter 7, n. 80), the Pouring Satyr may be a transposition into the round of a traditional two-dimensional element of Banquet Reliefs. This suggestion alone would not eliminate the possibility of a fourth-century date, since the Oil-Pourer and the Apoxyomenos motifs may have a similar derivation. Yet the serving function of adolescent figures seems best at home in the Late Hellenistic/Late Republican–Early Imperial period. The types attested so far are in Archaistic, severizing, and classicizing (Polykleitan) styles; why not some "Praxitelean" revivals? It may be significant that the various Oil-Pourer types, although also originally in bronze, hold their left arm close to their torso; that this position is not demanded by the marble translation is demonstrated by the many versions of the Pouring Satyr, which support the forward extension of the forearm through substantial struts but do not alter the original pose. It could therefore be assumed that both the Satyr and the Marathon Youth were conceived of as functional statues only, the first even as a fountain, the second as a tray-bearer, for all their aesthetic appeal. Are both types, therefore, late creations rather than fourth-century works? For the Satyr, we can only look at Roman marble copies, but for the Marathon Youth, we have a bronze. Perhaps a full technical examination will provide a solution to the puzzle.

The last sculpture to be examined could fall into the next category, that of portraits, since its expressive face has occasionally prompted identification with a specific person: the Satyros by Silanion, victorious at Olympia in two competitions.

Random Harvest

Yet a chronological discrepancy with the style of the head, as understood at present, seems to prevent this conclusion. I shall discuss here the **Olympia Boxer** (Pls. 85 a–e) as an example of athletic statuary, since even the swollen (cauliflower) ears and the squashed nose are typical, rather than individual, traits.[40]

Plates 85a–e

This head was found carefully separated from the body and buried between two blocks, a few steps north of the Olympia Prytaneion, although attempts in 1972 to locate the original findspot were in vain. This lifesize piece has been well described and discussed, and only a few comments are here necessary. We may once again note the human scale of a piece with definite athletic connotations (as contrasted with the Antikythera Youth). We may also stress how the very same devices were used from the Archaic period to the late fourth century and the Hellenistic phase to indicate a boxer: ears and nose are the most vulnerable features of the athlete engaging in that sport, and are consistently singled out, with greater or lesser realism but in a sort of hieroglyphic system of communication. Note also the lack of obvious scars and wounds, as contrasted with the Hellenistic Boxer in the Terme, which exploits the coloristic possibilities of copper inlays to convey the impression of cuts oozing droplets of blood;[41] the fourth century, despite its increased theatrical effects, is still considerably restrained as contrasted with later phases and tastes.

The Boxer wears a wreath, whose separately attached leaves are now mostly lost; he is therefore a victorious athlete. His hair, for all its apparent unruliness, is carefully organized according to a quasi-Polykleitan formula, with a prominent starfish whirligig atop the cranium. Its massive overshadowing of the face has made photography difficult, with special angles and lighting often lending the face a brutal expression absent from the original. The engraved eyebrows (not so rendered in younger types, and certainly not indicated—except by lost paint?—in Classical marbles) follow an angular course that recalls the Maussollos. The eyes, now lost, would have been unusually small, as noted by Bol, as if narrowed in their sockets. They were inserted from the front, to rest on uncommonly wide ledges, in a somewhat unusual procedure. The bulging brows increase the impression of frowning. Note also the crow's feet at the outer corners, the bags under the eyes, and the sagging cheeks, all indications of a certain age. Yet this is verism rather than likeness, as we have mentioned before in discussing portraiture.

PORTRAITS

That portrait statues were made as early as the fifth century is well known; some of them may have come down to us in Roman copies, although some may be later retrospective creations. But the fourth century seems to have witnessed a sharp increase in the use of honorary portraits, in a variety of media, although they are mostly known through literary sources, possible echoes in Roman works, and empty statue bases. Lykourgos promoted at the Theater of Dionysos a program of

portraits of famous playwrights that highlighted the past glories of Athens, together with a revival of their century-old plays and performances. Portraits of Sokrates and Plato were also commissioned, for various locations. Orators' statues were set up in the Agora. On the Akropolis, images of priestesses made their appearance, as well as bronze statues of common worshipers—bearded and beardless men and children not otherwise described in the extant inventories, but likely to have been portraits, the latter even "bears" in the Brauronian tradition.[42] Phryne dedicated her gilded statue at Delphi, and other portraits of generals there have been mentioned in previous chapters. The Macedonians, especially Philip II after the Battle of Chaironeia, started erecting their own images in Greece—for instance, the five chryselephantine statues by Leochares in the Philippeion; and Euphranor was asked to make bronze statues of Philip and Alexander in chariots. The Karian rulers in the East were also becoming influential in Greek cities: at Delphi stood the portraits of Ada and Idrieus made by Satyros; at Kaunos, and at Mylasa, there were statues of Maussollos and his father Hekatomnos; at Erythrai, a portrait of Maussollos stood in the agora, one of Artemisia was housed in the Temple of Athena, and even Idrieus may have had his portrait there; other images of the Hekatomnids were at Miletos, Rhodes, and, as we have seen, probably at Priene.[43] In brief, there must have been a great number of such important monuments, true predecessors to those of the later Hellenistic rulers. Here we can deal only with a few preserved instances of Greek originals.

We have already mentioned the bronze feet wearing *trochades* recovered from the Antikythera Shipwreck. They were part of a group of at least four individuals, one of whom has been dubbed the **Philosopher**, although no secure identification exists for his impressive head. I have already discussed this piece elsewhere,[44] and shall comment here only on its relationship to the Olympia Boxer. Both heads represent mature men with rather unkempt hair and full beards; both have somewhat narrowed eyes and sagging cheeks, and both faces are just as symmetrically composed in general layout, except for the small distortions demanded by the intended viewpoint. Yet, as a whole, the Olympia head appears more patterned, the Antikythera one more plastic and naturalistic. This difference is particularly obvious in the eyebrows, which in the Boxer are basically linear, whereas in the Philosopher the hairy volume of the feature overrides the underlying design. The Philosopher's hair is clumpier, its curls either longer or (where shorter) less lively, less finely detailed; by contrast, the Olympia head has a great deal more engraving of individual strands. Yet the Philosopher's hair looks almost sparser, leaving the forehead free, as contrasted with the overhanging mass of the Boxer. Surprisingly, however, the Boxer has the more modeled forehead, the Philosopher the more linear scoring of wrinkles, in a reversal of the approach previously noted between the two.

Although both men sport a florid mustache, the Antikythera head's is so volumi-

nous that it almost entirely hides the upper lip. Is this feature enough to justify calling this head a philosopher's portrait? One suggestion would even make him a Cynic, in keeping with the disregard for personal appearance practiced by those thinkers. Once again, I find myself unable to decide whether we have here an excellent example of verism applied to a mythological creature or a definite attempt at a character portrait of a specific individual of the philosophical profession.[45]

Also a portrait should be the **Vergina Peplophoros** dedicated to (Artemis?) Eukleia by Eurydike, daughter of Sirras, wife of Amyntas and mother of Philip II, and therefore a member of the Macedonian royal house. Perfect correspondence is said to exist between the plinth of the figure and the inscribed base with the cavity for the sculpture, yet the laconic inscription (name, patronymic, recipient) does not explain whose image was set up. A second base with the very same dedicatory formula was found nearby, but its statue is missing. One wonders, therefore, whether Eurydike donated two statues of herself, or one of herself and one (currently missing) of Eukleia. According to the published reports, the head of the peplophoros, which was carved for separate insertion and has also been recovered, has the traits of a mature woman, but not enough can be told from photographs.[46] We would also not expect Eukleia to be wearing the encumbering form of the peplos. What is of primary interest here is in fact that the type is comparable to the Eirene of Kephisodotos—the kind of rendering that can be used for matronly divine images, but also (as we shall see below) for funerary sculpture. The Vergina evidence would give us proof of that ritual costume being used for a living, albeit royal, woman—a deliberate hint at heroization? The head associated with the body is veiled by the long and heavy mantle over the back, perfunctorily treated; the peplos in front is articulated by a series of catenaries that appear monotonous and fairly regular, in contrast with the directional lines of the Eirene's overfold; yet the left weight leg pushes the hip to the side and a long groove outlines it. The rounded kolpos below the apoptygma seems, however, little affected by the pose. A buttoned chiton sleeve is visible along the extant arm.

As a final mention in the portrait category, a **fourth-century inscription** can be cited (*IG* II² 3838, recovered from the Athenian Akropolis), because it straddles the fine line between a votive and a funerary offering: "Polyllos, the son of Polyllides, of Paiania. Polystratos dedicated this portrait (εἰκόνα), his own brother, an immortal memorial (μνημοσύνην) of a mortal body." We are not told what Polyllos did to deserve honor on the Akropolis; probably his brother simply wanted to preserve his memory, and was allowed to do so, without need for further justification. But the wording suggests commemoration of the dead, and surprises in a sanctuary context. The statue has not come down to us, but its portraitlike quality may have been relative in any case, if Polyllos was already deceased when the image was set up. We may see here the beginning of a form of private heroization that produced

also the practice of ancestral veneration through portrait statues set up in private homes, like the famous Delian sculptures of Kleopatra and Dioskourides of the second century.[47]

FUNERARY STATUES

With this last entry in the portrait category we have, once again, entered the realm of funerary sculpture. We had briefly mentioned some pieces in the round as part of the discussion on gravestones: they were mostly matching pieces, like mourning servants or Skythian archers (Chapter 5, n. 22). Here we can list only a few of the statues relevant to the fourth century, and some of the recent discoveries, primarily from Athens and environs, omitting, however, animals and monsters, like lions and sirens, or even dogs and bulls, of which a certain number remain. It should be noted that the authoritative monograph on the subject of free-standing memorials, by Collignon, was published in 1911 and is sorely in need of updating, using more stringent criteria in the determination of what constitutes a funerary monument, by context, and distinguishing between Greek originals and Roman copies.[48] Regrettably, many eligible Greek works were found reused or removed from their original setting, or through salvage excavation, and to some the funerary label was applied purely because of their general appearance or subject matter.

Perhaps the most surprising is a young **female figure from Rhamnous**, excavated in the family plot of Phanokrates in 21 fragments and still headless and incomplete. Yet enough is preserved to show that she wore a long-sleeved costume with repetitive catenaries, perhaps a himation as well. What is remarkable about her is that she rests her right arm on a tree trunk that seems to be much more than the usual support for marble statuary. Her pose, however, seems straight, without pronounced lean, at least as reconstructed at present. From the same site, but a different area, the peribolos of Diogeiton, comes a **servant figure**. Her status is identifiable through her long-sleeved costume with long overfold, waist- and shoulder-cords, and a sakkos that completely envelops her hair. Her head tilted upward may have been looking toward a larger figure to whom she was bringing a footstool or a chest(?), thus forming the kind of composition common on gravestones.[49]

It is difficult to decide, in fact, despite the presence of their own plinths, whether such statues in the round were meant to stand in the open air or were to be enclosed in a naiskos frame, thus resembling contemporary stelai in very high relief. Two sculptures recovered in Athens from **61 Marathon Street**, in a definite funerary context, were published as monuments in the round, like the lion found with them, whereas two additional figures, also from the same context, were assigned to a naiskos because of their unfinished backs. Yet another opinion would place the first two images within a similar frame, and produce a composition very close to the stele of a young girl and her attendant in the Metropolitan Museum.[50] In fact, of the two statues recovered in Athens, one depicts a young woman wearing a sleeved

Random Harvest

chiton, a peplos with belt, cross-straps, and central medallion, and a fluttering back mantle held with one hand; the other shows a younger attendant, as suggested by her peplos with overlong apoptygma, high girdle, and shoulder-cords. Both figures are headless.

A **head** is, however, all that remains of another funerary statue, found in Athens at the corner of Aiolos and Lykourgos Streets. That it was meant for insertion into a separate body is shown by the tenon below the neck, which, by its shape, confirms the fourth-century date suggested by the features.[51] This technique of separately carved heads even for funerary statues that carry no real pretense of portraiture strengthens the possibility that our next entry, although not from Athens, had in fact the same commemorative purpose.

A **Seated Woman in Chalkis** has occasionally been identified as a divinity, and in fact it bears a general resemblance to the Demeter of Knidos discussed above. Yet the sculpture probably comes from the nekropolis of the same city, and its iconography conforms to some of the matrons on Attic grave stelai—for instance, that of Demetria and Pamphile. The headless statue in Chalkis should probably be completed with a head (allegedly from Eretria) now in Berlin, but attempts to combine the two could not obtain a perfect join, since both attachment surfaces were damaged in antiquity or altered by modern installation. Certainly, the Chalkis statue once had a separately inserted head, and the one in Berlin fits so well in general scale, style, and chronology that little doubt should remain as to the connection.[52] With the veiled head in position, the work's affinity to the Demeter of Knidos is even more striking, yet, as its three-quarter pose suggests, the Chalkis lady was meant to be seen at an angle from her right side, and therefore lacks the frontality typical of a divine image. If its provenance could be verified, a funerary purpose for the monument would be assured; in addition, a large kalathos as wool basket under the seat is a typical *semeion* for the virtues and activities of a perfect housewife and strengthens the identification. That the seat itself was a throne (with legs and backrest once separately attached and now missing), complemented by a footstool, is no hindrance to the argument, given the evidence of gravestones. The larger-than-life size of the image can also be matched on stelai, and confirms the heroizing tendencies of the late fourth century in commemoration of the dead. The date suggested for the Chalkis statue, c. 330, is perhaps too low, since the drooping drapery that in places clings to the body with strong transparency effects recalls some of the Epidauros figures or even the "Timothean" Leda.

As a final comment, we may stress the predominance of animal and female sculptures for funerary purposes, as contrasted with the apparent lack of male ones; except for the two Skythian archers mentioned above, which still fall within the category of subsidiary images rather than primary monuments, no other male example could be cited, as contrasted with later periods, where statues like the Hermes of Andros could serve as the main tomb marker. Perhaps funerary male figures have

not been recognized in museum storerooms and salvage excavations; yet the fact that so many female ones have been recovered and identified would seem to belie the supposition. Perhaps men were more often immortalized in bronze and their statues have therefore not survived, although there seems to have been a tradition of sepulchral art in stone, as suggested by the great lion monuments commemorating battles. Be that as it may, the point deserves further consideration.

THE DERVENI KRATER

Plates 86a–b

It may seem peculiar to conclude a book on fourth-century sculpture with a discussion of a relief vase (Pls. 86a–b), but to some extent this spectacular object seems to epitomize the various trends and problems of the entire phase.

The basic facts about this huge (almost 1 m. high) bronze volute krater are well known, and need not be repeated in detail.[53] Interpretation of the scenes on the body of the vessel is still open to debate, and its dating has not been fixed with certainty, although it was recovered from the closed context of a tomb. But it could have been buried as an heirloom, so that the coin of Philip II found inside it gives only a relative chronology around 336. The name of the owner, Astion (Asteiounios?) son of Anaxagoras, from Larisa, inlaid in silver letters on the moldings of the rim, is given in Thessalian dialect, although the tomb for which the krater served as ashurn was located near Thessalonika, in Macedonian territory. The deceased was probably a warrior, since a leather cuirass and bronze and iron weapons were found within the grave, together with many other vessels in different media, including alabaster. He may also have been wealthy: more than 20 silver vessels accompanied the Derveni Krater, itself a spectacular and costly example of metalwork.

Why is it representative of the fourth century? Perhaps the first and most obvious reason is the mixture of many influences on its shape and decoration. At first glance, the Derveni vase recalls the similarly enormous terracotta kraters found in South Italian tombs, with comparable head roundels in the eyes of the volutes. Even its exuberant appearance, with additions in different metals for color contrast, and a combination of figurework in relief and in the round, suggests the unrestrained love for polychrome painting and plastic decoration of Magna Graecian vessels like the Canosan or the Centuripe wares. Yet the gold color of its surface—shown to be due to the high proportion of tin in the bronze alloy, and not to gilding—and the added silver wreath-leaves and other details speak of the love for precious metals typical of the Macedonians and of the minerally rich peoples with whom they were in close contact: the Skythians and the Thrakians. The different finds from the Royal Tombs at Vergina reveal a similar mixture of ethnic origins.

Artistically, influences are equally varied. The main decoration, with its high calligraphy in the swirling draperies, the presence of landscape (the rocky background), and the touches of textures and contrasting colors (*Metallmalerei*—a true form of painting with metals), may be derived from monumental painting. At the same time, the figures in the round that rest on the krater's shoulders are monu-

mental works in their own right. Seen in isolation, without reference to scale, they could be taken for lifesize creations.

Even more important is the mixture of stylistic trends that makes chronology so baffling. The relief satyr, with his sail-like animal skin lined with red copper, like a bleeding hide just flayed from an animal, recalls the pose of the Herakles Farnese, and has almost the same type of face. Yet the satyr in the round, with his head twisted in drunken merriment, his grotesque features, his angular pose, his wineskin, is closest to Late Hellenistic renderings, such as we find in Pompeian and Herculanean houses. The relief Dionysos has the gesture of the Apollo Lykeios and the elongated body with attenuated musculature that is commonly associated with late Lysippan proportions. He looks as young as a typical fourth-century rejuvenated god; his relaxed pose with one leg thrown over Ariadne's lap surprises for its intimacy, in divine context. The Dionysos in the round, gesturing toward the sleeping maenad on the shoulder of the krater, in its dignity and torsional pose is a foil to the satyr on the opposite side, and, with his straight arm supporting him on his seat, presages Hellenistic seated Nymphs.

The relief Ariadne could fit well within the Parthenon pediments, with her chiton revealingly clinging to her breasts in concentric semicircles as the sleeves slip down, creating a seductive, if implausible, décolleté. In general, all the maenads wear costumes that could have been copied from the Bassai frieze or the Nike Balustrade. In particular, note the chlamys of the "Monosandalos," flaring out on either side of his body in a virtually impossible movement, while the hem of his chitoniskos creates swirls and curves like sanguisuga folds, and almost forms the "Lykian wavelet." Undoubtedly, these are formulas of the so-called Rich Style of late fifth-century Athens, transposed into metalwork and kept alive in areas away from Attika, which had long since abandoned them. We may ask whether this delay is natural, a product of the slow diffusion of style to peripheral areas, or whether it is an intentional allusion to the Athens of imperial times, at its political and cultural heyday, fittingly evoked in a new climate of monarchical supremacy and territorial expansion.

As a final detail, note the androgynous look of the seated maenad restraining (or supporting) her half-naked companion; it is so pronounced that a recent suggestion identifies the scene as Pentheus in disguise trying to subdue his mother, Agave, although I find this interpretation hard to believe. But the revealed torso of the frenzied (or collapsing) maenad recalls the naked Amazon of the Maussolleion frieze, while her exposed thigh repeats the motif of the Nike of Paionios, and her proportions are as elongated as any Lysippan attribution. This is a composition of excesses—from the brutality of the scene in which an animal is about to be torn apart by two maenads moving in opposite directions, to the psychological impact of a child flung over the shoulder of another Bacchant, but with face hidden from view, and thus more compelling to our imagination than any actual rendering: is that concealed visage distorted in terror, mouth open in a scream?

Random Harvest

In its conservative and allusive retention of earlier styles, its innovative poses and proportions, its colorism and love for texture, its psychological content, its religious inferences of mystery cults, the Derveni Krater is truly a product of the fourth century, on the threshold between the past and the future.

NOTES

1. Peiraieus Athena: *LIMC* 2, s.v. Athena, p. 1033 (commentary; original by either Euphranor or Kephisodotos), no. 254, pl. 734; Palagia 1980, 21–23, figs. 32–33 (an unusual rear view); Todisco 1993, 98, pl. 214; Stewart 1990, 179 ("either an original of c. 350 or a copy of around 100"), fig. 511; Dontas 1982; Waywell 1971, pls. 67, 68a; Ridgway 1990, 363, with additional bibl., esp. Morrow 1985, 71 and pl. 52 on p. 76; Houser 1983, 58–61; Boardman 1995, fig. 46. For the Larger Peiraieus Artemis, see, e.g., *LIMC* 2, s.v. Artemis, no. 161, pl. 456 (mid-4th c.); Todisco 1990, pl. 213; Stewart 1990, figs. 569–70; Houser 1983, 62–65; Boardman 1995, fig. 47. See also A. H. Borbein's important review of Palagia 1980, with comments on both the Athena and the Artemis: *Gnomon* 59 (1987) 45–52, esp. 48–49.

Mattusch 1996, 129–40, discusses all the bronzes from the Peiraieus, with special focus on the Apollo; for the female figures, see pp. 131, 135. She accepts a 1st-c. date for the context (Sullan destruction), and therefore is inclined to date all four statues (Apollo, Athena, Larger and Smaller Artemis) to the 2nd c., probably from the same workshop because of their comparable copper-tin-lead alloys (p. 137). I am not sure enough evidence has been provided to date the destruction level of the findspot. In addition, the eclecticism implied by 4th-c. bodies and Hellenistic sandals for both the Athena and the Smaller Artemis suggests to me a "Roman" date, albeit one that is difficult to pin down. The problem is well explored by Mattusch within a wider context.

Mattei Athena: Waywell 1971 (first recognition of connection), pls. 66, 67b; *LIMC* 2, s.v. Athena, no. 255, pl. 734; Todisco 1993, pl. 215; Palagia 1980, figs. 36–40. Note that her visor is decorated with two ram's heads, rather than with owls.

Corinth Torso fragment: Ridgway 1981b, 442 n. 79.

Velletri Athena: *LIMC* 2, s.v. Athena, no. 247, pl. 733 (c. 430); cf. s.v. Athena/Minerva, no. 146, pl. 796; Waywell 1971, pl. 69a.

2. Copenhagen Niobid: e.g., Ridgway 1981a, 58, figs. 31–32. Both the Herculaneum bronze and the Gardner marble are well illustrated and discussed (as classicizing works) by R. Tölle-Kastenbein, *Frühklassische Peplosfiguren: Typen und Repliken*, AntP 20 (Berlin 1986) 75–79 (Excursus, cat. no. 58), pls. 68–72. Note that another type, considered derived from a true Severe original of c. 450, approximates the shifting of the apoptygma tip over the front that we find in the Peiraieus Athena: cat. no. 57, Berlin Type (with replica in Frankfurt), 67–71, pls. 64–67; see, however, my review in *Gnomon* 60 (1988) 523–27, esp. 526–27. If this gesture truly originates within Severe/severizing works, the evidence of the Peiraieus Athena needs reconsideration.

The rendering of the apoptygma is correct in the Boiotian stele of Polyxena (e.g., Ridgway 1981a, fig. 108), with which the bronze Athena has often been compared. On the gesture, with other examples and bibl., see Ridgway 1984b, 48–49 and n. 79, 52 and nn. 93–95.

3. Athena Giustiniani: *LIMC* 2, s.v. Athena/Minerva, no. 154a–c, pls. 797–98 (the colossal head, from Ostia, is no. 154c; no. 154b, a replica in the Capitoline Museum, has no aigis),

Random Harvest

dated to the early 4th c.; Todisco 1993, 98, pl. 10—cf. Agorakritos' Nemesis, conveniently juxtaposed on his pl. 11; differences cannot be explained in terms of date, since both works are represented by Roman copies. Note, in particular, how the chiton and mantle of the Nemesis mold the abdominal area with curving lines, as contrasted with the straighter folds of the Athena. For list of replicas, see Waywell 1971, 381, and cf. p. 376, pl. 69b. The helmet type, with ram's heads, can occur with more than one body type.

4. Athena Albani: *LIMC* 2, s.v. Athena, no. 248, s.v. Athena/Minerva, no. 147, pl. 797. For the giant from Mazi, see supra, Chapter 2.

5. Athena Farnese: *LIMC* 2, s.v. Athena/Minerva, no. 148 (the specific replica in Naples is dated to the 1st c. A.C.; the type is called Hope/Farnese); Todisco 1993, 64, 98, pl. 14.

6. Athena Vescovali/Arezzo: *LIMC* 2, s.v. Athena/Minerva, no. 156, pl. 798; Todisco 1993, pl. 123—cf. his pl. 289c (Athens NM 217), the central Muse with the scroll, for a comparison with the Mantineia Base. List of replicas in Waywell 1971, 378, and cf. 382, pl. 71c; he calls the type Vescovali/Capua/Benevento/Arezzo from the findspot of some replicas.

7. Rospigliosi Athena: *LIMC* 2, s.v. Athena, no. 257, pl. 735 (replica in Berlin, with chiton), cf. Athena/Minerva, no. 155, pl. 798 (Florence replica, without chiton), and comments on p. 1033; Todisco 1993, 135–36, pls. 299, 301; Waywell 1971, 377–78 (dated too early, first half of 4th c.), with list of copies on p. 381, pl. 71b. Because of the presence of a short right sleeve, even the replicas with lower legs exposed could not depict the goddess chitonless; the assumption is therefore that she wears a chitoniskos, as appropriate under a cuirass. This explanation would emphasize the military meaning of the type even more than the apparent masculine fashion. Himmelmann 1990, 98–100 and n. 226, calls it a strategos image, but also cites Borbein (*MarbWPr* 1970, 29), who sees the type as representative of Attic culture and intellectual life.

This type is occasionally compared to the Athena (with smooth mantle and chiton) on a Document Relief of 375/4, heading a treaty between Athens and Kerkyra (Athens NM 1467): *LIMC* 2, s.v. Athena, no. 609, pl. 763; Boardman 1995, fig. 149. Yet to me that goddess, despite her long and plain himation, seems different from the Rospigliosi Type, definitely more feminine, and still within the 5th-c. tradition. The relief is therefore important primarily because it confirms Athena's change of attire, rather than for any stylistic parallel.

8. Areopagos House Athena: Roccos 1991, with catalogue of replicas on pp. 408–10; of her 12 examples, nos. 3–6 are Document Reliefs, nos. 7–12 are votive reliefs; her no. 9 lacks the underlying chiton. Roccos' no. 1 is the Areopagos House figure (pls. 107–8), headless, pres. h.: 1.14m.; her no. 2 is a statuette in Palazzo Corsini, Florence, h. 0.71 m. (pl. 109.2). It retains a head with Corinthian(?) helmet. Roccos illustrates also comparable examples of the costume on humans, on grave stelai. On the costume, see also supra, Chapter 5, n. 46.

9. Castra Praetoria Athena (h.: 2.20 m.): *LIMC* 2, s.v. Athena/Minerva, no. 159, pl. 798 (prototype dated end of 4th, beginning of 3rd c.); Roccos 1991, 400, with extensive bibl. in n. 16, pl. 112d; Waywell 1971, 378, pl. 72a. For the Document Relief (Athens NM 1482, dated 323/2 to 318/7), see *LIMC* 2, s.v. Athena, no. 613; *LIMC* 3, s.v. Demos, no. 58, pl. 275.

10. Knauer 1992, esp. n. 69 on pp. 395–96, for the appearance of the motif in later works, the latest of which may be the Ares of the Pergamon Gigantomachy. Yet the author seems to suggest that Athens eventually abandons the rendering, once it is adopted on coins of Corinth.

One more Athena, the so-called **Ince Type**, sports the tiara under the helmet, but her

dating is close enough to the 5th c. to allow for the rendering: see, e.g., Waywell 1971, 376–77, list of replicas on p. 381, pls. 68b, 70; Todisco 1993, pl. 9; Ridgway 1994, 53–56, no. 15, with additional bibl. (A.-M. Knoblauch).

11. For a discussion of Artemis types wearing short costumes, and of related deities such as Bendis and Kotytto, see Sturgeon 1995, 490–92. See also the commentary by L. Kahil in *LIMC* 2, s.v. Artemis, pp. 747–48, and contrast with representations in the 5th c. (pp. 746–47). For Hellenistic representations of Artemis with animal skin, and short skirt, in motion, see nos. 361–79, pls. 475–76.

12. Larger Peiraieus Artemis: supra, n. 1. For the Artemis of Versailles, see, e.g., Ridgway 1990, 93–95; Todisco 1993, pl. 228.

The Larger Peiraieus Artemis seems comparable to the **Beirut Type** (*LIMC* 2, s.v. Artemis, no. 129, pl. 454), which has a regularly belted apoptygma as well as a quiver strap; Todisco 1993, 69, pl. 106 (= Vatican 2834), groups it, however, with two other Artemis types, Dresden and Munich/Braschi, on which see infra, n. 16. The Vatican replica of the Beirut Type (with alien head) seems in the act of removing an arrow from the quiver, but the right arm is restored; it appears lowered, probably once holding a phiale, in the Berlin replica (from Beirut): *LIMC* 2, s.v. Artemis/Diana, no.7. A variant of the Beirut Type, in Venice, adds a chiton under the peplos: *LIMC* 2, s.v. Artemis, no. 130, pl. 454. For another comparable Artemis rendering, see also *LIMC* 2, no. 133, pl. 455 (Holkham Hall A.), with a long kolpos below the apoptygma. These types and variants seem generically classicizing. See also *LIMC* 2, s.v. Artemis/Diana, nos. 17 (D. Borghese, single example, with belted overfold, peplos over chiton) and 18 (several examples with chiton), both on pl. 590.

13. Smaller Peiraieus Artemis: *LIMC* 2, s.v. Artemis, no. 162, pl. 457 (dated third quarter of the 4th c.); Boardman 1995, fig. 48 ("copy [?] of original of about 325"); Houser 1983, 66–69 (dated early 3rd c.). Houser points out that the mantle forms a separate bronze layer over Artemis' dress, and so does the overfold over the skirt of her peplos, as is true also for the other Peiraieus goddesses: the underlying surface is visible through the cracks of the upper garment. For comments on the Artemis' sandals, see Morrow 1985, 71–72, pl. 53 on p. 76.

14. Artemis on Paros (Mus. 757): *LIMC* 2, s.v. Artemis, no. 100, pl. 450; the main publication is Kleemann 1962. Inspiration from Alkamenes' Hekate: Fullerton 1987, 262.

15. Artemis of Gabii: *LIMC* 2, s.v. Artemis, no. 190, pl. 460 (dated 350–330, L. Kahil), and s.v. Artemis/Diana, no. 16 (dated c. 300, with diplax, E. Simon); both entries doubt the connection with the Brauronia, and with Praxiteles; the latter mentions the virtual lack of replicas. See also Todisco 1993, 72–73, pl. 116 (cautiously supporting traditional interpretation and dating c. 360–355); Stewart 1990, 179, fig. 508; Morrow 1985, 207 n. 22 (sandals belong with eclectic Graeco-Roman statues); Ridgway 1984a, 53 and n. 31 with additional bibl.; Boardman 1995, figs. 86.1–2.

For the Pergamon Dancer and the Miletos Karyatid, see Fullerton 1987, 266–72, pls. 18.1, 19.3. For Isiac iconography, see, e.g., E. J. Walters, *Attic Grave Reliefs That Represent Women in the Dress of Isis* (*Hesperia* Suppl. 22, 1988). For my definition of archaizing, see Ridgway 1993, 445: works which, created after 480, exhibit their own contemporary *style*, but retain underlying *patterns* (whether of costume or of head features) that are typically Archaic. Note the difference between the pattern of the Gabii Artemis and that of the female

on the best-preserved Ephesos column drum, who makes approximately the same gesture in mirror-image (e.g., Ridgway 1990, pl. 5, extreme left); because of the lack of horizontal accents, the contrast there is entirely lost.

16. Dresden Artemis Type: *LIMC* 2, s.v. Artemis, no. 137, pl. 455, and, s.v. Artemis/Diana, no. 9, with replica *c* (in Kassel) shown on pl. 583 ("after a bronze original of the second half of the 4th c."); Boardman 1995, fig. 84. See also Todisco 1993, 69, pl. 105, and cf. his pl. 107 for a similar type, the Munich statue once in Palazzo Braschi, Rome. For a Hellenistic version of the Dresden Artemis, also with lowered arm, from Brauron, see *LIMC* 2, no. 140, pl. 455.

17. Colonna Artemis: *LIMC* 2, s.v. Artemis, no. 163, pl. 457 (dated Hellenistic), and s.v. Artemis/Diana, no. 15, pl. 589 (*c*, a replica in Rome; *k*, a head in the Vatican); Todisco 1993, 55, pl. 64 (attributed to the Polykleitan School); Boardman 1995, fig. 85.

18. Roccos 1986, 365–98, lists all the Artemis-Hekate representations with the back mantle, but concludes (p. 378) that the relatively few depictions do not go back to a free-standing prototype. For the theory of a possible contamination with an Artemis statue, see Ridgway 1972, 43–44, no. 15. See also supra, n. 8, and Chapter 5, n. 46, for additional references.

19. Epidauros Aphrodite (Athens NM 262): *LIMC* 2, s.v. Aphrodite, nos. 243–45, pl. 28 (no. 244 is the replica in Munich), and comments on p. 36; Todisco 1993, 52, pl. 43 (c. 400; Polykleitos II); Delivorrias 1995, with much bibl. and arguments against Amyklai, n. 2 on pp. 212–13. The copy in Munich has an added animal skin, which was originally read as an allusion to the Spartan victory at Aigospotamoi (the "goat rivers"), but is more probably a transformation of the Aphrodite type into a Maenad, with another iconographic conflation of somewhat compatible identities. Some features of the Epidauros marble remain peculiar, such as the unusual headcover and the arrangement of the mantle over the right hip, that have suggested a classicizing date to some scholars. Within the context of the "armed Aphrodite," the statue is extensively discussed by J. Flemberg, *Venus Armata: Studien zur bewaffneten Aphrodite in der griechisch-römischen Kunst* (Stockholm 1991) 46–56.

See also Delivorrias 1991, for his latest opinion on Aphrodite types, although I cannot agree with some of his dates (e.g., for the Este Aphrodite, which for me remains late and classicizing). His article is also important for the recognition of iconographic traits typical of Aphrodite but shared by other goddesses; see esp. his discussion of Kore, p. 145, and his figs. 23–24 on p. 146; the **"Kore" Sion House–Munich Type** recalls both the Nemesis of Rhamnous and the Velletri Athena, except for her expanded neckline. On another possible 4th c.-type, the **Capua Aphrodite**, see supra, Chapter 7, n. 75; see also L. M. Gadbery, "The Statue of Armed Aphrodite on Acrocorinth," Abstract, *AJA* 96 (1992) 358.

Boardman 1995, figs. 81–82, illustrates two more images of Aphrodite: the so-called **Euploia** (because she leans on an anchor around which a dolphin is entwined); and the so-called **Kallipygos**, lifting her garment to look at her "beautiful behind." This latter is attested in the minor arts, and may have cultic significance, although, as a statue in the round, it seems to me a typical Hellenistic conception. The former, in her semi-nude attire and pose, recalls the 2nd-c. Poseidon of Melos, and I wonder whether it could be a Roman transposition of a male type—Poseidon or even Asklepios; certainly her pose, with both feet flat on the ground, seems awkward, as is the veiling of the head.

20. Original statuettes (peplophoroi): those in Venice, once in the Grimani Collection, come from Crete; see Ridgway 1981a, 194–98, with bibl.; add *LIMC* 4, s.v. Demeter (adden-

dum), nos. 70, pl. 568 (c. 370; = Todisco 1993, pl. 93), 71 (mid-4th c.; = Hera, no. 107; Todisco 1993, pl. 95). From Kyparissi on Kos: Ridgway 1990, 214–15 with bibl. in n. 7; add *LIMC* 4, s.v. Demeter, nos. 72 (c. 350), and 73 (c. 340–330), both on pl. 568, and cf. no. 74 (beginning of 3rd c.) on same plate (= Todisco 1993, pl. 118). From Eleusis: *LIMC* 4, s.v. Demeter, no. 75, pl. 569 (mid-4th c.). All these pieces are original statuettes, as are also nos. 68, pl. 567 (Venice, Contarini Collection, beginning of 4th c., peplophoros with back mantle), 69, pl. 568 (in Paris); etc.

Herculaneum Women, Large and Small: Ridgway 1990, 92–93, pls. 56a–b; Todisco 1993, 133–34 (uncertain on identification), pls. 291–92. A bronze female statue, possibly of the Large Herculanensis type, was found in early Jan. 1995 by a Greek fisherman off the coast of Kalymnos, but so far only newspaper accounts and photographs have been available. It would be important to have it confirmed that the type was executed also in bronze.

21. Demeter of Knidos: Carpenter 1960, 173, 213–14, pl. 40. The most influential article was Ashmole 1951, and cf. his debate with Carpenter in Ashmole 1977. Additional bibl.: *LIMC* 4, s.v. Demeter (addendum), no. 138, pl. 571; Stewart 1990, 191, figs. 571–72; Todisco 1993, 106–7, pl. 221; Boardman 1995, fig. 49. The comparable Grimani statuette is *LIMC* 4, no. 70 (supra, n. 20). For the Aischines, see, e.g., Todisco 1993, pl. 300; for female statues, e.g., pls. 286–87.

22. On the type in general, see Kilmer 1977, esp. 133–34 (on function), 135–44 (on dating), for what he calls the "Transitional Hellenistic" types; his figs. 58–83 show Sicilian types, his figs. 86–91, those from South Italy. For the Sicilian examples, see Bell 1981; he reviews historical conditions in the 4th c. and previous theories (pp. 22–27), and specifically discusses the shoulder busts on pp. 27–33—their greater popularity in the second half of the 4th c., especially after 325 (p. 28), and the continuous life of the patterned hair of the Archaic period (p. 29). See in particular his cat. no. 106a–c, pp. 140–41, pls. 27–28, text figs. a–b on pp. 31–33, for painted depictions on the costumes: the Rape of Persephone (106c) and Preparation for the Wedding (106a). For Severe-style traits, see, e.g., cat. 106a, pl. 27.

For more general, but helpful comments, see also Wescoat 1989, 97, 99–101 with cat. nos. 19–21, esp. the last with remnants of a painted scene of ecstatic or ritual dancing: color pls. on pp. 62–63 (no. 21), 64 (no. 19), 69 (no. 20).

23. Flashar 1992, 45–46 on the history of the peplos, especially the Attic type with belted overfold; but see also Ridgway 1984b and Roccos 1986 and 1989. On the Apollo Rhamnousios by Skopas, see supra, Chapter 7, n. 47, and Flashar 1992, 40–45, who dates it shortly before 360; since he knows no sure replicas of the type, he bases his understanding of the statue's costume on a verse of Propertius (*Eleg.* 2.31.16: *Pythius in longa carmina veste sonat*) describing the Apollo Palatinus, and on the correlation between the Palatinus and the Rhamnousios mentioned by a Late Roman source. But the equation is by no means assured, and the evidence, as I have stated above, seems to me very tenuous.

24. Apollo Patroos (Agora S 2154): the official publication is Thompson 1953; extensive discussion, in the context of Euphranor, in Palagia 1980, 13–20, figs. 6–17, and comparative material in figs. 18–25 (omit fig. 26, the so-called Apollo Barberini, now known as an eclectic Augustan creation). See also *LIMC* 2, s.v. Apollon, no. 145, with replicas and variants listed as 145a–m, pl. 195. Roccos 1986, 12–26, 503 (with discussion of revival traits). Flashar 1992,

Random Harvest

50–60. Todisco 1993, 96–97, pl. 210. Boardman 1995, fig. 30. The headless statue is at present 2.54 m. high.

On the cult of the Patroos and its temples, see also Hedrick 1988, in part rebutted but mostly followed and supplemented by Flashar. Knell 1994, within the context of the temple, discusses also the cult and the statue (pp. 231–37), but basically agrees with Flashar; see, however, fig. 8 on p. 237 for a sketch of the Agora marble within the temple.

25. All sources on Euphranor have been collected and discussed by Palagia 1980; see, however, the reviews of her book by Borbein (supra, n. 1), and by J. J. Pollitt, *AJA* 88 (1984) 417–19. See also Todisco 1993, 91–103, who would assign to Euphranor even more works than Palagia, including the Apollo Lykeios, the "Praxitelean" Eubouleos, the Hope Herakles, and the Antikythera Youth (on which see infra).

Bronze molds for kouros or Apollo from area of Temple of Patroos: C. C. Mattusch, "Bronze and Ironworking Techniques from the Athenian Agora," *Hesperia* 46 (1977) 343–47; ead., *Greek Bronze Statuary: From the Beginning through the Fifth Century B.C.* (Ithaca/London 1988) 54–59, esp. 59. Hedrick 1988, 190–91, figs. 4–5, believes that the molds were just for a votive kouros, rather than a cult image, but at mid-6th c. such a large bronze offering would have been quite unusual. It could be argued that the Athena and Hephaistos by Alkamenes, in the Hephaisteion, had to be in bronze because of those deities' special connection with metal-workers; but, to my knowledge, there is no ancient rule specifying the material appropriate for cult images.

26. Altar, Athens NM 1730, *IG* II2 4995: *LIMC* 2, s.v. Apollon, no. 219, pl. 202. Comments on the iconography and cult of the Patroos: Hedrick 1988, 198–299; he stresses the Ionian character of the costume, as appropriate first to the Pythios, then to the Patroos. On the costume of the Agora statue, see also Ridgway 1984b, 52–53, and nn. 97–102.

I find it ironic that Apollo should appropriate Athena's belted peplos just at the time when Athens had witnessed a definite change in fashion in sculptures of the goddess. The last third of the 4th c. seems to have revived the attire even for Athena, in keeping with other classicizing trends.

For fragments of another kithara-playing statue, found along the north side of the temple, see Thompson 1953, 37–38, figs. 7a–b on p. 39. Hedrick 1988, 199, and Stewart 1990, 288, (cf. p. 179), had already noted that these fragments opened up other possibilities for attribution, but Flashar 1992, 52–53, objects on the basis of dimensions and iconography. Note, however, that the benches (postulated on the basis of the double thickening of the wall on the north side of the doorway) are 0.69 m. in width: H. A. Thompson, "Buildings on the West Side of the Agora," *Hesperia* 6 (1937) 1–226, esp. 98–99. They could therefore, albeit tightly, accommodate the extant Apollo's plinth, which is 0.62 m.

The source associating Apollo Patroos and music is a scholion to Aristophanes, *Clouds*, 984, (Hedrick 1988, 200 n. 111 for entire text; mentioned by Flashar, pp. 57–58); Lykourgan politics (Flashar, pp. 58–59) would have prompted the creation of a draped Apollo as counterpart to the naked Lykeios.

27. I had the opportunity to see the statue for the first time in early 1956, when it was still in an open courtyard of the National Museum, and under natural lighting conditions. At that time, the colorism of the surface was such that I thought the sculpture was Hellenis-

tic. In the semi-shadow of its present location, the peplos texturing is much less visible—one more argument to suggest that the Apollo might not have stood in the dark interior of a cella? On the other hand, the summary finish of its back implies that it was not visible, but this seems to be a trait of other 4th-c. statues meant for frontal viewing. The colossal size of the piece alone is not enough to make it a cult image.

28. Hermes Andros/Farnese: Todisco 1993, 54, 133, pl. 285 with bibl. (attributed to Attic School); *LIMC* 5, s.v. Hermes, no. 950, pl. 278; Boardman 1995, fig. 78.

Hermes Richelieu: Todisco 1993, 53, 54, pl. 53; *LIMC* 5, s.v. Hermes, no. 946, pl. 276 (and 277 for additional replicas); Ridgway 1972, 45–48, no. 16, with list of copies and echoes, a slightly different sequence of prototypes, and discussion of the *Nestbausch* formed by the mantle.

Hermes Troizen: Todisco 1993, 53, pl. 46; *LIMC* 5, s.v. Hermes, no. 298, pl. 225; Boardman 1995, fig. 32.

Hermes Pitti/Berlin: Todisco 1993, 53–54, pl. 50; *LIMC* 5, s.v. Hermes, no. 943, pl. 276. On these types, see also supra, Chapter 7, n. 15.

Maderna 1988: Hermes Richelieu, 82–84, pl. 26.3; Late Hellenistic variants (H. Atalanti, pl. 27.1) 86–87, (H. of Aigion, pl. 27.2) 87–88; ideal portraits, 88–94; Roman portraits, cat. nos. H 2–16, pp. 225–36; with classicizing variation, cat. nos. H 17–27, pp. 236–44. Hermes Andros-Farnese, 84–86, pl. 32.3; ideal portraits, 94–95; Roman portraits, cat. nos. H 28–29, pp. 244–46. It is clear that the Hermes Richelieu is the more popular of the two types with the Romans.

29. Dionysos Sardanapalos Type: Ridgway 1990, 91–92; *LIMC* 3, s.v. Dionysos, no. 89, pl. 303, and cf. s.v. Dionysos/Bacchus, no. 37, pl. 430 (the name piece); Todisco 1993, 135, pl. 296; Boardman 1995, fig. 69. See supra, Chapter 6, n. 59 for the three-sided base; there, the Dionysos resembles the Sardanapalos Type in his heavy attire, but not in his long beard; whether the relief image is truly beardless, as usually claimed, is made somewhat uncertain by the damage to the face.

30. Asklepios Giustini: Todisco 1993, pls. 157–58, with ample bibl. The detailed recent study is Meyer 1988, who distinguishes four types; however, see also Berger 1990, who distinguishes three, but divides Version III into two subgroups. See also *LIMC* 2, s.v. Asklepios, nos. 154–233 (including several variants, not all pertinent to my discussion, e.g., nos. 193–94), pls. 647–52, with comments on pp. 894–95; two head types are acknowledged (nos. 215–30, and nos. 231–33), but both are bearded; the beardless statue in the Vatican (no. 157, pl. 647 = Boardman 1995, fig. 67) is considered the portrait of a young doctor on an Asklepios body type, but to me it seems to lack individualized features, and could correspond to one of several statues of a young Asklepios mentioned by Pausanias: 2.10.3 (at Sikyon, by Kalamis, and chryselephantine), 2.11.8 (at Titane in the Corinthia, "copying" the Gortynian A.), 2.13.3 (at Phlious), 2.32.3 (at Troizen, by Timotheos, thought locally to be Hippolytos), 8.28.1 (at Gortys of Arkadia, with Hygieia, by Skopas).

31. Hygieia Hope: e.g., Todisco 1993, 53–54 (associated with both Polykleitos II and Naukydes), pl. 54, with bibl. *LIMC* 5, s.v. Hygieia, no. 160, pl. 392 (and cf. nos. 161–83 for works in the round, nos. 184–87 for reliefs); Boardman 1995, fig. 88.

32. Agora S 2370: Todisco 1993, 156 (with identification left open), pl. 304; Ridgway 1990, 54–56; Boardman 1995, fig. 51. For the new identification as Agathe Tyche, see Palagia 1994,

Random Harvest

with a careful study of dimensions of statue bases and related sculptures. On Tyche, see also refs. supra, Chapter 6, n. 42.

33. Antikythera Youth (Athens NM 13396): the most detailed publication after the more recent (1951–52) restoration of the bronze is Karouzos 1969, with photographs and drawings. Technical details and thorough discussion also in Bol 1972, 18–24, pls. 6–9; and now Mattusch 1996, 87–90, esp. 88 and n. 43. See also Houser 1983, 92–99; Palagia 1980, 34, no. 5 (and fig. 57), with bibl.; Todisco 1993, 102, pl. 202 (with additional bibl.); Stewart 1990, 185, fig. 550; Boardman 1995, fig. 43 and frontispiece; *LIMC* 7, s.v. Perseus, no. 65, pl. 284 (with various identifications mentioned, all tentatively). For general comments on the cargo of the Antikythera ship, which contained "antiques" as well as new objects for the Roman market, see N. Himmelmann, "Mahdia und Antikythera," in G. Hellenkemper Salies et al., eds., *Das Wrack: Der antike Schiffsfund von Mahdia* (Cologne 1994) 849–55. For the findspot of the statue, see N. Yalouris, "The Shipwreck of Antikythera: New Evidence of Its Date after Supplementary Investigation," in J.-P. Descoeudres, ed., *Eumousia: Ceramic and Iconographic Studies in Honour of A. Cambitoglou* (*MeditArch.* Suppl. 1, Sydney 1990) 135–36. The original assessment of the cargo and its chronology is G. Weinberg et al., *The Antikythera Shipwreck Reconsidered* (*TAPS* n.s. 55.3, Philadelphia 1965).

34. Houser 1983 suggests that the left hand held a "polelike shaft" long enough to reach the ground, against which the arm rested slightly; yet this object was not big enough to be a club, and therefore the Youth could not be Herakles, given the lack of other attributes. The labor of the Apples of the Hesperides (appropriate for the gesture of the right hand) is dismissed because the youthful appearance of the bronze contrasts with the sequential order of the Labors, which gives the Hesperides adventure as the last; yet see the 5th-c. Three-Figure Relief with the same theme, where Herakles is shown young. I believe that the object held in the Youth's left hand ran obliquely, rather than perpendicular to the ground, as I could tell by inserting my pencil through the fingers.

35. Bol 1972, 22–23, admits that certainty can be achieved only by looking into the interior of the bronze, which he could analyze exclusively from the outside when it was already set up. Many technical details in the statue do not specifically help: the lips are cast separately as a massive piece (as are those of Riace Warrior A and the Terme Boxer: infra, n. 41), and a plate inserted from behind adds teeth (cf. Karouzos 1969, figs. 1–3 on pp. 63–66). The feet were cast in two halves (the front part being separate): the left had an open sole, for the insertion of the lead fastening, but the right was closed except for a small opening at the big toe and the corresponding portion of the ball of the foot: cf. Karouzos 1969, figs. 10–11 on pp. 74–75. The eyes and lids with lashes were introduced from the outside, like those of the Olympia Boxer (see infra, n. 40).

Houser 1983 attributes the Antikythera Youth to the same hand that made the Larger Peiraieus Artemis, not only because of their facial similarity, but also because both statues have an unusually wide torso (p. 64).

36. Athletic statuette from Antikythera Wreck (Athens NM 13399): see supra, Chapter 8, n. 9, for Moreno's suggestion (in *Lisippo* 1995), and counterarguments. Todisco 1993, 140, pl. 308, allows the possibility that the small bronze is Hellenistic. On the bronze sandals from the wreck, see Morrow 1985, 115, pls. 98–102.

37. Petworth Oil-Pourer: well discussed by P. Zanker, *Klassizistische Statuen: Studien*

zur Veränderung des Kunstgeschmacks in der römische Kaiserzeit (Mainz 1974) 39–40, no. 39, pl. 41, who considers it a classicizing creation of the first half of the 2nd c. A. C. Todisco 1993, 51, attributes the type to the master of the Dresden Youth, a pupil of Polykleitos. The Pitti Oil-Pourer is discussed by Linfert 1990, 278–80, in connection with Daidalos, but he points out that no statue type has been recovered with arms and gesture intact, and therefore beyond doubt. He would tentatively accept the Munich Oil-Pourer as a Lysippan work.

38. Bronze Marathon Youth (Athens NM 15118): Todisco 1993, 133, pl. 298; Stewart 1990, 177, figs. 497, 499; Boardman 1995, fig. 42; Papaioannou 1984 (concentrating exclusively on the meaning of the fillet ornament as allusion to the palaistra); Houser 1983, 102, 104–7. *Mind and Body* 1989, 179–81, no. 71 (P. G. Calligas), mentions both the possibility of a restored left arm and a later location in Herodes Atticus' villa—the latter a theory that I too had suggested orally several years ago. Rhomaios 1924, published shortly after discovery of the bronze, gives some helpful details and measurements; fig. 3 on p. 152 shows the bottom of the left foot, with two cavities filled with lead and an open big toe.

That the fillet ornament is not exclusive to the palaistra realm may be shown by gravestones of children too young to be considered athletic: see, e.g., the stele of Mnesikles in the Princeton Museum: Ridgway 1994, 12–15, no. 2 (T. M. Brogan), here **Pl. 36**. The presence of a toy cart and of a bird in the child's hand confirms the impression of a toddler.

39. Toledo Youth: S. C. Jones, "The Toledo Bronze Youth and East Mediterranean Bronze Workshops," *JRA* 7 (1994) 243–56.

Houser 1983 mentions that conservators of the Athens National Museum suggested both arms of the Marathon Youth may have been replaced; Calligas (supra, n. 38, in *Mind and Body* 1989) speaks only of the left hand. This has a hollow palm with a central pin (cf. Rhomaios 1924, fig. 4 on p. 154), which served to fasten a large object with a flat bottom that reached almost to the Youth's elbow, as shown by the smoothed area of the lower arm. This object has usually been thought to be a tray from which the Youth lifted a fillet with his right hand, but this reconstruction was based on images on white-ground lekythoi and had a funerary connotation; the bronze was therefore visualized as a commemorative monument for ephebes, since an ephebic garrison was stationed at Marathon in Greek times. For two such reconstructions, see R. Carpenter, "Two Postscripts to the Hermes Controversy," *AJA* 58 (1954) 1–12, esp. 9, pl. 1. 1–2.

Other solutions connected with the proposed identification of the Youth have him holding a cock (as a love gift to an adolescent) or a tortoise, to which Hermes would be snapping his fingers, since the index and thumb of the raised right hand are too close to have held a substantial object. The names of Hermes Agonios or Enagonios have also been suggested. Some of these interpretations are discussed by Papaioannou 1984, esp. 3 n. 3.

40. Olympia Boxer (Athens NM 6439): fully discussed by Bol 1978, 40–43, 114–15, cat. no. 159, pls. 30–32 with new lighting; and now by Mattusch 1996, 84–87. The head calotte was cast separately, with the join falling approximately along the line of the wreath, which would have concealed it; Mattusch notes that the curls above and below the wreath do not line up. The lips are sharply outlined and Bol assumes that they were once lined with copper sheets, now lost; Mattusch suggests that they are inlaid in the same metal as the head. The Olympia victories by Satyros were probably achieved in 332 and 328 (he won at Oropos in

Random Harvest

335/4), but the head is dated at mid-4th c., and its hair rendering is compared by Bol to that of the Antikythera Youth. See also Houser 1983, 36–37; Stewart 1990, 180, fig. 514; Boardman 1995, fig. 44; Todisco 1993, 109, pl. 232, with additional bibl. Todisco discusses the Olympia head in the context of Silanion: pp. 108–11. I must admit that his comparison of the bronze Boxer with a marble head in Naples from the Villa of the Papyri (his pl. 233) is striking and convincing, but identification of the Naples head with the sculptor Apollodoros is far from proven, and attribution to Silanion is uncertain. Mattusch stresses the massive wax additions to the working model, which are responsible for the considerable weight of the Olympia head; the piece is therefore "a unique work of sculpture."

41. See supra, Chapter 8, n. 4. P. Moreno, in *Lisippo* 1995, 97–102, no. 4.13(1), reiterates his belief that the Seated Boxer in Rome dates from c. 335, portrays the athlete Mys of Taras, winner at Olympia in 336, and is a work by Lysippos; and he uses the Olympia Boxer as a parallel. The difference between the two seems to me irreconcilable with approximate contemporaneity. The fact that the Terme Boxer's lips are a massive inlay rather than a copper lining simply indicates the continuity of certain casting practices rather than an early chronology. Note also the sophisticated use of a special alloy to convey a black-blue color in spots, as if for livid contusions.

42. On Lykourgos' program, see, e.g., Stewart 1990, 192, and cf. 179–80 for Plato and portraiture by Silanion. On portraits of priestesses, see Mantis 1990, 70–74, and passim. For Lykourgan inventories of the Akropolis statues, see Harris 1992, esp. 645, on the classes of persons who made dedications. On statues of children at Brauron, not yet fully published, see Ridgway 1990, 338 and n. 39, pls. 175–76.

For judicious comments on the problems of 4th-c. portraiture, see now Boardman 1995, 103–6. I find myself uneasy about several traditional identifications, and prefer to concentrate on Greek originals that may qualify as portraits, even if we cannot name their subjects.

43. Phryne: Paus. 10.14.4; its dedicatory inscription is cited by Athenaios 13.591, who repeats the criticism of Krates the Cynic deploring the position of her statue between those of Archidamos, King of Sparta, and Philip II, king of Macedonia. Philippeion chryselephantine statues: see supra, Chapter 7, n. 36; the most recent discussion is by Shapiro Lapatin, forthcoming (supra, Chapter 1, n. 28). On the Hekatomnid portraits, see, e.g., Waywell 1978, 77–78 n. 1; Gunter 1995, 20–21 and nn. 48–56, and cf. p. 52. On the Delphi statues, see also supra, Chapter 7, n. 39, and cf. Chapter 4 for possible portraits at Priene.

44. Antikythera "Philosopher" (Athens NM 13400): Ridgway 1990, 57, and bibl. in n. 41, pl. 32. The most detailed study is by Bol 1972, 29–30, but see 24–34 for the whole group; the Philosopher may be reconstructed with a raised right arm, the left holding a stick, on the basis of the few recovered fragments. See now also Mattusch 1996, 90–94, esp. her comments that damage gives the head "a rather misleadingly disheveled appearance," the hair once being carefully engraved and looking less matted than it does now, with the tips of the curls broken off (pp. 92–93). The Antikythera head is usually considered Hellenistic; Houser 1983, 100–101, says 3rd or 2nd c.; but a late 4th-c. date is here tentatively advocated on the basis of the footwork, as argued by Morrow 1985, 115; Mattusch 1996, n. 54, seems to doubt that this type of *trochades* can be precisely dated; she mentions other suggested dates (n. 58) but seems to support a mid- to Late Hellenistic chronology because of the rapid method

of production, which implies increased demand. This head is 0.29 m. high; the Olympia Boxer's is 0.28 m., the longer beard perhaps accounting for the difference. They are therefore both lifesize, as would befit a human image.

45. In this context, it is instructive to note that Flashar and von der Hoff 1993 have investigated the findspot of the so-called Philosopher of Delphi (an early Hellenistic original) and have concluded that it belongs to a group monument, since it was found with two headless figures: a female and a draped male that recalls the "Sardanapalos" Dionysos. Both (and perhaps also a naked male with Mantelbausch) seem to come from the same workshop. The group was probably dedicated by a technites or a choregos, and would have included two of his relatives together with the god. The "philosopher" should therefore be no more than just a "citizen."

46. M. Andronikos, "Vergina," *Ergon* 1990, 80–88, esp. 83–85, figs. 114, 116–17; the head is shown in fig. 118. Fig. 115 shows a second base with the same inscription, and with the lead for fastening the plinth still in place, but without the corresponding image. Both bases were found near the second temple of Eukleia (NE corner). The headless statue is 1.65 m. high; therefore over-lifesize with head in position. It has been dated c. 340, probably on historical evidence. Cf. also A. Pariente, "Chronique des Fouilles en 1990," *BCH* 115 (1991) 899, and figs. 91–92 on p. 901. Saatsoglou-Paliadeli 1990, fig. 7, shows a frontal photograph of the head, which is described as flat on the back, "like a *Gesichtsmaske*"; holes suggest added metal ornaments to the hair; see also her figs. 1–12, on pp. 31–34, for further details of statue and base. I owe the opportunity to consult this publication to the kindness of Prof. S. Miller-Collett.

47. Kleopatra and Dioskourides: e.g., Stewart 1990, 227, fig. 837. The Akropolis inscription and comments on ancestral commemoration are cited from J. Harward, "Greek Domestic Sculpture and the Origins of Private Art Patronage" (Ph.D. dissertation, Harvard University, 1982) 139–40. Prof. G. R. Edwards cautions me that, after the Greek revolution for independence, in 1828, the Akropolis was used as a safekeeping place for antiquities from everywhere. Not every object on the Akropolis therefore need have stood there originally.

48. J. Collignon: *Les statues funéraires dans l'art grec* (Paris 1911). An unpublished 1993 M.A. thesis for Bryn Mawr College, by K. J. Hame, "Greek Funerary Sculpture," has tried a limited update of Collignon, for all periods of Greek art; I am indebted to it for several 4th-c. refs.

49. Rhamnous, young woman from Peribolos of Phanokrates: *BCH* 103 (1979) 547, fig. 57; attendant from Peribolos of Diogeiton: 546, figs. 58–59.

50. Statues from 61 Marathon Street: O. Alexandris, "Burial Terrace near the Road to Academy," *AAA* 2 (1969) 257–64, with English summary on pp. 265–68; the two figures assumed to be in the round are illustrated in figs. 2–3; figs. 4–5 show the statues meant for a naiskos, one of which is a peplophoros with kolpos and apoptygma comparable to the Eirene of Kephisodotos. The differing opinion, placing even the first two statues in a naiskos, is by Roccos 1986, 500–501, cat. no. 176, pl. 80. For the New York monument, MM 44.11.2/3, see supra, Chapter 5, n. 20.

51. Female head from Athens: *BCH* 103 (1979) 537–38, fig. 32.

52. For the attempt at joining the head Berlin K43 and the Chalkis statue, see Fuchs 1966; the probable provenance of the seated figure from the Chalkis nekropolis is mentioned in n.

Random Harvest

9 on p. 37; for the combination, and preferred angle of head inclination, see figs. 10–13, the last probably the intended view. The woman is said to wear a hefty undergarment below the himation drawn over her head; to judge from the folds near her feet, the "undergarment" should be a peplos—again, the resemblance to the seated Demetria is striking. For the stele of Demetria and Pamphile, see, e.g., Ridgway 1990, pl. 8. Note that the restored height of the Chalkis statue (c. 1.83–85 m. with head in place) makes it larger than the Demeter of Knidos (1.53 m.).

53. The most detailed and best-illustrated account of the Derveni Krater at present is still Giouri 1978; for a technical account, see Varoufakis 1978. A monograph by B. Barr-Sharrar is in preparation. A recent discussion is Hartle 1986 (reference kindly provided by Prof. S. Miller-Collett). Another is Völker-Janssen 1993, 180–228, esp. 197–200, 207–9, who discusses the krater in the context of luxury tableware at the court of Alexander. On the basis of the other finds from the tomb, the theory is advanced that the deceased had taken part in Alexander's campaigns in Asia, and therefore was buried in the last third of the 4th c. (n. 140). Some vessels among the gravegoods are, however, as early as the second half of the 5th c. The Derveni Krater was probably created for the symposion, to attract the attention of the participants, although its iconography would not exclude its creation for burial. Völker-Janssen believes, however, that specific shapes were invented for court use (pp. 203 and n. 121, 210), and that the originality of the krater was due to social processes, rather than to an independent artistic development.

The inscription has been discussed by Bousquet 1966; it could, of course, have been added later, and the krater could be a Macedonian, rather than a Thessalian, product. The best that can be said at present is that it is a typical product of Northern Greece, with all its varied influences. See also Ridgway 1982, 49–56. Comparison of the shape and decoration with South Italian vases and the later Neo-Attic marble renderings of the same shape is briefly made by D. Grassinger, *Römische Marmorkratere* (Mainz 1991) 44–48; although she cites the Derveni Krater as the possible prototype for the marble vessels, she speaks of a general dependency, not of specific imitation.

For identification of the seated maenad as Agave in Pentheus' lap, see *LIMC* 7, s.v. Pentheus, no. 69, pl. 264; the same entry mentions that the child is probably baby Hippasos, with the daughters of Minyas; the krater is there dated c. 350.

Conclusions

At the beginning of this book three questions were asked: (1) is fourth-century sculpture the logical continuation of fifth-century sculpture, or does it represent a break with the past and a movement toward the future, the Hellenistic style? (2) Can the style of the fourth century be called Classical? and (3) Are the chronological limits we set for this survey, 400–331, valid or indefensible? Partial answers were attempted in the same chapter. We shall now try to provide a more comprehensive overview in light of what has been discussed throughout. Many topics and chapters concluded with their own summary, which therefore need not be repeated; this is the place to look at the broader picture and at specific issues. I shall therefore answer the questions, in reverse order.

Are the chronological limits valid?
As already stated, they find their own validity in calendar terms, if not in historical and stylistic ones. In a practical sense, as I admitted from the start, I wanted to fill the gap between my survey of the fifth century and that of the first Hellenistic period, and I found that indeed some monuments had to be understood in the light of what went on before them, rather than what was to follow. Here, however, it can be confirmed that no true "break" occurs, either at the beginning or at the end of the chosen span of time. If something of a turning point could be singled out, it would probably be the middle of the fourth century, around 350, when new themes are introduced in votive reliefs, changes take place in funerary art, and a greater interest in texture is visible in the rendering of cloth. It should also be noted how many of the works in the round—as recoverable primarily through later copies, but including the few originals—seem to fall toward the end of the phase, as contrasted with the architectural sculpture that crowds the first half of the century. Indeed, I may have overstepped my self-imposed chronological boundaries in reviewing freestanding sculpture. Finally, it is important to stress that plastic renderings do not

Conclusions

all seem to follow the same conventions: in the world of terracotta statuettes, the incipient traits of Hellenistic style appear as early as 380, to judge by Athenian and Corinthian production.[1] We see there dramatic changes in drapery arrangements, the inclusion of female nudity, an interest in age characterization, which, in the depiction of older women, becomes caricature rather than expression of venerability or physical impairment. Yet these terracottas appear independent of contemporary monumental sculpture, and once again confirm the impact of purpose and context on iconography and medium.

After acknowledging these factors that affect our understanding of fourth-century sculpture, I nonetheless believe that it is impossible to break down my chosen span into discrete phases (e.g., the Rich Style), since I can find no logical development from one stylistic trend to another, and am convinced that many diverse currents coexisted at one time, as indeed was by and large true for the fifth century, and is even truer for the Hellenistic period.

Can the sculptural style of the fourth century be called classical?
Here, of course, the answer depends on the definition of Classical, and I can only advance my own. In the sense of a style that is more or less universal (within the limits of the Greek world), that relies on idealization and formulas, that controls excesses while seeking special effects and contrasts, that remains intellectual and abstract despite its apparent realism, and, most of all, that retains a strong religious content, the answer has to be positive. This is all the more valid when we consider the alternative nomenclature that has been proposed: High Classical, with its hint of superiority over the previous century, or post-Classical, with its emphasis on the break with the past. It should be understood, however, that the definition of Classical applies to both the fifth and the fourth century, in recognition of the intellectual continuity between the two, while—once again—acknowledging that many stylistic trends coexisted in both time spans, the fourth century in particular witnessing the diffusion of Greek style to non-Greek territories, with important consequent changes in aesthetic expression and content.

At the same time, it should be accepted that increases in naturalism and expressions of emotion, the use of drapery for dramatic purposes, the emphasis on the individual as a member of a family and thus provided with ancestors and descendants, the interest in personifications and foreign gods, are all harbingers of what we consider typical of the Hellenistic period, and yet find their beginnings within the fourth century.

Is there continuity or a break with the past?
It is obvious by now that all three questions interconnect and overlap, and therefore are bound to receive repetitious answers. Yet here geographic distribution becomes of paramount importance. In the sense that Athens is no longer at the sculptural

Conclusions

forefront in the early fourth century, this phase represents a break; yet it is essentially Attic style that now diffuses abroad, both on the Greek Mainland and across the Aegean. Freed from Athenian programs and propaganda, sculpture acquires new contents and formulas, and leaps forward in emotional content and coloristic effects, but the vocabulary remains Attic, albeit with a foreign cast. We have also noted a deliberate retrospective outlook (a form of classicizing), which brings back fifth-century costumes and poses, primarily in divine images, but also in some funerary and honorary sculpture. Each case needs to be studied for itself, since each may respond to a different agenda and intended meaning. Archaistic style occurs side by side with "contemporary" renderings, and "baroque *ante litteram*" appears not only in narrative contexts, but also in details of sculpture in the round. The multiplicity of artistic forms within the fourth century is remarkable, made greater by the increased skill and mobility of its practitioners.

In final assessment, however, I have to admit that the sculpture of the fourth century remains only imperfectly known. It can still be debated whether some monuments, extant in a plethora of Roman copies, go back to true Greek originals, and whether others, attested by a single replica, have an equal claim to a fourth-century prototype. We can still disagree over the extent to which Roman taste and purposes demanded changes in the reproduction of bona-fide copies. We are still uncertain about chronology—especially those of us who no longer believe in a logical, linear stylistic development that can be followed step by step, as it were, through each decade. How much should our chronological assessment make allowances for traditionalism, reuse of molds, need for collaboration, the influence of Schools, or even the creative leaps of geniuses in the field? How do we fill the apparent gaps—for instance, at Delos, where French excavators seem to have recovered only three fourth-century pieces[2] from an island that was so productive in earlier and later times? How can the same monument be dated to the fourth century and to the second (e.g., the Antikythera "Philosopher"), according to the individual scholar? Most important of all, we have come to mistrust the ancient sources and the motives behind their lists of masterpieces and masters, but we have not been able to replace them with more objective evidence, nor have we established firmer criteria for attribution. And we still labor under the subconscious impact of our earlier indoctrinations in art history, although we no longer hold by Furtwängler's *ipse dixit*.

Rather than dwelling on the negative aspects of our inquiry, I shall here summarize what I think we can safely say about fourth-century sculpture, although not all developments occurred simultaneously. And, since the above statement begs the question "How do we know?" I shall try to define my method, at the end of the book, more explicitly than I could at the beginning. In assessing architectural sculpture, we could use the supporting evidence of the structures to which it belonged, and, whenever possible, their building accounts, thus establishing a broad-based

Conclusions

chronological framework. The abundant series of (primarily Attic) gravestones and votive reliefs also lent themselves, because of their very numbers, to an approximate temporal organization based on the archaeological principle of the "latest find." Therefore, retrospective styles could be recognized and acknowledged, but new elements, albeit not necessarily the "most advanced" from a naturalistic point of view, could also be perceived, thus leading to an assessment of fourth-century renderings. On the strength of this perception derived from undisputed Greek originals, I finally tried to review the large and disparate corpus of Roman copies attributed to named masters, inevitably expressing my opinion through the ambiguous language of the traditional *Kopienkritik*. I have thus accepted certain traits as more typically "fourth-century" than others, while rejecting whatever to me seemed incongruous or incompatible with my vision of the sculpture of the time. The subjectivity of such a procedure is openly admitted, and so is the uncertainty of my classification of any given prototype as being early, middle, or late within the century, or, I should add, even as being fourth-century at all.[3]

I must also reiterate that concepts of originality, stylistic coherence, collaboration, and even the definition of "group" are modern constructs that almost certainly do not correspond to ancient notions. A fourth-century Greek no more thought in terms of "copies" than he thought in terms of minor versus major arts, nor was he influenced by sculptural beauty and size except in the sense of being impressed by the costly and the colossal. Especially in the bronze-casters' workshops, expediency prevailed over singularity, and artists were also, perhaps primarily, artisans.[4] Against this general premise, we can now attempt a more specific summary.

Sculptural (and architectural) production moved away from Athens and Attika, and spread to the Peloponnesos and the East (in the sense of both the Greek and the non-Greek cities of Asia Minor and neighboring territories). This shift permitted an infusion of new blood and eventually facilitated artistic expansion after Alexander's conquests and under his successors. Athens remained as a continuous source of inspiration, and, in turn, after approximately 350, could compete in an impressive series of funerary stelai and some high-quality votive reliefs. It may also have had major masters working in the round, like Praxiteles and his family, although those monuments are hard to reconstruct with certainty. The gaps in our geographic knowledge are major: in Magna Graecia, the lack of proper stone might have hampered development; we still have to learn a great deal about Northern Greece, which is only now coming into focus; the Kyklades continued to produce the material and the carvers, but seem to have contributed little on their home ground. Yet the general picture still makes sense, and is complex and rich.

Architectural sculpture shifted emphasis, from exterior embellishment to interior positions, such as decorated coffers, which, however, seem to have outlived the fourth century by only a short time. A love for color was transmitted to architec-

Conclusions

tural structures through the use of various colored stones; sculptural experimentation took the form of interiors articulated through rippling colonnades and floral capitals and moldings, made possible by the mixture of orders. Some temples respected tradition and repeated the sculptural embellishment of their predecessors on the spot, but in general architectural sculpture, except for akroteria, seems to have dwindled, perhaps because of an increase in the use of the Ionic order, which lent itself to different forms of decoration. In non-Greek territory, funerary architecture and sculpture multiplied in many noncanonical ("barbaric") ways and have left us outstanding documentation. Patronage by individual rulers began on a large scale.

The diffusion of Attic (or just plain Greek) motifs abroad must have taken place through the use of models, in whatever form we envision them. If not pattern books, perhaps whitened tablets, ostraka, ceramics, or even relief metalwork—but certainly linear, two-dimensional renderings—served the purpose. They retained conventions and types that could be repeated through the centuries and ultimately formed the repertoire of Neo-Attic art, as we have already suggested for the Derveni Krater. Apparently the fourth century itself started converting into three-dimensional form compositions that had previously been known only through painting or reliefs, but this trend was at its strongest in the Late Hellenistic period, and it is therefore difficult to discriminate between earlier (that is, Classical) and later creations.

In the rendering of the male figure, Polykleitan proportions and stances continued to exert a strong influence, with variations introduced in the turn of the head toward the free rather than the weight leg, in the position of the feet (the free one not always trailing but occasionally in front and even diagonally to the side), and in the opening of the composition toward one side. Eventually, anatomical divisions became less sharply articulated, if not quite effeminate. The Polykleitan canon was replaced by the "Lysippan," which made heads smaller and bodies more elongated, and poses became off-balance, requiring supports, or moved into three-dimensional space either through axial torsion or through forward extension of the limbs. Torsional experimentation, however, was not limited to male figures, and appeared as early as the first quarter of the fourth century, in akroterial figures. In the rendering of facial features, the Michelangelo bar occupied the lower half of the forehead, the superciliary muscle overshadowed the outer corner of the eye, the inner corner became a dark cavity. Faces became progressively rounder, hair more unruly despite strict underlying patterns. Emotion was expressed through the upward angling of eyebrows and open mouths; wrinkles and crow's feet were introduced together with sagging flesh to suggest age.

In female figures, the nude made its appearance in large scale with the startling Aphrodite of Knidos, although it took some time before it became accepted and popular. Yet female anatomy, whether entirely revealed or simply hinted at through

Conclusions

transparent drapery, often took attenuated, almost androgynous forms, in a course virtually parallel to the comparable developments in male renderings. Draped females used chiton and himation for dramatic textural contrasts, once certainly enhanced by color but obviously relying on primary sculptural devices, like drilled channels, deep valleys between folds, press lines, fingerprints, and illogical rosettes. Directional accents were formed by slashing overfolds and tension pleats. Perhaps drapery-through-drapery found its initial and tentative expression at this time. In female hairstyles, strands were brushed back from temples and forehead into chignons and high-piled curls, eventually into the melon coiffure. Eyes became smaller and concave, mouths shorter, faces more refined and oval, foreheads triangular. Absentminded glances frequently replaced directed stares.

A term often used to describe fourth-century renderings, especially in connection with Praxiteles, is the Italian "sfumato": the blurring of features as if seen through a veil of smoke. Although this effect is often more obvious in Roman copies than in undoubted Greek originals, a certain softening of facial traits and a lack of sharp definitions can be acknowledged. Perhaps the even diffusion of light over the shiny surface of a newly cast bronze or a freshly quarried marble might have created this effect. Yet most bronzes had sharply outlined or separately cast lips in contrasting color, which must have undermined the "sfumato" appearance, and marble statues were completed in paint, which served to give to mouth and eyebrows those lines that are now missing. Once again, we should beware of turning modern perceptions into ancient canons.

All of the above developments in the rendering of the human figure can be summarized under the general heading of increased naturalism:[5] through facial features, expressing age, emotion, and characterization, albeit by means of superficial patterns; through proportions, closer to what "men appeared to be, rather than what they were," although still responding to abstract principles of composition rather than to direct reproduction of human models posing for a master;[6] through drapery, whether flamboyant and illogical, or textured and coloristic; and finally through poses, increasingly penetrating space.

To these formal modifications, as we have already mentioned, corresponded conceptual changes: in the nature of the gods, some of whom were rejuvenated while others were added; in the increase in personifications; in the interest in age ranges, suggested through specific forms of costume and hairstyle, as well as anatomy. Yet I should note here that even Eros is not quite a child, as he shall be in the Hellenistic period, and that, at least to judge from gravestones, adolescents are still smaller adults, young girls are characterized by relative scale and dress rather than by features, and decrepit old age is absent entirely. But the contraposition of adult and infant seems favored at this time in allegorical and mythological representations, and, among humans, the deceased or the votary is surrounded by family members at different scales, in attributive fashion.

Conclusions

In the sphere of emotions, distress is expressed within proper limits, and laughter has not yet appeared. No gory details (like mutilation or decapitation) are given in battle scenes, which retain a sense of unrealistic, balletlike confrontation, despite hair pulling and stepping on bodies. Hostile gestures threaten rather than execute. But narrative can now be encompassed within individual figures, requiring the viewers to supply the elements of a story they already know, or asking them to watch the pageant unfolding around them, as if they themselves were brought into the composition. A sense of the theatrical is manifest in both settings and controlled viewpoints.

Despite a continuous interest in animals and monsters (sirens) for funerary purposes, I see few satyrs in the round that are truly fourth century, and surely no centaurs. Portraits are still character studies, not likenesses, and many of them are retrospective. Athletes are not necessarily shown victorious; warriors are rare, even in funerary art; women seem to predominate.

The fourth century *may* have seen the emergence of specific artistic personalities—certainly not the masters we have envisioned through the mentions in the ancient sources. It is perhaps suggestive that the Hellenistic period returns to a certain anonymity, at least in our modern literature, despite the fact that quite a few names have come down to us through inscriptions and Roman writings. I am firmly convinced that we have sinned in the sense of excessive optimism, credulity, and wishful thinking, and have thus created artistic phantoms that do not correspond to fourth-century reality. How much these ancient masters traveled and produced should be a matter of open debate, rather than a statement of fact.

The danger of attempting such a summary is that its slanted nature is not immediately apparent. How different would our picture be if we had the great bronze groups that stood at Delphi, the chryselephantine statues of gods and rulers, the Olympia athletes, the original Knidia by Praxiteles, rather than Roman copies? Yet the attempt is valid, and, I believe, it should be made, as long as each student of ancient sculpture continues to refine and modify the picture, rather than taking it for granted, and as long as new archaeological discoveries or scholarly insights provide the incentive to rearrange it freely.

NOTES

1. I am indebted to G. S. Merker for discussing Corinthian and Athenian terracottas with me, in the light of her forthcoming catalogue of the figurines from Akrokorinthos. For comments on old women in general, see S. Pfisterer-Haas, *Darstellungen alter Frauen in der griechischen Kunst* (Frankfurt 1988).

2. This statement is made in *GdDélos* 1983, 68–69; the three pieces are the architectural frieze here mentioned in Chapter 2 and n. 93, and two herms.

3. After my main text was completed, it cheered me greatly to read the very similar

Conclusions

comments in Boardman 1995, 14, and especially his statement: "Perhaps we should accept that there was change rather than progress." Boardman's entire introductory Chapter 1 should be read by any student of 4th-c. sculpture.

4. Once again, Mattusch 1996 reached me too late to be reflected in my main text, but her important position on originals versus copies should be carefully considered.

5. I would accept here the definition of 4th-c. naturalism given by Childs 1994, 49, in conformity with Platonic thinking: the appearance of reality conveyed by formal deformations, which are not simply the use of foreshortening or of linear perspective, as introduced in previous centuries, but a "psycho-apparence, c'est-à-dire une apparence de n'importe quel sujet auquel s'attache une profondeur psychologique."

6. The quotation paraphrases Pliny's pronouncement on Lysippos, *NH* 34.65.

Bibliography
Credits for Plates
Selective Index

Bibliography

Abbreviations of periodicals follow the conventions of the *American Journal of Archaeology* 95 (1991) 4–16.

Aleshire, S. B., 1989: *The Athenian Asklepieion: The People, Their Dedications, and the Inventories* (Amsterdam).
Amandry, P., 1976: "Trépieds d'Athènes: I. Dionysies," *BCH* 100, 15–93.
Antonaccio, C. M., 1994: "Contesting the Past: Hero Cult, Tomb Cult, and Epic in Early Greece," *AJA* 98, 389–410.
Antonssohn, O., 1937: *The Praxitelean Marble Group in Olympia* (Stockholm).
Arias, P., 1952: *Skopas* (Rome).
Arnold-Biucchi, C., 1995: "Reflections of Polykleitos' Works on Ancient Coins," in W. G. Moon, ed., *Polykleitos, the Doryphoros, and Tradition* (Madison) 218–28.
Ashmole, B., 1951: "Demeter of Cnidus," *JHS* 71, 13–28.
Ashmole, B., 1969: "A New Join in the Amazon Frieze of the Mausoleum," *JHS* 89, 22–23.
Ashmole, B., 1972: *Architect and Sculptor in Classical Greece* (New York).
Ashmole, B., 1977: "Solvitur Disputando," in U. Höckmann and A. Krug, eds., *Festschrift für Frank Brommer* (Mainz) 13–20.
Bartman, E., 1992: *Ancient Sculptural Copies in Miniature* (Columbia Studies in the Classical Tradition 19, Leiden).
Bell, M., III, 1981: *Morgantina Studies 1: The Terracottas* (Princeton).
Benndorf, O., and Niemann, G., 1889: *Das Heroon von Gjölbaschi-Trysa* (Vienna).
Berger, E., 1983: "Dreiseitiges Relief mit Dionysos und Niken," *AntK* 26, 114–16.
Berger, E., 1987: "Zur Nachwirkung des Herakles Epitrapezios," in J. Chamay and J.-L. Maier, eds., *Lysippe et son influence* (Hellas et Roma 5, Geneva) 105–11.
Berger, E., 1990: *Antike Kunstwerke aus der Sammlung Ludwig. Die Skulpturen 3* (Mainz) 183–210.
Berger, E., 1992: *Der Entwurf des Künstlers: Bildhauerkanon in der Antike und Neuzeit* (Basel).
Bielefeld, E., 1969: "Drei Akroter-Statuen reichen Stils," *AntP* 9, 47–64.
Biesantz, H., 1965: *Die thessalischen Grabreliefs: Studien zur nordostgriechischen Kunst* (Mainz).
Blümel, C., 1966: *Die klassisch griechischen Skulpturen der Staatlichen Museen zu Berlin* (Berlin).
Boardman, J., 1978: *Greek Sculpture: The Archaic Period* (London).
Boardman, J., 1985: *Greek Sculpture: The Classical Period* (London).
Boardman, J., 1993: *The Oxford History of Classical Art* (Oxford).
Boardman, J., 1995: *Greek Sculpture: The Late Classical Period* (London).
Bol, P. C., 1972: *Die Skulpturen des Schiffsfundes von Antikythera* (AM BH 2, Berlin).
Bol, P. C., 1978: *Grossplastik aus Bronze von Olympia* (OlForsch 9, Berlin).
Bol, P. C., 1992: *Forschungen zur Villa Albani: Katalog der antiken Bildwerke 3* (Berlin).

Bibliography

Borbein, A. H., 1973: "Die griechische Statue des 4. Jahrhunderts v. Chr.: Formanalytische Untersuchungen zur Kunst der Nachklassik," *JdI* 88, 43–212.

Borchhardt, J., 1976: *Die Bauskulptur des Heroons von Limyra*, (IstForsch 32).

Borchhardt, J., 1990: "Das Heroon von Limyra," in *Götter, Heroen, Herrscher in Lykien* (Vienna/Munich) 75–78, with catalogue entries by A. Dinstl: 127 (no. 10), 128 (no. 12), 140 (no. 31), 169–71 (nos. 57–58).

Borchhardt, J., 1993a: *Die Steine von Zêmuri: Archäologische Forschungen an den verborgenen Wassern von Limyra* (Vienna).

Borchhardt, J., 1993b: "Zum Ostfries des Heroons von Zêmuri/Limyra," *IstMitt* 43, 351–59.

Bousquet, J., 1966: "L'inscription du Cratère de Derveni," *BCH* 90, 281–82.

Bremmer, J., 1990: "Adolescents, Symposion, and Pederasty," in O. Murray, ed., *Sympotica* (Oxford) 135–48.

Brown, B., 1973: *Anticlassicism in Greek Sculpture of the Fourth Century B.C.* (New York).

Bruns-Özgan, C., 1987: *Lykische Grabreliefs des 5. und 4. Jahrhunderts v. Chr.* (IstMitt BH 33, Tübingen).

Bryce, T. R., 1986: *The Lycians in Literary and Epigraphic Sources* (Copenhagen).

Burford, A., 1969: *The Greek Temple Builders at Epidauros: A Social and Economic Study of Building in the Asklepian Sanctuary during the Fourth and Early Third Centuries B.C.* (Liverpool/Toronto).

Burford, A., 1972: *Craftsmen in Greek and Roman Society* (Ithaca).

Buschor, E., 1950: *Maussollos und Alexander* (Munich).

Büyükkolancı, M., 1993: "Fragmente der Bauplastik des Artemision von Ephesos: Funde aus den Grabungen bei der Johanneskirche in Selçuk," *ÖJh* 62, 95–104.

Cahill, N., 1988: "Taş Kule: A Persian-period Tomb near Phokaia," *AJA* 92, 481–501.

Cain, A.-V., 1989: "Zur Bedeutungsgeschichte eines archaischen Throntypus," in *Beiträge zur Ikonographie und Hermeneutik: Festschrift für Nikolaus Himmelmann* (BJb BH 47, Mainz) 87–98.

Calcani, G., 1989: *Cavalieri di bronzo: La torma di Alessandro opera di Lisippo* (Rome).

Cambi, N., 1988: "The Relief of Kairos from Trogir (Dalmatia)," *Praktika tou XII Diethnous Synedriou klasikes archaiologias, 4–10 Sept. 1983* (Athens) vol. 3, 37–41.

Carpenter, R., 1960: *Greek Sculpture* (Chicago).

Carroll-Spillecke, M., 1985: *Landscape Depictions in Greek Relief Sculpture* (Frankfurt).

Carter, J. C., 1973: "The Figure in the Naiskos: Marble Sculpture from the Necropolis of Taranto," *OpRom* 9.11, 97–104.

Carter, J. C., 1979: "The Date of the Sculptured Coffer Lids from the Temple to Athena Polias at Priene," in G. Kopcke and M. B. Moore, eds., *Studies in Classical Art and Archaeology: A Tribute to P. H. von Blanckenhagen* (Locust Valley, N.Y.) 139–51.

Carter, J. C., 1983: *The Sanctuary of Athena Polias at Priene* (London).

Carter, J. C., 1990: "Pytheos," in *Akten des XIII. internationalen Kongresses für klassische Archäologie, Berlin 1988* (Mainz) 129–36.

Carter, R. S., 1982: "The 'Stepped Pyramids' of the Loryma Peninsula," *IstMitt* 32, 176–95.

Childs, W. A. P., 1976: "Prolegomena to a Lycian Chronology, II: The Heroon from Trysa," *RA*, 281–316.

Childs, W. A. P., 1978: *The City-Reliefs of Lycia* (Princeton).

Bibliography

Childs, W. A. P., 1994: "Platon, les images et l'art grec du IV siècle avant J.-C.," *RA*, 33–56.

Childs, W. A. P., and Demargne, P., 1989: *Le Monument des Néréides: Le décor sculpté* (Fouilles de Xanthos 8, Paris).

Clairmont, C. W., 1983: **Patrios Nomos:** *Public Burial in Athens during the Fifth and Fourth Centuries B.C.—The Archaeological, Epigraphic, Literary, and Historical Evidence* (BAR Int. Ser. 161).

Clairmont, C. W., 1993: *Classical Attic Tombstones*, introductory vol., catalogue vols. 1–4 (in numerical order; vol. 1 includes also miscellaneous monuments, vol. 4 covers all numbers from 4. to 7.330), vol. 5 (Prosopography), vol. 6 (Indexes), plate vol., with monuments arranged in numerical order (Kilchberg, Switzerland). [A Supplementary vol. on inscribed and uninscribed roof simas, pediments, and epistyles, with tentative attributions to stelai, 1995, was not consulted.]

Clinton, K., 1992: *Myth and Cult: The Iconography of the Eleusinian Mysteries* (Stockholm).

Coarelli, F., 1968: "L'ara di Domizio Enobarbo e la cultura artistica in Roma nel II secolo a.C.," *DialArch* 2, 302–68.

Connelly, J. B., 1996: "Parthenon and *Parthenoi*: A Mythological Interpretation of the Parthenon Frieze," *AJA* 100, 53–80.

Connor, W. R., ed., 1966: *Greek Orations* (Ann Arbor).

Conze, A., 1890–1922: *Die attischen Grabreliefs* (Berlin/Leipzig).

Cook, B. F., 1976: "The Mausoleum Frieze: *Membra Disjectanda*," *BSA* 71, 49–54, pls. 6–7.

Cook, B. F., 1989: "The Sculptors of the Mausoleum Friezes," in T. Linders and P. Hellström, eds., *Architecture and Society in Hecatomnid Caria: Proceedings of the Uppsala Symposium, 1987* (Uppsala) 31–42.

Cook, J. M., and Plommer, W. H., 1966: *The Sanctuary of Hemithea at Kastabos* (Cambridge).

Corso, A., 1988: *Prassitele: Fonti epigrafiche e letterarie, Vita e opere* I: *Le iscrizioni e le fonti letterarie fino al medio impero compreso (IV secolo a.C.–175 d.C. circa)* (Quaderno di *Xenia* 10, Rome).

Couilloud, M.-T., 1974: *Les monuments funéraires de Rhénée* (*Délos* 30, Paris).

Coupel, P., and Demargne, P., 1969: *Le Monument des Néréides: L'architecture* (Fouilles de Xanthos 3, Paris).

Dallas, C., 1992: "Syntax and Semantics of Figurative Art: A Formal Approach," in P. Reilly and S. Rahtz, eds., *Archaeology and the Information Age: A Global Perspective* (One World Archaeology, New York) 230–75.

D'Arms, J. H., 1995: "Heavy Drinking and Drunkenness in the Roman World: Four Questions for Historians," in O. Murray and M. Tecusan, eds., *In Vino Veritas* (symposium held in March 1991; Oxford) 304–17.

Davies, G., 1985: "The Significance of the Handshake Motif in Classical Funerary Art," *AJA*, 627–40.

Davis, W., 1990: "Style and History in Art History," in M. W. Conkey and C. A. Hastrof, eds., *The Uses of Style in Archaeology* (Cambridge) 18–31.

Dehl, C., 1981: "Eine Gruppe früher Lutrophorenstelen aus dem Kerameikos," *AM* 96, 163–78.

Bibliography

Delivorrias, A., 1973: "Skopadika (I): Télèphe et la bataille du Caïque au fronton ouest du temple d'Athéna Alea à Tégée," *BCH* 97, 111–35.

Delivorrias, A., 1974: *Attische Giebelskulpturen und Akrotere des 5. Jahrhundert v. Chr.* (Tübingen).

Delivorrias, A., 1990: "*Disiecta Membra:* The Remarkable History of Some Sculptures from an Unknown Temple," in *Marble: Art Historical and Scientific Perspectives on Ancient Sculpture* (Malibu) 11–46.

Delivorrias, A., 1991: "Problèmes de conséquence méthodologique et d'ambiguïté iconographique," *MEFRA* 103, 129–57.

Delivorrias, A., 1993a: "Der statuarische Typus der sogennanten Hera Borghese," in H. Beck and P. C. Bol, eds., *Polykletforschungen* (Berlin) 221–42 (with plates).

Delivorrias, A., 1993b: "Lakonika Anthemia," in O. Palagia and W. Coulson, eds., *Sculpture from Arcadia and Laconia* (Oxbow Monographs 30, Oxford) 205–16.

Delivorrias, A., 1995: "Polykleitos and the Allure of Feminine Beauty," in W. G. Moon, ed., *Polykleitos, the Doryphoros, and Tradition* (Madison) 200–217.

Demakopoulou, K., and Konsola, D., 1981: *Archaeological Museum of Thebes: Guide* (Athens).

Demargne, P., 1990: "Das Nereiden-Monument von Xanthos," in *Götter, Heroen, Herrscher in Lykien* (Vienna/Munich) 65–69, 126, 166–67.

Dentzer, J.-M., 1982: *Le motif du Banquet Couché dans le Proche-Orient et le monde grec du VIIe au IVe siècle av. J.-C.* (BEFAR 246, Rome).

Despinis, G., 1993: "Ena symplegma ephedrismou apo ten Tegea," in O. Palagia and W. Coulson, eds., *Sculpture from Arcadia and Laconia* (Oxbow Monographs 30, Oxford) 87–97.

Dierichs, A., 1990: "Leda-Schwan-Gruppen in der Glyptik und ihre monumentalen Vorbilder," *Boreas* 13, 37–50.

DOG 1977, 1979: E. Pfuhl and H. Möbius, *Die ostgriechischen Grabreliefs*, vols. 1, 2 (Mainz).

Döhl, H., 1968: *Der Eros des Lysippp: Frühhellenistische Eroten* (Göttingen).

Donderer, M., 1988: "Nicht Praxiteles, sondern Pasiteles—Eine signierte Statuenstütze in Verona," *ZPE* 73, 63–68.

Dontas, G., 1982: "La grande Artémis du Pirée: Une oeuvre d'Euphranor," *AntK* 25, 15–34.

Dörig, J., 1957: "Lysipps letzes Werk," *JdI* 72, 19–43.

Dunbabin, K. M. D., 1986: "*Sic erimus cuncti..*: The Skeleton in Graeco-Roman Art," *JdI* 101, 185–255.

Dunbabin, K. M. D., 1993: "Wine and Water at the Roman Convivium," *JRA* 6, 116–41.

Eckstein, F., 1967: "Ephedrismos-Gruppe im Konservatoren-Palast," *AntP* 6, 75–87, pls. 48–52.

Edwards, C. M., 1984: "Aphrodite on a Ladder," *Hesperia* 53, 59–72.

Edwards, C. M., 1985: "Greek Votive Reliefs to Pan and the Nymphs" (Ph.D. dissertation, New York University, Institute of Fine Arts; University Microfilms 1989, Ann Arbor).

Eichler, F., 1919: "Skulpturen des Heraions bei Argos," *ÖJh* 19–20, 15–153.

Eichler, F., 1950: *Die Reliefs des Heroon von Gjölbaschi-Trysa* (Vienna).

Ensoli, S., 1987: *L'Heroon di Dexileos nel Ceramico di Atene* (Rome, Accademia Nazionale dei Lincei).

Bibliography

Eschback, N., 1986: *Statuen auf panathenäischen Preisamphoren des 4. Jhrs. v. Chr.* (Mainz).

Faustoferri, A., 1993: "The Throne of Apollo at Amyklai: Its Significance and Chronology," in O. Palagia and W. Coulson, eds., *Sculpture from Arcadia and Laconia* (Oxbow Monograph 30, Oxford) 159–66.

Fedak, J., 1990: *Monumental Tombs of the Hellenistic Age: A Study of Selected Tombs from the Pre-Classical to the Early Imperial Era* (Phoenix Suppl. 27, Toronto).

Felten, F., 1984: *Griechische tektonische Friese archaischer und klassischer Zeit* (Waldsassen-Bayern).

Felten, F., 1987: (With K. Hoffelner) "Die Relieffriese des Poseidontempels in Sunion," *AM* 102, 169–84.

Ferron, J., 1993: *Sarcophages de Phenicie: Sarcophages à scènes en relief* (Cahiers de Byrsa 3, Paris).

Fink, J., 1969: "Der grosse Jäger," *RM* 76, 239–52.

Flashar, M., 1992: *Apollon Kitharodos: Statuarische Typen des musischen Apollon* (Vienna).

Flashar, M., and von der Hoff, R., 1993: "Die Statue des sog. Philosophen Delphi ins Kontext: einer mehrfigurigen Stiftung," *BCH* 117, 407–33.

Fleischer, R., 1983: *Der Klagefrauensarkophag aus Sidon* (IstForsch 34, Tübingen).

Fraser, P. M., and Rönne, T., 1957: *Boeotian and West Greek Tombstones* (Lund).

Frel, J., 1969: *Les sculpteurs attiques anonymes* (Prague).

Froning, H., 1988: "Anfänge der kontinuirenden Bilderzählung in der griechischen Kunst," *JdI* 103, 169–99.

Fuchs, M., 1992: *Glyptothek München, Katalog der Skulpturen,* vol. 6: *Römische Idealplastik* (Munich).

Fuchs, W., 1966: "Zur Rekonstruktion einer weiblichen Sitzstatue in Chalkis," *JBerlMus* 8, 32–49.

Fuchs, W., 1986: "The Chian Element in Chian Art," in J. Boardman and C. E. Vaphopoulou-Richardson, eds., *Chios: A Conference at the Homereion in Chios 1984* (Oxford) 275–93.

Fullerton, M. D., 1987: "Archaistic Statuary of the Hellenistic Period," *AM* 102, 259–78.

GdDélos 1983: P. Bruneau and J. Ducat, *Guide de Délos* (Paris).

GdDm 1991: *Guide de Delphes: Le Musée* (Ecole Française d'Athènes, Paris).

GdDs 1991: J. F. Bommelaer and D. Laroche, *Guide de Delphes: Le Site* (Ecole Française d'Athènes, Paris).

Geyer, A., 1989: "Ein griechisches Grabreliefs in Tarent," *JdI* 104, 1–17.

Giouri (Youri), E., 1978: *Ho krateras tou Derveniou* (Athens).

Gogos, S., 1993: "Ein Herakles von Naupaktos," *ÖJh* 62, 45–56.

Golden, M., 1990: *Children and Childhood in Classical Athens* (Baltimore/London).

Goodlett, V. C., 1989: "Collaboration in Greek Sculpture: The Literary and Epigraphic Evidence" (Ph.D. dissertation, New York University, Institute of Fine Arts).

Gruben, G., 1982: "Naxos und Paros: Klassische und hellenistische Bauten auf Paros," *AA,* 621–89.

Gschwantler, K., 1993: "Bäume, Säulen, Mauern: Zum Fugenschluss der Reliefs vom Gölbasi-Trysa," in J. Borchhardt and G. Dobesch, eds., *Akten des II. Internationalen Lykien-Symposions, Wien 6.–12. Mai 1990* (Vienna) vol. 2, 77–85, pls. 17–20.

Gulaki, A., 1981: *Klassische und klassizistische Nikedarstellungen: Untersuchungen zur Typologie und zum Bedeutungswandel* (Bonn).

Bibliography

Gunter, A. C., 1989: "Sculptural Dedications at Labraunda," in T. Linders and P. Hellström, eds., *Architecture and Society in Hecatomnid Caria: Proceedings of the Uppsala Symposium, 1987* (Uppsala) 91–98.

Gunter, A. C., 1995: *Labraunda, Swedish Excavations and Researches 2.5: Marble Sculpture* (Stockholm).

Güntner, G., 1994: *Göttervereine und Götterversammlungen auf attischen Weihreliefs: Untersuchungen zur Typologie und Bedeutung* (Würzburg).

Hafner, G., 1988: "Die Rhea des Praxiteles," *AA*, 63–68.

Hale, J. M., 1995: "How Argive Was the 'Argive' Heraion? The Political and Cultic Geography of the Argive Plain, 900–400 B.C.," *AJA* 99, 577–613.

Hallett, C., 1986: "The Origins of the Classical Style in Sculpture," *JHS* 106, 71–84.

Hamiaux, M., 1992: *Les sculptures grecques: Des origines à la fin du IVe siècle av. J.-C.* (Musée du Louvre, Catalogue I, Paris).

Hanson, E. A., 1990: "The Medical Writers' Woman," in D. M. Halperin et al., eds., *Before Sexuality: The Construction of Erotic Experience in the Ancient Greek World* (Princeton) 309–37.

Harris, D., 1992: "Bronze Statues on the Athenian Acropolis: The Evidence of a Lycurgan Inventory," *AJA* 96, 637–52.

Harrison, E. B., 1972: "The South Frieze of the Nike Temple and the Marathon Painting in the Painted Stoa," *AJA* 76, 353–78.

Harrison, E. B., 1985: "Early Classical Sculpture: The Bold Style," in C. G. Boulter, ed., *Greek Art: Archaic into Classical* (Cincinnati Symposium, April 2–3, 1982; Leiden) 40–65.

Harrison, E. B., 1988: "Style Phases in Greek Sculpture from 450 to 370 B.C.," *Praktika tou XII Diethnous Synedriou klasikes archaiologias, 4–10 Sept. 1983* (Athens) vol. 3, 99–105.

Harrison, E. B., 1992: "New Light on a Nereid Monument Akroterion" in H. Froning et al., eds., *Kotinos: Festschrift für Erika Simon* (Mainz) 204–10.

Hartle, R. W., 1986: "An Interpretation of the Derveni Krater: Symmetry and Meaning," in *Ancient Macedonia* (Fourth International Congress, Sept. 1983; Thessaloniki) 257–78.

Hausmann, U., 1960: *Griechische Weihreliefs* (Berlin).

Havelock, C. M., 1971: "Round Sculptures from the Mausoleum at Halikarnassos," in D. G. Mitten, J. G. Pedley, J. A. Scott, eds., *Studies Presented to G. M. A. Hanfmann* (Mainz) 55–64.

Havelock, C. M., 1995: *The Aphrodite of Knidos and Her Successors: A Historical Review of the Female Nude in Greek Art* (Ann Arbor).

Hedreen, G., 1991: "The Cult of Achilles in the Euxine," *Hesperia* 60, 313–30.

Hedrick, C. W., 1988: "The Temple and Cult of Apollo Patroos in Athens," *AJA* 92, 185–210.

Heimberg, U., 1973: "Boiotische Reliefs im Museum von Theben," *AntP* 12, 15–36, pls. 2–5.

Heinz, W., 1982: "Gemme mit Darstellung des Pothos," in *Praestant Interna: Festschrift für H. Hausmann* (Tübingen) 306–10.

Hellström, P., and Thieme, T., 1981: "The Androns at Labraunda: A Preliminary Account of Their Architecture," *MedMusB* 16, 58–74.

Hellström, P., and Thieme, T., 1982: *Labraunda: Swedish Excavations and Researches, 1.3: The Temple of Zeus* (Stockholm).

Hibler, D., 1993: "The Hero-Reliefs of Lakonia: Changes in Form and Function," in O. Pa-

Bibliography

lagia and W. Coulson, eds., *Sculpture from Arcadia and Laconia* (Oxbow Monographs 30, Oxford) 199–204.

Hiller, F., 1960: "Zu den Sockelfriesen des Klagefrauensarkophagus in Istanbul," *MarbWPr*, 1–12.

Hiller, H., 1975: *Ionische Grabreliefs der ersten Hälfte des 5. Jarhunderts v. Chr.* (IstMitt BH 12, Tübingen).

Himmelmann (Wildschütz), N., 1956: *Studien zum Ilissos-Relief* (Munich).

Himmelmann, N., 1990: *Ideale Nacktheit in der griechischen Kunst* (JdI EH 26, Berlin).

Hitzl, I., 1991: *Die griechische Sarkophage der archaischen und klassischen Zeit* (Jonsered).

Hornblower, S., 1982: *Mausolus* (Oxford).

Houser, C., 1983: *Greek Monumental Bronze Sculpture*, with photographs by D. Finn (New York).

Inan, J., 1975: *Roman Sculpture in Side* (Ankara).

Inan, J., 1993: "Der Sandalenbindende Hermes," *AntP* 22, 105–16.

Isager, J., 1991: *Pliny on Art and Society: The Elder Pliny's Chapters on the History of Art* (Odense University Classical Studies 17, London).

Isler, H. P., 1970: *Acheloos* (Bern).

Jacob-Felsch, M., 1969: *Die Entwicklung griechischer Statuenbasen und die Aufstellung der Statuen* (Waldsassen-Bayern).

Jacobs, B., 1987: *Griechische und persische Elemente in der Grabkunst Lykiens zur Zeit der Achämenidenherrschaft* (SIMA 78, Jonsered).

Jeppesen, K., 1989: "What Did the Maussolleion Look Like?" in T. Linders and P. Hellström, eds., *Architecture and Society in Hecatomnid Caria: Proceedings of the Uppsala Symposium, 1987* (Uppsala) 15–22.

Jeppesen, K., 1992: "*Tot operum opus*: Ergebnisse der dänische Forschungen zum Maussolleion von Halikarnass seit 1966," *JdI* 107, 59–102, pls. 19–32.

Jung, H., 1986: "Die Reliefbasis Athen, Nationalmuseum 1463: Spätklassisch oder Neuattisch?" *MarbWPr*, 3–38.

Junker, K., 1993: *Der ältere Tempel im Heraion am Sele: Verzierte Metopen im architektonischen Kontext* (Cologne/Weimar/Vienna).

Karouzos, Ch., 1969: "Chronikon tes anasustaseos tou chalkinou Neou ton Antikutheron," *ArchEph*, 59–79.

Karouzou, S., 1968: *National Archaeological Museum: Collection of Sculpture* (Athens).

Karouzou, S., 1979: "Bemalte attische Weihreliefs," in G. Kopcke and M. B. Moore, eds., *Studies in Classical Art and Archaeology: A Tribute to P. H. von Blanckenhagen* (Locust Valley, N.Y.) 111–16.

Kelly, N., 1995: "The Archaic Temple of Apollo at Bassai: Correspondences to the Classical Temple," *Hesperia* 64, 227–77.

Kilmer, M., 1977: *The Shoulder Bust in Sicily and South and Central Italy: A Catalogue and Materials for Dating* (Göteborg).

Kleemann, I., 1962: "Eine Weihgeschenk an die delische Artemis in Paros," *AM* 77, 207–28.

Knauer, E. R., 1992: "Mitra and Kerykeion: Some Reflections on Symbolic Attributes in the Art of the Classical Period," *AA* 373–99.

Knell, H., 1983: "Dorische Ringhallentempel in spät- und nachklassischer Zeit," *JdI* 98, 203–33.

Bibliography

Knell, H., 1994: "Der jüngere Tempel des Apollon Patroos auf der Athener Agora," *JdI* 109, 217–37.

Knigge, U., 1988: *Der Kerameikos von Athen* (Guidebook, Athens).

Koenigs, W., 1983: "Der Athenatempel von Priene," *IstMitt* 33, 134–75.

Kokula, G., 1984: *Marmorlutrophoren* (*AM* BH 10, Berlin).

Kraay, C. M., and Hirmer, M., 1966: *Greek Coins* (London).

Krause, B., 1972: "Zum Asklepios-Kultbild des Thrasymedes in Epidauros," *AA*, 240–57.

Kreikenbom, D., 1992: *Griechische und römische Kolossalporträts bis zum späten ersten Jahrhundert nach Christus* (*JdI* EH 27, Berlin).

Kris, E., and Kurz, O., 1979: *Legend, Myth, and Magic in the Image of the Artist: A Historical Experiment* (based on a text originally published in 1934, with later additions by O. Kurz, and preface by E. H. Gombrich, New Haven).

Krull, D., 1985: *Der Herakles vom Typ Farnese: Kopienkritische Untersuchungen einer Schöpfung des Lysipp* (Frankfurt am Main).

Kurtz, D. C., and Boardman, J., 1971: *Greek Burial Customs* (Ithaca).

Kuttner, A., 1993: "Some New Grounds for Narrative: Marcus Antonius's Base (the *Ara Domitii Ahenobarbi*) and Republican Biographies," in P. J. Holliday, ed., *Narrative and Event in Ancient Art* (Cambridge) 198–229.

Landwehr, C., 1985: *Die antiken Gipsabgüsse aus Baiae* (Berlin).

Lapatin, K. D. Shapiro, 1992: "A Family Gathering at Rhamnous? Who's Who on the Nemesis Base," *Hesperia* 61, 107–19.

La Rocca, E., 1985: *Amazzonomachia: La scultura frontonale del tempio di Apollo Sosiano* (Catalogue of the Exhibition at the Palazzo dei Conservatori, Rome).

La Rocca, E., 1986: "Le sculture frontonali del tempio di Apollo Sosiano a Roma," in H. Kyrieleis, ed., *Archaische und Klassische griechische Plastik*, vol. 2 (Akten des Internationalen Kolloquiums vom 22–25. April 1985 in Athen; Mainz) 51–57.

Lattimore, S., 1976: *The Marine Thiasos in Greek Sculpture* (Berkeley/Los Angeles).

Lattimore, S., 1987: "Skopas and the Pothos," *AJA* 91, 411–20.

Lauter, H., 1971: "Heiligtum oder Markt?" *AA*, 55–62.

Lauter, H., 1980: "Zur wirtschaftlichen Position der Praxiteles-familie im spätklassischen Athen," *AA*, 525–31.

Lauter, H., 1988: "Der praxitelische Kopf Athen, National Museum 1762," *AntP* 19, 21–29.

Lawton, C., 1992: "Sculptural and Epigraphical Restorations of Attic Documents," *Hesperia* 61, 239–51.

Lawton, C., 1995: "Four Document Reliefs from the Athenian Agora," *Hesperia* 64, 121–30.

Lebendis, I., 1993: "Ta agalmata tou Asklepiou kai tes Hugeias sto nao tes Athenes Aleas sten Tegea," in O. Palagia and W. Coulson, eds., *Sculpture from Arcadia and Laconia* (Oxbow Monographs 30, Oxford) 119–27.

Lehmann, Ph. W., 1982: "The Sculptures," in Ph. W. Lehmann and D. Spittle, *Samothrace 5: The Temenos* (Princeton).

Linfert, A., 1990: "Die Schule des Polyklet (Kat. 103–153)," in *Polyklet: Der Bildhauer der griechischen Klassik* (Ausstellung im Liebieghaus Museum alter Plastik, Frankfurt am Main) (Mainz) 240–97.

Linfert-Reich, I., 1971: *Musen- und Dichterinnenfiguren des vierten und frühen dritten Jahrhunderts* (Cologne).

Bibliography

Lisippo 1995: *Lisippo: L'arte e la fortuna* (Exhibition in Rome organized by P. Moreno; Fabbri Editori, Monza).

Lorenz, T., 1968: "Mänaden des Skopas," *BABesch* 43, 52–58.

Luzón, J. A., 1978: "Die neuattischen Rund-Aren von Italica," *MM* 19, 272–89.

Maderna, C., 1988: *Iuppiter, Diomedes und Merkur als Vorbilder für römische Bildnisstatuen: Untersuchungen zum römischen statuarischen Idealporträt* (Heidelberg).

Madigan, B. B., 1992: *The Temple of Apollo Bassitas 2: The Sculpture* (Princeton).

Mangold, M., 1993: *Athenatypen auf attischen Weihreliefs des 5. und 4. Jhs. v. Chr.* (Bern).

Mantis, A. G., 1990: *Problemata tes Eikonographias ton Hiereion kai ton Hiereon sten Archaia Hellenike techne* (Athens).

Marcadé, J., 1953: *Recueil des signatures de sculpteurs grecs* (vol. 1, Delphi) (Paris).

Marcadé, J., 1957: *Recueil des signatures de sculpteurs grecs* (vol. 2, Delos) (Paris).

Marcadé, J., 1969: *Au Musée de Délos* (Paris).

Marcadé, J., 1979: "Les métopes mutilées de la tholos de Marmaria à Delphes," *CRAI*, 151–70.

Marcadé, J., 1986a: "Les sculptures décoratives de la tholos de Marmaria à Delphes: état actuel du dossier," in H. Kyrieleis, ed., *Archaische und Klassische griechische Plastik*, vol. 2 (Akten des Internationalen Kolloquiums vom 22–25. April 1985 in Athen; Mainz) 169–73.

Marcadé, J., 1986b: "Tegeatika," *BCH* 110, 317–29.

Marcadé, J., 1987: "À propos de la base de Poulydamas à Olympie," in J. Chamay and J.-L. Maier, *Lysippe et son influence* (Hellas et Roma 5, Geneva) 113–24.

Marcadé, J., 1988: "Le classicisme dans la sculpture grecque du IVe siècle," *Praktika tou XII Diethnous Synedriou klasikes archaiologias*, 4–10 Sept. 1983 (Athens) vol. 3, 185–86.

Marcadé, J., 1993: "Acrotères delphiques," *RA*, 3–31 and post-scriptum on p. 32.

Mattusch, C. C., 1996: *Classical Bronzes: The Art and Craft of Greek and Roman Statuary* (Ithaca).

Métraux, G. P. R., 1995: *Sculptors and Physicians in Fifth-Century Greece: A Preliminary Study* (Montreal).

Meyer, M., 1988: "Erfindung und Wirkung: Zum Asklepios Giustini," *AM* 103, 119–59.

Meyer, M., 1989a: "Alte Männer auf attischen Grabdenkmälern," *AM* 104, 49–82.

Meyer, M., 1989b: *Die griechischen Urkundenreliefs* (AM BH 13, Berlin).

Mind and Body 1989: Athens, National Archaeological Museum, *Mind and Body: Athletic Contests in Ancient Greece* (May 15, 1989–Jan. 15, 1990; Athens).

Mingazzini, P., 1971: "Sui quattro scultori di nome Scopas," *RivistArch* 18, 69–90.

Morris, I., 1992: *Death-Ritual and Social Structure in Classical Antiquity* (Cambridge).

Morrow, K. D., 1985: *Greek Footwear and the Dating of Sculpture* (Madison).

Naumann, F., 1983: *Die Ikonographie der Kybele in der phrygischen und der griechischen Kunst* (IstMitt BH 28, Tübingen).

Neumann, G., 1964: "Ein spätklassisches Skulpturfragment aus Athen," *AM* 79, 137–44.

Neumann, G., 1979: *Probleme des griechischen Weihreliefs* (Tübingen).

Noll, R., 1971: *Das Heroon von Gölbaşı-Trysa: Ein fürstlicher Grabbezirk griechischer Zeit in Kleinasien* (Führer durch das Kunsthistorische Museum no. 16, Vienna).

Norman, N. J., 1984: "The Temple of Athena Alea at Tegea," *AJA* 88, 169–94.

Bibliography

Norman, N. J., 1986: "Asklepios and Hygieia and the Cult Statue at Tegea," *AJA* 90, 425–30.

Nylander, C., 1970: *Ionians in Pasargadae* (Uppsala).

Oberleitner, W., 1990: "Das Heroon von Trysa," in *Götter, Heroen, Herrscher in Lykien* (Vienna/Munich) 71–74, 155–57 (cat. nos. 44–46), 167–68 (cat. no. 56).

Oberleitner, W., 1994: "Das Heroon von Trysa," *AntW* 25, Sondernummer.

Onians, J., 1990: "Quintilian and the Idea of Roman Art," in M. Henig, ed., *Architecture and Architectural Sculpture in the Roman Empire* (Oxford) 1–9.

Østby, E., 1986: "The Archaic Temple of Athena Alea at Tegea," *OpAth* 16, 75–102.

Palagia, O., 1980: *Euphranor* (Monumenta Graeca et Romana 3, Leiden).

Palagia, O., 1984: "The Hope Herakles Reconsidered," *OJA* 3, 107–26.

Palagia, O., 1994: "No Demokratia," in W. Coulson et al., eds., *The Archaeology of Athens and Attica under the Democracy* (Oxbow Monograph 37, Oxford) 113–22.

Papachatzis, N., 1980: *Pausaniou Hellados Periegesis: Achaika kai Arkadika*, vol. 4 (Athens).

Papaioannou, A., 1984: "Ho ephebos tou Marathonos," *ArchEph*, 191–215.

Paschinger, E., 1985: "Zur Ikonographie der Malerein im Tumulusgrab von Kizilbel aus etruskologischer Sicht," *ÖJh* 56, Beibl., 2–47.

Pedersen, P., 1989: "Some General Trends in Architectural Layout of the 4th Century Caria," in T. Linders and P. Hellström, eds., *Architecture and Society in Hecatomnid Caria: Proceedings of the Uppsala Symposium, 1987* (Uppsala) 9–13.

Pemberton, E., 1989: "The Dexiosis on Attic Gravestones," *MeditArch* 2, 45–50.

Peschlow-Bindokat, A., 1972: "Demeter und Persephone in der attischen Kunst," *JdI* 87, 60–157.

Pfaff, C. A., 1992: "The Argive Heraion: The Architecture of the Classical Temple of Hera," (Ph.D. dissertation, New York University, Institute of Fine Arts; University Microfilms, Ann Arbor).

Pfisterer-Haas, S., 1990: "Ältere Frauen auf attischen Grabdenkmälern," *AM* 105, 179–96.

Pfrommer, M., 1985: "Zur Venus Colonna: Eine späthellenistische Redaktion der knidischen Aphrodite," *IstMitt* 35, 173–80.

Picard, C., 1954: *Manuel d'archéologie grècque: La sculpture*, vol. 4.1 (Paris).

Picard, G. C., 1988: "Le problème du thiase marin de Scopas," *Praktika tou XII Diethnous Synedriou klasikes archaiologias, 4–10 Sept. 1983* (Athens), vol. 3, 217–220.

Picón, C. A., 1993: "The Oxford Maenad," *AntP* 22, 89–99.

Plommer, H., 1981: "The Temple of Messa on Lesbos," in L. Casson and M. Price, eds., *Coins, Culture, and History in the Ancient World* (Festschrift B. L. Trell, Detroit) 177–86.

Pochmarski, E., 1990: *Dionysische Gruppen: Eine typologische Untersuchung zur Geschichte des Stützmotivs* (Vienna).

Pollitt, J. J., 1972: *Art and Experience in Classical Greece* (Cambridge).

Posch, W., 1991: "Die τύποι des Timotheos," *AA*, 69–73.

Raftopoulou, E. G., 1971: "Kephale ek tou Heraiou tou Argous," *ArchDelt* 26 (1971) 264–75, French summary on pp. 329–31.

Raftopoulou, E. G., 1980: "À propos du torse de Chonika," *Études Argiennes* (*BCH* Suppl. 6, Paris) 115–31.

Rhomaios, K., 1924: "Ho Ephebos tou Marathonos," *ArchDelt* 9, 145–87.

Rice, E., 1993: "The Glorious Dead: Commemoration of the Fallen and Portrayal of Victory

Bibliography

in the Late Classical and Hellenistic World," in J. Rich and G. Shipley, eds., *War and Society in the Greek World* (London/New York) 224–57.

Richter, G. M. A., 1954: *Catalogue of Greek Sculptures in the Metropolitan Museum of Art* (Oxford/Cambridge, Mass.).

Ridgway, B. S., 1964: "The Date of the So-Called Lysippean Jason," *AJA* 68, 113–28.

Ridgway, B. S., 1970: *The Severe Style in Greek Sculpture* (Princeton).

Ridgway, B. S., 1972: *Classical Sculpture: Catalogue of the Classical Collection, Museum of Art, Rhode Island School of Design* (Providence).

Ridgway, B. S., 1976: "The Aphrodite of Arles," *AJA* 80, 147–54.

Ridgway, B. S., 1977: *The Archaic Style in Greek Sculpture* (Princeton).

Ridgway, B. S., 1981a: *Fifth Century Styles in Greek Sculpture* (Princeton).

Ridgway, B. S., 1981b: "Sculpture from Corinth," *Hesperia* 50, 423–48.

Ridgway, B. S., 1982: "Court Art and Hellenistic Art: The Role of Alexander the Great," *ArchNews* 11, 43–58.

Ridgway, B. S., 1983: "Painterly and Pictorial in Greek Relief Sculpture," in W. G. Moon, ed., *Ancient Greek Art and Iconography* (Madison) 193–208.

Ridgway, B. S., 1984a: *Roman Copies of Greek Sculpture: The Problem of the Originals* (Ann Arbor).

Ridgway, B. S., 1984b: "The Fashion of the Elgin Kore," *GettyMusJ* 12, 29–58.

Ridgway, B. S., 1985: "Late Archaic Sculpture," in C. G. Boulter, ed., *Greek Art: Archaic into Classical* (Cincinnati Symposium, April 2–3, 1982; Leiden) 3–17.

Ridgway, B. S., 1990: *Hellenistic Sculpture I: The Style of ca. 331–200 B.C.* (Madison).

Ridgway, B. S., 1992: "Aristonautes' Stele, Athens Nat. Mus. 738," in H. Froning et al., eds., *Kotinos: Festschrift für Erika Simon* (Mainz) 270–75.

Ridgway, B. S., 1993: *The Archaic Style in Greek Sculpture*, 2nd ed. (Chicago).

Ridgway, B. S., 1994: *Greek Sculpture in the Art Museum, Princeton University: Greek Originals, Roman Copies and Variants* (with contributions by other authors; Princeton).

Ridgway, B. S., 1995a: "Lo stile severo: Lo stato della questione," in N. Bonacasa, ed., *Lo stile severo in Grecia e in Occidente: Aspetti e problemi* (Studi e materiali, Istituto di Archeologia, Università di Palermo, no. 9, Rome) 35–42.

Ridgway, B. S., 1995b: "*Paene ad exemplum:* Polykleitos' Other Works," in W. G. Moon, ed., *Polykleitos, the Doryphoros, and Tradition* (Madison) 177–99.

Rieche, A., 1973: "Die Kopien der Leda des Timotheos," *AntP* 17, 21–55, pls. 10–34.

Roccos, L. J., 1986: "The Shoulder-Pinned Back Mantle in Greek and Roman Sculpture" (Ph.D. dissertation, New York University, Institute of Fine Arts; University Microfilms, Ann Arbor).

Roccos, L. J., 1989: "Apollo Palatinus, the Augustan Apollo of the Sorrento Base," *AJA* 93, 571–88.

Roccos, L. J., 1991: "Athena from a House on the Areopagus," *Hesperia* 60, 397–410.

Roccos, L. J., 1995: "The Kanephoros and Her Festival Mantle in Greek Art," *AJA* 99, 641–66.

Roller, L. E., 1994: "Attis on Greek Votive Monuments: Greek God or Phrygian?" *Hesperia* 63, 245–62.

Root, M. C., 1979: *The King and Kingship in Achaemenid Art* (Acta Iranica 9, Leiden).

Roux, G., 1961: *L'Architecture de l'Argolide aux IVème et IIIème siècles avant J. C.* (Paris).

Bibliography

Roux, G., 1979: "Le vrai temple d'Apollon à Délos," *BCH* 103, 109–35.

Roux, G., 1988: "La tholos d'Athéna Pronaia dans son sanctuaire de Delphes," *CRAI,* 290–309.

Rügler, A., 1988: *Die Columnae Caelatae des jüngeren Artemisions von Ephesos* (IstMitt BH 34, Tübingen).

Rumscheid, F., 1994: *Untersuchungen zur kleinasiatischen Bauornamentik des Hellenismus* (Mainz), 2 vols.

Rupp, D. M., 1974: "Greek Altars of the Northeastern Peloponnese, c. 750/725 B.C. to c. 300/275 B.C." (Ph.D. dissertation, Bryn Mawr College; University Microfilms, Ann Arbor).

Saatsoglou-Paliadeli, Ch., 1990: "Vergina: The Sanctuary of Eukleia," *To Archaiologiko Ergo ste Makedonia kai Thrake* 4 (1990), Eng. summary on p. 29.

Salapata, G., 1993: "The Lakonian Hero Reliefs in the Light of the Terracotta Plaques," in O. Palagia and W. Coulson, eds., *Sculpture from Arcadia and Laconia* (Oxbow Monographs 30, Oxford) 189–97.

Scheibler, I., 1975: "Leochares in Halikarnassos: Zur Methode der Meisterforschung," in *Wandlungen* (Festschrift E. Homann-Wedeking, Waldsassen-Bayern) 152–62.

Schiering, W., 1975: "Zum Amazonenfries des Maussoleums in Halikarnas," *JdI* 90, 121–35.

Schild-Xenidou, W., 1972: *Boiotische Grab- und Weihreliefs archaischer und klassischer Zeit* (Munich).

Schmaltz, B., 1970: *Untersuchungen zu den attischen Marmorlekythen* (Berlin).

Schmaltz, B., 1983: *Griechische Grabreliefs* (Darmstadt).

Schmidt, E., 1975: "Bemerkungen zu einem Relief in Chalkis," in *Wandlungen* (Festschrift E. Homann-Wedeking, Waldsassen-Bayern) 141–51.

Schmidt, E., 1982: *Geschichte der Karyatide* (Würzburg).

Schmitt, R., 1992: *Handbuch zu den Tempeln der Griechen* (Frankfurt).

Scholl, A., 1994: "Πολυτάλαντα Μνημεῖα: Zur literarische und monumentalen Überlieferung aufwendiger Grabmäler im spätklassischen Athen," *JdI* 109, 239–71.

Schröder, S. F., 1989: *Römische Bacchusbilder in der Tradition des Apollon Lykeios: Studien zur Bildformulierung und Bildbedeutung in späthellenistisch-römischer Zeit* (Rome).

Seiler F., 1986: *Die griechische Tholos* (Mainz).

Simon, E., 1987: "Kriterien zur Deutung 'pasitelischer' Gruppen," *JdI* 102, 291–304.

Six, J., 1918: "Die Mänaden des Skopas," *JdI* 33, 38–48.

Smith, R. R. R., 1991: *Hellenistic Sculpture: A Handbook* (London).

Sources 1986: *The Maussolleion of Halikarnassos: Reports from the Danish Archaeological Expedition to Bodrum* (Copenhagen) vol. 2: K. Jeppesen and A. Luttrell, "The Written Sources."

Stähler, K., 1983: "Giebelfiguren eines hochklassischen Tempels," *Boreas* 6, 72–78.

Stähler, K., 1985: "Klassische Akrotere," in *Pro Arte Antiqua: Festschrift für Hedwig Kenner* (Vienna/Berlin) vol. 2, 326–32.

Stähler, K., 1992: *Griechische Geschichtbilder klassischer Zeit* (Eikon, vol. 1, Münster).

Stamatiou, A., 1989: "A Note on the Mausoleum Chariot," *AA*, 379–85.

Stampolidis, N., 1987: "Ena neo apoktema apo to Mausoleio tes Alikarnassou," in *ΑΜΗΤΟΣ* (Festschrift M. Andronikos, Thessaloniki) vol. 2, 813–28, Eng. summary on p. 829.

Bibliography

Stephanidou-Tiveriou, Th., 1993: *Trapezophora me plastike Diakosmese: He Attike homada* (Publications of *ArchDelt* vol. 50, Athens).
Stewart, A., 1977: *Skopas of Paros* (Park Ridge).
Stewart, A., 1978: "Lysippan Studies 2: Agias and Oilpourer," *AJA* 82, 301–13.
Stewart, A., 1990: *Greek Sculpture: An Exploration* (New Haven/London).
Stucky, R. A., 1984: *Tribune d'Echmoun* (*AntK* BH 13, Basel).
Stucky, R. A., 1988: "Sidon-Labraunda-Halikarnassos," in M. Schmidt, ed., *Kanon: Festschrift Ernst Berger* (*AntK* BH 15, Basel) 119–26.
Stucky, R. A., 1991: "Il santuario di Eshmun a Sidone e gli inizi dell'ellenizzazione in Fenicia," *Scienze dell'Antichità* 5, 461–82.
Stucky, R. A., 1993a: *Die Skulpturen aus dem Eschmun-Heiligtum bei Sidon: Griechische, römische, kyprische und phönizische Statuen und Reliefs von 6. Jahrhundert vor Chr. bis zum 3. Jahrhundert nach Chr.* (*AntK* BH 17, Basel).
Stucky, R. A., 1993b: "Lykien-Karien-Phönizien: Kulturelle Kontakte zwischen Kleinasien und der Levante während der Perserherrschaft," in J. Borchhardt and G. Dobesch, eds., *Akten des II. Internationalen Lykien-Symposions, Wien 6.–12. Mai 1990* (Vienna) vol. 1, 261–68.
Stupperich, R., 1977: *Staatsbegräbnis und Privatgrabmal im klassischen Athen* (Münster).
Stupperich, R., 1978: "Eine 'Gefässgruppenstele' aus dem Kerameikos," *Boreas* 1, 94–102.
Stupperich, R., 1994: "The Iconography of Athenian State Burials in the Classical Period," in W. Coulson et al., eds., *The Archaeology of Athens and Attica under the Democracy* (Oxbow Monograph 37, Oxford) 93–103.
Sturgeon, M. C., 1995: "The Corinth Amazon: Formation of a Roman Classical Sculpture," *AJA* 99, 483–505.
Svoronos, J. N., 1908: *Das Athener Nationalmuseum* (Athens).
Tagalidou, E., 1993: *Weihreliefs an Herakles aus klassischer Zeit* (*SIMA* PB 99, Jonsered).
Tancke, K., 1989: *Figuralkassetten griechischer und römischer Steindecken* (Frankfurt).
Tancke, K., 1990: "Wagenrennen: Ein Friesthema der aristokratischen Repräsentationskunst spätklassisch-frühhellenistischer Zeit," *JdI* 105, 95–127.
Thompson, H. A., 1953: "The Apollo Patroos of Euphranor," *ArchEph* 1953–54 (publ. 1961) in Memory of G. P. Oikonomos, vol. 3, 30–44.
Thönges-Stringaris, R. N., 1965: "Das griechische Totenmahl," *AM* 80, 1–99.
Todisco, L., 1993: *Scultura greca del IV secolo: Maestri e scuole di statuaria tra classicità ed ellenismo* (Repertori fotografici Longanesi 8, Milan).
Trell, B. L., 1988: "The Temple of Artemis at Ephesos," in P. Clayton and M. Price, eds., *The Seven Wonders of the Ancient World* (New York) 78–99.
Trianti, A.-I., 1985: *O glyptos diakosmos tou naou sto Mazi tes Eleias* (Thessaloniki).
Trianti, I., 1986: "O glyptos diakosmos tou naou sto Mazi tes Eleias," in H. Kyrieleis, ed., *Archaische und klassische griechische Plastic* vol. 2 (Mainz) 155–68.
Valavanes, P. D., 1991: *Panathenaikoi Amphoreis apo ten Eretria* (Athens).
Van Straten, F., 1976: "Daikrates' Dream: A Votive Relief from Kos, and Some Other Kat'onar Dedications," *BABesch* 51, 1–27 (figs. on pp. 29–38).
Van Straten, F., 1993: "Images of Gods and Men in a Changing Society: Self-Identity in

Bibliography

Hellenistic Religion," in A. W. Bulloch, E. S. Gruen, A. A. Long, A. Stewart, eds., *Images and Ideologies: Self-Definition in the Hellenistic World* (Berkeley/Los Angeles/London) 248–64.

Varoufakis, G. J., 1978: "Metallourgike ereuna guro apo ton kratera tou Derveniou," *ArchEph* (publ. 1980) 160–80 (with English summary).

Vedder, U., 1988: "Frauentod-Kriegertod im Spiegel der attischen Grabkunst des 4. Jhs. v. Chr.," *AM* 103, 161–91.

Verbanck-Piérard, A., 1992: "Herakles at Feast in Attic Art: A Mythical or Cultic Iconography?" in E. Hägg, ed., *The Iconography of Greek Cult in the Archaic and Classical Periods* (Symposium held Nov. 16–18, 1990; Athens/Liege) 85–106.

Vermeule, C. C., 1975: "The Weary Herakles of Lysippos," *AJA* 71, 323–32.

Vermeule, E., 1970: "Five Vases from the Grave Precinct of Dexileos," *JdI* 85, 94–111.

Vierneisel-Schlörb, B., 1979: *Glyptothek München, Katalog der Skulpturen*, vol. 2: *Klassische Skulpturen des 5. und 4. Jahrhunderts v. Chr.* (Munich).

Vierneisel-Schlörb, B., 1988: *Glyptothek München, Katalog der Skulpturen*, vol. 3: *Klassische Grabdenkmäler und Votivreliefs* (Munich).

Vikela, E., 1994: *Die Weihreliefs aus dem Athener Pankrates-Heiligtum am Ilisos: Religionsgeschichtliche Bedeutung und Typologie* (*AM* BH 16).

Visscher, F. de, 1962: *Héraclès Epitrapezios* (Paris).

Visscher, F. de, et al., 1962: "Le sanctuaire d'Hercule et ses portiques à Alba Fucens," *MonAnt* 46, 336–96.

Viviers, D., 1992: *Recherches sur les ateliers de sculpteurs et la cité d'Athènés à l'époque archaique: Endoios, Philergos, Aristokles* (Brussels).

Voigtländer, W., 1989: "Vorläufer des Maussolleion in Halikarnassos," in T. Linders and P. Hellström, eds., *Architecture and Society in Hecatomnid Caria: Proceedings of the Uppsala Symposium, 1987* (Uppsala) 51–62.

Völcker-Janssen, W., 1993: *Kunst und Gesellschaft an den Höfen Alexanders d. Gr. und seiner Nachfolger* (Quellen und Forschungen zur antike Welt 15, Munich).

Von Steuben, H., 1989: "Belauschte oder unbelauschte Göttin? Zum Motiv der knidischen Aphrodite," *IstMitt* 39, 535–60 (with contributions by others).

Waywell, G. B., 1971: "Athena Mattei," *BSA* 66, 373–82.

Waywell, G. B., 1978: *The Freestanding Sculptures of the Mausoleum at Halicarnassus in the British Museum* (London).

Waywell, G. B., 1980: "Mausolea in South-west Asia Minor," *Yayla* 3, 5–11.

Waywell, G. B., 1988: "The Mausoleum at Halicarnassus," in P. Clayton and M. Price, eds., *The Seven Wonders of the Ancient World* (New York) 100–123.

Waywell, G. B., 1989: "Further Thoughts on the Placing and Interpretation of the Freestanding Sculptures from the Mausoleum," in T. Linders and P. Hellström, eds., *Architecture and Society in Hecatomnid Caria: Proceedings of the Uppsala Symposium, 1987* (Uppsala) 23–30.

Waywell, G. B., 1993: "The Ada, Zeus and Idrieus Relief from Tegea in the British Museum," in O. Palagia and W. Coulson, eds., *Sculpture from Arcadia and Laconia* (Oxbow Monographs 30, Oxford) 79–86.

Weber, M., 1990: *Baldachine und Statuenschreine* (Rome).

Bibliography

Weber, M., 1993: "Zur Überlieferung der Goldelfenbeinstatue des Phidias im Parthenon," *JdI* 108, 83–122.

Wegener, S., 1985: *Funktion und Bedeutung landschaftlicher Elemente in der griechischen Reliefkunst archaischer bis hellenistischer Zeit* (Frankfurt).

Wescoat, B. D., ed., 1989: *Syracuse, the Fairest Greek City: Ancient Art from the Museo Archeologico Regionale 'Paolo Orsi'* (Rome/Atlanta).

Willemsen, F., 1977: "Zu den Lakedämoniergräbern im Kerameikos," *AM* 92, 117–57.

Wilson, R. J. A., 1990: *Sicily under the Roman Empire: The Archaeology of a Roman Province, 36 B.C.–A.D. 535* (Warminster).

Wörrle, M. 1993: "Perikles von Limyra—endlich Etwas mehr Griechisches," in J. Borchhardt and G. Dobesch, eds., *Akten des II. Internationalen Lykien-Symposions, Wien 6.–12. Mai 1990* (Vienna) vol. 1, 187–90.

Woysch-Méautis, D., 1982: *La représentation des animaux et des êtres fabuleux sur les monuments funéraires grecs* (Lausanne).

Yalouris, N., 1986: "Die Skulpturen des Asklepiostempels von Epidauros," in H. Kyrieleis, ed., *Archaische und klassische griechische Plastik*, vol. 2 (Mainz) 175–86.

Yalouris, N., 1992: *Die Skulpturen des Asklepiostempels in Epidauros* (*AntP* 21, Munich).

Zadoks-Jitta, A.-N., 1987a: "Herakles Epitrapezios Reconsidered," in J. Chamay and J.-L. Maier, eds., *Lysippe et son influence* (*Hellas et Roma* 5, Geneva) 97–99.

Zadoks-Jitta, A.-N., 1987b: "Lysippos and Herakles: A Re-assessment," in J. Chamay and J.-L. Maier, eds., *Lysippe et son influence* (*Hellas et Roma* 5, Geneva) 101–4.

Zagdoun, M.-A., 1977: *Monuments figurés: Sculpture. Reliefs* (*FdD* 4.6, Paris).

Zagdoun, M.-A., 1989: *La sculpture archaïsante dans l'art hellénistique et dans l'art romain du Haut-Empire* (*BEFAR* 269, Athens/Paris).

Zahle, J., 1979: "Lykische Felsgräber mit Reliefs aus dem 4. Jahrhundert v. Chr.: Neue und alte Funde," *JdI* 94, 245–346.

Credits for Plates

1. Ministry of Culture, Athens
2a–d. Professor M. J. Mellink
3–5, 28, 45, 51, 56, 57, 63, 73, 84b–c, 85a–e. Bryn Mawr College, R. Carpenter Collection
6, 7, 20–22, 24, 25a–c, 26, 27, 29–31, 38, 40, 50, 53, 54, 58, 59, 61, 66–68, 72, 75–78, 79a, 83d. Bryn Mawr Photographic Collection
9a–b, 35, 62. Courtesy of Dr. C. A. Picón
13. W. A. P. Childs (courtesy of Professor Childs)
14–19, 23. Courtesy of the Trustees of the British Museum
33. Courtesy of Dr. Helena Savostina
36, 42. Courtesy of The Art Museum, Princeton University
39. Staatliche Antiken sammlungen und Glyptothek München
41. University of Pennsylvania Museum, Philadelphia (neg.# NC35-3319)
43, 82. Courtesy of Museum of Art, Rhode Island School of Design, Providence
44. University of Pennsylvania Museum, Philadelphia (neg.# S35-134350)
46. Bryn Mawr Photographic Collection (courtesy of Dr. H. Biesantz)
48. Courtesy of Mrs. Eleanor Ferris
49. Deutsches Archäologisches Institut, Athens
52. The Metropolitan Museum of Art, Fletcher Fund, 1929
55a–c. Courtesy of Professor R. A. Stucky
60. Courtesy of Professor E. Simon
64. N. Stournaras, Bryn Mawr Photographic Collection
69. S. I. Jashemski (courtesy of Professor W. Jashemski)
70. Courtesy of M. Alain Pasquier
71. Courtesy of Professor J. Inan
79b–c. Dr. P. Webb
80a–b. Dr. A. Frantz
83a–c. Alison Frantz Collection. American School of Classical Studies at Athens

Selective Index

This index concentrates primarily on Classical monuments and topics as discussed in the main text. References to notes (which should be consulted in conjunction with the text) have generally not been included, except in cases where they provide additional information. Sculptural types are indicated in boldface and are listed under subject represented rather than by attributed master or by museums; architectural sculpture is listed by provenance rather than by museum.

Acheloos, 198
Achilles, 38, 49–50, 84, 181 n. 14; and Penthesileia, 15, 37; and Telephos, 49; and Troilos, 108 n. 33
Ada (Hekatomnid queen), 49, 112, 113, 126, 134, 140, 250, 346
Agias. *See* Delphi, Museum, Daochos Monument
Agorakritos (sculptor from Paros), 13–14, 325
Aigina: Temple of Aphaia, 65 n. 23, 67 n. 40
Akroteria: in Louvre Museum, 22 n. 25; on buildings (and roof decoration), 13, 14, 35, 39, 43, 51, 55–56, 86–87, 97–98, 114, 119, 127–28, 271 n. 21; on sarcophagi, 192 n. 63; on stelai, 9, 161, 167; Oriental type, 92
Albani Relief, 20 n. 1, 21 n. 9, 200
Alexander portrait: **Akropolis**, 249; by Lysippos, 293, 305
Alkamenes (Athenian sculptor), 60 n. 2, 198, 230 n. 50, 236 n. 77, 329, 357 n. 25
Amazons, Amazonomachy, 21 n. 9, 28, 30, 33, 44, 58, 64 n. 23, 89, 91, 98, 101, 129, 141; at Priene, 136; pseudo-Amazonomachy at Xanthos, 83; taking place in Athens, 6, 33; taking place at Themiskyra (with Herakles), 15–16, 114, 120–21, 124, 129, 130–32; taking place at Troy (with Achilles), 15, 26, 33, 35, 37; with Theseus, 12
Amphipolis: lion monument, 144
Anapauomenos (leaning satyr, by Praxiteles?), 266–67
Anatomical votives (**Pl. 48**), 194, 219 n. 7
Anatomy and proportions, 28, 38, 40, 63 n. 11, 88, 132–33, 304, 340, 341, 351, 368; on Attic gravestones, 166
Antalya, Museum: Yalnızdam Stele (**Pls. 2a–d**), 3–4, 7–9
Antiphanes (sculptor from Argos), 240–41, 243, 267, 288

Aphrodite: **Arles**, 264; **Capua**, 283 n. 75, 355 n. 19; **Epidauros** (**Pl. 78**), 331; **Euploia**, 355 n. 19; **Kallipygos**, 355 n. 19; **Knidia** (by Praxiteles; **Pl. 66**), 51, 218, 261, 263–65, 308, 329, 368; **Knidia**, Munich variant (**Pl. 67**), 264; on goat (Pandemos, Ourania), 205, 251–52; on goose, 74 n. 84; on votive reliefs, 205; **Sion House/Munich**, 355 n. 19
Apollo, 334–35; and Hyakinthos(?), 87; and Koronis, 39; and Marsyas, 194, 206; **Belvedere**, 249; head from Halikarnassos (**BM 1058**), 127, 135; **Lykeios** (by Praxiteles?), 265, 334, 351; on votive reliefs, 334–35; **Sauroktonos** (by Praxiteles?), 265, 266, 334, 336; Smintheus, 257–58. *See also* Athens, Agora Museum; Rhamnous
Apollo Sosianus: sculptures (from Eretria?), 12, 22 n. 22
Apollo Maleatas, Sanctuary: sculptures, 41 (Athens, **NM 4703, 4837**), 48
Apoxyomenos (by Lysippos), 306, 307, 308, 341, 343
Archaistic, archaizing, style, 11, 29, 38, 88, 98, 126, 134, 140, 143, 145, 218, 232 n. 59, 279 n. 57, 324, 329, 338, 366; definition, 354 n. 15; on Document reliefs, 216; on Epidauros Altar, 210–11; on gravestones, 166; on votive reliefs, 196, 202; statue of Delian Artemis, 328–29
Ares: akrolithic statue at Halikarnassos, 122, 248; **Borghese**, 244
Argive Heraion, 25–30, 32, 33, 41, 82; akroteria, 27; chronology, 26; cult image, 25, 27; metopes, 28–29, 34, 193; pediments, 28 (Athens **NM 1578+4035**), 29, 63 n. 14 (heads **NM 1565, 1566, 4817**), 29 ("Hera" **NM 1571**; idols), 38, 61, n. 3
Artemis, 72 n. 67; **Beirut**, 354 n. 12; **Colonna**, 330; **Dresden**, 329–30, 354 n. 12; from Kala-

Selective Index

Artemis (*continued*)
podi, 57; from Paros (Delian), 328–29, 332; from Peiraieus, Larger/Smaller, 328, 336, 359 n. 35; **Gabii**, 329; **Munich/Braschi**, 330, 354 n. 12; riding hind, from Sorrento, 74 n. 84; **Versailles**, 249

Asklepios, 194; beardless, 275 n. 45, 338, 358 n. 30; **Giustini**, 338; in votive reliefs, 197, 200, 203. *See also* Epidauros

Athena: akrolithic, at Priene, 135, 140; **Albani**, 324–25; and children, 202, 227 n. 36; **Areopagos House**, 326; **Arezzo**, 325; **Castra Praetoria**, 326–27; **Farnese**, 325; **Giustiniani**, 324; **Ince**, 217, 353 n. 10; on Document reliefs, 216–17, 326–27; on votive reliefs, 202; **Peiraieus/Mattei** (Pls. 74a–c), 322–24, 336; **Rospigliosi** (Pl. 76), 325–26; **Velletri**, 217, 322, 324; **Vescovali**, 325. *See also* Athens, City, Parthenon, cult image

Athens, Agora Museum: Apollo Patroos (**S 2154, Pls. 80a–b**), 335–37; "Aura" (**S 182**), 56; Document reliefs (**S 366, 2311, 2495**), 216; Neoptolemos' relief (**I 7154**), 198, 199, 205; relief showing cobbler Dionysios' workshop (**I 7396**), 225–26 n. 29; Tyche (formerly Demokratia, **S 2370**), 339

Athens, Akropolis Museum: Athena and Pig Sacrifice (**148**), 202; stele of warrior Silanion, 181 n. 14; votive relief with body parts (**7232**), 219–20 n. 7

Athens, City: influence of building program, 17, 33, 35, 41, 43, 45, 47–48, 54, 57, 58–59, 62 n. 8, 64–65 n. 23, 78, 102, 102 n. 1, 142

Athens, City: monuments
—Erechtheion, 13, 24 nn. 33–34, 47, 49, 79, 103 n. 4, 142; Karyatids, 29, 94, 98–99, 169, 214, 216, 260
—Funerary shrine: with carved metope, 57; with carved pediment (now in Zurich), 75 n. 88
—Hephaisteion, 6, 13, 24 n. 34, 31, 65 n. 23
—Ilissos Temple, 13, 65 n. 23, 88
—Lysikrates Monument, 142, 208, 266
—Nike Balustrade, 6, 13, 14, 121, 235 n. 67, 351
—Nike Temple, 6, 13, 35, 64 n. 23, 79, 94, 218 n. 2
—Parthenon, 13, 26, 35, 36, 42, 45, 103 n. 3, 123, 146, 218 n. 2; cult image, 12, 14, 27, 137, 217, 325; frieze, 27, 96, 125, 127, 143, 169, 179 n. 9, 227 n. 35, 228 n. 43, 307, 329; metopes, 6, 13, 44, 64 nn. 22–23, 82, 138; pediments, 16, 38, 139, 227 n. 35, 351
—Temple of Apollo Patroos, 335; pediment, 57
—Temple of Ares, 13, 22 n. 25

Athens, Epigraphic Museum: Document relief for Molossian king Arybbas (**EM 13291**), 215; Document relief with satyr (**13262**), 266

Athens, Kerameikos Museum: **P 692** (Charon stele), 185 n. 30; **P 1131** (stele with priestly figure), 180 n. 9. *See also* Dexileos, precinct and stele

Athens, National Museum
—Reliefs, bases: **NM 215–217** (Mantineia base), 169, 194, 206–9, 325; **1463** (tripod base with Dionysos and Nikai), 232–33 n. 59, 337; **1733** (base signed by Bryaxis), 250, 274 n. 41. *See also* Epidauros, so-called Altar (**NM 1425**)
—Reliefs, Document: **NM 1467** (treaty with Kerkyra), 183 n. 19, 353 n. 7; **2948** (Molossian king Arybbas), *see* Athens, Epigraphic Museum
—Reliefs, funerary: **NM 722** (stele of Archestrate), 168–69; **732** (stele of Kallisto, **Pl. 40**), 168; **737** (stele of Prokleides), 165; **738** (Aristonautes' stele), 197, 246; **743** (stele of Damasistrate, **Pl. 31**), 160; **754, 2744** (from polyandrion), 3, 20 n. 1; **834** (stele of warrior, **Pl. 32**), 160; **869** (Ilissos stele), 164; **870** (stele with family scene, **Pl. 34**), 160; **1863** (stele of Hagnostrate), 178 n. 5; **1953** (old-woman stele), 185 n. 29; **2574** (stele of Alexos), 183 n. 19; **3624** (stele of Hegeso, **Pl. 38**), 167, 324; **3709** (amphiglyphon with lion/lioness), 178 n. 5; **3716** (*telauges mnema*), 188 n. 43; **3891** (stele of woman leaning on hydria), 181 n. 14; **4487** (stele of Aristion), 181 n. 19
—Reliefs, votive: **NM 173–174** (Asklepios/Apollo panels from Epidauros, **Pl. 54**), 66 n. 33, 67 n. 39, 211; **1332** (to Asklepios), 183 n. 19; **1333** (to Asklepios and Hygieia), 199, 224 n. 23, 226 n. 31; **1351** (Birth of Asklepios, **Pl. 53**), 200, 205; **1377** (to Asklepios,

Selective Index

Pl. 50), 197, 226 n. 31; **1403** (Kore/Artemis?), 183 n. 19; **1455** (Mt. Helikon personified, from Thespiai), 225 n. 26; **2012** (Eukles' relief from Vari, **Pl. 51**), 197, 223 n. 20, 224 n. 21; **2557** (to Asklepios), 221 n. 14; **3369** (Archinos to Amphiaraos, **Pl. 49**), 195–96; **4466** (Agathemeros' relief), 198, 199. See also Telemachos Relief
—Sculpture in the round: **NM 774** (siren from Dexileos' Precinct), 5–6; **808** (funerary loutrophoros, **Pl. 30**), 159; **3619–3620** (funerary griffin cauldron), 158; **6439** (Olympia Boxer, **Pls. 85a–e**), 344–45, 346; **13396** (Antikythera Youth, **Pls. 83a–d**), 340–42, 345; **13400** (Antikythera "Philosopher"), 342, 346–47, 366; **15118** (Marathon Youth), 266, 343–44
—Sculpture, architectural: head **NM 3602** (so-called Hygieia), 54. See also Apollo Maleatas; Argive Heraion; Epidauros; Tegea
Athletic statuary, 339–45, 370. See also Apoxyomenos; Diskobolos; Hermes; Lysippos; Meleager; Polykleitos
Attis. See Foreign cults
Auge, 49, 86–87
Aura/Aurai: at Delphic Tholos, 42; at Epidauros, 40, 245; in Copenhagen (**Pl. 10**), 55; **Palatine**, 55. See also Loukou

Baltimore, Walters Art Gallery: bronze boy with melon coiffure, 188 n. 41
Banquet scenes, including funerary (*Totenmahl*), 82–83, 89, 91, 92, 107 n. 29, 172, 200–204, 266, 344; recipients of Banquet Reliefs, 201, 226 n. 30
Bassai, Temple of Apollo, 17, 31–33, 36, 53; chronology, 15, 25, 69 n. 50; cult image, 61 n. 4, 70 n. 63; frieze (**Pl. 6**), 15–16, 28, 33, 41, 44, 351; metopes (**Pls. 3–5**), 15
Bellerophon (and Chimaira), 36, 91–92, 94, 98, 129, 189 n. 49, 194
Berlin, Staatliche Museen: athlete ("by Lysippos"), 306; dancer ("by Lysippos," **Pl. 73**), 312 n. 11; relief to Amphiaraos, 196; relief to Attis, 203. See also Priene, heads from
Boston, Gardner Museum: dancer (**Pl. 75**), 323
Boston, Museum of Fine Arts: Amazon (Penthesileia), 40–41, 247; Aphrodite on goose, 75 n. 84; gravestone (**1979.510**), 169; Leda and Swan, 75 n. 84, 247, 271 n. 21; Roman seated statue (Argive Hera?), 60 n. 3
Brauron Museum: Aristonike's relief to Artemis (**1151[5]**), 201; "bears," 346
Bryaxis (sculptor), 121–22, 250–51; signatures, 250

Centauromachy: at Bassai, 15–16; at Delphic Tholos, 44; at Ephesos, 141; at Halikarnassos Maussolleion, 114, 123, 129; at Sounion, 24 n. 34; at Trysa, 89, 91
Chaironeia: lion monument (**Pl. 37**), 144, 166
Chronology, 364–65; based on historical events, 3, 9–10, 31, 34–35, 69 n. 56; based on style, 10–11, 33, 145, 365–66; expressed in clothing fashions, 30
Chryselephantine (statues). See Technique
Classicizing (style), 60 n. 3, 162, 166, 201, 218, 232 n. 57, 244, 246, 260, 327, 328, 330, 333, 342, 366
Coffers, 27, 58–59; at Epidaurian Asklepieion, 35–36; at Halikarnassos Maussolleion, 114, 124; at Priene, 136–39; at Samothrake, 143–44; on Delphic Tholos, 43; on Epidaurian Tholos, 47–48; on Nereid Monument, 80
Color (including in building materials), 35–36, 39, 43, 53, 96, 128, 142, 151–52 n. 33, 175
Continuous narrative, 82, 195–96
Copenhagen, Ny Carlsberg Glyptotek: Alba Youth, 40–41; "Aura" (**Pl. 10**), 55; Niobids, 22 n. 22, 323; Panathenaic amphoras from Nemi, 180 n. 10; votive relief **197**, 193
Corinth Museum: votive relief **S 2567**, 196
Costume. See Drapery

Damophon (sculptor from Messene), 73 n. 80
Delos: Building 42 (frieze), 58; sculptural production, 366; Temple of the Athenians, 45
Delphi, Museum: Daochos Monument, 289–90, 292, 305, 336, 342; peplophoroi, from limestone Athenaion (?; **Pl. 11**), 56; "philosopher," 362 n. 45; votive relief, 196
Delphi, site: Arkadian Dedication, 240–41; Krateros' (Alexander's) Hunt, 122, 248–49, 290, 293; Lysander Monument, 240, 243; Temple of Apollo (fourth century), 57, 76 n. 91; Tholos (in Sanctuary of Athena Pronaia, **Ills. 6–7**), 18, 42–45, 47, 65 n. 28, 79, 145

Selective Index

Demeter (and Kore), 332–34, 338; from Knidos, *see* London, British Museum; on votive reliefs, 202, 203, 204, 205

Derveni Krater (in Thessaloniki Museum, **Pls. 86a–b**), 14, 318 n. 41, 337, 350–52, 368

Dexileos: life, 3; motif (triumphant rider), 9, 84, 305; precinct (**Ills. 1–2**), 5, 21 n. 6; stele (Kerameikos Mus. **P 1130**; **Pl. 1**), 3–7, 16, 17, 162

Dionysos, 50, 55, 57, 60 n. 2, 72 n. 67, 194, 337; chryselephantine, by Alkamenes (base for), 198, 223 n. 19; on tripod base, with Nikai, 232–33 n. 59, 337; **Sardanapalos**, 337–38, 362 n. 45

Diskobolos (by Naukydes; **Pls. 56–57**), 243–44, 343

Document (Record) reliefs, 52, 127, 157, 215–17, 338; chronology, 193, 215–16; frame, 183 n. 19, 215

Doryphoros (by Polykleitos), 242, 243, 270 n. 15, 278 n. 54; bronze herm in Naples, 295

Drapery and costume, 6, 17, 38–39, 59, 133, 322–24, 369; Aphrodite's, 331; apron, 175, 209–10, 322; Artemis', 327–28, 330–31; Asklepios', 338; Athena's, 322; back mantle, 169–70, 216, 226 n. 31, 260, 322, 330, 326, 336, 349; Demeter/Kore's, 332; "effeminate," 336; long-sleeved, 207, 336; Lykian mannerisms, 87, 93, 99, 105–6 n. 22, 176; on Attic gravestones, 166–67; on Mantineia base, 208–9; Oriental, 8, 59, 175, 203; press folds, 133, 152–53 n. 41, 170, 336; "rosettes," 167, 173, 209; selvedge, 246; woven decoration, 334

Eirene and Ploutos (by Kephisodotos I, **Pl. 62**), 20 n. 3, 259–60, 332, 338, 362 n. 50

Elis: male figure like Hermes of Olympia, 261–62; relief with warrior, 68 n. 47

Emotions, rendering of, 59, 162, 322, 368, 370; pathos, 6, 17, 29, 38, 50, 139, 217, 253–54, 277 n. 51, 325

Ephesos: Artemision (Archaic), 18, 174; Classical, 141, 144, 210, 336

Epidauros
—Sanctuary, 14, 46
—so-called Altar (Athens, **NM 1425**), 209–11
—Temple of Asklepios, 34–41, 43, 46, 48, 53, 245; cult image, 36, 194; sculptures (**Ills. 5a–b**), 18, 32, 37–40, 44, 50, 97, 217, 245
—Tholos (**Ills. 8–9**), 35, 45–48, 54
—Triglyph Altar, 54, 70 n. 61

Eros, 212, 369; as variant of Apollo, 283–84 n. 76; by Lysippos, 291, 305, 308, 343; by Praxiteles, 282 n. 70, 291; by Skopas, 252, 253, 254, 279 n. 58

Etruria and Etruscan monuments, iconography, 7, 12, 108 nn. 33 and 35, 302, 318 n. 42

Euphranor (Athenian sculptor and painter), 21 n. 13, 218, 239, 284 n. 77, 322, 328, 335–36

Eupolemos (Argive architect), 27

Eurydike's dedication. *See* Vergina Peplophoros

Eyes: apotropaic, 195; inserted: 29, 61 n. 3; rendering, 17, 28, 38, 44, 50, 97, 132, 175, 345

Footwear, 8, 133, 153 n. 42, 168, 170, 207, 328, 342, 352 n. 1, 361 n. 44

Foreign cults/divinities, 203, 216

Friezes, 58, 77 n. 93, 79, 100. *See also* Halikarnassos; Kastabos; Limyra; Messa; Samothrake; Trysa; Xanthos

Funerary sculpture, 157–58, 337, 348–50
—Attic, Atticizing, 157, 158–70, 173, 176–77, 177 n. 3; age groups and renderings on stelai, 164–65, 169–70; chronology, 157, 160, 161, 170, 179 n. 8, 186 n. 31; economic considerations, 163; epitaphs, 163; flanking (subsidiary) figures, 162, 184 n. 22, 349; gazes, 164; generic message, 163–65; heroizing connotations, 159–61, 164; identification of the dead, 163–64; masters, 165–66; material, 166; naiskos stelai, 160–62; relief frames (pediments, sima roofs), 9, 161, 181 n. 14, 182–83 n. 19; stone vessels (**Pl. 30**), 158–59; style and composition, 166–69, 187–88 n. 38; symbolism, 159
—Boiotian stelai (**Pl. 45**), 157, 170–71, 187 n. 38
—Delian stelai (from Rheneia), 177–78 n. 4
—East Greek stelai, 157, 173
—Lakonian reliefs, 172
—Macedonian stelai, 190 n. 53
—Tarentine reliefs, 172–73
—Thessalian stelai (**Pl. 46**), 157, 171–72

Selective Index

Ganymede and the Eagle (**Pl. 58**, by Leochares?), 247
Gattungstil, 87, 175
Getty Youth, 311 n. 9, 306
Gigantomachy: at Argive Heraion, 27; at Athens, 64 n. 23; at Ephesos, 141; at Kalapodi, 57; at Mazi, 30; at Priene, 127, 136; on Pergamon Altar, 44, 127, 140
Gjölbaschi-Trysa. *See* Trysa
Gods, fourth-century conception of, 202–3, 204–5, 321, 331–32, 369
Granikos Monument, by Lysippos, 291–92, 305
Gravestones. *See* Funerary sculpture
Griffins, 72 n. 72; on funerary vase, 158; on helmet, 323

Hairpieces (in metal?), 134, 140
Hairstyles, 17, 51; anastole, 135; archaizing, 88, 98, 126, 134, 140, 232 n. 59; beard, with central part, 298, 315 n. 33; bow-knot, 151 n. 30; braids, 29, 38, 63 n. 14, 168, 209, 265; impressionistic, 34, 139; krobylos, 30; loose curls (classicizing), 260; Lykian, 83; mane-like, 266; melon coiffure, 168, 169, 209, 328; on Attic gravestones, 168–69, 177; piled up, 168, 209
Halikarnassos, Maussolleion (**Pls. 26–29, Ills. 16–18a–c**), 13, 18, 37, 52, 54, 99, 100, 111–35, 144–45, 176, 214, 239, 245, 267; building, 114–17; chronology, 126–27; history, 111–12; meaning, 128–30; sculpture, 16, 39, 56, 88, 117–28, 251, 351 (*see also* London, British Museum, "Maussollos and Artemisia"); site, 113–14; technique, iconography, and style, 123, 130–35
Headdresses. *See* Helmets and headgears; Hairstyles
Hektoridas (sculptor), 36–37, 39
Helmets and headgears, 59, 96, 323; animal-heads, 30, 34, 50, 71 n. 66 (on various monuments), 84, 324; Attic, 28, 51, 131, 152 n. 38, 325; Corinthian, 72 n. 69, 131, 182 n. 14, 323, 324, 325–26; kausia and other N. Greek headdresses, 172, 190 n. 53; leaf-fillet, 343, 360 n. 38; Persian tiara orthè, 95; Phrygian (Oriental), 28, 38, 44, 98, 131, 199, 327 (under Athena's helmet); piloi, 199; poloi, 166, 171, 201, 334
Hera: **Borghese** (Amyklai Aphrodite?), 275 n. 44; head from Argive Heraion, *see* Argive Heraion; in Thessaloniki, 61 n. 3; of pear wood, 62 n. 9
Herakles, 113, 128, 151 n. 32, 300–302; and Auge, 86, 317 n. 40; deeds, 44–45, 57, 124, 129, 141, 219 n. 4; **Epitrapezios** (**Pls. 69–70**), 294–304; **Farnese/resting** (**Pl. 68**), 289, 295, 297, 305–6, 342, 351; **Farnese** variants, 311 n. 10; from Alba Fucens, 297–98, 302; in Athens, 57; in Olympia, 62 n. 7; in Taras, by Lysippos, 288, 292–93, in Tegea, 50; on Attic votive reliefs with tetrastylon, 197. *See also* Amazons, Amazonomachy
Herculaneum Runners (from Villa of the Papyri), 307–8
Hermes: and baby Dionysos, by Kephisodotos, 260; and baby Dionysos, from Leptis Magna, 307; **Andros/Farnese** (**Pl. 81**), 181 n. 14, 262, 337, 349; by Naukydes (various types), 243, 270 n. 15; from Minturnae (**Pl. 63**), 260–61; in Elis, 261–62; **Ludovisi**, 166; of Olympia (**Pls. 64–65**), 206, 261–62, 265, 341, 344; **Richelieu** (**Pl. 82**), 181 n. 14, 288, 337; **Sandalbinder** (**Pls. 71–72**), 292, 307–8, 339; seated, from Herculaneum, 306
Heroization: of athletes, 342; of the dead, 21, 89, 99, 100, 101, 108 n. 31, 159–61, 164, 172, 347–48, 349
Honorary statues, 345–46
Hunt, hunters, 82, 107 n. 29, 124–25, 130, 171, 175, 191 n. 61, 254. *See also* Delphi, site, Krateros' Hunt; Kalydonian boar hunt
Hygieia, 49, 51, 338–39; head from Tegea (Athens, **NM 3602**), 54; **Hope**, 338–39; statue from Epidauros (Athens **NM 299**), 245–46
Hypnos, 265, 291

Idrieus (Hekatomnid ruler), 49, 52, 99, 112, 113, 250, 346
Ilioupersis, 63–64 n. 15; at Argive Heraion, 26–27; at Epidauros, 33, 35
Istanbul, Archaeological Museum: sarcophagi. *See* Sidonian sarcophagi

Selective Index

Kaineus, 89, 104 n. 14
Kairos (by Lysippos), 291, 304–5, 308
Kalamis (sculptor; I or II), 335, 358 n. 30
Kalapodi, sanctuary of Artemis and Apollo, 57
Kallimachos (sculptor, from Chios?), 14
Kalydon: Artemision, metopes, 58
Kalydonian (Meleager's) Boar Hunt, 24 n. 34, 49, 72 n. 67, 82, 107 n. 29, 108 n. 34
Karyatids, 13, 98, 183 n. 20, 262. *See also* Athens, City, monuments, Erechtheion
Kastabos: Temple of Hemithea, 142–43, 145
Kephisodotos I (Athenian sculptor), 21 n. 13, 183 n. 20, 258–61; as maker of grave monuments, 165; as maker of votive reliefs, 226 n. 31
Kephisodotos II, 242
Kızılbel and Karaburun (painted) tombs, 93
Knidos: Lion Tomb, 144, 147 n. 9, 156 n. 54
Kolotes (sculptor), 17
Koronis, 39, 50,
Kos: Charites relief, 88, 223 n. 19
Kourotrophos groups, 259–61
Kresilas (sculptor from Crete), 14
Kyklades/Kykladic masters, 42; and architectural sculpture, 58, 76 n. 92, 146, 367

Labraunda: sanctuary of Zeus Labrandeus, 99–100, 112, 115, 123, 129, 135
Landscape (elements), 44, 77 n. 93, 81, 92, 94, 107 n. 29, 108 n. 32, 123, 124, 170–71, 172, 175–76, 192 n. 62, 195, 220 n. 11, 223 n. 19, 225 n. 26 (Mt. Helikon). *See also* Votive reliefs
Larisa (Thessaly), Museum: gravestones of women suckling baby, 171
Leda: and egg, 172; and Swan, 75 n. 84; and Swan, "by Timotheos," 246–47, 326, 349
Leochares (Athenian sculptor), 121–22, 247, 248–50, 332, 335–36; signatures, 248
Letoon, near Xanthos, 99, 103 n. 3
Limyra (Lykia): Heroon of Perikle (**Ills. 14–15**), 94–99
Lingering styles (Archaic, Severe, fifth century), 11–14, 333, 351
Lion-heads, waterspouts, 13, 28, 35, 42, 47, 53, 79, 94, 100, 114, 139, 192 n. 63. *See also* Helmets and headgears

Lions: at Halikarnassos, 114, 119, 125, 127, 130, 156 n. 54, 282 n. 69; at Lampsakos, by Lysippos, 313 n. 17, 320 n. 57; at Priene (on coffer), 139; funerary, 184 n. 22; on Nereid Monument, 79, 82, 103 n. 6; on stelai, 178 n. 5. *See also* Amphipolis; Chaironeia; Knidos
London, British Museum: bust of girl **BM 1153** (from Priene), 140; classicizing head (Hera?), 60 n. 3; Demeter of Knidos (**Pls. 79a–c**), 249, 332–34, 349; funerary stele from Delos (**BM 1825.7–13.1**), 187 n. 38; heads **BM 1051, 1054, 1055, 1058** (from Halikarnassos), 127, 134–35, 140; "Maussollos and Artemisia" (**Pl. 28**), 124–25, 126–27, 132–34, 148 n. 17, 170, 328, 336, 345; relief from Tegea, 49, 52, 113, 134, 145, 147 n. 3, 275 n. 45. *See also* Xanthos, Nereid Monument
Loukou, estate of Herodes Atticus: sculpture from (Aura), 55, 74 n. 83
Lysippos (sculptor of Sikyon): and Lysippan style, 19, 44, 165, 248–49, 266, 267, 282 n. 68, 286–308, 341, 368; as animal sculptor, 320 n. 57; as maker of vessel, 293–94, 297; locales of activity, 290–94; School of, 242, 269 n. 11, 308; signatures, 286–90, 295

Machaon (and Podaleirios; sons of Asklepios), 38, 50
Maenads, 262, 351, 355 n. 19; **Dresden** (by Skopas?, **Pl. 61**, **Ills. 21a–d**), 121, 255–57, 258; "Kallimachean," 223 n. 19, 235 n. 67; (?) in Bracciano, 261; in Oxford (akroterial, **Pls. 9a–b**), 55
Magna Graecia, 12, 23 n. 28, 55, 146, 176, 333–34, 367; influence, 28, 48, 70 n. 60
Mantineia Base. *See* Athens, National Museum; Reliefs, bases
Marathon Youth. *See* Athens, National Museum, Sculpture in the round
Marine Thiasos (by Skopas?), 257–58
"Maussollos and Artemisia." *See* London, British Museum
Mazi (ancient Makistos): Temple of Athena (**Ills. 3–4**), 30–34, 41, 324
Meleager, 87, 105 n. 20; attributed to Skopas, 254–55, 340

Selective Index

Messa (on Lesbos): Temple of Aphrodite, 142–43
Messene: Heroon/Mausoleum, 48; Temple of Zeus Soter, poros metope: 76 n. 91
Metal additions, 3, 6, 8, 29, 30 (curls), 34, 35, 38, 88, 93, 100, 114, 128, 130, 139, 181 n. 14, 183 n. 20, 187 n. 38 (earrings on male figures), 189 n. 50, 362 n. 46. *See also* Technique
Metopes, 57–58
Moscow, Pushkin Museum: stele of two warriors (**Pl. 33**), 160, 181
Motifs, compositional: hair-pulling, 38, 82, 93, 139; handshake (*dexiosis*), 162, 172, 184 n. 21; hero in distress, 39; stumbling horse, 88, 93. *See also* Dexileos, motif
Munich, Glyptothek: stele from Rhodes (**GL 482**), 173; stele of Mnesarete (**GL 491, Pl. 39**), 167–68; stele with hunter (**GL 492**), 190 n. 50
Muses, 54, 57, 153, 169, 176, 188 n. 42, 206–9, 259, 280 n. 61, 290, 339
Mythological reliefs, 204–15

Nashville, Tenn.: Athena Parthenos by A. LeQuire, 14
Naukydes (sculptor), 25–26, 243–44, 252, 267; signatures, 243
Nemea: Temple of Zeus, 52–54, 145
Neo-Attic, reliefs, 198, 206, 207, 211, 213–15, 230–31 nn. 52–53, 232 n. 58, 233 n. 59, 368
Nereids: from Athenian Agora, 56; from Formia (Naples NM), 56; in Ostia; 257. *See also* Xanthos
New York, Metropolitan Museum: **MM 08.258.41** (stele of Sostratos), 181 n. 19, 188 n. 41; **11.100.2** (classicizing stele, **Pl. 35**), 162, 183 n. 20, 226 n. 31; **29.47** (battle relief, **Pl. 52**), 199–200; **44.11.2/3** (figures in the round to be placed in naiskos), 183 n. 20, 348; **48.11.4** (stele from Acharnai), 181 n. 14; **57.151** (Eukleia's stele), 179 n. 8; **65.11.11** (stele of Philte), 170, 182 n. 19
Nike/Nikai, 339; as akroteria, 13, 30, 32, 34, 100; at Cyrene, 72 n. 71; at Epidauros, 39–40, 254; at Halikarnassos?, 128; at Tegea, 51; at Titane, 57; on Epidauros Altar, 209; on tripod base with Dionysos, 232–33 n. 59. *See also* Olympia
Nudity ("heroic"), 6–7, 8, 28, 34, 38, 72 n. 69, 82, 92, 131, 160, 164
Nymph reliefs, 197–99, 213–14; chronology, 223 n. 19

Oil-Pourer (**Pitti, Munich**, and other types), 342–43, 344
Old age, rendering of, 17, 164, 169, 368
Olympia
—Hermes and child Dionysos. *See* Hermes
—Metroon, 68 n. 47
—Nike (by Paionios), 16, 39, 56, 88, 246, 254
—Philippeion (including statues), 45, 122, 142
—Poulydamas Monument, 287, 290, 292
—Temple of Zeus, 26, 28, 34, 41, 73 n. 78, 86; cult image, 14, 17, 26, 36; cult image (throne), 23 n. 28, 41; sculptures, 39, 60 n. 2, 62 n. 7
Oxford, Ashmolean Museum: Maenad (**Pls. 9a–b**), 55

Paionios (sculptor from Mende), 14–15, 16; Nike by, *see* Olympia
Panainos (painter), 17
Panathenaic amphoras: in clay, 234 n. 64, 259–60; in stone, 159, 179–80 nn. 9–10
Pandaites, family of (group by Leochares), 248
Paris, Louvre: figures to be placed in naiskoi, 183 n. 20; votive relief to Demeter (**Ma 756**), 204. *See also* Akroteria
Paros: Doric buildings, 76–77 n. 92
Pasiteles (Magna Graecian sculptor), 24 n. 31, 262
Pathos. *See* Emotions, rendering of
Patras, Museum: sculptures from unknown temple, 32–33 (inv. **100, 621**), 41
Pattern books, 88, 93, 106 nn. 23 and 25, 368
Pediments, 57
Peleus, 49; and Thetis, 84–87
Penthesileia. *See* Achilles; Amazons, Amazonomachy (at Troy); Boston, Museum of Fine Arts
Pergamon "Altar," 44, 82, 123, 127, 136, 154 n. 47
Perseus: and Andromeda, 76 n. 91; and Medousa, 36, 92, 97–98, 108 n. 33, 192, 340

397

Selective Index

Personifications, 203, 338–39
Pheidias (Athenian sculptor), 10, 14, 17, 36, 60 n. 2, 61 n. 4, 207, 240, 282 n. 68; as maker of metal vessels, 294
Philadelphia, University of Pennsylvania Museum: stele of Krinylla and family (**MS 5470**, Pl. 41), 169; stele **5675** (**pl. 44**), 170; vessels from Nemi, 180 n. 10
Phoenician monuments, iconography, 7, 12
Phryne, 264, 346
Political/social influence on sculpture, 9, 27, 35, 50, 144, 162, 183–84 n. 21, 198, 218, 259–60, 363 n. 53
Polykleitos I (sculptor from Argos): and Polykleitan forms, 10, 23 n. 27, 25–26, 166, 172, 187 n. 38, 217, 241, 251, 282 n. 68, 295, 337, 342, 345, 368; School of, 60–61 n. 3, 240–42, 268–69 n. 11, 289
Polykleitos (architect), 46
Polykleitos the Younger (II, and later generations), 26, 243, 252, 287, 331. *See also* Polykleitos I, School of
Portraiture, 126, 132, 292, 344–45, 345–48, 370
Poseidon: **Lateran**, 307, 310 n. 6, 337
Pothos (by Skopas? **Pls. 59–60**), 253–54, 319 n. 47, 340
Poulydamas, monument of. *See* Olympia
Praxilla (poetess): statue of, by Lysippos, 290, 312 n. 11. *See also* Berlin Museum, Dancer
Praxiteles (Athenian sculptor): and Praxitelean style, 19, 21 n. 13, 57, 121, 217, 242, 253, 254, 258, 261–67, 282 n. 68, 325, 329–30, 338, 344; and Mantineia Base, 206, 208; as maker of base for Alkamenes' Dionysos: 223 n. 19; as maker of funerary monuments, 165, 186 n. 33; as maker of metal vessels, 294; as maker of tripod base with Dionysos and Nikai, 232–33 n. 59; as maker of votive reliefs, 226 n. 31; signatures, 262
Priene: Athenaion (**Ills. 19–20**), 115, 127, 135–40, 142, 145, 176; heads from (in Berlin and London), 140
Priestly images, 346; on funerary monuments: 159, 171, 179–80 n. 9
Princeton University, Museum of Art: stele of boy Mnesikles (**y86.67, Pl. 36**), 164–65, 360 n. 38; stele of young girl (**y204; Pl. 42**), 169, 181 n. 14
Providence, Rhode Island, School of Design Museum: statue of young girl, (**13.1478, Pl. 43**), 169. *See also* Hermes, **Richelieu (03.008, Pl. 82)**
Pytheos (architect and sculptor from Priene), 122–23, 135, 145
Pythodoros' relief (in Eleusis Museum), 200

Ram, bronze, from Syracuse, 308
Record reliefs. *See* Document reliefs
Reliefs. *See* Banquet scenes; Document reliefs; Funerary sculpture, Lakonian and Tarentine; Mythological reliefs; Votive reliefs
Rhamnous: Apollo from, 275–76 n. 47, 334; funerary monuments from, 218, 348; Temple of Nemesis and cult image, 13, 75 n. 84, 231 n. 53, 271 n. 21, 324
Roman copies, copyists, 12–13, 18–19, 25, 51 (Nikai from Side), 55, 56 (Nereids on dolphins), 72 n. 73, 74 n. 83 (from Loukou), 158, 166, 211, 218, 237, 244, 249, 254, 261, 264, 270 n. 15, 282 n. 70, 307, 323 (Peiraieus Athena), 340, 366–67
Roman sculpture, 88, 96, 151 n. 31, 154 n. 47, 195, 204, 227 n. 35, 247, 248
Rome, Conservatori Museum: Ephedrismos group (**Pl. 8**), 55
Rome, National (Terme) Museum: Greek votive relief (**393**), 221 n. 14; male torso attributed to Argive Heraion, 63 n. 11
Rome, Temple of Apollo Sosianus. *See* Apollo Sosianus

Sacrifice scenes, 83, 92, 124–25, 130, 194, 204
Samothrake: Propylon to Temenos, 142–43, 234 n. 64, 276 n. 50
Sandalbinder. *See* Hermes
Sarcophagi: Etruscan, 7; Lykian, 89; Phoenician, *see* Sidonian; Roman, 81, 101–2, 105 n. 20
Satyros (boxer), 344–45
Satyros (sculptor from Paros), 122, 249–50, 346
Satyrs, 204, 206, 208, 281 n. 66, 351, 370; by Praxiteles (Pouring; Leaning), 265–67, 344

Selective Index

Scale of importance, 49, 83, 160, 181 n. 14, 201, 203–4, 216, 227 nn. 32 and 36

Schools (of sculptors), concept of, 241–43, 366. *See also* Lysippos; Polykleitos

Seven against Thebes, 6, 89

Severizing and Lingering Severe styles, 11–13

Sfumato (renderings), 261, 369

Sidon: Tribune of Eshmoun (**Pls. 55a–c**), 174, 211–15

Sidonian sarcophagi, 7, 12, 100, 158, 173–76, 213–14; Alexander's, 56, 71 n. 66, 173, 175; chronology, 173–74; Likyan, 173; Mourning Women's (**Pls. 47a–b**), 105 n. 21, 153 n. 45, 174–76, 208, 213–14; Satrap's, 173

Signatures, by masters, 36, 121, 135, 166, 238–39, 286–90, 295–96

Silanion (sculptor), 344

Silenos, holding baby Dionysos (by Lysippos?), 305

Sirens: from Dexileos' Precinct (**NM 774**), 5–6, 158; funerary, 162, 370; on stelai, 182 n. 19, 189 n. 49

Skopas (I?), 251–52

Skopas (fourth century Parian sculptor, II): and Skopasian style, 19, 26, 53–54, 97, 145, 165, 217, 242, 253, 262, 326, 340; as maker of metal vessels, 294; at Ephesos, 142; at Halikarnassos, 121–22; at Samothrake, 143–44; at Tegea, 51–52; signatures, 239, 251–58

Skopas *minor* (IV?), 252, 275–76 nn. 45 and 47

Sokrates: portrait by Lysippos, 292

Sorrento: akroterial(?) figures, 74 n. 84. *See also* Artemis, riding hind

Sounion: Temple of Poseidon, 13

Sparta: Amazonomachy metopes, 58

Sphinxes, 100, 110 n. 45, 171, 181 n. 14, 182 n. 19, 192 n. 63

Style, fourth-century, 6, 19, 50, 131–32, 244, 365; "baroque," 135, 366; forerunners (at Bassai), 17; in Lykia, 87, 93; linear development, 19, 264

Stymphalos: Temple of Artemis, 56

Taras: poros frieze, 64 n. 16

Technique, 38–39, 128, 149 n. 19, 281–82 n. 67; akrolithic, 122, 135, 248; appliqué, 49, 71 n. 64, 93; chryselephantine, 14, 17, 25–26, 36, 45, 49, 60 n. 2, 122, 194, 248, 358 n. 30; cookie-cutter, 88; in metal (including bronze-casting, engraving, imitation, and painting), 16, 24 n. 31, 48, 62 n. 10, 100, 133, 320 n. 57, 343, 345, 350, 352 n. 1, 359 n. 35, 360 n. 40, 361 n. 41; separately carved heads, 51, 88, 150 n. 26, 332, 349; struts, 307, 320 n. 55

Tegea
—Federal Altar, 54
—relief from (with Ada and Idrieus). *See* London, British Museum
—symplegma (ephedrismos), 55
—Temple of Athena Alea, including sculptures (**Pl. 7**), 14, 46, 48–52, 53, 55, 97, 116, 145; cult images, 49, 51; echo of cult images in votive relief, 70 n. 63, 275 n. 45

Telemachos Relief (fragments in various museums), 200, 221 n. 14

Telephos, 49–50, 87

Terracotta busts, from Magna Graecia, 333–34

Thebes: stele of hunter, from Thespiai (**Pl. 45**), 171; Temple of Herakles, 57

Thodoros (architect from Phokaia), 43

Theodotos (architect of Epidaurian Asklepieion), 43

Theokosmos (sculptor from Megara), 17, 26, 240

Theseus, 12, 86, 88, 94, 152 n. 38, 229 n. 44; deeds, 44–45, 58, 64 n. 23, 77 n. 93, 92, 124, 129, 141; in boar hunt, 49. *See also* Amazons, Amazonomachy

Thrasymedes (sculptor from Paros), 36, 37

Timotheos (sculptor; from Epidauros?), 36–37, 54, 55, 121–22, 244–48, 326, 358 n. 30

Titane: Asklepieion, 57, 358 n. 30

Tribune of Eshmoun. *See* Sidon

Triptolemos, 205

Trojan themes (on various buildings), 23 n. 25, 64–65 nn. 23–24, 92

Trysa, Heroon (**Pls. 24, 25a–c; Ills. 12–13**), 78, 87, 88–93, 129

Tyche, 203, 339

Vergina Peplophoros, 347

Volo Museum: stele from Larisa (**Pl. 46**), 172

Votive reliefs, 194–204; chronology, 193;

399

Selective Index

Votive reliefs (*continued*)
frame, 183 n. 19, 195, 198–99; landscape renderings, architectural, 195–97; landscape renderings, cave-like, 197–99; landscape renderings, with natural features, 199–200; mass-produced, 210; masters (influence), 217; materials, 194–95; presence of children/families on, 201–2. *See also* Banquet scenes; Funerary sculpture, Lakonian and Tarentine; Mythological reliefs

Waterspouts. *See* Lion-heads

Xanthos, Nereid Monument (**Pls. 12–19, Ills. 10–11**), 12, 78–88, 93, 94–95, 101, 115, 125, 126, 129, 139, 149 n. 22, 191 n. 61; akroteria (**Pl. 23**), 84, 86; Nereids (**Pls. 20–22**), 84–86, 175, 246

Yalnızdam Stele. *See* Antalya Museum

Zeus, 337. *See also* Olympia, Temple of, cult image

Plates

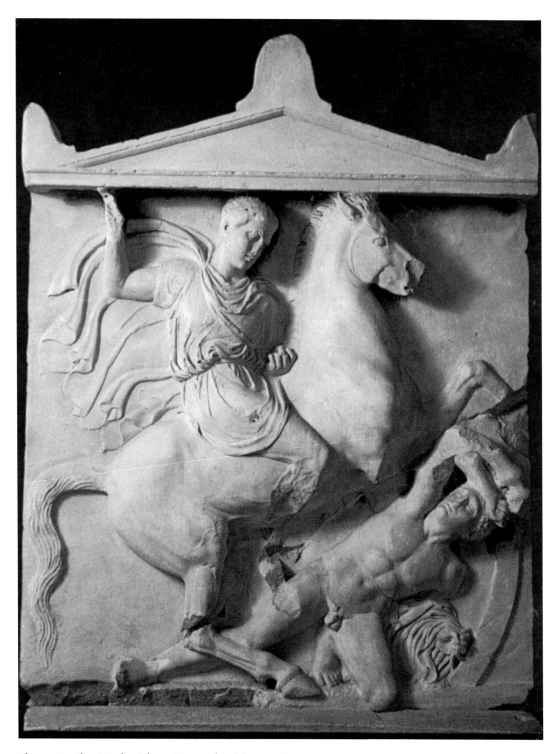

Plate 1. Dexileos' Stele, Athens, Kerameikos Museum P 1130

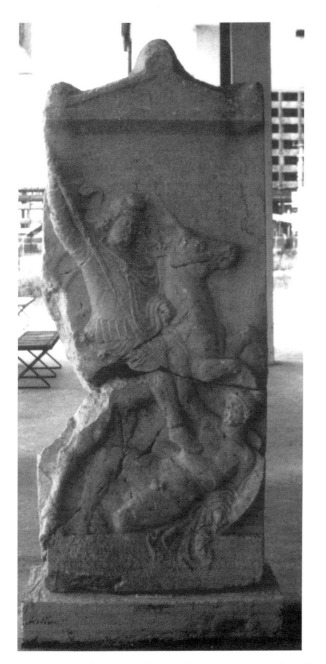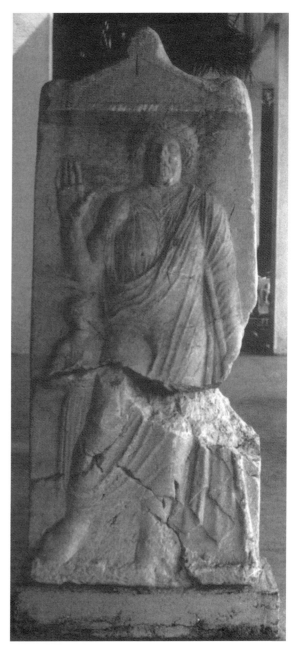

Plates 2a–d. Yalnızdam Stele, Antalya Museum: (a) Side A; (b) Side B; (c) detail of Side A; (d) detail of Side B

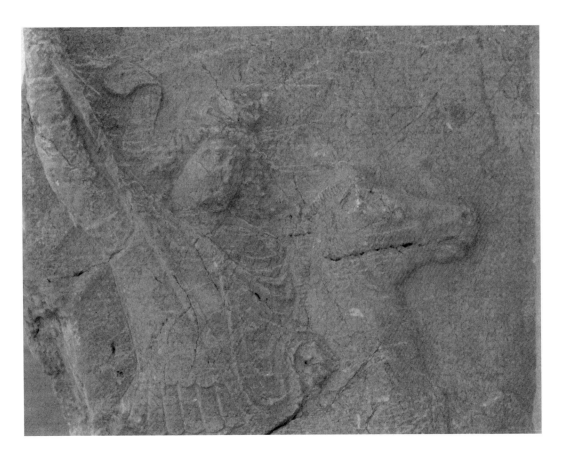

Plate 3. Bassai, Temple of Apollo, metope, London, BM 512 (Madigan 1992: Pronaos 1.1, no. 45, pl. 15)

Plate 4. Bassai, Temple of Apollo, metope, London, BM 517A (Madigan 1992: Opisthodomos 5.1, no. 35, pl. 12)

Plate 5. Bassai, Temple of Apollo, metope, London, BM 519 (Madigan 1992: Opisthodomos 6.2, no. 43, pl. 14)

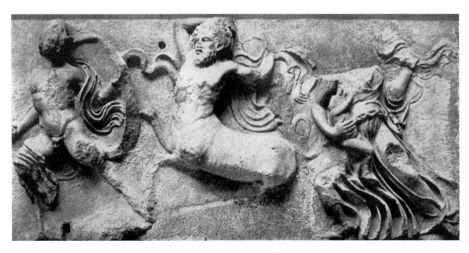

Plate 6. Bassai, Temple of Apollo, frieze (Centauromachy), London, BM 525 (Madigan 1992: no. 134, pl. 43)

Plate 7. Tegea, Athenaion, helmeted head from west pediment (without restorations), Athens, NM 180

Plate 8. Ephedrismos group from Tegea (without restorations), Rome, Conservatori Museum 1465

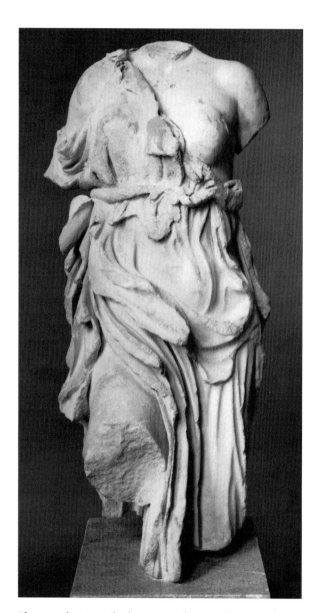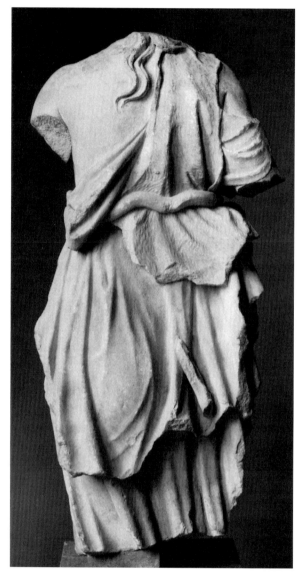

Plates 9a–b. Maenad (akroterion), front and back, Oxford, Ashmolean Museum 1928.530

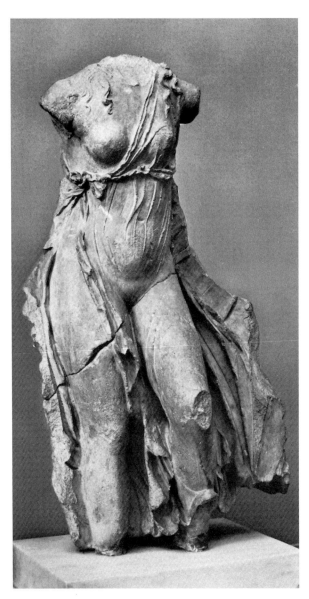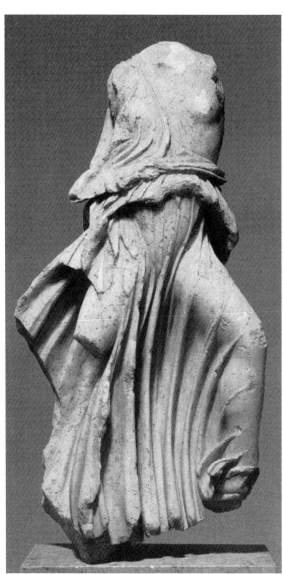

Plate 10. So-called Aura (akroterion), Copenhagen, Ny Carlsberg Glyptotek 2432

Plate 11. Running peplophoros, akroterion from limestone Athenaion (?), Delphi Museum 8605

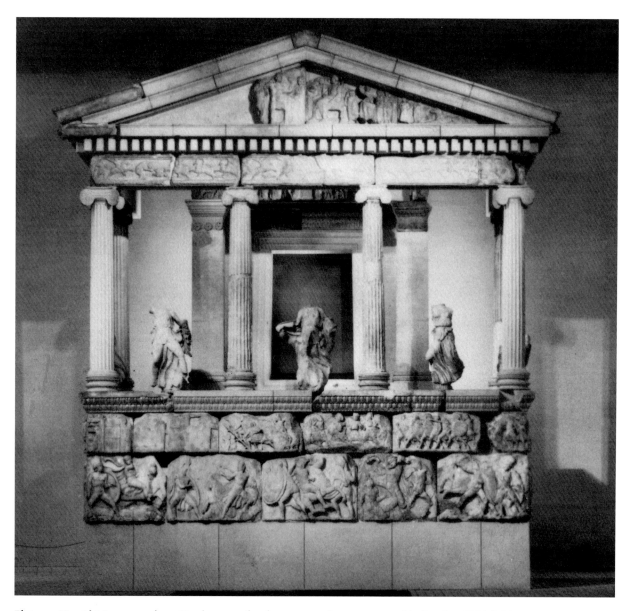

Plate 12. Nereid Monument from Xanthos, east façade, as presently reconstructed in London, British Museum

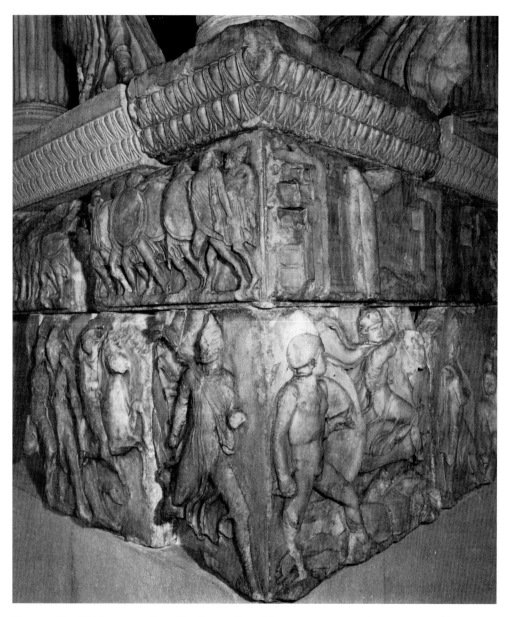

Plate 13. Nereid Monument from Xanthos, podium friezes 1–2, as presently reconstructed in London, British Museum (corner view)

Plate 14. Nereid Monument from Xanthos, frieze 2, west façade, London, BM 877 (Childs/Demargne 1989, pl. 60.1). Note funerary monument.

Plate 15. Nereid Monument from Xanthos, frieze 2, north side, London, BM 876L (Childs/Demargne 1989, pl. 65.2). Note rough terrain or river.

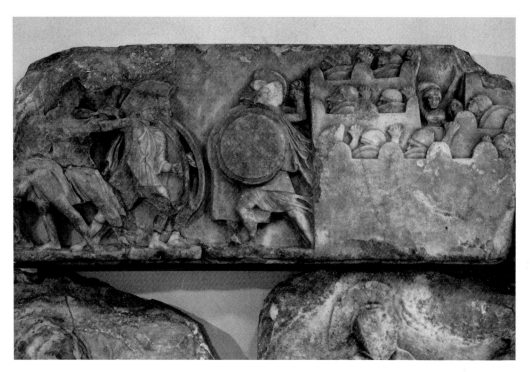

Plate 16. Nereid Monument from Xanthos, frieze 2, south side, London, BM 869 (Childs/Demargne 1989, pl. 48.1). Note woman in distress.

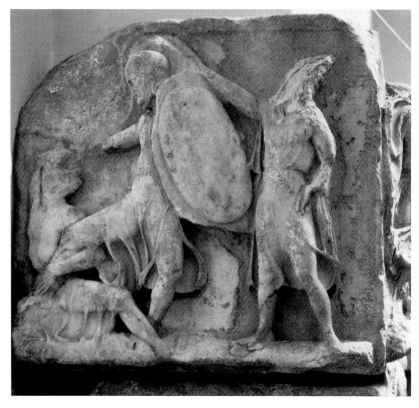

Plate 17. Nereid Monument from Xanthos, frieze 2, west façade, London, BM 868c (Childs/Demargne 1989, pl. 65.1)

Plate 18. Nereid Monument from Xanthos, frieze 3, north side, London, BM 886/893 (Childs/Demargne 1989, pl. 128.3)

Plate 19. Nereid Monument from Xanthos, frieze 1, north side, London, BM 857 (Childs/Demargne 1989, pl. 32.1)

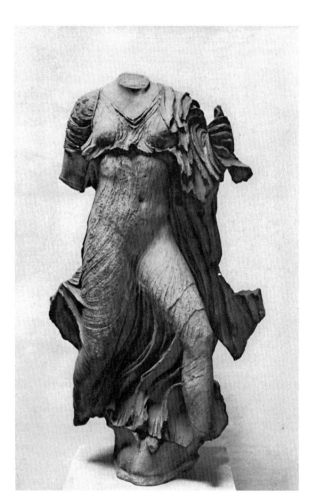

Plate 20. Nereid from Xanthos, Nereid Monument, north side, London, BM 909

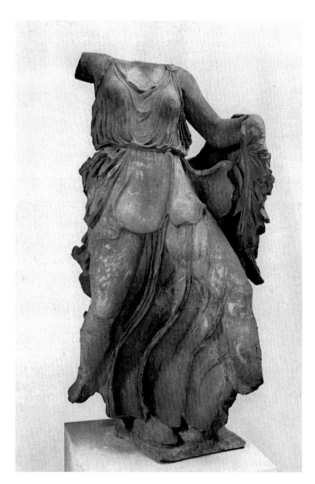

Plate 21. Nereid from Xanthos, Nereid Monument, north side, London, BM 911

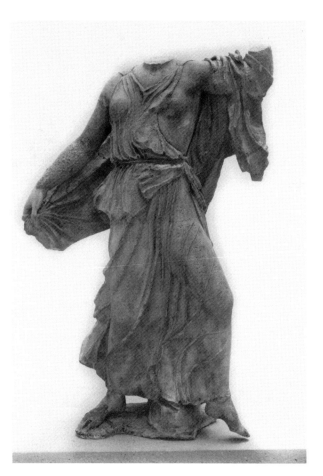

Plate 22. Nereid from Xanthos, Nereid Monument, west façade, London, BM 912

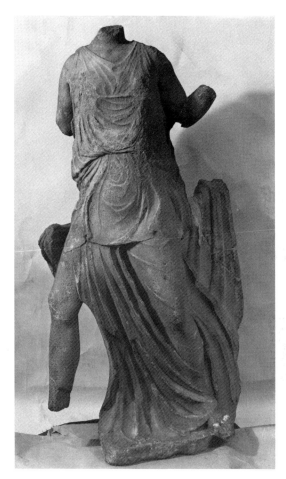

Plate 23. Akroterial figure from Xanthos, Nereid Monument, east façade, London, BM 919 (Childs/Demargne 1989, pl. 151.1)

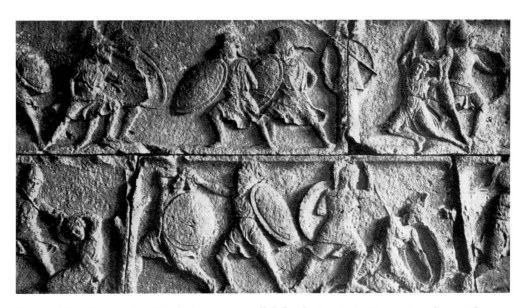

Plate 24. Trysa Heroon, Land Battle frieze, west wall (left side, interior), Vienna, Kunsthistorisches Museum

Plates 25a–c. Trysa Heroon, City Siege sequence (Troy?), west wall (center, interior), Vienna, Kunsthistorisches Museum

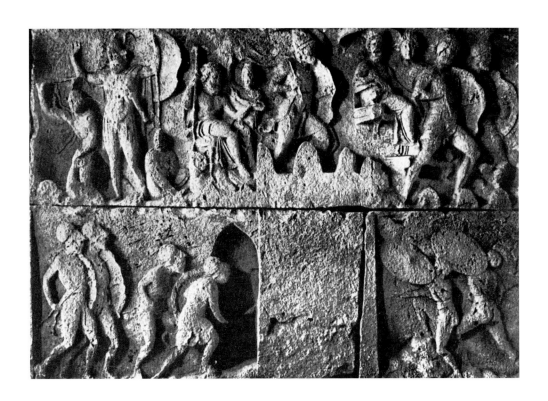

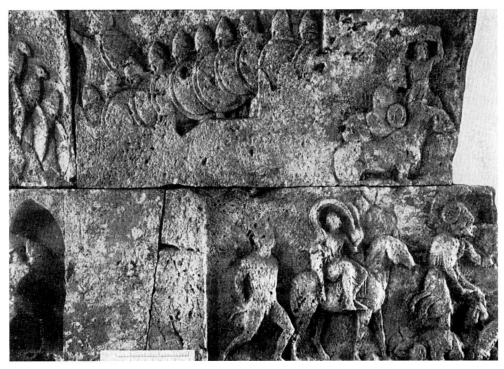

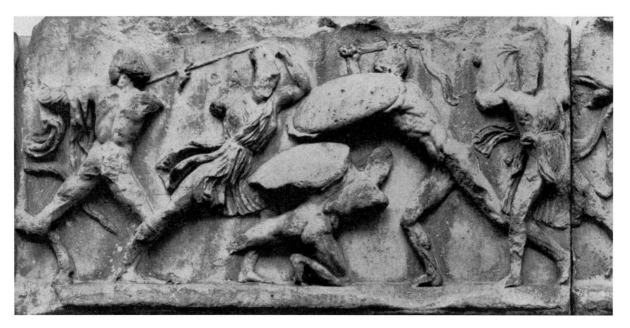
Plate 26. Halikarnassos Maussolleion, Amazonomachy (podium) frieze, London, BM 1020–1021

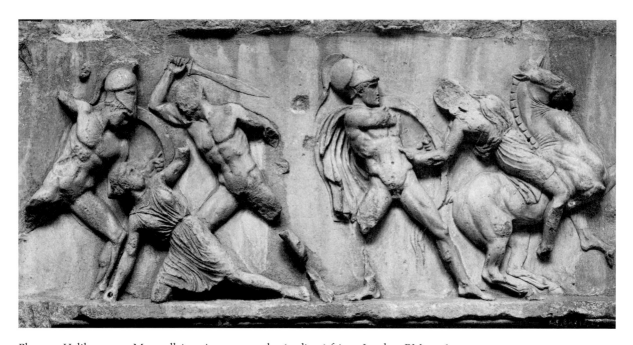
Plate 27. Halikarnassos Maussolleion, Amazonomachy (podium) frieze, London, BM 1006

Plate 28. Halikarnassos Maussolleion, so-called Maussollos, London, BM 1000

Plate 29. Halikarnassos Maussolleion, horse from crowning quadriga, London, BM 1002

Plate 30. Funerary loutrophoros, Athens, NM 808 (foot, neck, and handles restored; cf. Kokula 1984, 200, Cat. O 30, and p. 130 n. 55)

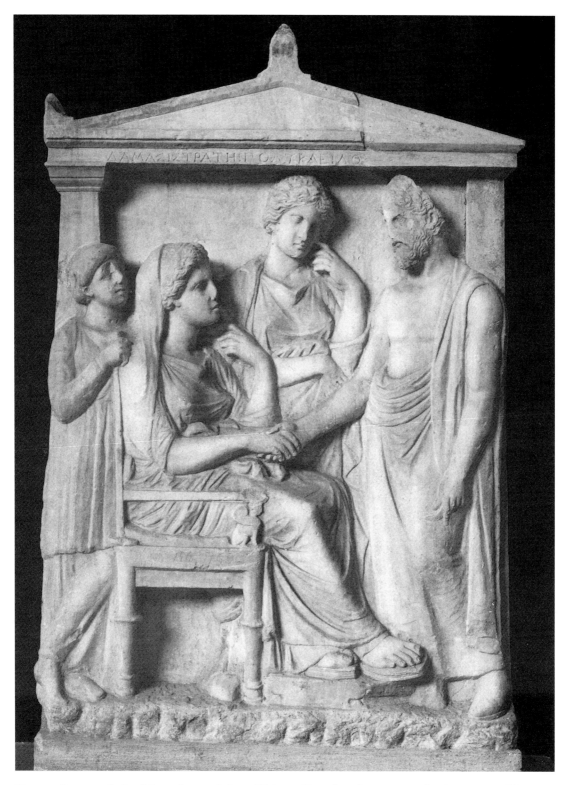

Plate 31. Funerary Stele of Damasistrate, Athens, NM 743. Note the sphinx-support for the armrest of the throne.

Plate 32. Stele of a warrior, Athens, NM 834

Plate 33. Stele of Two Warriors, Moscow, Pushkin Museum

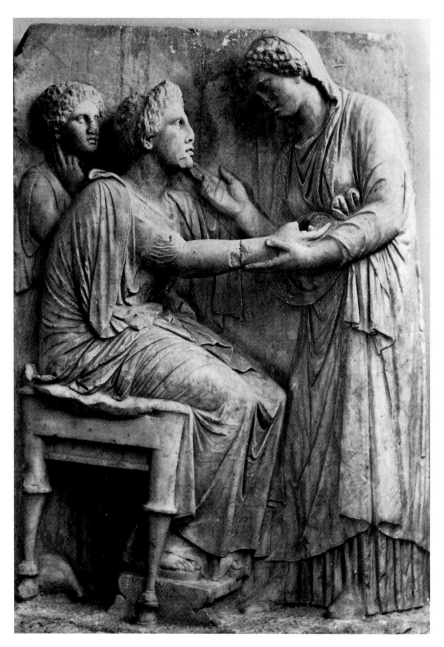

Plate 34. Funerary stele with family scene, Athens, NM 870. Note the seated woman's hairstyle.

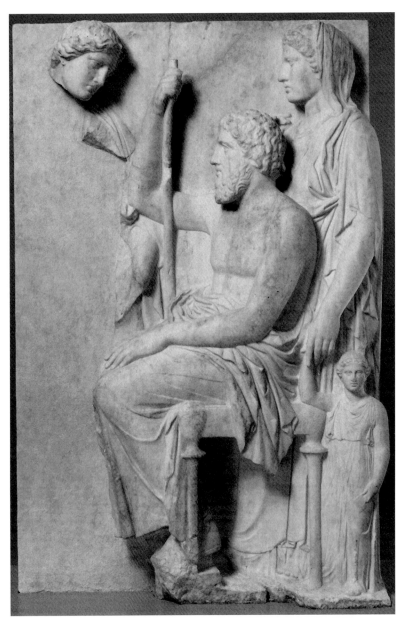

Plate 35. Funerary stele, New York, Metropolitan Museum of Art 11.100.2, Rogers Fund 1911

Plate 36. Stele of Mnesikles, Princeton University, The Art Museum y86.67, Fowler McCormick, Class of 1921, Fund

Plate 37. Funerary Lion, Chaironeia, Greece

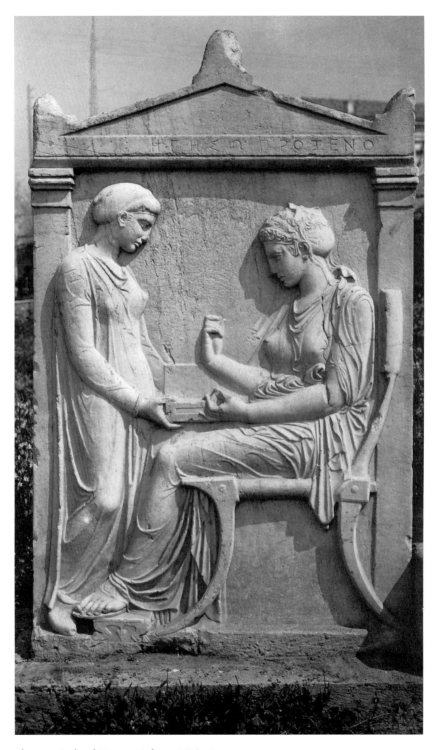

Plate 38. Stele of Hegeso, Athens, NM 3624

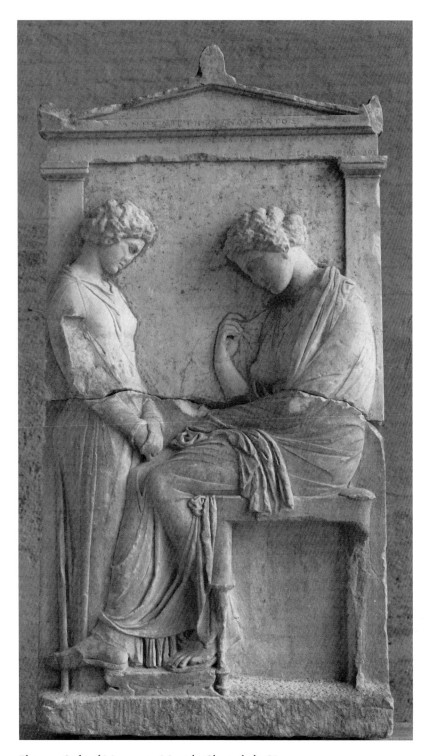

Plate 39. Stele of Mnesarete, Munich, Glyptothek, GL 491

Plate 40. Stele of Kallisto, Athens, NM 732

Plate 41. Stele of Krinylla and family, Philadelphia, University of Pennsylvania Museum, MS 5470

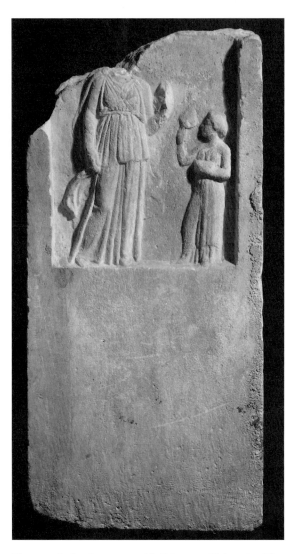

Plate 42. Stele of a young girl, Princeton University, The Art Museum y204, Gift of Mrs. Ernest Sandoz

Plate 43. Young girl, Providence, Museum of Art, Rhode Island School of Design 13.1478, Gift of Mrs. Gustav Radeke

Plate 44. Funerary stele, Philadelphia, University of Pennsylvania Museum MS 5675

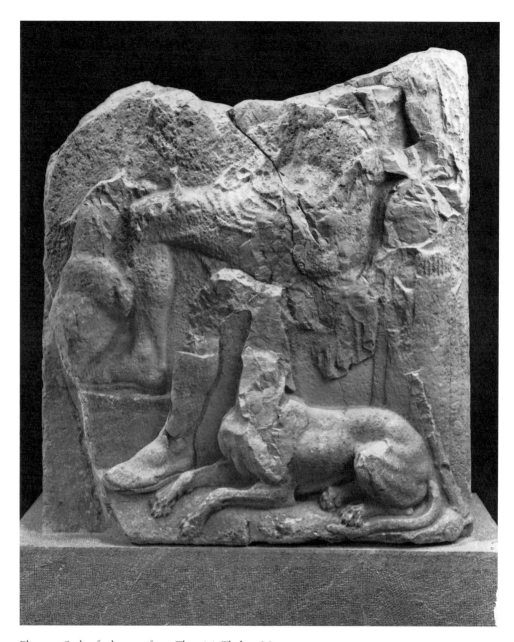

Plate 45. Stele of a hunter, from Thespiai, Thebes, Museum no. 33

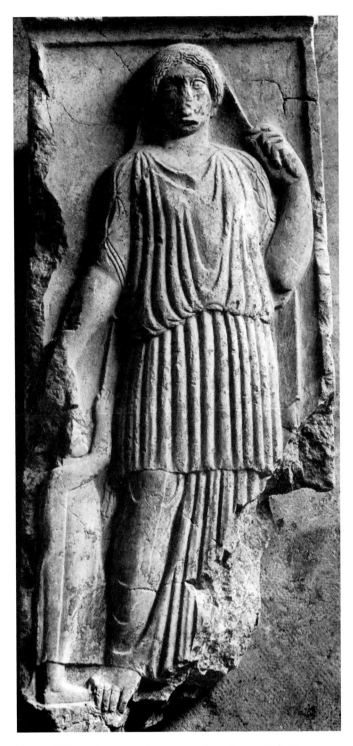

Plate 46. Thessalian stele of a woman, from Larisa, Volo Museum

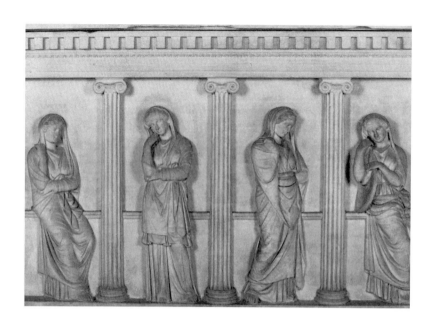

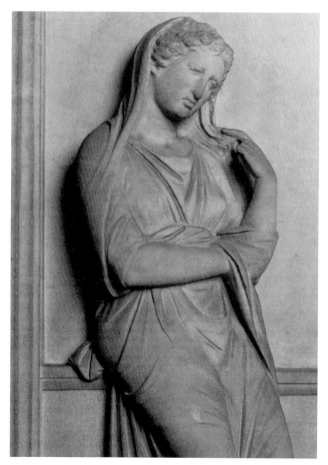

Plates 47a–b. Sarcophagus of the Mourning Women, Istanbul Archaeological Museum 368

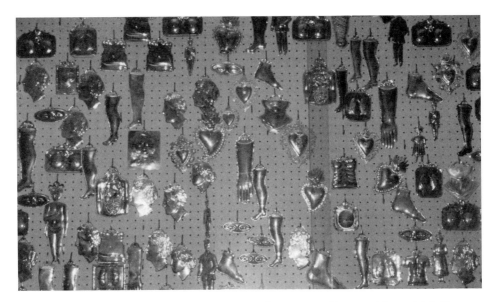

Plate 48. Modern ex-votos in the grotto of St. Rosalia, Monte Pellegrino (Palermo) (cf. Chapter 6, n. 7)

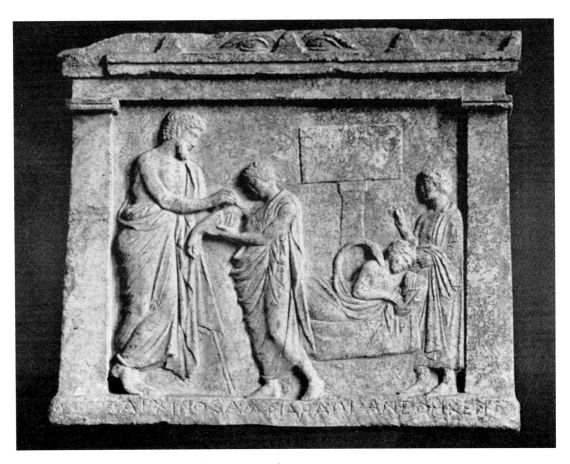

Plate 49. Votive relief to Amphiaraos from Oropos, Athens, NM 3369

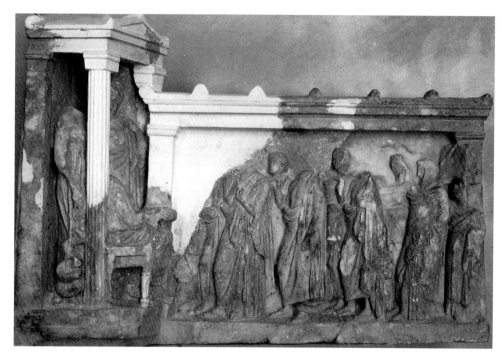

Plate 50. Votive relief to Asklepios, from south slope of Akropolis, Athens, NM 1377

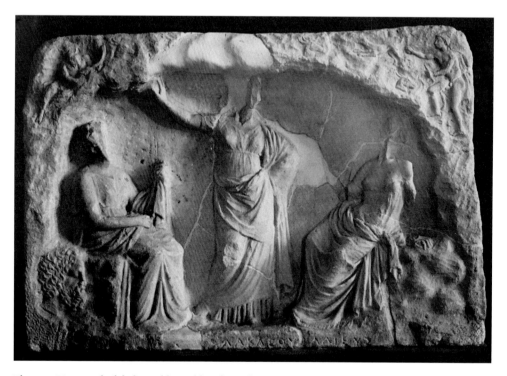

Plate 51. Votive relief dedicated by Eukles, from the Vari cave, Athens, NM 2012

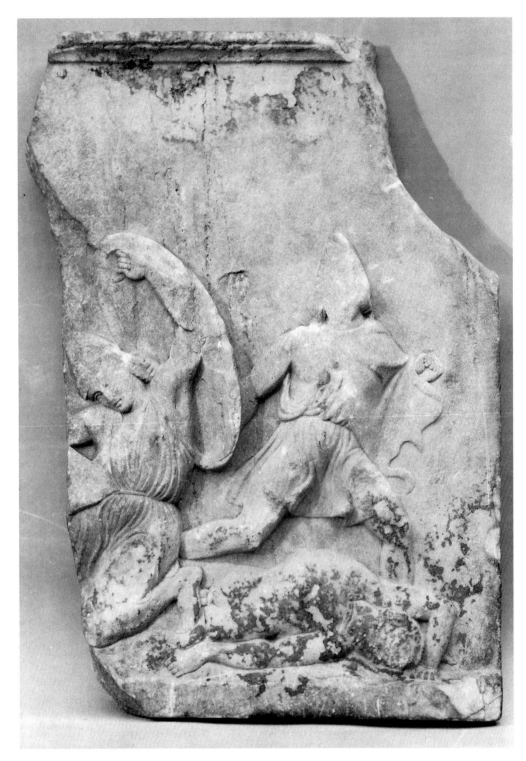

Plate 52. Battle relief, New York, Metropolitan Museum of Art 29.47, Fletcher Fund 1929

Plate 53. Votive relief with Birth of Asklepios, from south slope of Akropolis, Athens, NM 1351

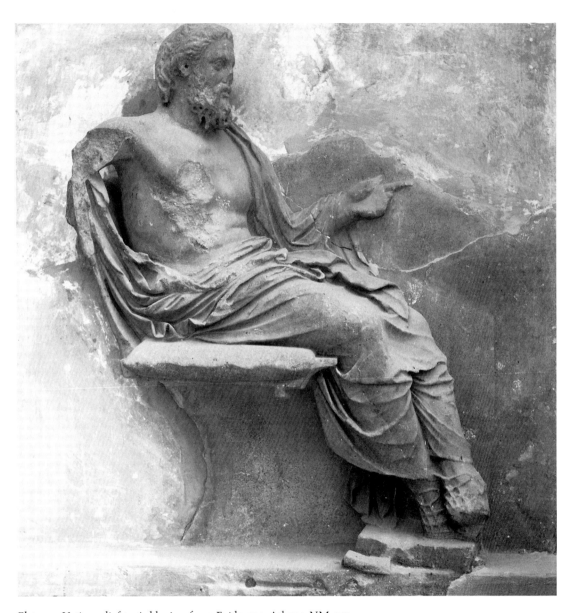
Plate 54. Votive relief to Asklepios, from Epidauros, Athens, NM 173

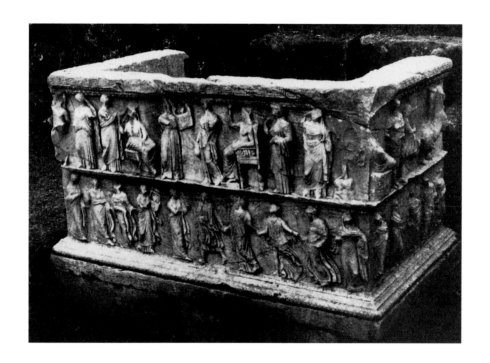

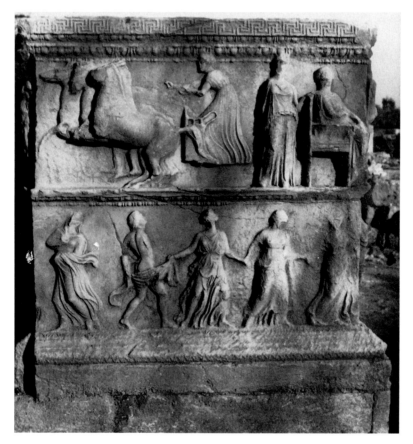

Plates 55a–c. Tribune of Eshmoun, Sidon: (a) three-quarter view; (b) left side; (c) rear

Plate 56. Diskobolos (by Naukydes?), replica, Rome, Capitoline Museum 1865

Plate 57. Diskobolos (by Naukydes?), replica, Vatican Museum 2349

Plate 58. Ganymede and the Eagle, Vatican Museum 2445

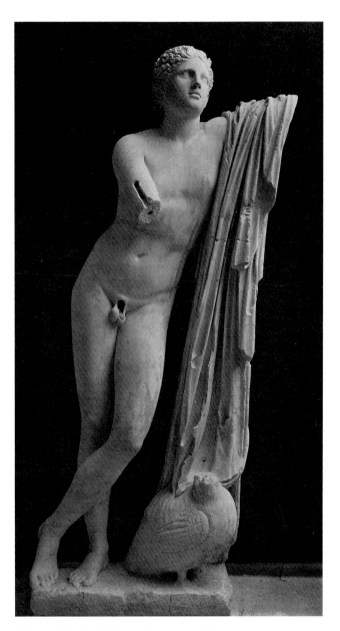

Plate 59. "Pothos," Rome, Conservatori Museum 2417

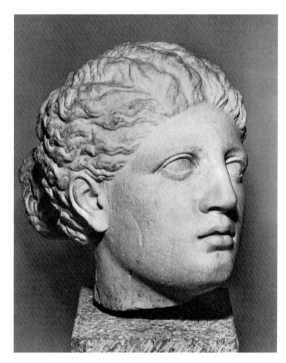

Plate 60. Head of "Pothos," Würzburg, Martin von Wagner Museum

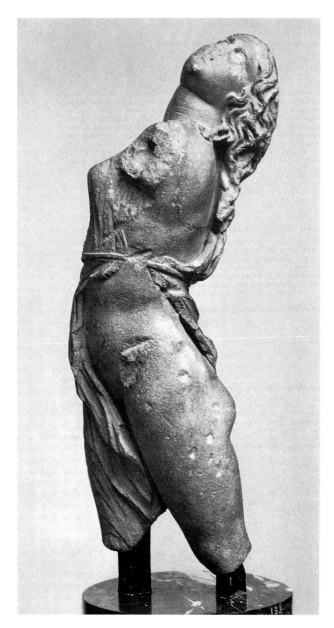

Plate 61. Frenzied Maenad, Dresden, Albertinum und
Staatliche Kunstsammlungen 133

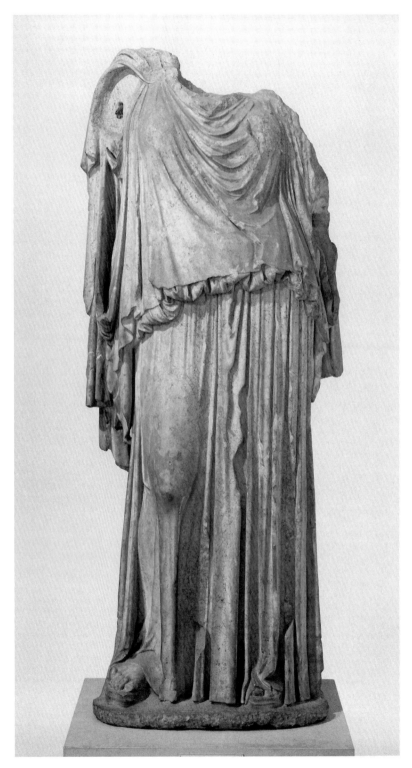

Plate 62. Eirene (and Ploutos), by Kephisodotos, New York, Metropolitan Museum of Art 06.311, Rogers Fund

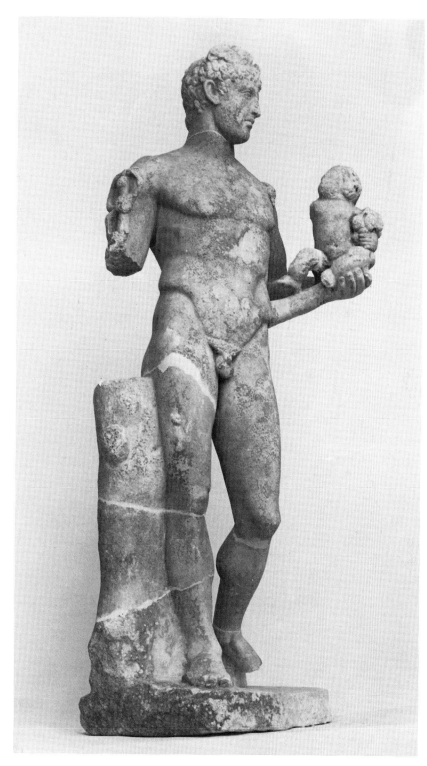

Plate 63. Hermes and Child Dionysos, from theater at Minturnae, Naples, Museo Nazionale 155747

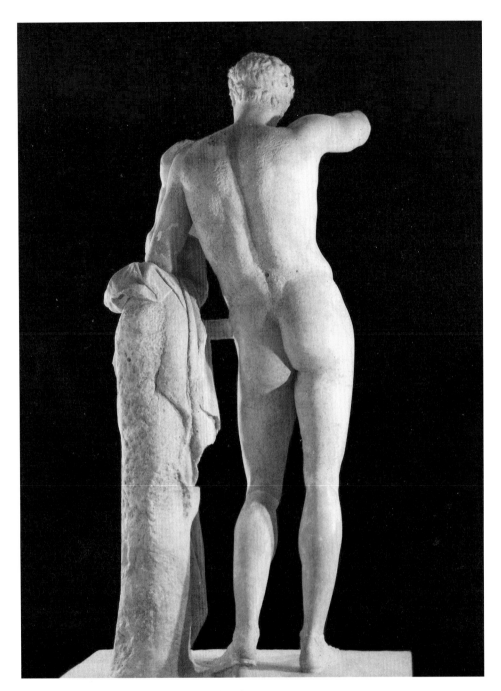

Plate 64. Hermes of Olympia, view of back, Olympia Museum

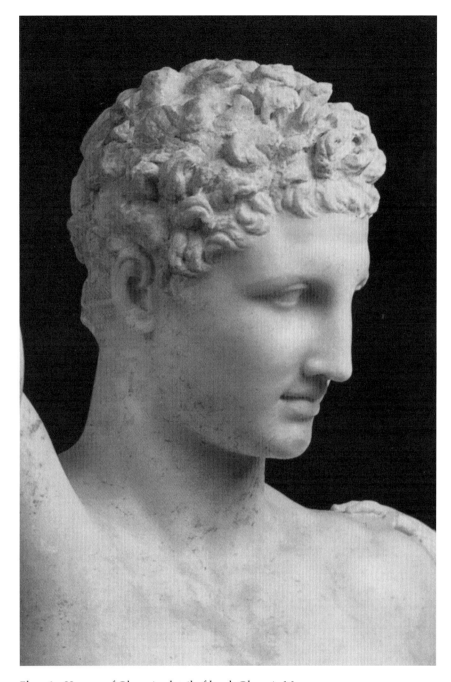

Plate 65. Hermes of Olympia; detail of head, Olympia Museum

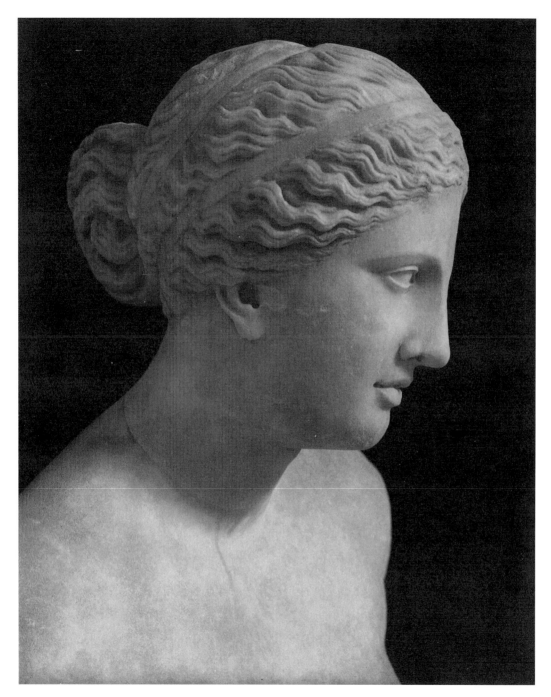

Plate 66. Aphrodite Knidia, by Praxiteles, replica, Vatican Museum 812, detail of head, right profile

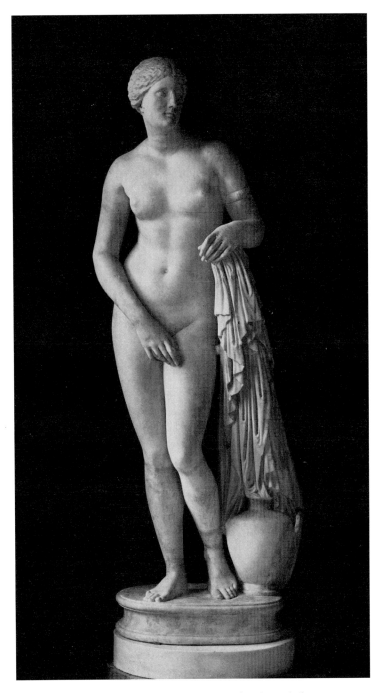

Plate 67. Variant of Knidian Aphrodite, Munich, Glyptothek GL 258

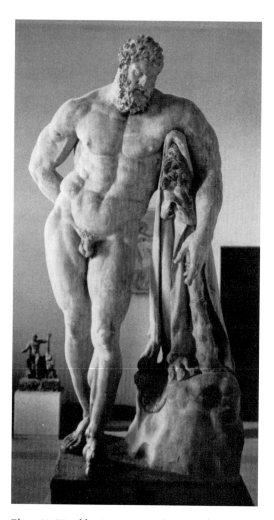

Plate 68. Herakles Farnese, Naples, Museo Nazionale 6001

Plate 69. Herakles Epitrapezios, from Villa del Sarno, near Pompeii, Naples, Museo Nazionale 2828

Plate 70. Herakles Epitrapezios, Paris, Musée du Louvre MA 28

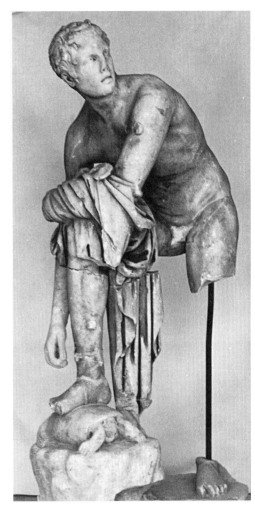

Plate 71. Sandalbinder (Hermes) from Perge, Antalya Museum 3.25.77

Plate 72. Sandalbinder, unfinished, Athens, Akropolis Museum 2192

Plate 73. Dancer, Berlin, Staatliche Museen SK 208 (cf. Chapter 8, n. 11)

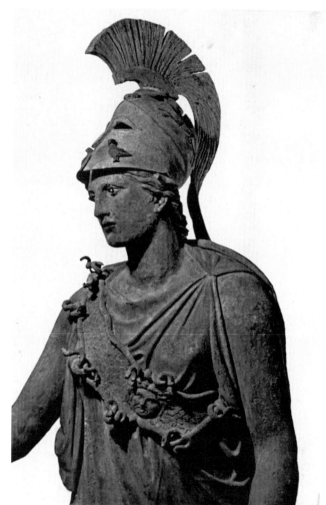

Plates 74a–c. Bronze Athena from the Peiraieus, Peiraieus Museum, various views

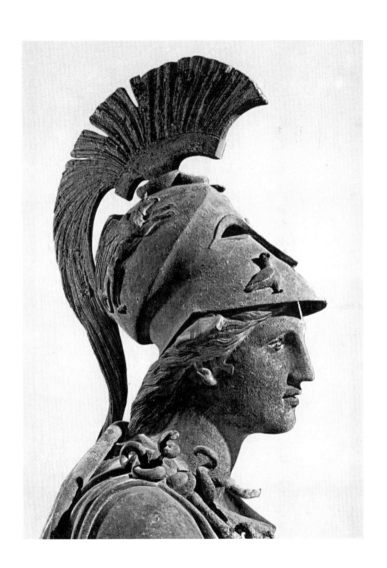

Plate 75. Classicizing Peplophoros, rear view, Boston, Isabella Stewart Gardner Museum

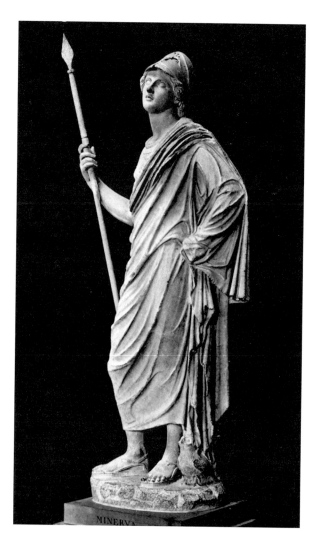

Plate 76. Athena, Rospigliosi Type, from Velletri, Florence, Uffizi 185

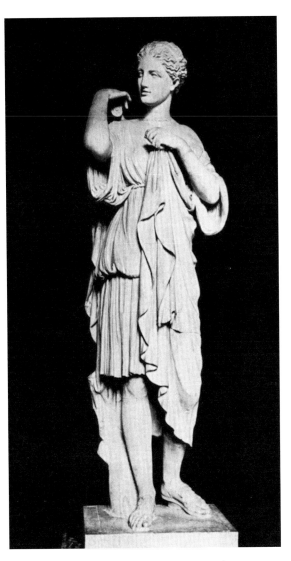

Plate 77. Artemis from Gabii, Paris, Musée du Louvre MA 529

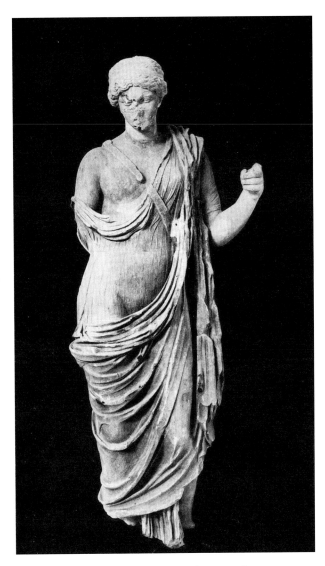

Plate 78. Armed Aphrodite, from Epidauros, Athens, NM 262

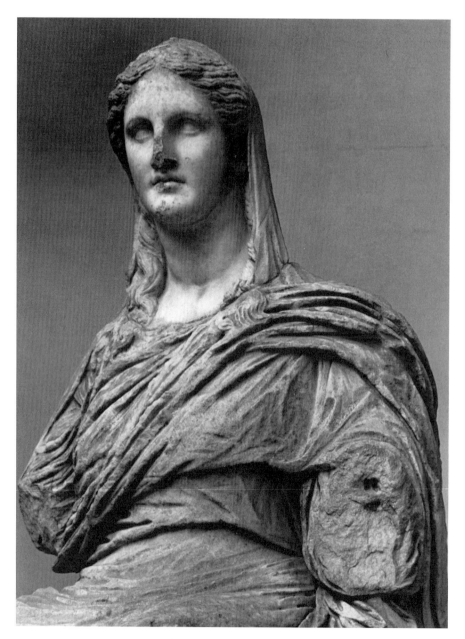

Plates 79a–c. Demeter from Knidos, London, BM 1300: (a) detail of front; (b–c) views of head from rear

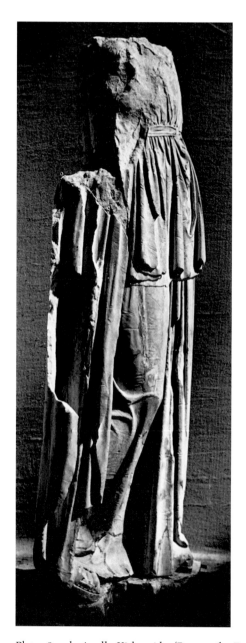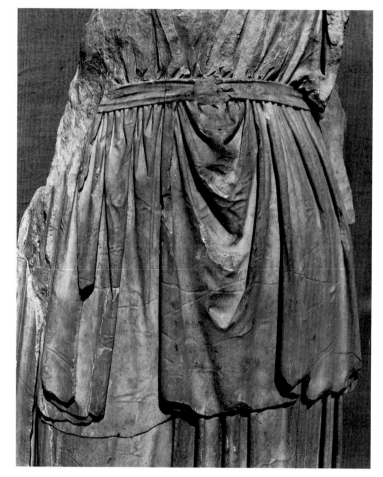

Plates 80a–b. Apollo Kitharoidos/Patroos (by Euphranor?), Athens, Agora Museum S 2154: (a) right profile; (b) detail of torso

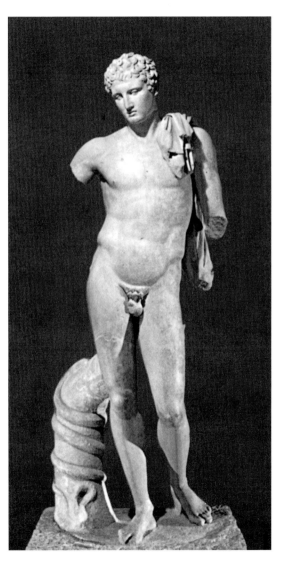

Plate 81. Hermes from Andros, once Athens, NM 218 (now Andros Museum 245?)

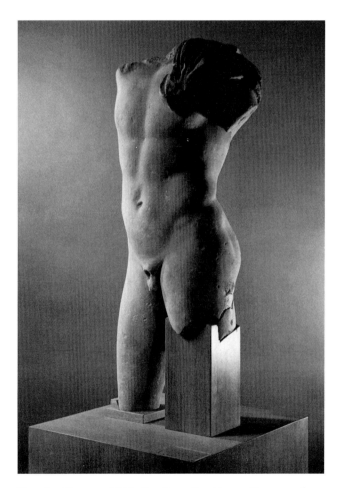

Plate 82. Hermes of Richelieu Type, Providence, Museum of Art, Rhode Island School of Design 03.008, Gift of Mrs. Gustav Radeke

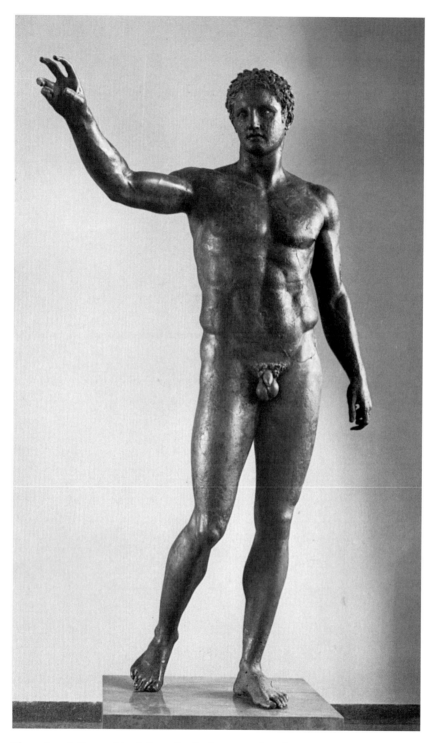

Plates 83a–d. Bronze Youth from Antikythera Wreck, Athens, NM 13396: (a) front; (b) detail of torso, front; (c) detail of torso, back; (d) face

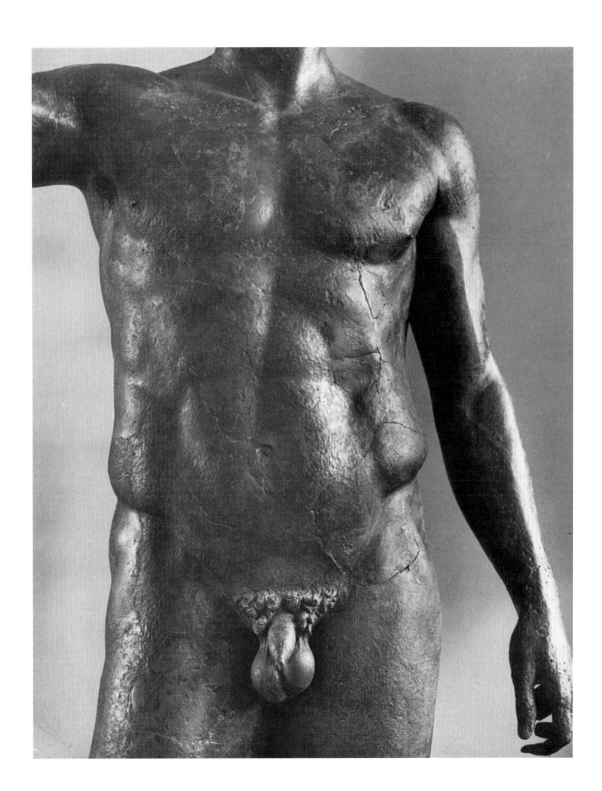

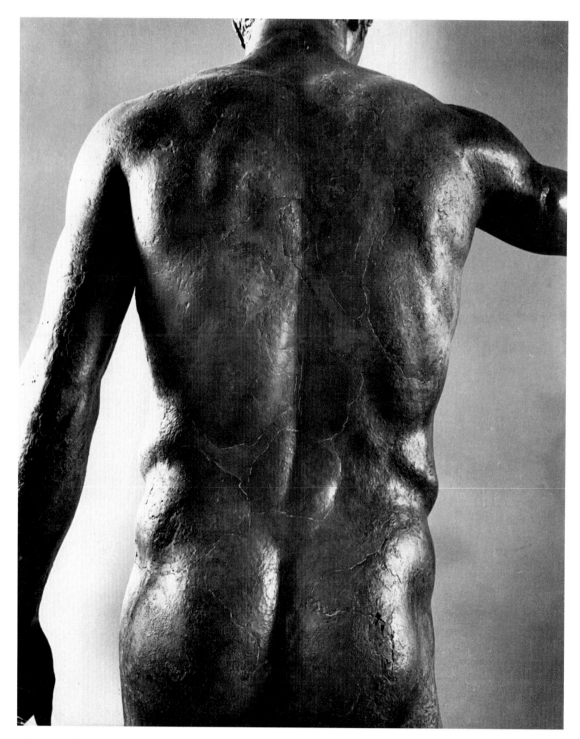

Plates 83c–d.

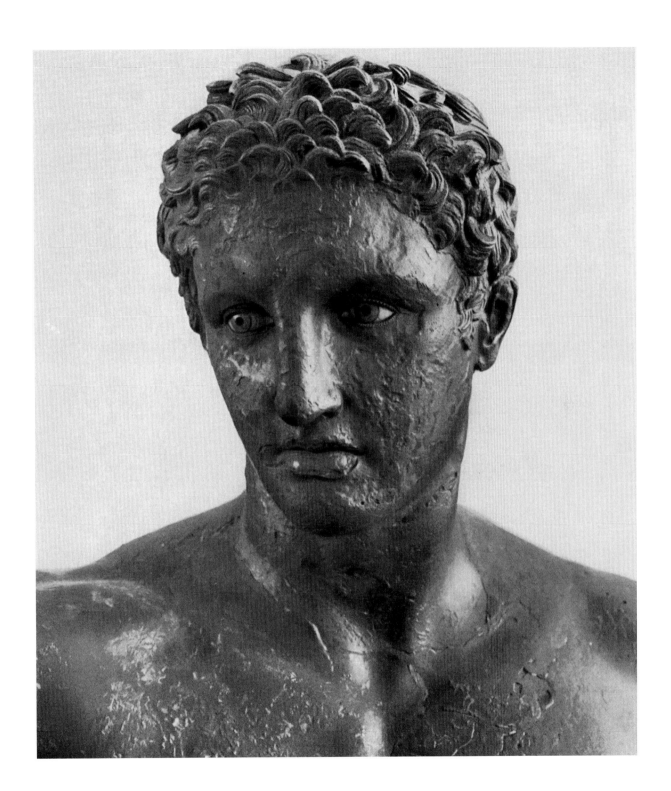

Plates 84a–c. Bronze Youth from Marathon, Athens, NM 15118: (a) front; (b) reconstruction by R. Carpenter; (c) reconstruction by R. Heidenreich

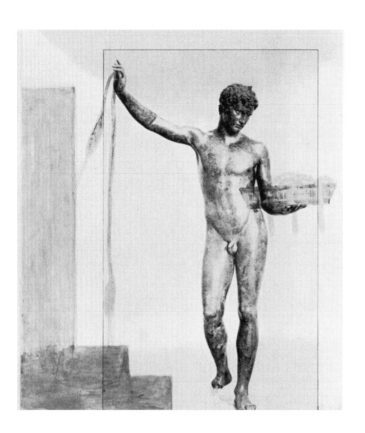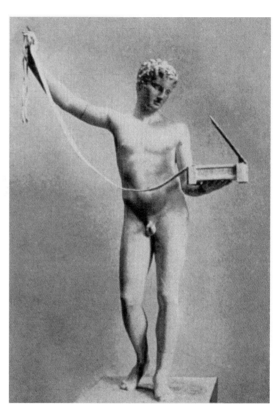

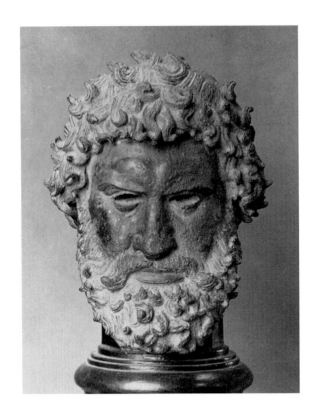
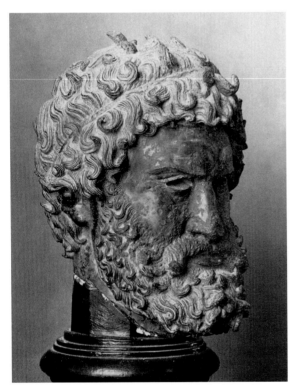
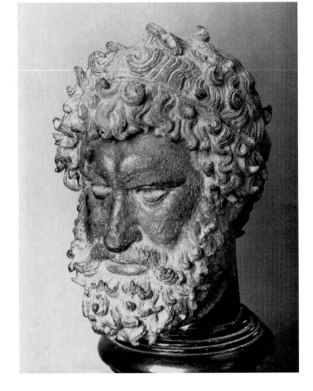

Plates 85a–e. Bronze Boxer from Olympia, Athens, NM 6439

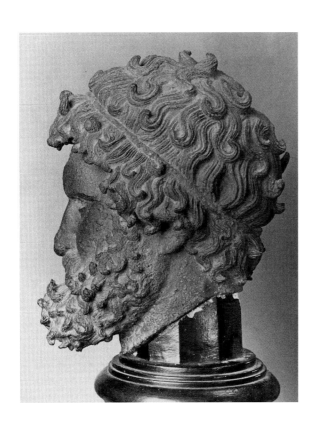 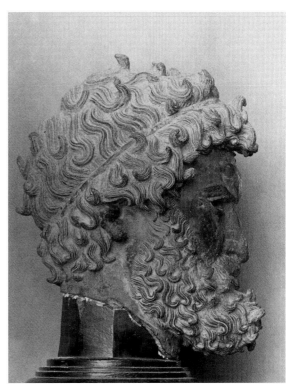

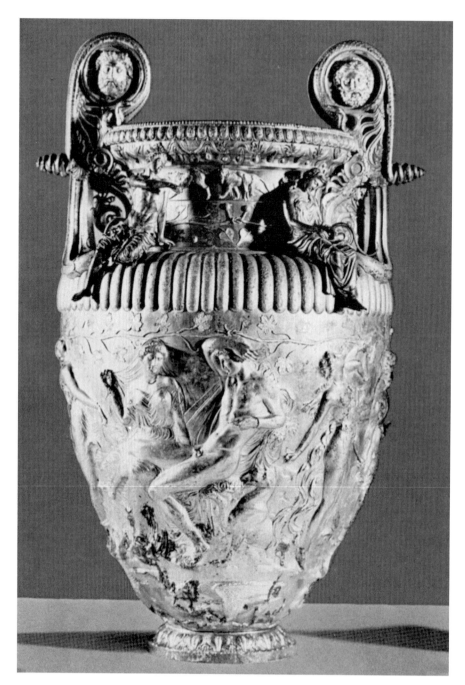

Plates 86a–b. Bronze krater from Derveni, Thessaloniki Museum: (a) full view; (b) detail of shoulder figure

WISCONSIN STUDIES IN CLASSICS

General Editors
Richard Daniel De Puma and Barbara Hughes Fowler

E. A. THOMPSON
Romans and Barbarians: The Decline of the Western Empire

JENNIFER TOLBERT ROBERTS
Accountability in Athenian Government

H. I. MARROU
A History of Education in Antiquity
Histoire de l'Education dans l'Antiquité, translated by George Lamb (originally published in English by Sheed and Ward, 1956)

ERIKA SIMON
Festivals of Attica: An Archaeological Commentary

G. MICHAEL WOLOCH
Roman Cities: Les villes romaines by Pierre Grimal, translated and edited by G. Michael Woloch, together with A Descriptive Catalogue of Roman Cities by G. Michael Woloch

WARREN G. MOON, editor
Ancient Greek Art and Iconography

KATHERINE DOHAN MORROW
Greek Footwear and the Dating of Sculpture

JOHN KEVIN NEWMAN
The Classical Epic Tradition

JEANNY VORYS CANBY, EDITH PORADA, BRUNILDE SISMONDO RIDGWAY, and TAMARA STECH, editors
Ancient Anatolia: Aspects of Change and Cultural Development

ANN NORRIS MICHELINI
Euripides and the Tragic Tradition

WENDY J. RASCHKE, editor
The Archaeology of the Olympics: The Olympics and Other Festivals in Antiquity

PAUL PLASS
Wit and the Writing of History: The Rhetoric of Historiography in Imperial Rome

BARBARA HUGHES FOWLER
The Hellenistic Aesthetic

F. M. CLOVER and R. S. HUMPHREYS, editors
Tradition and Innovation in Late Antiquity

BRUNILDE SISMONDO RIDGWAY
Hellenistic Sculpture I: The Styles of ca. 331–200 B.C.

BARBARA HUGHES FOWLER, editor and translator
Hellenistic Poetry: An Anthology

KATHRYN J. GUTZWILLER
Theocritus' Pastoral Analogies: The Formation of a Genre

VIMALA BEGLEY and RICHARD DANIEL De PUMA, editors
Rome and India: The Ancient Sea Trade

RUDOLPH BLUM
HANS H. WELLISCH, translator
Kallimachos: The Alexandrian Library and the Origins of Bibliography

DAVID CASTRIOTA
Myth, Ethos, and Actuality: Official Art in Fifth-Century B.C. Athens

BARBARA HUGHES FOWLER, editor and translator
Archaic Greek Poetry: An Anthology

JOHN H. OAKLEY and REBECCA H. SINOS
The Wedding in Ancient Athens

RICHARD DANIEL De PUMA and JOCELYN PENNY SMALL, editors
Murlo and the Etruscans: Art and Society in Ancient Etruria

JUDITH LYNN SEBESTA and LARISSA BONFANTE, editors
The World of Roman Costume

JENNIFER LARSON
Greek Heroine Cults

WARREN G. MOON, editor
Polykleitos, the Doryphoros, and Tradition

PAUL PLASS
The Game of Death in Ancient Rome: Arena Sport and Political Suicide

SUSAN B. MATHESON
Polygnotos and Vase Painting in Classical Athens

JENIFER NEILS, editor
Worshipping Athena: Panathenaia and Parthenon

PAMELA A. WEBB
Hellenistic Architectural Sculpture: Figural Motifs in Western Anatolia and the Aegean Islands

BRUNILDE SISMONDO RIDGWAY
Fourth-Century Styles in Greek Sculpture